Empire of Emptiness

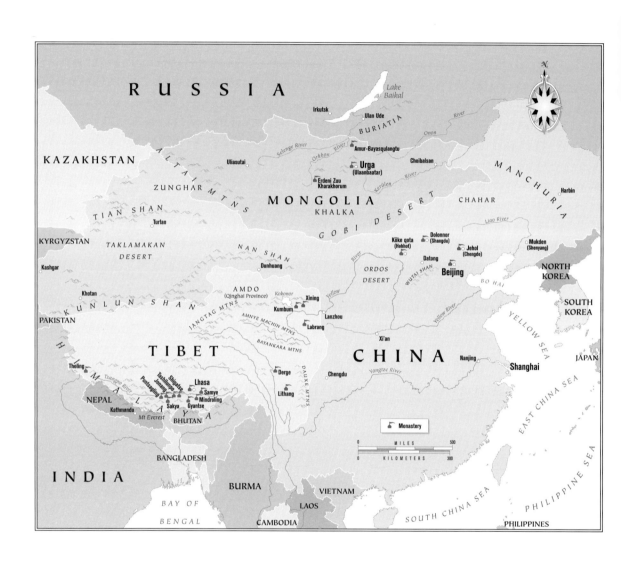

Empire of Emptiness

BUDDHIST ART AND POLITICAL AUTHORITY

IN QING CHINA

PATRICIA BERGER

 University of Hawai'i Press
Honolulu

Library of Congress Cataloging-in-Publication Data
Berger, Patricia Ann.
Empire of emptiness : Buddhist art and political authority in Qing China / Patricia Berger.
 p. cm.
Includes bibliographical references and index.
 ISBN 0-8248-2563-2 (alk. paper)
 1. Art, Buddhist—China. 2. Buddhist art and symbolism—China. 3. Art, Chinese—
Qing dynasty, 1644–1912. 4. Art and state—China—History—Qing dynasty, 1644–1912.
5. Buddhism—China—Tibet—Influence. I. Title.

N8193.C6 B47 2003
709'.51'0903—dc21

 2002009067

MM Publication of this book has been aided by a grant from the Millard Meiss Publication Fund
of the College Art Association.

University of Hawai'i Press books are printed on acid-
free paper and meet the guidelines for permanence
and durability of the Council on Library Resources.

Designed by David Alcorn, Alcorn Publication Design,
Graeagle, California

Printed by Butler and Tanner, Ltd.

Contents

Color plates follow page 102

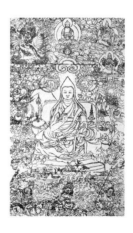

Acknowledgments

The origins of this book lie in Mongolia, where I first traveled in 1991 with my good friend and colleague Terese Bartholomew, curator of Himalayan art at the Asian Art Museum in San Francisco. We were on a self-propelled mission to persuade the newly democratic Mongolian government to allow us to organize an exhibition of their national treasures, which eventually opened at the Asian Art Museum in 1995 as *Mongolia: The Legacy of Chinggis Khan.* Most of the objects in the exhibition dated to the seventeenth, eighteenth, and nineteenth centuries, a period during which Mongolia was closely tied, first as rivals and later as allies, to the Manchu Qing empire. We rapidly learned that no history of later Mongolian art, particularly Buddhist art, could be constructed without also writing the entwined history of Qing court relations with its Inner Asian colonies. That is one of the aims of this present book.

Many Mongols helped us in this initial project, including N. Enkhbayar, then deputy minister of culture (and subsequently prime minister) and his able staff, and N. Tsultem, a great painter in his own right and Mongolia's premier art historian. In 1996, Tsultem's daughter, T. Uranchimeg, an art historian, accompanied my husband Charles Drucker and me to Amur-bayasqulantu (Amarba-yasgalant), a Qing imperial monastery established in 1736 near the Mongolian-Russian border. It was there that the germ of this present book was born under the benign gaze of the Venerable Gurudewa, the monastery's immensely learned head lama, who allowed us complete access to this still remarkable site and to his daily audiences.

My project to disentangle the complex uses of art in the Buddhist practices and Inner Asian diplomacy of the Qing court rapidly focused on Beijing and the collections of the Palace Museum. The museum's talented, devoted staff have been a tremendous help, especially former Vice-Director Yang Xin, who arranged to have Luo Wenhua, a specialist in Tibetan art, show me several of the main Buddhist chapels within the Forbidden City. I have kept in constant contact with Luo, who has my sincere gratitude for his many substantial contributions to this study. My thanks also to curators Yu Hui and Shan Guoqiang, for generously arranging me to see a number of paintings critical to this project, and to the director of information services, Li Shaoyi, who has been invaluable in providing photographs of objects from the palace collections. Significant numbers of objects crucial to this study were taken to Taiwan in 1947, and I also thank members of the staff of the National Palace Museum, among them registrar Sung Hou-ling and archivist Ho Lien-lien, for allowing me access to their extensive photographic archive, library, and collections.

Closer to home, the University of California, Berkeley, where I began teaching in 1996, has been a source of inspiration and substantial financial support. This project could not have been completed without several Junior Faculty Research grants, a Humanities Research Fellowship, all provided by the university's Council on Research, and a Career Development grant, which allowed me to write unimpeded during a sabbatical in 2000. My colleagues in the Department of the History of Art, among them Gregory Levine, Joanna Williams, Margaretta Lovell, Anne Wagner, and T. J. Clark, have been an exemplary source of always benevolent advice and counsel. Thanks are also due to any number of graduate students who have read through or listened to earlier drafts of this manuscript and contributed perceptively to its revision. Among them are Shana Brown, Charlotte Cowden, Larissa

Heinrich, Catherine Karnitis, Soo Kim, Sung Lim Kim, Mayuko Kinouchi, J. Lee Patterson, and Sharon Yamamoto. My special thanks go to Meiling Williams for generously helping me work through the thicket of Qianlong's innumerable edicts (though whatever errors remain in translations are strictly mine).

Any research project goes through innumerable transformations before being committed finally to valuable paper and ink, and as a manuscript grows and evolves, so too does its author. This book began as a study of Qing court art but it rapidly became apparent that such a study would not be possible without confronting Manchu multilingualism head on. By very fortunate coincidence, in 1998 I learned from Frederic Wakeman that Mark Elliott, then a professor of history at the University of California, Santa Barbara, would be offering a course in Manchu via closed-circuit television. Cynthia Col, a student in Chinese religion at the Graduate Theological Union, and I both leaped at the chance to learn this rarely taught language. I have both Elliott and Col to thank for teaching me that distance learning does not have to be alienating but can create communities over the airwaves and via the Worldwide Web. Emboldened by this new language adventure, Col and I both began studying Tibetan under the tutelage of Steven Goodman, whose insights into the Tibetan language and Tibetan Buddhist images have been a revelation to me. I thank him for long hours spent poring over Rolpay Dorje's texts, allowing me a clearer glimpse of a culture that was a significant part of the complex tapestry of Qing court life and key to understanding its production and use of Buddhist art.

My thanks are also due to any number of readers who patiently read through drafts of chapters and provided the benefit of their expertise. Among them are Stephen Teiser, who invited me to present a chapter to the Princeton Buddhist Workshop, Susan Naquin, Sarah Fraser, Pamela Crossley, Raoul Birnbaum, Richard Vinograd, and several other anonymous readers who reviewed the manuscript for the University of Hawai'i Press and for my own department at Berkeley. Thanks also to members of the Visualization Group first funded by Margaret Miles of the Graduate Theological Union and hosted by her colleague Judith Berling. This group, which has included Reindert Falkenberg, Richard Payne, Bruce Williams, Hank Glassman, Martha Stortz, and others, has provided an interactive forum for the discussion of visualization as a practice used in many different religious traditions.

On a more practical note, the University of Hawai'i editorial team, headed by the wonderful Patricia Crosby, has shepherded this project through its many stages with grace and efficiency. My thanks to Crosby and Managing Editor Ann Ludeman for deeming this project worthy of the Press' resources in the first place and for seeking subventions to enhance the production values of the book. My very special thanks are also due to Don Yoder, editor extraordinaire, for his gentle, thoughtful, and thorough copy editing of my final draft.

In the end, the ability to work on any lengthy project depends on the saintliness of one's immediate and extended family (nonhuman members included). My husband Charles Drucker has been a sounding board, a broad shoulder, and an enthusiastic companion throughout, always ready with cameras, computers, Russian jeeps, and perceptive comments. Our daughter Laura, though tender in years, made dozens of scans of objects, printed out chapters, and kept good cheer while creatively manning her own camera even on the hottest, muggiest days in Beijing and Chengde. For all these years of support and for their unflagging conviction that, one day, the manuscript would be done, I thank them. This book is for them.

Empire of Emptiness

Introduction: Raining Flowers

O great King, listen to how
Your body will be adorned
With the thirty-two signs
Of a great being.
Through proper honoring of stupas,
Honorable beings, Superiors, and the elderly
You will become a Universal Monarch,
Your glorious hands and feet marked with [a design of] wheels.

—Nāgārjuna, Precious Garland,
trans. Jeffrey Hopkins

In 1753, Hongli, the Qianlong emperor of the Manchu Qing dynasty, had himself painted into the role of Buddhism's greatest layman, the Licchavi merchant Vimalakīrti (Plate 1). The artist, a court painter named Ding Guanpeng, took no chances with this important commission. He chose a composition that had been in use since as early as the fifth century to illustrate the sutra in which Vimalakīrti takes a starring role: the *Vimalakīrti-nirdeśa* (Teachings of Vimalakīrti). Like many other early illustrations of the story, Ding's *Bu'er tu* ("Not Two," or "Nonduality Picture") seats the savant merchant Vimalakīrti on the right facing his visitor and partner in debate, Mañjuśrī, the bodhisattva of wisdom. The topic occupying them is nonduality and the apprehension of emptiness. The moment in the story Ding gives us appears in the sutra's seventh chapter, when a beautiful goddess, a longtime resident of Vimalakīrti's house, appears and throws flowers over the gathered company surrounding Mañjuśrī. These raining blossoms glide gracefully over the many spiritually advanced bodhisattvas who are present, but they stick conspicuously to everyone else. Most annoyed—and visibly so in Ding's painting—is the Buddha's disciple Śāriputra, who tries futilely to shake the flowers off. When the goddess asks what he and his monastic brothers are doing, he answers:

> "Goddess, these flowers are not proper for religious persons and so we are trying to shake them off."
>
> The goddess said, "Do not say that, reverend Śāriputra. Why? These flowers are proper indeed! Such flowers have neither constructual thought nor discrimination. But the elder Śāriputra has both constructual thought and discrimination."[1]

Shortly after this pointed and embarrassing exchange, Śāriputra (who plays the worrywort and butt of Vimalakīrti's jibes throughout this often comical sutra) asks the goddess how, if she is such an advanced being, she finds herself still occupying the inferior body of a woman. Not wasting too many words, the goddess switches bodies with Śāriputra, leaving him aghast. In a brief but effective defense of the notion that all forms are impermanent, transitory, and illusory, she wryly asks: "Reverend Śāriputra, what prevents you from changing out of your female state?" And Śāriputra is forced to concede: "I do not know what to transform!"

Ding's composition mirrors ancient and authoritative versions of the scene that underscore the theme of nonduality in a seemingly paradoxical way: by dividing everything neatly into twos. As was often the case in his practice, the painter creatively interprets a work already in the emperor's collection, a handscroll that may have been done by the Jin-dynasty painter Ma Yunqing (who was himself inspired by the Northern Song painter Li Gonglin).[2] Ding's rendition is also complicated and enriched by his deployment of two or more disjunctive styles of representation. The combination of the emperor's distinctive—and disturbingly present—face with the bland, anonymous faces and agitated, archaistic line that describes the garments of the gathered crowd, which casts the knowing viewer back to moments and monuments in Buddhism's specifically Chinese past,[3] ultimately hints at the dissolution of a different two—a mythic, Indian past (or, perhaps more aptly, a moment in the history of Chinese art) and a Qing-dynasty present—into one.

The effectiveness of Ding's painting depends, of course, on the text of the sutra, a text not provided for the viewer to consult but which ends famously by casting the usefulness of language into doubt. It is this culminating moment that Qianlong alludes to in his poetic inscription. Vimalakīrti and Mañjuśrī have been discussing emptiness in a typically long, florid exchange. Offering an insightful summation, Mañjuśrī seems to have captured the essence of it. The floor is now Vimalakīrti's and, in a brilliant tour de force, he chooses to remain silent—a moment of speechless eloquence so profound that it has come to be called the "lion's roar," the moment when a bodhisattva reaches the tenth, final stage of development. Qianlong writes:

> Vimalakīrti silently rested—
> Mañjuśrī said, "Skillful!"
> This is truly entering nonduality,
> Not speaking is what right conduct ought to be.
> But understanding in silence,
> Seizing shadowy form, what is empty becomes full.
> Say—how can you make a picture like this?
> The sound we hear is a laugh: "Ha, ha!"[4]

Mañjuśrī capitulates in complete admiration and the debate comes to an end with every listener raised up several levels on the enlightenment path.[5]

Qianlong's elegant and very private pictorial conceit, which he kept at Bishushanzhuang, the Manchu summer retreat at Chengde (also known as Rehe or Jehol), northeast of Beijing, must have been doubly piquant to those favored few who had seen it there. For it was in Chengde, among other select sites, that Qianlong played out before an audience of privileged Chinese, Mongolian, and other Inner Asian subjects one of his more famous, if limited, public roles as an emanation of Mañjuśrī, the bodhisattva of wisdom and denizen of China's own Wutaishan. Thus already securely identified with Mañjuśrī in the minds of his guests, in this painting he chooses the guise of Vimalakīrti, a layman so advanced that, by eschewing speech, he outshone one of the greatest bodhisattvas, whom he happens to embody himself. What better way to represent nonduality and the contingency of form?

The enlightened layman Vimalakīrti occupied Qianlong's private musings throughout his life, but never more so than in the 1750s, a decade during which, in his late thirties and forties, he devoted considerable energy to Buddhist practice and patronage.[6] His ten volumes of collected Chinese-language poems reveal he returned to the subject of the goddess' "rain of flowers" many times over, as in 1754, when he wrote a poem titled "Hall of Raining Flowers" ("Yuhuashi"). In it he reiterated his desire to "manifest emptiness," just as Vimalakīrti had done:

During the three months of spring I came to a peaceful, quiet lodging

Where, for five days, I practiced pure amusements.

Each time I chanted I took a turn and

Discrimination returned.

On the other side of the window, the vaporous shadow of a kingfisher—

I enter and sit in solitude in the cypress's shade

To put Vimalakīrti's investigations to the test,

So that I might yet manifest emptiness.[7]

"Hall of Raining Flowers" (and the *Vimalakīrti-nirdeśa* itself) pivots on the shifting quality of things as "the vaporous shadow of a kingfisher" strikes a responsive chord that pushes Qianlong into solitude to test Vimalakīrti's silent method. Yet the poem and Ding Guanpeng's painting both throw into relief one of the most significant paradoxes in Qianlong's practice (in fact, in the practice of Buddhism in general): The construction of a path to enlightenment and the apprehension of emptiness must take place in a sensory world filled with desirable, fascinating things. Qianlong's own enthusiastic engagement with the material world is well known and has been the object of considerable (often negative) critique.[8] Judging from the outpouring from his court workshops, this emperor was obsessed with things and could not or would not stop proliferating and collecting substantial, tangible, material objects in all their discriminating shapes and sizes. A flood of what has been variously characterized as excessive ornament or bloated overdecoration, ever-growing collections of works of art and craft in all the media of the day, productions in which one medium masqueraded as another, miniature and gigantic objects—all occupied his delighted gaze up until the end of his very long life in 1799. His regular and, by most evidence, sincere Buddhist practice was consumed by the construction of chains of temples,[9] each conceptually linked to an earlier model, and by the design and fabrication of huge pantheons of hundreds of carefully individualized deities, the production of "corrected" replicas of some of the most charismatic icons of the past, and the composition and publication of edicts and inscriptions to launch his projects properly into history.

Qianlong's creative use of forms took on an especially significant twist when, between 1750 and 1757, he oversaw and funded the construction of a meditation chapel, the Pavilion of Raining Flowers (Yuhuage), in the northwestern sector of the Forbidden City. This undisguised homage to the wisdom of Vimalakīrti's shape-shifting household goddess, who used the impermanent forms of flowers to test who-was-who at Vimalakīrti's house, was filled with hundreds of Tibetan-style sculptures, three-dimensional mandalas, and thangkas (Tibetan-style hanging scrolls), all assembled and put into order by Qianlong's Tibeto-Mongolian guru, the Zhangjia Khutukhtu and National Preceptor, Rolpay Dorje, also known by the Sanskrit translation of his name, Lalitavajra (1717–1786). The Pavilion of Raining Flowers was intentionally reconstructed as a "tower of forms" that was really not what it seemed, since it concealed four separate floors of images, outlining a carefully graduated, four-step path to enlightenment, behind a facade that promised only three. This project markedly asserted the transience and phenomenality of material form, yet it also simultaneously promoted the view that form has value not simply as support for the unenlightened, stumbling seeker. Form, in the Pavilion of Raining Flowers, is also inextricably enmeshed with its own transcendence in the paradox of the Double Truth: the identity of samsara (the phenomenal world of the senses) and nirvana, the ultimate, irreversible goal of Buddhist practice in which the true, contingent nature of things is revealed.

The rich Tibetan-style contents of the Pavilion of Raining Flowers pose an intriguing cultural counterpoint to Ding Guanpeng's Chinese-style portrait of Qianlong-as-Vimalakīrti. The *Vimalakīrti-nirdeśa,* one of the most influential and enduring texts in Chinese Buddhism, has long been beloved

as a tract that justifies the layman's path as a worthy alternative to celibate monasticism. Despite his worldliness, Vimalakīrti is enlightened and the master of what Robert Thurman has translated as "liberative technique," the outreaching compassion that, when combined with wisdom, results in enlightenment.[10] Vimalakīrti's own liberation, foreshadowing the esoteric techniques of Vajrayāna Buddhism, is in fact gained *because* of his open engagement with the world of form rather than in spite of it. But his allure for Chinese Buddhists had to do with more than just his status as a liberated layman. Even in very early Chinese illustrations of the sutra, his representation merges imperceptibly but thoroughly with images of Daoist immortals and venerable recluses. The description of Vimalakīrti's thin, disease-ravaged body, a ruse he designed and magically projected to attract Śākyamuni's sympathy and elicit a personal visit, likewise recalls the dried, husklike bodies of practitioners of Daoist longevity regimens. His concern for his family and his moral uprightness (among other things, he went to brothels but remained chaste) reminded admirers of the virtuous actions and "inner reclusion" of loyal officials trapped in the service of corrupt rulers. Despite his foreignness, he seemed also to be a perfect exemplar of Chinese cultural values, both Daoist and Confucian.

Qianlong's use of Vimalakīrti's persona and teachings therefore transcended easy cultural or sectarian categorization. Moreover, his embodiment of Vimalakīrti in painting, poetry, and architecture informs two quite distinct Buddhist roles he defined for himself: the emperor as an enlightened Chinese layman living in this world (as in his portrait by Ding Guanpeng) and as a *cakravartin,* or wheel-turning sovereign and emanation of the bodhisattva Mañjuśrī, presiding over a clarified field of enlightened activity (as during his regular practice in the Pavilion of Raining Flowers). In a certain sense, Vimalakīrti enabled Qianlong to reconcile this particularly sticky aspect of the Double Truth. If the practitioner is enjoined to model himself on the Buddha, following a gradual discipline that bears fruit only after countless aeons, he must also anticipate, if only intellectually, that the enlightened state corresponds to realization of timeless emptiness. The Double Truth recognizes that enlightenment can only be found in the world of the senses; it is built on the premise that path and goal are the same. Its first paradigm—samsara—stresses the shifting, temporally fluid nature of things, calling for an awareness of the equally contingent nature of the self. But the Double Truth also puts forward a second paradigm—nirvana—in which time is replaced by a transcendent vision of the cosmos with the enlightened Buddha—potentially the practitioner himself—at its center.

Recently Charles Orzech has argued that this seeming contradiction also permitted, even demanded, political interpretation—particularly in esoteric Vajrayāna, or "Diamond Vehicle," Buddhism, which first had a significant impact on Chinese concepts of rulership during the second half of the Tang dynasty (618–906) and certainly formed the core of Qing imperial Buddhist practice in its Tibetan form.[11] Orzech's study focuses on the *Scripture of Perfected Wisdom for Humane Kings Who Wish to Protect Their States (Renwang huguo boruoboluomituo jing),* which was, as he argues, most likely a Chinese apocryphal text "translated" into Chinese in the fifth century and again, with significant transformations, by the esoteric master Bukong Jingang (Amoghavajra) in the later eighth century at the behest of the Tang emperor Daizong (r. 763–779). The text outlines a concept that is fundamental to Vajrayāna Buddhism—that ritual action has two distinct benefits, inner and outer. In Vajrayāna practice, ritual performance allows practitioners to imagine themselves as enlightened beings, but it also results in conspicuous rewards that can be directed to the community at large by means of an accommodating "grammar" and elaborate "vocabulary" of ritual action. Thus Vajrayāna Buddhism offers hope of practical realization of the Double Truth—the simultaneous achievement of worldly and transcendent goals in what Orzech terms "the recursive cosmos of ritual performance." From the perspective of the Manchu emperors of the Qing dynasty, as for many Chinese emperors before them, the Diamond Vehicle (along with Confucianism and Daoism) provided an ideal path for historically conscious political action *and* personal cultivation.

Empire of Shifting Forms

These issues of duality, even plurality, of private identity and public presentation were all part of the shifting landscape the Manchu emperors of the Qing dynasty faced as their culturally complex empire grew. The Qing empire reached its greatest size under Qianlong. Territories stretching far into Xinjiang (the "New Borderlands") were added to the territory of the Manchu homeland, China proper, Inner and Outer Mongolia, and, for all practical purposes, Tibet, through a series of "Ten Great Campaigns," the subject of extensive, boastful poeticizing on the emperor's part. The phenomenon of the ever-expanding frontier brought the Qing emperors and their government into fluctuating contact with subjects from increasingly diverse cultural and linguistic backgrounds.[12] This contact was to a certain extent controlled and organized by the elaborate guest ritual of the Ministry Ruling the Outer Provinces (Lifanyuan) that demanded certain subjects undertake an annual *chaojin* to the Qing capital at Beijing and the Chengde summer retreat—what Ning Chia has translated as a "pilgrimage to court." Others, including the stream of Tibetan lamas who visited Beijing and other Qing-controlled areas regularly, came to *chaogong*, "pay tribute."[13] To all of these guests Qianlong, in particular, paid the supreme compliment (for so he certainly saw it) of learning their languages so that he could converse with them without the mediation of an interpreter. This habit of language study, which carried his imperial ancestors' forbearance for and interest in other cultures to unprecedented lengths and which he continued even into his seventies, may seem, if only superficially, to contradict his equally adamant assertion and creative reinterpretation of Manchu identity. But it may be, in fact, precisely what constituted Manchuness at the imperial level.

A new generation of Qing historians spent the 1990s debating exactly what this new construction of a cultural identity might mean for a group of people who were historically vague until their mid-seventeenth-century consolidation of Manchuria and conquest of Inner Mongolia and China. Among them Mark Elliott, with a broad and deep reading of Manchu-language documents, has carefully crafted a picture of what the "Manchu Way" comprised in political, social, ethnic, and legal terms; others, especially Evelyn Rawski and Pamela Crossley, have explored the complex, multicultural Qing concept of rulership, which had several different sources in China and Inner Asia.[14] The Manchu language, which has experienced a resurgence of interest among Qing scholars ever since Beatrice Bartlett's seminal *Monarchs and Ministers* appeared in 1991,[15] was an aspect of Manchu culture that was, more or less, legislated into conformity by the confederation of loosely related tribes that eventually chose to call themselves Manchu. Manchu vocabulary, owing small but growing debts to Mongolian and Chinese, was ultimately established and controlled by fiat and stabilized into official form in the several dictionary projects Qianlong subsidized. Though this legislation of a national or dynastic language (Chinese: *guohua* or *chaohua*) under Qianlong suggests the importance the Manchus themselves eventually placed on language as a marker of cultural difference, these concerns actually surfaced very early. Some of the earliest writings in the Manchu language detail the new dynasty's conscious and well-reasoned borrowing of the Mongolian alphabet to create a written version of their own language and, with it, the possibility of a new historical literature of themselves. The Manchus' refusal to give up what they convinced themselves were "traditional" Manchu ways (defined and codified after the conquest), their ever more ritualized reenactment of a unified sense of Manchuness in their annual retreats to the regions beyond the Great Wall, their emphasis, especially in pictorial representations of themselves, on hunting, archery, and horsemanship—all suggest that they saw significant political benefit in remaining forever "other" in the eyes of the majority of those they ruled, the Han Chinese.

Nonetheless all the Qing emperors, most prominently Qianlong, often behaved like their Chinese subjects in the privacy of their own quarters and in the performance of many of their ritual

responsibilities.[16] Qianlong's daily diaries, for example, document the fact that he spent part of most afternoons in pursuit of specifically Chinese cultural activities—poetry, painting, and calligraphy—engaged in a personal (though ultimately publicized) reverie that allowed him to occupy a Chinese mind and body, however transiently. Ding Guanpeng's Chinese-style portrait of the emperor as Vimalakīrti, which Qianlong kept at Chengde, suggests that he contemplated this culturally complicated role privately even as he received pilgrimages from his Mongol subjects at the summer retreat. Even so, it would be difficult to argue that Qianlong ever understood himself as simply Chinese. Despite his clear admiration for certain aspects of Chinese culture and the Sinitic flavor of many of his court productions, all evidence points to the fact that he was, at the very least, fluent and at home in more than one culture. His daily Buddhist practice, largely but not exclusively carried out according to the reformist, Gelukpa (or Yellow Hat) tenets of Tibetan Buddhism, provides an especially broad window into understanding this fluid sense of self.

For these reasons it is, I believe, difficult to maintain that the Manchu emperors' increasingly easy multilingualism and their continued interest in and respect for cultural difference (certainly up to and including the Qianlong reign) was an epiphenomenal by-product of their political needs. In certain ways, their cultural and personal fluency was the very characteristic that defined them most surely, just as much as cultural fluency and bilingualism—the Hellenized veneer laid over Italic culture—defined the Romans and their empire. But unlike the Roman Empire in its heyday, when all roads led predictably to Rome, the Qing empire was pan-Asian and decentered. As James Hevia has put it: "A central precept in the Qing imagining of empire was the notion that the world was made up of a multitude of lords over whom Manchu emperors sought to position themselves as overlord."[17] This was not a political model that developed after the Manchus found themselves masters of many different cultural groups but one that emerged strikingly in the early years of the empire, designed consciously to emulate patterns established centuries before during the Mongol Yuan dynasty (1280–1368). Once the Manchus' main capital was moved from Mukden (Chinese: Shengjing, modern Shenyang) to Beijing, they still refused to remain stationary for long but kept moving between several different residences (some of them movable Mongolian-style ger, or yurts) in an annual transhumance that, during Qianlong's reign, became established tradition. This pattern of movement, which was clearly articulated during the reign of the Kangxi emperor, Qianlong's grandfather, took the court from Beijing to their summer retreat at Chengde, to other summer residences just outside of Beijing, and beyond: to Changchun and Wutaishan, a site sacred to both Chinese and Mongolian Buddhists, to Dolonnor in Inner Mongolia, and, following early Chinese imperial precedents, on regular tours of the northern and southern regions of China proper.

If the earlier Qing emperors did not fall into a pattern of hermetically sealing themselves within the Forbidden City, emerging only on ritual occasions to perform the responsibilities of office, even Qianlong, one of the most mobile of his lineage, had only secondhand experience of large portions of his empire, significantly Xinjiang, Outer Mongolia, and Tibet. Tibet especially was a realm of the imagination for him—one of several imaginaries he set about constructing both mentally, in his Buddhist practice, and materially and symbolically in his artistic and architectural projects in Beijing and especially in the world-in-miniature he built on his grandfather's foundations at Chengde. Modeling the overall form of the empire in visual terms ultimately became a prime focus in his life, as if representing it at a scale that the eye could scan and the mind encompass would "make it so." The model had to conform to the original but, as we will see, the reverse was also true as Qianlong's modeling became more and more an effort of revision and editing. More and more the interpretation of the original was also forced to live up to the expectations of the copy.

Balancing on the Hyphen

This complex modeling process brings us to two points. The first is that artistic representation—the creation of a visual world of symbolic, meaningful form of which Buddhist art was just a part—occupied a significant place in the Manchu project of empire building. The second is that the theory and practice of Tibetan Buddhism, adopted in the decade before the Manchus' conquest of China, offered not just political advantages in the emperor's relations with his Inner Asian subjects but also a proven method to envision a complex system of things in crystal clear, materially substantial, often architectural, terms.[18]

The emperor's own artisan workshops were just as decentered as the empire itself. Artists and craftsmen from all over China, Mongolia, and Tibet collaborated on projects that included scholarly, Chinese-style landscapes, portraits, decorative paintings, Buddhist, Daoist, Confucian, and shamanist ritual objects, enameled wares, furniture, and finely crafted storage boxes to hold all of the above.[19] Other types of Buddhist and non-Buddhist objects—lacquerware, ceramics, and textiles—were produced for the court in the great manufacturing cities of the south from designs set in Beijing, often with the oversight of Qianlong's guru, Rolpay Dorje. The continued presence at court of European Jesuits, who in Qianlong's day were corralled into artistic production and restricted from missionizing (which they understood was a long slide from their heyday under his grandfather Kangxi, who valued their scientific and mathematical skills), contributed substantially to the creation of modes of depiction that addressed multiple goals and diverse audiences.

What we might term the overall visual culture of the Qianlong period, in other words, cannot be categorized in simple terms but, to borrow a linguistic metaphor, often seems to speak in several languages simultaneously, representing a range of hybrids that maps out the world as the Manchus understood it, with all of its shaded, ambiguous zones of cultural interaction. This may explain why art historians have struggled to find a terminology that does justice to the complexity of production at the Qianlong court. One particularly thorny problem is the art that was made at court to serve the emperor's practice of Tibetan-style Buddhism. For here we enter into a realm of orthodox, authorized imagination where we might expect cultural differences to dissolve and dualities to disappear, but which has always been politically charged, ever more so given the present, strained relationship between the Chinese government and Tibet. The series of neologisms or hyphenated terms currently in use among Western writers—Sino-Tibetan, Tibeto-Chinese, Lamaist, International Gelukpa style—all seem conspicuously designed to highlight the collage-like juxtaposition of representational intent these works embody. But as we focus on this corpus of work as a manifestation of a larger project, we are forced to ask what effect these contested, hybridized terms have on the way we view the Tibetan-style Buddhist products of the Qing imperial workshops: How does the teeter-tottering hyphen alter our own expectations of inspiration and practice?

Form and Emptiness

More than any other type of Buddhist meditation, Vajrayāna practice depends on form and its manipulation and proliferation. Buddhist masters of the Diamond Vehicle—originally in India but, after the tenth century, primarily in Tibet—developed an extensive repertory of visual, aural, olfactory, and tactile supports to aid initiates, including mandalas (architecturally conceived diagrams of complex buddha fields and all their inhabitants, which take form as image-filled buildings, sculptural groups, or, most typically, as paintings that read like architectural plans), codified, language-like utter-

ances (mantras and *dhāraṇī*), chanting, incense, body postures *(āsana)*, and hand gestures *(mudrā)*. All of these depend on the ability of the initiate to remember, recall, and recognize his or her own buddha nature through a series of *samādhi* (meditative states), to reconfigure in the recursive arena of ritual performance the triple, contingent landscapes of body, speech, and mind, and to bring them into a unified state that conforms to enlightened buddhahood.

In directing this path, Vajrayāna texts and images characteristically deliver information and insight in several different registers at once, some of them deeply encoded or intentionally hidden in plain view so as to bring the viewer up short like a quotation from a foreign language in the midst of an otherwise completely transparent text. Images, for example, might incorporate language in the pictorial field as script or hint at orality through visual puns or rebuses. Likewise inscriptions might be designed to be read several ways (or in different directions) or to block access to signification in the quotidian sense even when clearly pronounceable. The flexibility these texts and images require in terms of audience response—the ability to leap seamlessly from one register to the next (or, in Qianlong's practice, from one language or visual style to another)—is what makes Vajrayāna training so arduous and so dependent on transmission through a lineage of acknowledged masters. What is expressed and transferred through a multiplicity of multivalent, divinized forms are qualities of body, speech, and mind. These forms establish patterns that initiates must to come to recognize as their own. Thus Vajrayāna requires the kind of imaginative role playing we see Qianlong engaging in as he assumes the identity, for example, of Vimalakīrti or projects himself as Mañjuśrī. Vajrayāna's goal is for the actor to enter his role so thoroughly that no distinction remains between the two: The path becomes the goal and vice versa.

One of Rolpay Dorje's two biographies, written in Tibetan by his disciple Thukwan Losang Chökyi Nyima, provides significant insight into the emperor's study, practice, and questioning of Buddhism.[20] Thukwan reports that Qianlong first underwent initiation into Tibetan Buddhist practice in 1745, almost a decade after he ascended to power, and he documents Rolpay Dorje's advice to the emperor on matters ranging from Tibetan politics and military campaigns in the borderlands to the proper sequencing of the graduated path to enlightenment. Much of what Thukwan says about public affairs is corroborated in official histories of the Qing dynasty and in historical records compiled in Mongolia, but his notes on the emperor's practice are unparalleled elsewhere. From him we learn that Qianlong worried constantly about the difficulties of translation from one language to another or from one representational style to another—about the hazards that any sort of mediating mechanism could pose to a serious disciple of the enlightenment path. How, he wondered, could the pure sound of mantras be accurately transcribed in Chinese characters? How could Manchu Buddhists develop a monastic community of their own or a canon translated into their own language without diluting the potency of the Buddha's original teaching? How should Buddhist temples be designed? How should images be proportioned? There were also more philosophical questions focusing on core Buddhist concepts, among them nonduality and emptiness, two related issues that Qianlong engaged repeatedly until the end of his long life in 1799. These intriguing problems had long since been addressed in the Mādhyamika or Middle Way philosophy of Nāgārjuna, to which the Gelukpa founder, Tsongkhapa, wrote an important commentary. Thukwan tells us that Rolpay Dorje recommended Tsongkhapa's commentary to the emperor for study and that he even lectured on it for an assembled group of the emperor's closest associates. The Middle Way offered a Buddhist perspective that accepted the existence of the world as we experience it while also suggesting a scheme unperceived by all but the most advanced beings for comprehending how everything fits together into an interrelated, nondualistic, constantly shifting whole.[21]

As the Qing emperors worked to expand and stabilize their increasingly polyglot, culturally diverse empire, their actions seem very much in keeping with this Buddhist message. The Manchus never

totally conformed to the thesis promoted in the mid-twentieth century by John King Fairbank, who argued that they envisioned their empire as "concentric rings of progressively lesser-civilized peoples radiating out from a pure Sinic center in China proper."[22] Although they certainly projected this idealized and essentialist view as they faced their Chinese subjects, when they turned outward they simultaneously saw the empire as a confederation of discrete, culturally distinct blocks. Their imperial philosophy also contrasts sharply with the attitudes of modern Chinese regimes, including the present one, which have promoted sinicization of the frontiers as movement *back* toward a historical ideal. Thus while contemporary China occupies almost the same landmass as the Qing empire did at its greatest extent (excluding Outer Mongolia), its leaders contend that non-Han territories to the north and west have always been an inalienable part of China, not pawns in an ideological construction serving early modern Chinese nationalism. As James A. Millward says in his discussion of current Chinese attitudes toward Xinjiang (though we might apply his insights to Tibet or Mongolia as well), "investigation of the frontier as *process* is precluded by the ahistorical treatment of the region as a static, eternally Chinese *place*."[23]

These two cosmologies—the one changing, the other static—are strikingly counterposed and reconciled in Vajrayāna Buddhism, where the temporally and physically bound individual disciple seeks to realize a spacious and spatial view of reality and thus bring two very different experiences together in ritual to produce benefits that are both personal and public. The assumptions of Vajrayāna thus preempt to a certain extent the critique that has been repeatedly launched against the Qing emperors (and their Mongol predecessors during the Yuan)—the critique which questions the sincerity of their Buddhist practice and claims that the extensive political benefits they realized, particularly among their Inner Asian tributaries, were achieved cynically by simply going through the motions. Strangely this critique does not extend itself to the Qing emperors' Confucian practice, which has been taken as a sign of their ready and complete sinicization and capitulation to a classical Chinese worldview.[24] I think the Qing emperors saw benefits in both practices that were more than merely cynical. The real problem may be in attempting to lash these culturally adept chameleons to any single view of the world they ruled. Much of the visual and verbal art they patronized and deployed for a larger audience demonstrates their ongoing effort to reconcile everyday events and ordinary human differences with the paradigmatic models of history and cosmology they borrowed from several different systems of thought. If the syncretic concept and realization of "three doctrines united into one" *(sanjiao heyi)*—Confucianism, Daoism, and Buddhism—occupied Chinese intellectuals during the late Ming and Qing, the Qing emperors, particularly Qianlong, sought synthesis on many different levels, not the least of which was their very careful design of a new, Buddhist visual culture.

Qing Translations of Buddhist Art and Practice

Of all the Qing emperors, the fourth, Qianlong, was the most enthusiastic in his support of Tibetan-style Buddhism—indeed, in his assiduous attention to ritual practice in general. It might be argued (and it is admittedly an underlying assumption of this book) that the influence of Tibetan Buddhism peaked in China during Qianlong's reign, particularly during the lifetime of his boyhood friend and National Preceptor, Rolpay Dorje. In fact, several of the apparent contradictions in Qianlong's own Buddhist life (most notoriously his edict of 1792, *Lama Shuo*, in which he excoriates the Tibeto-Mongolian Buddhist establishment for their complicity in the Gurkha invasion of Tibet and claims his own long support of Buddhism as merely expedient) can be explained, at least in part, by Rolpay Dorje's death in 1786. Despite Qianlong's central position in the patronage of Buddhism in China, Mongolia, and Tibet, the story that unfolds in the following pages is not intended as a biography of him in his prodigious role as a religious practitioner and protector. This is a subject too vast and

complicated to fit easily between the covers of any book (or at least this one). My focus instead is on the broad range of visual materials produced in and for the Qing court in the service of both Buddhist practice and Inner Asian diplomacy—and, in semiotic terms, what and how they meant and now mean. Several pressing issues emerge from this variously hybridized body of work, a few of which have begun to pique the interest of Qing historians, such as Susan Naquin, Pamela Crossley, Evelyn Rawski, and Angela Zito,[25] and, to a much lesser extent, art historians.[26] Among these issues are the nature of the Manchu rulers' use of Buddhist images as a way of establishing themselves as religious kings, their concern for visual precedents and orthodox form, their desire to categorize and schematize their huge collections of art, their unique approach to the visual imbrication of the mundane and supermundane, their multilingualism and its echo in visual practice, and their efforts to reconcile memory and the construction of history in visual terms.

Chapter 1 begins with a painting produced in Qianlong's midcareer. Titled *Ten Thousand Dharmas Return as One*, it introduces a cast of characters drawn from several different parts of Inner Asia and an artistic practice that was conspicuously collaborative, even in 1771. *Ten Thousand Dharmas*, also known as *The Return of the Torghuts*, celebrates the joined birthdays of Qianlong and his mother, the Empress Dowager Xiaosheng, at Chengde and the coincidental return of the Mongolian Torghut tribe to the Qing empire in the same year. Qianlong ultimately used this politically significant painting as a backdrop for his annual reception of the Mongol tribes at Chengde and for the singular visit of the Sixth Panchen Lama there in 1780—demonstrating "in the recursive arena of ritual" the confluence and resonance of past and present events and his ability to propel this understanding of them into the future. The painting is a triumph of the collaged style that distinguishes so much of Qing court production, posing straightforward, European-style portraits of the group gathered to honor the emperor and his guests against a Tibetan-style, magically revealed setting replete with auspicious signs. It does all this within an architectural setting, the Putuozongchengmiao, that replicates the Dalai Lama's Potala in Lhasa and with a composition borrowed from a mural in the same Potala depicting the 1642 meeting in Beijing between the first Qing Shunzhi emperor and the Great Fifth Dalai Lama.

What can Qianlong have meant by ordering this painting? Its multiple references back to the historical past—Manchu, Mongolian, and Tibetan—reveal the degree to which the Qing relied upon Mongolian and Tibetan precedents in their self-creation as rulers of Inner Asia. Their Buddhist practice had a Mongolian source, as David Farquhar, Samuel Grupper, and others have shown,[27] and their visual culture owed huge debts to seventeenth- and early-eighteenth-century Mongolian art. Yet the Buddhist art of the Qing court was also cautiously designed to deliver a complex but unified message in several different languages simultaneously, all the while effectively producing a reconciliation of the Double Truth: an orderly, mandalic, spatially conceived view of a world that was nonetheless inhabited by familiar, memorable faces.

Images are notoriously "dense," to borrow a term from Nelson Goodman.[28] They defy simplification; they are typically multivalent, offering different readings to different viewers, whose expectations and assumptions may change over time. They also pose immense problems in translation—much knottier even than the problems encountered in translating text. How, for example, was the immense Tibetan pantheon of symbolically rich, divine forms, recorded verbally in such texts as the *Nispannayogāvalī* and other collections of *sādhana* (realizations) or instructions for constructing mandalas, to be rendered visually so as to be both correct (incorporating all the right attributes) and identifiable (producing the same experience of recognition in the practitioner)? How could a non-Tibetan artist convey all the many layers of meaning each image embodied, weighting each with appropriate caution, particularly in a system so profoundly encoded and schematically organized as Gelukpa Buddhism? More pressingly, was it possible to avoid the shock strange images invoke in uninitiated viewers, or

was this shock advantageous because it revealed just how dense things could be? In Chapter 2, the issue of transcultural and "translingual" practice in the Qing court serves as the starting point for an investigation of how the Buddhist images court artists produced were designed to yield meaning in several different registers, some of them transparent, others purposefully impenetrable.[29] Here the untranslatable presents itself as a kind of transformative black hole where quotes from alien visual systems, the juxtaposition of bits of images by hands trained in different idioms, add up to integrated compositions that speak in several different modes simultaneously, conveying a message controlled only by the sender.

Impenetrability and the refusal to yield meaning emerge as significant features of Qing Buddhist art, which was designed to represent insights both directly *and* esoterically. The very relationship between a representation and what it represents was repeatedly questioned and stretched in the Qing court in images embedded with visual puns or rebuses or in icons bearing inscribed mantras that represent both symbolically (transcribed sound standing for something else) and indexically (sound as trace), operating at the edge of language's ability to convey meaning. Likewise, in portraiture, Qianlong in particular (but also his predecessors) took advantage of several distinctive visual modes to present themselves in startling, culturally distinct, Buddhist contexts—in some cases for private reasons that produced musings on the nature of representation; in others to serve conspicuously political, public ends. In all these efforts, the interplay between image and text, between image and name, between fragments of images, coalesces into pictures that, in their diagrammatic clarity, seem to offer an unmediated glimpse into some profound secret but simultaneously leave us firmly planted in a world of unyielding things.

The buildup of things in the Qing palace—serving as supports to practice as well as to the diplomatic interchange of gifts that accompanied reverence for great gurus and the tribute due a *cakravartin*—was, in Qianlong's own words, "the result of one hundred years of peace." In Chapters 3 and 4, we turn to the ways in which the Qing court learned to deal with an embarrassment of riches, both in the production of a well-organized, taxonomically sound method of storage and cataloging and in another kind of cataloging that rigorously brought to order the dizzying array of deities employed in Tibetan Buddhist practice. These two parallel efforts, brought together in Qianlong's first attempt in 1744 to produce a comprehensive catalog of his Buddhist and Daoist collection (the *Bidian zhulin*, the Beaded Grove of the Secret Hall), were conspicuously dissociated in the much later supplement to the catalog produced in 1793. While the first catalog includes chapters on Chinese paintings and calligraphy (edited by leading Chinese scholars devoted to the latest empirical methods of evidential research), with chapters on non-Chinese materials (compiled by his guru, Rolpay Dorje), the supplement concentrates exclusively on Chinese art, including, however, the often polycultural products of the court itself. I use the word "art" very consciously, because the supplement also enhances the emphasis already placed in the first catalog on the treatment of religious images as works of art—that is, on the evaluation of them in material, aesthetic, and historical terms rather than simply their religious aspect. The organization of images used as supports in practice, most of them foreign at least in design, continued to be a major concern but now manifested itself in a separate realm of pantheon building.

Hans Belting, writing about a very different subject, the shift in the apprehension of religious imagery that occurred with the Protestant Reformation in Europe, has said that "the aesthetic sphere provided, so to speak, a kind of reconciliation between the lost way of experiencing images [as unmediated presence] and the one that remained [as work of art]." In this new world, with belief suspended, the power of icons was placed for reinterpretation into the hands of a new kind of master, the connoisseur, who, in Belting's words, "[knew] the rules of the game." Belting also argues that the Counter-Reformation Roman church challenged Reformation views of the earliest Christian tradi-

tion as imageless, resuscitating ancient pictures and sculptures as "relics of a bygone age,"[30] literal glimpses into the past. Thus on both sides of the European Reformation debate were theorists eager to historicize images that had once provided a direct, unmediated "presence" to the faithful.[31] Qing efforts at image making and image collecting were also often focused on issues of authenticity and orthodoxy and on the precise historical positioning of objects that were simultaneously appreciated as windows into a different understanding of the material world and as physical traces of past experience, hovering somewhere between memory and history. The real power of images, past and present, was never a matter of doubt, however. There were simply too many ways to demonstrate their continued active presence.

In Chapter 5, the phenomenon of the "pious copy," intended to faithfully reproduce charismatic, historic images and to provide corrective commentary on them, emerges as a means of constructing and manipulating the past, present, and future. Copying practice in the Qing court was complicated by several different expectations of the final product. At its simplest, a copy had to convey adequately the forms and colors of the original. But ancient paintings, however manipulated, were also traces of the past, remnants of authentic experience and action that, even in copying, still shone through. For the artist, the act of copying, whether line-by-line or as an act of broad emulation, was also a method of self-cultivation by means of which he could empathetically inhabit the past, retrieving it through reenactment as personal memory. These culturally embedded, Chinese expectations of the copy were also enmeshed in court practice with other, specifically Tibeto-Mongolian, Vajrayāna aims. From this alternative Inner Asian perspective, the act of copying might be more productively viewed as ritual performance, where transformations and corrections in the world of signs produce beneficial effects in the world of men. Thus in copies of such famous Buddhist paintings as Zhang Shengwen's *Long Roll of Buddhist Images*, produced in the late twelfth century for the Yunnanese Dali court, the copies' patron—Qianlong—could concern himself with multiple aspects of the original image: the fragmentation that beset the scroll in the fifteenth century and its various changes of format, the artist's brush style and the hints it provided about the scroll's provenance, the odd inclusion of unknown, local forms of otherwise well-known deities, and the presumptive insertion of the "usurper" kings of Dali at the head of the scroll. Once these issues were addressed and corrected in the copy (with the advice of Rolpay Dorje, a master iconographer), the original too was forever altered—if not materially, then certainly in significance.

The story of Zhang Shengwen's *Long Roll* does not end with the copies made of it in Qianlong's court. Like most images that claim to be "true," this emphatically local painting, embedded in bits of lore and scenery particular to Dali, nonetheless also laid claim to universalism in its attempt to reproduce every form of every deity in the Buddhist repertoire. Zhang's sources were clearly other works of art: everything from statues in Chinese, Indian, and Southeast Asian styles to frontispieces from sutras incorporated whole and without regard to apparent sequencing. His painting can thus be seen as a grand, collective meta-image rather than as a pantheon where stylistic eccentricities are erased and brought into conformity with a larger system. As Alexander Soper and particularly Wu Hung have shown in their work on famous images, these copies were not intended as icons to be worshiped but as auspicious signs of something akin to grace.[32] In the Qianlong copy of Zhang's scroll, all visual cues to the origin of each image in another, earlier image have been erased and the new scroll reveals itself as a different kind of sign—of a world brought into order. The latest irony of this politically charged act of copying, which was deeply implicated in Qing military ambitions in the southwest, has only emerged in the last few years: Recently the Qianlong copy, not Zhang's original, has been reproduced as *The Buddha Scroll*, a charmingly miniaturized, affordable pantheon marketed to practicing Western Buddhists.[33]

What remains of the original painting in *The Buddha Scroll*, where Zhang Shengwen is unmentioned, is still a potent, if altered, link to authentic experience for those who possess it. But what signs are there to mark this authenticity? How can true vision be recognized and represented? In Chapter 6, I approach this difficult, but central, question by posing the example of the visit to China in 1780 of the Sixth Panchen Lama, who, as a trusted ally of Qing concerns in Tibet, had by that time long been the object of Qianlong's interest. The Panchen's acceptance of the emperor's invitation, timed to correspond with Qianlong's seventieth birthday, set off a volley of reactions that are preserved in multiple series of representations in which the Panchen Lama was variously "recognized" in his fleshy reality, his charismatic position, and his unique, reincarnate inner landscape. More than five hundred communiqués and memorials detailing every aspect of his journey from Tibet and arrival at court; celebratory portraits of him and all his preincarnations; elaborate construction projects in Chengde and Beijing modeled on his home monastery, Tashilunpo; imperial poetry lauding him and recalling the banquets set for him; the emperor's final epitaph, written after he died of smallpox in Beijing a few months following his arrival—all reflect the court's effort to craft the event before, during, and after its unfolding. At the heart of this choreographed effort was Qianlong's sincere surprise as he encountered Tibet's most exalted lama and discovered him to be "familiar," his appearance not at all what might be expected from a *nirmanakāya*—a magically projected transformation body. The portraits done of him as he lay on his deathbed in Beijing give us the man with all his physical eccentricities, his everyday self, enthroned in a gemlike landscape of perfect order that reflects his "true likeness."

The conundrum any attempt at orthodox practice presents—religious or otherwise—ultimately forces the reconciliation of the actor and his actions with all of those who preceded him, in order to make the past present once again. Orthopraxis thus poses the individual will to uniqueness and the solitude of the single life against the greater need to realize a perfected, universalist scheme. In Buddhist practice, the resolution of this conflict between the embodied, transient life of the individual practitioner as it is actually lived and the transcendent emptiness he or she wishes to experience in enlightenment is a central goal that has repercussions both for the practitioners and for the world they inhabit. Thus Qianlong, in his momentary guise as the enlightened layman Vimalakīrti, practices what Robert Thurman has termed Vimalakīrti's incomparable, compassionate (if tough-minded) "liberative technique" both for his own sake and, as he surely believed, for the sake of the world in general. Vimalakīrti, Thurman writes, "makes it clear that the sole function of wisdom, gnosis, or any state of liberation is its function as a necessary complement to the indispensable great compassion that has no object. . . . Wisdom as a solitary possession, not integrated with liberative technique, is plainly declared to be bondage."[34] This insight, coupled with Vimalakīrti's head-on engagement with the material world of forms, makes his message, as Thurman points out, subtly tantric in its "reconciliation of extreme dichotomies": samsara and nirvana—but also the desire for enlightenment and the material benefits each ritual action brings to the world at large. In this view, shared by the emperors of the Qing dynasty, there is ultimately no contradiction between ritual and political action and none between the two apparently disparate goals of transcendence and political benefit.

Like a Cloudless Sky

Peace and prosperity, under the gentle rule of a fatherly lord paramount, dawned upon the tribes: their household *lares,* after so harsh a translation to distant climates, found again a happy reinstatement in what had in fact been their primitive abodes: they found themselves settled in quiet sylvan scenes, rich in all the luxuries of life, and endowed with the perfect loveliness of Arcadian beauty.

—Thomas de Quincy, "Revolt of the Tartars; or,
Flight of the Kalmuck Khan and His People from the
Russian Territories to the Frontiers of China" (1837)

In 1773, Jean Joseph Marie Amiot sent another in a long series of letters from the Jesuit mission in Beijing to Henri Bertin, noted sinophile and minister to the French king Louis XV. In his report, Father Amiot documented the return two years earlier of the entire Torghut Mongol tribe to the Qing empire, after more than a century in Russia, and the arrival of their leader Ubasi at the Qing summer retreat in Chengde. "The emperor," he wrote, "had foreseen that this would come about one day; why should he not have been infused with every joy when he learned that the day had finally arrived?" Qianlong, in Amiot's words, "trembled" to find the proper way to express his sense of "profound homage and feelings of respect" to heaven upon the Torghuts' homecoming. He began, as he often did, with an edict to be carved in stone in the four languages of the empire, which Amiot noted he appeared to dash off fluently in a quarter of an hour or so. Asked to explain the emperor's swiftness at composition (again according to Amiot), the grand councilor Yu Minzhong, one of Qianlong's favorite advisers and editors, said: "The emperor has come to grips with the difficult art of enclosing many things in very few words and of giving so few words the profoundest and most extensive meaning."[1] If Yu and Amiot were both struck by the emperor's eloquent economy ("like a cloudless sky"), in truth Qianlong could not stop effusing over the Torghuts' "spontaneous and free submission" as the last tribe and nation to be fitted into the Manchus' by then vast Inner Asian empire. He not only wrote the four-language (*siti*) edict of 1771 that Yu alludes to—eventually erected in far western Ili where the Manchus resettled the Torghuts with new homes and herds—he also found other formats in which to vent his joy, including another edict erected at Chengde, along with several carefully annotated poems celebrating Ubasi's bravery in bringing his people "home."[2]

Return of the Torghuts: Ten Thousand Dharmas Return as One

Several other events conspired to make Qianlong's reception of the Torghuts even more impressive and satisfying—in particular the coincidence of their arrival in the summer of 1771 with a round of spectacular celebrations at Chengde, the Manchus' summer retreat, of the Empress Dowager Xiaosheng's eightieth birthday and the emperor's own sixtieth. In filial recognition of his mother's pious Buddhist practice, Qianlong had decided to present her with (among many other things) a temple designed as a replica of the Potala, the Dalai Lama's palace-temple in Lhasa (Figure 1). The Lhasa Potala was itself modeled in more subtle ways on the mountain dwelling place of Avalokiteśvara,

the bodhisattva of compassion who manifested himself in the Dalai Lama's lineage. The empress dowager's new temple, its name transliterated into Chinese as Putuozongchengmiao, was finished just as the Torghuts arrived and its consecration was the setting for a celebratory gathering of Mongol khans, noblemen, and lamas who had come to Chengde for the birthday party.

It was there, in the innermost sanctuary of the temple, the pavilion called Wanfaguiyi (Ten Thousand Dharmas Return as One), that the Bohemian Jesuit painter Ignatz Sichelpart and a group of Chinese, Tibetan, and Mongolian artists led by court painter Yao Wenhan captured the event in a painting that stands as a summa of Qianlong's Buddhist-inspired political strategy toward Inner Asia (Plate 2). The picture and its extraordinary setting also possess what strikes the contemporary eye as most essential to the visual culture of the Manchu court: its easy internationalism, its collage-like juxtaposition of several different inculcated ways of seeing, its simultaneous interest in showing how the patterns of history revealed themselves against the apparent disorder of the moment, and, far from least, its sure sense that images of things—representations of the material world of form—mattered just as much as words.

Sichelpart and Yao's painting, done in bright, saturated Tibetan colors on Chinese silk, is a large, imposing screen that measures 164.6 by 114.5 centimeters—designed to be placed in the imperial *ger* at Chengde to serve as a backdrop for the emperor's reception of his Mongol allies. The emperor had this yurt-palace pitched in summer in the Wanshuyuan (Garden of Ten Thousand Trees), the summer retreat's "Prairie District," which replicated in miniature the grasslands and forests of Mongolia (Figure 2).[3] The division of labor in the production of the painting is clearly stated in court documents: Yao and his Tibeto-Mongolian associates provided the setting: the palatial, gold-roofed pavilion, its surrounding galleries, and the magical landscape behind. Documents also reveal that Yao undertook the emperor's portrait while Sichelpart depicted the Mongol guests and the two high

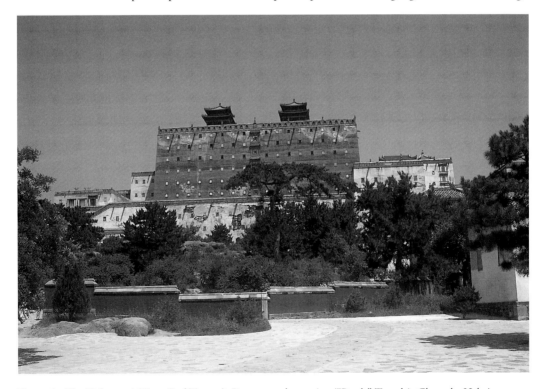

Figure 1. The Dahongtai (Great Red Terrace), Putuozongchengmiao ("Potala" Temple), Chengde, Hebei. (Photo: Charles Drucker.)

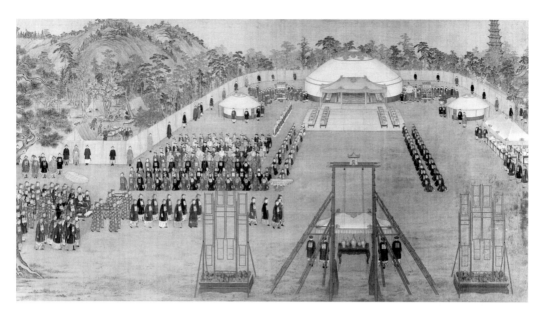

Figure 2. *Imperial Banquet in the Garden of Ten Thousand Trees (Wanshuyuan)*, detail. Hanging scroll, colors on silk. 221.2. x 419.6 cm. (Palace Museum, Beijing.)

lamas. Painters from other departments of the palace—the Ruyiguan (Office of Wish Fulfillment) and Zaobanchu (Imperial Manufactory)—filled in the more than three hundred participants from many different angles, quite a few of them from the back or only in part.[4]

Despite the crowdedness of the scene, nothing within the galleries intrudes directly on the fantastic visions in the sky above, and this strict, two-part, inner/outer arrangement clearly separates our perception of the ritual events below from the visionary events above. Palette also contributes to the sharp distinction between the two—against the predominantly red-lacquered architecture of the galleries and the pavilion's gilt roof, the emperor and his court of noblemen and officials wear formal, densely black surcoats appropriate to high court events, complete with rank badges and long, beaded rosaries, while the crowd of lamas is a sea of vibrant combinations of maroon, red, orange, and saffron. Only the ten ruddy-faced Mongol guests, seated across the pavilion to the emperor's right, appear in a motley assortment of brocaded robes in blue, green, brown, yellow, and red. Some of them even wear five-buddha crowns, marking them as initiates into the tantras of Tibetan Buddhism. The alternately dense and brilliant display of the emperor and his entourage glows against the blue-green hills, which give rise to unlikely blue- and green-tinged clouds that auspiciously form themselves into *ruyi* ("as-you-wish") fungi and, at top center, a chevron-shaped cloud in the form of a bat *(fu¹)*, a rebus that puns on the word for blessings *(fu²)*.

The scene seems strikingly symmetrical, but it is a symmetry constructed by means of balance rather than mirrored duplication. And the balance tilts gracefully in the emperor's favor. Thus Qianlong, seated within the pavilion on a dais to the right, weighs his substantial mass (he is taller seated than his courtiers standing) against the entire group of awed Mongols to the left, while Ishi-damba-nima (Tibetan: Ye shes bstan pa'i nyi ma), the young, Tibetan-born Third Jebtsundamba ("Venerable Holiness") of Urga (1758–1773), exponent of the greatest incarnate lineage of the Outer Mongolian Khalkha tribe, sits below on the Torghuts' side and echoes the posture and gesture of his companion to the right. This weighty personage is Qianlong's guru and National Preceptor (*guoshi*), Rolpay Dorje, the incarnate Zhangjia Khutukhtu (1717–1786). The entire, apparently harmonious gathering arrays itself in a way that makes the politics of the situation transparent, breaking down

into distinct affiliations that balance on the axis of the offering-laden altar, encased three-dimensional mandala, and image of the preaching Buddha, extending beyond on the golden roof finial and dragon vein of the mountain, ending with a flourish in the auspicious bat-cloud.

A dramatic ritual event is under way. The Third Jebtsundamba, Ishi-damba-nima, thirteen years old at the time, and the National Preceptor, Rolpay Dorje, preside over a dharma assembly, which everyone undistracted by Sichelpart and Yao leans forward to observe. Rolpay Dorje, born to a Monguor (ethnically Mongol) family in Amdo, was the single most powerful lama at Qianlong's court, the second in his line to attract significant Manchu imperial support and Qianlong's closest adviser on Mongolian and Tibetan matters. He was, as we will see, never far from the emperor's elbow whenever Buddhist affairs needed attention or definition. Sichelpart imparts a sense of his gravitas; he is second only to Qianlong in bulk and wears the tall, pointed pundit's hat that marks him as a learned lama. Sichelpart's portrait of Rolpay Dorje seems true to the man: His round nose and chin, full lips, and the pronounced enlargement of his neck (perhaps a goiter or lipoma) match other surviving images of him closely (Plate 3). Ishi-damba-nima, pale and elegant, is outmanned in this encounter, even though Rolpay Dorje is more distracted and glances over his shoulder to catch Sichelpart's (and our) eye. The emperor's guru, like the emperor himself, seems to focus on the historical implications of the event, as the young Jebtsundamba models his elder's posture but gazes steadfastly forward, riveted by the drama of the moment and, perhaps, by the wonder of finding himself alive at the center of it.

He had good reason to pay attention. A few weeks before, on Qianlong's order, the Jebtsundamba had been brought to Dolonnor in Inner Mongolia where he received extensive teachings and initiations at Shara Süme from Rolpay Dorje, who was officially head lama there, and another great lama from Amdo, the Second Jamjang Shepa (1728–1791) of Labrang Tashikhyil. A detailed account of the Jebtsundamba's preparation is included in the biography of Rolpay Dorje, written by his closest disciple, Thukwan, who records that the group underwent more than forty different teachings and initiations. A sizable crowd of great lamas from Inner and Outer Mongolia also participated in the young lama's accelerated instruction, including the Biligtü Nomun Khan (Biligtü Dharma King) from Dolonnor; two Khalkha lamas, Jampal Dorje Nomun Khan and Tsangpa Nomun Khan; and the Ilaghughsan Khutukhtu, whose incarnate lineage originated in Köke qota (Blue Fort), the largest city in Inner Mongolia.[5]

The thorough, if rapid, initiation of Outer Mongolia's primate was a stark assertion of power on Qianlong's part. The Third Jebtsundamba was a controversial figure in Khalkha because of his birth in the eastern Tibetan royal family of Lithang. Khalkha's nobles strongly objected to Qianlong's insistence that the third incarnation of this hitherto Outer Mongolian lineage not be reborn in Outer Mongolia proper (or, more precisely, in one of their own families). The emperor also ignored their requests to install the Tibetan boy away from Khalkha in Dolonnor. Rumors swirled around him, alleging he had been harshly treated, even beaten, by agents of opposing factions in Khalkha. Thus his pale, central presence in Chengde at the dedication of the Putuozongchengmiao represents a direct statement on Qianlong's part: Mongolia's days of autonomy were long over.

In narrative and symbolic terms, therefore, Sichelpart and Yao's picture outlines the relationship between the Manchu court and its Inner Asian dependents, both political and religious. Here the lifelike lamas may sit below the emperor and his guests, but it is their learned discourse that produces a choreography of Tibetan-style visions in the sky, beneath which the emperor sits, subtly and acquiescently sidelined. Heaven gets its due as the relationships of power are diplomatically ambiguated, even as they are laid out in a composition that appears at first glance almost diagrammatic in its clarity. The picture also summarizes Qianlong's understanding of time, memory, and history in remarkably economical terms. It presents a remembered event in such a way that the viewer

feels himself privileged to be present, just as he suspects the artists were (though they probably did not actually paint the scene as it unfolded).[6] Each member of the large crowd is individualized, though some participants more carefully so than others (especially the emperor, his closest attendants, the Mongols, and the two main lamas). Each also seems to find his own level of interest in the event at hand; some are absorbed, others withdrawn into themselves, others actively seeking the eye of history, represented by Sichelpart, Yao, their cohorts, and us, the unimaginable audience of the future. In other words: Qianlong required a precise record of the event as it actually happened or, at least, a painting that conveyed the *impression* of a report in which all details are given equal weight, recorded without prejudice. This is not exactly what the painting provides, however. Many participants, especially those painted in Chinese figural style, are only identified in a patterned way—this one pale, the next one swarthy; that one fat, his neighbor thin. But the idiosyncracies and coincidences of the moment—its subtle ripples of disorderliness—are not the emperor's only interest. Even more significant is his desire to see this singular but mundane event set against a larger pattern that is both historical and cosmological, a construction vividly revealed in the joyous but calm epiphany in the sky above. This desire may explain the mise-en-scène, not at the moment of greeting between Qianlong and the returned Torghuts, but in the middle of the lamas' ritual performance when "ten thousand dharmas returned as one."

The actual setting of the reconciliation of the Manchus and Torghuts was obviously fraught with meaning, even going beyond the birthdays of the emperor and his mother. The Putuo-zongchengmiao was not the first temple at the summer retreat at Chengde designed to replicate one of the great monasteries of Tibet. But as Anne Chayet has demonstrated in her detailed study of Chengde's Eight Outer Temples (Waibamiao) and their Tibetan sources, it was the first that even partially followed its chosen model in real architectural terms, translating its forms and spaces to fulfill very different needs.[7] Earlier temples at Chengde had depended on famous historical models, but their links to the past were often more a matter of pronouncement and intent than actual structural design. The Puning Temple (Temple of Universal Peace), built in 1755 to honor the Manchus' successful conclusion of their decades-long struggle against the western Dzungar Mongols, is a case in point. The temple's Dashengge (Pavilion of the Great Vehicle, that is, the Mahāyāna) contains a colossal statue, more than 22 meters high, of the thousand-armed (actually forty-two-armed), thousand-eyed Avalokiteśvara, the bodhisattva of compassion, which may be a copy of the famous, 22-meter-tall bronze colossus at the Longxing Temple in Zhengding, made in the third quarter of the tenth century. In the edict he wrote in 1755 to establish the temple, Qianlong ignored the Chinese source of its main icon, however, concentrating instead on the fact that the temple was modeled on Tibet's first monastery, Samye, which was founded by Trisong Detsen, a wheel-turning king, a *cakravartin* of profound virtue and an incarnation, like Qianlong, of Mañjuśrī, the bodhisattva of wisdom.[8] The original Samye was famously designed as a mandala—that is, in the form of a diagrammatic palace structure surrounded by graduated terraces, with its ruler, the mandala's main deity, at its center. This plan, Chayet argues, specifically enhanced the significance of the center chamber and its occupant and made it eminently suitable to the promotion of sovereignty, both of Trisong Detsen and, ultimately, Qianlong. But the Puning Temple's Tibetan style (more accurately its Tibeto-Chinese style) was also an homage to the Mongols' faith in the Tibetan Gelukpa (the Yellow Hat order). At the same time, the propriety of honoring the Torghuts' capitulation with a temple followed a precedent set by Qianlong's august grandfather, the Kangxi emperor (r. 1662–1723), who established the Huizong Monastery (Mongolian: Koke Süme) in Dolonnor for the Outer Mongolian Khalkha after their surrender to the Manchus in 1691. Qianlong thus claimed two prototypes for his new temple: one architectural (but followed only in plan) and the other a historically sanctioned model of ideological intent. It was proper to conclude great acts of war with the raising

of temples, Qianlong argued, for like his grandfather he believed an emperor had to combine "sagely virtue and divine merit" into a fabric whose "warp threads were civil *(wen)* and whose weft threads were martial *(wu)*."[9]

The Putuozongchengmiao's sources offer a different kind of complexity. In his founding edict of midautumn 1771, Qianlong explains that the temple was modeled specifically on the Tibetan Potala, the great fortress-temple completed in 1657 by the Great Fifth Dalai Lama on the sixth-century foundations of the earlier Potala of Tibet's first religious kings. But there are other Potalas as well, as the emperor notes, including the "Potala of the South Seas," the island off the southeastern Chinese coast that Chinese Buddhists considered to be Avalokiteśvara's (the Chinese Guanyin's) field of activities and the site of miraculous visions of the bodhisattva.[10] This island, which seems to "rise out of the ocean's billowing waves like an oceangoing ship," is really *the* Potala from the Han Chinese perspective, however, and the emperor is quick to note that his new monastery is not modeled on it, going so far as to call the Chinese monks who propagate this view "bold." In fact, he says that according to the sutras written on palm leaves, the most authoritative, original texts of Buddhism, there are three Potalas in all: the first in India,[11] the second in Tibet, and the third in the South Seas. And so he argues that the transmission of the Potala concept was clearly from west to east, with the Chinese Potala of the South Seas at the end of the chain. Qianlong goes on to mention that because India's "Diamond Seat" (Bodhgayā, the site of the Buddha's enlightenment) is so far away and beyond even his powers of inspection, he can only turn to Tibet for his model. He wraps up his demonstration of the historical, if not the formal, interrelatedness of the various Potalas with these words: "This then is the Summer Retreat Potala, which is like the Potala in Tibet and also like the Potala in India. How could it not also be like the Potala of the South Seas?"

It is, indeed, difficult to judge just how much Qianlong thought the Putuozongchengmiao resembled the original Potala in India—supposedly Avalokiteśvara's actual mountain dwelling—and as difficult to comprehend in what terms it might have resembled the collection of visionary sea caves and temples dedicated to Guanyin on Putuo Island. But just how much is it like its admitted architectural model, the Dalai Lama's Potala in Lhasa? Anne Chayet's research provides a carefully documented answer to this question: superficially a great deal, but in essence not very much. Chayet shows that the most overwhelming feature of the Dalai Lama's Potala—its typically Tibetan-style combination of massive white (lower and outer) and dark red (upper and inner) masonry bulwarks, which rise up to mimic the sharp incline of the mountain the whole complex caps—is only followed in the broadest terms in the gentler hill setting of the Putuozongchengmiao. In a revealing cross section of the two sites, she demonstrates that the blind, lower portion of the Lhasa Potala is strictly structural: a foundation that creates a series of staggered platforms enabling the construction of the separate towers of the Potala itself.[12] The Dahongtai (Great Red Platform) of the Putuozongchengmiao is very different, though its differences are cleverly hidden. It creates a similar aspect of multiple massive forms on a much less precipitous hill with its huge, apparently fenestrated (but actually blind) four-sided masonry wall. These four walls are not foundations but contain a courtyard ringed all around with galleries of red lacquered wood that mask the golden-roofed Wanfaguiyi Pavilion, the site of Qianlong's encounter with the Torghuts. As Chayet observes, the Putuozongchengmiao taken as a whole is essentially a Chinese-style temple complex, axial in plan and crowned with an example of Chinese terrace architecture, the Wanfaguiyi Pavilion, which is cloaked and hidden from casual view by its Tibetan masonry veneer.

So what did it mean, then, when Qianlong invited his latest loyalists, the Torghuts, to celebrate the simultaneity of their return to the Qing empire with his and his mother's birthday festivities in a Chinese-style pavilion enclosed within a Tibetan-style citadel? The very name of the pavilion, "Ten Thousand Dharmas Return as One," immediately suggests a rush to the center, which is indeed the

subject of Sichelpart and Yao's painting: the felicitous unification of several different, previously separate, groups into one, all under the benevolent gaze of the Qianlong emperor and underscored by the balanced juxtaposition of Mongolia's two leading lamas, the Jebtsundamba of Outer Mongolia and the Zhangjia Khutukhtu of Inner Mongolia and Beijing. But the painting also captures another significant aspect of the building—that it is essentially a classical Chinese pavilion. It exists in an open, though constrained, space and the visitor must scale the Tibetan-style battlements surrounding it to glimpse its actual structure at all. Its position is simultaneously inside and outside—inside a masonry embrace but open to the sky and its auspicious patterns. The building accomplishes what the whole of the Chengde complex also sought to do, namely, to reproduce the diversity of the empire, if not in miniature (for the Putuozongchengmiao complex is really very large), then at least in compact form. The Putuozongchengmiao expresses a symbolic, geopolitical accuracy: China exists surrounded by the protective layer of Tibetanized Inner Asia, and even the greatest Mongolian lamas are really Tibetans.

But Qianlong's edict seems to insist upon another issue as well: accuracy of transmission. Far from asserting that his project is something new or original, he searches hard for the most appropriate precedent—graciously, given the circumstances of the Torghuts' return, finding it in the residence of their mutual Tibetan ally, the Dalai Lama. Sichelpart and Yao, however, add another dimension to this politicized aspect, locating the pavilion and its events in a vaster cosmology. Here, in this most secret spot, their picture demonstrates, is where the enduring, repeating patterns of everyday life reveal themselves to be in balance and where scattered memory becomes, at least apparently, objective history.

Sichelpart and Yao offer us a picture that, to the contemporary eye, seems to anticipate some of the complexities of photography. They present what comes across as a true version of the event, capturing it in all its immediacy, however ritualized and posed, while at the same time highlighting some participants and consigning others to obscurity. Thus a few figures in the crowd disappear behind more prominent participants; still others preen or stare full-face, copying an old Chinese muralist's trick to make the pictorial surface seem transparent; the emperor, accustomed to having his portrait painted (Sichelpart did a formal portrait of him around the same time), shows us his best, left side. Most members of the crowd appear only as parts of a larger group that is randomized to suggest the general patterns of human diversity that day, while a select few, the main players, enjoy the additional dignity and interest of facial individuality.[13]

But Sichelpart and Yao do not just give us a picture of a moment in time, however manipulated. They are also complicit in an act of representation where the recognition that the events at hand are a fulfillment of a prophecy arrests the superficial disorderliness of the instant. Heaven states its approbation clearly. The picture's impact depends on the counterposition of the scene below, which is full of anecdotal interest rendered in a mélange of Chinese and Western style, against the careful, complex, but hardly stable patterns in the sky, rendered in an amalgam of Chinese and Tibetan style. Revelation, the artists suggest, is produced through counterpoint as the irregularities of the phenomenal world come into momentary balance against a shifting but deeply designed backdrop that only occasionally shows its true scheme. Yet something else is at play in the choice of the dharma convocation as the culmination of everything else that happened that day. The nearly symmetrical posing of the two protagonists is part of an all-encompassing choreography of balance, it is true, but the two incarnations are caught as they simultaneously raise bell and prayer beads in their right and left hands. Their shared gesture is enough to show that this moment, however specified by its cast of characters, is part of a ritual, an action that, when properly performed, is like every other performance of it in shape and intent. With this raising of hands, time is ritualized and momentarily suspended, or, in Qianlong's own apt phrase, "before and after are all gathered up in present

appearances."[14] What Sichelpart and Yao have produced is more than a snapshot of a moment in time; they have also suggested ways in which this moment is especially sanctified by its similarity to past events and by the promise it holds for the future.

Ten Thousand Dharmas Return as One represents a complex series of translations from the "original" moment, all of them carried forward in separate, juxtaposed visual modes. The very setting of the picture is a quote, an adjusted copy of the Dalai Lama's Potala, only partially translated into Chinese, on soil beyond the Great Wall whose character is hard to pin down—is it Mongolian or is it Manchu? But could the picture itself also be a quotation of some past image? One notable precedent presents itself: a mural in the Dalai Lama's own Potala, probably completed under the auspices of the Great Fifth, Ngawang Losang Gyatso (1617–1682), which records his meeting in Beijing in January 1653 with the Shunzhi emperor (r. 1644–1662), the first ruler of the Manchu Qing dynasty (Plate 4). Like *Ten Thousand Dharmas*, the double portrait of the Dalai Lama and Shunzhi is a large picture meant to invoke by its size and detail the immense significance of the event. And like *Ten Thousand Dharmas*, the Potala picture depicts a multiwalled palace compound. Its protagonists too sit in front of a splendid golden-roofed hall, this time located within the Forbidden City, where they face a similar convocation of reverent monks, officials, and tribute bearers. Beyond the four sets of palace walls, laid out in plan exactly like a mandala, is a verdant landscape where noblemen picnic and servants carry pitchers of beer back and forth. The entire scene is a beehive of activity and the larger-than-lifesize but almost equally giant emperor and Dalai Lama (the emperor may be a bit higher, but the Dalai Lama is a bit bigger) hold forth in the calm center. Samuel Grupper has suggested that the emperor "substantiated the 'rule of the saints' " by supporting Tibetan Buddhism at this historic meeting. He offers a Mongolian description of Shunzhi's reaction:

> [The Shunzhi emperor] abundantly supported the Jina's [that is, Śākyamuni's] religion of the powerful saints and venerated the son of the Jina, the Omniscient (Dalai Lama), as the ornament of his sinciput. He cherished the Lama in the absence of the Refuge of Sentient Beings, the Bogda Panchen Erdeni (who was too infirm to travel), giving protection to the Superior of the Buddhist religion (the Dalai Lama), and firmly established, to a high degree, the rule of the saints.[15]

How are these ideas carried forward visually? In the earlier Potala mural, Beijing's Forbidden City is translated pictorially to the Potala, with the Dalai Lama and emperor reigning benignly over a bustling scene of fecundity and wealth. In Sichelpart and Yao's picture, the Potala has been translated architecturally to Chengde and now opens pictorially to reveal the two great incarnations of Mongolia: the much-maligned youth, Ishi-damba-nima, representing the north and Rolpay Dorje the south, presiding side-by-side under the emperor's gaze. Given his costarring role, it is interesting to note that Rolpay Dorje most likely had seen the Lhasa picture. He traveled to Lhasa in 1734, when he accompanied the exiled Seventh Dalai Lama back to the Potala, and again in 1757 when he officiated over the selection of the Eighth Dalai Lama.

Ten Thousand Dharmas' simultaneous presentation of the congruence of events of 1771 in several distinct styles veils what in the earlier Lhasa picture is a clear mandalic structure: The Dalai Lama and his imperial patron jointly occupy the center and take on all the nuanced religious meaning this particular positioning conveys—that they also jointly occupy an "enlightened field" in the same sense that any lord of a mandala does, indeed, as any practitioner does. This suggestion required a great deal of manipulation on the Lhasa artist's part, since what he really depicts is the elongated axial plan of the Forbidden City, here compressed from top to bottom to produce something close to a mandalic square. The grand bird's-eye view Sichelpart and Yao give us into the galleries of the Putuo-

zongchengmiao, however, opens up its concealed courtyard space, while the emperor sits to the side (though subtly large) and two Mongolian lamas, the one well established, the other a bit tentative, direct the ritual events. These adjustments conceal (perhaps intentionally) the building's essential mandalic form, cloaking the religious essence of its message from casual view. Yet the clash of Western, Chinese, and Tibetan style we are given here also creates a sense of how very scattered the everyday world is. In fact, there are so many other levels of quotation—of style, architecture, and earlier event—interceding between the moment at hand and their representation that the picture seems like a gallery of mirrors, reflecting the past into the present and back, linking every possibility of real action to past precedent and future prediction.

In the abstract terms set out by the contemporary French historian Pierre Nora, Qianlong's record of his meeting with the Torghuts might be said to move beyond the often unfocused or telescopic quality of memory toward the realm of history. "History," in Nora's words, "binds itself strictly to temporal continuities, to progression and to relations between things"; it is tied to events whereas memory "takes root in things, in the concrete, in spaces, gestures, images, and objects."[16] Here, however, both contexts—temporal and chronological, material and spatial—are brought into resolution by setting the event in a building that is a manipulated copy of someone else's copy, a covertly sinified Potala, modeled on the Dalai Lama's own palace, which, in turn, reproduces the mountain home of Avalokiteśvara in an even subtler manner. As a representation of an event, their picture also reverses the viewpoint of an earlier representation, the mural in Lhasa.

In Buddhistic terms, Sichelpart and Yao's picture and the new Potala it represents emerge as knowing and telling examples of the Middle Way, the Mādhyamika philosophy of Nāgārjuna, which Qianlong studied under Rolpay Dorje's tutelage. In this view, all things are contingent: Their appearances, indeed, their claims to identity, are event-based, relational, not absolute—hence the famed "nonduality" of Mādhyamika, a phrase which urges the view that nothing exists independent of other things and acknowledges the shifting sands of the phenomenal world. But the balance the Middle Way provides is in its admission that things do, in fact, exist. They are not mere figments of the imagination, though their qualities are always in flux. Qianlong's projects often seem simultaneously to promote and subvert this view: to promote the fragile contingency of relationships (which dissolve and then return) and to subvert the impermanence of things.

Nora has also argued that the modern need to lodge memory prosthetically in materialized traces—to create "paper memory" like archives, film, or monuments, what he calls "sites of memory"—has to do with our estrangement from our own past. The Manchus, too, were estranged from their pre-dynastic past, which was only recorded spottily in Chinese, Mongolian, and Korean histories. To fill the void, they coopted the histories of others, especially the Mongols. They also insisted on modeling their works on authoritative sources like the Potala and the other great monasteries of Tibet and, in doing so, created new methods of legitimation that were based on appropriation, reinvention, and reimagination. By subsidizing a copy of the Tibetan Potala at Chengde, Qianlong aligned himself with the great religious kings of Tibet—who built the Potala Palace in the seventh century, married Chinese princesses, and were subsequently understood to be manifestations of Avalokiteśvara—and with the magnificent deeds of the Great Fifth Dalai Lama, who, with the Mongols' help, created a theocratic government in Tibet, bolstered by the notion that the Dalai Lamas too were manifestations of Avalokiteśvara. The Potala was a form that was worthy of encompassing and memorializing such a great event as the celebration of the emperor's and his mother's amazing longevity. It was also worthy of giving shape and meaning to the return of the Torghuts, radically restructuring this political event to reveal how it matched the deep patterns of heaven's plan.

Just how the Manchus understood history and its complicated formulation from the already subjective matter of memory is fundamental to unraveling their visual culture, Buddhist and other-

wise—and, vice versa, their visual culture was designed to embody their construction of their own history. In this process the role of the Middle Way was profound, especially in Qianlong's thinking. We will see him returning to its central tenet of nonduality over and over again, even in his comments on pictures of himself. This was not, I believe, sheer vanity, as some have said, since Buddhism urges that the proper focus of the mind should be on itself. But his fascination with nonduality also challenged him to postulate ways in which the shifting compositions of real things could be organized to serve his family's grand scheme. History, in his view, could do nothing but repeat itself; the trick for the world ruler he assumed himself to be was to discern its broad patterns and, by understanding the shape of the past, mold the present and foresee and secure the future. To this end he supported and practiced several different ways of constructing history, some public, some private. Among them were such time-sanctioned methods of representation as the archive and the picture, which were produced during his reign in volumes never seen before.

But it is also worth noting here that Qianlong regularly practiced a proprietary, personal communion with the past of praiseworthy individuals, especially with the great artists of China. Following a traditional Chinese method of self-cultivation, he communed daily with the ancients through the mechanism of imaginative memory, modeling his own physical actions on their actions as he wrote and painted copies of their works every afternoon, living vicariously inside a Han Chinese body, testing the effect of his practice by commanding portraits of himself as he lifted the brush or admired works of art. This sort of ritualized, meditative communion with the Chinese past as it was actually lived, or as he imagined it had been lived, hovers outside the requirement of history to represent the past outwardly, even as it impinges on unmediated memory. Qianlong's practice of Chinese-style self-cultivation through art in some ways resembles his Vajrayāna Buddhist practice, particularly in the requirement of both that he harness ritualized physical action to great feats of memory in order to demonstrate and exercise the contingent, fluid nature of the self. Both of these daily practices of his—the art of the brush and Buddhist meditation—seem to represent accommodations that eased the disjunction between his addiction to the mediated, represented historical past and his ardent desire for immediate, firsthand experience.

Mediation was the watchword during the Qing dynasty. The Manchus' court was a polyglot world. They commanded diverse styles of visual representation and they were heirs, as they saw it, to several distinct historical traditions that not only provided different points of view but also offered different conceptions of what was significant about the past. Sichelpart and Yao's picture suggests, not only the complexity of the Manchu cultural mix at its height, but also the fluency it required from those who wanted to participate in it. How then, in the midst of such complexity, did the Manchus construct and represent the history of their own success in words and images? What moments in the past did they believe resonated meaningfully in their own times? And just how much of the history and memories of others did they choose to remember as their own?

The New Mongols

Much of the Manchus' rendition of their own history, their official dynastic myth, had already been set firmly in place by court historians, lamas, and artists in the service of the founders of the Qing dynasty long before Qianlong came to the throne. Buddhism, particularly Tibetan Buddhism with its vivid, realized vision of endlessly repeating cycles, was deeply implicated in this process. Qing state Buddhism was explicitly built, by the Manchus' own admission, on a Mongolian foundation. The Manchus were first converted to Tibetan-style Buddhism by Mongolian lamas—and the success of this conversion, not surprisingly, was embodied in their premier dynastic image: a golden figure of the great protector Mahākāla, cast for the Imperial Preceptor of the Mongol Yuan dynasty,

Phagpa Lama (1235–1280), sometime around 1274. Phagpa Lama was a member of the ruling hierarchy of Tibet's then dominant Sakya order who with his uncle, Sakya Pandita, and his brother was sent as a "guest" (in truth a hostage) from Tibet to the Mongol court of Möngke Khan, in the northwest Gansu Corridor at Liangzhou. Phagpa eventually initiated Khubilai Khan's wife, Chabi, into Vajrayāna practices, and it was she who persuaded her husband, who was Möngke's brother, to undergo Buddhist initiation as well.[17] Khubilai and Phagpa forged the politically definitive lama/patron relationship (Tibetan: *chöyon*) that gave Phagpa oversight of Tibet and, as Imperial Preceptor (Chinese: *dishi*), control over the spiritual affairs of the whole of Khubilai's Yuan empire. This arrangement left Khubilai in undisputed command of political matters with the emperor and his guru sitting side-by-side, as "sun and moon," reigning over a huge Buddhist empire.[18]

Phagpa's Mahākāla, lost since at least World War II, is likely to have resembled a delicately carved stone image of the same form of the great protector (Musée Guimet, Paris) dated by inscription to 1294 (Figure 3). This stone figure, like the golden Mahākāla, has been linked to the artistic tradition of Anige (1245–1306), the Nepalese artist-prince who is credited with crafting the Newari Buddhist style of Khubilai's court at Phagpa's invitation.[19] In fact, the Guimet's Mahākāla is so thoroughly Nepalese in style that it would be difficult to recognize as a work made in China were it not for the Tibetan inscription carved into its base, which identifies its patron as a Tibetan monk resident in Dadu (modern Beijing), the northern Chinese capital of the Mongol Yuan dynasty. The anonymous artist of the Guimet's Mahākāla, perhaps Tibetan or Nepalese himself, made no attempt to "translate"

the figure into something discernibly Mongolian. Not only were there no such terms available, but the very style of the piece—the tricks its creator used to give us a sense of the transhuman form of the great protector: its chunky, blunt frontality, the paradoxical finesse and allure of its detailed, hideous ornamentation—carries meaning in a register separate though parallel to the easily readable symbolism of the deity's specific and terrifying attributes, particularly his skull-headed chopper and blood-filled skull cup.[20]

From the Mongols' point of view, the great protector Mahākāla embodied a number of traits, including piercing intelligence and prowess in battle, all of which Khubilai Khan hoped to acquire by undergoing initiation into his rites. Thus Khubilai understood that the practices of Tibetan Buddhism could work both internally, to improve his own perceptive powers, and also externally to protect his troops. Phagpa Lama's golden Mahākāla was originally designed as a palladium to be deployed in the Mongol campaign against pockets of Song resistance in the south. The image therefore acted symbolically and materially—literally transforming the phenomenal world. It proved to be a potent witness to earth-shaking events in the centuries that followed.

The image's subsequent history is an intrigu-

Figure 3. *Gurgyi Gompo* (Mahākāla, Lord of the Tent), dated 1292. Stone with polychrome. H: 48 cm., W: 29 cm. (Gift of Lionel Fournier, Musée Guimet, Paris. Photo: Réunion des musées nationaux, Evandro Costa.)

ing tale recounted in a 1638 Manchu inscription at the Mahākāla Temple in the Qing homeland of Mukden.[21] This inscription states that Phagpa cast the golden image of Gur Mahākāla, made an offering of it at Wutaishan (also the site of battle offerings made on behalf of subsequent Manchu exploits), and later took it west to Xixia (Tangut) territory. In the early seventeenth century, the Mongolian Sarpa Khutuktu brought the figure to Ligdan Khan (1604–1634), a descendant of the Yuan emperors who was trying to stage his own Mongol revival in Chahar, eastern Inner Mongolia. When the Qing founder Abadai defeated Ligdan in 1634, Mergen Lama (also known as Mañjuśrī Pandita) brought the Mahākāla to Mukden, where the newly Buddhist Manchus built a grand mandala-shaped complex to house it. On February 12, 1636, Abahai and his brother Dayisan, along with the Mongol prince and Manchu ally Jasagtu Dügereng, participated in a mandala ritual, kowtowing an auspicious nine times to the image of Mahākāla. In his study of the Mukden Mahākāla complex, Samuel Grupper underscores the ways in which this ceremony was consciously modeled on a "prestigious antecedent"—the Mahākāla initiation that Khubilai Khan and his Korchin Mongol allies staged in 1264, when Phagpa Lama recognized Khubilai as a wheel-turning world ruler, or *cakravartin*.[22] This would not be the only time the Manchus aligned themselves symbolically with the Great Khan and his guru.

The story of Phagpa's Mahākāla does not end with its arrival in Mukden. In 1694, shortly after the Kangxi emperor accepted the submission of the Outer Mongolian Khalkha tribe, he ordered that the image be brought to the capital at Beijing, a city that was already associated with Mahākāla's spiritual father, Vairocana, the central, all-generating cosmic Buddha.[23] There it was enshrined in a mansion that had been the residence of the Manchu regent Dorgon (1612–1650), the Qing dynastic founder Nurhaci's fourteenth son and Abahai's brother. In 1776 the Mahākāla Monastery was renovated and renamed Pudusi, the Monastery of Universal Passage.[24] Thus Phagpa's golden Mahākāla was present when the Mongol empire in China was first secured through a ritual on Wutaishan, survived incognito through centuries in the Tangut desert, reappeared in the early seventeenth century to witness and legitimize a second wave of Mongol aspirations, only to fall into the hands of the Manchus, who went on to found the next great Asian empire, taking the Mahākāla as an auspicious sign of their destiny. The image, in other words, stood for something beyond its esoteric usage in Buddhist practice: It had literally taken on a life of its own as an actor in the phenomenal world and, more precisely, on the political stage, where it was susceptible to creative reinvention.

Years later, when Qianlong underwent his first initiation (into the Śaṁvara tantra) in 1745, Rolpay Dorje speculated that the event was uncannily like Khubilai's initiation by Phagpa Lama. Both of the lama's biographers mention his reading of Qianlong's astounding toss of the *sho shing* (stick) to determine his spiritual family—the stick landed on the mandala right in the center, where it stood straight up. Thukwan put it this way:

> Previously, in the Water-Cow year, the Dharma-King Phagpa gave the Hevajra initiation
> to the Mongol emperor Khubilai Secen Khan. I gave the Śaṁvara initiation to the great
> emperor in the Wood-Cow year. Both initiations therefore happened during a Cow year,
> even though the "stems" were different.[25]

Rolpay Dorje masks his real meaning here. He does not claim outright that he is an incarnation of Phagpa; nor does he claim that Qianlong is Khubilai. Instead he relies on the congruence of larger cosmological and calendrical forces to suggest that this might be so. His disciple and biographer Thukwan certainly believed it was, pointing out that the Tibetan Panchen Lama had written a prayer identifying Rolpay Dorje as an incarnation of Phagpa and Qianlong as Khubilai's incarnation.[26] Thukwan himself lists Phagpa as the eighth incarnation in Rolpay Dorje's lineage. According to him, the

tenth incarnation was Sakya Yeshe (1352–1435), another politically astute lama whom Tsongkhapa, the founder of the Gelukpa, deputized to visit the court of the Ming Yongle emperor (r. 1403–1424), where he was titled Daci fawang (Great Compassionate Dharma King) and loaded down with splendid gifts of texts and Buddhist images.[27] Thus the lines of incarnation easily crossed the boundaries between orders, all the while weaving a pattern of emperor and honored guru that repeated itself in Qianlong and Rolpay Dorje.

The career of Phagpa Lama's Mahākāla, what contemporary writers such as Igor Kopytoff and Richard H. Davis would call its "biography," follows the contours of this series of political (dis)simulations closely.[28] Here was the authentic war god of Khubilai Khan, who presided over—literally ensured—the short period of Mongol greatness in the late thirteenth and early fourteenth centuries and who now stood as a reification of the fact that the Mongol empire would be recreated by the Manchus. The particular manner in which the Mahākāla asserted this, in terms that could not at first be translated, was just as important as what he embodied. His style of fabrication, about which we can make only an educated guess, was most probably alien. Even his identity was starkly foreign in the context of Han Chinese Buddhism and in the newborn Buddhism of the Manchus. But his ultimately Nepalese-inspired visual style rapidly became the style of the conquest—the starting point from which all the Manchus' attempts at appropriation and reinvention of the visual culture of Buddhism began.

The Diplomacy of Art

In between the story of the peregrinations of Phagpa's Mahākāla from Wutaishan to Mukden and on to Beijing and the dharma assembly held to celebrate the return of the Torghuts to China lies the scant biography of the boy Ishi-damba-nima, the third incarnate Jebtsundamba of Urga. His presence in 1771 at the Putuozongchengmiao was, as I have suggested, politically charged—indeed his trip does not even receive passing mention in the several Mongolian biographies of him and his lineage.[29] In their pictorial record of the event, Sichelpart and Yao diplomatically present him and his Mongol companions as counterbalancing Qianlong, his guru Rolpay Dorje, and a significant portion of the imperial court. The importance of his active participation in this convocation of great figures is underscored by Qianlong's urgent request to Rolpay Dorje to get the boy in shape for the event with intensive training sessions at Dolonnor just weeks before. Why did Qianlong have such a stake in making the Urga incarnation look good?

The boy was, as we have already seen, a controversial figure in Outer Mongolia because of his royal Tibetan birth, which Qianlong clearly manipulated from both ends. Not only did the discovery of the Jebtsundamba's incarnation in Tibet allow the emperor to sap the power of the Khalkha nobles, who naturally wanted to find him in one of their own families as they had before, but it simultaneously bestowed imperial favor on Lithang's royal family. Thus at Chengde, Qianlong was able to demonstrate his authority to the gathered Mongol nobles. Among them were the Torghuts, shell-shocked, but innocent in this particular affair of the Jebtsundamba, part of a context the Khalkha could hardly disturb with surly behavior. But coupled to Qianlong's political motive was a more nostalgic one, what we might call a matter of memory. Ishi-damba-nima was the third incarnation in the Urga lineage; the first was Zanabazar (1635–1723), the charismatic son of the Khalkha Tushyetü Khan and guru of Qianlong's grandfather, the Kangxi emperor. It was Zanabazar who brought Outer Mongolia into the Qing empire in 1691, paving the Khalkhas' way with gifts of his own brilliant sculpture.[30]

Zanabazar's hagiography describes him in the typically hyperbolic terms applied to saints as a prodigious child, born in the midst of miraculous apparitions, fascinated at an early age with reli-

gious ritual, and exceptionally talented as an artist in his own right. In 1639 a convocation of Khalkha nobles at the western Outer Mongolian monastery Erdeni Zuu accepted him as their primate (he was only fifteen by Mongolian count) and ten years later sent him to Tibet to be recognized by the Great Fifth Dalai Lama. The Great Fifth and the Fourth Panchen Lama, Losang Chökyi Gyaltsen (1569–1662), both granted him many initiations and teachings over the course of the next year. The Dalai Lama, sensitive to political possibilities, also gave the boy the title Jebtsundamba (Venerable Holiness) and recognized him as the reincarnation of Tāranātha (1575–1634), a lama he considered particularly troublesome, who had died just before Zanabazar's birth while missionizing in Inner Mongolia. Tāranātha was a notable historian and promoter of the liturgies of the universally beloved female bodhisattva Tārā, but he was also a Jonangpa, a politically powerful rival order to the Dalai Lama's Gelukpa. Tāranātha's rebirth in a prominent Khalkha—and now suddenly Gelukpa—family transferred in one stroke all the merit he had garnered in Tibet and Mongolia to his incarnation Zanabazar and, by extension, to the Gelukpa. The identification of Zanabazar as Tāranātha incarnate also allowed the Dalai Lama, for all intents and purposes, to absorb Puntsagling, Tāranātha's home monastery in Tibet, which the Dalai Lama renovated with murals by Nepalese painters.[31] More significantly for the creation of what would eventually be a Manchu imperial Buddhist style, at the Dalai Lama's order fifty painters and bronze casters (the number rises in some accounts to a hundred), all of them likely to have been familiar with Nepalese and other Tibetan styles, accompanied Zanabazar back to Outer Mongolia, where he began to build a new, Gelukpa establishment.[32]

Upon his return to Khalkha, Zanabazar constructed a stupa to house Tāranātha's remains; established a traveling palace, *örgöö* (which gives us the Russian name Urga), which the Mongols called Da Khuree or Ikh Khuree (Great Circle); and embellished its portable temples with painting, sculpture, textile hangings, and ritual objects. He composed liturgical music and designed monks' costumes and rituals—all based on the way things were done at the Panchen Lama's monastery, Tashilunpo. He also produced a body of bronze sculpture that is indirectly heir to Nepalese traditions (as in Figure 4). Apparently he first sent examples of his bronze sculptures to the Manchu court around 1655 and even produced sculptures in metal and gemstones on the spot during his visit to the court of the Kangxi emperor in 1691. His visit to the Manchu capital at Beijing immediately followed the Khalkhas' capitulation to Kangxi at Dolonnor, which he led to avoid the onslaught of the Western Mongolian Dzungars. Later in 1721, when he visited Beijing again to participate in Kangxi's birthday celebrations, he produced more sculpture, some of which apparently survives in the collection of the Palace Museum in Beijing.[33] Zanabazar died in Beijing in 1723, shortly after paying homage to the emperor's remains, and his own body was returned to Mongolia and then moved in 1779 to an elegant Chinese-style monastery, Amur-Bayasqulangtu, built by the Manchu court as his final resting place.[34]

Kangxi had great admiration for the Mongolian lama, as did the members of his family. It is not too much to say that Kangxi had the same feelings for Zanabazar that Khubilai had for Phagpa, though he never explicitly said so. Zanabazar's Mongolian biography tells us that Kangxi thought of him as a "buddha from former times" like the Dalai and Panchen Lamas.[35] By the late nineteenth century, the story went that Zanabazar once broadly hinted to the emperor that "we two have previously been lama and benefactor."[36] Both certainly understood the parallel between their relationship and the official lama/patron system of the Yuan dynasty in both spiritual and political terms. In 1694, the same year Phagpa's Mahākāla was moved from Mukden to Beijing, Kangxi titled Zanabazar "Da Lama" (Great Lama) and even traveled with him to holy Wutaishan, the Five Terrace Mountains near the Chinese-Mongolian border believed to be the bodhisattva Mañjuśrī's field of enlightened action. Zanabazar's biography also lays bare the degree of discomfort Kangxi's Chinese advisers felt as the emperor's attachment to his lama grew, tugging his attention away from China and back toward

Inner Asia. Increasingly, as his biography reports, the emperor "had faith in whatever his Serenity uttered, but the Chinese among his ministers in attendance did not believe."[37] In truth, from about 1701 until the time of his death in 1723, the intensity of Kangxi's Buddhist practice notably increased. During these years alone he produced more than four hundred handwritten copies of the *Heart Sutra,* a material testament to his heightened piety.[38]

How much of the sculpture currently attributed to Zanabazar is his actual work? This is a question that forces us to understand the work process in rather contemporary terms—as a complex series of steps from meditative visualization all the way to design and production, which may or may not have been handed off to experts in casting, a Nepalese specialty. Zanabazar is known to have established a retreat on the outskirts of Erdeni Zuu, in western Khalkha. Because most of his religious career was carried out in aid of the Fifth Dalai Lama's project of Gelukpa proselytization, he never took up residence in what was then Outer Mongolia's largest stationary monastery and is once again, as before, an adamantly Sakyapa stronghold.[39] His retreat at the nearby but almost inaccessible place called Tovghuun hardly seems conducive to the technical requirements of fine bronze casting. Yet surviving histories state explicitly it was there, around 1684, that he created his greatest masterworks, including his Vajradhara, still the main image in worship at Gandantegchinling Monastery, Ulaanbaatar, and his set of five transcendent buddhas.

Tovghuun at present consists of a modern log-built temple hall and a series of small, damp, and unadorned meditation caves carved high into a sheer cliff about 20 kilometers from Erdeni Zuu. There Zanabazar, who was also known as a great meditator, undoubtedly "created" his sculpture through visualization. Putting his visions into material form probably came a bit later and with the aid of his troop of fifty or more sophisticated craftsmen. Thus while Zanabazar's visionary life gave shape to a new, indigenous Mongolian Buddhism, his inner experience and the outer form

Figure 4. Zanabazar (1635–1723), *White Tārā,* ca. 1680s. Gilt bronze. H: 68.9 cm.; D: 44.8 cm. (Museum of Fine Arts, Ulaanbaatar, Mongolia. Photo: Kaz Tsuruta.)

it took both owed a great deal to the accepted (and therefore authentic) Nepalese-tinted tenets of the universalist, internationalist, but Lhasa-based Tibetan Gelukpa order.

Zanabazar's phrasing of his inner life in terms that had international valence suggests the degree to which a particular visual style—in his case Nepalese—had become an alternative universal language carrying meaning that was not necessarily religious. My use of the term "style" here is circumscribed. I mean specifically the mannerisms of line, modeling, or perspective as well as other abbreviations or amplifications of form that are not so much personal quirks of the artist as the conventional devices of a visual tradition that have coalesced to form a culturally delimited, encoded mode of representing things. Zanabazar's choice was not, I think, consciously made. He really had few, if brilliant, options and he was carefully directed. Nonetheless, his productions had a profound impact on the Manchus, reinforcing, among other things, the symbolism of reincarnation and prophecy the Manchu founders worked so hard to design. Like Phagpa, Zanabazar and his colleagues used art as a means of diplomacy and, in doing so, gave the Manchus direct access to a historically sanctioned international style—in fact, to a new, complex mode of cultural expression.

One of Zanabazar's most famous surviving works is a large bronze image of White Tārā cast around 1685 (Figure 4), a sublime example of the kind of creative borrowing he practiced. Before reinterpreting the outward sculptural forms he used to represent her materially, however, Zanabazar received significant preparation in the form of two spiritual transmissions that clearly mediated his understanding of who she was and what she might look like. Both of these transmissions can ultimately be traced to Atīśa (982–1054), one of several Indian pundits invited to Tibet to help restore the dharma after the Buddhist persecutions of the apostate king Langdarma (r. 838–842). Atīśa was a profound devotee of the goddess; his life was "filled with visions of her."[40] One insight thus came to Zanabazar via the Gelukpa's general adoption of Atīśa's precepts. But the second, he believed, came inherently by way of his immediate preincarnation, Tāranātha, whose *Origin of the Tārā Tantra*, written in 1604, dealt with the source of the goddess' main text and its promulgation.[41]

There are a few scattered records documenting Zanabazar's continuous relationship to Tārā; certainly images he made of her in her many forms predominate in his extant works. Before returning to Mongolia in 1651, he traveled to Tibetan monasteries where he had spent his earlier lives, collecting, among other things, the goddess' texts and images.[42] Zanabazar's White Tārā was originally kept at the Sakyapa monastery at Erdeni Zuu, and in scale, style, and detail she approximates the extraordinary group of the five transcendent buddhas he made around the same time—so much so they seem like members of the same family. His White Tārā is a pubescent girl exquisite in form and with an expression of focused, intelligent compassion. She sits on a moon disk placed on top of a single lotus pedestal, erect and alert, without any of the bending often seen in images of her. Nonetheless, her posture and even her flesh appear remarkably natural. As in much Nepalese sculpture, Zanabazar's abstractions take the subtler form of perfectly exquisite surface and proportion.

Few immediate sculptural prototypes exist to explain White Tārā's exquisite realization in Zanabazar's hands. Closest are the painted clay figures of Sarasvatī and Vasudhārā from the Kumbum at Taer monastery, in Xining, Amdo (now Qinghai province), which were made around 1595, early enough for Zanabazar to have seen them or other figures like them when he returned to Mongolia from Tibet in 1651 (Figure 5). This monastery was particularly influential in Mongolia. Not only was it strategically located on the main route between Mongolia and Tibet (and also between northern China and Tibet), but it was also the home monastery of the Gelukpa founder, Tsongkhapa, and as Mongolian Buddhists increasingly turned toward the Gelukpa it became a major training center for their monks.

The web of geographic and historical relationships between fundamental transmissions, earlier Himalayan styles, and different centers of production in which Zanabazar's work is implicated also

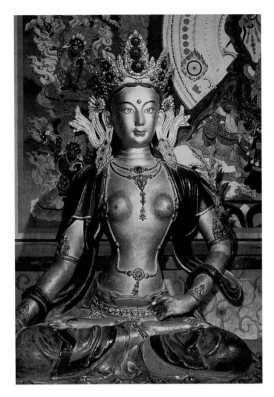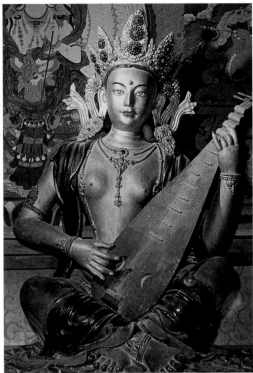

Figure 5. *Vasudhāra (left)* and *Sarasvatī (right)*, ca. 1595. Nine-Chamber Hall, Kumbum, Xining, Amdo. Polychromed clay. (After *Ta'ersi*, pls. 129–130.)

encompassed the earliest Manchu Buddhist images in metal, cast as early as the Shunzhi and Kangxi periods. These works were produced in places that were widely separated geographically, among them Beijing, Chengde, Dolonnor, Inner Mongolian Köke qota, and Amdo (northeastern Tibet). Two White Tārā figures (Figure 6) kept at the summer retreat at Chengde, for example, were made during the Kangxi period, when the retreat was first built, perhaps at the site itself. Both share the youthful body type of Zanabazar's Tārā and the Amdo Kumbum's Sarasvatī and Vasudhāra. Both also display a new mellowing of mood, however, in which they resemble another contemporaneous figure, an eight-armed Uṣṇīṣavijayā (the female embodiment of the Buddha's *uṣṇīṣa,* the supercranial symbol of his enlightened wisdom), now in the State Hermitage, St. Petersburg.[43] Typical of these Kangxi-period figures is the unusual array of the third necklace: a long beaded and ornamented strand that passes over the upper chest, swoops in to outline the inner contour of the nearly autonomous, hemispheric breasts, then curves back out to meet in a wide loop over the base of the ribcage. In both form and mood these figures do not depart much from the large bronze sculpture of Green Tārā and twenty-one smaller Tārās, all believed to be the work of the mature Zanabazar, which may have been cast in 1706 after his confederation in 1691 with the Manchus and return to Khalkha from Dolonnor and Beijing.

Determining sites of production for Tibetan Buddhist art of the seventeenth and early eighteenth centuries—Manchu, Tibetan, or Mongolian—is therefore complicated by the internationalist agenda of the Gelukpa upsurge under the Fifth Dalai Lama and his Manchu and Mongol associates. The Manchus' Chinese empire was also Tibetan and Mongolian and eventually encompassed the Muslim lands of Xinjiang. It was in no small measure founded on the ideologies of Tibetan, specifically Gelukpa, Buddhism and held together by alliances with northeastern and Inner Asian

tribes. By its very nature decentered, in a constant state of regular transhumance, it did not produce a simple triangulation of capitals, each producing works of religious art in its own style.

If Gelukpa power rapidly coalesced around Lhasa and the Dalai Lama's Potala Palace, there were numerous other centers of regional authority in Tibet; many of them, like the Panchen Lama's Tashilunpo to the west and the Karmapa camp to the east, were removed from the capital. But regardless of the difficulties of travel during the later seventeenth and eighteenth centuries, few famous lamas were stationary for long. They seem constantly to have moved from one great monastery to the next, giving and receiving gifts and teachings before pushing off to another venue. (Rolpay Dorje, for example, rarely saw the monastery where he had spent his first years, Youningsi in Amdo, but spent most of his time moving between Beijing, the Western Hills outside the capital where he escaped the heat and threat of smallpox, Chengde, Dolonnor, and his favorite meditation site, Wutaishan.) The Khalkha Mongols also continued their ancient seasonal migrations, even after their capitulation to Kangxi in 1691. Zanabazar's Da Khuree had at least seventeen different locations (over a range of about 500 kilometers) from the mid-seventeenth to the eighteenth century alone. The Manchus, with two main capitals, one in Beijing and one in their homeland, Mukden (Chinese: Shengjing, modern Shenyang), were similarly dispersed. They visited Mukden only occasionally, however, preferring to move regularly, with their artists in tow, between the Forbidden City in the center of Beijing, the Summer Palace on its outskirts, Wutaishan, Dolonnor, Chengde, and other sites beyond the capital.

From the earliest years of their dynasty, therefore, the Manchus acted as cultural brokers across much of Inner Asia, just as the Mongols had done during the thirteenth and fourteenth centuries. They were the vector for the reintroduction of Nepalese and Tibetan style in China, even as they introduced Chinese art and particularly architecture to the regions beyond the Great Wall. One such extraordinary project in Outer Mongolia spanned three reigns: the monastery of Amur-Bayasqulangtu, built to house Zanabazar's mummified body after his death in 1723 at the Yellow Monastery in Beijing just months after he had conducted rituals over the Kangxi emperor's remains. The emperor's heir, Yongzheng, honoring the relationship between his father and his lama, ordered that the Chinese-style monastery be built near the northern Outer Mongolian border, some distance north of modern Darkhan. This "Monastery of Blessed Peace" (Chinese: Qingningsi) was really a hermitage (Mongolian: *khid*), and its location was chosen because it was the site of Zanabazar's wandering Da Khuree at the moment he died in Beijing. The monastery, to which Yongzheng committed 100,000 *liang* of silver, was not finished until 1736, a year after his own death. Zanabazar's remains were only moved there in 1779 and they rested at the monastery until the Mongolian revolution of the 1920s and 1930s, when they were carried off and lost.

What was built at Amur-Bayasqulangtu is a

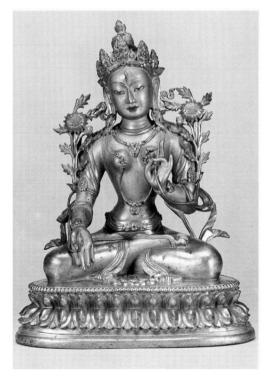

Figure 6. *White Tārā*, Kangxi reign (1662–1723). Gilt bronze. H: 29 cm. (Collection of the Chengde Summer Retreat.)

graceful and beautiful Chinese palace much like the Yonghegong in Beijing, Yongzheng's own princely mansion northeast of the Forbidden City, in all but setting (Figure 7). Its very remoteness and the sophistication of its construction underscore how very far the arm of the Qing emperor reached by the early eighteenth century. The monastery rises up unexpectedly from the lush green valley whose edge it hugs, looking for all the world like a sinified paradise. Like the Yonghegong, which was itself transformed into a monastery for Mongolian Buddhist monks once Yongzheng ascended the throne, Amur-Bayasqulangtu is axial in plan, unfolding over several courtyards from south to north, and it is likewise dedicated to Maitreya, the millenarian buddha of the future and Zanabazar's main object of meditation. In 1737, Qianlong established an edict in three languages (Mongolian, Manchu, and Chinese) in the first courtyard of the monastery, his first edict aimed at a Buddhist audience. The Chinese version begins with an invocation of the essential, multiple character of the Qing empire as the new emperor understood it: "Now," he wrote, "with heaven's protection our Qing dynasty has laid great claim to ten thousand nations, so that all that is illuminated by the sun and the moon and moistened by the rain and dew cannot but follow obediently." This passage is somewhat different in tone from the language of the same edict in Mongolian as translated by the Russian ethnographer and explorer Alexei Pozdneyev (and subsequently translated into English), which reads: "As I think, Heaven, in graciously creating our Dynasty of Ta-Ch'ing [Great Qing] has beneficiently united (under the latter's powers) myriads of peoples."[44] It is also far from the seemingly benign, multilevel representation of unity with which I began this chapter, *Ten Thousand Dharmas Return as One*, wherein Sichelpart and Yao give us an emperor who happily presides over a meeting that stars, among others, Zanabazar's third, controversial incarnation, as well as his own guru, Rolpay Dorje, with whom he stood in a relationship parallel to his grandfather's with Zanabazar. Although the tone of his rhetoric changed substantially between 1737 and 1771 (and would do so again before he stepped down from the throne in 1796), Qianlong was already well able to speak simultaneously in several different tongues, articulating what only seemed like the same message.

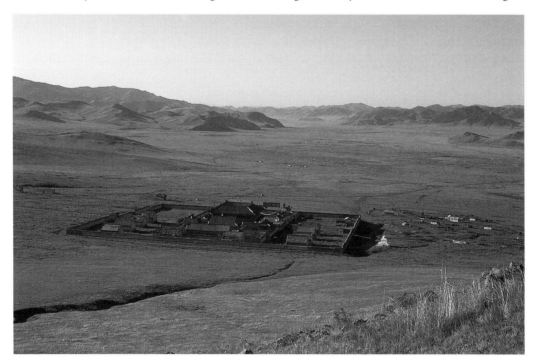

Figure 7. Amur-Bayasqulangtu (Amarbayasgalant), dedicated in 1736. Northern Mongolia. (Author's photo.)

In a Single Voice?

Yao and Sichelpart's *Ten Thousand Dharmas*, Phagpa's missing Mahākāla, and Zanabazar's White Tārā are all works that fit into what we might blanket with the term "Manchu Buddhist visual culture"—that is, the sum total of visible things, unified or not, that surrounded them. But a distinction emerges between the Manchus' admiration for borrowed images and their regular deployment of what I would like to call quoted style. Phagpa's Mahākāla was a "received" image, its form and manner of realization borrowed whole cloth. The artist who created it, perhaps Anige, did not translate his own Nepalese norms into a new language of form because he did not need to—his audience was, after all, the cosmopolitan Tibetan Phagpa Lama and the credulous Khan of Khans Khubilai—but also, more pressingly, because he could not without subverting the image's authenticity. In the context of Khubilai's conversion to Tibetan Buddhism and his fight to win southern China, the Mahākāla was therefore an exotic agent, a mercenary deity brought into China because of his disinterested penetrating wisdom and heroic force. The Mahākāla's ease of movement and its almost palpable potency right up until the twentieth century suggest that it maintained its exoticism no matter what context it found itself in. Constantly and easily shifting allegiances according to the winds of politics, it could never quite be contained. It was, in other words, autonomous and thus could serve first as the Mongols' palladium and then, without cynicism but perhaps with some irony, as their rivals'. Similarly, Zanabazar was also heir—though in the second generation—to an aggressively emigrant, fundamentally Nepalese mode of representation which the Fifth Dalai Lama actively imported into Tibet and then exported to Mongolia and northern China, a material represention of inner vision that could rightfully be called an "International Gelukpa Style."[45] The medium, in Zanabazar's case, was really indistinguishable from the message. For here was a system that recollected and permitted a codification of the interior life if only the viewer could engage all of its registers and realize its promise of seamless, transparent mediation. The eloquence of this style turned it into the first, but hardly the only, visual Esperanto of the Qing Buddhist empire in Inner Asia.

With the advent of the Qianlong emperor, another desire takes hold—what Pamela Crossley has characterized as the imperial will to simultaneity of speech and action.[46] She has argued that the emperor did not simply represent himself in his edicts and steles in several languages at the same time, conveying a unified message to all four quarters in Manchu, Chinese, Mongolian, and Tibetan. He also forced his readers to conform to his definition of who they were by speaking to each of them in a single language, always their own. Language, in this view, determined identity. And only the emperor was equally fluent in all of them at once, ever a constituent and ever an alien—empty, as Buddhists might put it, at the core. Crossley's reading of this Manchu habit also helps explain their predilection, particularly in the eighteenth century, for many different representational styles, not just Nepalese or Tibetan, but also Chinese and European. What, then, are we to make of such composite works as Sichelpart and Yao's *Ten Thousand Dharmas*, where several distinctly different styles have been "quoted" side-by-side to tell a particularly knotty tale—one susceptible to numerous interpretations depending on the viewer? Are such pictures also examples of imperial simultaneity, with the emperor speaking in clear terms, "like a cloudless sky," to several very different audiences at once? Or do they hint that the Manchus sensed some deeper, irresolvable incommensurability among the representational styles of their empire?

When Words Collide

Every foreign word contains the explosive material of enlightenment, contains in its controlled use the knowledge that what is immediate cannot be said in unmediated form but only expressed in and through reflection and mediation.

—Theodore Adorno, *Notes to Literature*

Two imposing octagonal pavilions dominate the east and west sides of the third courtyard of the Yonghegong, the Palace of Harmony in Beijing, which, in 1744, was rededicated as a center specifically for Mongolian practitioners of Tibetan Buddhism. The pavilions tightly contain two massive, rectangular steles that present one message four times: an edict composed by the Qing Qianlong emperor to celebrate the reuse of his father's palace (and his own birthplace) as a "Jetavana Garden," or Buddhist monastery.[1] Rendered in the four official languages of the Qing empire—Manchu and Chinese to the east, Mongolian and Tibetan to the west—the four texts roughly approximate the political geography of greater China as it was constituted then and as it has been reconstituted in the twentieth and twenty-first centuries. All four are difficult to read, their long strings of script nearly impossible to track in the shadowy gloom of the pavilions, where the upper and lower parts of each text fade into obscurity. In a sense, though, their readability seems intentionally compromised. Following a long Han Chinese tradition of publicly presenting imperial edicts as steles, Qianlong was just as interested in the way his stone proclamation underscored his resolute intention visually—carrying it universally in all four directions on the backs of a pair of immense tortoises—as he was in the contents of its written message.

Yet the phrasing of the multilingual edict was still very carefully managed. Despite the fact that by the Qianlong era Manchu was endorsed and forcibly maintained as the official language *(guohua* or *Qinghua)* of the Qing empire, the Chinese text was probably the first Qianlong composed. But according to Ferdinand Lessing, whose seminal but only partially published study of the Yonghegong still stands as the monastery's most thorough inventory, the four texts are far from identical; they can be considered *translations* of the Chinese text only in the loosest sense. They are, more accurately, liberal renditions designed to play to each of the four languages and to the cultural traditions within which they were used. They were clearly calculated to retool the filial message of the emperor so that it would be more profoundly "readable." Thus the Chinese text is laden with classical references that revolve around the hyperbolic and slightly awkward image of Qianlong's father, the Yongzheng emperor, lifted skyward on dragonback, finally revealed as an enlightened being who, in his skillful means and benevolence, is like Śākyamuni Buddha. It ends with a 256-character eulogy that reiterates the same message in poetic terms. The Manchu version, by contrast, also written in one of Qianlong's first languages, whose content follows the Chinese closely, is nonetheless more in keeping with the official Manchu self-image—plain and unembellished—and the imagistic poetry of the Chinese has been transformed into straight, unrhyming prose. To the west, the Mongolian and Tibetan versions take a separate tack by recasting the Confucian resonances of the eastern stele into the opulent flourishes of Buddhist description. The Tibetan especially is really a text unto itself, as Lessing points out, maintaining the poetry of the eulogy but restructuring it in an appropriately Tibetan style (where metrics rule, not rhyme). Qianlong and his scribes clearly understood that languages are not, strictly

Figure 8. Yonghegong Stele of 1792 with four-language text of the *Lama Shuo.* (Author's photo.)

speaking, commensurable—that there was no "hypothetical equivalence," as Lydia Liu has termed it,[2] between the languages of the empire. That equivalence would come much later—after Qianlong had commanded the production of a series of multilingual lexicons, meaningfully called "mirrors," in which strict equivalence was determined by imperial mandate.

Moving more deeply on a south-north axis into the Yonghegong, visitors encounter another multilingual stele, this one housed in a single pavilion in the fourth courtyard. The stele is four-sided. Its quadrilingual text, rendered in Chinese on the north, Manchu on the south, Mongolian on the east, and Tibetan on the west, maps out a hierarchy of power in the first pair of renditions (with Manchu taking the dominant position facing south) and a geographic relationship in the second pair (Figure 8).[3] The stele bears the famous, some would say notorious, proclamation that Qianlong composed in 1792, nearly fifty years after his first edict, when the Yonghegong had matured into a major college of Tibetan Buddhism and the emperor was under the disastrous sway of his personal Svengali, Heshen. Called *Lama Shuo* (Speaking of lamas), the Chinese version contrasts starkly with the sentimental juvenilia of the 1744 edict, both in its direct, businesslike, and occasionally crabby tone and in its singular, unnuanced message, the forcefulness of which is heightened by a monolithic presentation. *Lama Shuo* articulates Qing support for the Tibetan and Mongolian Buddhist establishment—all the while recording Tibetan treacheries and Mongol ambitions and cautioning the lamas against any other acts of rebellious hubris. Gone is the attempt at intercultural finesse. Here the emperor speaks plainly, in anger, and in a unified voice, excoriating the recently defeated Nepalese Gurkhas and their allies and claiming that Qing support for Tibetan and Mongolian Buddhism (and specifically for the lamas, incarnate and otherwise) has always been purely expedient, a mere device to keep the Mongols in line. As he put it: "By patronizing the Yellow Church we maintain peace among the Mongols. This being an important task we cannot but protect this (religion). (In doing so) we do not show any bias, nor do we wish to adulate the Tibetan priests as (was done during the) Yuan dynasty." While this—bringing Tibetans and Mongols to heel—is clearly one point

of the edict, it is also the only point deliberately blurred in translation—which adds to the Manchu version of the line "When I started to learn the [Tibetan Buddhist] scriptures I was criticized for being biased towards the Yellow Church" the barbed phrase "by some Chinese." Qianlong then goes on to say that it is only because of his familiarity with Tibetan Buddhism that he is uniquely equipped to reform its practices.[4] The shocking frankness in the Manchu version, separating the emperor's Manchu and Han Chinese subjects and impugning the loyalty of the latter, recalls the fact that, for the Qing emperors, Manchu was the language of secret dispatches, legible only to trusted members of the ruling class. As Lessing put it, the *Lama Shuo* is written in "the sober style of the imperial chancery," hardhitting, designed to seem uncontrived and straightforward, but all the while secretly ambivalent.[5]

Several other aspects of style separate the *Lama Shuo* from Qianlong's dedicatory edict of 1744. The first is that while the Chinese version of the text is written in literary style, its blunt directness creates an almost speechlike feel that adds to the reader's sense that we are privy to the emperor's own instruction, given generously in the four languages of the realm. The second aspect is the way in which Qianlong has uniquely woven the bodies of all four inscriptions through with his own commentary—parenthetical musings on the wrongs done to him as he rules, as a Confucian sovereign, in loco parentis. Though this self-commentary visually apes the typography of traditional Chinese printed books—where the primary, classical text is conspicuously larger and the commentary secondary and smaller (and ordinarily composed by a quite separate commentator or commenta-tors)—its tone is very different. The small-type commentary opens up an auxiliary space for the emperor to repeat and amplify his accusations, expand on his disappointment, thoroughly vent his feelings, and, not incidentally, lay out for the record the official Qing reckoning of all the incarnate Dalai Lamas (which skips over the scandalously bon vivant Sixth, whom the Manchus believed to have been put in place illegally), as well as a new plan for the discovery and consecration of other Buddhist incarnations. If the 1744 edict was sentimental, somewhat pretentious, and ultimately removed from its author's presence by his own still unsophisticated adoption of classical Chinese tropes and poetic structure and his obsessive regard for the difficulties of real translation, *Lama Shuo* recaptures the immediacy of the emperor as author in the consistent rhetorical tone it projects through all of its four renditions and then counters this immediacy with a visual technique drawn from the world of classical Chinese typography, which appears to pose exposition against response but actually does not. The unified square slab of the stele thus manages to embody the emperor's words and his self-justification, dominating the inner precincts of the Yonghegong with his voice, rendering it canon-ical through a simple trick of presentation.[6]

The Issue of Translation

It could be argued that the act of translation is at the very heart of the Buddhist enterprise—a propo-sition to which Qianlong and his National Preceptor and personal guru, the Zhangjia Khutukhtu Rolpay Dorje, would certainly have agreed. Many sutras, texts that claim to be Śākyamuni's own teachings, begin by saying: "In the languages of gods, nāgas, and mountain demons; in the languages of ghouls and men; in whatever languages sentient beings may have, in all of them I shall give my dharma." Translators—*lotsavas*—have been some of Buddhism's most revered saints, praised as the "gods and Nāgas who spoke two languages [and] caused abundant rains of precious Dharma trans-lation."[7] Implicit in this reverence for the translator's art is the recognition that the Buddha's dharma, simultaneously encompassing all possible languages, is also finally beyond words—that it was, in fact, conveyed silently through a grammar of signs whose meaning and logic are discernible only to enlightened beings.

As translator par excellence to Qianlong, Rolpay Dorje thought long and hard about the complexities of the translator's art, especially the problem of whether or not every word or phrase had a perfect equivalent in every language—if, indeed, languages could express exactly the same things at all. He did not simply speculate on the issue of commensurability theoretically; as a polyglot devoted to making the Buddha's teachings available in all the languages of the Qing empire, he considered it from a pragmatic perspective as well. Aside from leading a number of major translation projects for the emperor—including among others a translation into Mongolian of the complete Tanjur, the commentaries to the Kanjur (the Tibetan Buddhist canon); a similar project that put both Kanjur and Tanjur into Manchu; and a translation of the *Śuraṃgama Sutra* from Chinese into Tibetan— he also compiled authoritative dictionaries for Mongolian and Manchu to ease the translator's dilemma and probably spearheaded the effort that resulted in the monumental, pentaglot dictionary *Wuti Qingwen jian* (Pentaglot mirror of Qing languages, that is, Manchu, Tibetan, Mongolian, Chinese, and Chagatay).

One of his most important projects, the *Dictionary, the Source of Wisdom* (Tibetan: *Dag yig mkhas pa'i 'byung nas*), was a bilingual "mirror" of Tibetan and Mongolian. In his preface he outlined some of the pitfalls of the translation process. These ranged, in his view, from the difficulties of matching the original text in terms of brevity or discursiveness, sticking to a strict equivalence of terms, once established, and maintaining a consistent emotional tone. About faithfulness he wrote: "As far as it's possible the meanings should not be confused, and the translation should be exactly as the original is."[8] The translator, he continued, should resist adding anything of his own commentary or personal insight, even parenthetically, to the original meaning. He was hesitant, however, to recommend that the names of foreigners, deities, or exotic plants and animals be translated; this, he argued "impeded understanding," because sound, as well as the meaning, could trigger recognition and produce a surer sense of identity. Translation was more than just a matter of mechanically transforming individual words from one language into another. In his view it also involved capturing subtle allusions created by means of parallel phrasing and puns or more consciously through culturally circumscribed, clichéd metaphors. In situations like this, Rolpay Dorje urged, the translator might have to "use stylistic effects" to make up for the lack of strict equivalence. More than this, the tone of language also subtly shifted its meaning. "Other words," he noted, "like the (vocabulary of) admiration, abuse, wonder, and happiness, sorrow, fear, and all the like expressions must all be translated (from Tibetan) into such words in the Hor (Mongolian) language as show the same degree of power, capture the same attention, and take the same time." The same was true of poetry, whose meter had to be respected, and even the terminology used in debating, where "both attack and defense should be considered with regard to both their full range of meanings and their particular applications in different systems of debating. The words of propitiation and refutation should be sharp and translated into terms which can easily be understood." Finally, well aware of the fact that his work ultimately focused on esoteric texts whose meaning was carried forward in several distinct registers, not all of them producing meaning directly, he argued for choices of equivalents that could be "rearranged to make the upper and lower meanings clear." That is: The concealed message of the text, as well as its superficial meaning, had to be respected and remain fully articulate to those prepared to find it. He wrote: "In the book of specialized teachings, such names as the ones of gods, objects, numbers, etc., shall have different, concealed religious meanings. In such cases translate them as they are, do not translate only their outer meanings. If you follow the latter approach, the purpose of having concealed meanings is lost." What this purpose might be, he does not say, though we might hazard that concealment and managed revelation are at the heart of the type of graduated tantric practice the Gelukpa advocated.

In urging his corps of translators to "translate without obfuscating the literal and figurative mean-

ings of the text," Rolpay Dorje set a high standard of consistency and carefulness. This was because the work went beyond the simple translation of words. Translation also determined the authenticity of real action, in Buddhist ritual and in personal practice, even as it eased the cultural and linguistic divides that stood between Buddhist practitioners across the Qing empire to create new, Buddhist webs of unity. The *sādhana*, for example, the core realization texts that catalog the appearance of deities who act as supports in meditation practice, texts that were energetically translated during Qianlong's reign, describe in detail actual, historically validated, personal experiences of sensory phenomena produced in the course of one adept's visualization. Rendered in descriptive but highly standardized language, they are only supportive models for the meditator when accurately translated back and reexperienced in sensory terms during meditation. In other words, the realization texts archive significant visualizations of specific individuals in the past so that they may be accurately reimagined in the future. But visualization is only partly about the visual world. It encompasses all the other senses, as well, including hearing, taste, touch, and smell. How were these realms of experience to be translated and evoked accurately so that each meditator's experience was equivalent to every other's? And, even more pressingly, how could these experiences be translated across cultures? In the view of Rolpay Dorje and his disciple Qianlong, the question of whether different modes of seeing—or different modes of representing what has been seen—were susceptible to translation into other, more familiar modes similarly hung on the issue of accuracy. Sometimes, they concluded, it was better not to translate but simply to quote.

Manchu style in its fullest sense, by which I mean the sanctioned but shifting visual and verbal style of the Qing court that flowered most vividly during the Qianlong reign, thus depended in important ways on Manchu interest in the differences between the languages and visual cultures of the empire and on Qianlong's own attraction to the problem of the relationship between word (both written and sounded) and image. The emperor's mistrust and creative use of the verbal translation process, which we have seen evolving markedly from the beginning of his reign to the end, was to some extent the product of his own facile multilingualism.[9] Throughout his long life, even well into his seventies, he continued to study the languages of empire (and beyond), usually spurred by political, military, or diplomatic events. Late in life he recalled:

> In 1743 I first practiced Mongolian. In 1760 after I pacified the Muslims, I acquainted
> myself with Uighur. In 1776 after the two pacifications of Jinchuan I became roughly
> conversant in Tibetan. In 1780 because the Panchen Lama was coming to visit I also studied
> Tangut. Thus when the rota of Mongols, Muslims and Tibetans come every year to the
> capital for audience I use their own languages and do not rely on an interpreter . . . to
> express the idea of conquering by kindness.[10]

Wei Yuan (1794–1856), a historian and geographer whose history of Qing military actions *Shengwuji* includes a chapter on the Sixth Panchen Lama's 1780 visit to court, likewise observes that the emperor learned Tangut just "so that their conversation would be like that of members of the same family,"[11] unmediated and natural. But the emperor's interest in language and translation went beyond mere manners (though he understood how manners could impede or smooth understanding)—even beyond the problem of how to recast meaning accurately from one language to the next—to a deep concern over the way the classical Chinese written language, in which he was thoroughly if sometimes inelegantly fluent, radically dissociates visible, written text from the speech act. Qianlong also realized that even if speaking and writing in Chinese were different activities, painting and writing in Chinese were much the same, both of them conveying information visually.[12]

Chinese characters, however, make relatively ambiguous or insecure reference to the phonetic

value of speech. Chinese characters, he understood, could contain hints of the phonetic shapes of the words they represented, but usually they bore no direct indicators to the reader of exactly how a word might sound. The dissociation of spoken sound and written word turned speaking and writing in Chinese into different kinds of acts (in contrast to the experience Qianlong had with alphabetically rendered languages), but it also created other unusual opportunities. The phonetic economy of the Chinese language, where literally every spoken signifier is a prospective pun on something else, made every written character—and also every image—a potential site for constructing clever webs of word-based polysemy. At the same time, these rich paronomastic possibilities hindered untreacherous translation from Chinese into the other languages of the empire and back. Eighteenth-century China was a hotbed of punsters—isolating homophonic relationships formed, among other things, an important basis for the work of Qing phonologists (among whom was Qianlong's uncle and close adviser, Prince Zhuang, known as Hoshoi Zhuang Qinwang Yinlu, 1695–1767) and for the intellectually dominant philology of *kaozheng* (evidential research) scholars in Qianlong's court and those working independently in the vibrant Jiangnan region to the south. For Qianlong the unusual relationship of speech and writing in Chinese posed an intriguing problem that influenced his patronage of many of Rolpay Dorje's Buddhist translation projects, particularly his efforts at reforming the recording in Chinese of Buddhist mantras and *dhāraṇī*, which, as "true speech," depend on phonetic accuracy to be effective. Hence his order to Yinlu to consult with Sanskrit scholars and with Rolpay Dorje to reexamine all the mantras and *dhāraṇī* in the Chinese Tripitaka and transcribe them in Manchu script, using their Tibetan spellings as an authoritative guide to their pronunciation. This effort resulted in a four-part collection of mantras and *dhāraṇī* in the writing systems of Manchu, Chinese, Mongolian, and Tibetan, compiled between 1748 and 1758, which was finally printed and distributed to monasteries throughout China in 1773.[13] Commensurability in the representation of "true speech," where meaning is all about sound, where we might say the medium is the message, was thus achieved through reform of the transliteration process.

But what about other kinds of speech or forms of communication, including the production of "true images," especially Buddhist icons? The emperor's familiarity with other languages written with a phonetic alphabet or syllabary (including Manchu, Mongolian, Tibetan, Uighur, and Sanskrit), as well as his uncontainable delight in wordplay, also affected his patronage of visual productions in unexpected and highly creative ways that act on the ability of images to evoke specific words (through punning) or to produce meaning simultaneously in several different registers (what Rolpay Dorje might have called "upper and lower" readings). Embedded wordplay, sometimes multilingual, is in fact often a significant component of those images that fall into the mixed categories of painting and sculpture produced at the Manchu court, another central element of which is the unadulterated quotation or reformulation of Chinese and non-Chinese modes of rhetorical and visual representation. The abrupt juxtaposition or even counterposition of visual styles—Tibetan against Chinese, Chinese against European, European against Tibetan—is one of the essential characteristics of the Buddhist art of Qianlong's court. It was the very incommensurability of the goals of Chinese, Inner Asian, and European modes of representation—that they do not quite translate one another perfectly but are designed to capture different kinds of information—which may have attracted the Manchus to the possibility of using all of them at once, enabling the emperor-as-patron, just like the Buddha, to speak in all languages simultaneously. We might say that the Manchus' deployment of several visual or verbal styles allowed them, not to say the same exact thing to everyone, but to say the right thing. In these terms, the reams of copies of ancient images produced at the Manchu court take on a whole new meaning, embodying both the message of the original image and the emperor's timely commentary upon it, represented by juxtaposing faithfully copied parts of the original against new elements done in other, differently motivated, styles of representation. My guess is

that Qianlong would argue that no meaning was lost in this process—meaning was only amplified and articulated, made intelligible in a new and different age.

Collaged Vision

The notion of the Manchu as a people who originally lacked a singular visual style, though difficult to imagine, is easy enough to sustain in the absence of much predynastic evidence of Manchu visual culture (beyond their characteristic style of dress), at least before their consolidation and adoption of Tibetan Buddhism in the 1630s or earlier. Two Qing historians, Evelyn Rawski and Pamela Crossley, both of whom have made extensive use of Manchu-language documents, have demonstrated the remarkable degree to which Manchuness was fabricated just before, during, and immediately after the conquest, with the remembered details of predynastic life reconstructed and enshrined as myth, together with liberal borrowings from Mongolia and other parts of Inner Asia.[14] Qing historian Mark Elliott has argued that even the Manchu homeland, originally called Mukden (used in the broader, regional sense with the city of Mukden, modern Shenyang, at its center), had by Qianlong's day entered the realm of the imaginary. Few Qing emperors had any lengthy experience of it, even though most longed for it; in fact, the Qing imperial family was only partly "Manchu" by blood by the eighteenth century.[15] Qianlong's "Ode to Mukden," eventually published in a deluxe bilingual Chinese-Manchu edition, was probably composed in Chinese, Qianlong's literary language of choice, and only later translated into Manchu. It takes the form of a fu^3 rhapsody, listing the flora, fauna, and products of the region in dizzying detail, and thus falls into the class of capital poems that harks back to the Han dynasty.[16] Manchu styles of rulership were likewise collaged from a number of available models, Chinese, Mongolian, and Buddhist, and the Qing emperors presented themselves variously as *huangdi*, Khan of Khans, and *cakravartin*. This extraordinarily flexible view of community and rulership found particularly fertile ground in mid-seventeenth- and eighteenth-century China, where a similarly slippery construction of personal identity (if not Han Chineseness) was well established in the literate class by the late Ming.

How did all these issues of multilingualism, multiculturalism, cultural appropriation, reimagined ethnicity, and a contingent sense of self contribute to the emergence of the unwieldy category of artistic production the Qing designed to respond creatively to Tibetan and Chinese Buddhist imperatives? One place to begin a tentative answer to this question is in the large group of images made specifically as intercultural gifts, that is, as objects designed to bridge gaps in practice and intent. Throughout his reign, Qianlong actively commissioned works of Buddhist art and architecture to present as gifts to his dependents. Many of these commissions celebrated a particular event with the production of multiple images, often fashioned identically but in several different media, sometimes made and given all at once, sometimes spread over several decades of gift giving. Their function—to solidify Manchu relations with the great monasteries of Tibet and Mongolia and to underscore Manchu support—was as much political as religious. The biography of Rolpay Dorje shows the breadth of Qianlong's generosity by recording how Inner Asian lamas received huge numbers of gifts of images, ritual implements, and luxury goods whenever they came into contact with the Manchu court.[17] This impression may seem purely self-serving but is actually sustained in substance by the vast wealth of Buddhist paraphernalia that was once held (and to a much lesser extent still is) in Tibetan monasteries, in the former Qing palace, now the Palace Museum in Beijing, and in the collection of the National Palace Museum in Taipei. In the scope of his largesse, Qianlong modeled himself on his grandfather, the Kangxi emperor, who lavished so many presents on his favorite Outer Mongolian lama, Zanabazar, that when he returned to Mongolia his caravan of laden camels took three days and three nights to pass through the gates of Beijing.[18] As excessive as this may sound, Qianlong's

gifts were even grander, especially at his summer retreat at Chengde, where he had copies of the most famous monasteries of Tibet built as presents for, among others, the Torghut Mongols when they returned to Manchu territory and for the Panchen Lama when he made his fatal trip to visit the emperor in 1780.

Whenever Qianlong gave gifts, he simultaneously received them as tribute due the imperial court, and these acts of exchange created webs of reciprocity that materially tied the Manchus' outer territories to the emperor-as-collector. Moreover, he was not content to receive gifts from his dependents and then simply ignore them. He insisted, always the gracious recipient, on grouping, augmenting, repackaging, and displaying them, usually in ways that explicitly or implicitly changed their valences, making them mean more (or mean something other) than what they originally meant. Because of the serious cultural and economic imbalances that existed between what the emperor gave and what he got, his ritualized trade with Tibet and Mongolia has to be considered in ways that take into account more precisely how the movement of objects adumbrates their human and social contexts.[19] In the end, these objects tell us as much about Qianlong's inner life and his musings about meaning, language, and art as they do about the history of the Qing empire's relations with Inner Asia, and it is this aspect of their impact that I wish to concentrate on here. In particular, Qianlong's gifts reveal themselves as sites of epistemic collision where meaning is contested, however gracefully, in and by the very act of translation and intercultural exchange. They are also objects whose meaning depends heavily on the relationship between image and embedded text—literary *things* acting to mediate between semiotic, aesthetic, and cultural differences.

Gifts usually mean one thing to the giver and another to the receiver, a gulf in meaning that may simply be a matter of differences in taste, expectations, or custom. Some gift-givers, though, are particularly talented in choosing the right thing and some recipients are especially gracious in accepting the wrong thing, eliminating or smoothing over the gap between intent and result. Qianlong and his Buddhist allies clearly cleaved to a particular etiquette and vocabulary of giving and receiving, what and when to give, and how to receive with proper ceremony (a topic I discuss at greater length in Chapter 6). But to say that giver and receiver both were of the same mind over the significance of a gift would be misleading. Part of the art of giving from their perspective was in creating ambiguities about the real meaning of the gift. "Real meaning" might be understood in a couple of ways—in one sense focusing on the social and political implications of the act of exchange, in the other on a symbolic and even stylistic reading of the gift itself. Simply put: Qianlong, following long-established Chinese custom, understood things given to him as tribute or offerings, but things he gave to others were presents and boons, materialized aspects of his greater emanating virtue as emperor. Therefore things coming in automatically meant something other than things going out, regardless of what they were. But the items of exchange were also complicated in design and intent; some imperial gifts were deliberately multivocal in the messages they sent, presenting a long menu of possible positive readings, and it is these connotative aspects of the language of gifts that Qianlong seems to have explored with extraordinary sophistication through both choice of image and inscription. Still others present different sorts of ambiguities, raising questions of what relationship the gift bore to a real or reimagined original and the non-Manchu, often specifically Chinese, culture that produced it.

Consider the series of identical images Qianlong ordered in 1744 of the buddhas of the three ages (Chinese: Sanshi Fo), a triad of past, present, and future buddhas (Figure 9). At least two of these images survive, both woven in the delicate and demanding *kesi* ("slit silk") tapestry technique for which the silk factories of Suzhou were especially renowned. One example still hangs in the Potala Palace, Lhasa (apparently a gift to the Seventh Dalai Lama); the other, whose precise early career is unknown, is in the Asian Art Museum of San Francisco.[20] Both copies present the three buddhas

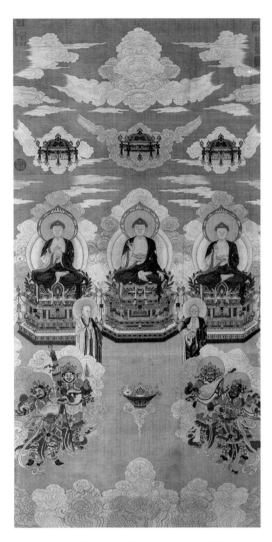

Figure 9. *Buddhas of the Three Ages*, dated 1744. *Kesi* "slit silk" tapestry. 118.1 x 61 cm. (Asian Art Museum of San Francisco.)

seated in a row on similarly decorated lotus thrones: Śākyamuni, the buddha of the present age, in the center,[21] flanked on the left by Maitreya, the buddha of the future, and, on the right, by Dīpaṅkara (Burning Lamp), the first of twenty-five buddhas of the past. The disciples Ānanda and Kāśyapa attend Śākyamuni just below his throne, and guardian kings of the four quarters stand to either side of a cloud-borne lotus offering at the bottom. Cloud puffs in auspicious pastels float symmetrically above, behind, and below the buddhas and their jeweled canopies, organizing themselves into *ruyi* wish-granting fungi and bats, a rebus or visual pun on "blessings." Both images also have identically placed seals, impressed and woven, of Qianlong and of his *Bidian zhulin* (Secret Hall of the Grove of Beads) collection of Buddhist and Daoist art. An inscription woven in gilt seal script at the top reads: "Venerable Buddha(s) of Boundless Life" *(Wuliangshou zun fo)*.

A smaller inscription not woven but written in gilt regular script in the lower left raises a number of questions. It reads, "Qianlong *jiazi* [1744], made with respect in the style of Lu Lengjia of the Tang," revealing that a work by the mid-eighth-century student of China's most admired figure painter, Wu Daozi, stands behind these woven images as a shadowy "original." A painting by Lu Lengjia of the same buddhas of the three ages is also listed in the original *Bidian zhulin* catalog, the written draft of which was completed in the same year as the weavings, 1744.[22] *Bidian zhulin* describes Lu's painting in some detail as a work in colors on silk with two gilt inscriptions, one the artist's signature ("Painted with respect by Lu Lengjia"), the other a title in seal script reading, like the woven copies, "Venerable Buddha(s) of Boundless Life." According to that catalog, the buddhas were attended by four generals and the painting had an (unrecorded) inscription by Qianlong and a seal of the early Qing collector Liang Qingbiao. The tapestry artists of Suzhou cannot have worked directly from the original by Lu Lengjia, however, whether it was a real Tang painting or not. They must have based themselves on some other authoritative version—a painting that represented a significant updating and translation of the Buddhist painting style of the Tang into the Tibetanized courtly style of the Yuan, Ming, and Qing dynasties.[23]

This more immediate source can be imagined, if not certainly located, in an identical, undated painting, complete with title and imperial seals, though not listed in the imperial catalog, by one of the emperor's own favorite painters, Ding Guanpeng, whose inscription says nothing whatsoever about Lu Lengjia's original (Plate 5). We know that Ding Guanpeng's work (for example, his copies of Guanxiu's Shengyin Monastery *Lohans*) was often reproduced in other formats and media—in

fact, he was as much a master designer as a painter. *Bidian zhulin, xubian* (the 1793 supplement to the first catalog), for example, lists four tapestry copies of his 1759 painting of the *Supreme Bliss World*, which Qianlong reexamined in 1782, when he drafted an inscription in four languages that he had transcribed onto the original and all four textile copies. Here in the case of the *Buddhas of the Three Ages,* however, the relationship of original composition to textile copies is likely even more direct—Ding's painting could be the cartoon for the tapestries, functioning like an authoritative master, or it could be a "file copy" gone mysteriously astray from the imperial collection. Despite its work-manlike purpose, Qianlong was sufficiently taken with Ding's painting (or with another example of the same subject by the same artist) to write a poem about it, though not on it. He cast his eulogy in the form of a sutra. Claiming authenticity through direct access to the Buddha's own speech, he begins, "Thus I have heard," describing the comings and goings of the Buddha as instantaneous, accomplished in the "snap of the fingers," and asserting that his painting master, Ding Guanpeng, has stimulated his own awakening.[24]

Why did Qianlong choose the buddhas of the three ages as the theme for his gift to the Seventh Dalai Lama (and others, Tibetan, Manchu, or Chinese)? And why did he have the buddhas set in a composition that mixes subtly Tibetanized icons with references to a respected ancient Chinese master, embedding the whole in an auspicious matrix of rebus-laden, Chinese subtext? Among other things, this particular group of buddhas represented the ever-shifting present, constantly affirmed the past, and assured the shape of the future in a beginningless and endless lineage of reincarnations, an unbreakable chain mirrored in lineages of incarnate lamas or "living buddhas" throughout Tibet and Mongolia. Qianlong's own poem on a set of three buddhas carved in Khotanese jade plays on the unity of the three: "Three are one, one is three" *(san yi yi san),* he writes, forming a balanced row of transforming characters that recalls the trigrammatic forms of the *Yijing.*[25] He adds that the buddhas "transmigrate boundlessly" *(du shi wu liang)*—underscoring his awareness that this group of three buddhas, first revealed to Chinese Buddhists in Kālayaśas' fifth-century translation of the *Guan Wuliangshou fo jing* (Contemplation of the Buddha of Boundless Life Sutra) and only just becoming popular in Lu Lengjia's day, also automatically calls to mind the single cosmic buddha of the same name, Wuliangshou Fo (Amitāyus), the Buddha of Boundless Life. Amitāyus was literally the favorite theme of gift giving in the Qianlong era, invoked in chantings of the *Amitāyus Sutra* that were conducted daily, biweekly, and on imperial birthdays in various chapels of the Forbidden City.[26] And, as I have suggested elsewhere, the Three Ages (Sanshi) had dynastic implications as well: Sanshi Juemu, Enlightenment Mother of the Three Ages, is one of Mañjuśrī's names; and one of Mañjuśrī's present emanations was, as we will see, Qianlong himself.[27]

The mutual dependence in this series of pictures between word and image—where nonlinguistic visual elements suggest words, create puns, and lay down a substratum of depersonalized, continuous benevolence and where linguistic elements conjure up other iconic forms, other artists, and other golden ages, adding up to a veritable Peircean universe of signifiers—also informs Qianlong's Buddhist-inflected thinking about the mind and its operations. What is particularly distinctive here is the fluency with which this apparently static, formalized, and even formulaic art translates instantaneously between one sensory realm and another, between words (read in time) and images (seen in space) and the degree to which its density taxes and defeats those who are not in the know. So we are moved to ask: Why give a gift to someone, like the non-Chinese-speaking Dalai Lama, who could not "read" it, a gift with hidden messages and acrostic ambiguities that even outshine its stated subject? One answer may lie in the ways in which Buddhists in the esoteric Vajrayāna tradition thought about language and its many uses, quotidian and ritual.

Another commission, produced fourteen years later, may demonstrate more clearly how the Qing court manipulated language and image to shift cultural and semantic registers seamlessly. This time

Qianlong had several images of Ṣaḍakṣarī Lokeśvara (Lokeśvara, or Avalokiteśvara of the Six Syllables) made in Suzhou, in both silk embroidery and tapestry, probably to honor the selection of the Eighth Dalai Lama in 1758. Rolpay Dorje's biography describes the huge supply of gifts he carried, among them images of Avalokiteśvara (and a well-received portrait of Qianlong himself), when he went to Lhasa to oversee the process of choosing the new incarnation.[28] Rolpay Dorje's stay had other motives as well, diplomatic and ritual, so he extended his visit through 1760 to visit monasteries all over Central Tibet, apparently distributing copies of the Lokeśvara image along with their implicit message of Qing support for the new Dalai Lama. A *kesi* tapestry version survives today in the Potala in Lhasa, presumably the very one Rolpay Dorje presented to the new incarnation (Plate 6).[29] Two "file copies"—a silk embroidery now in the National Palace Museum, Taiwan, and a second tapestry whose present location is unknown to me—were placed in the imperial collection. Both are listed in the 1793 supplement to the imperial Buddhist and Daoist art collection, the only record of the initial multi-unit commission, but they should not be taken as the "originals" upon which all the others were based.[30] A fourth copy (Plate 7), another identical silk embroidery, recently entered the collection of the Asian Art Museum in San Francisco, apparently recovered from an unknown Tibetan monastery (rumored to be in Shigatse, the seat of the Panchen Lamas) destroyed during the Cultural Revolution. All four bear identically placed seals of the Qianlong emperor and his *Bidian zhulin* collection.[31]

On the surface the three available pieces read like exuberant but tasteful congratulatory cards. And, like any really successful card, what they picture is entwined with the inscriptions they bear to produce meaning in several charged registers. In the two silk embroidered examples, some of the finest work of eighteenth-century Suzhou's textile factories, the palette, in contrast to the sharper, saturated hues of the Dalai Lama's tapestry version, is elegant and pastel. Lokeśvara's pearlescent white body rests on a luminous lotus of pale pink as delicate lotus sprigs shower down around him. The real subject of these gifts is not the evanescent, realized body of the bodhisattva, however, but the imaged sound that invokes him: the six syllables, *"Oṃ maṇi padme hūṃ,"* embroidered in brilliant blue Sanskrit script above him. This best-known of all mantras, roughly (and only partially) translatable as *"Oṃ* jewel-lotus *hūṃ,"* boldly competes for attention with the bodhisattva's exquisitely pale transformation body, casting into doubt which is the "real" Lokeśvara: embodiment or mantra? The choice of topic is especially felicitous and politically sensitive, since the Dalai Lamas, beginning with the Great Fifth, have all claimed to be emanations of exactly this sound form of Lokeśvara/Avalokiteśvara, envisioned manifesting himself from his six-syllable Sanskrit mantra.

What we have here, then, is a picture of a mantra, a particularly efficacious kind of speech act that, along with longer incantations *(dhāraṇī)*, represents the speech aspect of the body/speech/mind trilogy of Tibetan Vajrayāna practice. Mantras and *dhāraṇī* were, as we have seen, a special concern of Qianlong, who, in 1745, worried aloud to Rolpay Dorje that their transcriptions into phonically inflexible Chinese characters (mostly accomplished in the Tang dynasty when northern Chinese was pronounced very differently than in the eighteenth century) distorted the orthodox Sanskrit-based recording of their proper sounds.[32] The ritual power of mantras, as "true speech," depends on their correct pronunciation. And Qianlong was aware that they could be properly expressed only in a phonetic system like that of their original Indic language and that they were, because of their semantic wobbliness, sometimes only incompletely translatable and somehow culturally circumscribed.

So what, if anything, beyond acknowledgment of the Dalai Lama's status as the six syllables' emanation, did the emperor mean by this gift of a bold, beloved, and widely popular mantra? Even finding a stable register to attempt a reading is difficult because mantras may not always carry an easily discernible surface meaning. Their main functions are mnemonic, performative, and evocative; they are what Richard Payne has called "language conducive to awakening," arguing that they

are "verbal actions on, or perhaps over, the [semantic] margins of language."[33] They represent a special use of language-like sounds in a tradition that is conspicuously suspicious of the ability of ordinary language to reveal anything. Secretly compacting whole worlds of mnemonic significance and reference into their suggestive, but often semantically empty, syllables, the Sanskrit letters that make up the mantra can call to mind—invoke—the essence of the deities they represent, just as images do, mimetically, resembling them in their ultimate emptiness.[34] Mantras are not all empty cries for the presence of the deity, however. As Payne points out, they can indeed have clear semantic meaning and be structured grammatically as well. A ninth-century Tibetan grammatical text cites Lokeśvara's mantra *"Oṃ maṇi padme hūṃ,"* in particular, as an example of the vocative case—a call out to the jewel lotus that comprises its superficial and literal center. Repetition of the six-syllable mantra, which is deployed performatively as part of a practice that stresses mindful recall—recalling the parts of the mind that resemble Lokeśvara's compassion—is also the most common, and simplest, ritual act in Tibetan Buddhism, an act that lies at the heart of ritual transformation.

Germane to unraveling Qianlong's Buddhistic understanding of language and ritual (and the intent behind the Ṣaḍakṣarī Lokeśvara mantra images) is Ryūichi Abé's *The Weaving of Mantra*, which focuses on Japanese Vajrayāna Buddhism. Abé utilizes, among other things, the ritual theory of Maurice Bloch to adumbrate the differences between ordinary and ritual uses of language.[35] He argues that the mantra is ritually "formalized" language, fixed and made rote in its constant repetition, to the point that its "locutionary force declines and its illocutionary force intensifies." Whatever semantic content the mantra has is not clarified through repetition; it is blurred and ambiguated—heightening, not its power of argument, but its power to persuade emotionally and even somatically, as Bloch argues, in the same way a song does. Citing Bloch, Abé also stresses that in ritual words "function less as parts of a language and more as things, in the same way as material symbols. . . . Material symbols are therefore of their nature like words in formalized communication. They can only be part of a message with very weak propositional force, but as a result gain in ambiguity, and hence their illocutionary and emotional force." A mantra's strong point, like that of a visual image, is therefore precisely its impenetrable density and inarticulateness,[36] what Abé calls its "propositional ambiguity," and it is the very inability or wise refusal of the ritual actor to disambiguate the mantra that "depersonalizes and dehistoricizes" its repetition. The actor is "dissolved into the past, and the future is made to seem an inevitable repetition of this past." It is just this process of ritual formalization through (corrective) replication, resulting in dissolution of the present and future into the past (or of past and future into the present), that seems to run as a constant thread through all of Qianlong's many replicative projects and is especially appropriate here in a gift that celebrates the rebirth of an incarnate lama, the timeless emanation of one of Buddhism's most central bodhisattvas.

Mantras must necessarily have a different effect on native speakers, nonnative speakers, and nonspeakers of the original language in which they were conceived. Thus we can expect that Qianlong's six-syllable images were likewise given in a slightly different, and possibly more anxious, spirit than the one in which they were reportedly happily received. For native speakers or constant users of ritualized Sanskrit—Indian pundits and learned Tibetan lamas, for example—the mantra should initially produce at least a partial interpretation on a semantic level; it is its repetition that creates ambiguity. For a multilingual Buddhist like Qianlong, however, the process was complicated, not eased, by his passing acquaintance with Sanskrit, which made him aware that Chinese transliterations misrepresented mantras and *dhāraṇī*, obfuscating and erasing their semantic and grammatical references. But even when rendered in Sanskrit letters, they may still have initially worked only symbolically for him: as conventionally accepted, arbitrary signs standing for something other than themselves. The frustrations of this very Buddhist language dilemma were intense, as we see from his complaints to Rolpay Dorje, even as they might well have hastened his appreciation of mantra as

formalized language in Bloch's sense. As Rolpay Dorje's biographer reminds us repeatedly, for an emperor who was an emanation of Mañjuśrī, bodhisattva of wisdom (and who thus shared Mañjuśrī's own particularly apt mantra, *"om arapacana,"* loosely equivalent to "om ABCDE"),[37] the formal uses of language were both fascinating and troubling.

Qianlong's multiple images of the six syllables and their embodiment in Lokeśvara pose an additional language-based problem, however, one that goes beyond their unusual, bold, and richly ambiguous presentation of the bodhisattva's mantra as their generative image. The Manchu habit of juxtaposing inscriptions in four languages, as at the Yonghegong, suggests a broad understanding of the possible applications of verbal practice—the belief that the simple repetition of a message in more than one language (and, of necessity, in more than one register) enhances the chances that it will be efficiently received. In the six-syllable images, however, this understanding is taken a step closer to Buddhist views of the correct and multiple uses of language in both everyday and ritual speech. If we can take the boldly inscribed mantra as either mnemonic (recalling Lokeśvara to mind), vocative (calling successfully for his embodied presence), or performative (stressing repetition and collapsing past, present, and future), the Tibetan inscription embroidered below Lokeśvara has a completely different function. It repeats an official *deleg* (prayer-poem) of the Manchu imperial household, one of four in constant use on bales of *khatak* (prayer scarves) woven in Beijing from as early as 1715, reading: "Fortunate days, fortunate nights. May all your days and nights be fortunate. Depend on the Three Jewels for good fortune!"[38] Here the message is straightforward and simple, a wish that the recipient have a happy enthronement (and many happy returns!). Its very directness contrasts starkly with the Sanskritized mysteries of the embroidered mantra above, which materially embodies the same depersonalized and dehistoricized message. Although any educated Tibetan Buddhist could easily "read" both scripts—and read them in their intended registers, as well—the delicate counterposing of the felicitous wish at the bottom is a disarmingly direct twist.

Fungus, Bats, and the Number Nine

Of course, such inventive uses of language were not original to the Qianlong court—the prayer-poem "Fortunate Days," for example, was a favorite of the Buddhist emperors of the Ming, who emblazoned it in Tibetan on their own blue-and-white porcelains. The Manchu, though, practiced wordplay with more enthusiasm and flair than ever before or after. Word-wary Buddhists have toyed creatively with the interplay between verbally and visually imparted meaning since the time of Śākyamuni, whose postenlightenment sermons have famously been described as wordless. Buddhist theories of consciousness, particularly as presented in one of Qianlong's favorite texts, the *Śūraṃgama sūtra* (Chinese: *Lengyanjing*), also suggest that experiential data are fluidly transmutable from one sensory form to another; thus what can be seen, smelled, and tasted can also, the sutra argues, be directly heard. Even more important to artistic production in the Qianlong court is the opposite of this notion—that what can be heard can also be seen, and what can be seen can be reconstructed as language, literally or figuratively.

To say that the visual was privileged, or at least proliferated over other kinds of data, particularly in the Vajrayāna ritual of the Qing court, would be an understatement. But in Qianlong's time the text, especially when written in visually resonant Chinese characters, was inevitably considered a source of secret revelation. Thus ways of blending text and image—writing directly on images, building the shadow presence of words into images as rebuses, creating images out of written characters—were all popular practices that fall under the umbrella of "visualization." Following ancient Chinese precedent, the Kangxi emperor wrote out copies of the *Heart Sutra* and *Medicine Buddha Sutra* in the form of pagodas, especially during the second half of his reign, when his own Buddhist

practice appears to have been particularly intense, and Qianlong followed suit. These texts-arranged-as-pictures, a venerable practice throughout East Asia, point emphatically to the congruence of the Buddha's teachings with his physical body, symbolized and contained in the pagoda-reliquary form, and to the sense that both teachings and body are traces of a once-present being who is now, paradoxically, completely gone. Other creations were based on even trickier conceits. For example, Xu Yang's "painting" of the White-Robed Guanyin (Avalokiteśvara), the bodhisattva of compassion, on close inspection turns out to be composed entirely of smooth lines and blocks of *shou* ("long life") characters, making the bodhisattva's physical presence, quite literally, a text, albeit a repetitive, mantra-like one, where even her spiritual father, Amitābha, normally placed as an icon in her crown, is transformed into the character for long life (Figure 10).

This digression on Buddhist uses of language and the incorporation of language's ability to be both clear and not so clear in Qianlong's gifts and other commissions should shed some light on another Manchu custom: the recording and repackaging of gifts received. A complex problem created by receiving so much tribute was how to keep it all straight. Qianlong's catalogers and collections managers were faced with the same pressing responsibilities most modern museum personnel also face: how to store works safely to conserve them for posterity, how to organize them spatially for convenient retrieval, how to mark each permanently with the collector's approved reading. The emperor's collection of tribute was a materialized record of his successful reign—each gift marking a moment of harmonious, ritualized contact between the court and its dependents—and the collections of the palace museums in Beijing and Taipei, in no small measure, are both still managed to perpetuate

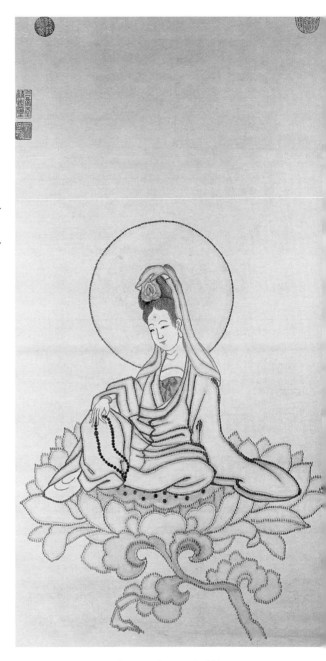

Figure 10. Xu Yang, *Guanyin Composed of Shou Characters.* Hanging scroll, ink on paper. 91.2 x 48.7 cm. (National Palace Museum, Taipei.)

that history, though for different reasons. In fact, the eighteenth-century artifacts of collections management, the labels and tags of acknowledgment, approval, and reevaluation that tribute items continue to bear, have become significant bits of material cultural history in their own right.

Qianlong and his predecessors had most gifts boxed in custom-fitted containers after they were received at court and, from Qianlong's reign forward, they were also equipped with identifying silk labels in four languages, usually recording who among the imperial corps of lama-iconographers

examined the piece, when it was given, who gave it, and authoritatively stating what it was. Only Tibetan and Mongolian gifts and works in Tibetan style had their provenance and identification pasted, tied, or sewn onto them in this way; few of them, in contrast to palace-made paintings and calligraphy or historical Chinese works of art, were recorded in the official collection catalog, *Bidian zhulin.* This labeling process represents what amounts to an Inner Asian alternative to the Chinese habit of writing comments directly on paintings and calligraphy—or, in Qianlong's innovative and often criticized practice, having his rhapsodic reactions to his hundreds of inkstones, or objects in media like jade (especially Khotanese), lacquer, and rhinoceros horn, carved into them.

Still other objects presented special problems requiring the collaboration of some of the best Chinese decorative artists at court to bring out their real meaning in a Chinese context. One particularly important gift was a group of eleven buddha figures Qianlong's father, the Yongzheng emperor, received in 1727 from his brother. Wang Jiapeng notes that court records explicitly state the original gift was eleven images, but apparently Yongzheng found the number inappropriate, not because it was too small, but because it was too big.[39] He therefore asked a learned lama to put the pieces in order and, on the lama's advice, had his palace workshop fabricate a shrine to house nine of the figures, bringing them into a more auspicious state numerologically. (The fate of the other two is unknown, though they were probably held in reserve to compensate for another, relatively skimpy gift.)

The number nine was a fundamental organizing principle for the Qing, particularly in their gift giving. Qianlong's escalating extravagance in the birthday gifts he gave his mother always was calculated in terms of nines; he presented her with nine figures of her favorite Amitāyus, then ninety, then nine hundred, and even nine thousand.[40] The reasons for this enthusiasm were multilingual. Wang Jiapeng points out that nine has always been considered particularly lucky by Han Chinese because it is the largest single-digit number (though, in fact, ten too is written with a single graph);[41] it also stands as an especially significant limit guarding against the unfortunate pun of ten *(shi)*, a near homophone for death *(si)*. In Chinese the punning possibilities of nine *(jiu)* were in play before the Han dynasty, when it already sounded similar to other words clustering around the meaning "long time" *(jiu¹)*, including *jiu²*, a character that signifies the permanent resting place of postmortem identity, a site that is graphically constructed as either an inscribed tablet or a portrait.[42] Some of these same associations applied in the Tibetan language (as they do in Japanese). Nine was also a number that had special weight for Mongols, whose shamanic heaven had nine layers and who annually gave the Qing court a tribute of the Nine Whites, nine flawlessly formed and perfectly white animals (eight horses and a camel) drawn from herds all over Mongolia. Likewise the careful analysis Larry Moses has done on the famous *Secret History of the Mongols* shows that in this text the number nine is reserved strictly for the pivotal doings of Chinggis Khan, while its square root three is democratically strewn throughout simply to indicate a number larger than two.[43] Other numbers rarely appear, and nine conspicuously disappears from the tale with the description of the great conqueror's death.

Nine also has perfect symmetry, playing thrice on the fundamentally satisfying balance of three (a number Qianlong loved to toy with), and as a multiplier it was particularly suitable to the stable, hierarchic, but subtly ambiguous compositions favored by the court and to mandalic constructions in general.[44] In fact, it is difficult to think which came first: numerological underpinnings or choice and arrangement of subject matter. Qianlong's Chinese artists were truly inventive in creating compositions where the eye finds multiple ways to break nine down into three triplets, so that the whole yields up many alternative ways to scan its parts. Thus ambiguity and a sense of richly embedded meaning could be added to the simplest gifts just by rearranging them with almost diabolical cleverness and by placing them into frames whose shapes carried auspicious meanings of their own.

One of the most resonant examples is from Chengde: a Chinese-made cloisonné shrine in the shape of a *ruyi,* wish-granting fungus, set on a lotiform terrace and designed to hold nine minia-

ture gilt brass images of Ami-
tāyus, each in an individual
ogee-arched niche (Figure 11).[45]
Here stable lotus seats, focused
meditation gestures, crowns
topped with *vajra* (diamond
scepters with clawed ends), and
vials of elixir rigorously ground
the main Tibetan-style icons of
long life, all of them absolutely
identical. It is only their refusal
to break down into stable groups
of three that makes them impos-
sible to stabilize, forcing the eye
to dance over the assemblage
until the whole finally reveals
itself as a branching refuge tree
where all the generations—past,
present, and future—are the
same and equally vibrant. And
if this demonstration of conti-

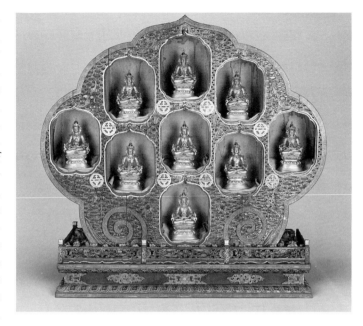

Figure 11. *Shrine in the Form of a Ruyi ("As-You-Will") Fungus.* Brass with cloisonné enamels and gilt. H: 64.8 cm. (Chengde Summer Retreat.)

nuity, embedded sporelike in a wish-granting fungus, were not enough, there is also a lattice of clouds and coin-shaped long-life characters (whose symmetry mimics the fungus-shaped frame) hung with bat rebuses who present homophonous blessings of "as-you-will" scepters, peaches of immortality, auspicious jade chimestones, and *bi* disks. This is a fascinating artifact in more ways than one that combines both goals of Vajrayāna *sādhana*—not only realization of the object of contemplation through visualization but also wish granting—into a multipurpose, portable unit. Like a Tibetan *ga'u* amulet shrine or a portable Manchu *tangse* (god box), or, even better, like the *duobaoge* ("many-treasures boxes," or curiosity cabinets) the Qing loved, this object owes much of its allure to its miniature size and impenetrability, inviting entrancement, focused meditation, or unharnessed daydreaming.[46]

Another cloisonné Chengde shrine takes a slightly different tack by piling rebuses on formal visual play (Figure 12).[47] This shrine is shaped like a swollen double gourd plastered with five gleaming gold bat-blessings splayed against an enameled backdrop of flowers, bamboo, and butterflies and topped with a crescent moon and blazing sun, just like a pagoda. This detail points directly to the function of the shrine as a reliquary for the nine flame-aureoled Amitāyus images it holds, each one ensconced in a double-gourd-shaped niche. Here, however, the play is not on what is gone beyond but on the gourd, an old Chinese symbol of chaos, infinite undifferentiated possibility, and fecundity whose ripe shape resembles a Tibetan *chorten* or stupa (itself both indexically and symbolically conflated with the enlightened Buddha's body). The nine buddhas of boundless life are thus presented as ripening seeds ready to pop and their message is long life, fertility, and infinite rebirth. Other bits of meaning—for example, the svastika (read: *wan*) at the top of the gourd—jump registers completely, creating apparently coincidental, but truly intentional, readings simply by means of juxtaposition. The svastika is an ancient Indian solar symbol that came to be used in Chinese Buddhism as an alternate form of the character "*wan*" (ten thousand). Here it overarches all the buddhas below and is meant to be read in combination with them as "*wan fo*" (ten thousand buddhas) or "*wanshou*" (long life ten-thousand-fold), skipping neatly (and with utmost clarity) over the gulf between written symbol and sculptural icon.

As all these messages fold over one another, they reveal several motives. The first subtly enhances the meaning of Amitāyus, following a Chinese direction already well established in the Pure Land Buddhism of his inflection Amitābha, Buddha of Boundless Light, who promises rebirth as a fertile lotus seed in the Western Pure Land if only he is called to mind. The second suggests that the true message is a hidden, encoded one shaped and written across several registers and in several distinct idioms. Through the use of rebuses—for which phonetically spare Chinese is particularly appropriate—and the coincidence of formal likeness, these seemingly wordless shrines unlock their meaning both visually and verbally in a kind of extended, puzzling play that recalls the ways in which Vajrayāna texts are often coded mnemonically and acrostically to cache their true significance, only hinted at in a superficial reading. This is not a particularly Tibetan practice; concealed messages had wide currency in Vajrayāna circles everywhere. Take, for instance, the eminent late-Ming monk Hanshan Deqing (1546–1623), some of whose practice was distinctly tantric, who wrote a fairly conventional poem that was actually composed of the first syllables of his name and the names of all his disciples (an undertaking not at all unique to him).[48] Or consider the Mongolian *Secret History of the Jebtsundambas of Urga*, a text in Tibetan inscribed on the back of a twentieth-century painting of the same subject, which reveals syllables making up all the names of the rebirths in the lineage, interspersed through what reads on the surface like a eulogy of the Buddhist cosmos.[49] What is unique in the Chengde shrines is their "multilingualism." The "text"—visual, verbal, or both—is like a palimpset whose layered cultural references can be peeled away to reveal deeper and deeper meaning.

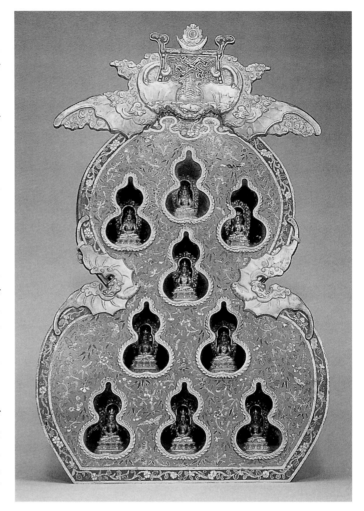

Figure 12. *Shrine in the Form of a Double Gourd.* Brass with cloisonné enamels. H: 69.5 cm. (Chengde Summer Retreat.)

This sort of complex structuring does not only appear in images made for frontier audiences, even if some of the effects of conscious stylistic collage and quotation are most vividly apparent there. Nor were all of these pictures intended as part of an elaborate public relations spin put into play by the Qing court. Some were intensely private, literally accompanying and stimulating the emperor in his most solitary reveries, and it is to this group I turn now.

"One and/or Two"

"Are they one or two?" *(shi yi shi er)* is a phrase Qianlong often worked into his inscriptions, flipping at times to the apophatic "Neither one nor two" *(fei yi fei er)*. He applied the comment, which reads as both question and affirmation ("It is one and/or two"), over and over again for decades, to paintings of lohans, to portraits of himself, to the epitaph he wrote in 1780 for the deceased (but soon to be reincarnated) Sixth Panchen Lama,[50] and even to his court painter Ding Guanpeng, whose name (and style) played resonantly on another of the emperor's favorites, the late-Ming Buddhist layman-artist Ding Yunpeng (1547–ca. 1628). "One and/or Two" appears most famously, however, in the inscriptions on a series of at least three almost identical portraits of the emperor in the guise of a Han Chinese Buddhist layman wearing a pale wide-sleeved robe and black horsehair hat. He sits casually on a divan backed by a landscape screen depicting no place in particular in the orthodox, literati style of his grandfather's court painter, the Chinese master Wang Yuanqi (Figure 13). This screen is a historically resonant detail—a "mind-landscape" that describes the harmonious contours of the sitter's inner self. The screen is partly obscured by a hanging portrait of the emperor: bust-length but otherwise mirroring his seated image. He is surrounded by things—elaborately carved tables bearing antique bronzes, strange rocks, and a large blue-and-white vase inscribed with a *dhāraṇī* in *siddham* script. The Chinese inscription by his own hand varies slightly from one version to the next, both in calligraphic style and in signature, but the content of the four main lines of text, arranged as a series of binaries, remains constant:

[It] is one and/or [it] is two—	*shi yi shi er*
Neither contingent nor separate.	*bu ji bu li*
Maybe Confucian, maybe Mohist.	*ru ke mo ke*
Why get excited? Why think?	*he cong he si*

Figure 13. *One and/or Two?* (with Yangxindian inscription). Screen painting, ink and slight color on paper. 90.3 x 119.8 cm. (Palace Museum, Beijing.)

From the perspective of literary (and visible) structure, the inscription explores binary opposition through repetition, parallelism, and inversion, stating its premise (or posing its question) affirmatively—"[It] is one and/or [it] is two"—then switching to paired negatives—"Not contingent, not separate"—then inverting nominative and verb in the third line—"Maybe Confucian, maybe Mohist"—and in the fourth inverting again and adding a "man" radical to the "ke" (maybe) of the preceding line to produce the questioning "he"—"Why?"

Both Angela Zito and Wu Hung have published perceptive readings of the "One and/or Two" portraits and their inscriptions; indeed these pictures are among the most discussed of the Qianlong period.[51] Angela Zito compares them aptly to a handscroll portrait of the Yuan master Ni Zan (1301–1372), which Qianlong owned and revered. It shows the artist similarly seated on a divan before a landscape painted in his own distinctive dry style. Wu Hung finds an even closer precedent in a scroll the emperor actually kept in his study: a double portrait of an anonymous scholar. Although Qianlong dated this scroll to the Song dynasty, it is more likely a Ming composition. Wu is palpably uneasy with the emperor's "One and/or Two?" paintings, however. He says they "finally and completely destroy the original (Ming) work," dropping everything from the Ming sitter's kindly regard for his servant to the even-handed (and hence, in his view, nonhierarchical) distribution of his prized objects in the foreground. This judgment meshes with his evaluation of Qianlong as someone engaged in an intentional project of "self-mystification," a project abetted by the double-screen formula (the main object of Wu's study), which allows the artist to conceal what lies behind by offering an illusion in its stead. Justifiable or not, Wu's reaction diverts him from the inherent message of the series: nonduality, the mutual dependence of all phenomena, the core concept of Mādhyamika Buddhist thought that intrigued Qianlong throughout his adult life.

It is easy to see how the "One and/or Two" series visually supports speculation on the question it poses; even in photographic reproductions, the composition seems to tunnel forward and back endlessly into mental space, like the infinite series of selves Mañjuśrī reflected, mirrorlike, when he took the guise of Yamāntaka to do battle with death. In fact the pieces were even more effective in situ, because, as Wu Hung notes, they were originally composed as large-scale *tieluo* ("paste up and take down")—movable paintings that were literally glued onto walls or, in this case, more likely onto screens much like the ones shown in the paintings themselves. They thus formed a life-sized backdrop, or perhaps a point of contemplation, for the emperor's ritualized and, it should be stressed, relatively private reenactment of a profoundly puzzling philosophical question, a reenactment in which he was both performer and audience.

The "One and/or Two" series thus addresses the relationship of object and representation and fluid versus fixed identity in a number of ways both verbal and pictorial. The juxtaposition of painted landscape and miniaturized bonsai, the rectilinear tables to the left and the round tables to the right, the ancient sacrificial vessel set against the *dhāraṇī*-inscribed porcelain jar—all echo the emperor's mirrored faces. From one version to the next, the shape of Qianlong's "mind-landscape" also subtly shifts, as if he sits on a boat slowly floating down a river, passing from one phase of his life to another. This play of similarity and difference also drives Qianlong's calligraphy, as he writes the same, repeated character—for example: *shi*, "is, are"; *bu*, "not"; *ke*, "maybe"; and *he*, "why?"—first in regular and then in cursive script. Qianlong continued to push his calligraphy to express ambivalence in the several versions of the inscription he wrote and rewrote as the original painting wore out or ripped and another version was done to replace it. Putting all three inscriptions together, the privileged modern reader winds up with *two* shuffled versions of the text, written in (formal) regular and (informal) cursive scripts, a text that is only clearly legible when all *three* texts are brought together. Are these repeated inscriptions the same, then, or are they different? Their constantly shifting forms help cast the relationship between the "real" Qianlong and his portrait in terms of mutual dependence: Both

sitter and representation are there and not there at the same time, and one cannot exist without the other. Because if the portrait needs the emperor to take form in the first place, the emperor likewise needs his portrait to project himself into history as a series of mirrored, familiar, but ever transforming shapes.

Both Angela Zito and Wu Hung mention that on one version of "One and/or Two" attributed to Yao Wenhan, Qianlong signs himself with a studio name, Naluoyan Ku (Nārāyaṇa's Cave), which both scholars interpret as referring to Nārāyaṇa (Firm and Stable), a three-faced avatar of the Indian deity Vishnu. This reading allows a clever play on the two imperial faces depicted in the portrait and a third, unseen face—that of the emperor as imaginer and viewer of himself. Nārāyaṇa's popularity at the Qing court as alter ego of the three-faced Vishnu was at best limited, however. He appears as a bodhisattva in Tibetan Buddhism, but in the several pantheons of Buddhist deities Rolpay Dorje produced during the Qianlong era, he never has three faces and does not live in a cave. It is more likely that "Nārāyaṇa's Cave" had little to do with Vishnu or even with his tantric Buddhist avatar. This particular affectation was probably chosen to play on notions of repetition and doubling in another way: Nārāyaṇa's Cave appears famously in the politically important *Flower Ornament Sutra,* where it is described as the abode of many bodhisattvas and the source of penetrating visions.

But why should such a place have struck the emperor as a site to lodge a fragment of his identity? Perhaps because, by the eighth century, quite a few of the most significant places named in the *Flower Ornament Sutra* had been located (or relocated) in China, not the least of which was Wutaishan, identified as Mañjuśrī's field of activity. In a famous commentary on the sutra, the Tang master Qingliang Dashi (the Qingliang Master, or Master of Mount Wutai, 737/8–820/38), first patriarch of the Huayan school, similarly located Nārāyaṇa's Cave at Laoshan (Mount Firm and Stable), near Qingdao in Shandong. Hanshan Deqing, the eminent monk of the late Ming and admirer of the Qingliang Master, subsequently adopted Naluoyan Ku as his studio name when he went into self-imposed exile in Shandong, in the very cave the Qingliang Master indicated.[52] It was from Deqing that Qianlong probably borrowed the name; the emperor certainly knew Deqing's influential work, especially on the *Śūraṃgama Sūtra,* a scripture he greatly admired.[53] Thus when "Nārāyaṇa's Cave" appears on "One and/or Two" as Qianlong's most private self-reference, it creates an encoded tie with both Hanshan Deqing and the Qingliang Master (whom Rolpay Dorje himself praised in a poem he wrote on Wutaishan), as well as with the sacred mountain itself. Claiming the same visionary life as revealed in the *Flower Ornament Sutra* enabled the emperor to root his practice not once, but twice, in the Chinese landscape. But Nārāyaṇa's Cave, a "mind-landscape" if there ever was one, had another location as well, as the inscription on our second version of "One and/or Two" suggests. There Qianlong records that he wrote his inscription in the Yangxindian (Hall of Cultivating the Mind), his private residence in the Forbidden City and his own "Cave of Nārāyaṇa."[54]

If part of the success of the "One and/or Two" series depends on its repetitive stress on a single message of nonduality and on its relatively large scale (and therefore on its ability to act as a setting for imperial action or private reverie), part also stems from its subtle combination of a refined *baimiao* (plain drawing) style with portrait techniques drawn from both Chinese and Western traditions. Qianlong's identity is established, Chinese style, by his explicitly Chinese-style dress and by the tasteful objects surrounding him; they also proclaim him to be a Buddhist layman who engages in Vajrayāna practice. The emperor's two faces are also strikingly realized, displaying the same concern for precise physiognomy as the Italian Jesuit Giuseppe Castiglione's many portraits of him do.[55] They especially resemble the 1748 preparatory drawing Castiglione did for his large-scale, collaborative panorama of *Qianlong Receiving Tribute from the Dzungars* (Figure 14), revisited by the emperor in an inscription dated 1786.[56] Their illusionary quality, therefore, is the key to their success—they were intended to be mistaken briefly for something real. But unlike many of Qianlong's other *tieluo* portraits, they

were also meant to be revealed quickly by the emperor's own inscription as nothing more than marks on a surface, as Zito perceptively argues. His poetic query points directly to his own hand and to the representation of it eternally poised to commit his thoughts to the page.

Smooth Lord

The striking if momentary illusion, what Chinese theorists have long denigrated as mere "form likeness," conspicuously separates Qianlong's use of Buddhist painting from his patronage of, for example, Chinese landscape painting. In writing about his portraitist-of-choice, Giuseppe Castiglione, Qianlong often commented on the uncanny effect of the artist's veristic technique, which brought the emperor face-to-face with earlier selves.[57] Qianlong's 1782 inscription on *Spring's Peaceful Message*, a much

Figure 14. Giuseppe Castiglione (1688–1766) et al., *Qianlong Receiving Tribute from the Dzungars.* Preparatory drawing, ink on paper. 41 x 150 cm. (Musée de l'Homme, Paris.)

earlier double portrait whose precise subjects are enigmatic, records his inability to recognize his younger self when he encountered the painting after many years. He wrote: "In portraiture [Castiglione] is masterful. He painted me during my younger days. The white-headed one who enters the room today does not recognize who this is."[58]

Nor does the modern viewer recognize him with any certainty. Do both figures represent Qianlong, as boy and as man, as Harold Kahn has suggested (a reading Wu Hung dismisses as "fantastic")? Or do they represent Qianlong as a boy receiving the blessings of his father, the Yongzheng emperor, as Wu Hung proposes?[59] This ambiguity has nothing to do with Castiglione's crystal-clear technique; rather it arises from Qianlong's veiled inscription. In a sense, Castiglione's particular *verismo* was honed by the emperor's very special needs. Qianlong commented critically on Castiglione's "lack of brush," the very element of his approach that put the Italian in a class of artists quite distinct from Chinese painters in all categories. But this "lack of brush" was not an aspect of Castiglione's original, baroque-derived style. Rather his bravura was something the emperor, contradictorily, worked actively to refine, ordering him to tone down his palette and heavy use of chiaroscuro and to work on silk and paper and thus forfeit the surface effects of impasto. Castiglione ultimately became a painter specializing in illusion, harnessing his brush, however uniquely, to produce something akin to what Norman Bryson calls an "erased" technique that points away from the painter and toward the object of representation.[60] This motive contrasts sharply with the indexical aims of much

Chinese painting (for which Bryson uses the linguistic term "deictic"),[61] which, like calligraphy, retains traces of the artist's moving hand, provoking in the viewer the illusion of personal memory and allowing him to participate, if only vicariously, in someone else's lived past. Castiglione's portraits project a similarly vicarious sense of privileged access—only now the viewer is invited to contemplate, not the traces of the artist's hand, but a lifelike simulacrum of the sitter that masquerades as unmediated and hence "natural."

Castiglione, whose unrequited mission at Qianlong's court was to proselytize Catholicism, ironically came to participate in an even more extraordinary project: the emperor's presentation in the great monasteries of China and Tibet (including the Potala, Tashilunpo, the Yonghegong in Beijing, the Pule and Puning monasteries in Chengde, and at least one chapel in the Forbidden City itself) as an initiate into Vajrayāna Buddhism, *cakravartin*, and emanation of the bodhisattva Mañjuśrī—the universalist Mañjughoṣa Emperor (Plate 8). The Palace Museum in Beijing maintains that the success of the project depended in part on subterfuge or, more likely, on Castiglione's straightforward willingness to collaborate. The artist was most likely called in to reproduce his canonical version of the imperial face on several blank expanses of cloth and, when finished, simply turned them over to lama-painters from the Zhongzhengdian (Hall of Central Uprightness) who then completed the paintings, dressing the emperor in the robes of a lama and a triple-peaked cap or conical Indian pundit's hat. Lotuses bearing Mañjuśrī's *Prajñāpāramitā sūtra* and sword sprout above his shoulders as he holds the *cakravartin*'s wheel of the law *(dharmacakra)*. In four of seven extant examples, the emperor sits suspended as part of a self-generated pantheon of 108 Buddhist figures, all carefully labeled in Tibetan, set against mountain peaks that suggest Mañjuśrī's Chinese home, Wutaishan. The disruption in representation is shocking and, given what we have seen so far, essential—Qianlong stares out full face from a radiantly colored background as though posing for a boardwalk photograph, a quote from another language that makes him brilliantly, centrally, but only momentarily there. Small wonder that when Rolpay Dorje brought a similar portrait to Lhasa in 1758 as a gift to the newly discovered Eighth Dalai Lama, Jampel Gyatso, the Tibetan dignitaries surrounding the incarnate child expressed their clear delight. (Perhaps, however, this reaction masked a more complex emotion as they gazed directly at the face of the emperor who now asserted dominion over them.)[62] Unlike the smoothly blended, consciously retooled Chinese style of "One and/or Two," Qianlong's *cakravartin* portraits force attention by formulating an entire scenario of lineage and incarnation and arraying the dazzling stuff of visions around the strikingly materialized imperial face.

What prompted these surprising—and relatively public—images? Was it sheer egomania, as some claim? Or was Qianlong, once again, positioning and transforming himself to fit into what he understood to be a well-established historical pattern? We might gauge the significance of his gift to the tiny Dalai Lama by asking how much Qianlong knew about the origins of his supposed identity with Mañjuśrī. As a close student of his own family's history, he certainly was aware that the equivalence was instigated by the Dalai Lama himself in his former life as Ngawang Losang Gyatso, the fifth exponent of the line (1617–1682). In 1640, the Great Fifth and his close associate and tutor the Fourth Panchen Lama (1570–1662) jointly penned a strategic letter to Qianlong's great-grandfather, the dynastic founder Abahai (1592–1643), in response to an invitation Abahai sent to the Dalai Lama to visit him in Mukden. The letter was addressed to the "Mañjuśrī Great Emperor," a salutation that reflected a millenarian prophecy first offered by Sonam Gyatso, the Third Dalai Lama (1543–1588), who predicted that a great ruler, an incarnation of Mañjuśrī, would join forces with the Dalai Lama to unite China, Tibet, and Mongolia in a sweeping, Gelukpa-inspired alliance. This prediction was not offered randomly but was designed specifically to tie the Manchus' imperial project to precedents set centuries before by the Mongols.

The early Manchu rulers of the Qing actively searched out Mongol antecedents as they quite

consciously developed their own dynastic myth, seeking what we might term an Inner Asian, Buddhist style of rulership that departed notably from the Chinese Confucian model.[63] They arrayed themselves and their new Tibetan lama-allies with titles and honors directly lifted from the Mongol empire, and they assumed a number of other Mongol symbolic prerogatives as well. But their most ambitious borrowing, which they did not undertake on their own, was the identification of the emperor as an emanation of the great bodhisattva of wisdom Mañjuśrī.[64] This identification was so risky that even the Mongols did not reveal it publicly before their brief Yuan dynasty was half over (and then only discreetly to those subjects who were literate in languages other than Chinese). Audience response to such a bold claim clearly mattered, and the Mongols' handling of this radical idea suggests their keen appreciation for cultural differences.

The first place the Mongols tested the equivalence of emperor and bodhisattva was at a border site, the Juyong Gate, built in 1345. They did so only in print, however, and only to a carefully targeted audience. The Juyong Gate was only one of four stupa gates originally planned to mark the four cardinal entries into the Yuan capital. Commissioned by the last Mongol emperor, Togon-temür (Uqagatu, r. 1333–1367), in 1345 as an offering to the Buddha, to Buddhist doctrine, and to Togon-temür's ancestor, Khubilai Khan, the Juyong Gate, located about 70 kilometers north of Dadu and just south of the Great Wall, is apparently the only one of the four that was ever built.[65] All that remains is the stone gateway itself; the bulbous, Himalayan-style stupa that stood on top has long since disappeared. The arched entries on either end of the tunnellike structure are crowned by a typically Nepalese image of a splayed *garuḍa* bird clasping a snake in its jaws (symbolizing the dominance of the heavens over the morally ambivalent waters), an image that often forms the back of a Himalayan "throne of glory," the typical seat of the Buddha. Here the long since ruined stupa-reliquary originally stood for the body of the Buddha and the surviving gateway itself represented the "gate of universal passage" to enlightenment the Buddha alone provides. Inside the vault, brilliant relief sculptures of the guardians of the four quarters, two on each side, dominate the lower walls; carved mandalas of the buddhas of the five directions (Vairocana—center; Amitābha—west; Akṣobhya—east; Ratnasambhava—south; and Amoghasiddi—north) form another, unevenly distributed, register above. A five-language inscription (in Mongolian, Chinese, Tibetan, Uighur, and Tangut), the earliest known source for the conflation of the Mongol Yuan emperors with the bodhisattva Mañjuśrī, interrupts the decoration of the inside wall. David Farquhar, the first Western writer to draw attention to the significance of this inscription for later Manchu formulations of divine kingship, has translated the relevant passage from the Mongolian (the least damaged of the inscriptions):

> That blessed bodhisattva the Emperor Secen (that is, Qubilai), possessed of vast wisdom, about whom the prophecy was made that there would be someone named "the Wise one from the vicinity of Mount Wu-t'ai" (namely Mañjuśrī) who would become a great emperor, who would adorn his country with great and high pagodas, and who would reach the age of eighty years—[this emperor] brought peace to the creatures of this vast nation, propagated the religion and doctrine of the possessor of vast merit (i.e., the Buddha), erected great pagodas up to the edge of the sea, and brought vast merits continually to all creatures. Commemorating in gold the marvelous deeds which have been brought about by those bodhisattvas destined by heaven (i.e., the earlier Yuan emperors), [I], the Emperor-Bodhisattva, the Son of Heaven and Master of Men, have caused this extensive and vast pagoda to be founded.[66]

Farquhar notes that the placement of the "Wise one" on Wutaishan is less than explicit in the Mongolian version of the text, where Wutai is referred to as "Utai," a simple transliteration into Mongolian

script in which the meaning of the Chinese term, "Five Terraces," is lost. The Tibetan version is much clearer: "There will appear a king called 'The Wise' beside the Five Peaks." The equivalent portion of the Chinese version has been effaced. Nor do surviving sections make any direct reference to Mañjuśrī; in Chinese Khubilai is simply *renwang*, "benevolent king," following a long and sanctioned Chinese tradition. This identification of Wutaishan, near the border between China and Mongolia, as Mañjuśrī's dwelling place dates back to at least the fifth century, when the *Flower Ornament Sutra* was first translated into Chinese. In that translation, Mañjuśrī's dwelling is said to exist to the northeast of India at a place called Qingliangshan (Clear Cool Mountain), another name for Wutaishan. Despite the early date of the translation of this fundamental text, the Mongols were the first to identify China's own resident bodhisattva so directly with the emperor of China; earlier Chinese emperors confined themselves to the more political blandishment "*cakravartin*" or, as we have just seen, "benevolent king."

But other fourteenth-century Mongolian inscriptions are more subtle than the Juyong Gate's on the issue of who is being identified with whom. A colophon to a *Pañcarakṣa* translation made between 1308 and 1311, for example, simply says: "Then the Holy One, because he was born as a reincarnation in the third generation, had the name Qubilai, and he was raised to the highest peak."[67] If any direct reference to Mañjuśrī or Wutaishan is suppressed here in the cagey "Holy One" (Mongolian: *qutuqtu*) and "highest peak," the exact status of the emperor as a reincarnation is very clear—the Mongolian word "*qubilgan*," which Farquhar points out is a clever play on Qubilai, typically translates the Tibetan "*tulku*" *(sprul sku)* or Sanskrit "*nirmāṇakāya*" (transformation body). This term is generally applied to reincarnate lamas—literally directed rebirths of one individual into another physical form—but it also translates, ambiguously, the Tibetan "*namtul*" *(rnam sprul)*, which means something like an "emanation," an assumed (and only apparently material) form or representation projected magically into the phenomenal world.[68] This distinction is significant because it was not until the early Yuan dynasty that the Second Black Hat Karmapa Karma Paksi became the first Tibetan lama to assert his ability to direct his own rebirth as a *tulku*.

This innovation among Tibetan Buddhists, however, also complicates any understanding of how the Mongols looked at their own equivalence of emperor and bodhisattva just a few decades later. Did the Mongols mean to suggest that their emperors did not just *represent* Mañjuśrī's inimitable qualities of wisdom and skillful means but actually embodied the bodhisattva materially? Or were they using "Mañjuśrī" as an epithet—much as they bolstered their imperial status through the assumption of other historical and multicultural titles, such as the Inner Asian *khan*, the Chinese *huangdi* (sovereign lord or emperor), the Buddhist *cakravartin*, or even more specific and personal appellations such as Chinggis ("Ocean") Khan or Tang Taizong? All of these names expanded the emperor's reach beyond the visible, phenomenal world, broadening his power both spatially and temporally, granting him the flexible, shifting identity that is the desired goal of Vajrayāna practice.

The Fifth Dalai Lama also seems to have pioneered the promotion in visual terms of the Qing emperors as wheel-turning kings. His well-known liturgical work on the sixteen arhats (Chinese: *luohan*), *gNas brtan bcu drug gi mchod pa rgyal bstan 'dzad med nor bu* (Inexhaustible jewel of the victorious teaching of veneration of the sixteen elders), which was published in Lhasa with six wood-block illustrations, concludes with an image of a seated king holding a wheel of the law in his lap (Figure 15).[69] The caption reads: "The Wheel-King *(cakravartin)*, the supreme emperor *('khor los sgyur rgyal gong mthar hu rgyal)*,"[70] describing a generic Buddhist monarch, perhaps even the Qing founder, Shunzhi, whom the Fifth Dalai Lama visited in Beijing in 1653 and whom he recognized as a patron. This same liturgical text, which had important political implications (see Chapter 5), was recut and republished in Beijing during the reign of Qianlong's grandfather, the Kangxi emperor. Although the Tibetan title is altered in the Beijing edition,[71] very little else is changed; the main text

Figure 15. *The Emperor as Cakravartin.* Final page of a woodblock-printed *Lohan Sutra*, dated 1711. Printed at the Temple for the Protection of the Nation, Beijing. 44.5 x 13 cm. (East Asian Library, University of California, Berkeley.)

and illustrations clearly reproduce the Lhasa original. The author of its Tibetan colophon was none other than Rolpay Dorje's preincarnation, the Second Zhangjia, Ngawang Losang Chöden, who disparagingly refers to himself as a "lazy old monk" (thus ensuring he wrote the colophon himself), saying that he undertook the republication of the work because he was prodded by his colleagues. The Zhangjia's Tibetan colophon, however, neither dates the republication nor locates its source. This information is contained in a second, Chinese-language colophon, just below and to the right of the wheel-turning king, which precisely places the new version of what it calls the *Sixteen Lohan Sutra (Shiliu luohan jing)* in the fiftieth year of Kangxi (1711) and states it was made at the Longshan Monastery for the Protection of the Nation (Longshan Huguosi) in Beijing, a major monastery located at the edge of Beihai, just off the northwest corner of the Forbidden City. Here the wheel-turning king is, by reason of contiguity and implication, clearly Kangxi.

In his preface to the "Red Kanjur," written just a few years later in 1718 to 1720, Kangxi went beyond Buddhist kingship to straightforwardly claim bodhisattva status for himself. Sketching out the early history of the dynasty's relations with Tibet (including his father's invitation of the Fifth Dalai Lama to Beijing), he wrote in a supplement to the final volume:

> Then Mañjuśrī, the savior of all living forms, [with the] intellect of all the Buddhas, was transformed into human form, and ascended the Fearless Lion Throne of gold; and this [was] none other than the sublime Emperor K'ang-hsi-Mañjuśrī, who assisted and brought joy to the entire vast world, and who, because he was the veritable Mañjuśrī in his material essence (etc.) . . .[72]

There is, nonetheless, a great distance between the lay role, however exalted, of world ruler or even emanation of Mañjuśrī and that of ordained monk. Yet even this divide was breached a few decades after Kangxi's death when, according to a biography of Rolpay Dorje, an image of his son and heir Yongzheng, dressed in lama's robes, was installed sometime between 1723 and 1735 at the *khutukhtu's* own Songzhusi in Beijing. Describing this picture, Rolpay Dorje's biographer Thukwan states that the emperor was regarded as "the bearer of the crown of the Gelukpa and the Buddha's universal doctrine, as a great lord of religion and possessor of immeasurable compassion gained through his activity as a *lama* who had promulgated the ancient traditions."[73] Although this image has not yet been identified with any certainty, at least two of the surviving emperor-as-lama thangkas (one now at the Yonghegong, the other at the Panchen Lama's seat, Tashilunpo) present a man whose face is noticeably different, both in physiognomy and style of representation, from the Qianlong Castiglione gives us (Figure 16). We know that Qianlong followed his father's example by presenting Rolpay

Dorje with a similar portrait of himself in 1784. In fact Qianlong, like some of the emperors of the Ming dynasty, distributed pictures of himself to allies far and wide. This habit, which continued late into his life, may explain the very different portrait now in the Yonghegong, while the Tashilunpo portrait was probably a gift from Qianlong to the Panchen Lama, who visited Beijing (where he succumbed to smallpox) in 1780. Castiglione's absence—he died in 1766—might therefore explain the stunning difference in portrait styles.

Wu Hung also finds another, quite different, precedent in an album that shows Yongzheng in fourteen different guises.[74] Wearing the robes and hat of a Gelukpa lama, Yongzheng (or is it really Qianlong?) appears on one leaf sitting in a craggy mountain cave, deep in *samādhi*, while a menacing snake replays the same action captured in an icon of Chinese Chan painting: the Southern Song

monk-painter Muqi's well-known image of a meditating lohan (Sanskrit: *arhat;* adept, elder) unmoved by a similarly ill-intentioned serpent. This lama portrait, however, represents only one of a dozen fantastically multicultural imperial roles, including the emperor as a Daoist wonderworker, as a figure out of the Arabian Nights, and as a Frenchified tiger-slayer wearing brocaded breeches and a curled peruke. In comparison to these flights of fancy, the emperor-as-lama portrait is strikingly suited to the devoutly Buddhist (and also Daoist) Yongzheng—if indeed it does represent him and not his more playful son. Yongzheng wrote his own Chan-style *Yulu,* a collection of well-known *gong'an* (Japanese: *kōan*) that also includes his opinion that the second Zhangjia Khutukhtu (Rolpay Dorje's immediate preincarnation) was infinitely wiser than any Chinese monk he had ever met.[75] This portrait as a lama thus seamlessly combines

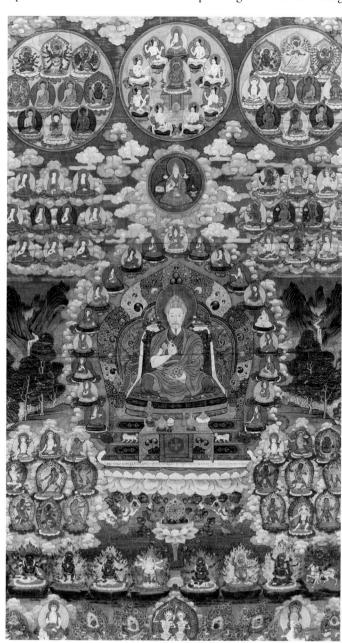

Figure 16. *Mañjughoṣa Emperor.* Thangka, ink and colors on silk. 111 x 64.7 cm. (Palace Museum, Beijing; former Tashilunpo Monastery Collection.)

two aspects of the emperor's Buddhism, as well as his avid Daoism, in an album that often (and this leaf is no exception) verges on lèse-majesté. Guise portraits such as this, as James Cahill and Richard Vinograd have both demonstrated, were not a Qing court innovation but a regular part of Chinese portrait practice, well established by the late Ming dynasty, and they often left their sitters looking uncomfortable and even somewhat silly.[76] Could it be that this fanciful album was designed to respond to the Mencian requirement that the ruler be allowed room for creative play and imaginative reverie, activities ultimately beneficial to the people? In this case the emperor's guise portrait album more than fulfills Chinese expectations of the ruler's versatility.

If Yongzheng's lama portrait stands as one precedent for Qianlong's, however different in tone and intent, a more immediate and more audacious model is the field of assembly or "refuge tree" portraits designed to demonstrate the spiritual lineages of Tibetan and Mongolian Buddhist masters. Qianlong shows his indebtedness first and foremost to his spiritual master, whose image hangs just above the emperor's head in all seven known examples. He is identified by inscription only as Qianlong's "root lama" (Tibetan: *rtsa ba'i bla ma*) and by his attributes of bell and *vajra*, which mark him as an emanation of Cakrasaṃvara (and not Mañjuśrī, with whom he is also identified). Just above Rolpay Dorje is Tsongkhapa, who occupies the premier position at the apex of the top central medallion in five versions. And above him is a pantheon of historical teachers, buddhas (Śākyamuni, Bhaiṣajyaguru, Amitāyus, the buddhas of confession, and others), and *yidam* (tutelary deities including Cakrasaṃvara, Guhyasamāja, and Vajrabhairava), who were the main focus of Gelukpa practice. In other words, the emperor is imagined here as part of an alternative hierarchy of power, that of Tibetan Buddhism, inserting him indispensably into its very center.

Rolpay Dorje's appearance as the emperor's root lama, equipped with the attributes of Cakrasaṃvara, points to another of his several identities and to one of his teaching specialties, the *Cakrasaṃvara Tantra*. His biography claims that in 1745 he gave the thirty-four-year-old Qianlong his first tantric initiation, which was into the Cakrasaṃvara Tantra. The initiation was a huge success and the emperor's spiritual brilliance led Rolpay Dorje to compare the event to Phagpa Lama's initiation of the great Mongol khan Khubilai into the *Hevajra Tantra*, thus underscoring the historical precedent for Manchu sovereignty over Tibet.[77] The emperor continued to refine his practice through daily study and meditation over the course of his life and received many more initiations, into the *Vajrayoginī Tantra* and others, and instruction in the graduated path *(lam rim)* and Tsongkhapa's works on Mādhyamika.[78]

Qianlong was, therefore, rightfully heir through his guru to the lineages of figures that surround him in these thangkas, which may thus be read as records of his many initiations and meditation practice. They are also strikingly consistent with the hierarchies of images Qianlong set up with Rolpay Dorje's help in Tibetan-style temples scattered throughout the innermost part of the Forbidden City. No other lay practitioner was ever granted such special treatment, however, not even the religious kings of Tibet. Only Gelukpa pictures of their founder Tsongkhapa's refuge tree, also an innovation of the eighteenth century, match the fullness and clarity of detail of the emperor's. Of course, Qianlong, shown here in the guise of a monk, shared an important element of identity with both Tsongkhapa and Rolpay Dorje—all three were emanations of Mañjuśrī, though they acted out their role in very different spheres: Tsongkhapa in his visualization practice, Qianlong as ruler of the universalist Qing empire, and Rolpay Dorje as the emperor's guru. And so, part of a cosmic plan, the emperor floats against a backdrop of Wutaishan's five peaks, which appear magically through *ruyi* fungus-shaped clouds that part and reform themselves to articulate an auspicious rebus. Even more important, Qianlong is a *cakravartin*—a universal monarch who holds the wheel of the law in his left hand as he raises his right in argument in the *vitarka mudrā*. The inscription in gilt Tibetan script below his three-cushion throne reveals his multiple identity:

Mañjuśrī (Smooth Lord), sharp-witted sovereign of men.	'Jam dpal rnon po mi'i rje bor
Playful, unexcelled, great dharma king,	rol pa'i bdag chen chos kyi rgyal
On the diamond seat, feet firm.	rdo rje khri la zhabs brtan cing
May your wishes spontaneously meet good fortune!	bzed don lun grub skal pa bzang.[79]

As Robert Clark has noted, "there is a significant play on words here" and a covert message embedded acrostically in the brief text.[80] Consider the first two syllables of the first three phrases in sequence: 'Jam dpal (Jampel) or Mañjuśrī (whom Rolpay Dorje also embodies, even if not here, perhaps in deference to Qianlong's prior claim);[81] rol pa'i (Rolpay), meaning "playful"; and rdo rje (Dorje), "diamond" or "vajra." The inscription not only pays homage to Qianlong, the Mañjughoṣa emperor, but also acknowledges his debt to his guru, Mañjuśrī-as-Rolpay Dorje, who sits with his cakravartin emperor at the new center of the Tibetan Buddhist world, Mañjuśrī's Wutaishan. The appellation Mañjuśrī, literally translated into Tibetan as 'Jam dpal (Smooth Lord), specifically targets one of the marks of the Buddha this bodhisattva embodies in his role as exemplar of wisdom: the "smooth" (Sanskrit: mañju; Tibetan: jam) modulation of his voice, the enlightening sound that soothes and tames. Meanwhile Mañjuśrī himself, seated at the top of a wheel of male bodhisattvas and wildly dancing ḍākinī in the lower right, appears in his profoundest role as the mnemonic, alphabetic Arapacana ("ABCDE") embodying the very stuff of speech.[82]

Mañjuśrī is therefore everywhere in this series of paintings—the bodhisattva of wisdom who permeates the entire Qing realm due to the universal benevolence of the emperor-as-bodhisattva. He appears in his body of bliss and as Arapacana; he is Yamāntaka/Vajrabhairava, destroyer of death and patron deity of Beijing; he is Tsongkhapa, he is Rolpay Dorje, he is Qianlong; and last, though far from least, he evokes the new Eighth Dalai Lama, whose religious name, Jampel, was borrowed from the Smooth Lord himself (despite his identity as Avalokiteśvara). Qianlong's enclosure of a portrait of himself in the array of gifts he sent to Tibet to celebrate the boy Dalai Lama's selection in 1758, presumably the thankgka still in the Potala collection, therefore flatters absolutely everyone. No wonder it met with such an enthusiastic reception in Lhasa.

The short verse below the emperor-cakravartin's throne also embeds a number of other clues that clarify the meaning of the image as a whole, including an intriguing hint that helps establish when the earliest of the series of portraits may have been done. At the time of the Eighth Dalai Lama's selection the emperor was, by Chinese count, forty-eight years old—an appropriate moment for Rolpay Dorje to begin a series of zhabten (zhabs brtan, "feet firm") rites on his behalf to ensure the stability of his energy, longevity, and worldly status. So the third line, "On the diamond seat, feet firm," refers not just to the composition of the image before us, where Qianlong is indeed steadfastly planted on his cushioned throne, but to the wishful ritual itself, endlessly performed in pictorial space. And another phrase suggests that Qianlong need not worry, because the "good fortune" (skal pa bzang) all his wishes meet spontaneously in the fourth line is also a pun on "fortunate kalpa" (bskal pa bzang), the blessed era over which this cakravartin-emperor already presides.[83]

Image as Speech

Visually Qianlong's portraits as Mañjuśrī's emanation play specifically on the shock value of juxtaposing Castiglione's true-to-life modeling technique against the brilliantly captured phantasms of Tibetan and Mongolian painters—countering the apparent immediacy of the imperial face with a patterned, canonical pantheon of visions. He seems to be right before us, tempting us to take his image for the real thing, but ultimately forcing us to see it for what it is: daubs of color on a flat surface, depending equally on clever technique and encoded inscription to produce multiple and

sometimes contradictory readings. The striking characteristic of Buddhist painting at Qianlong's court, aside from its overblown busyness, is the degree to which it insists on this recognition of its own methods by means of what, at first, seems like unresolved pastiche. To put it less charitably, as many have, Qianlong's Buddhist productions often come across to modern eyes as "pure" kitsch, which iconologist W. J. T. Mitchell has said is characterized by its free (or perhaps conventionally inappropriate) mixture and adulteration of verbal and visual media. Of course, Mitchell's argument focuses on modern Western art, where, he argues, an elitist avant-garde has decried the contamination of mass culture, posing itself against it by tacitly assuming the superiority of words against images and then by insisting on images devoid of words or narrative line. But something akin to this attitude also prevailed in late imperial China, certainly well into the eighteenth century, when, however, many educated artists and writers in the southern Jiangnan region began to foray creatively into the popular world. For his part Qianlong, despite his manic daily participation in Chinese literati culture, was truly unleashed by his multilingualism and transcultural practices. Mitchell concludes: "When mute images begin to speak, when words seem to become visible, bodily presences, when media boundaries dissolve . . . the 'natural' semiotic and aesthetic order undergoes stress and fracture. The nature of the senses, the media, the forms of art [are] put into question: 'natural' for whom? since when? and why?"[84]

This mode of questioning seems particularly apt to Qianlong's productions because Manchu style was so patently constructed in ways often deliberately contrived to set what masquerades as the immediate (the shockingly present imperial face, the visionary experience of apparitions) against blatantly mediated, word-driven (even speech-driven) imagery. Qianlong's artists regularly produced works that juxtaposed dense, layered, multivalent images—such as the buddhas of the three ages or Ṣaḍakṣarī Lokeśvara—against articulate but discontinuous pictured "texts." These texts were often Chinese-language-based rebuses, the ever-present clichés of Qing visual culture, almost simple-minded in their readability and clarity, but actually requiring several levels of instantaneous translation on the very literate viewer's part—from picture to word, from name to homophone, from homophone to formless abstraction. In the way they abruptly interrupt otherwise continuous compositions to produce a sense of rupture in the pictorial fabric, these rebuses resemble the "quotes" from other visual systems of the empire that Qianlong's painters were so prone to use. Such quotes carry a message of ultimate intranslatability—here is something that cannot be said in any other language or in any other form, at least not yet. Inscriptions in Chinese and Tibetan (and the other languages of the empire) provide still other discontinuities between phonic and semantic registers, encoding messages acrostically, punning madly, creating symmetries of graphic form, sonic arc, and number, pointing indexically to the imperial hand, and even crossing time zones to create links with the historical past and project prophecies into the future. In this constellation, mantras and *dhāraṇī*, a source of recurring anxiety to Qianlong, represent the ultimate "foreign language" operating at the margins of everyday speech, inverting it, making it dense (like a picture or a thing), forgoing semantic precision to gain in immediacy. What all these disparate images share is a deceptive, intentionally superficial articulateness—they masquerade as a precisely stated language. They may seem transparently clear, but in the end what they reveal is still veiled—a disconcerting, impenetrable density. Enlightenment is ultimately compromised by mediation, they proclaim, and piling one mode of mediation on top of another, leaving no base untouched, does not provide immediate relief from this dilemma. As instruments of enlightenment, these pictures do not, however, recoil from admitting their own inadequacy. In not doing so, they point us in another direction: away from the platitudes of the received truths they portray so eloquently and toward actualized experience.

Artful Collecting

> The set of objects the Museum displays is sustained only by the fiction that they somehow constitute a coherent representational universe. The fiction is that a repeated metonymic displacement of fragment for totality, object to label, series of objects to series of labels, can still produce a representation which is somehow adequate to a nonlinguistic universe. Such a fiction is the result of an uncritical belief in the notion that ordering and classifying, that is to say, the spatial juxtaposition of fragments, can produce a representational understanding of the world.
>
> —Eugenio Donato, "The Museum's Furnace"

Sometime in the 1750s, if his still youthful face is reliable evidence, Qianlong had Giuseppe Castiglione and his associates paint him in the role of a connoisseur of the arts (Plate 9). The portrait was intended as a clever triple entendre that played on both language and images. The emperor appears seated in a garden, surrounded by objects from his many collections, as an attendant unfurls a hanging scroll before him for his appreciation. Castiglione's bland but pristine technique allows us to see that the scroll is none other than the Ming-dynasty master Ding Yunpeng's version of *Washing the Elephant (Xixiang tu),* a Buddhist theme that was already ancient by the time Ding became entranced with it. The original composition plays on the pun of "*xiang*" as meaning both "elephant" and "form." In Ding Yunpeng's version, we see the bodhisattva Mañjuśrī in his almost unornamented guise as meditation master (a role he takes in Chan monasteries where he serves as an exemplar to monks), observing a crew of workers and officials scrubbing down a white elephant. The first pun intended is linguistic: As the elephant is washed (or in some versions "swept"), so too is the notion of the permanence of form washed away. Even such a bulky creature as an elephant has no permanent existence; its form is still contingent upon conditions. But there is another intertextual reference here as well, this one visual. Probably around the same time Castiglione set to work on this portrait of the connoisseur-emperor, Qianlong had himself interpolated into the same scene of *Washing the Elephant* in a painting by another Ding, his favorite painter of the moment, Ding Guanpeng (Figure 17). In this second portrait, the emperor assumes the role of Mañjuśrī (a role he also played in different form around 1758 in his portrait as *cakravartin* and Mañjuśrī's worldly emanation). The implication of this pair of uninscribed portraits seems to be that the emperor is witness to the impermanence of the grandest and most exotic of forms, even as he uses the mechanism of form and the act of appreciative collecting and viewing as supports to make his point.

A Brilliant Scheme

The intersection of these self-representations with the reality of Qianlong's many collections of things alters our understanding of his collecting practice. Qianlong's two portraits are particularly relevant to the imperial collections of religious and secular painting, texts and textiles, which were collated and cataloged by his command between 1744 and 1745. The emperor laid out explicit instructions for the catalogs of both collections and went to great lengths to tie both projects to great imperial

Figure 17. Ding Guanpeng, *Washing the Elephant.* Hanging scroll, ink and colors on paper. 132.5 x 62.6 cm. (Palace Museum, Beijing.)

efforts of the past, especially in his choice of titles. For the collection of Buddhist and Daoist works he chose *Bidian zhulin,* "The Beaded Grove of the Secret Hall," a title that is layered with references—particularly when read against the title he chose the next year for his collection of secular calligraphy, painting, and textiles: *Shiqu baoji,* "Precious Book Box of the Stone Drain." For both collections Qianlong relied on ample precedent, deliberately playing with an arresting, historically resonant phrase. The Shiqu Ge—Stone Drain Pavilion—was the library of the Western Han emperors and the site of imperially sponsored scholarly debates on the classics, memorialized in poetry in the first century by Ban Gu (32–92) in his preface to the "Two Capitals Rhapsody,"[1] recorded in the same author's official history of the Western Han dynasty *(Hanshu),*[2] and mentioned in such standard classical references as the fifth-century *Shuijing zhu* (Commentary on the Water Classic).[3] Qianlong owned a renowned inkstone made of a fragment of this stone drain, which once belonged to the great Northern Song literatus Su Shi and, in the emperor's words, still "had the mustiness of Old Po's brush-hand."[4] In choosing a name with such austere, elegant connotations, Qianlong established the legitimacy of his own collection and simultaneously paid homage to China's long history of imperial collecting—of calligraphy, books, and painting—as a cultivated, scholarly, and classically sanctioned pursuit.[5] The name *Shiqu baoji* also acknowledged the meaning of collecting in a subtler sense—that its primary role was not simply to accumulate material goods but to forge links between present and past and, by extension, between present and future, through precisely the sort of exacting, imperially endorsed argument that went on in the Stone Drain Pavilion.

If the name *Shiqu baoji* immediately conjures images of a glorious past, even as it embodies in translated form what Qianlong believed was the finest calligraphy and painting in the empire, *Bidian zhulin,* at least on the surface, seems to play to other sensibilities. The *Bidian* (Secret Hall) of the title suggests that the catalog is a different kind of site, this time of esoteric revelations, though

few of the works contained in the collection at the time of its first collation were esoteric in a technical Buddhist or Daoist sense. In fact, Qianlong's inspiration was not Buddhist or Daoist at all but relates more directly to Confucian statecraft and empire building. The term "*bi*" (mysterious, obscure, secret) was used in the context of cataloging and archiving as early as 159, when the Eastern Han emperor Huandi (r. 147–168) created a special government office, the Bishujian, to collect and collate scrolls of all sorts—texts, charts, and pictures.[6] Qianlong's choice of title, therefore, carries the implication that this new collection of Buddhist and Daoist material (both written and pictorial) was something like a library where recondite information of all kinds was gathered together under a single, secret rubric.

Zhulin—the Beaded or Pearled Grove that forms the second half of the title—is another intriguing choice bringing to mind, among other things, one of the fundamental compendiums of Chinese Buddhism: the monk Daoshi's seventh-century *Fayuan zhulin* (Beaded Grove of the Dharma Garden). The word *"lin"* (grove) carries the scent of scholarly cultivation—as in the *Shuolin* section of the third-century-B.C.E. *Huainanzi* or the Qing novel *Rulin waishi* (Informal history of the Confucian Grove)—or of Daoist eremetism, as in the name of the most famous collection of recluses, the third-century *Zhulin qixian* (Seven sages of the Bamboo Grove). *"Lin"* can also mean "collection," something like an English "garden of verse." Thus *"zhulin"* can signify a collection of like-minded people—in other words, a monastery—or, if beaded or pearl-covered, a Jetavana Garden, the bejeweled grove within which the Buddha Śākyamuni preached to his disciples.

Qianlong's "grove of beads" conjures up other shades of meaning as well, suggesting that the paintings and calligraphies in his possession are like beads which can be counted and ordered in series like a rosary. Such strings of beads are used in Buddhism to tally the times the Buddha is called and recalled, a type of meditative practice *(nian fo)* that is an act of constantly reasserted "memory," of holding fast through endless repetition, ultimately producing the enlightenment mind. Taken in this sense, the term has the same resonance as the Tibetan *'phreng ba*, meaning "garland," which often appears in titles of works that are collections of *jataka* tales, of saints' biographies, or histories. In these collections each astounding tale is rounded and perfected through countless tellings and retellings, matched in contour and trajectory by the tales that precede and follow it, and enhanced by repetition and similarity. And this is what Qianlong seems to suggest is part of his intent as he negotiates a position for his religious art collection somewhere between a cultivated "garden of verse," a more evocative "forest of symbols," and a descriptive but cut-and-dried temple inventory—to establish a sense of the consistency, commonality, and potency of the objects in his possession.

In his edict of January 1744, which called for the collation of the dynasty's Buddhist and Daoist art, Qianlong approved a politically sensitive document with broad implications:

> On the sixteenth day of the twelfth month, Qianlong eight [1744], we have respectfully received his majesty's superior command:
>
> The state has been at peace for one hundred years and the kinds and categories of things have multiplied and become entangled. Although our imperial ancestors never taught that we should regard precious curios as the highest quest, they did occasionally take pleasure in ink and in the company of antiquities. Consequently, there is an abundance of works on silk that are mounted in imperial yellow in the Palace Treasury [Neifu]. From among these, select out the Buddhist and Daoist materials and combine them with the Chinese and western materials contained in jeweled boxes and beaded cases. The traces of eminent personages, those of great virtue and true spirit, are reckoned to number 1,235. Moreover, there are a great many examples of the work of our ancestors Emperor Shizu Zhang [Shunzhi], Emperor Shengzu Ren [Kangxi], and Emperor Shizong Xian [Yongzheng].

Thus we must respect them and carefully wrap them to show our sons and grandsons. Editors Zhang Zhao, Liang Shizheng, Li Zongwan, and Zhang Ruo'ai will arrange and collate valuables from the central region; the Zhangjia Khutukhtu will examine and identify Buddhist texts from India and the western regions. Whatever is stored in the Qianqing Palace [Qianqing Gong], whatever is stored in the Wanshan Hall [Wanshan Dian] and other great halls, will be categorized and divided into groups according to location so that nothing is out of place with respect to anything else. Following the precedent of the [*Peiwenzhai*] *shuhua pu*, the whole will be edited into a book so that those who come after may open the register and know where everything is. From now on, whenever anything is returned to the Imperial Household it will be numbered and added to the register. This is an undertaking worthy of a time of peace. Respect this.[7]

In stately, formal, and only moderately embellished language the text of the edict reveals complex motives for the special compilation of the collection of Buddhist and Daoist objects. First it immediately asserts that the rapid growth of the collection is not a sign of chaos or greedy expropriation by the Qing emperors but rather the opposite: the result of exactly one hundred years of uninterrupted peace under Manchu rule. This massing of objects represents the serious-mindedness of Qianlong's predecessors, who have, nonetheless, occasionally found time to take pleasure in art. Qianlong envisions the collection as a site of mediation where Buddhist and Daoist materials, Chinese and foreign ideas, are gathered together harmoniously, but he nonetheless believes that religious art, from whatever source, should be separated out and grouped together in a special section of a larger collection. We see this careful balancing of categories and factions throughout the edict: The traces of great masters and lofty scholars are posed against the devout productions of past emperors; the actual work of compilation is divided between a corps of Chinese scholars (several of them from the southern Jiangnan region) and the Tibetanized Mongol and polyglot Zhangjia Khutukhtu, Rolpay Dorje; and the collection is defined to include Chinese and non-Chinese objects, as well as sacred texts in languages other than Chinese. Finally, the edict constructs an open-ended system of ordering based first and foremost on *where* things are and only secondarily on *what* they are. Cataloging the collection is a way of formalizing memory so that the 1,235 treasures it contains can be easily counted, retrieved, and recalled—each one in proper, balanced relation to every other one.[8] The introduction to the catalog that follows the imperial edict explicitly outlines a set of criteria that likewise respects the mnemonic, ideological, and material needs of such a large, diverse collection.

From the modern perspective the decision to catalog objects primarily according to where they are stored, though it has ideological advantages, has serious practical flaws. These flaws and advantages are not so pronounced in the *Bidian zhulin* (a collection narrowly confined to a few halls of the palace) as they are in its companion catalog, *Shiqu baoji*, the contents of which were more widely distributed over the whole Forbidden City. Qianlong's grand scheme is markedly original. It departs from the organizational schemes of earlier catalogs, imperial or otherwise, which most often take a biographical approach, organizing calligraphy and painting by artist and beginning each section with a sketchy life history, in a system that consciously privileges the artist over the work of art. Qianlong's decision may have been influenced by the need to account for the large numbers of works in the imperial collection that could not be handled biographically simply because they were anonymous or indeed were just the opposite of anonymous—the products of emperors who required a different kind of biographical setting. But beyond taking location as a primary organizing principle, the catalog also displays more common biases: Calligraphy is superior to painting; works by emperors are superior to works by historical artists, which in turn are superior to anonymous works and textiles;

early works are superior to later works. Media are likewise ranked: Original calligraphy and painting come first, followed by imperially written texts that have been engraved into stone or wood and works in other two-dimensional media, such as textiles.

However original this new architectonic system was, the decision to catalog Buddhist and Daoist pieces in *Bidian zhulin* before undertaking the secular catalog, while presented in the edict as imperial evenhandedness toward China and the outer regions (some of them already under Manchu control), actually reflected a system of ranking that had significant historical weight. An imperial comment added to the instructions to the catalog in 1786 enumerates famous precedents for this scheme, including the Northern Song catalog of Emperor Huizong's collection, *Xuanhe huapu*, where Buddhist and Daoist paintings make up the first of ten categories, or the *Dengchun huaji*, whose first category is "Immortals, Buddhas, Ghosts, and Spirits." This same addendum also defends the notion of further dividing the collection into distinct subcategories. After all, it argues, the Buddhist Tripitaka and the Daoist canon, though unified in intent, were both broken into several smaller and more manageable sections, the first into three baskets and the second into seven parts.

The preparation of the *Shiqu baoji*, the second imperial catalog, covering secular painting and calligraphy, was undertaken in 1744, as soon as *Bidian zhulin* was completed. This project involved the same group of scholars, Zhang Zhao, Liang Shicheng, Li Zongwan, and Zhang Ruo'ai, as well as others, but by its very nature it did not require the assistance of specialists like the Zhangjia Khutukhtu, Rolpay Dorje, because all the works it contained were products of Han Chinese culture (including Qing imperial works done by the emperors in their Han guise). Still the imperial edict that introduces this second catalog is instructive for the very reason its tone is so noticeably different from that of the *Bidian zhulin* edict:

> On the tenth day of the second month, Qianlong nine [March 1744], we have respectfully received his majesty's superior command:
>
> The objects stored in imperial collections of the past three reigns are a resplendent canon of great weight, indeed surpassing those of the past. Every time I pick them up to examine them I increasingly feel that they ought to be wrapped up respectfully to be handed down to our successors. Now the historical calligraphies and paintings accumulated in the Palace Treasury number more than ten thousand scrolls. Since there are so many, some [no doubt] are authentic and some must [obviously] be forgeries. Both the Buddhist and Daoist collections have just been compiled as the first edition of *Bidian zhulin*. Aside from this, it is fitting that we carefully examine and add others, selecting the best and gathering them together to produce [another] compilation. When I was young I "waded and hunted" through calligraphy and painting and, since I ascended the throne, whenever I have had an opportunity during vacations or holidays I have not forgotten this practice. Playing with the brush and expressing myself with bristles has resulted in piles of scrolls. There should be an overall classification scheme to keep track of when they were done. Moreover, the calligraphies and paintings of my officials and artists that have entered the Imperial Household in the past are also often worth viewing. We should compare them, make selections, and assign them to categories so as to represent the refinement of the collection. Furthermore, the ink treasures bequeathed by our ancestors remain forever fresh. Even the fragments of paper or the odd-sized light-yellow-colored silk of former masters are worth examining. After a light meal, when I occasionally unroll and view them, my heart is happy and my worries are ground to dust. With paintings on my left and histories on my right, how can the ancients seem distant? Respect this.[9]

Here the emperor needs no excuse to produce a catalog of "precious curios," nor does he even insist upon the absolute authenticity of each and every piece recorded in it. His language is made even more immediate by the personal, imperial pronouns strewn throughout the text and hints at a longing for the easy elegance of the scholar at leisure, a habit of mind, he assures us, he has practiced since his youth when he first "waded and hunted" through calligraphy and painting. Moreover, the success of the organizational scheme used in *Bidian zhulin* clearly pleases him—so much so that he mandates its use again here. He must have been aware of the originality of this approach, indebted to the methodology of evidential research, which gives precedence to the physical nature of each entry and only then amplifies on its unique history by recording colophons and seals. And the scheme is, in fact, a brilliant one, even if in its original form, lacking an index, the catalog is cumbersome and difficult to use. What both *Bidian zhulin* and *Shiqu baoji* accomplish is to foreground the complex nature of calligraphy and painting—indeed, of objects in general. On the one hand, works of art may seem like static, definable material entities that should be judged, first and foremost, on the basis of their physical qualities. But, on the other, paintings and calligraphies also move their viewers and, in turn, have been moved by the weight of their viewers' opinions and reactions (particularly the emperor's), manipulated both physically and ideologically, and constantly reinvented. Works of art also have the power to transform the spaces they occupy. Hence both edicts portray the "return" or "transfer" of such an immense number of masterworks to the imperial palace, not as a series of heavy-handed expropriations, but as a well-regulated process of tribute and gift giving—a rush to the center that is part of a much vaster scheme of rational state building during a time of peace.

Though Qianlong's edict of 1744 commands that works of art be registered in the *Bidian zhulin* as soon as they are transferred to the palace, casting the catalog as a constantly updatable inventory, in practice this order was not carried out past 1748.[10] And so, more than forty years later in 1793, Qianlong once again felt the weight of his uncataloged acquisitions pressing on him (it was time to sweep the elephant again) and he ordered that a joint supplement be prepared for both catalogs. Now eighty-three years old and full of confidence in his own judgment, he produced a handwritten preface for the supplement that reiterated his earlier concerns and added some new insights:

> Preface to the supplementary collections of *Bidian zhulin* and *Shiqu baoji*:
>
> *Bidian zhulin* was compiled beginning in the *guihai* year [early 1744] and completed in the *jiazi* year [late 1744], *Shiqu baoji* from *jiazi* [1744] to *yichou* [1745], both over forty years ago. This second compilation takes the brushwork of the three previous emperors as a lineage and divides the calligraphy and painting of historical figures and subjects of our own reign into schools and types, examining them all thoroughly. Now, as I look on the colophons of my close subjects Zhang Zhao, Liang Shizheng, and others, which are all that survive of them, I am full of regret. During the forty-eight years from 1745 to today, whenever there have been birthday audiences, my subjects have sought favor by presenting ancient and contemporary calligraphies and paintings of all types. There are also many other works [I have] done at leisure. We do not know how many there are altogether. In the process of time, errors and spurious information will creep in. Now the system of this second compilation is all laid out in the supplement and is not very difficult. I have ordered [Grand Secretary] Wang Jie and others to rely on the first compilation as a precedent and so if works by the previous three emperors have already been cataloged in the earlier compilation, they are not recorded again here. If there are stone engravings that were not entered, then they are recorded at the beginning of each chapter. However, the reason why I have elevated them to

the status of treasures is to recall what has fallen into ruin and not at all simply to flaunt them as antiquities.

Now, a person must be careful in his likes and dislikes. The investigation of ancient calligraphy and painting involves lodging the emotions; it is achieved through refinement and is superior to drowning in music, sensual pleasure, and material profit. But suppose one applied the same determination needed to grasp at these things to the task of governing with diligence and loving the people instead? The more than forty years' worth of objects that need to be compiled as a supplement should once again be strung together [like beads]. In putting it this way, I recall that I should do no damage but should diligently govern and love the people. For me to say so is humbling—and much more humbling [to say so] publicly! This is written as a cautionary record for my sons and grandsons so that they will know the correct way to scrutinize things and will make selections according to principle. Whatever can be put in the same categories as in *Xiqing gujian* [Ancient mirror of the Xiqing Hall] need not be discussed again here.

Qianlong *guichou* [1793], spring, imperial brush.[11]

Central to this new message is Qianlong's command that many different kinds of artistic products be "strung together" to form a cohesive whole—religious and secular works, even the stone engravings of ancient texts, whose primary role is not to show off Qianlong's connoisseurship but to memorialize what has fallen into ruin. Though the preface makes no distinction between all these different categories, the supplement maintains *Bidian zhulin* and *Shiqu baoji* as discrete units within the set, with the Buddhist and Daoist collection coming first as precedent suggested. Yet the grouping of the two together underscores a significant shift in attitude between the supplement and the original catalog, one that blurs any differences between art made for religious purposes and art made for purposes of personal cultivation. Qianlong's first edict of 1744 clearly marked this difference, hinting that the objects in the *Bidian zhulin*, both images and printed texts, had a purpose beyond mere appreciation; they were, he argued, powerful tools for mediating between contending schools of thought and even between different regions of the empire and beyond. Now the emperor urges the same caution for collectors in all categories, imperial or otherwise. Art can be as dangerous as music, sensual pleasure, and material profit, he suggests, because it engages the emotions. But works of art are not only sites where emotions can be safely lodged but tools with which the connoisseur refines himself. In a masterful twist, the emperor turns the interior uses of art to the purposes of government, claiming that the same energy we apply to our addictions would be better used to administer and love the people. And his desire to catalog his huge collection, to bring order to his own obsession, he insists, is precisely this: another way for him to govern and demonstrate his universal love.

The Compilers and Their Method

At eighty-three, Qianlong had long outlived most of his earlier associates and in his preface to the catalog supplement he mourns the loss of Zhang Zhao, Liang Shizheng, and the entire coterie of scholar-connoisseurs who compiled both *Bidian zhulin* and *Shiqu baoji*. Other sources tell us that he also sorely missed his much-beloved Zhangjia Khutukhtu, Rolpay Dorje, who died in 1786, but Qianlong, significantly, does not mention his name here because the supplement would not include any Tibetan, Mongolian, or Manchu materials. The emperor's choices for the first group of nine or ten catalogers were an otherwise tight-knit group in education and background; a few of them came from the southern Chinese heartland, the Jiangnan region; all of them were highly educated *jinshi*

degree holders who held entry-level positions as compilers in the Hanlin Academy and eventually went on to work in the Imperial Study and serve as presidents of various boards and as sub-chancellors in the Grand Council. But as Kohara Hironobu has noted in his study of Qianlong's connoisseurship, the group was also remarkably diverse in terms of age and experience, particularly in art historical matters.

Other talents recommended them—chiefly their proven ability to read and analyze difficult texts. A hallmark of the connoisseurship of this group was what Kohara has characterized as their reliance "upon the written word as a carrier of truth," though not to the exclusion of other types of hard, physical evidence.[12] This is not surprising, given the intellectual affinity of all the compilers to the influential methods of evidential research. The editor-in-chief for the first project was Zhang Zhao (1691–1745), whose scholarly and artistic abilities set the rationalist, exegetical tone for the project. Born in Jiangsu, he was a talented scholar, diarist, musician, calligrapher, painter, poet, and drama-tist, as well as a devout Buddhist. Prior to undertaking the *Bidian zhulin*, however, Zhang's public career was uneven. He was sentenced to death for his alleged misdoings during the Yunnan campaign in 1736 (we will meet him again in this capacity in Chapter 4) but was apparently pardoned because of his talent as a calligrapher. In fact, he served as the emperor's amanuensis and presented Qian-long with a significant number of his own copies of the Buddhist *Śuraṃgama Sutra* and *Heart Sutra,* which are listed only posthumously in the supplement to the catalog. Like the other members of the cataloging team, Zhang was called on to assemble other catalogs, including *Lülü zhengyi houbian,* a revised compendium of ceremonial music he compiled with Qianlong's uncle, the Manchu Prince Zhuang, named Yinlu (1695–1767), not printed until 1746. Cataloging was not his only respon-sibility however. While laboring over *Bidian zhulin* and *Shiqu baoji,* Zhang simultaneously served as president of the Board of Punishments. He died in Jiangsu in 1745, immediately after completing *Shiqu baoji.*[13]

The second member of the team was Liang Shizheng (1697–1763), another Jiangnan man, origi-nally from Qiantang, Hangzhou. He also had a brilliant political career as Hanlin compiler and vice-president and president of the Board of Revenue and was equally active in the arts. He contributed to a number of other imperial catalogs, including a compilation of rhymes commissioned in 1750. He was, in fact, a noted poet, much admired by Qianlong, and he was called upon to produce a set of poems to match the emperor's in the collection *Shiyin ji.* He also served as editor-in-chief for the catalog of imperial bronzes, *Xiqing gujian,* and for its appended catalog of ancient coins, *Qian lu,* which was completed in 1751. Liang provided other special cultural insights for Qianlong; among other things, he wrote a topography of West Lake, the consummate Jiangnan tourist destination, which he expanded after the emperor's third southern tour in 1762.[14]

Two other compilers the emperor cites directly, Li Zongwan (1705–1759) and Zhang Ruo'ai (1713–1746), were quite a bit younger than Zhang and Liang. Both got their start in the Hanlin Academy but went on to hold an array of high positions in the imperial government: Li as vice-president of the Censorate and Board of Punishments,[15] Zhang as subchancellor in the Grand Council. Zhang Ruo'ai, who was quite young at the time and barely survived his service as cataloger, was the son of the distinguished statesman and diplomat Zhang Tingyu (1672–1755), one of Qianlong's closest advisers in the early years of his reign.[16] These men, in other words, were all insiders, part of a pool of educated scholars, most of them Han Chinese, who moved through the many branches of the Qing bureaucracy with ease.

For the supplement to both catalogs, Qianlong appointed another multifaceted scholar-bureaucrat as editor-in-chief, Wang Jie (1725–1805). Wang and his associates Dong Gao (1740–1818), Shen Chu, Peng Yuanrui (1731–1803),[17] and Jin Shisong, unlike their predecessors, were approxi-mate age-mates and had all entered government service in the Nanshufang (Southern Library) in

1767. In 1770 they were transferred to the Mouqin Hall (Mouqindian), part of the Qianqing Palace, a major repository for both the religious and secular collections, where they copied sutras for the empress dowager's eightieth birthday.[18] When Qianlong mandated the supplement to the collection catalog, a number of other scholars joined the group in the Mouqin Hall, including the Manchu official Nayancheng (1764–1833) and Ruan Yuan (1764–1849).[19] In his preface to his colleague Shen Chu's informal reminiscence *Xiqing biji* (Brush record of the Xiqing Hall), Ruan Yuan described the work of the catalogers (who were required to keep their day jobs while going through the collection) as an informal and very pleasant gathering of like-minded scholars in a graciously attended hall:

> On days when the weather was fine, right after the morning session at court ended, we
> would open the windows and, with thousands of pieces scattered about on desks and
> benches, we were able to see more than our share of famous works from the Tang and Song,
> not to mention from the Yuan and Ming. Eunuchs hung the paintings and laid papers out
> in front of us. We all sipped tea and savored the dishes granted by imperial grace. We were
> determined to separate the genuine works from the spurious and to study the colophons and
> inscriptions, the silk, the paper, and the blackness of the ink. When we could not make out
> seals or inscriptions, we began by classifying them. During that first year we strained our eyes
> to become acquainted with ancient seal script and finally completed the compilation. Toward
> the end of the workday, more or less around the hour of *wei* [1–3 P.M.], we listened for the
> great bell in the Qianqing Palace to ring once or twice and then departed.[20]

This idyllic description belies some of the more grueling facts. Each scholar was required to investigate, judge, and write up complete entries on two hundred or more paintings in the space of about a year, depending for the most part on colophons, titles, and seals, always subject to the emperor's inevitable intervention and final approval. Ruan Yuan mentions that he and his colleagues also examined the quality of silk, paper, and ink, which they duly recorded at the beginning of each catalog entry. Though Kohara goes so far as to say that "if the painting in question was without identifying signatures, seals, colophons, or labels, the emperor and his staff were at a loss" and that, in the end, Qianlong "desisted from approaching the painting visually," in fact all of them put great stock in the physical, if not the stylistic, qualities of an object.[21] Their evidential research approach, combining epigraphy, philology, and close physical examination, informs these catalogs as much as it does the rest of Qianlong's catalogs and collation projects—most notably the huge imperial library, *Siku quanshu*, but also including, for example, *Xiqing gujian* (the imperial bronze catalog) and *Xiqing yanpu* (the catalog of inkstones). Unlike these two catalogs of three-dimensional objects, which were illustrated with drawings done in Western perspective, *Bidian zhulin* and *Shiqu baoji* contained no illustrations, probably for reasons of technical difficulty. But Qianlong's insistence on balancing the physical evidence of the object against its history, laid out in his edict for the first edition of *Bidian zhulin*, was answered in terse, precise descriptions of each composition along with detailed records of materials and measurements.

Naturally this method of close physical description and careful recording of readable marks resulted in different kinds of entries for religious versus secular works, since a far greater percentage of the contents of *Bidian zhulin* than of *Shiqu baoji* was anonymous and uninscribed. And though the emperor more and more skewed his inscriptions on religious works in the supplement to *Bidian zhulin* toward the protocols of gentlemanly artistic interchange—when he often discussed brushwork, mood, and the occasion of viewing in poetic terms—his other interest was in iconography and in the historical significance of famous, charismatic objects. His emphasis on the work of art

as evidence of something other than itself, specifically its historical context and claim to factual accuracy, is made more apparent in the fact that the two-tier ranking system of authentic and inauthentic works (or fine and not-so-fine) employed in the first editions of *Bidian zhulin* and *Shiqu baoji* was dropped in the supplement. Now every painting and calligraphy chosen for the catalog—good, bad, or indifferent—received the same careful attention appropriate to a significant historical source.[22] When Qianlong's son and successor, the Jiaqing emperor, ordered a third compilation of the collection *(Bidian zhulin, sanbian)*, completed in 1816, his catalogers, headed by Hu Jing, also followed this much less judgmental but more detailed scheme.

Evidence of Imperial Piety

Qianlong's compilers operated under the assumption that the truth about the past (and, by extension, the veracity of the classics) was preserved in and corroborated by the hard evidence of things—a primary tenet of evidential research. But they also used their seemingly scientific, quantitative method to smooth over the facts that the nature of the things in the imperial collection was far from consistent and that the emperor's attitude toward them was not exactly as evenhanded as he claimed. In the first *Bidian zhulin* catalog this evidence embodied in things is brought together, by the emperor's own reasoning, to bridge the gap between different schools of thought. In fact, however, in terms of sheer numbers, Buddhist (Chinese and non-Chinese) works far outweigh Daoist (Chinese) works, and imperial calligraphy in Chinese, predominantly Buddhist but also Daoist, represents one of the largest categories of all and appears first in all three editions of the catalog.

In addition to recording the collection as a group of objects, complete with format, materials, dimensions, and marks of ownership and appreciation, all three editions of the catalog also serve as a concise and indisputable accounting of imperial piety—if only Chinese-style piety—spanning four reigns from Shunzhi (the author of only a handful of Chan-style pieces) through Qianlong, the devoted practice of a lineage of Buddhist (and also intermittently Daoist) emperors inscribed, duly listed, and carefully filed away.[23] Some of the evidence for imperial belief presented here is startling. The Kangxi emperor, whose Buddhism by all other reports did not reach the devotional pitch of his father's or his son's or grandson's and who early in his life roundly and specifically criticized the practice of copying the *Heart Sutra,* between 1702 and 1723 produced a series of 420 copies of this same text (193 in gold and 227 in black ink)—about one every two or three weeks for more than twenty years—every one precisely described and dated.[24] These are not the only signs of Kangxi's Buddhist practice recorded in the catalog. He also did numbers of copies of the *Diamond Sutra, Medicine Sutra,* and unspecified *dhāraṇī* sutras, the "Pumenpin" (Universal gate) chapter of the *Lotus Sutra,* as well as many more single versions of the *Heart Sutra* and a small handful of Daoist works. In contrast to this heroic output, Kangxi's successor and son, the Yongzheng emperor, who famously and simultaneously practiced Chan meditation and Daoism,[25] produced only four recorded copies of Buddhist sutras, all of them listed in the first edition of the catalog. His three listed Daoist works are all exact copies of famous historical calligraphies by the renowned artists Zhao Mengfu and Dong Qichang. These efforts all speak of his ardent interest in Daoism, which, along with Buddhism and Confucianism, he believed was a manifestation of a "single path." Yongzheng was, in fact, passionately devoted to Daoist promises of immortality; he apparently succumbed to a life-enhancing elixir composed of black lead.[26] But his emulation of the calligraphic style of Daoist texts written by famous early artists also shows that he saw these works as proper material for the aestheticized interests of a serious connoisseur who could, like a true immortal, happily consort with antiquity and simultaneously extend his reach back into history and forward into immortality.

Qianlong's productions in the first catalog, relatively early in his career, were already volumi-

Figure 18.
Qianlong,
transcription of
the *Heart Sutra,*
with appended
paintings.
Accordion-
folded book,
ink on paper.
(Palace Museum,
Beijing.)

nous—thirty-two are listed in the first chapter alone and quite a few more ambitious public printing projects appear in later chapters. There are many *Heart Sutras,* of course, and the third edition of the catalog, recording three large albums of *Heart Sutra* copies Qianlong made (Figure 18), presents evidence that the emperor, like his grandfather, saw copying this scripture as an indispensable part of his personal practice. Two of the albums brought together copies he produced between 1736 and 1774; each held 309 examples. The third, done between 1775 and 1798, held an additional 618 copies, all carefully dated, showing that he consistently wrote out the sutra once every two weeks over a period of twenty-three years. These three groups of copies may not have been listed in the 1793 edition because they were an ongoing work in progress and hence difficult to count. Or, more likely, they may have been withheld out of modesty, feigned or real. By 1793, three years short of retirement, Qianlong had long surpassed his grandfather's already amazing production and was still going strong.

Though writing out the *Heart Sutra* was a constant in Qianlong's life, the list of texts he copied, Buddhist and Daoist, is much richer than those of his predecessors, on the whole, and it includes some historically significant pieces: the very lengthy *Lotus Sutra,* of immense importance to Chinese Buddhism, and a copy of an important calligraphy already in the imperial collection: Zhao Mengfu's version of the *Sutra in Forty-Two Chapters (Sishier jiang jing),* one of the earliest Buddhist texts translated into Chinese. Qianlong's recorded works number quite a few other copies of calligraphy by his favorite masters (Zhao Mengfu, Huang Tingjian, Su Shi, and others). These are a fascinating group because they combine two very different motivations, the one based on the pious practice of copying the Buddha's own words, the other not particularly Buddhist at all, to commune in spirit with a great artist by mimicking his hand and body. Qianlong made other works that push his Buddhist practice closer to refined aestheticism, such as illustrated sutras, especially the *Heart,* which he introduced with quick ink sketches of the bodhisattva Guanyin and finished with the young guardian Weituo (Sanskrit: Skandha),[27] paintings of Guanyin as Great Being (Dashi; Sanskrit: Mahāsattva), and copies of the late-Tang painter Guanxiu's famous lohans, several of which he owned. Many of these pieces, like Kangxi's productions, were done for special occasions such as birthdays of the empress

or empress dowager or the birthday of the Buddha. The majority, however, fall into a pattern of constant, regular Buddhist practice, which, in the emperor's mind, more and more collapsed into the refined and scholarly habit of self-cultivation through the mental, physical, and spiritualized practice of art.

The *Bidian zhulin* supplement gives us a somewhat different picture, one that similarly underscores the evolving nature of Qianlong's interest in Buddhist art. The number of examples of imperial copying of sutras and other texts, all by Qianlong, that are registered upfront in this second edition is much reduced (out of a total of 493 works there are only 23 examples listed for the more than forty years since the first edition) or, at least, so it seems on the surface. What the updating of the catalog does not immediately reveal, however, is how present Qianlong's hand is in each and every work listed, historical or otherwise. He has seen, touched, and added to everything, recorded his viewings and reviewings with seals, and even encapsulated his reactions in poetic or art historical inscriptions. His relationship to the collection—from his orderly vision of it to the traces of his hand and the marks of his special appreciation—have, in a certain sense, become the real subjects of the catalog.

How exactly was the emperor's presence brought forward in the 1793 supplement to his catalog? Primarily by the new and meticulous recording of his interactions with his collection. Unlike the first edition of *Bidian zhulin*, which simply remarks on the presence of imperial inscriptions on first-class (*shangdeng*) works, occasionally summarizing their contents laconically, the supplement records literally every word of commentary and poetic embellishment Qianlong wrote and also details the seals he used to impress each piece. Imperial commentary (*yuti*) or short titles written by the emperor immediately follow the catalogers' physical description, where they are typographically enhanced in typical court fashion by bumping the word "imperial" up to the top margin of the page. Any other written commentary by earlier viewers, regardless of its placement on the original work, follows in a smaller typeface. This makes it easy to scan the catalog's top margin for signs of special imperial interest. Even a quick count shows that Qianlong titled, discussed, or praised about 80 of the paintings and textile images recorded in the supplement, or about 30 percent of the 288 pictorial pieces.

The different ways in which Qianlong recorded his attention to certain paintings (and, surprisingly, almost never to calligraphies, which he seems to have flattered by imitation) all try to reconcile Buddhist practice with critical viewing in one way or another. He seems to have been keenly aware of the dual status of the works in his religious collection. They were, as he pointed out as early as 1744 in his edict ordering the first edition of *Bidian zhulin*, simultaneously admirable (and costly) works of art, attracting a purely sensual appreciation, and also evidence of pious practice (and thus ammunition in his campaign to mediate between different schools of thought). In his preface to the supplement he faced a slightly different problem: the need to provide a mandate that would cover both religious icons and secular works of art. And so he juxtaposed his worries about (his own) addiction to art against the assertion that stringing things together in a coherent series—the goal of his catalog—was akin to benevolent governance, exhibiting a praiseworthy disinterestedness.

In fact, however, Qianlong's inscriptions focus on issues that seem at first to have little to do with either benevolence or governance. Instead he comments (often at length) on the historical evidence surrounding certain especially charismatic works of art: the material signs of their authentic or inauthentic claims to antiquity, the historical circumstances surrounding their creation, their states of preservation, the credibility of their inscribers. He behaves like a responsible connoisseur, always intent on establishing whether or not the work is what it claims to be, searching scrupulously and often astutely for contradictions between reputation or attribution and material evidence. Often his evidence-based research produces troubling concerns about ancient images, especially from the per-

spective of orthodox religious practice: They are "out of order" or "fragmentary," improperly transmitted, badly remounted; or the passage of time has somehow compromised their validity. His concerns swirl around the issue of authentic visionary experience—is this, he asks, what the artist's original insight was really like or has some error crept in? These same concerns appear again in his comments on secular paintings. Are they, he wonders, the "true traces" of the artist's hand or something more thoroughly mediated, blurred by a restorer's intervention, and riddled with error? And if this is the case, can they be made whole again by corrective description or reproduction? The point of serious art, he suggests, is to provide an unobstructed view into the subjective truth—the mind or heart—of the past. The way to secure this view and assure its correctness, as his method sets out to reveal, is through objective analysis of the evidence.

Qianlong's more lyrical interventions into his collection take on a slightly different set of problems, however. Objects, he stresses, may be repositories of past experience, but they are unstable because of the inherent impermanence and contingency of things and the fleeting nature of the events that generate them and mold their meaning. The numerous poetic eulogies he wrote, the majority on the many images of the sixteen and eighteen lohans in the collection, dwell on certain core Buddhist principles that reflect this concern—primarily the unity and identity of the Buddhist pantheon, nonduality or dependent coarising, and the shifting, uncertain nature of the relationship between an object and its representation, where both are equally implicated in the continued existence of the other. Because of this never slackening focus, his poetic inscriptions, however badly or repetitively phrased, really should be understood as collaborative efforts intended to bridge the gap between himself in the present and the visionary artists of the past (such as Guanxiu, Zhao Mengfu, and Dong Qichang) or between himself and the prosthetic hands of his court painters (especially Ding Guanpeng). The catalog as a compilation of all these interactions may be only a limited representation of the collection as a whole, able only to suggest its most striking qualities, which were primarily visual, and not the whole "nonlinguistic universe" Eugenio Donato refers to in the passage with which I began this chapter. But it is far more stable in the way it recalls the collector's response to his collection because of its "boxed" compactness and diagrammatic efficiency. Even if the collection loses its coherence the catalog will still stand, Qianlong fervently hopes, as a warning to his sons and grandsons.

Filling in the Gaps

Aside from its increased attention to the actions of the emperor-as-collector, the 1793 supplement to *Bidian zhulin* also contains many more works by famous painters of past dynasties than the first edition—and, conspicuously, a certain number of elaborately staged copies of famous Buddhist and Daoist works by court painters under Qianlong's command to the extent that duplication in all its varieties emerges as a powerful motivating force behind the collection as a whole. If copying sutras and Daoist scripture enables the writer to internalize the words of the Buddha or of proven immortals, literally to make them so present that they become part of muscle memory, then copying famous *copies* of sutras allowed practitioners such as Qianlong himself and his scribes Zhang Zhao and later Dong Gao to gain confidence in their own experiences—to obliterate, that is, the distance between themselves and their historical models. Thus to copy Dong Qichang's version of the *Heart Sutra* is to live imaginatively in his body and mind for that moment and to experience firsthand his reactions to the message and material expression of the text.[28] The physical presence of the model and the awareness of its historical source thoroughly mediate this type of experience, however, even if the goal of such practice is to break down distinctions of self and other, of present and past, just as the repetition of a mantra does. Whenever Qianlong ordered copies of charismatic icons of the past, such as Guanxiu's *Lohans* or Zhang Shengwen's *Long Roll of Buddhist Images*, both of which I will

Figure 19.
Zhang Sengyou
(sixth century),
*The Five Emperors
and Twenty-Eight
Constellations.*
Handscroll, ink
and colors on
silk. H: 27.3 cm.
(Abe Collection,
Osaka Municipal
Museum.)

take up in detail later, he also reasserted his belief that all religious experience begins with the stimulus and mediation of past example.[29]

In more pragmatic terms, the regular copying of famous works of both religious and secular art that went on in Qianlong's court after the completion of the first edition of the catalog also suggests he intended his collection to be comprehensive—even as he admitted it was a serendipitous grouping of gifts and tribute, a pile of unsorted things that was the result of one hundred years of peace, and even if its completeness was sometimes only simulated. In this regard the first two editions of *Bidian zhulin* reflect another important change in attitude on Qianlong's part about the nature of the collection. While the 1744 edition of *Bidian zhulin* was designed to account for what was really there, the 1793 supplement goes a step further to fill in the gaps in the collection with contemporary versions of fragmentary historical works, faithfully recording the emperor's process of historical reconstruction. In other words: The supplement, in concert with the original edition, diagrams the perfect collection, one that contains all the touchstones of Buddhist and Daoist experience, and lovingly, obsessively, and without prejudice records all the physical details of its real treasures and of the copies that make it whole. It is worth repeating that the system of judging works that was put into place in the first edition of *Bidian zhulin* was eliminated in the supplement; originals and copies appear side-by-side though Qianlong occasionally deploys the old ranking system in passing to compare the copies of his court artists favorably with their antique models. Now the details of copying, the events that triggered the emperor's interest in an unattainable or fragmentary work, become part of the history of the original object and the copy becomes a projection or completion of its model.

There are several notable examples of this type of replication in the *Bidian zhulin* supplement, especially of Guanxiu's *Lohans,* which Qianlong ordered copied and recopied many times, as we will see. Another illuminating entry describes the elaborately collaborative work the emperor ordered in

Figure 20. Ding Guanpeng et al., copy of Zhang Sengyou's *Five Emperors and Twenty-Eight Constellations.* Handscroll, ink and colors on paper. (National Palace Museum, Taipei.)

1744 to fill in Zhang Sengyou's famous sixth-century scroll, the *Five Emperors and Twenty-Eight Constellations (Wu huang ershiba xiu zhenxing tu)* (Figure 19). This ancient painting (now in the Abe Collection, Osaka Municipal Museum, Japan) appears as an incomplete group of seventeen Daoist deities and inscriptions in the first edition of *Bidian zhulin*, which reports that only twelve of the original twenty-eight constellations survived at the time, leaving a diminished total of seventeen pictures, and that Qianlong had noticed that the painting's mounting as an accordion-folded album *(ce)* was not original either.[30] He therefore ordered Zhang Zhao and the academicians Ding Guanpeng, Wang Youdun, and Chen Xiaomu to "fill in" the "abrupt" gaps in both inscription and image, based on a description of the painting a former owner, Zhang Chou, included in his own catalog, *Qinghe shuhua fang.* These new and reimagined additions were not to be clumsily inserted into the original. They were to be mounted separately as part of a "completed" series of all thirty-three sections, a commentary on the fragmentary original that "rounded out the whole *bi* disc," as the emperor put it, and brought the composition full circle (Figure 20). In the supplement to *Bidian zhulin* the copy and its additions appear as a separate entry, credited as works of art in their own right. Also there are the emperor's slightly rephrased comments that direct our attention not to Zhang Sengyou's work but to the product of his own academicians. Writing in 1767 he points out how valuable the reconstituted images are: "Today we have not just added [the missing] half but have copied the whole. It could not be better—Sengyou exceeds these painters' work only slightly," he claims.[31]

The emperor and his loyal crew of catalogers and court artists—among them Zhang Zhao who simultaneously played several roles as scholar, compiler, and calligrapher—have set up a series of mirrors here with the express intent of producing a clearer, more "rounded" view of a tantalizing but fragmentary bit of evidence from the remote past. In this they seem to share Donato's concern that museums (and collections) operate according to an uncritically accepted fiction that "the spatial juxtaposition of fragments can produce a representational understanding of the world," displacing objects with labels and reality with fragments. What Qianlong and his associates present instead is a series of reconstituted fragments, pieced together to form a reimagined whole that will be tied forever to its original inspiration as a corrective comment. There is Zhang Sengyou's actual (if partial)

original; there is the formatted notice of it in the first edition of *Bidian zhulin* along with the first mention of the emperor's plan to create a reconstituted copy; there is the expanded and largely imaginative copy itself; and, finally, there is the laudatory imperial record in the catalog supplement of the seamless *completeness* of the copy. Original and copy begin to blend with one another in the viewer's experience to the extent that the original no longer exists free of the pressures and effects of present reinvention. The two works join together, bridging the two editions of the catalog in a choreography of action and reaction, dragging Zhang Sengyou's unique masterpiece out of the sixth-century past and placing it squarely in a new Qing present. Is this deluded fiction? Or is the very materiality of the emperor's freshly manufactured visual commentary enough to make it fact?

This same heady sensation of displacement might be said to apply to the catalog as a whole (as indeed to any catalog), especially from the perspective of the modern reader. That is to say: The catalog is not the same type of thing as the collection, but a rigorously ordered, schematic rendering of it that, in its focused attention to the material details of each and every piece, becomes a disembodied simulacrum—recording just enough to keep the memory of a whole mass of individual things alive. The sensation that we are being granted easy access to everything, while far from true, is intentional. A major purpose of the catalog—and we have the emperor's word on this—is mnemonic: to encapsulate the essence of each item and pull (or push) it forward, reinterpreted and completed, through time.

The Catalog as Space

Qianlong's concept of the catalog as a beaded grove or book box that could accommodate all the unwieldy objects in his possession and bring them down to manageable size is reflected in his decision to have everything organized spatially. The method is clearest in the first edition of *Bidian zhulin*, where objects were distributed over several halls, each strikingly defined by its contents. The overall physical organization of storage in the palace was very sensible. Objects that were similar in type or function (and, more than that, objects with the same general shape) were stored together in the same building or palace compound. Buildings were further divided into cabinets that allowed refinements of the scheme. In the 1744 and 1793 editions of the catalog, large divisions of text therefore explicitly represent buildings. Following this analogy, smaller *juan* (chapters or fascicles) might be seen as representing cabinets, as the contents of the 1744 edition demonstrate:

Qianqing Palace

Buddhist works

Juan 1: Buddhist and Daoist imperial works, Shunzhi–Qianlong: not rated, all formats

Juan 2: Signed Buddhist calligraphy (Tang–Ming): first-class albums

Juan 3: Signed Buddhist calligraphy (Song–Ming): second-class albums

Juan 4: Anonymous Buddhist calligraphy (Song–Ming): first-class albums

Juan 5: Anonymous Buddhist calligraphy (Ming–Qing): second-class albums

Juan 6: Signed Buddhist calligraphy (Tang–Ming): first- and second-class handscrolls

Juan 7: Signed Buddhist calligraphy (Song–Ming): first- and second-class hanging scrolls

Juan 8: Signed and anonymous Buddhist paintings (Song–Ming): first- and second-class albums

Juan 9: Signed Buddhist paintings (Six Dynasties–Ming): first-class handscrolls

Juan 10: Signed Buddhist paintings (Song–Ming): second-class handscrolls

Juan 11: Anonymous Buddhist paintings (Tang–Ming): first-class handscrolls

Juan 12: Signed Buddhist paintings (Tang–Qing): first- and second-class hanging scrolls

Juan 13: Anonymous Buddhist paintings (Tang–Ming): first- and second-class hanging scrolls and one signed collaborative handscroll with calligraphy

Juan 14: Illustrated, printed Buddhist works by known calligraphers, old printed works by unknown calligraphers, embroideries, and *kesi* tapestries: first- and second-class albums, handscrolls, and hanging scrolls

Daoist works

Juan 15: Signed and anonymous Daoist calligraphy: first- and second-class albums

Juan 16: Signed Daoist calligraphy: first-class handscrolls

Juan 17: Signed Daoist calligraphy: second-class handscrolls and first-class hanging scrolls; anonymous first- and second-class handscrolls

Juan 18: Signed Daoist paintings: first- and second-class albums and handscrolls; anonymous first-class albums

Juan 19: Anonymous Daoist paintings: first- and second-class handscrolls

Juan 20: Signed and anonymous Daoist paintings: first- and second-class hanging scrolls; one Buddhist-Daoist collaborative handscroll, first class

Juan 21: Printed Daoist works, embroidery, and *kesi* tapestries: first- and second-class albums and hanging scrolls

Juan 22: Works by Qing court painters: Buddhist calligraphy and painting; Daoist calligraphy and painting; not ranked; all formats

Cining Palace

Juan 23: Records of imperially written Buddhist scriptures carved in stone and wood and printed books; Daoist woodblock-printed scriptures; anonymous sutras; not ranked; all formats

Wanshan Hall, Qin'an Hall, and Cining Palace

Juan 24: Presented Buddhist paintings (Wanshan Hall)
 Presented Daoist paintings (Qin'an Hall)
 Esoteric and exoteric Buddhist scriptures in Mongolian, Tibetan, and Manchu (Cining Palace)
 Not ranked; all formats

From this schematic list it is apparent that the catalog is not, after all, a three-dimensional place or series of places but a linguistic representation of a collection that contains both images and texts. What the particular system of this catalog does is throw into relief the degree to which the storage of objects defined the character of the spaces they filled and were likewise pigeonholed in and by these spaces. The contents of the first edition of *Bidian zhulin* reveal that the vast majority of pieces were housed in the Qianqing Palace, one of the complex of buildings on the main axis of the For-bidden City and, before Qianlong's reign, the private quarters and bedchamber of the emperor. This is also true of the secular painting and calligraphy cataloged in *Shiqu baoji*, much of which was stored in the Qianqing Palace (as well as in thirteen other halls, notably Qianlong's private quarters in the Yangxin Hall, the Yushufang or Imperial Library, and the Zhonghua Palace). Moreover, *all* of the pieces listed in the 1793 supplement to *Bidian zhulin* wound up in the Qianqing Palace. This palace complex was thus defined by the ecumenical nature of its contents. Once the site of the emperor's personal life, it became something like a black hole into which the products of the empire disap-peared, a compact reification of a multifaceted and universalist imperial ideology—at least the Chinese portion of it. It is not surprising that after the Qing emperors abandoned it as their bedchamber, it served as a reception hall for foreign embassies. (In sharp contrast, Jiaqing's 1816 edition brings together objects from a large number of halls in the Forbidden City and even from as far afield as the Bishu Shanzhuang summer retreat in Chengde.)

The first edition of *Bidian zhulin* also shows that Buddhist and Daoist paintings presented to the throne, that is, not imperial or previously owned works, were placed into two specially dedi-cated halls—the Qin'an Hall, where Daoist priests regularly performed rituals, and the Wanshan Hall, where the first Qing emperor Shunzhi customarily met with his favorite monks—but that all non-Han Chinese materials went to the Cining Palace.[32] By Qianlong's day the Cining Palace had become the residence of the emperor's mother, the devoutly Buddhist Empress Dowager Xiaosheng (1693–1777), Mongolian by birth.[33] This complex of buildings and its garden were also the site of daily chantings of the *Amitāyus Sutra* and eventually housed a comprehensive sculptural pantheon for the dowager's meditation practice, which, as we will see shortly, was scrupulously organized accord-ing to esoteric Tibetan Buddhist principles. The Cining Palace was thus, at least in material terms, one of the least "Chinese" places in the entire Forbidden City. Just to the east of the central axis, it is a particularly clear example of how the public and personal preferences of the Qing could be expressed in microcosm—if not explicitly in building style, then implicitly in the ways space was allocated and filled.

The documentation the Zhangjia Khutukhtu, Rolpay Dorje, provided for the non-Chinese images and texts in the Cining Palace is, however, notably terse compared to the often copious research Zhang Zhao and his team mustered for the Chinese portion. Rolpay Dorje gives us a simple list unadorned with the measurements and careful physical description provided for first-class Chinese objects. Non-Chinese objects, it seems, were really not susceptible to the same standards of connoisseurship and judgment traditionally applied to Chinese objects, nor even to the same rigorous quantitative approach of measurement and description. And, indeed, this category of things was dropped in the supplement to *Bidian zhulin*, along with any mention of the halls that housed them. A new method for controlling the huge numbers of Tibetan and Mongolian pieces—produced in the palace or pour-ing into it as gifts—quickly evolved. This method focused, not on the objective material qualities of the objects nor on the personal biographies of the artists who made them, but on the protocols and occasions of giving and the need to establish a system of authorized names of deities in the four official languages of the empire.

Kohara Hironobu has pointed to another way in which the catalog was less than comprehensive. Neither the 1793 supplement to the imperial art catalogs, *Bidian zhulin* and *Shiqu baoji*, produced

under Qianlong, nor the third edition of 1816, compiled under the auspices of his son, the Jiaqing emperor, were full accountings of all the things in the imperial painting and calligraphy collections. Both were sharply edited to avoid outshining the first editions in size and thus not put Qianlong's ancestors to shame.[34] (We may have already seen this principle at work in the initial suppression of Qianlong's biweekly revisiting of the *Heart Sutra*.) There were, in other words, countless works of art, religious and otherwise, that never became part of the official register for reasons that were at least partly sentimental. Large numbers of other works also filled the Qing summer palace (whose collections were decimated during the Opium Wars and Boxer Uprising, flooding the art markets of China and Europe), the palace in the ancestral capital at Mukden (Shengjing), and the palaces and temples of Chengde. The Mukden material, 450 pieces of painting and calligraphy, was eventually listed separately in a much later work, *Shengjing Gugong shuhua lu* (Catalog of calligraphy and painting of the palace in Shengjing), which was not compiled until 1908–1913, when the collections of the northern capital were packed up and moved to Beijing.[35] The treasures of Chengde, except for the few listed in the third edition of *Bidian zhulin*, were only recorded in 1925 when the *Neiwubu chenliesuo shuhua mulu* (Catalog of painting and calligraphy in the exhibition hall of the Imperial Household) was finally assembled. This catalog, which lists 2,917 works in all in thirteen different formats, also reiterated what remained of the contents of *Shengjing Gugong shuhua lu*, much of which had wandered out of the control of the former Imperial Household and into the antiquities market on Beijing's Liulichang.[36] But however complete or incomplete these and all the other earlier catalogs of the collection were, they did not even begin to take into account the things Qianlong's artists produced as gifts for monasteries inside and outside China proper.

Counting the Collection

Qianlong's plan to organize his collection in architectural terms and then to string everything together like beads has a certain Buddhist flavor. The emperor's goal was to solidify and even reify the memory of his collection, to make it whole rather than scattered, and in his comments on the collection he wove together references to two very different, though equally Buddhist, mnemonic systems, the one visual, the other oral. The building-by-building account of the collection he ordered (notably dropped in the catalog's third edition, produced after his death) recalls the mnemonic, architectural system of the mandala, which enables the meditator to recall an otherwise incomprehensible number of deities in detail by placing them neatly within its palace structure. This type of architecturally structured system of recall was part of Qianlong's daily meditation practice, as the biography of his guru, Rolpay Dorje, asserts, but Qianlong was also fully aware of the elaborate "memory palaces" of Jesuit mnemonics, introduced to China by Matteo Ricci in the seventeenth century.[37] These architectural mnemonics, whether they lodge the components of the mind or an otherwise random assortment of facts, are all about relationships; things are defined and placed by the company they keep, a key principle in Qianlong's catalogs.

Seriation, however, presents another way of aiding recall—one that introduces the element of time and is eminently suitable to linear systems such as inventories. Seriation or repetition is also a core Buddhist practice, especially in the recollection of the Buddha *(nian fo)* through the diligent repetition of his name, counted on a rosary or string of beads. What the emperor wanted to recall, however, was not just the contents of his collection but the qualities these things embodied. As he said, in stringing the collection together, "I recall *(nian)* that I should do no damage, but should diligently govern and love the people," a justifiable goal both for a Confucian emperor and for a wheel-turning Buddhist *cakravartin.* But what the stringing together of the collection also accomplished is a curious flattening of its individual components as each is duly measured, diligently described,

and filed away. One by one, they fill the pages of the catalog producing a collapse of early and late, good and bad, into a single, rhythmically organized whole. Past and present are really no different—just as these time-based categories mean nothing when recalling the Buddha's name—and viewing the list whole takes on all the qualities of repeating a mantra as one *Heart Sutra* after another marches by, counting off the weeks of the emperor's pious practice. But however past time may be countable, its palpable materiality is no longer really within the emperor's grasp, at least not entirely. His efforts to make it whole through the mechanism of the perfect, gapless catalog hint at the degree to which his theory of governance was, in fact, grounded in the materialized signs provided by things.

Remembering the Future

People were always aware of time as moving between . . . two poles. Memory thus had a retrospective and, curious as it sounds, a prospective character. Its object was not only what had happened but what was promised.

—Hans Belting, *Likeness and Presence* (1994)

I have been arguing that the accounting of the imperial collection of religious art was designed from the outset to answer specific ideological needs. These included (but were by no means confined to) an initial desire to present the collection as a microcosmic embodiment of the empire as a whole, where two distinctive religious systems, Buddhist and Daoist, were combined under a single rubric. But the technologies of catalog production were intimately tied to a specifically Chinese system of selection, judgment, and connoisseurship that traditionally put religious pictures, called *xiang* or "images," with all the implications of representing authentic vision, and *tu*, far more generic "pictures," in a separate category from "painting" *(hua)*—an entirely different activity more consonant with the linguistic abstractions of writing and thus the province of educated, cultivated men.[1] Qianlong's catalogs pay no real attention to these distinctions, however; *xiang* and *tu* appear side-by-side interchangeably and all pictures are "painted" *(hua)* to distinguish them from calligraphy *(shu)*, except when they are "done in the style of" *(fang)* an earlier artist's work, or straightforwardly "copied" *(mo* or *lin)*, or even "written" *(xie)*. The division that has often been perceived in Chinese image making—between pictures designed to accomplish religious or practical ends, or to render visionary experience accurately and authentically, and those that served a more purely personal function, to preserve the traces of a gentleman's brush and spirit—falls dramatically away here, even as the emperor more and more uses his icons as a site to ground his increasingly aestheticized and historicized spirituality. In its place a new division emerges, between China proper and the rest of the Qing empire, a split that produced a different urge to catalog, not works of art, but qualities of the enlightened mind.

This new interest surfaced around 1745, about a year after Qianlong ordered the first edition of *Bidian zhulin*, when he asked Rolpay Dorje to initiate him into the tantra of the tutelary deity Cakrasaṃvara (Chinese: Shangle). Rolpay Dorje's biography suggests that this request followed a number of queries the emperor put to him about the history of Tibetan Buddhism and about the nature and identity of the many Tibetan-style images flooding into his palace as gifts from Mongolian and Tibetan dignitaries. According to Thukwan, the *khutukhtu*'s disciple and biographer, the emperor said: "When the Han and the Mongols arrive at court they all present quantities of Buddhist images, Buddhist sutras, Buddhist stupas, and so forth, so many that they cannot be counted. Nor can we differentiate between the materials used to make the images or the details of their appearances, making it difficult to put them in order. I ask that you take these Buddhist images, categorize them, and indicate their names in Mongolian and Tibetan script."[2] Rolpay Dorje then apparently gathered together all the incarnations and high lamas in Beijing, along with all the most talented scribes in the Lifanyuan, and accomplished the task within two months.

The exact product Rolpay Dorje conceived to answer the emperor's request cannot be identified with any confidence today, though it could not have been his portion of the monolingual *Bidian zhulin* or any of the elaborate iconographies he produced in the decades that followed.[3] More likely

he responded by instituting the practice of attaching explanatory labels in the four languages of the empire to every gift that entered the palace. Each of these labels carefully details the circumstances of the gift, if known, records the identity of the lama making the identification (quite often Rolpay Dorje himself), and, taking the emperor's request a step further, provides the name of the deity represented in Chinese, Mongolian, Manchu, and Tibetan. This project had little to do with the concerns for artistic value and historical authenticity of authorship or physical condition that informs the Han Chinese portions of the first edition of *Bidian zhulin*. The objects Rolpay Dorje and his crew of iconographers dealt with were not really susceptible to such standards of connoisseurship; their "authenticity" depended only on whether or not they had been correctly, rather than well or anciently, rendered (a principle, it cannot be denied, Qianlong also applied to such fragmentary ancient Chinese paintings as Zhang Sengyou's *Constellations and Planets*). In this sense the project had a great deal in common with the wide assortment of other attempts at rectification and ordering that occupied so much of Qianlong's time throughout his long reign. Even as early as the late 1740s and 1750s, for instance, the emperor also had Rolpay Dorje apply his expertise to the conduct of Buddhist rituals in the capital—making sure they followed standards set in Lhasa—as well as to ritual music, masked dance (Tibetan: '*cham*), the correct pronunciation of mantras and *dhāraṇī*, and the proper structural proportions and historical models for imperial temples.[4]

Taking the Buddha's Measure: *Zaoxiang liangdu jing* (1742)

Qianlong also accepted the system Rolpay Dorje recommended in 1742, contained in *Zaoxiang liangdu jing* (Sutra on iconometry), as a standard for his own, strikingly hands-on interest and participation in the work of monk-artists resident in the Zhongzheng Hall, where he would later be seen approving and even personally correcting working sketches.[5] This scantily illustrated text was the brief *Pratimālakṣaṇa*, translated from what is most likely to have been a Tibetan version by a specialist whose name was Gonpokyab (Chinese: Gongbu Chabu). Gonpokyab refers to himself as a translator of Tibetan and Mongolian, in fact, of "all scripts," and provides the tantalizing information that he came "from north of the sandy desert."[6] He was a famous figure among the Mongols, at least until the last years of the nineteenth century, when the Inner Mongolian historian Dharmatāla described him as "foremost among the best" of the translators working on Qianlong's Mongolian Tanjur project (1741–1742).[7] The first (and latest) of five prefaces to the text, written in 1748 by Prince Zhuang, Qianlong's uncle Yinlu, which he may have done to pay his respects to Gonpokyab as a recently deceased relative of the imperial clan by marriage, fills this scanty biography out a bit by including the laconic comment that he was a member of the eastern Inner Mongolian Üjümüchin tribe.[8] The other prefaces that accompany the text were written between 1741 and 1742 by such luminaries as Rolpay Dorje and three other monks: Dingguang Jiezhu; Dingming, a second monk of the Chuhuang lineage; and Cishan. Dingming tells us that Gonpokyab received Kangxi's "grace and nurturance" from an early age; Kangxi considered him an imperial relative by marriage and had him study the languages of the lands to the west (at the very least, Tibetan and Sanskrit). He continued in Yongzheng's favor and was put in charge of Tibetan studies and translations.[9] Cishan reports that Gonpokyab had great insight into Buddhism and the difficulties of translation and that he conceived the project of translating the *Sutra on Iconometry* on his own before meeting with Rolpay Dorje to discuss the prospect of publishing it.[10]

Although the *Sutra on Iconometry* is just that—an old, originally Indian text that systematizes a method for designing Buddhist images properly—the authors of its prefaces all recognize that the inherent difficulty of representing the Buddha has less to do with measurements and proportions than with his simultaneously having and not having form. Historically, each writer argues, the Buddha

certainly occupied a human body, even a myriad of human bodies into which he was reborn over and over again, yet his nirvana liberated him from rebirth and from such categories as form, time, and space. Nonetheless, he continues to affect the events of the world. Seeing the true, formless body of the Buddha is equivalent to enlightenment in this view. Prince Zhuang, for example, quotes the Buddha's own teaching in the *Prajñāpāramitā Sutra*, saying: "If you see that all forms are formless, then you see the Tathagata." He then goes on to say:

> Moreover, because phenomenal form is [just] a vehicle, any sort of thing is equally sufficient. Form (Chinese: *seshen;* Sanskrit: *rūpakāya*) fuses like a rainbow's display. Everything, great and myriad, universally sharpens perception. Lands countless as dust, worms and wriggling grubs, sound and fragrance, [all] arouse light and boundless joy. Since the Han dynasty we have shaped grass, gold, and iron and have seized upon clay to give it form, so that all who are blind or dim-sighted can "put their eyes together" to see. Is this not the bright lamp of the dharma world? Is this not a precious raft on a fruitful sea? If the root is bright and clear and if wisdom is penetrating and fluid, if we reverence the cloud of compassion and truly perceive this great explanation, then it follows that there is form, which, when apprehended, is formless. Eyes, ears, noses, tongues—all are empty. All men and myself are creatures alike; there is no barrier or obstruction between us.[11]

Prince Zhuang's Chan-like glossing over of any apparent distinctions between the Buddha's body and "worms and wriggling grubs" might seem an unusual place to launch a work devoted to the protocols of depiction. But, in fact, his thinking fits into the same mode as that of his colleagues, who also worry (if more circumspectly) about a figure whose body is so elusive, so difficult to define and perceive. Rolpay Dorje picks up the same thread in his earlier preface, which he wrote at his retreat at his residence, the imperial Songzhu Monastery in Beijing, in 1742, on the anniversary of the Buddha's first sermon. He opens by saying:

> All the sutras say the Buddha has a body; [in fact] they say he has two. The first is called the dharma body *(dharmakāya)*, the second is called the form body *(rūpakāya;* Chinese: *seshen).* The dharma body is the reward of the virtue of wisdom, the meritorious action of cultivated practice, self-discipline, and pure thought, the perfect, ultimate ground. The form body is the fruit of the virtue of blessedness; its benefits and skillful means can be perceived. It is the final abode of great and rightfully deserved success. The Buddha, in order to save transmigrating creatures, displayed his *bodhi* mind and, over repeated kalpas, he diligently acted to bring forth his essence. Moreover, he cultivated the two virtues of wisdom and blessedness.[12]

These two virtues, wisdom and blessedness (or, we might translate, insight and good fortune), result in the reward of two very different bodies, one formless, the other perceptibly endowed with glorious form. Thus, Rolpay Dorje asserts, the Buddha can act in two very different spheres, the one beyond ordinary perception, the other purposefully lodged in the world of the senses. What he outlines here were, in fact, two very different goals of practice for Buddhists in general (and the Qing court was no exception)—insight and the granting of blessings, the second even more intimately connected with image making than the first.

Perhaps the most intriguing preface, though, is Dingguang Jiezhu's. He casts his contribution in the form of a question-and-answer session, one that displays the type of logic the Mādhyamika school was most famous for, and, in doing so, he reveals the degree to which Buddhist monks surrounding the Qianlong emperor were caught up in ongoing Tibetan debates on the Middle Way.[13]

The opening passages suggest that Qianlong's own repeated queries about the nature of phenomena and representation would often draw on the same sources:

Question: "Does the Buddha have form?"

Answer: "He has form."

Question: "Does the Buddha not have form?"

Answer: "He does not have form."

Question: "Can it be that, in the midst of having form, the Buddha is formless?"

Answer: "Certainly."

Question: "Can it be that, in the midst of not having form, the Buddha has form?"

Answer: "Certainly."

Question: "How is it that the Buddha has form?"

Answer: "All creatures have form. How could the Buddha be formless?"

Question: "The Buddha's form and the form of all creatures—are they one or are they two?"

Answer: "They are not one and they are not two."

Question: "How are they not one?"

Answer: "The Buddha spent kalpas in cloudlike cultivation. He went on a hundred, a thousand, ten thousand travels. His form was like an ornament, perfected by the fruited sea [the sea of enlightenment]. All other creatures are wasteful, unenlightened since antiquity. Their natures are not yet clear. They are affected by whatever they experience. They have not left the six paths [of rebirth]. Hence they are not one."

Question: "How are they not two?"

Answer: "The Buddha said, 'I used to come like a swarm of locusts when I had not yet achieved buddhahood. How is this different from other creatures? Now, however, in the midst of creatures, all at once [I experienced] a great awakening. I already had buddha nature in the midst of the sea of birth and death and I consciously leaped over to the shore of consciousness. Previous buddhas, later buddhas—there is nothing between them. Therefore they are not two.' "[14]

This passage plays on a theme that crops up in Qianlong's repeated invocation of the paradox of "One and/or Two," which we have already seen him applying to his own double portraits and which we will continue to find him using in all sorts of different contexts. But it also highlights the ways in which Tibetan and Chinese modes of Buddhist discourse and representation were joined in dialogue, even in the earliest years of Qianlong's reign and before. For the text that Gonpokyab presents is distinctly Indo-Tibetan in flavor—a point he is quick to make in his own introduction. He says that there are two strains of Buddhist style in China. The first, which he calls the "Han style," derives from the image of the golden man that the Eastern Han Emperor Ming saw in a dream. This style thrived during the Six Dynasties and into the Tang, when it was revitalized by images from the west, including Buddha images made for the pious Indian Emperor Aśoka and brought back to China by

Figure 21. Proper proportions for a bodhisattva and *vajra*. From the *Zaoxiang liangdu jing.* Image size: 8.7 x 13.5 cm. (After *Taishō*, vol. 21, no. 1419.)

the Tang-dynasty pilgrim Xuanzang. The second style, which Gonpokyab calls "Indian," he also characterizes as the official style of the Yuan Mongol rulers, introduced by the Nepalese artist Anige, under the patronage of Khubilai Khan's preceptor Phagpa Lama. But Gonpokyab wishes to delve more deeply into the history of Buddhist representation, plumbing it to its origin. This source, he claims, is the very *Sutra on Iconometry* he now translates, a teaching solicited from the Buddha himself by his ever curious disciple Śāriputra.[15]

To this fundamental text Gonpokyab has added a set of illustrations, all of them provided as patterns by Rolpay Dorje (Figure 21).[16] Some of these prints diagram and establish measurements in finger-widths for the proportions of the seated Buddha in *bhūmisparśa mudrā* (earth-touching gesture), the standing Buddha holding an almsbowl, and the faces of the Buddha, a bodhisattva, a buddha mother *(fomu),* and a guardian *(mingwang).* The instructions they present are generic. The inscription under the seated Buddha, for example, says that the image represents "the image of Śākyamuni Buddha's naked body" and continues with the comment that "all buddha images are constituted according to this pattern." Other illustrations depict specific deities but urge the viewer to take broader lessons from the way they are proportioned. Avalokiteśvara, who does not vary much from the woodblock illustration of him in the Mongolian Kanjur of 1718–1720, produced under Kangxi (Figure 22), is inscribed: "All bodhisattvas standing in attendance to the side of 'the One Honored by the World' [that is, the Buddha] are depicted in this manner." The very short text of the sutra lays out the rules for proportioning the figure of the Buddha in a similar way. Exhaustively it lists the proper lengths of every part of his body, based on the width of a finger.

Figure 22. Avalokiteśvara and Kṣitigarbha. From the Mongolian Kanjur, Kangxi period, 1717–1720. Image and text size: 30.3 x 8.8 cm. (After Chandra, ed., *Mongolian Kanjur*, vol. 56, p. 2.)

Gonpokyab appended a slightly longer piece to the text, also reportedly instigated by the Buddha's disciple Śāriputra—a work titled *Foshuo zaoxiang liangdu jing jie* (Explanation of the Buddha's teaching of the *Sutra of Iconometry*), which covers the proper proportioning of the Buddha's form-body in minute detail. Neither of the two texts, however, deals with what must have been a most pressing issue for artists at the Qing court: how to represent the rest of the pantheon. So yet another series of nine short texts, all "handed down" by Gonpokyab, presents answers to the question of how to depict the increasingly large numbers of deities the Gelukpa accepted and introduced to court. These short chapters introduce the proper form of bodhisattvas; the "Nine Measures System" for depicting bodhisattvas and some lesser figures; the "Eight Measures System" for *mingwang* and other guardians; the forms of male and female guardians; the "Proper Decorum" for representing mudras (hand gestures, or "seals"), *āsana* (postures), scarves, drapery, and all sorts of ornament; "Precepts for (Avoiding) Error," or the spiritual pitfalls of bad drawing; how to consecrate an image with talismans; the different forms of relics; and the many "Blessings of Image Making."[17]

Rolpay Dorje went on after his collaboration with Gonpokyab to produce works of many different sorts, including a substantial body of systematic iconographies or pantheons. A few of these, the *Three Hundred and Sixty Icons, Three Hundred Icons,* and *Pantheon of Five Hundred,* were graphic works presented as unique, hand-painted volumes or as woodblock-printed books that were issued and reissued even in the early twentieth century. Others were works in situ—sculptural and painted pantheons installed in imperial temples—designed to satisfy the needs of a specific regimen of ritual and practice. None of these works, printed, painted, or sculpted, is identical to any of the others, though many of the same deities appear and reappear throughout in the same or slightly different company. This very inconsistency demonstrates that Rolpay Dorje and his imperial patron did not for a moment consider that the pantheon of Buddhist deities was a static entity. Their broad-mindedness conforms to a more general Buddhist message that stresses fluidity of identity and contingency of the self. But it also raises the question of how it might be possible to reconcile such open-ended amplitude with orthodoxy and orthopraxis. Can the urge to create canons of iconographic forms be compared to the motivation behind such centrally controlled collections of "authorized texts" as *Peiwenzhai shuhua pu*, the huge compilation of works on art brought together and edited (or, more precisely, censored) under the Kangxi emperor? Or are Rolpay Dorje's several iconographies more like the numerous examples produced in Tibet, Mongolia, and China of the Tibetan Buddhist canon, the Kanjur? The Kanjur (or, more properly, Kanjurs) represents another open-ended set (or sets)—differing in contents, in organization, and in the criteria it offers for identifying authentic transmission from one lineage to another and from place to place—a repository theoretically open to accept rediscovered texts.[18] Qianlong and his guru certainly believed in the Kanjur's capacity to embrace additional material, a position made clear in the emperor's command in 1763 that Rolpay Dorje translate the *Śūraṃgama Sutra* from Chinese to Tibetan, Mongolian, and Manchu and insert it into the Beijing Kanjur. Yet Qianlong also apparently believed that adding the *Śūraṃgama Sutra* to the canon completed it or at least made it consistent with the Chinese canon.[19]

Broad-mindedness, in Qianlong's view, therefore had to be balanced against orthodoxy and correctness. But the notion of the pantheon as a reference that divorces individual deities from their original contexts in *sādhana* (the actual realization of the deity by an adept practitioner in meditation, as well as the written descriptive record of that realization) and reinforces their visual, formal similarities, bringing them all down to the same scale and refining them into a symbolic language, was not unique to Rolpay Dorje and Qianlong by any means.[20] The simple shifting of attributes, resulting in a new and slightly different identity, is a core principle in Tibetan Buddhist iconography. Images are "correct" insofar as they point accurately, using an already brokered and accepted symbolism of form and color, to the realizations of a particular adept.[21] Correct representation thus

enables a transition between the timeless qualities each deity represents and the historical, biographical context of personal enlightenment. Precision is ensured by a complicated set of hundreds of possible attributes (color, gender, facial expression, body type, mudra, tools, ornament), which can combine, practically speaking, in an infinity of ways, leaving the pantheon of deities an open set that the skilled practitioner, like Rolpay Dorje, could manipulate to suit any number of different ritual needs. We might say that the urge to establish the correct way different deities can be represented symbolically is something like the desire to set standard spellings of words (or pronunciations of mantras and *dhāraṇī*) without insisting upon smoothing over differences in local custom or limiting the possibility of neologisms.

Another productive way of looking at the pantheons created during the Qianlong reign might be to think of them as collections—much like the blossoming, ever-changing, *Bidian zhulin,* which refused to remain static as objects continued to "return" to the palace after the completion of the first edition in 1744. *Bidian zhulin* was conceived, if not executed, as a kind of rolling inventory designed to produce a detailed, highly formalized, but always evolving record of the immensity and richness of the collection—as it was stored. What the pantheons collect, however, are not the records of individual works of art but the distilled essence of individual meditations, collated as the prescribed paths of different lineages of adepts—as they are stored in memory. Like the works brought together in *Bidian zhulin,* these visionary experiences are schematized and symbolically represented to produce vertiginous inventories of forms whose precise differences are often difficult to appreciate. As each pantheon unfolds, however, it reveals the uniqueness of its organizational method like an animated comic book that produces the illusion of movement as it is flipped. The march through the pantheon necessarily takes on a cinematic temporality; there is simply no way to take it in immediately as a whole. Thus placement becomes all important as different forms acquire meaning according to where they are situated. The very immensity and initial incomprehensibility of the entire body of gods represented in pantheons played well to the gradual approach to enlightenment promoted by all forms of Tibetan Buddhism but particularly to the *lam rim* (graduated path) that Rolpay Dorje introduced to Qianlong.[22] No progress, this method argued, could be made without the mediation and support of past experience.

The spatial qualities that determine the organization of both *Bidian zhulin* and Rolpay Dorje's several pantheons emphasize the importance given to siting as a mnemonic aid in Tibetan Buddhist practice. These pantheons, in other words, however complex and disjunctive they may seem at first glance, serve the same needs as the compact, schematic, and diverse architectures of the mandalas by which they are often explained: to clarify and replace (or reorient) the components of the mind and body during meditation. They accomplish this goal by assisting in the creation of ritual space and ritual time through time-defying repetition, the insertion of subtle difference, and precise, hierarchical placement. All of these are attributes we have already noted in Qianlong's artistic projects and even in his otherwise mundane cataloging efforts. Once again, however, none of these things is unique to the Qianlong period. There are ample precedents for Rolpay Dorje's pantheonic displays—particularly in the printed collections of buddhas and bodhisattvas of the early Ming dynasty and in other earlier productions from domains beyond China's borders, including Tibet, Mongolia, and the Tangut Xixia realm.

Pre-Qing Precedents

Heather Karmay's seminal *Early Sino-Tibetan Art* laid out in detail the debt the Manchus owed to earlier rulers and their pious publication projects.[23] Systematically she analyzed a number of printed, illustrated Buddhist canons beginning with those produced in the Xixia (Tangut) language in the

thirteenth and early fourteenth centuries. The chief heirs to Xixia style, which introduced Tibetan figural mannerisms, ornament, and setting to the illustration of the canon, were the Mongols. In the first years of the fourteenth century, Mongol rulers subsidized the production of a Chinese Tripitaka at the Jisha Monastery, near Hangzhou, which included frontispieces of the Buddha preaching before an audience or joyfully discussing dharma with learned monks (Figure 23). These images, as Karmay shows, have a strong Tibetan flavor—both in the way they are drawn and proportioned and in the style of dress of the Buddha's learned companions. These monks appear as Tibetan lamas with a unique Tibetan, vestlike undergarment covering the right shoulder; some even wear the tall, cone-shaped hat with long ear flaps still in use by lamas today (which Karmay identifies as a type of hat appropriate for an Indian pundit). Such illustrations also accompany the Tangut Tripitaka, which was produced around the same time under the pious patronage of Guanzhuba, probably Tangut himself.

Even more important precedents for the Manchus were two projects undertaken in the early Ming dynasty: The first was a complete, imperially subsidized, Tibetan-language Kanjur done in 1410; the second was a pantheon titled *Zhufo pusa miaoxiang minghao jingzhou* (Marvelous images, names, sutras, and *dhāraṇī* of all the buddhas and bodhisattvas). The 1410 Kanjur was apparently undertaken at the command of the Ming Yongle emperor (r. 1403–1424), whose interest in Tibetan Buddhism and Tibetan lamas is a major focus of Karmay's study. She demonstrates that the extremely generous emperor did not begin to send gifts of religious texts to his favorite lamas until 1413 or 1414, quite late in his campaign to woo high prelates, when Kuntepa, the thirty-second abbot of Sakya Monastery, visited the Ming court and received copies of Buddhist texts. These offerings proved popular and when Tsongkhapa's delegate, Sakya Yeshe, visited Beijing in 1415 and 1416, he too received volumes of the Kanjur to take home to his teacher. These volumes, Karmay suggests, can have been none other than the illustrated, woodblock-printed 1410 Kanjur.[24] Moreover, her analysis shows that when the famous "Red Kanjur" was printed in Beijing at Kangxi's order beginning in 1685 (and not completed until 1724, a year after his death), its compilers apparently still had access to some of the original blocks used in the 1410 Kanjur and happily integrated them into their design. Thus

Figure 23. *Śākyamuni Preaching.* From the Jisha Tripitaka, early fourteenth century (Yuan dynasty). Woodblock-printed book. 29.85 x 12.07 cm. (Los Angeles County Museum of Art.)

the first twenty-five volumes of the Red Kanjur
have illustrations that literally duplicate those of
the 1410 edition, while the other volumes, 26 to
106, all have newly carved illustrations. Kenneth
Chen has said that the printing blocks for the
1410 Kanjur, along with those produced for
another edition of 1620 in the Ming Wanli reign,
were all long since destroyed.[25] Clearly, however,
some of them survived long enough to be pirated
for the Manchu project.

According to Karmay, the 1431 pantheon of
All the Buddhas and Bodhisattvas was designed as
a popular work that claims to be a compilation
and iconography of deities according to the teach-
ings of Dezhin Shegpa, the Fifth Karmapa. The
Karmapa was a great favorite of Yongle and, in
1407, he even performed the funeral services for
Yongle's parents in Nanjing, an occasion of great
miracles. *All the Buddhas and Bodhisattvas* is a series
of woodblock illustrations beginning with Dezhin
Shegpa himself and including a host of sixty
deities and their Chinese and Tibetan names
(given in Chinese transliteration) (Figure 24).
There are also prefaces in Chinese, Lantsa script,
Tibetan, and Mongolian, portions of some tantras
and sutras and a collection of *dhāraṇī*, numer-
ous independent illustrations of deities and famous
pagodas, and even a catalog of the texts Xuan-

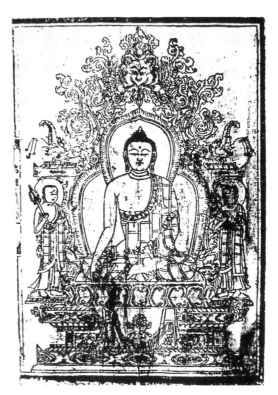

Figure 24. Frontispiece from *Zhufo pusa miaoxiang minghao jingzhou* (Marvelous images, names, sutras, and *dhāraṇī* of all the buddhas and bodhisattvas), 1431. Woodblock-printed book, ink on paper. 19.5 x 13.5 cm. (Musée Guimet, Paris.)

zang brought back from India. The text finishes with a colophon, rendered in Chinese, Lantsa, Tibetan,
and Mongolian, and an image of Weituo (the boy-guardian Skanda).

Karmay suggests that the patron of the text was probably a Chinese Buddhist; his name appears
as Xiujishanzhu (which she translates as "he who dwells in cultivating Buddhism and storing up
merit"),[26] and he probably produced it long after the Karmapa first came to the attention of the
Ming and several years after Yongle's death. The work itself is a seemingly random collection with
woodblock images that, as Karmay observes, are not as vitalized or refined as those of the 1410 Kanjur
but are, nonetheless, opulently ornamented and decidedly Tibetanized. Regardless of the slippage
in elegant clarity since 1410, *All the Buddhas and Bodhisattvas* is an important production because
it aimed at comprehensiveness and strove also to provide insight into a specifically Tibetan pantheon
for a Chinese-reading audience. It functioned as a popular reference, much like the Chinese vernac-
ular encyclopedias of its day, containing a blizzard of information on Tibetan Buddhist beliefs, both
practical and arcane, in two compact volumes.

The Mongolian Kanjur: 1718–1720

Another particularly potent and charismatic precedent for the iconographies of the Qianlong period
was the brilliantly illustrated Mongolian Kanjur produced under the patronage of the Kangxi
emperor between 1718 and 1720.[27] This project is one I have already touched upon; its imperial
preface contains the extraordinary and groundbreaking claim that the bodhisattva of wisdom,

Mañjuśrī, transformed himself into the occupant of the "Fearless Lion Throne of Gold" to appear as none other than the "sublime Kangxi-Mañjuśrī." Kangxi seems to have been particularly bent on finding precedents for his own actions and dynastic claims in this publication effort. The Mongolian Kanjur he commanded reproduces the text of a complete, early-seventeenth-century Kanjur handwritten in gold and silver in the Mongolian language. This monumental work of translation and calligraphy was undertaken between 1628 and 1629 at the Qotala Bayasqu Monastery, Inner Mongolia, under the patronage of the Chahar Mongol Ligdan Khan (1594–1634). Ligdan, it will be recalled, was nearly successful in his bid to reunite the Mongols into a powerful empire; his claims were enhanced by his legitimate use of the title Chinggis Khan (whose direct descendant he was). Ligdan was also, like his ancestor Khubilai Khan, an ardent Buddhist with strong connections to the Tibetan Sakya order of Khubilai's guru Phagpa Lama. Ultimately the Manchus forced Ligdan and his troops westward, and, after Ligdan's death in 1636, Manchu leaders accepted the most important symbol of his legitimacy, Phagpa's golden Mahākāla, from his wife and children, establishing the figure in Mukden in the center of a mandalic architectural complex.

By the early eighteenth century, copies of Ligdan Khan's Kanjur were extremely rare. Lokesh Chandra mentions that examples were so valued that their very appearance merited special mention in Mongol histories. Copies were made as early as 1650 (by Neyiči Toyin for the Eastern Mongolian princes; his 1739 hagiography mentions the momentous event), and the Kanjur was still an object of power and desire when an example reappeared in 1817 as an heirloom in the collection of Prince Geligrabai of Kesigten Banner. Kangxi rightly feared that Ligdan's Kanjur would disappear completely from view unless it was carved and promulgated xylographically. So in 1718 the abbot of Dolonnor's Koke Süme (Blue Monastery) ordered all the best scholars and calligraphers in Mongolia to gather together to edit, retranscribe, carve, and print the Kanjur for distribution to monasteries throughout Mongolian-speaking lands. This immense project took only about two years and the completed Kanjur, printed in red ink on thick paper, was ready for distribution in 1720.

As Chandra's analysis of the illustrations to the Kangxi Mongolian Red Kanjur shows, issues of symbolism were never far from the Qing emperors' minds, even beyond the Mongol claims Kangxi appropriated for the Manchus simply by promulgating Ligdan's work. Ligdan's original Kanjur, for example, consisted of 113 volumes. Kangxi's printed version redistributes the contents of each volume to arrive at a more significant Buddhist number: 108. Kangxi's specialists also provided an elaborate series of illustrations for the new Kanjur, and these too give the work a sense of historical legitimacy less because of what they present than how they are presented. Exactly how the visual content as a whole illuminates the text is far from simple and still, in large measure, elusive. There are two images on the first page of each volume (see Figure 22, for example) and five on the last (Figure 25), for a grand total of 756. Chandra explains that these illustrations comprise two separate series: one running through the initial illustrations to each volume and a second running through the final illustrations. The sequencing of the series does not make sense, Chandra feels, until volume 27, which begins with an illustration of Dīpaṅkara, the buddha of the immediate past kalpa; in his words, in the earlier volumes the groupings of images "defy precise classification." Put in the simplest terms: The initial series begins with such profoundly esoteric, primary deities as Vajrasattva and Kālacakra, Cakrasaṁvara and Vajravārāhī (an established *yab yum,* or father-mother, pair), Kapāla-Hevajra and Nairātmā (another pair), Guhyasamāja and Mañjuśrī-vajra (closely related forms that can conflate into one), and proceeds hierarchically down with pairs of *ḍākinī* and tamer buddha mothers *(fomu)* alternating with other major esoteric figures (Hevajra, Vajradhara, Guhyasamāja) and less esoteric buddhas (such as the Medicine Buddha, Amitābha, and Dīpaṅkara, who begins volume 27). Established groups of figures then begin to appear in sequence: the thirty-five buddhas of confession, the figures surrounding Amitāyus (who appears several times), the eight great bodhisattvas, various groups

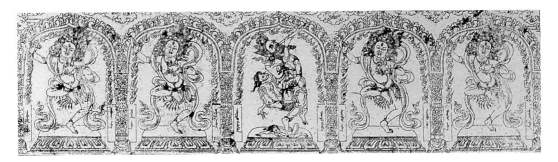

Figure 25. Śrī Mahākāla and *ḍākinī*. Closing images from the Mongolian Kanjur, volume 1, Kangxi period, 1717–1720. Image and text size: 30.3 x 8.8 cm. (After Chandra, ed., *Mongolian Kanjur*, vol. 1, p. 792).

of buddhas (five, seven, eight), and, finally, the sixteen *śravaka* and sixteen lohans. This pattern suggests that the illustrations were chosen to underscore the arrangement of the Kanjur's contents, with tantras placed before sutras, ending with texts dealing with *vinaya* (monastic rules for which the monkish *śravaka* and lohans are excellent exemplars).

The final series contrasts sharply with this multifaceted but overwhelmingly benign initial group. It includes an impressive array of protectors and other fierce *(khroda)* deities. Mahākāla in his several forms begins the series, appropriately, given his role as protector of the Mongols, followed by Rematī, the five *yamarāja,* Hayagrīva, and so on, all serving as guardians at the end of each volume. But there are also many secondary, benign female figures (like the five goddesses of the senses and the five long-life sisters). And as Chandra points out, many deities in both the initial and final series (over two hundred of them) appear repeatedly and without variation, making it difficult to say exactly how the illustrations are supposed to illuminate the contents of the text beyond providing a regular visual rhythm for its unfolding. Yet these illustrations are materially tied to the text in which they find themselves embedded, even as they seem to operate like two separate subtexts, initial and final, welcoming and guarding. The two series flow without impediment through all 108 volumes, revealing two series of deities, more or less hierarchically arranged, the first the exemplars and the second the protectors of several categories of texts, all equally representing the true speech of the Buddha.

The artists who produced the illustrations to the Mongolian Kanjur of 1718–1720 were obviously among the group of specialists the abbot of Dolonnor called to his monastery from all parts of Mongolia in 1718. They produced an extraordinary group of 756 images, each presented frontally with every attribute in full view, surrounded by subtly varied ogival arches, and with each deity's name inscribed on either side in Mongolian and Manchu and below in Tibetan. There is constant invention and variation in the cloud, ray, flame, and landscape backgrounds that fill the rest of each frame, and many figures normally shown without attributes (the thirty-five buddhas of confession, for example) hold them here. The clarity of detail and finesse of the carved line are unparalleled in earlier printed Buddhist pantheons, raising all sorts of questions about the artists who worked on it. Where did they come from, and how did they suddenly acquire such sophisticated graphic and iconographic skills?

The answer to this question in all likelihood leads back to Outer Mongolia and the First Jebtsundamba of Urga: Zanabazar.[28] Zanabazar's own brilliant career as a sculptor (or as a designer of sculpture) was already well established when he capitulated to the Kangxi emperor at Dolonnor in 1691. He subsequently won the emperor's and empress' hearts and apparently produced numbers of images (some of them visionary and thus scarcely palpable) during his visits to Beijing.[29] Comparing Zanabazar's extant sculpture to the woodblock illustrations to Kangxi's Mongolian Kanjur reveals many more similarities than differences—especially in the emphasis in both bodies of work

on fine outline and delicate detail set against broad expanses of smooth flesh. (See, for example, Figure 4 in Chapter 1). There are also telling matches in the Kanjur with some of Zanabazar's more unusual mannerisms such as his unique and spare lotus thrones, complete with stamens. These similarities raise the question of Ligdan's original Kanjur and the degree to which its illustrations set patterns for the Khalkha Mongols and the Qing to repeat and refine throughout the seventeenth and eighteenth centuries.

The Longshan Monastery's "Sixteen Lohan Sutra": 1711

That this elegant style, ultimately Nepalese in inspiration, should have attracted Mongol and then Manchu attention is no surprise. Certainly the new Nepalese style resonated harmoniously with the official productions of Khubilai Khan's thirteenth-century Beijing workshops directed by Phagpa Lama's protégé, the Nepalese prince Anige (an art historical moment the Manchus would come to know well, described, as we have seen, in Gonpokyab's 1742 introduction to the *Sutra on Iconometry*). While it may seem dubious that the Kangxi emperor would have cared about such coincidences, in fact he was driven by them, deeply interested in uncovering parallels between the Manchu Qing dynasty and the Mongol Yuan.

Kangxi also presided as patron over another project that explores the sources of Buddhist imagery and reveals the indebtedness of the Manchus to the Fifth Dalai Lama. This was the reprinting in 1711 at the Great Longshan Monastery for the Protection of the Nation (Da Longshan Huguo si) in Beijing of the Dalai Lama's text, *Inexhaustible Jewel of the Victorious Teaching of Veneration of the Sixteen Elders*, already discussed briefly in Chapter 2.[30] The Beijing edition bears two colophons, one in Tibetan, the second in Chinese. The Chinese refers to the work as the "Sixteen Lohan Sutra," obscuring its true identity as a historically grounded liturgical work in which the Dalai Lama lays out the proper number, order, and names of the lohans.[31] Except for the addition of these two colophons and a slight change in title, the Beijing edition duplicates the Tibetan text and its illustrations as they are reproduced in the Potala version of the Dalai Lama's complete works.

The lohans, numbering sixteen, eighteen, or five hundred, appealed to the emperors of the Qing because of their position in the Mahāyāna tradition, not as self-seeking adepts, but as members of Śākyamuni's original following assigned to protect the dharma until the coming of Maitreya, the Future Buddha. They exemplified the concept of the decline of the dharma, which was very much in vogue among Chinese Buddhists in the late Ming and Qing, and they were also, conversely, harbingers of a new age that would be ushered in by the arrival of a wheel-turning ruler, or *cakravartin*. And, indeed, the emperor himself appears in this very role in an illustration to the left of the Chinese-language colophon on the final page of the Longshan Monastery edition (Figure 15), paired with an image to the right of the last of the eighteen lohans in the Tibetan system, the pot-bellied monk Hvashang. The Tibetan inscription and the spoked wheel the royal figure presents in front of his belly identify him straightforwardly as a "wheel-turning king."

The opening illustrations to the sutra, four in number, create a provocative context for these last two images in that they specifically raise the question of what the lohans looked like and respond by presenting the act of portrayal itself. This act unfolds from the initial image of Śākyamuni, who appears seated and in the *bhūmisparśa* mudra (earth-touching gesture) on the left of the first page recto (Figure 26). The inscription below leaves the Buddha unnamed while stessing his family lineage as "the impartial, sole protector of sentient beings, the son of Śuddhodana." In the second illustration, on the right, a monk, his head encircled by an aureole, sits on a mat with his hands forming the *dharmacakra* mudra (wheel-turning gesture). He turns to look at a diminutive painter who gazes back intently even as he works on a painting lashed to a Tibetan-style wooden frame. This painting-in-progress depicts Śākyamuni just as he appears in the first illustration to the left.

Figure 26. The "Lohan Sutra," pages 1 and 2 recto, dated 1711. 44.5 x 13 cm. (Courtesy of the East Asian Library, University of California, Berkeley.)

The inscription reads: "Elders from China [or India] in the tradition of Lumey Drom [-chung]." According to legend Lumey, a mysterious ninth- or tenth-century figure, went to China and obtained sixteen paintings of the lohans (presumably as they appeared there in a dream), brought them back to Tibet, and established them in a monastery at Yerpa where they came to be known as the Sixteen Elders of Yerpa. These paintings of the sixteen lohans ultimately became an authoritative source for the lohans' forms in Tibet—just as the contemporaneous Chinese Chan master Guanxiu's (832–912) much stranger lohans, likewise envisioned in a dream state, did in China.

In other words: Here the text illustrates not the forms of the lohans themselves, as we might expect, but the initial, oral act of transmission of their forms, which begins with Śākyamuni's teaching and example. The third and fourth illustrations on the front of the second page carry this theme of correct transmission further. To the left is another act of portrayal, with another lama offering advice to a painter, who in turn produces a lohan image that strikingly resembles the figure of Lumey shown on the page above. The inscription states that this lama is "Ngök, the great teacher, the venerable Jangchub Jungney," a direct disciple of Lumey whom Giuseppe Tucci identified as having painted a series of lohans in Indian style based on the teachings of one of the Indian sage Atīśa's disciples.[32] Finally, on the right, a solitary fourth figure appears with the inscription "Lamp of the Kadampa teachings, the renowned Chimchen Namkha" (1210–1267 or 1285), a lama from Narthang who energetically proselytized Atīśa's liturgy for paying homage to the lohans and stabilized the list of sixteen that would prove persuasive at the court of the Qing Qianlong emperor.

In his detailed discussion of the history of lohan painting in Tibet, which he shows to have been a particularly "Sino-Tibetan" enterprise (that is, Tibetan work in borrowed Chinese style), Giuseppe Tucci questions just how direct the lineage that is presented so straightforwardly here actually was. He suggests that the traditions of Lumey and Jangchub Jungney had separate origins, the one in China, the second following the precepts of the Indian Atīśa, Chinese in style only because it developed in Kham, where a Sino-Tibetan painting style particularly flourished. According to Tucci, then, these two lohan painting lineages represent two different Tibetan approaches to envisioning and stabilizing the baffling transmutability of the sixteen lohans—the first originating in a ninth-

century Chinese vision, the second in an eleventh- or twelfth-century Indian textual transmission. In the Fifth Dalai Lama's text and its republication as the Longshan Monastery "Sixteen Lohan Sutra," however, the two masters are presented as part of the same continuous (if incomplete) lineage, later supported by Atīśa's infusion of liturgical orthopraxis. Culture affects vision, this text and its illustrations seem to say, but true vision, the vision possessed, for example, by lamas and the artists who work with them, ultimately vaults over cultural differences. In the construction presented here, the two transmissions—visual and liturgical—are really one.

The Longshan Monastery "Sixteen Lohan Sutra" also demonstrates that, in the Buddhist view, there are several approaches to insight—some verbal, some visual—and that these different approaches intertwine and link together in concealed ways. Its illustrations, therefore, do not so much enable the reader to envision the sutra's cast of characters in the mind's eye as they illuminate, extend, and independently comment upon the text's deeper, paradoxical message of historical lineage set against a backdrop of magical, time-defying transmutation. This is a message that culminates on the final page with a replay of the first page—only now it is the emperor who takes Śākyamuni's place, balanced against the portrait of another lohan to the right: the fat Chinese monk Hvashang, eighteenth and last to join the group (most likely, Tucci argues, not until the eighteenth century).[33] The sutra leaves its readers to imagine all the other lohans who occupy the gap between the first two (and who implicitly promise in the painting lineages they invoke that their group will only number sixteen) and the eighteenth and last, as well as to ponder the differences between several variously composed, contending collections of sixteen or eighteen (and even seventeen and five hundred) lohans, each claiming to represent authentic transmission within a specific cultural context. Legislating a reconciliation among these various lineages would continue to occupy a great deal of Qianlong's and Rolpay Dorje's time, as we will see in Chapter 5.

The Longshan Monastery "Sixteen Lohan Sutra" and the Mongolian Kanjur, both produced under Kangxi's patronage, set up complex and indirect relationships between text and illustration. The illustrations to the "Sixteen Lohan Sutra," in fact, seem simultaneously to support and subtly subvert the message of the text, leaving the neophyte reader in a state of confusion and doubt even over such simple questions as how many lohans there are. Not all the publications subsidized by the Qing court were so inventive or challenging, of course. Qianlong's massive Chinese Tripitaka, the *Longzang* (Dragon, or Imperial, Canon), has pedestrian illustrations that simply copy the frontispieces of earlier imperial canons (and thus tie his version in an unbroken chain to every other previous version). These earlier works typically present the Buddha preaching before a large audience of bodhisattvas, guardians, and disciples to assert that the text which follows is his true speech. But, in general, the Qing approach to the Tibeto-Mongolian canon and the huge pantheon that embodied it much more creatively raises a host of questions about the nature of transmission. The works Rolpay Dorje compiled and organized at Qianlong's request are no exception.

Sites of Enlightenment

Rolpay Dorje's pantheon collections fall into a number of different categories, some of them designed to illuminate texts, some intended as imaged embodiments of text, and some as contexts—collections of deities brought into a state of three-dimensional, sculptural realization in order to support text-based practice and driven by the same orthodox conception of a graduated path to enlightenment as the Kanjur. But however Rolpay Dorje systematized his pantheons, they never deviate completely from a text- or word-based understanding of this path. In some cases remarkably textlike notions of vocabulary, grammar, structure, and movement seem to inhabit them. Moreover, though Rolpay Dorje's pantheons are by no means identical, several of them are linked intertextually

by common groupings of deities or by a common understanding of the trajectory of practice through a body of texts.

One of the best places to begin to appreciate these issues is in the Forbidden City itself, where dozens of halls or parts of halls were dedicated to the recitation of scripture for the good of the imperial family and, by extension, the entire nation, especially during Qianlong's reign. Wang Jiapeng has put together a list of all the halls equipped, completely or in part, to support Tibetan Buddhist practice, both public and private, and notes in passing that there were thirty-five freestanding buildings dedicated entirely to Tibetan Buddhism, as well as ten other shrines established in other buildings, primarily the living quarters of the imperial family.[34] The most important of these—in fact, the center of Tibetan Buddhism in the Forbidden City—was the now-lost Zhongzheng Hall (Hall of Central Uprightness), which Kangxi established in 1697 in the northwest corner of the inner city, well away from the central (read: Confucian) axis.[35] Here, in this building and its surrounding cloister, Tibetan and Mongolian lamas orchestrated Buddhist activities for the court and artists designed and fabricated many of the works of sculpture and painting needed for contemplative exercises and for the interchange of gifts with Tibetan and Mongolian lamas. Its administration, according to *Da Qing huidian*, was in the hands of two officials from the Neiwufu (Imperial Household) and a small group of great lamas—a system very different from the Buddhist and Daoist text bureaus set up in the Ming-dynasty palace, which were always staffed by palace officials.[36]

Pavilion of Raining Flowers (Yuhuage): 1750

The Zhongzheng Hall burned to the ground in 1923, leaving nothing but a pile of rubble,[37] but the building immediately in front of it, the Yuhuage (Pavilion of Raining Flowers), still stands, protected from the rest of the inner city by the Chunhua Gate.[38] The Pavilion of Raining Flowers, the tallest structure in the western half of the Forbidden City, was designed in a mixture of Han Chinese and Tibetan style specifically as an initiation hall. It is a complex and intentionally esoteric structure. Apparently a three-story building from the outside, its facade actually conceals another masked floor within, hidden between what seems to be the first and second floors (Figure 27). Rolpay Dorje designed the pavilion at Qianlong's request in 1750; inspiration for its function and plan came from one of the most innovative and influential Tibetan buildings, the three-story Golden Temple (Serkhang) at Tholing, built in 996 in the old capital of the Guge kings in western Tibet. The Golden Temple's designer—the translator and proselytizer Rinchen Zangpo (958–1055), who reconstructed the Buddhist establishment in western Tibet after Langdarma's mid-ninth-century persecution—is said by some to have modeled it intentionally on Bodhgayā,

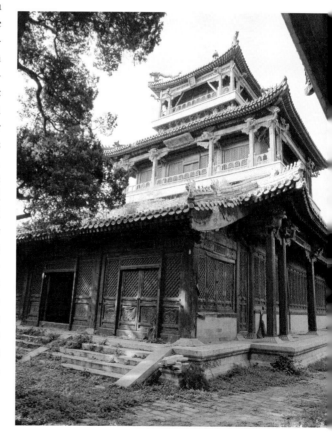

Figure 27. Yuhuage, exterior view. (Reproduced with permission of the Palace Museum, Beijing.)

the Indian temple that marked the site of the Buddha's enlightenment and was a source plan for temple building across Buddhist Asia. Others claim the Golden Temple duplicated Samye, Tibet's oldest monastery, presumably founded by Padmasambhava himself right after the first transmission of Buddhism to Tibet in the seventh century. The Qing also copied Samye at Chengde, perpetuating its own Indian inspiration, Odantipur, a temple-monastery in Bihar. Regardless of its precise antecedents, Tholing was famous for the Indian or Kashmiri-style wall paintings, which depicted the deities of various tantric cycles and were in place at least from the time of Tibet's other great second-wave proselytizer, Atīśa.

Rolpay Dorje's biographer Thukwan describes exactly how Qianlong and Rolpay Dorje chose the prototype of Rinchen Zangpo's Golden Temple for the Pavilion of Raining Flowers.[39] During the construction of another of Rolpay Dorje's projects, the three-story Foxiangge (Buddha Fragrance Pavilion) at the Beijing Summer Palace's Yiheyuan (Garden of Nurturing Harmony), lightning struck its unfinished pagoda. Qianlong had another Indian-style pagoda, called Da Xitian (Great Western Heaven, or Great India), erected in its place. When the emperor subsequently asked Rolpay Dorje about the proper way to design Tibetan-style temples, he responded with a description of Rinchen Zangpo's design for Tholing, which Thukwan says he understood to have four floors (when it actually had three). Intrigued, Qianlong insisted on building a similar one. And so he and his guru set out to design what would be the Pavilion of Raining Flowers on the old Ming foundation of the Longde Hall, a Daoist temple devoted to the worship of the Sanqingshen, the Daoist trinity.

Although the real meaning and function of the building are cloaked from the outside, its complex purpose becomes clearer within. Part of that purpose is political and part seeks to submerge a worldly agenda in its construction of a rational, text-based system of private, esoteric practice. In other words, as we might expect, several different strands of presentation weave together in the Pavilion of Raining Flowers to produce a multilevel understanding of the path to enlightenment—one that, befitting a *cakravartin* like Qianlong, never entirely leaves everyday or politically symbolic concerns behind. The present state of the pavilion's interior may belie this interpretation—sculptures and ritual implements are scattered around in apparent disarray and centuries of dust veil everything—but the Qing mania for inventories and self-commentary provides a clear glimpse into the way things once were. The main three-niche shrine in the center of the first floor, for example, which the visitor confronts behind rows of pagodas, sculpted trees, metal offerings, and incense burners on entering the building, now holds a sculpted Śākyamuni and two mismatched Amitāyus figures on either side. But originally the shrine's deities promoted a covert political agenda; according to a Qianlong-period court record, they were the same Śākyamuni accompanied not by Amitāyus but by a four-armed Avalokiteśvara (Lokeśvara of the Four Syllables), who appears on earth as the Dalai Lama, and Mañjuśrī, who regularly appeared in the guise of (among others) the emperor, Rolpay Dorje, and Tsongkhapa, the Gelukpa founder.[40]

This main shrine, though centrally placed and architecturally massive, seems to be almost an afterthought in comparison to the three large and three-dimensional cloisonné enamel mandalas of great *yidam* (tutelary or personal refuge deities). Their mandalas sit isolated, displayed like specimens inside elaborate wood and glass cases. Set on monolithic marble lotus bases, these three constructions loom massively to the sides and rear of the shrine, dominating the high front room. Inside their impenetrable cases (Plate 10), all three mandala-palaces rest on huge crossed *vajra*. What they conceal and foreshadow is a secret group of deities that will be more explicitly revealed on the fourth floor: Guhyasamāja (Secret Union) in the center and just behind the front shrine; on the left Vajrabhairava, the fierce bull-headed transformation of the bodhisattva Mañjuśrī; on the right Śaṃvara, Lord of Ultimate Bliss. This same powerful Gelukpa threesome also dominates the design of Qianlong's portraits as a *cakravartin* emanation of Mañjuśrī, which, as we have seen, were multipurpose

paeans to the emperor, his dominion over China, and the spiritual lineage he inherited from his root lama, Rolpay Dorje. Despite their apparent centrality to the entire program of the pavilion, these three-dimensional mandalas were not even ordered until 1753 and other orders for bronze roof dragons and a pagoda dedicated to Amitāyus from as late as 1776 show that the building and its contents were a work in progress, constantly refined over at least two and a half decades.[41]

As we read the series of four large, blue-black signs, written in gold in the four languages of the empire, we see immediately that the primary organizational principle of the Pavilion of Raining Flowers truly does correspond to the original vision Rolpay Dorje borrowed from Rinchen Zangpo's Golden Temple (a vision based, however, on a slightly different path to enlightenment). Their messages show that each floor represents a different level of practice, contained in the four very different and evolving classes of tantric texts collected (and variously organized) in the several versions of the Kanjur. As a student climbs up the narrow, treacherous stairways at the rear, he also moves to new and increasingly difficult levels of potential insight, crystallized in the arrays of deities who fill each of four shrines. The back shrine on the first floor, reduced in height to a single story, holds nine images, each identified by name in the accompanying pair of signs (Chinese and Manchu, Mongolian and Tibetan): a central figure of Amitāyus, the Buddha of Boundless Life, surrounded not quite symmetrically (at least from an iconographic standpoint) by eight female deities, four on each side (see Table 1). These nine (a number we have already seen particularly associated with Amitāyus) represent *kriyatantra,* or performance-based practice, an entry to the path to enlightenment available to everyone, spiritually adept or not. This group and its label point out a path for diligent practice, the goal of which finally reveals itself in two very different ways on the third and fourth floors.

The upper three floors proceed in systematic order. According to the inscription posted there, the low-ceilinged second floor, hidden behind a wall that separates it from the upper reaches of the high front room of the first floor, supports *caryatantra,* or action-based ritual practice, with an altar that focuses on Mahāvairocana surrounded by four buddha mothers and four *jingang* (guardians who brandish diamond scepters). The third floor is devoted to *yogatantra,* advocating a series of eso- teric, transformative exercises that involve visualizations in which the practitioner invites the deity into his presence and honors him or her with visualized offerings, laying the groundwork for the final consummation of the completion phase, when, on the fourth floor, he will literally merge with and become the deity himself through a painstaking inner yoga. The third floor altar houses five buddha images, all of them secret forms of Vairocana, the central, all-generating, shape-shifting cosmic buddha of the *yogatantra's* Diamond World.

On the fourth floor (Figure 28), all the promises of the practices performed on the three lower floors come to fruition in the *anuttara-yogatantra,* the supreme yoga that enables the practitioner either to merge into the deity's form and transform himself symbolically into a buddha or see the clear light (as in the father, or *upāya,* skillful-means tantras of Vajrabhairava and Guhyasamāja) or experience inner heat (Sanskrit: *caṇḍālī;* Tibetan: *gtum mo;* as in the mother, or *yogini,* wisdom-based tantra of Śaṃvara). The fourth floor altar houses this exact group, the same three whose palace-mandalas appear on the ground floor: Vajrabhairava, Guhyasamāja, and Śaṃvara. These deities all appear in their most esoteric *yab yum* (father-mother) forms, the main, masculine figures joined sexually with their feminine *śakti.* All of them are multi-armed and horrific; they symbolize the great bliss of enlight- enment and the ultimate consummation and completion of profound practice.

Wang Jiapeng has said that the Pavilion of Raining Flowers and all the other freestanding temples in the Forbidden City served a single and very political (though not exactly public) purpose—the protection of the nation—and that this altruistic aim accounts for their undiluted Tibetan flavor.[42] And it is true that however much the pavilion plots out a personal path to enlightenment—that of the emperor himself—through the evolution and transfiguration of its pantheon on four different

Table 1. Layout of Bronzes in the Pavilion of Raining Flowers, According to the Original Wall Labels (based on Luo Wenhua 1997 and Clark 1937)

4th floor — Supreme Yogatantra (無上瑜伽品)

	Guhyasamāja	Saṃvara
Vajrabhairava	**Miji Jingang**	Shangle Jingang
Da Weide Jingang		
大威德金剛	密集金剛	上樂金剛

3rd floor — Yogatantra (瑜伽品)

Vajradhātu-Vairocana	Sarvavid-Vairocana	Uttamasri (Buddha)	Tib: 'Gro ba' dulba	Amoghasiddhi
Jingangjie Bilu Fo	**Puhui Bilu Fo**	Zuishang Gongde Fo	Dusheng Fo	Chengjiu Fo
金剛界毗盧佛	普慧毗盧佛	最上功德佛	度生佛	成就佛

Caryatantra (行德品)

Buddha-locana	Vairocanā-bhisambodhi	(Blue) Nila Tārā	(White) Paṇḍara-vāsini	Nairātmā
Foyan Fomu	**Hongguang Xianyao Puti Fo**	Lan Fomu	Baiyi Fomu	Wuwo Fomu
佛眼佛母	玄光顯耀菩提佛	藍佛母	白衣佛母	無我佛母

Kriyatantra (智行品)

Mārīci	Amitāyus	Vijayā	Ṣaḍakṣarī Lokeśvara	(White) Sita Tārā
Jiguang Fomu	**Wuliangshou Fo**	Zun Sheng Fomu	Sibei Guanyin	Bai Jiudu Fomu
積光佛母	無量壽佛	尊勝佛母	四臂觀音	白救度佛母

2nd floor

Acarya-Vajrapāṇi	(Blue) Vajra-vidāraṇa	Bhuta-ḍāmara-Vajrapāṇi	(White) Hayagrīva
Xianxing Shouchi Jingang	Lan Cuisui Jingang	Fumo Shouchi Jingang	Bai Matou Jingang
顯行手持金剛	藍摧碎金剛	伏魔手持金剛	白馬頭金剛

1st floor

(White) Sitātapatrā	(Green) Śyāma Tārā	Great Compassionate Guanyin	Pratisarā
Bai Sangai Fomu	Lu Jiudu Fomu	Dabei Guanyin	Suiqiu Fomu
白傘蓋佛母	綠救度佛母	大悲觀音	隨求佛母

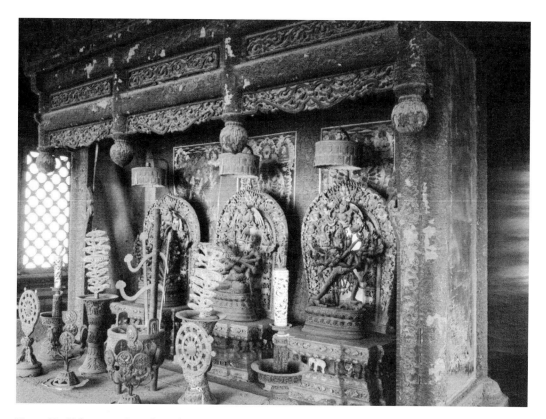

Figure 28. Yuhuage, main sculptural group, fourth floor. (Reproduced with permission of the Palace Museum, Beijing.)

levels, its goal is the harmony and well-being of the whole empire, which only an enlightened ruler can bring about. How this goal is achieved is literally a state secret in which deity and mandala, emperor and empire, are metonymically linked, part for whole, through the imaginative powers of the guru and his disciple. Luo Wenhua has recently made a similar suggestion—that the pavilion's most concealed deities were far from random choices, not simply picked because of their centrality in Gelukpa practice, but selected because they were saturated with politically significant undertones.[43] Two of the final three deities, both prefigured in the mandalas on the ground floor, point indirectly to Qianlong: the central figure, Guhyasamāja, a favorite deity of the Gelukpa, who can join with Mañjuśrī to produce the esoteric deity Guhya-Mañjuvajra (Secret Smooth Diamond Scepter), already associated with the emperor in Ming Yongle's day (1403–1424); and Vajrabhairava, who is Mañjuśrī's fiercest transformation and the guardian deity of Beijing. (The city itself was understood to be his mandala.)[44] To Luo's important insight we can add this: The belief that Rolpay Dorje was Śaṃvara's emanation, and that the first initiation Qianlong took from his guru was into Śaṃvara's tantra, adds more weight to his presence in this most secret shrine. Śaṃvara was, for Qianlong, both a starting point and a point of completion, a deity to whom he returned many times over the course of his life, and Rolpay Dorje designed him into every project he ever undertook.

Luo Wenhua also explains how the Pavilion of Raining Flowers was given a second, separate purpose in the thangkas that decorated its walls.[45] There are now fifty-eight thangkas in the hall, but Luo produces a court document dated to the fifteenth year of the Daoguang reign (1834) that lists eighty-four, originally hung in sixteen separate suites on the first, second, and third floors. The Daoguang document also records the names of all the main deities in the thangkas, evidence that

since the early nineteenth century a few key suites have been either stolen, rearranged, or moved to different floors. Thus the paintings as they now hang do not faithfully represent the iconographic scheme Rolpay Dorje designed for the pavilion. (And the Daoguang document, we have to admit, may not do so either.) In Luo's analysis, the original scheme relies in part on the architecture of a mandala—in particular, the well-known Guhyasamāja-Akṣobhyavajra mandala, whose central deity, Guhyasamāja, is truly the pavilion's ultimate focus. The subjects of the thangkas on the successive floors of the pavilion, Luo believes, were once grouped to represent the outer rings of his mandala and to bring the viewer closer and closer to the mandala's center. According to the Daoguang inventory, on the first floor (called *Zhizhu xinyin*, or Wisdom Bead Mind Seal, after a sign in Qianlong's hand that hangs there), paintings of the buddhas of the five directions should appear behind the sculptures of the back altar, where paintings of five esoteric buddhas now hang. (Originally these must have hung just upstairs.) The directional buddhas immediately surround Guhyasamāja in all transmissions of his mandala, and nine of the ten great protectors who watch over the outer ring of the Guhyasamāja mandala (called the Guhyasamāja-Akṣobhyavajra mandala to emphasize this deity's ties to the Immovable Buddha of the east, Akṣobhya; Chinese: Budong Fo) occupy the left wall of the back room.[46] The guardians face nine Tārās—all of them in different colors to symbolize different geographic orientations and aspects of the goddess, none of them, however, found in any form of the Guhyasamāja-Akṣobhyavajra mandala.

On the second floor (called *Xianlou*, or Immortals' Upper Story), the groups of thangkas deviate from the mandala again, with (originally) five esoteric buddhas (back), five Tārā figures (left), and five *fomu* (buddha mothers, in this case the five wish-granting Pañcarakṣā, right). There are also two groups of bodhisattvas on the front and back of a secondary wall that runs behind the main altar. The front group includes ten of the bodhisattvas of the twelve directions; the back group breaks down into two triplets of the best-known bodhisattvas.[47] Finally, on the fourth floor (to which the Daoguang document pays no attention), the sculpted and painted deities are the same, with the sculptural Vajrabhairava, Guhyasamāja, and Śaṁvara partly obscuring their own images in the thangkas that hang behind them.

Although the outer/inner, heavily directional hierarchy of the mandala explains some of the content and arrangement of the Pavilion of Raining Flowers thangkas, it does not explain everything—and not simply because Guhyasamāja ultimately shares the final altar with two other deities in a transcendant spiritual and political moment. There is still another subcurrent of intent at play. The Daoguang inventory lists only three thangkas for the third floor (called *Puming yuanjue*, Universally Bright Rounded Consciousness, after its calligraphed plaque): Amitāyus, flanked by Sitātapatrā and White Tārā, all powerful symbols of long life and good fortune. This threesome reiterates part of the sculptural pantheon on the back altar of the first floor, where Amitāyus appears with eight auspicious female figures, including the two that join him here, in a context explicitly designed, according to the explanatory sign, for performance. Here the three reappear in a very different context, one that stresses the *sādhana*-based visualization practices of *yogatantra,* and in doing so they create a separate thread that connects the pantheon to more private realizations of long life and good fortune. Luo Wenhua has characterized the iconographies of the Pavilion of Raining Flowers by saying that if its bronzes follow doctrine (doctrine, moreover, tied to the way texts are cataloged), its thangkas also support Qianlong's recognition of the needs of his deceased ancestors and extended family, stressing worldly concerns and the benefits that reward meritorious acts.[48] But it is also a fact that in their practice of Tibetan Buddhism the Manchus, like their Tibetan and Mongolian counterparts, regularly emphasized the wish-granting aspect of *sādhana*; their realizations often were aimed at palpable, material change. The real purpose of visualization practice, in their minds, was to make wishes come true in the here and now through the sheer power of imagination.

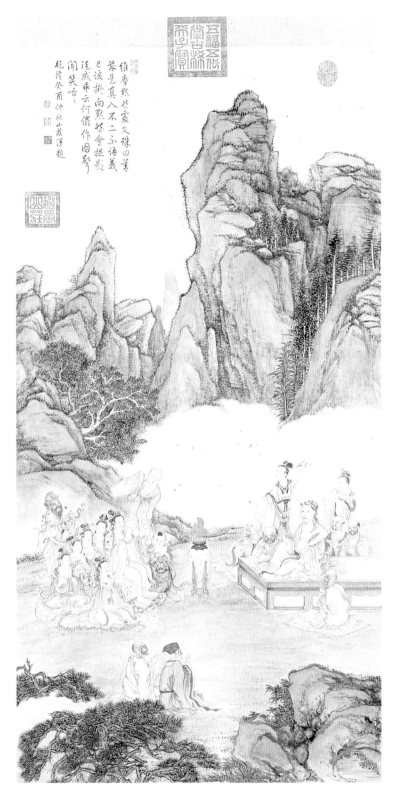

Plate 1. Ding Guanpeng, *Nonduality Picture (Bu'er tu),* 1753. Hanging scroll, ink and colors on paper. 118.3 x 61.3 cm. (Palace Museum, Beijing.)

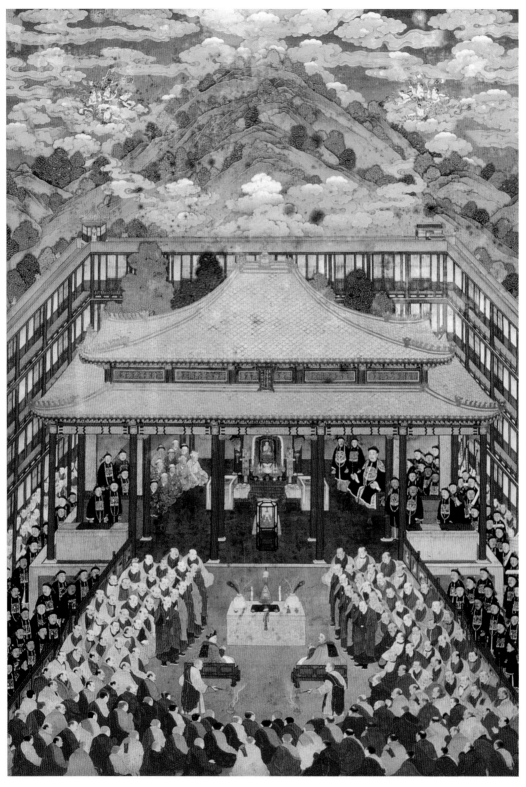

Plate 2. *Ten Thousand Dharmas Return as One.* Screen painting, colors on silk.
164.5 x 114.5 cm. (Palace Museum, Beijing.)

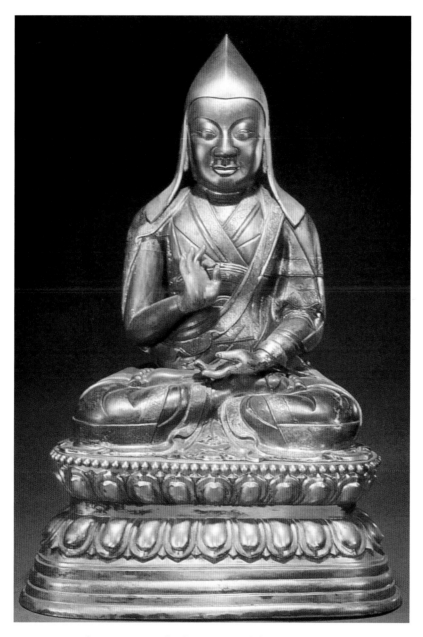

Plate 3. Portrait of Rolpay Dorje. Gilt bronze. H: 75 cm.;
W (of base): 52 cm. (Palace Museum, Beijing.)

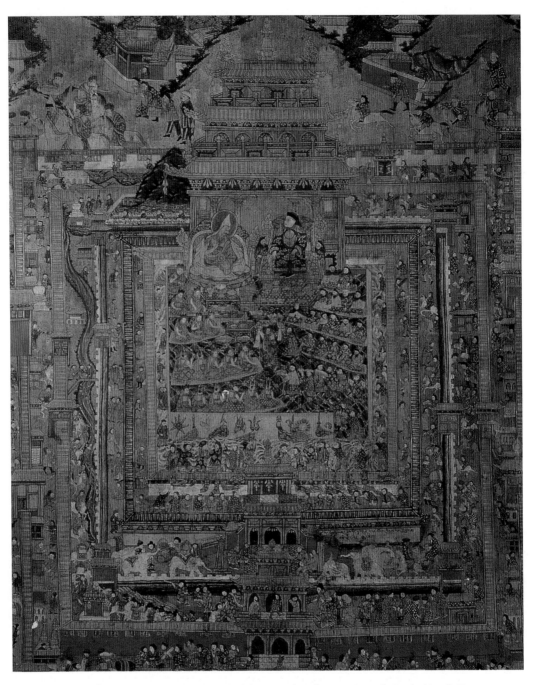

Plate 4. *The Great Fifth Dalai Lama and the Qing Shunzhi Emperor in the Baohedian, Beijing,* ca. 1653. Mural painting, Potala Palace, Lhasa. (After *Baozang,* vol. 5, pl. 2.)

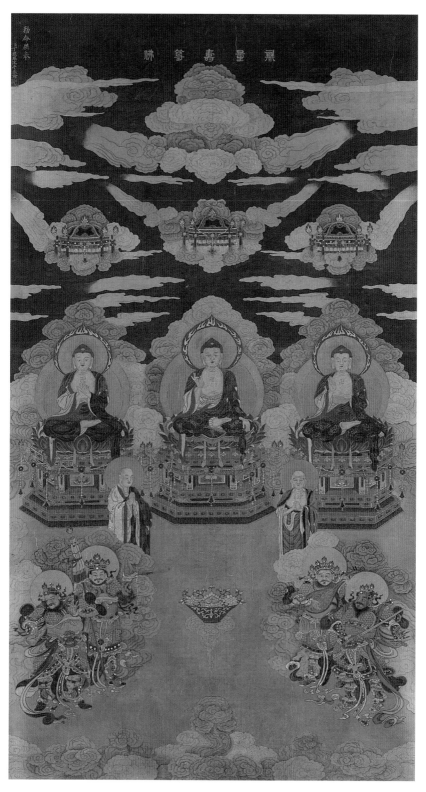

Plate 5. Ding Guanpeng, *Buddhas of the Three Ages*. Hanging scroll, ink and colors on paper. 233.7 x 78.8 cm. (Asian Art Museum of San Francisco.)

Plate 6. *Ṣaḍakṣarī Lokeśvara* (Lokeśvara of the Six Syllables). *Kesi* "slit silk" tapestry. Potala Palace, Lhasa. H: 365 cm. (After *Baozang*, vol. 5, pl. 20.)

Plate 7. *Ṣaḍakṣarī Lokeśvara* (Lokeśvara of the Six Syllables). Silk embroidery. 209.45 x 86.7 cm. (Asian Art Museum of San Francisco.)

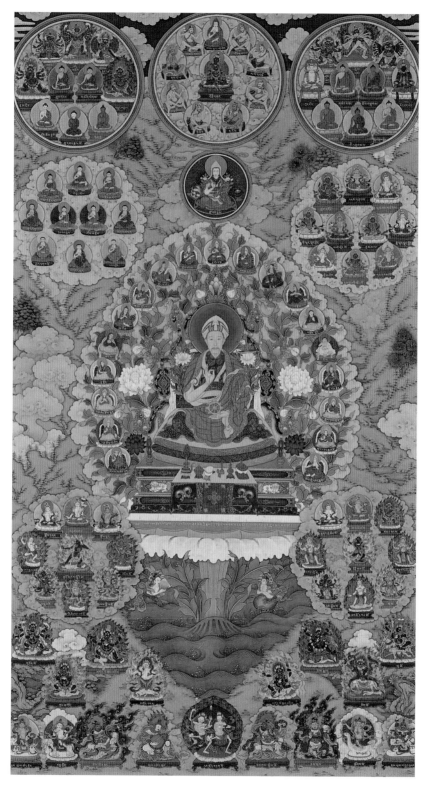

Plate 8. *Qianlong as Mañjughoṣa Emperor.* Thangka, ink and colors on silk. 113.5 x 64 cm. (Freer-Sackler Gallery, Smithsonian Institution, Washington, D.C.)

Plate 9. Giuseppe Castiglione (1688–1766) et al., *Qianlong as Connoisseur.* Hanging scroll, ink and colors on paper. 136.4 x 62 cm. (Palace Museum, Beijing.)

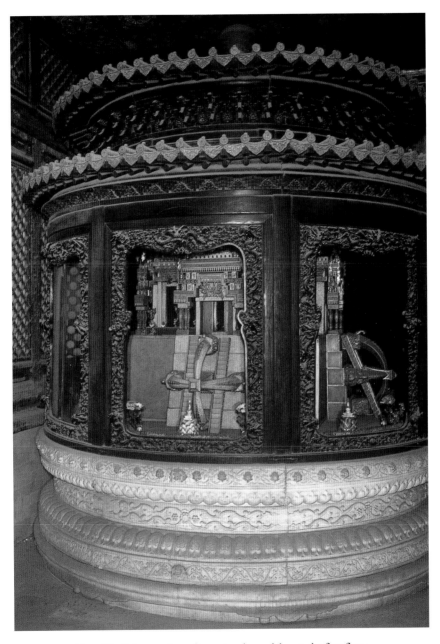

Plate 10. Yuhuage, three-dimensional mandalas on the first floor.
(Reproduced with permission of the Palace Museum, Beijing.)

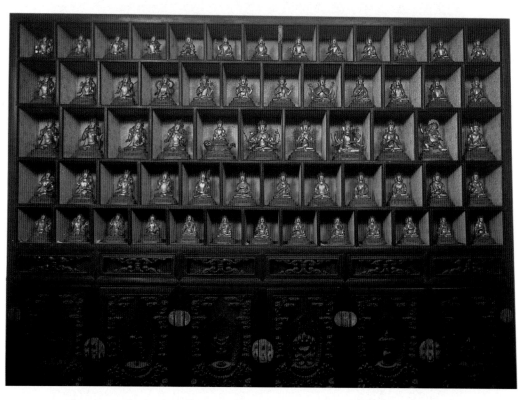

Plate 11. Fanhualou, second floor. Cabinet with figures from the Buddhist pantheon.
(Reproduced with permission of the Palace Museum, Beijing.)

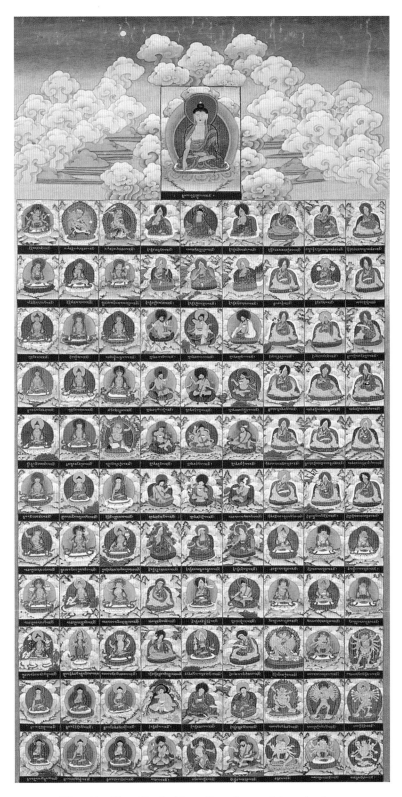

Plate 12. *Three Hundred Icons.* One of a set of three thankgas,
ink and colors on cotton. (American Museum of Natural History.)

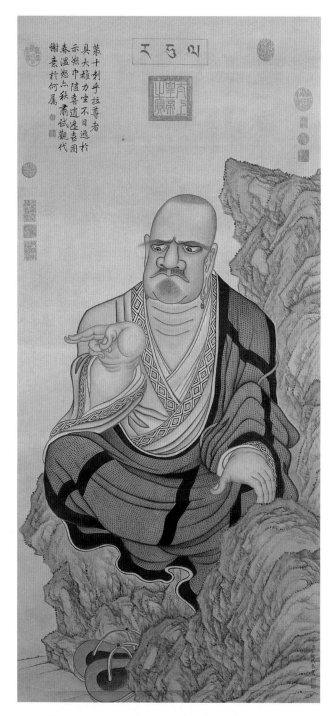

Plate 13. Ding Guanpeng, *The Sixteen Lohans. Rāhula*
(number 10) (National Palace Museum, Taipei.)
Copy based on Guanxiu's *Sixteen Lohans* from the Shengyin
Monastery, Hangzhou, 1758. One of sixteen hanging scrolls
(and a seventeenth depicting Śākyamuni Buddha),
ink and colors on paper. Each scroll 127.5 x 57.5 cm.
(National Palace Museum, Taipei.)

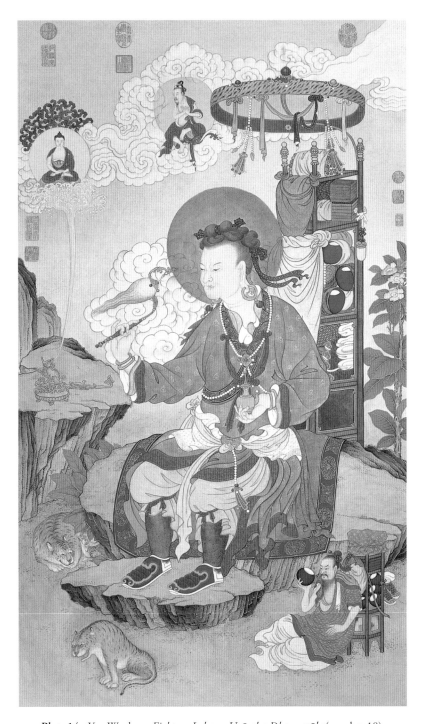

Plate 14. Yao Wenhan, *Eighteen Lohans: Upāsaka-Dharmatāla* (number 18).
One of a set of twenty-three hanging scrolls also depicting the guardians
of the four directions, all ink and colors on paper. 114.4 x 66.8 cm.
(National Palace Museum, Taipei.)

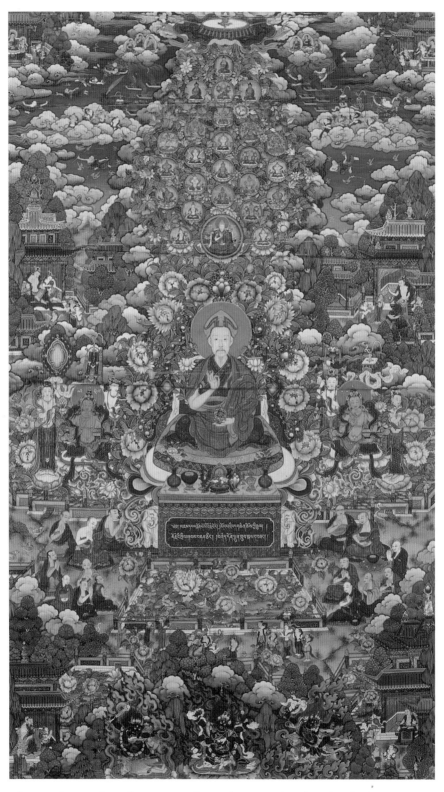

Plate 15. *Portrait of Qianlong as Mañjughoṣa-Cakravartin.* Thangka, ink and colors on cotton.
117 x 71 cm. (Palace Museum, Beijing; formerly in the Pule Temple, Chengde.)

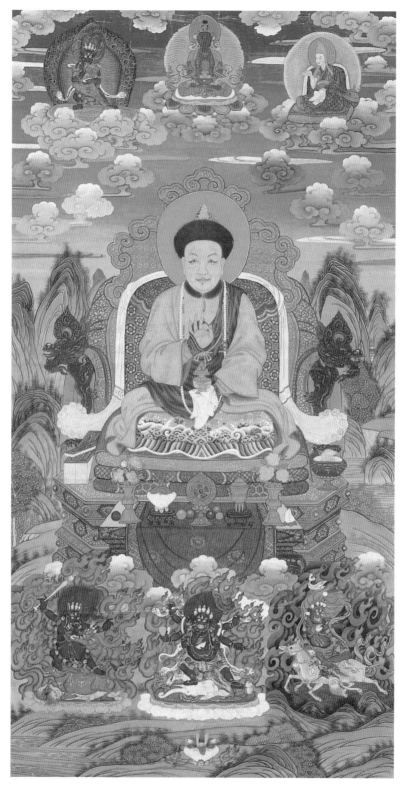

Plate 16. *The Sixth Panchen Lama in Court Dress*, 1780. Thangka, colors on cloth. 124 x 68 cm. (Palace Museum, Beijing.)

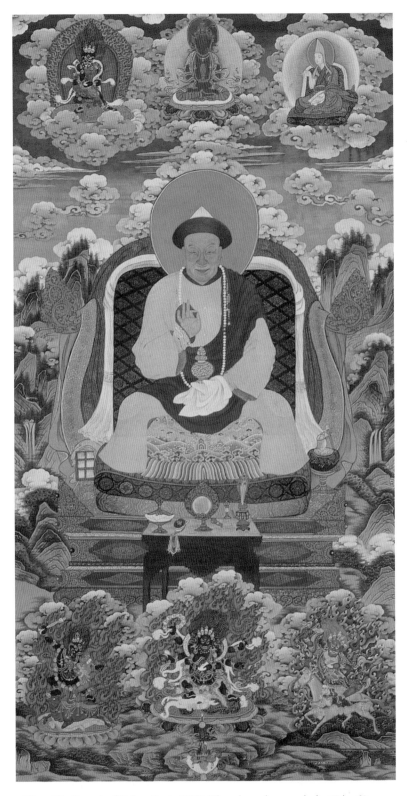

Plate 17. *Portrait of Rolpay Dorje,* 1787. Thangka, colors on cloth. 124 x 68 cm.
(Palace Museum, Beijing.)

This goal may help to explain why the building got its unusually evocative name: Yuhuage—the Pavilion of Raining Flowers. The name comes from one of Qianlong's favorite sutras, the *Vimalakīrti-nirdeśa*, and one of the most riveting moments in the debate between the layman Vimalakīrti and the bodhisattva Mañjuśrī when the Buddha's disciple Śāriputra is unable to keep the rain of flowers tossed by Vima's household goddess from sticking to him because of his continued addiction to the world of forms. Embarrassed, he makes matters worse when he insults the goddess' own spiritual achievements by asking why, if she is truly enlightened, she inhabits a woman's (that is, inferior) body. The goddess then famously switches forms with Śāriputra, leaving him totally bewildered and humiliated, though somewhat wiser than before. Those who are enlightened are not bound by form, her skillful actions show; gender and all the overt signs of difference are contingent, impermanent, meaningless. Qianlong, of course, had Ding Guanpeng paint him into this moment in his *Bu'er tu* (Nonduality picture), in midautumn of 1753, just a few years after the Pavilion of Raining Flowers was first completed and just a few months after its three great sculptural mandalas were ordered.[49] In Ding's painting, not even a petal sticks to the emperor-as-Vimalakīrti; he will shortly demonstrate his own profound understanding of the shallow contingency of form and language when he responds to Mañjuśrī's (paradoxically and simultaneously his own) cogent explanation of nonduality with an inarticulate belly laugh. Here, in the Pavilion of Raining Flowers and transmuting forms, physical reality also takes on a certain slipperiness: If things are not necessarily what they seem, perhaps they can be whatever the emperor imagines.

This sketch of the now-jumbled contents of the aptly named Pavilion of Raining Flowers suggests that as a designer of texts, images, and buildings, Rolpay Dorje favored complexity over simplicity, developing plans that served several purposes at the same time. His scheme for this initiation hall, which literally occupied the heart of the heart of the Qing empire, follows an ancient tradition set in Tibet by the Golden Temple at Tholing, by Samye, and by their Indian precedent, Odantipur. The venerable plan these buildings followed, based on the progressive wheel of teaching (Tibetan: *chökhor*; Sanskrit: *dharmacakra*), called for buildings of three stories that transported the would-be initiate through the different approaches of all three vehicles of Buddhist practice in the order the Buddha himself allegedly preached them.[50] The plan typically lays out the Buddha's biography through a succession of lives in Hinayāna fashion on the first floor, the Mahāyāna bodhisattva path on the second, and the Vajrayāna mystical union of female wisdom *(prajñā)* and male means *(upāya)* on the third. At sites like the early thirteenth-century Sumstek at Alchi (in modern Ladakh), a bit later in date than the Golden Temple (and designed under Rinchen Zangpo's inspiration, though not by him),[51] these three systems unite in the sculptures of three bodhisattvas (Avalokiteśvara, Maitreya, and Mañjuśrī), whose colossal forms pierce through the ceilings of the first and second floors so that their gazes finally rest on and illuminate the secrets revealed in the gender-switching mandalas at the top. This three-in-one approach appealed to the triplet-addicted Manchus also; in fact, they used it to organize the Beijing Red Kanjur, produced under Kangxi's patronage. The Tibetan-language Red Kanjur simply reverses the order of presentation: tantras first and sutras second. In the sutra class, Mahāyāna texts precede Hinayāna texts, and everything ends with *vinaya* texts (the rules of monastic life, most akin to the biographically anchored teachings of the earliest Buddhist texts).[52]

Rolpay Dorje's aim was a bit more complex than this: to honor a respected architectural model and to apply it to the four-part organization of the tantras, understood both as a table of contents for a collection of texts and as an evolving series of practical methods. His problem was somewhat akin to squaring the triangle: to take a tripartite scheme and make it work for a four-part system. His solution was to hide another floor between what appears from the outside to be the first and the second and, in doing so, reconcile the need for historical legitimacy with the highest standards of doctrinal purity. And, as we now know, this was not all Rolpay Dorje hid in the Pavilion of Rain-

ing Flowers. Side-by-side with the text-based system of the four types of tantra, which presents a temporally bound program through which the initiate is expected to progress in body and mind, there is also the partially articulated mandala of the temple's central deity, Guhyasamāja, which pervades the building as a static, incomplete shadow architecture. Finally, but hardly least, there is the discrete play made by the building and its contents to the political and personal purposes of prayer-as-practice, which Rolpay Dorje answered in the network of central images and peripheral wish-granting deities designed to serve the spiritual and material needs of his imperial patrons equally.

In this still incomplete scheme the Pavilion of Raining Flowers emerges as a building dedicated to the evolving private meditations of the emperor and his guru and also to a much vaster project: the protection of the nation. But how did this second goal work out in practice? Wang Jiapeng's meticulous combing of court documents shows that the building was the site of regular recitations of texts—part of an elaborate schedule of mandala offerings by monks who, he mentions, commuted daily into the Forbidden City from monasteries outside its walls.[53] The first floor, designed to support ritual performance, accommodated fifteen monks who made a mandala offering to Śākyamuni four times a year (eighth day of the third and sixth months, fifteenth day of the ninth and twelfth months). On the thirteenth day of every month, fifty monks (about all this small building could accommodate) gathered on the second, action-tantra floor of the building to make a mandala offering to Zunsheng Fomu (Sanskrit: Vijayā, or Victor). Ten monks made a mandala offering to Vairocana biannually (on the eighth day of the second and eighth months) on the third *yogatantra* floor; and on the fourth, supreme *yogatantra* floor, five monks made the "alms-giving, fear-removing" mandala offering on the eighth day of the fourth month. The choice of these offerings reflected the teachings and pantheons embodied in each floor, and the number of monks participating in each recitation—fifteen on the first floor, ten on the third floor, five on the fourth floor—decreased as the practice became more difficult and the space more inaccessible. But what should we make of the second floor, which outstripped all the others in frequency of offering (monthly) and manpower (fifty monks)? Its schedule emphasizes one particular deity, Vijayā, the goddess of victory and mother of buddhas, whose figure in bronze only appears once flanking Amitāyus on the back altar of the floor below. The especially intense ritual attention paid to Vijayā on the second floor suggests that successful *performance* and mundane results were really the point of Rolpay Dorje's multimedia design. What better way to transform private devotion into political display than to honor a goddess who promised victory and achievement on the second floor, a place dedicated specifically to the transformative virtues of skillful action?

Tower of Precious Forms (Baoxianglou): ca. 1771

The four-part scheme of the Pavilion of Raining Flowers is one of the clearest of all the many chapels devoted to Tibetan Buddhist practice in the Forbidden City—in fact, it seems to have been a prototype that was exploited creatively in at least two later buildings. Of these, one of the most intriguing and best known is a project that has received sustained attention in the West because it was meticulously, but only partially, documented by Baron von Staël-Holstein and his associate and photographer Benjamin March between December 1926 and February 1927.[54] This is the sculptural pantheon of 787 copper alloy figures once housed in the Baoxianglou (Tower of Precious Forms), a temple located in the garden of the Cining Palace, the residence of the empress dowager, Qianlong's mother. Von Staël-Holstein's photographs went to Harvard Library and were later published in 1937 by Walter Eugene Clark as one of *Two Lamaistic Pantheons*.

The Cining Palace appears in the 1744 edition of *Bidian zhulin* as the sole repository of Buddhist gifts to the throne written in Manchu, Mongolian, and Tibetan, all of which Rolpay Dorje himself cataloged. The palace is actually a complex of buildings surrounding a garden, and in the

mid-eighteenth century all of them were devoted to the empress dowager and other widowed impe-rial concubines. Three temples clustered around the main palace structure itself (the actual Cining Palace), and five more (the Baoxianglou, Ciyinlou, Jiyunlou, Xianruoguan, and Linxiting) stood in and around the garden. Of all of these buildings, the chapel in the rear chamber of the Cining Palace, called the Da Fotang (Great Buddha Hall), was the central site of the empress dowager's devotion,[55] but the sheer number and diversity of the chapels and temples in the vicinity of her palace give a keen sense of the breadth and depth of her practice.[56] Of all of these, the Baoxianglou, an icono-graphic project of almost dizzying scale, is by far the most sophisticated.

Clark concludes that the Baoxianglou with all its contents was most likely a special present Qian-long organized for his mother's eightieth birthday in 1771. Clark notes the escalation of Qianlong's flamboyant gift giving to his mother as she passed her milestone sixtieth and seventieth birthdays (by Chinese count) in 1751 and 1761, all thoroughly documented in the *Guochao gongshi*. This palace history says that for her sixtieth birthday she received a set of nine buddhas (probably all Amitāyus figures, the most potent symbol of boundless life) and another unquantified but "complete set" of Amitāyus buddhas. A decade later, when she turned seventy, Qianlong gave her more buddhas, the size of the gift seemingly calculated as a mathematical expansion of his earlier offering, because this time she got nine sets of Amitāyus buddhas (for a total of nine hundred figures), nine more larger sets of Amitāyus (totaling nine thousand), as well as a caravan load of smaller sets (nine times nine): nine buddhas (of unknown identity), nine Amitāyus buddhas, nine unidentified buddhas, nine more Amitāyus buddhas, nine bodhisattvas, nine buddha mothers, eighteen lohans (nine plus nine), and nine more unidentified buddhas.[57] The arithmetic brilliance and satisfying thoroughness of this gift concept was difficult to outdo, so it is indeed very likely, as Clark argues, that it was for his mother's eightieth birthday in 1771 that the emperor came up with an entirely new approach—the presen-tation of a complete pantheon laid out in the Baoxianglou. This gift does not appear in the supple-ment to the *Guochao gongshi*; but if his other projects are any indication, the carefully articulated nature of the Baoxianglou pantheon seems to suit the temper of Qianlong's mind during this period of his life. He himself turned sixty in 1771—making the year the occasion for a double jubilee during which he gifted himself with the most ambitious cataloging and reproduction project of his career, the *Siku quanshu*. The "Four Treasuries of All Books" was a compilation of titles culled in a review of ten thousand, three thousand of which, judged anti-Manchu, were purged and destroyed. The four copies of the 3,461 titles that made the final cut totaled 2.3 million pages, all hand-copied in shifts by 3,826 scribes.[58] In the same year, Qianlong also ordered the compilation of the *Nanxun shengdian*, the "Magnificent Record" of his southern tours, which documented and rhapsodized four of his trips through the southern part of the empire in a relatively spare six thousand pages.[59] And it was in 1771 that he also set a whole crew of young Hanlin scholars, the same bright new stars who would two decades later produce the supplement to the *Bidian zhulin* and *Shiqu baoji*, to copy-ing hundreds of volumes of Buddhist sutras as another present for his mother.[60]

The Baoxianglou is a two-story building situated just to the east of the Xianruoguan, also a Buddhist temple. It was finished in 1653, over a century before Qianlong decided to put it to new use for his mother's pantheon. Von Staël-Holstein and March were only able to document the pantheon on the second floor before the Palace Committee ordered them to discontinue their project (which was to have covered the entire Cining Palace complex) even before they could move on to the first floor. The second floor was in disarray, at least in part; of the 787 original figures, 31 had been stolen (although the thieves left behind ten empty, but inscribed, pedestals). What remained, however, was extraordinary: a storehouse of three-dimensional deities, each clearly identified on its lotus pedestal in Chinese and bearing the Qianlong reign mark. The second floor had seven separate chapels in all arranged in a row running north to south and linked by a corridor at the front of the building. The

central chapel held a single, life-sized image of the Gelukpa founder Tsongkhapa on a central altar. In the other six chapels, three to either side, similar central altars each had nine figures. On both of the side walls of these six chapels, partitioned cabinets each held 61 figures in five horizontal rows of 13, 12, 11, 12, and 13. The original total, including Tsongkhapa, therefore reached 787: (6 x 9) + 6(2 x 61) + 1.

Given the satisfying symmetries of these large numbers, it is the arrangment of the hundreds of components that make up the Baoxianglou pantheon which almost inevitably takes front stage, rather than the qualities of each individual sculpture. Yet without ensuring the uniqueness of each figure, a point insisted upon in the careful differentiation and identification of each, the whole assemblage would not have the same wondrous impact of thoroughness. The figures were mostly wrought in the elegant, ultimately Nepalese-derived style that the Manchus borrowed from, among other places, the Ming Yongle court and the works of such Outer Mongolian artists as Zanabazar but embellish slightly by playing on the multiple tonalities of partial gilt. They are clearly the work of many different hands—notice-

Figure 29. Baoxianglou, *Śākyamuni Buddha*, chapel 1. Partial gilt bronze. (After Clark, *Two Lamaistic Pantheons*, p. 6.)

able, for example, in the very different facial types of the major bodhisattvas and buddhas of confession who surround Śākyamuni in Chapel 1 (Figure 29). Some of these have the almost hawklike nose and chin of Zanabazar's style (as in Clark's 1 A 3–4); others reveal the slightly swollen features (Clark's 1 M 6 and 8)—the apple cheeks, diminutive, rounded chin, bee-stung lips, and puffy eyelids—of Buddhist figures of the Ming Xuande period (1426–1435).[61] The multi-armed group presented in the more esoteric chapels fall prey to cookie-cutter sameness, identified only by the movable attributes they clutch in their many hands. What they suggest is that, with one flick of an attribute, they could transform into someone else.

March also photographed the large indigo-blue plaques in each chapel, written in the four languages of the empire, which explained exactly how each chapel's pantheon of 131 was tied to text and practice, just as in the Pavilion of Raining Flowers. Only now, instead of four levels of tantra, the pantheon breaks down into six parts: one devoted to the Mahāyāna Prajñāpāramitā (essence of wisdom sutras), the other five to tantra. The supreme *yogatantra* class, moreover, has been split into two different chapels, making the very different goals of the father and mother supreme *yogatantra* more distinct (see Table 2).

If we compare the bronze figures from the Pavilion of Raining Flowers with this larger display, several interesting points emerge. First, all the main figures in the pavilion were also main figures in the Baoxianglou; in fact, the vast majority of figures in the first also appeared on the central altars of the second. Guhya-Akṣobhyavajra (or Guhyasamāja) in Chapel 2 (specifically representing father tantras), Sarvavid-Vairocana in Chapel 4, Vairocanābhisambodhi in Chapel 5, and Amitāyus in Chapel 6 of the Baoxianglou correspond to the main deities of the fourth, third, second, and first floors of

Table 2. Classes of Text and Practice and Main Deities in the Chapels of the Baoxianglou (numbering of chapels follows Clark 1937)

	Chapel 1	Chapel 2	Chapel 3	Middle	Chapel 4	Chapel 5	Chapel 6
Text class	Prajñā-pāramitā class	Supreme yoga class—father tantras	Supreme yoga class—mother tantras		Yoga class	*Caryayoga*—action-ritual class	*Kriyayoga*—devotion class
Main figure	Śākyamuni	Guhya-Akṣobhya-vajra	Śaṁvararāja	Tsongkhapa	Sarvavid-Vairocana	Vairocanā-bhisambodhi	Amitāyus

the Pavilion of Raining Flowers. But there were three new casts of characters in this horizontally expanded space: Śākyamuni now represented the Prajñāpāramitā sutra class and Śaṁvararāja (another form of Śaṁvara) took center stage in Chapel 3, especially set aside for generating the inner heat of the mother tantras. Tsongkhapa presided over the entire pantheon as founder of the Gelukpa, turning the entire second floor into a three-dimensional tree of refuge with the great reformer at the center.

A glance at these diagrams of Chapel 1 (Table 3) suggests that the designer of the Baoxianglou was committed to patterns based much more on arithmetic game playing than on symmetry. In fact, looking at the blended groups of figures—disciples and lohans, saints and lamas, fading into waves of buddhas of times past and buddhas of confession (visually undifferentiated as separate groups)—is very much like taking a microscopic but random glimpse at a portion of a much larger pattern, like, for example, a piece of intricately woven, polychromatic brocade. Such a clear vignette of the fabric of the "weave" convinces us that what we see is only part of a carefully articulated but indiscernible pattern that can only be understood by digesting a huge sample of equally tight views (or by taking a huge step backward to take in the whole). The other chapels in the Baoxianglou are set up in a similar way, even though the flavor of each is distinctive.

The next two chapels, devoted to supreme yoga of the father and mother tantras, once exploded with *yab yum* couples, benign and fierce, and wildly dancing *ḍākinī*. There were also other deities in supernatural classes, including *krodha* (fierce) guardians, devas, garudas, and benign, crowned bodhisattvas. The chapels on the other side of the central chamber were much calmer. Chapel 4 *(yogatantra)* presented a benign pattern of buddhas, Pāramitas, bodhisattvas, buddha mothers, and crowned buddhas. Chapel 5 *(caryatantra)* was full of Tārā figures, buddha mothers, Amitāyus, bodhisattvas, minor gods and goddesses, many Vijayā figures, and, to counter this sweetness, a host of fierce, horse-headed Hayagrīvas. Finally, Chapel 6 played to *kriyatantra* with wish-granters of all sorts: Mārīci, Tārā, Vijayā, Avalokiteśvara, Jambhala, Vaiśravaṇa, and other wealth-producing kings squeezing their gold-spitting mongooses.

Thinking about the Baoxianglou, even given von Staël-Holstein and March's meticulous records and Clark's systematic reconstruction of its original layout, still has to be an act of imaginative reconstruction, a process aided by a computer that places, encodes, and remembers buddhas and all their diverse company with a keystroke. The building has long been stripped of its contents, March's photographs were not taken in situ and are sadly incomplete, and we have no detailed information about the deployment of the spaces on first floor. The pursuit of the building as it once was is also fraught with all the difficulties—indeed, the impossibility—of reexperiencing or even contemplating someone else's visionary life. But of course from the outset the Baoxianglou was a site specifically designed to provoke a memory of something not yet consciously apprehended but always there, precisely by invoking the visionary lives of earlier practitioners, just as its name—Tower of Precious Forms—suggests. It was also apparently very successful in this mission. Just a few years after it was completed,

Table 3. Baoxianglou: Chapel 1

Case A (left wall)

Buddha of Confession	Bodhisattva	Bodhisattva	Bodhisattva	Bodhisattva	Buddha	Buddha	Buddha	Buddha	Bodhisattva	Bodhisattva	Bodhisattva	Bodhisattva
Buddha of Confession	Buddha of Confession	Buddha of Confession	Buddha of Confession	Buddha		Buddha	Buddha	Buddha	Buddha	Buddha	Buddha	Buddha
Tsongkhapa	Milarepa	Buddha of Confession	Buddha of Confession	Buddha of Confession	Buddha of Confession	Buddha of Confession			Buddha	Buddha	Buddha	Buddha
Buddha of Confession	Buddha of Confession	Buddha of Confession	Buddha of Confession	Buddha of Confession	Buddha of Confession	Buddha of Confession	Buddha of Confession	Buddha of Confession	Buddha of Confession	Buddha of Confession	Buddha of Confession	
Buddha of Confession	Buddha of Confession	Buddha of Confession	Buddha of Confession	Buddha of Confession	Buddha of Confession	Buddha of Confession	Buddha of Confession	Buddha of Confession	Buddha of Confession	Buddha of Confession		

Central Altar

Maitreya	Varnaviṇkambhin	Avalokiteṇvara	Mañjuṇrī	Śākyamuni	Vajrapāni	Kṣitigarbharājā	Akāṇagarbha	Samantabhadra

Case B (right wall)

Disciple	Disciple	Disciple	Disciple	Buddha	Buddha	Buddha	Buddha	Lohan	Lohan	Lohan	Lohan	Lohan
Disciple	Disciple	Disciple	Disciple	Buddha	Buddha	Buddha	Buddha	Lohan	Lohan	Lohan	Lohan	
Buddha	Buddha	Buddha	Buddha	Buddha	Buddha	Buddha	Buddha	Buddha	Buddha	Dalai Lama		
Lohan	Lohan	Lohan	Buddha	Buddha	Buddha	Buddha	Buddha	Buddha	Buddha	Buddha	Buddha	
Lohan	Lohan	Lohan	Lohan	Buddha	Buddha	Buddha	Buddha	Buddha	Buddha	Buddha	Buddha	Buddha

in 1774, Qianlong had yet another temple designed in the Forbidden City, this one in the northeast corner, close to what would eventually become his retirement palace. This building, the Fanhualou (which publications of the Palace Museum render in English as Hall of Buddhist Brilliance, though perhaps "Flowering" or "Efflorescence" would be closer), is largely intact and its plan, though not an exact duplicate of the Baoxianglou's, has much in common with what we know of the earlier building and its pantheon.

Hall of Buddhist Efflorescence (Fanhualou): ca. 1774

The name of the building is provocative. *"Fan"* has many meanings; a basic sense is "pure and clean"; in later Buddhist literature, it came to mean "Brahman," that is, Indian. It can also refer to "prayer" in the sense of mantras and sacred texts or, more broadly, to the Sanskrit language and alphabet. *"Fan"* can also mean "Buddhist" (as in *fansheng*, the "voice of the Buddha," or *fanyu*, "Buddhist monastery"). But the unusual combination of *"fan"* and *"lou"* also suggests a deliberate play on the *Fanfulou*, the second Brahmaloka, that is, the second region of the first *dhyāna* heaven of form. If the Baoxianglou was once a "Tower of Precious Forms," then the Fanhualou still is. Just as in the

earlier building, its first- and second-floor chapels hold a basic pantheon of 787 sculptures (with an additional large standing image of Śākyamuni in the ground-floor entry and a second figure of Tsongkhapa added in 1781); 732 of these are arrayed in the six side chapels on the second floor in staggered pigeonholes; another 54, nine per chapel, sit on central altars, exactly as they did in the Baoxianglou (Plate 11).

All the decorations and fittings on both the first and second floors of the Fanhualou, however, remain in excellent condition. All this helps clarify the many goals of the building as a site of ritual, supplication, and meditation and at the same time sheds light on what the Baoxianglou must once have been. The most striking feature of the building is unique, though. After the shock of encountering the 210-centimeter-tall, silk-robed figure of Śākyamuni, larger than lifesize, that stands with his hand raised in greeting on top of a marble altar in the entry hall, the visitor is outflanked by six

immense cloisonné enameled stupas that balloon out in the first-floor chapel alcoves, three to either side (Figure 30). These stupas are a bit taller than the first floor can accommodate—by design—and their *harmika* spires pierce through square openings in the ceiling. All six have the Qianlong reign mark on their bases, where they are also dated specifically to 1774. Since their design is so integral to the building, these inscriptions provide an important terminus for the Fanhualou's decoration as another tower of forms.

Here, as in the Baoxianglou, is a display that serves many different needs from the explicitly material (Vaiśravaṇa and the desire for wealth, Bhaiṣajyaguru and well-being or good death) to the formal requirement of paying homage to a lineage of teachers (Śākyamuni and Tsongkhapa) and the clearly specified inner goals of different supreme *yogatantras* (inner heat, a buddha body, clear light)—all incorporated into a graduated, multiple path toward enlightenment (Table 4). Here, also, the integrity of the building's physical fabric is deliberately dissolved when its six stupas, symbolizing the relic body of the Buddha and significant moments in his life, pierce through the ceiling and penetrate into the upper level. What, then, is the real message of this new tower of forms? What it is not, I would guess, is simply to proliferate forms mindlessly. Rather its design seems to question the very integrity of form— an utterly Buddhistic end it accomplishes by forcing the limits of the building's structure and by presenting the essentially open set of the pantheon as paradoxically both closed and shifting. The more the size and specificity of the pantheon increase, the clearer we can see that there is really

Figure 30. Fanhualou, first floor. Cloisonné stupa, dated 1774. (Reproduced with permission of the Palace Museum, Beijing.)

Table 4. Array of Images on the First and Second Floors of the Fanhualou

	Kriyatantra	Supreme yoga—father tantras	Supreme yoga—mother tantras		Prajñā pāramitā	Yogatantra	Caryatantra
2	122 sculptures + 9	122 sculptures + 9	122 sculptures + 9	Tsong-khapa + 2 figures	122 sculptures + 9	122 sculptures + 9	122 sculptures + 9
1	Vaiśravaṇa (thangkas) Stupa	Guhyasamāja (thangkas) Stupa	Śaṁvara (thangkas) Stupa	Standing Śākyamuni (sculpture)	Bhai-ṣajyaguru (thangkas) Stupa	Mārīci (thangkas) Stupa	Vijayā (thangkas) Stupa

no end in sight; there will always be new, as yet unknown, characters in this play, each symbolizing some other nuanced, momentary aspect of "rounded consciousness." What the shapes subtly morphing in the Tower of Buddhist Efflorescence finally suggest is that any accumulation or aggregate of forms (Sanskrit: rūpaskanda; Chinese: seyun) is contingent, phenomenal, and empty, with no claim whatsoever to permanence. What we call the material world is really just another "in-between" state, like the transition from death to rebirth or the life lived in dreams.[62]

The Shifting Pantheon

All these sculptural pantheons, as Wang Jiapeng has said many times, were really private rather than public constructions, formalized embodiments of inner musings on the nature of form and emptiness. They are thus, as Wang also argues, material "proof" of Qianlong's devotion to Buddhist practice, a lifetime of habit and curiosity that has most often been characterized as cynical or, at best, pragmatic by scholars who have based their opinions on the very late (and expedient) edict of 1792, Lama Shuo. But Lama Shuo, composed years after Qianlong's guru's death, is also a most public and political document, as its placement on a stele in the very middle of the Yonghegong, itself the centerpiece of Tibeto-Mongolian Buddhism in Beijing, attests. The question that begs to be answered is: What lies between the exquisite privacy of the Pavilion of Raining Flowers and the public, angry denouncement of the Tibetan Buddhist establishment in Lama Shuo?

Qing court documents demonstrate over and over again that the man behind the plan at the Pavilion of Raining Flowers was Rolpay Dorje, who even provided sketches for some of the decorative details of the building, including those added decades after its inauguration in 1750. Rolpay Dorje's biography corroborates these facts and is especially valuable in the way it specifically connects his work in Beijing to legitimate sources in Tibet and India. The standards for chanting, translation, ritual conduct, and music Rolpay Dorje generated (expedited by scores of multilingual scholars and scribes commandeered from the Lifanyuan) were born, it seems, out of Qianlong's intrusive, incessant concern for getting things right at home and his sense that the sands were always shifting, especially as his confidence in his own practice grew stronger. The authority of the standards Rolpay Dorje established for the emperor eventually reached beyond the court and into the Tibetan and Mongolian Buddhist community.[63]

This chain of events—from private ordering to public example—is especially clear in the instructional pantheons Rolpay Dorje created at Qianlong's request, the most influential of which were the painted album, Zhufo pusa shengxiang zan (In praise of the sacred images of all the buddhas and bodhisattvas), last seen in the Beijing National Library, and the woodblock-printed Three

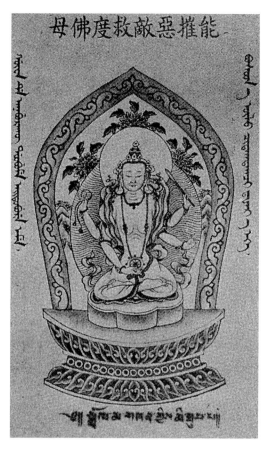

Figure 31. Aparājitā-Tārā. From *Zhufo pusa shengxiang zan* (All the buddhas and bodhisattvas) album. Ink and colors on paper. (After Clark, *Two Lamaistic Pantheons*, p. 213.)

Hundred Icons, in print almost continually since its creation. The pantheon of *All the Buddhas and Bodhisattvas,* despite its greater scope, is probably the earlier of the two. Still, the *Three Hundred Icons* is not a simple culling from an original three hundred and sixty but represents a somewhat different approach to bringing a slightly altered universe of Buddhism into order for a very separate purpose.

All the Buddhas and Bodhisattvas is a unique, internal document—an exquisite, hand-painted album intended to be a source for representing, naming (in all four languages of the empire), and eulogizing (in Chinese) three hundred and sixty representatives of twenty-three classes of beings, including the greatest masters in several Indian lineages, the buddhas of eight different classes, a dozen different forms of Mañjuśrī and Avalokiteśvara, the deities of Vairocana's mandala, all kinds of bodhisattvas and buddha mothers (female protectors, Tārās and *ḍākinī*), lohans, guardians, gods of wealth, and miscellaneous fierce protectors (Figure 31).[64] Walter Eugene Clark, who published von Staël-Holstein's photographs of the album as the second of his *Two Lamaistic Pantheons*, says that the album was most likely the model for innumerable *tsa tsas*, Tibetan-style gilt clay votive plaques, that bear the Qianlong reign mark and the names of the deities in four languages; Von Staël-Holstein claims to have found more than a hundred of the bronze molds used to make these *tsa tsas* in the antique shops of Beijing, presumably in the late 1920s. These molds and the entire pantheon of *All the Buddhas and Bodhisattvas* are similarly numbered using a two-part system of large and small numbers indicating the category of each piece and its precise place in its category.[65]

Luo Wenhua suggests that the subject matter of the thangkas in the Pavilion of Raining Flowers helps place the creation and compilation of *All the Buddhas and Bodhisattvas* sometime between 1750 and 1756.[66] His reasoning is this: The Chinese versions for the names of the horrific guardians of the ten directions and the twenty-one Tārā figures in the thangkas are basically the same as those in *All the Buddhas and Bodhisattvas*. The names of deities who were already long known to Chinese Buddhists have well-established Chinese names, he argues; often these have little to do with their Tibetan names. (These Chinese names may be translations or transliterations of the original Sanskrit and therefore can either carry descriptive meaning or attempt to "spell" the Sanskrit name to capture its sound.) But Tārā was a newcomer to China,[67] despite her long history in Tibet and India, and the Chinese versions of her twenty-one names in the pavilion faithfully follow Tibetan meaning while also conforming to Chinese style. In other words: The names are translations from the Tibetan, but they also formally answer Chinese taste in their symmetry (each adds four characters to the four that mean "Tārā," that is, Savioress Buddha Mother, Jiudu Fomu), making them easier

to recall for chanting. Whoever came up with these names was clearly expert in the Tibetan language, as well as in spoken and canonical Buddhist Chinese, and this man, Luo says, could only have been Rolpay Dorje.

Moreover, Luo notes that the arrangement of many of the deities in the pavilion thankgas also corresponds to *All the Buddhas and Bodhisattvas*. These include the seven buddhas of the past, the bodhisattvas of the ten worlds, the five protective *fomu*, and the ten fierce protectors, as well as the twenty-one Tārā figures. There are, however, many differences. Given these divergences, in Luo's view *All the Buddhas and Bodhisattvas* cannot have been completely formulated in 1750, when the pavilion was redesigned as Qianlong's initiation hall. A court document dated to 1756 supports this assumption and corroborates von Staël-Holstein's thinking about the uses of the pantheon as a design model for *tsa tsa* molds. It states that the same eunuch who supervised the pavilion project, Hu Shijie, responding to a command from Prince Zhuang (Qianlong's uncle, Yinlu), transmitted the instruction to produce 360 gilt metal molds for 360 different figures to be set up for viewing behind glass doors over three floors, 120 per floor, in the Yangxindian, Qianlong's residence.[68] These numbers alone suggest they were based on a specific authoritative source—most likely Rolpay Dorje's 360-figure *All the Buddhas and Bodhisattvas*, completed sometime between the 1750 of the Pavilion of Raining Flowers and the 1756 of the mold order. (This reasoning is incidentally sustained by the absence of the Eighth Dalai Lama in this huge pantheon—his previous incarnation, the Seventh, lived until 1757.) The entire plan, moreover, seems like a foreshadowing of the much larger pantheons cast for the Baoxianglou and Fanhualou in the 1770s. It was a huge project, in other words, with an intensely private aim.

This date of around 1750 to 1756 for *All the Buddhas and Bodhisattvas* also makes a great deal of sense when held up against some of Qianlong and Rolpay Dorje's other, later projects. If Luo is correct, by 1756 the Qing court, thanks to Rolpay Dorje, already had at least one orderly system for naming, numbering, systematizing, and displaying recurring groups of images, particularly the ranks of buddhas, bodhisattvas, Tārā figures, protectors, great masters, and lohans. Thus when Qianlong visited the south on one of his many grand tours in 1757 and saw China's consummate lohan paintings, the set of sixteen done by the late-Tang-dynasty monk Guanxiu for the Shengyin Monastery in Hangzhou, he immediately recognized that they were out of order from the Tibetan point of view. This may seem like a small point, but such details were the essence of the all-encompassing, precise orthopraxis Qianlong longed for and which, coincidentally, was also supported by the methods of evidential research.[69]

To push Luo Wenhua's analysis a bit further, though, *All the Buddhas and Bodhisattvas* was an internal document, the refined product (as he sees it) of a pragmatic construction, the Pavilion of Raining Flowers, executed on behalf of the Manchu imperial family's private practice, possibly organized by Qianlong's uncle Yinlu to benefit Qianlong and the empress dowager. It is likely to have served as an iconographic aide-mémoire for subsequent projects, the equally private set of molded images for the Yangxindian, and, at the very least, another set for the empress dowager in the Xianruoguan, where it helped stabilize momentarily the complex hierarchies and systems of attributes of a subtly transforming series of figures. There is no evidence that *All the Buddhas and Bodhisattvas* evolved into the single, authoritative source for artisans working in the Forbidden City, however, nor does Luo suggest that this was so. On the contrary, Rolpay Dorje rarely reproduced the same system twice. But often his systems did urge certain subtle lessons, both spiritual and political.

First and foremost, *All the Buddhas and Bodhisattvas*, unlike the pantheon of the Pavilion of Raining Flowers, presents the essential Tibetan principle of the centrality of the guru. Buddhism in general proposes the refuge of the Three Jewels—Buddha, Dharma, and Sangha (the community of monks). To this refuge its Tibetan inflection adds Three Roots—the lama, the *yidam* (personal

meditational deity), and the *dharmapāla* and *ḍākinī*, who represent powerful internal energies. Thus Rolpay Dorje's first pantheon-as-album begins with ten Indian masters of the Prajñāpāramitā (Nāgārjuna, Asaṅga, Āryadeva, Vasubandhu, and others); eight *mahāsiddha* (masters of tantric practice); and ten Tibetan masters, beginning with Atīśa and his lineage, through Tsongkhapa and his immediate disciples, to the Seventh Dalai Lama, Kalsang Gyatso (1708–1757).[70] Only after this impressive array of teachers and practitioners do we see the buddhas themselves, *dharmapāla* and *ḍākinī*, lohans, gods of wealth, and protectors. The album thus forcefully asserts the primacy of lamas over would-be students and calls for their acceptance as the living embodiment of the symbolic system that follows. This hierarchy was briefly a bone of contention in the relationship between the Mongol emperors of China and their Tibetan gurus in the Yuan dynasty, which Khubilai Khan resolved by agreeing to sit at the same level as his guru, Phagpa Lama, "as sun and moon," creating a newly explicit epistemological split between political and spiritual realms. Though Qianlong never formally adopted this *chöyon* (lama/patron) relationship of the Mongols (eventually denouncing the Mongols in his *Lama Shuo* for their slavish adoration of lamas and their use of the title "Dishi," Imperial Preceptor), he did overtly demonstrate his obeisance to Rolpay Dorje on more than one occasion, sitting at the same level with him, kneeling before him—even, shockingly, touching his head to his guru's feet.[71]

The album pushes this same message visually in a number of ways by positioning teachers upfront and by the consistent rhythm of its images over 360 pages. All 360 images occupy the same space (just as in the Baoxianglou and Fanhualou), one to a page, set against a eulogizing *stotra* on the opposite page. This plan gives its human protagonists the same setting as its fully evolved ones. (The meaning, of course, is that these teachers, guardians, bodhisattvas, and lohans are all equally buddhas). Each figure sits or stands on the same type of double lotus pedestal, strangely tipped up to reveal a lozenge-shaped base, upon which stands an ogival aureole, all exactly repeated 360 times. Each unit is framed by identifications written in the four languages: Chinese on top, Tibetan on the bottom, Manchu and Mongolian left and right. These consistent frames and their central subjects must have been the product of an assembly line of specialists: throne and aureole painters, multilingual scribes, and a battery of figure painters. (All of them, I would hazard, were well trained in the delicate, pastel tonalities of the Chinese tradition, and even aware of European modeling, but frankly disarmed by the world of Tibetan painting with its suave nudes, skeletons, and anatomically convincing multi-limbed deities.)

Despite the restrictions of the format, these painters created all kinds of supplementary thrones, bases, and vehicles for their subjects: flat, plain, or foliated pods, lotuses that float on bubbling water, carts, flattened animals and humans, miniature mountain ranges, benches, thrones, piles of leaves, even a garland of hearts. Rays of light fan out behind each figure, creating a sensation of the luminosity that comes in meditation, and layered behind these radiant aureoles are miniature landscapes, clouds, strange rocks, and licking flames. The artists who produced *All the Buddhas and Bodhisattvas* apparently found their way to a certain kind of liberated invention in their handling of essential decorative elements. The result is an album that has the impact of a miniature collection, a true *duobaoge* (treasure box), with all the allure to introspection and dreaming of something small, jewel-like, compact, and assertively but improbably complete.

The so-called *Three Hundred Icons* (Tibetan: *sKu brnyan brgya phrag gsum*), with an undated preface by Rolpay Dorje in Mongolian and Tibetan, is a very different sort of production best known in its many xylographic editions (Figure 32).[72] Some of the categories of this pantheon are notably different from *All the Buddhas and Bodhisattvas*. Despite its shorter length, for example, it devotes much more space to masters of various times, places, and disciplines (fifty-one versus twenty-eight in *All the Buddhas and Bodhisattvas*). This emphasis makes sense—especially if, as its mostly monolingual, Tibetan presentation suggests (against the mostly Chinese text of *All the Buddhas and*

Bodhisattvas), the *Three Hundred Icons* was intended for an audience of Tibetan-style monks with broad theoretical and practical interests. There are a few other discrepancies in focus rather than organization. The *Three Hundred Icons* exalts Mahākāla, the protector deity of the Mongols, and his retinue, which further suggests that the text may have been intended to serve an audience of Mongolian monks who could read Tibetan (such as the large groups resident at the Yonghegong, the Yellow Monastery, and other monasteries in Beijing). By contrast, *All the Buddhas and Bodhisattvas* downplays Mahākāla by positioning his forms near the end (even though there are still eight of them) in favor of the many transformations of Mañjuśrī and Avalokiteśvara, along with the whole mandala of Vairocana.

There is yet another substantial difference between these two collections: *Three Hundred Icons* is not simply an iconography but also an authoritative compilation of masters and deities together with Rolpay Dorje's sanctioned versions of their mantras and *dhāraṇī* rendered in Tibetan. In other words: The two works serve different functions as well as different audiences—the first designed to delineate each figure's visible attributes clearly (in a blended Tibeto-Chinese style) and to establish the names of each in four languages, probably as a pattern book for an audience of court artists, the second to present each figure's visible *and* audible forms for an audience of practicing monks. The *Three Hundred Icons* filled a significant void—it was an incontrovertible work in which Rolpay Dorje brought together three hundred figures he chose from any number of written *sādhana* collections in a small, portable handbook of one hundred pages measuring about 23 by 7.6 centimeters. Its earliest editions bear all the marks of imperial patronage—red ink; fine line quality; soft, smooth paper; a silk and paper cover lined in gold- and silver-flecked paper—equivalent in many ways to the Kangxi emperor's Red Kanjur even though lacking an imperial colophon.[73]

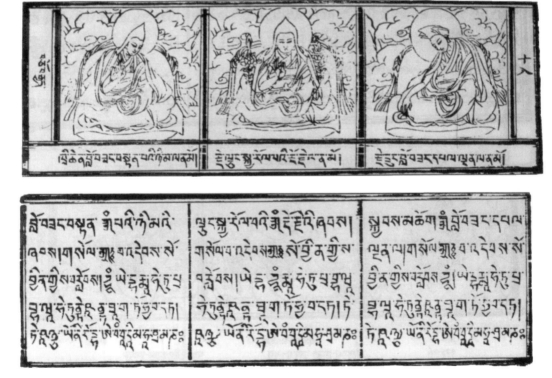

Figure 32. *Three Hundred Icons*, p. 18 (Trichen Losang Tenpi Nyima, Rolpay Dorje, Jedrung Losang Palden), with preface attributed to Rolpay Dorje. Woodblock-printed book, red ink on paper. 23 x 7.6 cm. (Courtesy of the East Asian Library, University of California, Berkeley.)

The latest possible date for the publication of the *Three Hundred Icons* can be broadly approximated because Rolpay Dorje included a group of prominent Gelukpa gurus in his assemblage—most of them representing an incomplete selection of Dalai and Panchen Lamas (the First, Fifth, and Seventh Dalai Lamas, surprisingly excluding the Third;[74] and the Second, Fourth, Fifth, and Sixth Panchen Lamas), as well as the Fifty-fourth Thrichen (Great Throne) of Tibet's Gandan Monastery, Ngawang Chöden (1677–1751; see Chandra, *Buddhist Iconography,* no. 49). The last three gurus are Rolpay Dorje himself (Chandra, no. 53) flanked by two of his closest associates in the Qing religious hierarchy: his tutor, the Gandan Shiregetü Losang Tenpay Nyima (1689–1772; Chandra, no. 52), and Jedrung Losang Palden (known in Chinese as the Jilong Khutukhtu; Chandra, no. 54).[75] The death of the Seventh Dalai Lama in 1757 or perhaps even the death of the Fifty-fourth Thrichen of Gandan in 1751, along with the absence of their already initiated reincarnations, may provide a terminus for the production of the *Three Hundred Icons* in one of the most productive decades of Rolpay Dorje's life. (Or these absences may reflect the fact that the Eighth Dalai Lama was simply too young to be included.) More accurately, these dates provide a shaky terminus for Rolpay Dorje's compilation and his preface; the work may well have been xylographed long afterward as an homage to him from his disciples.

The *Three Hundred Icons* systematizes the pantheon by organizing everyone into triads, which results in sometimes incongruous juxtapositions when some of the larger groups of figures are not divisible by three. But the choice of three is more than simply expedient. The first threesome, Maitreya (left), Śākyamuni (center), and Mañjuśrī (right), simultaneously symbolize Buddhism's immediate present and future. That these three figures are not simply to be read as an arbitrary grouping (unlike many of the others that follow) is apparent in the way they have been rearranged in a set of three thangkas now in the American Museum of Natural History (for example, Plate 12). These three paintings, all in brilliant color, each portray one hundred figures: ninety-nine in the main grid of nine figures across and eleven down plus a single, larger figure presiding over the pantheon below. These three are Śākyamuni, Mañjuśrī, and Maitreya, with the first, second, and third parts of the pantheon arrayed below them respectively in three columns each three figures wide. (Note the significant shift in order to privilege Mañjuśrī.) This arrangement is geometrically satisfying but causes significant ruptures in the larger groupings of figures that run down the center three columns, then over to the right three columns, and on to the left three, reproducing the pages of the book triad by triad. The deities of the four classes of tantras (Chandra, nos. 64–96) thus begin in the bottom right three columns of the first thangka (headed by Śākyamuni), then move on to the upper right three columns; the thirty-five buddhas of confession (Chandra, nos. 97–131) begin at the bottom left three columns of the first thangka and continue in the middle three columns of the second; the eighteen lohans (Chandra, nos. 193–210) span the bottom left of the second and the middle columns of the third; and so on. Quadruplets, such as the four *lokapalas* (Chandra, nos. 280–282 and 284), follow the arrangement of the printed book, with three of the four grouped together (as on a single page) and the fourth placed in the middle of the next triad, forming a group much like an interlocking puzzle piece. These 297 units, all perfectly equivalent in size, and their differently numbered groups now link together to form the whole picture, which asserts no real hierarchy—except that of its three presiding deities—and finally blends into a balanced, complete field of assembly where identity is a matter of association and location.

Such a set of thangkas is more likely to have served as a reference chart for artists than for practitioners. All extraneous information is eliminated, making each image extremely clear in its equivalent space, and each group of figures, despite the draconian grid, is relatively easy to spot because the energies they generate are so different (famous teachers in their special headgear; quiescent meditating buddhas and bodhisattvas; active *ḍākinī,* enflamed, multi-armed guardians). An interesting

point of depiction is that the deities whose bodies are colored red, blue, green, white, and yellow in Tibetan paintings are all skin-toned here, even when their inscribed names explicitly prescribe their colors. Is this because Chinese artists chose to shift alien attributes into different, more conventional categories (such as clothing) or because Mongol or Tibetan artists made adjustments in a received system to suit a new audience? Or is it merely evidence that the starting point for these paintings was a monochrome woodblock-printed book?

The figures in the *Three Hundred Icons* gain meaning as much by contiguity as by attribute, once again recalling a textile whose pattern may be panoramic but is repeatable with all the assurance regular numbers can provide. But as a guide to visualization, the book also leaves much to the imagination: The "beholder's share" is far greater than what the slight, abbreviated images can provide, especially in later editions, where line quality had seriously disintegrated. In the book and the three derivative paintings, some of the deities, especially the horrific ones with multiple heads, arms, legs, and attributes set against aureoles of raging flames, become indistinguishable webs of lines, refusing to come into focus, challenging the keenest gaze. Yet here, the book's preface proclaims, are the guides to the enlightenment mind roped into a kind of momentary confinement that speaks of perfect possibility. This scratchy edition—for that is what it was for most of its users—is simply a schematic sketch meant to be colored and filled in during long years of daily meditation.

Recalling the Future: The Yonghegong Maitreya

The Yonghegong, still the largest Tibetan-style monastery in Beijing, was designed specifically as a refuge for Mongolian monks and later reconstituted in the model of the great monasteries of Tibet as a university with four colleges of exoteric and esoteric Buddhism, medicine, and mathematics and calendrical sciences (Figure 33). From the beginning the Yonghegong was a project of multiple redefinition, its identity changing according to its contents. The complex was originally the palace of Yinchen, the prince who in 1723 became the Yongzheng emperor, and it was also the place where the young prince Hongli, who became the Qianlong emperor, was born in 1711. In its conversion from private to public use the Yonghegong resembles the Qianqing Palace in the Forbidden City, which, in the first two reigns of the Qing dynasty, served as the bedchamber, general residence, and temporary abode of the coffins of the emperors but in Qianlong's day became, as we have seen, the major storage center for the imperial art collection. In this redefined role, the Qianqing Palace was a repository for tributary art "returned" there from various parts of the empire and, colored by its contents, was also a nonverbal representation in miniature of the empire and its history in China. It might be said that the Yonghegong took a similar but inverted role as a public reification of the future, not just of the empire, but of the entire Buddhist world.

In his first Yonghegong edict of 1744, Qianlong proclaimed that the palace of his birth be transformed into a Jetavana Garden—namely a monastery and a site for promulgating dharma. To this end he deputized Rolpay Dorje and another of the great incarnate lamas in Beijing, Gandan Shiregetü Losang Tenpey Nyima, to organize the overall design. In fact half of the palace grounds had already been given over to monastic use in 1725, a few years after Yongzheng ascended the throne. (He kept the other half as a traveling palace.) More fundamentally, however, following historical models, the filial Qianlong also established his boyhood home as the site of his father's epiphany, giving us the unforgettable image of Yongzheng rising on dragonback (with all his "beard clingers" left behind), identified in his skillful means and benevolence with none other than Śākyamuni.[76] The Yonghegong was the place where Yongzheng's encoffined body *(lingjiu)* rested while his tumulus at Dongling was finished (its roof tiles were changed from green to imperial yellow to mark this new, solemn role), the place where his ancestral tablet was installed, and the temple where Qianlong offered annual

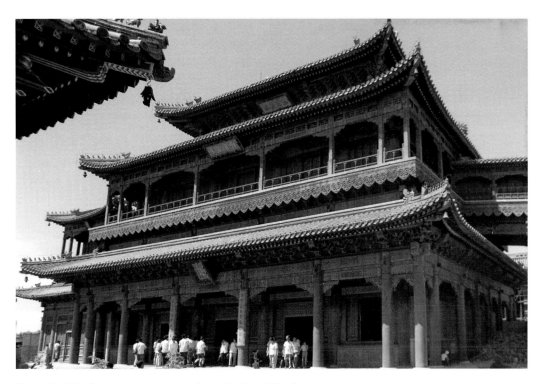

Figure 33. Yonghegong, exterior view of the Wanfuge. (Yonghegong photo.)

sacrifices to him. As a site of practice and patronage the Yonghegong thus existed in a space that was at once deeply personal to the emperor, embodying his relationship to his father, and blatantly political—an overt sign of his own fatherly kindness to the Mongols, whose newly installed lamas Qianlong finesses in the Chinese version of his edict as "Brahmanic" or "Indian monks" (*fanseng*). His language suggests a complex purpose: to act on a precedent requiring that the personal spaces of deceased emperors be converted to monastic use and to conscript and control the Mongolian Buddhist establishment while simultaneously granting them the extraordinary honor of maintaining his father's shrine. He carefully avoids any reference to Yongzheng's diverse personal practices (especially his Daoism) but dwells instead on his talent and kindness, his profound grasp of Buddhist meditation, even his nirvana, that is, all the qualities that made him so much like Śākyamuni.[77] These very qualities made it appropriate that Yongzheng's ancestral tablet be housed at the monastery as a kind of contact relic which would continue to act benevolently in the world even after his body was moved to its final resting place.

With Qianlong's edict the Yonghegong became a lineage temple for the Manchus, established to honor the link in the dynastic chain between Yongzheng and his son. But even though Qianlong initially organized the monastery around veneration of the past (specifically the dynastic past), its second, more public purpose was to look directly forward to the future. It could be said that the Yonghegong was all about time and potentiality, both private and public. Its name in Tibetan is much more explicit in this regard than the Chinese "Yonghegong" (Palace of Harmony). Gandenchinchöling means "Splendid Heaven of Joy," that is, Tuṣita, the present heavenly abode of the Future Buddha, Maitreya. The name Ganden also copies that of the first monastery Tsongkhapa established in 1407, and it reverberates with the millennial message he promoted. Maitreya's presence, shadowy and explicit, is invoked from one end of the monastery to the other. One of the inscribed plaques in the monastery's first courtyard reads: "Bestowed kindness (Sanskrit: *maitrī*) abounds in the

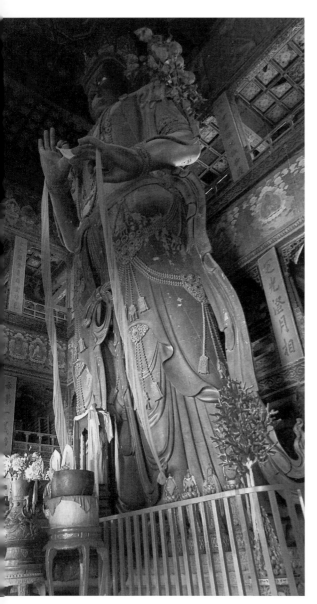

Figure 34. Yonghegong, Wanfuge. Colossal Maitreya. Sandalwood. (Reproduced with permission of the Yonghegong.)

precious leaves" *(ci long bao ye)*—that is, *maitrī* abounds in the precious palm-leaf texts, the tantras Maitreya personally communicated to the Indian sage Asaṅga. These tantras (Chinese: *wei*) are the weft threads (also *wei¹*) that make the pattern of the warp, the sutras *(jing)*, intelligible. Maitreya appears in full flesh in the first hall of the monastery as the plump avatar, the "Laughing Buddha" Hvashang, whom Lessing describes as "an almost dwarfish image of disproportionate growth, a caricature of a monk,"[78] and he appears again in the second to last hall, the Wanfuge, as a colossus carved of sandalwood (Figure 34). The iconography of the monastery is, in broad plan, futuristic. And this, coupled with Qianlong's identification of his deceased father with Śākyamuni, the buddha of the present age, urges the view that the emperor understood the Yonghegong as a place where he could realize practical political benefits by promoting his reign as the latter days of the law, those last moments of the present kalpa over which a *cakravartin* will preside.

Given this scenario, it is not surprising to learn that the Yonghegong was also a war temple. In the final courtyard, just west of the Wanfuge, is a tower devoted to Yamāntaka, the enemy of death and patron protector of Beijing, where monks chanted every day and where Qianlong kept his own weapons and sent his high officials to offer sacrifice during times of war. Further to the west, accessible through the west wall of the Yamāntaka Tower's ground floor, beyond the main monastery wall, was a satellite courtyard with a small bodhisattva hall dedicated to Avalokiteśvara, Samantabhadra, and Mañjuśrī. Just behind it was the larger Wushengdian, the Hall of the War God, variously called Guan Yu, Guan Laoye, Guandi, or Guan Yunchang. This subsidiary temple, which was separately established under Yongzheng, has long since disappeared.

Walther Heissig has said that even in the very last years of the dynasty the Qing actively subsidized borderland temples to Guan Yu, a euhemerized Han Chinese general who actually lived in Shu (modern Sichuan) in the third century. Guan Yu, he points out, was a figure who had a great deal in common with Inner Asia's Gesar, an epic figure lauded in Tibetan and Mongolian poetry, song, drama, and painting.[79] He was, in other words, already a familiar type among the Tibetans and Mongols, much like the Chinese Daoist figure Shoulao, the longevity god whose huge cranium and long white beard resembled the Mongols' beloved shamanic Caghan Ebügen, the White Old

Man.[80] But Guan Yu's peripheral presence at the Yonghegong was probably more than just a gesture to the Mongol monks in residence there. He was also a recurring participant in Rolpay Dorje's dream life, as the *khutukhtu's* biography amply demonstrates. In 1736 (auspiciously the dragon year), as Rolpay Dorje was making his return trip to Beijing after the death of Yongzheng, he had a dream while camped at the foot of Mount Xiangling in the border region of Sichuan. A "great red man" appeared, claiming to live on the mountain. He invited the young lama to his home, where his wife and daughters honored him, fed him, and gave him presents. All the lands from the mountain on down to China belonged to him, the red giant said, and he also received tribute from lamas as far away as Zang (outer Tibet). He vowed he would be Rolpay Dorje's protector. His name was Trinring Gyalpo, "King of the Long Cloud," roughly equivalent to the Chinese Guan Yunchang. This episode had a profound effect on Rolpay Dorje, who later told his biographer Thukwan that when he returned to Tibet he left an offering to the red giant at the foot of Mount Xiangliang. It was apparently accepted, for the group noticed that a tiger followed them until they had passed safely through the mountains.[81]

A few years later, the red giant reappeared as Rolpay Dorje lay painfully ill with an ailment that affected his eyes and numbed his hands and feet. Qianlong visited him and showered him with compassionate attention. Famous Chinese doctors tried to cure him. Finally the lama Palsang Chöje performed a divination ritual over him, and in his vision he saw a swarm of huge spiders surrounding Rolpay Dorje's body ready to attack. Just then the red giant appeared and drove them away. That night Rolpay Dorje dreamed of his helpful guardian again and learned that he lived just to the right of the palace's front gate. Rolpay Dorje sent his attendant the next day to see what this could mean and, sure enough, right outside the gate, to the right, was a Guan Yu temple complete with a clay image of the hero that had been continuously honored with incense over the course of many dynasties. With this extraordinary series of events, Guan Yu became one of Rolpay Dorje's personal tutelary deities. Urged by his close colleague Jedrung Khutukhtu (the same Jilong Khutukhtu who appears next to Rolpay Dorje in his *Three Hundred Icons*), he even composed a prayer to Guan Yu.[82]

Guan Yu and his shrine have long since disappeared as active presences at the edge of the Yonghegong, but the annual sacrifices offered to him there on the thirteenth day of the fifth month from the Yongzheng reign right up until 1911 demonstrate his importance in the Buddhist life of the monastery. The placement of his shrine just beyond but still attached to the monastery's primary walls, to the northwest and accessible only through the first floor of the martial Yamāntaka Tower, is also redolent with meaning: Guan Yu was essentially a border figure who represented the betwixt and between areas of the empire where Chinese and Inner Asian communities came into regular contact. His former presence is especially intriguing in the context of the rest of the monastery, where almost every aspect of exoteric and esoteric practice received some attention but where another Mongol favorite, Maitreya, the Future Buddha, reigned supreme.

Maitreya is, in many ways, the focus of Gelukpa attention—particularly so in Mongolia. I have already mentioned that Tsongkhapa named his own first monastery after Maitreya's Tuṣita Heaven, Ganden, that is, the place where the new buddha literally would be hatched. The Gelukpa also annually celebrated Maitreya's coming on New Year's Day, when his image, usually colossal, was hauled in a great cart around monasteries, halting at the four points of the compass for readings from the Five Tracts of Maitreya transcribed by Asaṅga. The Maitreya festival took such a central role in Mongolian Buddhist life that, quite naturally, its first performance in Mongolia has been attributed in legend to Zanabazar, the First Jebtsundamba of Urga and leading prelate among the Khalkha of Outer Mongolia. In 1655, Zanabazar received word in a dream that his mentor the Panchen Lama was on his deathbed and, apparently still in a trance state, he traveled in seven days to Tibet to see him, a trip that would normally take months. There he found the great lama, seated in the lotus position,

already dead. He made mandala offerings to him (mentally constructed and proffered) and the Panchen revived. He taught Zanabazar how to perform the Maitreya festival according to the rites of Tashilunpo—a monastery renowned for its colossal Maitreya figure. Zanabazar returned home to promulgate this ritual of renewal, during which Maitreya literally is understood to descend into his own image (several examples of which Zanabazar cast himself) in a prefiguration of the beginning of the next kalpa.[83] Throughout Mongolia, the ritual was performed annually, either on New Year's Day, as at Zanabazar's traveling monastery, Urga, or, at other monasteries, to mark the day on which it was first received.

Maitreya had another symbolic meaning for the Mongols and especially for Zanabazar, whose immediate preincarnation, the Jonangpa lama Tāranātha, had missionized actively in Inner Mongolia in the early seventeenth century. Tāranātha came to be known popularly as Maidari—Maitreya—an association that stuck to his line of incarnations, at least among the people. (Officially the Jebtsundambas are emanations of Vajrapāṇi, the third great bodhisattva, making a trinity of Avalokiteśvara–Dalai Lama, Mañjuśrī–Zhangjia Khutukhtu, and Vajrapani–Jebtsundamba.) Thus the Future Buddha and his emanations, the primary prelates of Outer Mongolia, began ritually to play out the millennial vision of cyclical renewal in ways that strongly resemble the calendrical, New Year–focused rituals of the emperors of China, taken up by the Manchus around the same time.

The colossal Maitreya image that is the culminating moment of a visit to the Yonghegong is one of two surviving colossi made during the Qianlong period. (The other is Avalokiteśvara at Chengde's Pule Temple; the immense, gilt copper Tsongkhapa in the Yonghegong's central Dharmacakra Hall is a product, probably of Dolonnor, of the 1920s, built by popular subscription.)[84] But there were also others, for Qianlong admired the effects of gigantism as much as he loved the miniature. Among them were the giant thousand-armed Avalokiteśvara at the Yiheyuan Summer Palace that burned in the same fire that destroyed the Foxiangge (and stimulated Qianlong's questions to Rolpay Dorje concerning standards for temple building), as well as a huge, lion-mounted Mañjuśrī, erected at Wanshoushan in 1767, which Eugen Pander reports was taken as the emperor himself in his role as Mañjughoṣa-*cakravartin*.[85] The Yonghegong Maitreya is very big indeed; standing 18 meters high and extending 8 additional meters into the ground, it was carved from the trunk of a single great sandalwood that the Seventh Dalai Lama sent to Qianlong as a gift from Nepal. The trunk took a year to arrive, floated along rivers from Sichuan to the capital. Once it reached Beijing, workmen from several departments of the Forbidden City, the Yangxindian, the Ruyiguan, and the Zhongzheng Hall all converged to work on the figure. Their labors extended over three years, from 1750 to 1753, while they carved the Maitreya, planted it in the ground, then built the paradisal three-story Wanfuge with its flying bridges around it.

The impact of the Wanfuge Maitreya is startling. Because he stands so tightly enclosed within the building, shooting up vertically through three stories, he does not present himself to be viewed from a distance or to be taken in as a whole. This compact housing had ample historical precedent; indeed, most colossi in China originally sat within similar closely fitted structures and their easy viewing now has only to do with the ravages of time on their wood and stucco temple facades. This design is particularly suitable for Maitreya, though, since the traditional view has him simultaneously waiting for his final rebirth in Tuṣita Heaven and generating, egglike, in a remote mountain cave (like a monk on extended retreat), the walls of which he will shatter when the right moment arrives. In the first view, Maitreya awaits his coming as a young, lithe prince dreaming of his own enlightenment amidst the ornamented opulence of his elegant palace. His generation of his own buddhahood is mental—conceived of as a process analogous to achieving maturity. In the second, Maitreya is all potential and his final form—the visible transform *(nirmāṇakāya)* his enlightened self will take—is essentially unknowable to the unenlightened. The Wanfuge figure answers both

these views, just as earlier colossal sculptures of him did, because this hard, mirrorlike form, while palpably and thoroughly *there* in all his gilt, bejeweled princely glory, stabilized by his white jade Mount Sumeru base and holding a string of amber glass prayer beads the size of soccer balls, is only knowable as a whole through reflection and recollection. It simply is not possible to take him all in at once.

Though the Wanfuge has three levels, its upper two mezzanines, like the upper reaches of the Pavilion of Raining Flowers and the Fanhualou, were originally accessible by narrow stairway only to those with ritual business upstairs. From above, the privileged few could gaze directly into Maitreya's penetrating eyes, which secretly look out through the upper-story windows to oversee the entire monastery and, beyond, the whole empire to the south. In other words: Those with access could carefully examine the Maitreya piece by piece and, in doing so, would learn that the artists who carved him took into account the distortions of viewing him from the level of his feet and there-fore adjusted his proportions accordingly. He is, in the original sense of the word, a simulacrum: a copy of an imagined form manipulated to produce the impression of true, if limited, sight.

Collected along the west and east walls on either side of his huge bare feet, with toenails like great shields, are a brightly colored set of forty-one thangkas depicting events in the biographies of Śākyamuni, presented to Qianlong by the Seventh Dalai Lama,[86] and somber sculptures of eight-een lohans divided among two rows of three shrines, three figures per shrine. These eighteen were already historical pieces in the eighteenth century, rumored to date from the Ming dynasty. The lohans, as protectors of the dharma, are thoroughly implicated in Maitreya's coming. They must wait patiently in their mountain abodes through the latter days of the law until he descends from Tuṣita, when they will all enter nirvana. The ensemble of Maitreya, murals, and lohans, so thoroughly dis-junctive in style, scale, and approachability, thus reconciles the life of the historical buddha Śākya-muni (which foreshadows Maitreya's because every buddha must ultimately follow the same path) with the larger, Mahāyānist, cosmological view that sees Śākyamuni as far from unique. Meanwhile the lohans, self-seeking disciples of Śākyamuni in their earlier, pre-Mahāyāna role, transform into stalwart protectors of the law in their mythic relation to the Future Buddha.

The great cyclical time shift that Maitreya both promises and withholds was played out in many different ways at the Yonghegong, coming together in a pattern of visible form and ritual practice that even today is only partly legible to casual visitors. The monastery was literally initiated in the first lunar month of 1745 with a "Great Vow" Monlam Assembly, which Rolpay Dorje, following Qianlong's request, modeled after the annual New Year's Monlam that Tsongkhapa first staged in Lhasa in 1409. This lengthy festival lasted twenty-one days, from the fourth to the twenty-fifth of the first month, and consisted of rituals and sutra chanting, alternating day and night.[87] A few days later, on the twenty-ninth, a great round of exorcistic performances called *buzha* (a transliteration of the Tibetan *'bag drag* or translated as *dagui*, "beating the devils," in Chinese) began, lasting through the first day of the second month.[88] These masked dances were part of the complex inheritance of local traditions that Buddhism absorbed and transformed in Tibet and Mongolia, reified as a ritual drama of conversion, where powerful protectors battle successfully against autochthonous demonic foes embodied in a figure of dough.[89]

Finally, but far from least, the Yonghegong also became a site specializing in a particularly Tibeto-Mongolian form of millennialism: the rites surrounding the *Kālacakra Tantra*, the wheel of time. Wang Jiapeng notes that the tantra was recited repeatedly there by two differently constituted groups of monks over the first two weeks of the third month. (These are notably the only chantings of any text he cites for the Yonghegong.) One group of ten monks recited it seven times annually in the third month, from the first through the thirteenth days; another group of one hundred, picking up from the smaller group, recited it three times, from the fourteenth through the fifteenth days.[90] The

tantra is still a special focus for the Gelukpa. Revealed to the king of a mysterious northern land called Śambhala by Śākyamuni himself, the *Kālacakra Tantra* describes the unfolding of future time and Śambhala's role in the tale. The people of Śambhala regularly practice the teachings of the tantra, which reveals that their land will have thirty-two kings in all. The last of these, Rudacakrin, will wage a terrible war against the forces of evil (who embody the obstacles to enlightenment) and bring about a new era of peace and harmony. The wheel of time was embodied in a number of ways at Yonghegong: as mandala (based on its description in the influential *sādhana* collection, *Niṣpannavaliyogāvalī*, no. 26); as paintings of the whole wheel-shaped kingdom of Śambhala, rolling over the landscape like a huge juggernaut; and as Kālacakra himself, a lithe but fierce deity with anywhere from eight to twenty-four arms embracing his consort, Viśvamāti.

"Before and after are all gathered up in present appearances . . ."

I began the previous chapter on collecting by citing Eugenio Donato's thoughts on the essentially fictive nature of museum displays, which, in his analysis, are meant to be taken as "somehow constitut[ing] a coherent representational universe." Donato judges as "uncritical" the view that putting things in order and labeling them "can produce a representational understanding of the world." Standing behind this judgment is the notion that what he calls "a representation which is somehow adequate to a nonlinguistic universe"—something approaching comprehensiveness—can be satisfied by juxtaposing a series of fragments in space. Viewed in this light, Qianlong's efforts at building a collection whose gaps have been restoratively filled, sometimes only with commentary, seem vain and misguided—susceptible, therefore, to the negative judgments of scholars who find him "grandiose," "omnivorous," and "egocentric." And there is no doubt that a significant part of Qianlong's collecting had to do with what Jean Baudrillard has called a need for the collector to "construct an alternative discourse that is for him entirely amenable, in so far as he is the one who dictates its signifiers—the ultimate signified, in the final analysis, being none other than himself."[91] Indeed Harold Kahn has, I think rightfully if partially, characterized Qianlong precisely this way: as a "collector of himself," placing his activities as a collector firmly in the same realm as his empire building.[92]

Reading his collection and its catalog against his iconographic projects can also produce a slightly different interpretation, however, since, as we have seen, Qianlong's reasons for gathering and aggregating depended on what he was collecting. The emperor defended his desire to catalog his growing collection of Buddhist and Daoist art (things that had found their way "back" to the palace because of a century of Manchu-inspired peace) as a way of reconciling disparate teachings. His need for what we might call harmonious comprehensiveness appears most vividly in his order that every aspect of each work, physical, iconographic, and historical, be systematically recorded, with works of like character stored together. Thus his collection of religious painting and calligraphy begins to seem like Donato's phantom representation—spatially arrayed to mimic the world at large but ultimately inadequate to the "nonlinguistic universe" and requiring creative restoration, like Zhang Sengyou's *Planets and Constellations*. Qianlong's urge to comprehensiveness begins with what he perceives to be gaps in the fabric of the historical record, which he mends with patches—actual and imaginative—applied to simulacra of the material object. This part of his collecting can also be productively tied to his interest in Chinese-based systems of aesthetic appreciation, the goal of which was to enable the living to inhabit vicariously the world of the dead, to experience it through the mediation of materialized "traces of the brush."

Baudrillard senses that comprehensiveness, the total representation of a set of things in the collection, is really a "mirage." The collection, he suspects, *"is never really initiated in order to be com-*

pleted" (his and his translator's italics).[93] In fact its gaps are essential, the real "basis of the subject's ability to grasp himself in objective terms." In this he edges wonderfully close to what I perceive to be the stimulus behind Qianlong's other kind of collecting—namely his patronage of elaborate, systematic pantheons of Buddhist deities and his close regard for their proper order. In every project he and Rolpay Dorje undertook, from the translation of the *Sutra on Iconometry*, with its lengthy prefaces on the inadequacy of form to represent the formless, to his ever-growing, private sculptural assemblages in the Pavilion of Raining Flowers, the Tower of Precious Forms, and the Hall of Buddhist Effloresence, with their indistinct drifts of incomplete pattern, we sense that the pair confronted the same issue over and over again—that the totality of forms is both continuous and infinite but that, in the end, form, no matter how proliferated, can never rise to represent emptiness.

The pantheons of the Qianlong period, like the collection cataloged in *Bidian zhulin*, take on patterns that are supported by their arrangement in space: their juxtaposition and contingency. But as I argued earlier, the patterns they reveal are fragmentary at best. Here enters a temporal dimension that is radically different from the projection into the past that *Bidian zhulin* supports. Because instead of asking the viewer to recollect what is claimed to be a complete representation of the past, he must recollect something he only knows piecemeal, to weave together a scenario of what might finally constitute a subjective apprehension of the whole *sometime in the future*. In this way of revelation, the process of viewing is purposefully gradual and, for ease of learning, systematically graduated—just as the Yonghegong's Maitreya refuses to reveal himself all at once. Apprehending him is a mental process that requires upward movement, a trajectory that mimics the "wheel of teaching" organization of sacred texts and initiation halls. In its more esoteric sense, this method also requires an understanding of the meaning of memory that includes Buddhist mindfulness: the meditative cultivation of qualities of mind that are already present but may not yet have been consciously sensed or accessed.

CHAPTER 5

Pious Copies

The links of emulation . . . do not form a chain but rather a series of concentric circles
reflecting and rivalling one another.

—Michel Foucault, *The Order of Things:*
An Archaeology of the Human Sciences

"Derivative" is a term often applied to the arts of the Qing court, sometimes in the same sentence as "formulaic." But these value-laden words suggest that Chinese imperial art, indeed the bright flowering of Chinese imperial culture, stagnated after the Manchu conquest in 1644 and that the Manchus added little to what they appropriated except overblown taste and an ego-driven enthusiasm for misplaced written commentary. This perception of Qing court culture has also been used in the West to prop up the essentialist notion that China is eternal and unchanging, mired in the past, and incapable of the extensive cultural rupture and transformation that resulted in the West's modern age. Many of the details of Qing court life contradict this notion, however, as so much recent scholarship has shown. The Qing were quick and interested learners—culturally fluent, multilingual, deeply involved in the study of native and foreign technologies and in rethinking the limits of art and representation. Yet theirs was also, paradoxically, a "culture of the copy,"[1] where replication, restoration, renewal, and renovation were understood as highly creative ways of honoring and appropriating the past, structuring the present, and assuring the future and where the very word for personal cultivation—*wenhua*—carried with it the meaning of transformation by pattern.[2] Central to this formulation of cultivation and acculturation is the concept, shared by Confucians, Daoists, and Buddhists (and those who espoused all three), that transformations of thought follow rather than precede transformations of behavior—that education is a process of molding and modeling,

learning by doing, and personal, mental, and physical discipline instilled by repetition and replication.

In fact, one of the first projects Qianlong inherited when he came to the throne in 1736 at the age of twenty-five reestablished the copy as a significant artistic mode in and of itself. In 1727 Qianlong's father, the Yongzheng emperor, appointed a team of five court painters to produce a new and complete version of a famous early cityscape, Zhang Zeduan's *Qingming shanghe tu* (Spring Festival on the river; Figure 35).[3] The *Qingming* picture depicts a bustling, prosperous city, an apparently unmediated but actually idealized vision of what is most likely Bian, the Northern Song capital, on a Spring Festival day. The exact date of the scroll's creation continues to be the subject of controversy centering on the issue of whether it represents a contemporaneous portrait of the northern city or a nostalgic one commissioned after the Song fled south. As early as the Yuan or Ming, however, the scroll survived only in part, notably lacking its final section, which numerous earlier copies hint probably depicted the imperial palace and gardens.

The Qing court copy (Figure 36) was not intended as a line-by-line copy, and the artistic team that produced it did not present it as such, using the term *"hua"* (to paint) to sign off on their work. Rather the new *Qingming* picture was an ideological reenvisioning of an ancient masterwork that had long stood as an imaginative record or recollection of a peaceful, well-ordered city, one that was conquered by the Manchus' own ancestors, the Jurchen, who founded the Jin dynasty in northern China in 1127. Zhang Zeduan's *Qingming* picture presents a view of Bian that compresses the city's distances to present an experiential vision of a moving eye—one that is "perigraphic," or "written on a wandering line," a term Stephen West has used to describe the twelfth-century text *Dongjing meng Hua lu.* Although this detailed memoir of Bian was written after its fall, it nonetheless vividly conveys the sensations of everyday life there in its heyday.[4] The Qing court version of the *Qingming* picture, however, reveals a world ordered from a single viewer's standpoint—or, more accurately, along a single trajectory—using a Western-derived perspective scheme that has been made cinematically dynamic so that what we see is what the emperor perceived in his mind's eye as he looked down

Figure 35. Zhang Zeduan, *Qingming shanghe tu* (Spring Festival on the river), detail. Handscroll, ink and light colors on silk. Size of whole: 24.8 x 528 cm. (Palace Museum, Beijing.)

Figure 36. Chen Mei, Sun Gu, Jin Kun, Dai Hong, and Cheng Zhidao, Yongzheng-Qianlong period copy of the *Qingming shanghe tu*. Handscroll, ink and colors on silk. Detail. (National Palace Museum, Taipei.)

from an imaginary perch like a director on a gurney rolling smoothly on a parallel line high above the city below. We might say that the Qing version is cast as a translation of the original, an unfaithful copy whose forms and spaces are bloated, opened up, and smoothed out and whose bustling masses are organized to produce a sense of peaceful, orderly harmony and imperial largesse. The political and ideological implications of such an "untrue" copy are thus boldly stated—the Qing have brought into being a perfected and well-ordered society that the original fragment of the *Qingming* picture only presents in part. Bian is no longer Bian but a utopian capital located, we have to guess, somewhere near Beijing.

The Status of Copies

For Chinese artists and theorists, imitation has more often than not been seen as a constructive act: the "sincerest form of flattery" that discharges the obligations of the present to the past and converts impersonal history into a memory of genuine, inner, experience. Certainly centuries before the time of Qianlong's reign the duplication in China of earlier works of art had been complicated by ideas of spiritual communion *(shenhui)*, an explicitly positive, nostalgic, and personal reverie on the past. But the practice of copying was also validated by a loosely constructed sense of intellectual property where mental products, once expressed, enter the public domain and where the privileged copyright is still loosely interpreted.

Copying and all its variants have been nuanced lexically in Chinese by a sometimes ambiguously differentiated battery of terms that evolved to describe a wide range of derivative (or simply culturally sanctioned) behavior, not all of which are commensurate with the English word "copy." These terms range at one extreme from forms of mechanical reproduction (woodblock printing, for example, or pulling rubbed copies from carved stone steles), to outright tracing and line-by-line copying, and finally to "emulation," a practice limited to painters or calligraphers who purposefully assume the stylistic guise of an admired historical predecessor in order to commune with him and

inhabit his mind through the traces of his hand. There are just as many reasons why Chinese artists, including those working in the Qing court, made copies of historical works—to produce fakes for financial gain, to fulfill a quixotic wish to possess some remnant or trace of a particularly resonant historical object, to acquire merit through the repeated reproduction of Buddhist icons or texts, or even to manipulate the phenomenal world through sympathetic magic and the creation of images. The result, at least for contemporary art historians, has been a legacy where it is often impossible to separate the original from the copy—still a nagging issue in the field of Chinese art—and where the capacity of images to interface with history has been altered, producing, to borrow art historian Michael Camille's words, "an arena in which history itself is forever only simulated rather than engaged with."[5]

Nowhere is this intentional confusion or conflation of past and present more apparent than in the copious copies produced at the court of the Qing Qianlong emperor. Qianlong had a voracious desire for copies of all sorts of works of art—and specifically for objects that served the ritual and contemplative needs of Buddhist practice. Some of his models were objects he could not (or would not) possess; but some, surprisingly, were already part of his vast collection. Qianlong's urge to understand the meaning of duplication in all its ramifications—everything from the initial act of painting a likeness to the production of overt copies, the editing or translation of prior works of art from one idiom into another (like the *Qingming* picture), and the rewriting of more than just art history—is clearly demonstrated in his writings on art, particularly in the colophons he inscribed with such irrepressible energy on almost every clean surface. For this emperor, the image was a profound and mysterious thing that by its very physical nature could survive long past its creation and even outlast its creator to witness history, to forge a career and life of its own, and even to spawn a family of derivative works. For Qianlong, copying was a way of harnessing the careers of charismatic objects, of possessing them, of channeling their energy in unexpected, powerful ways. Copying was also, as I will show, an indirect way of intervening in the historical past to manipulate the outcome of contemporaneous events, a process akin to performance, prophecy, and translation, which allowed Qianlong to muse on some of the gnawing questions that obsessed him about the nature of the individual self, the autonomy of things, and the resonance of the past, present, and future.

The first edition of the Qing imperial catalog of works of Buddhist and Daoist art, *Bidian zhulin*, demonstrates vividly that the Qing emperors prior to Qianlong concentrated their collection of religious art on copies—and, as we have seen, in no small measure on copies of Buddhist sutras they had piously written themselves, including the hundreds of copies of the *Heart Sutra* the Kangxi and Qianlong emperors made as a regular practice. There are also numerous copies of the *Heart Sutra* and others written and decorated by all of the early Qing emperors to that date, as well as by noteworthy calligraphers of historical dynasties (especially Qianlong's favorite model, the late-Ming artist Dong Qichang).[6] Copying the *Heart Sutra* carries a special satisfaction that the Qing emperors were quick to appreciate, not just because it is so brief, enabling merit to be gained painlessly (except when written in blood), but because it addresses the issue of duality and the codependence of all things— if the copy depends ultimately on its model for its conception, the model depends just as much on the copy for its future.[7]

The Southern Tours and Guanxiu's *Lohans*

It was right after the completion of *Bidian zhulin* with its long lists of copies that Qianlong began to collect paintings and other works of art with an eye to building a comprehensive imperial collection. He also began to commission what would be a large body of copies of famous Buddhist and secular works, linking these commissions to his musings on identity, memory, and history in a carefully recorded corpus of inscriptions, several of them tied to specific politically driven events.

In 1751 Qianlong undertook the first in a series of six tours of the southern regions of his empire, replays of the earlier itineraries of past emperors and especially of his grandfather Kangxi. Qianlong's tours were designed to reveal his status as universal monarch to the world at large, but, in no small measure, he also wanted simply to satisfy his own curiosity and to please and divert his beloved mother. This is the sense richly conveyed in the 6,700-page illustrated record of the first four tours, *Nanxun shengdian* (Magnificent record of the southern tours), published in 1771, a year after his sixtieth birthday, and sorrowfully repented as wasteful and extravagant after his retirement in 1795. The *Magnificent Record*, Maxwell K. Hearn has suggested, was modeled on his grandfather's *Wanshou shengdian* (Magnificent record of longevity), composed in honor of Kangxi's own sixtieth birthday, fifty-seven years earlier,[8] and it capped the grandly conceived celebration that honored both the emperor and his octogenarian mother. The festivities, as we have seen, included the construction at the Manchu summer retreat, Chengde, of the Putuozongchengmiao, the large-scale copy of the Potala that was built to honor the return to China of the Torghut Mongols. Again following his grandfather's lead, in 1764 Qianlong commissioned a group of long handscrolls to record and celebrate the details of his fourth trip. These were submitted to the throne in 1770, just in time to honor the imperial birthdays.[9]

If Qianlong consciously conceived of his southern tours as restagings of historic imperial trips, he also used them to demonstrate and test his broader notion that the present in general duplicated or, perhaps more accurately, rhymed with the past. This was a theme that found constant resonance in his patronage of painting and in the new critical language he advanced to discuss the meaning of Buddhist images, in particular, and the lives of the artists who painted them. Consider the moment in his southern tour of 1757 when the emperor visited the Shengyin Monastery in Hangzhou and was shown a series of paintings of sixteen lohans there, the work of the late-Tang-dynasty Chan master, Guanxiu (832–912), who had famously envisioned them in a dream. If the emperor's own writing about these now-lost paintings is any indication, he was extremely taken with them. (He already owned several lohans attributed to the Tang master and had himself painted a copy of at least one of them.) But rather than appropriating them outright for his own personal use, a common pattern in his collecting, he immediately commanded his court painter Ding Guanpeng to produce copies in the form of seventeen hanging scrolls—sixteen lohans and a central image of Śākyamuni, the historical Buddha, who personally named the enlightened lohans "protectors of the dharma" (Plate 13 and Figures 37 and 38).[10] Qianlong's satisfaction with Guanxiu's visionary semblances of the lohans was troubled, however. In his colophon for the Ding Guanpeng scrolls he noted: "Arriving at the monastery I reverently unrolled them for a look. The order of the old images did not agree with the sutras, nor did the names harmonize with Sanskrit sounds, so I placed them in order, editing their sequence."[11] What the emperor objected to specifically was the names that had been assigned to Guanxiu's lohans, either by the artist or a later commentator, which went astray from the record as he understood it. It is most likely that these names were based, if only loosely, on a scripture that had immense authority among Chinese Buddhists: Nandimitra's *Da Aluohan jing Nandimiduoluo suo shuofazhuji*, which not only listed the names of these obscure, imprecisely described, slippery figures but also assigned them to their different mountain abodes.[12] Their reassigned identities, switched with their neighbors, were emblazoned in red Tibetan script, which accurately spells out the proper pronunciation of the lohans' Sanskrit names. There are also eulogies, which Qianlong himself composed and wrote in Chinese, where he renders the lohans' names in a complex, new transliteration system that uses small characters to indicate precise Sanskrit initials and vowels. ("Ba-ha-da-la," for example, all written in smaller characters, gives the Sanskrit reading Bhadra.)

Qianlong's fascination with Guanxiu's *Lohans* did not fade away after Ding Guanpeng's initial edited duplication. The same year, he ordered palace artisans to produce a black-and-gold lacquered

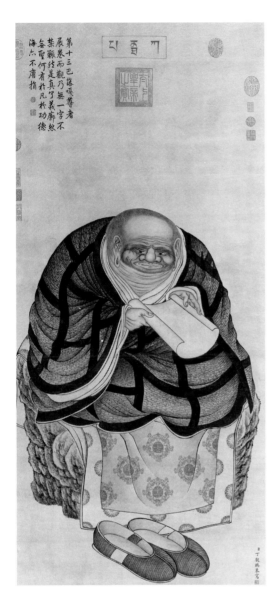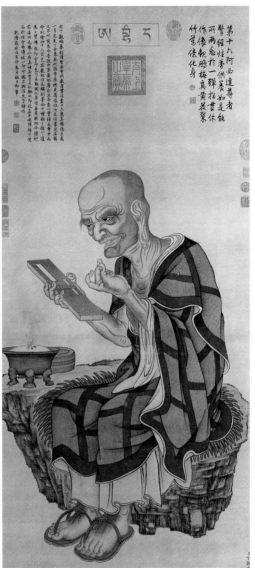

Figure 37. Ding Guanpeng. *The Sixteen Lohans: (left) Panthaka* (number 13); *(right) Abheda* (number 16). Copies based on Guanxiu's *Sixteen Lohans* from Shengyin Monastery, Hangzhou, 1758. Sixteen hanging scrolls (and a seventeenth depicting Śākyamuni Buddha), ink and colors on paper. Each scroll 127.5 x 57.5 cm. (National Palace Museum, Taipei.)

set of two eightfold screens based on the Shengyin Monastery originals (Figure 39). These screens have a somber, almost monochromatic, effect. Like rubbings of stone engravings, they project an air of instant antiquity acquired by third-hand contact with revered originals. Despite this some-what spurious aura of authenticity, however, the screens are not quite exact renditions of Guanxiu's originals, at least as we understand them from Ding Guanpeng's copies. Six of the lohans in the screens appear as mirror images of Ding's in an arrangement that brings neighboring pairs and triplets of lohans into cozy conversational groupings where once there was an air of self-absorbed backturning, isolation, and rarefied individualism. In fact, Guanxiu's compositions fight against the notion that the lohans are a group of friendly associates gathered to exchange views. Their huddled shapes could

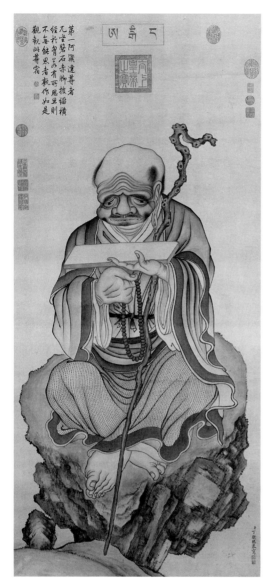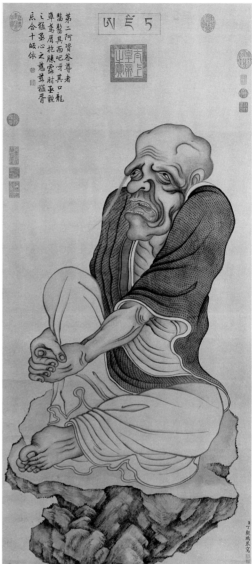

Figure 38. Ding Guanpeng. *The Sixteen Lohans: (left) Aṅgaja* (number 1); *(right) Ajita* (number 2). Copies based on Guanxiu's *Sixteen Lohans* from the Shengyin Monastery, Hangzhou, 1758. Sixteen hand scrolls (and a seventeenth depicting Śākyamuni Buddha), ink and colors on paper. Each scroll 127.5 cm. x 57.5 cm. (National Palace Museum, Taipei.)

not be more solipsistic, and even their rudimentary settings—arching trees and snug caves, thrones of rock and wood—do not interact harmoniously to create a unified setting. Still the transposition of the lohans onto the two eightfold screens may provide some valuable information about how Guanxiu's originals were arrayed at the Shengyin Monastery. The entire set of sixteen reads continuously across the two screens from right to left, like a handscroll or a continuous wall mural, and not as two series of eight meant to face off across a classic lohan hall and create a gamut of protectors through which the viewer passes.[13]

Other innovative messages present themselves by contiguity. The gold-lacquered carvings on the reverse of traditionally auspicious plants *(jixiang tu)*, such as peony, bamboo, wisteria entwined

around rocks, and flowering plantain, underscored the lohans' auspiciousness, if only discreetly from the back.[14] The screen was displayed in the Forbidden City's Cloud Radiance Hall (Yunguanglou), where the lohans as protectors of the dharma acted out a benevolent commentary on the emperor's reign. Qianlong also composed a new text to be carved on the screen, once again describing and reidentifying the lohans. As he put it, reiterating in part what he wrote on Ding Guanpeng's scrolls, "the old names do not agree with the original Indian classification; their names from beginning to end, and their points of identity and difference, are set [here] in accordance with the Zhangjia National Preceptor's reading of the Sanskrit sutras."[15]

The Zhangjia National Preceptor was, of course, Rolpay Dorje. A later text amends Qianlong's account of Rolpay Dorje's participation slightly by giving him a more active role: "Because the emperor considered that the old transcriptions of the lohans' names had errors, he had the Zhangjia National Preceptor correct them by changing the original order to the order commonly used in Tibet."[16] This order, established centuries before by the thirteenth-century lama Chimchen Namkha as a way of organizing the lohans' liturgy, was only one of several very different Tibetan sequences numbering variously sixteen, seventeen, and eventually eighteen, but it was the only order of the first sixteen that Rolpay Dorje endorsed in his many iconographic projects. In 1764 Qianlong ordered that Ding Guanpeng's paintings, together with their imperial colophons, be engraved into stone, again according to the Tibetan system. Rubbings of them soon proliferated throughout the empire and beyond and still stand as a unique if edited record of Guanxiu's originals, sadly lost in the destruction of the Shengyin Monastery during the Taiping Rebellion (Figure 40).[17]

Even before Qianlong's promotion of them, however, Guanxiu's *Lohans* were a must-see for anyone visiting Hangzhou with an interest in the past. Guanxiu's exemplary biography provides some insight into why this was so.[18] Born in Zhejiang to a family of impoverished scholars, he was sent at age nine to study Buddhism in a nearby monastery, where he showed great prodigy in his ability to memorize the sutras and where he also read Daoist and Confucian texts and poetry. He was lauded for his powerful abilities as a meditator, his mad-cursive calligraphy, and his own "lonely and profound" verse (a significant body of which survives in his *Chanyue ji*, Record of the Meditation Moon), a bit less so for his painting. Although he spent the last years of his career in Sichuan under the patronage of a local prince who granted him the title Chanyue Dashi (Grand Master of the Meditation Moon), most of his life passed in the many Chan monasteries along China's east coast, where, in Hangzhou, he apparently was invited to paint a series of lohans for a pharmacist's shop. Many other commissions followed, from Guangdong to Sichuan, commissions that often shadowed him as he moved from monastery to monastery. His inscription on the eleventh lohan, Rāhula, in the Imperial Household Collection set (Figure 41), traditionally held to be a self-portrait, shows a monk-painter whose commitments sometimes went unfulfilled for decades:

> The Sixteen Lohans for Huaiyu Shan, Xinzhou. Ten scrolls were sent without any strain in the first year of Guangming [880], on the ninth day of the ninth month. On the twenty-third day of the third winter month, first year of Jianning [894], I added to the original ten scrolls at Jiangling [in Hubei]. Sixteen years have passed in between. Now the Chan monk Jingzhao has come from the north to see me, asking for the pictures. He will take them away to Huaiyu this year. Xiyue Guanxiu.

Despite Guanxiu's reported productivity, all that survives today of his paintings are several groups of lohans in Japan (including the sixteen in the Tokyo Imperial Household Collection, which most closely resemble what we know of the original Shengyin Monastery set)—and, of course, multitudes of fakes that vary in style from wild and "untrammeled" to controlled and elegant, all of them

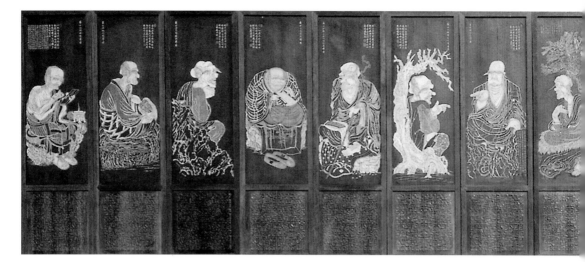

Figure 39. *Sixteen Lohans,* 1758. Two eightfold screens, lacquer and gilt on a wooden armature. Great Buddha Shrine, Yunguang Lou. (Palace Museum, Beijing.)

casting the lohans as grotesque and strange, emaciated or fat, with gray skin, huge, hooked noses, nasty grins, long eyebrows, and jowly flesh like tree bark or fungus. Ironically the "authenticity" of these surviving pictures has been judged against Ding Guanpeng's copies and the now canonical ink rubbings, which themselves became significant objects of desire.

Why should this be so? Because, along with their great antiquity, Guanxiu's *Lohans* were not copies of any image that had come before. They were more than simple paintings; they were visions from the past, perfectly imagined, an authentic, barely mediated record of an inner life, glimpsed, the artist said, in a "dream," or, more likely, in a state of *samādhi* or deep meditation. Their charisma, certainly by the Song dynasty, was undeniable and perhaps contributed to the idea that the lohans as a group, originally Indian, were really local figures, or at least naturalized Chinese, with distinct magical powers that made them seem like Daoist immortals.[19] Guanxiu's images of them were already the object of nearly cultic admiration among the literati and common folk of the Northern Song, who believed they had the power, among other things, to bring rain. Even more extraordinary miracles were attributed to them as well. The Northern Song scholar-official and poet Su Shi's family, for example, owned one that Su remembered from his childhood as having the power to turn tea milky white and make it bloom with patterns of pear, peach, and chrysanthemum. Su later wrote eighteen eulogizing *gāthā* on another set of eighteen lohans by Guanxiu he saw in Guangdong during one of his periods of exile from the capital.[20]

In *Boundaries of the Self,* Richard Vinograd discusses an even more striking example of the continued allure of Guanxiu's *Lohans:* In 1743, about a decade and a half before Qianlong laid eyes on them, the Yangzhou painter Jin Nong visited the Shengyin Monastery and was invited to write a series of title labels for the scrolls (presumably in the Chinese order Qianlong later criticized), which had been freshly remounted by a friend. A few decades later, Guanxiu's *Lohans* inspired the lay Buddhist and painter Luo Ping to represent the same Jin Nong, who was his teacher, in the pose of Guanxiu's fourth lohan, Nandimitra (and Rolpay Dorje's sixteenth, Abheda). Vinograd provocatively describes this painting as "a kind of reincarnation portrait" and as a work that both "embodies and subverts" the spiritual communion *(shenhui)* between a living artist and his historical model, the desideratum of all scholar-painters but particularly sought by Jin Nong and his circle, whom Vinograd notes were given to "retrospective musings."[21]

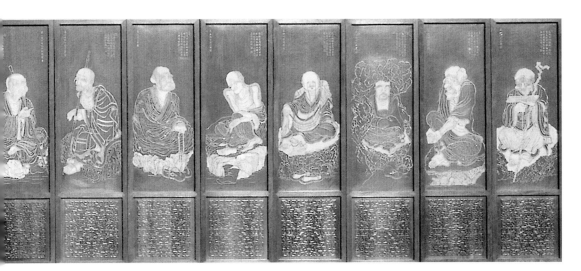

The effort to find validation for present practice in the authentic (if manipulated) past, in other words, characterized both private and courtly production of images in the eighteenth century—certainly nothing new in the history of Chinese art. But as Vinograd also notes, the purity of the Yangzhou painters' practice was undermined by "issues of inauthenticity and imposture," which included their use of ghost painters to fill the orders that poured into their studios and an almost desperate seeking after precedent, whether spurious or not. While Vinograd constructs this collection of facts to shade the quiet desperation of Jin Nong and his friends into portraits of rich psychological complexity, he finds the same traits in the Qianlong emperor to be "grandiose," "pretentious," and "inflated,"[22] an opinion easy enough to sustain given the harsh literary inquisition that enveloped his *Siku quanshu* project, his omnivorous habits of collection, and his enthusiasm for writing commentary on (or at least about) every work that came into his hands.

Yet, in striking ways, Qianlong's behavior mimicked actions condoned, indeed promoted, among educated Chinese painters. He showed restraint and reverence in his handling of the famous scrolls: He did not take Guanxiu's *Lohans* back to Beijing, nor did he write on them, however much he may have wanted to. In fact his actions were conservative, leaving us with the question of why, given his obsession, he chose instead to commission edited copies of them—why indeed he commissioned copies of so many of the great masterworks of the past, even those he already owned. What exactly did he hope to gain through such acts of corrective duplication? Was his motive simply to own everything, whether it could be physically appropriated or not, as Harold Kahn and Wu Hung suggest?[23] Or can we tease out some deeper catalyst for his urge to copy—whether private, public, or both? Qianlong's large body of writings on and about painting provides a wealth of evidence upon which we can begin to construct a rudimentary response to some of these questions. This sophisticated, multilingual emperor, whether purposefully or haphazardly, deftly or flat-footedly, built a vocabulary of criticism that entwined strands of Chinese literati art theory and practice, particularly that of a favorite object of his collection, the late-Ming painter-theoretician Dong Qichang, with the rigorous, philological methods of evidence-based research and a distinctly Buddhist understanding of the illusory quality of perception and visual representation. In this sense, Qianlong differed little from Han Chinese collectors of the Jiangnan region. But added to the accepted Han Chinese style of connoisseurship was Qianlong's complex use of two complementary, yet not precisely identical, views of time and history, the one Chinese and the other Tibetan, which led him inevitably to a nuanced and original notion of artistic agency and to a complex understanding of the uses and meaning of copying.

Shenhui, or spiritual communion, has long been a part of Chinese thinking about painting, whether explicitly or not, and by the eighteenth century it was a deeply embedded idea. Spiritual communion is related conceptually to the very early concept of breath resonance *(qiyun)*, which likewise posits the existence of a harmonic accord between several historically fluctuating sets of polarities: the artist and his subject, the viewer and the painting, the viewer and the artist, and the artist and his historical model. By the late Ming, China's literati artists sought spiritual communion in all these dimensions. Far from using painting to break down the distance between the representation and what it represented, between signifier and signified (E. H. Gombrich's ideal, which celebrates progress toward the "realistic" or "natural" while accepting the impossibility of perfect correspondence between image and model),[24] Chinese literati painters cared little for capturing what they denigrated as mere form-likeness in painting. Their stated aim was to experience the past viscerally and to cultivate and mold the self by working in the style of an admired predecessor, literally breaking down the barrier between subject (the painter) and object (the artist-as-model). In Dong Qichang's hands, this search for spiritual communion turned into an orthodox grammar detailing what was correct (and what was not) and dictating which artists were worthy of communion (and which were not). The practice of spiritual communion through the emulation of the styles of earlier artists was very loose, however. Dong Qichang's own albums of landscapes, in which he carefully cites the objects of his desire, are strangely homogeneous in style, and his spiritual communion with earlier painters therefore takes on a peculiarly disembodied and antivisual quality, dependent on his often terse inscriptions. Clearly the thought, the psychological component of modeling, was what counted, not the precise replication of style

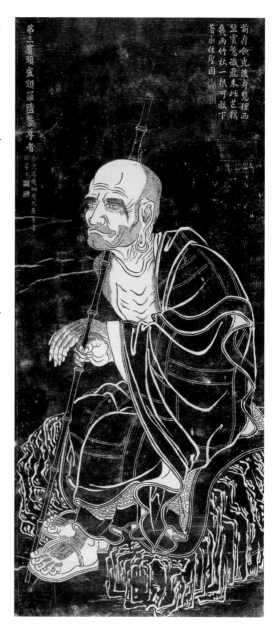

Figure 40. *Piṇḍola-bharadvāja, the Third Lohan.* Rubbing of a stone engraving made in 1764 based on Ding Guanpeng's copies of Guanxiu's *Sixteen Lohans*, originally at the Shengyin Monastery, Hangzhou. 118 x 50.8 cm. (Art Institute of Chicago; gift of Tiffany Blake.)

or content. Style in this usage was broadly construed to include individualized mannerisms of the brush, which accurately, even systematically, reflected a man's character, as well as the details of personal demeanor recorded in portraits, both painted and written, which, however bland or reticent, were laden with concealed clues pointing to the true essence of the model. Thus by late Ming, as Vinograd has shown so well, the notion of spiritual communion could also be acted out in portraiture, as gentle-

men had themselves painted in the guise of their heroes, allowing them to "compose" or "collect" themselves both visually and spiritually using historically validated fragments of biography.[25]

Dong Qichang's efforts at separating correct and incorrect models and his often flawed and occasionally self-serving attempts at clarifying the authenticity of ancient paintings predates by only a few decades the early Qing emphasis on evidence-based research.[26] In the hands of the Qianlong emperor's scholarly staff (many of whom came from the Jiangnan region and carried out similar editing projects on their own), this approach, resulting most famously in the massive compendium of all Chinese literature, *Siku quanshu*, also masked an effort to edit the past by censoring certain texts as false and reconstituting others, more pleasing to dynastic goals, as true. And this is certainly one way of understanding Qianlong's rigorous reordering of Guanxiu's *Lohans* to conform with a Tibetan system promulgated by, among others, the National Preceptor, Rolpay Dorje, in which the emperor complains that their Chinese names did not "harmonize with Sanskrit sounds." But the new Tibetan order Qianlong imposed on the lohans was not exactly censorship so much as it was an act of translation that recognized the incommensurability of Chinese and Tibetan visual systems. The new versions of the lohans wrested one of the most influential records of Chinese visionary life

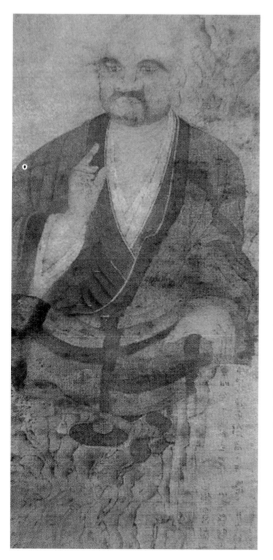

out of the Han cultural sphere and complicated its identity and meaning by rendering it, at least in part, in Tibetan. The subsequent assignment of this act of reordering to Rolpay Dorje (and the fact that it is only by virtue of Qianlong's commissioning of stone engravings of Ding Guanpeng's copies that these lohans became such familiar and widely seen icons) similarly blurs Guanxiu's agency as visionary and painter. Though Qianlong never laid the blame for the lohans' disorder at Guanxiu's feet (nor even at Jin Nong's for perpetuating the old sequence in his rewriting of their titles), his desire for a series of edited copies raises a number of questions. Was Guanxiu's vision true or not? Had his original vision somehow become illegible, confused by the addition of later inscriptions or by the inaccurate transcription of Sanskrit sounds?[27] Did the relationship of the images to their originals require translation by a transcultural emperor and his multilingual guru to make them readable once again? Were they, in other words, intended from the start as something other than copies, not images simply endowed with resemblance, but images explicitly understood as distinct from the originals?

Figure 41. Guanxiu, *Rāhula, the Eleventh Lohan* (reidentified as Vanavāsin, the third, in the Ding Guanpeng set), Tang dynasty, late ninth–tenth century. Hanging scroll, ink and colors on silk. 90 x 45 cm. (Japanese Imperial Household Collection, Tokyo.)

Guanxiu's paintings and the tale of their creation provided both an authoritative way of depicting the lohans (ultimately one of two extremely persuasive modes of representation) and a precedent for future painters to claim legitimacy for their own innovative representations of them. Qianlong was hardly the first to recognize their significance. Nor was he the first to think that mere looking had to be extended to reenactment of the process of their creation—that they literally begged to be copied, reperformed, and translated into personal experience. Guanxiu's *Lohans* were copied by pious Buddhists not long after they were painted; in their own way, they very quickly became as canonical as, say, the *Heart Sutra*.[28] Some of the earliest recorded copies of Guanxiu's *Lohans* were done by the scholarly Buddhist layman Li Gonglin, friend of Guanxiu's other admirer, Su Shi, and interest in the lohans continued to flourish in the late Ming.

One of the most influential late-Ming reinterpreters of the iconography of the lohans was Wu Bin (active ca.1583–1625), whose grotesque and fantastic style played on Guanxiu's and whose work Qianlong avidly collected.[29] Wu Bin's inspiration, again like Guanxiu's, reportedly came to him during a dream. James Cahill has said that according to the Nanjing scholar Gu Qiyuan (1565–1628), whose impressions of Wu Bin's lohan paintings at the famed Qixia Monastery are included in *Jinling fancha zhi* (Record of the monasteries of Jinling, that is, Nanjing), Wu Bin was approached in 1596 by a monk from Sichuan who asked him to undertake a painting of the five hundred lohans for the monastery. Wu declined the request but then fell asleep and dreamed he saw the same monk leading a crowd of people to worship the Buddha. Suddenly the sky filled with miraculous sights, including a troop of fantastic beings. Wu heard a voice command him to paint all of them before he could leave. He did so and then, just as a soldier was about to behead him, he awoke. After relating this Gu Qiyuan went on to question the difference between the dream and waking state and claimed that Wu Bin's experiences were genuine.[30]

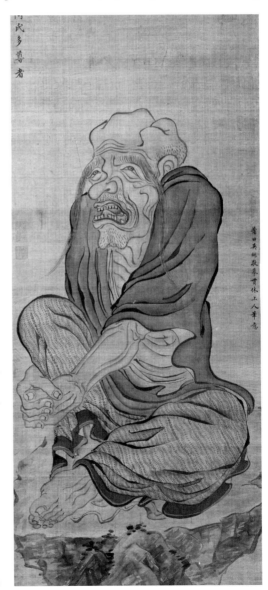

Even more compelling is another inscription Cahill discusses, also recorded in *Jinling fancha zhi*, in which Dong Qichang himself postulates a complex agency for the production of Wu Bin's now lost *Five Hundred Lohans*, saying: "You have used your predecessors' eyes and your own hand. Doing this has to be considered going

Figure 42. Wu Bin, *Sixteen Lohans: (left) Ajita (number 2); (center) Panthaka (number 12); (right) Vanavāsin (number 16).* From *The Sixteen Lohans*, also after Guanxiu's Shengyin Monastery set, Ming dynasty, early seventeenth century. Sixteen hanging scrolls, ink and colors on paper. (National Palace Museum, Taipei.)

beyond painting."[31] This, in Dong's view, was the most fulfilling sort of spiritual communion: The artist sees through the eyes of another, looks out from the same private (but to him initially alien and historical) vantage point, and experiences a moment of egolessness translating him beyond distinctions of self and nonself. Here Dong Qichang lauds Wu Bin's cultivation and his mastery of the past; he praises his literary abilities, suggesting that Wu Bin's talents were molded through long discipline and practice that included copying the work of his admitted model, Guanxiu.

Wu Bin, like Li Gonglin before him, also made copies of the Shengyin Monastery lohans (Figure 42).[32] Wu Bin's versions, which entered Qianlong's collection sometime after 1744 (they are included in the collection catalog supplement of 1792), were never intended to be exact copies; the artist modestly indicates in his inscription that he reverently modeled himself on Guanxiu's "brush idea" *(biyi)*. Some of his changes are simple ones seemingly introduced only to highlight the distinction between his work and his model and to cast his own paintings as a reflection of an earlier experience. Seven of the sixteen scrolls, for example, are mirror images of the originals as we know them

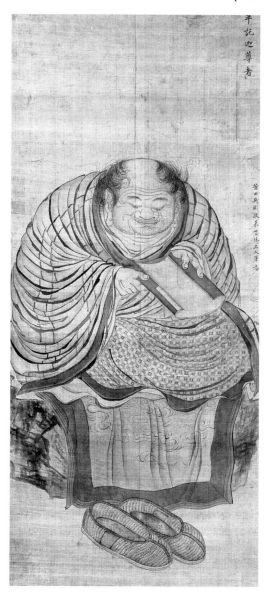
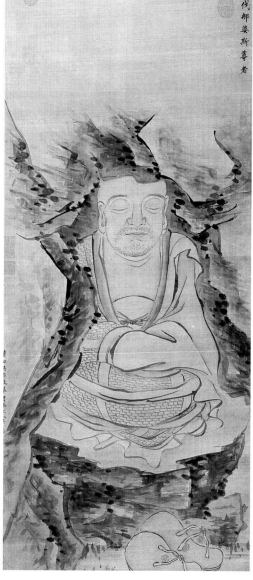

from Ding Guanpeng's versions (the same ones that are reversed on Qianlong's lacquered screens), and all radically pull the figure of the lohan up to the picture plane, compressing space on all sides, top and bottom, front and back. Wu Bin inserts himself into the pictures aggressively—at least when seen against the "erased," self-effaced model of Ding Guanpeng. He paints with noticeable "hand," physically capturing the pictures for himself, personalizing indentations of the flesh, body and facial hair, textile patterns, and rocky settings with rough strokes of the brush that evoke the work of painting, skillfully capturing the directness, if not the detail, of Guanxiu's *Lohans*. In other words, he conflates two ideas about Guanxiu's work that were certainly current in the late Ming—that he painted in the careful line-and-wash style of the Japanese Imperial Household Collection lohans and that he was also a master of the *yipin* (untrammeled class).

Wu Bin's deviations from the originals were noted with approval by the high official and painter Dong Gao (1740–1818). Writing in 1796 as an imperial proxy for the retired Qianlong, Dong Gao avers that Wu Bin had confused the order of the lohans, now rectified and brought into accord with Sanskrit sounds by imperial order, but had, nonetheless, managed to "report on the spirit egolessly." "Are they one or two?" he asks—leaving us wondering whether he is referring to the lohans as equivalent, codependent models of Buddhist perfection, incapable of dualistic thought, or whether he means that Wu Bin and Guanxiu are bound together by Wu's act of creative replication. This ambiguity is probably deliberate; it is a rhetorical device we have already seen Qianlong and others using in a wide range of inscriptions beginning as much as four decades earlier, reiterated to question the meaning of the image (and especially the copied image) against the meaning of the original (or, in Guanxiu's case, the vision copied into painted image).

Several years before ordering Ding Guanpeng to copy Guanxiu's *Lohans*, Qianlong began to write a series of colophons on paintings by the artist that played upon the coincidental but sweet correspondence of the artist's name with that of an illustrious late-Ming predecessor, the innovative painter, print designer, and Buddhist layman Ding Yunpeng (1547–ca. 1625). Here the emperor adapted another precedent set in late Ming by Dong Qichang and others. Dong proclaimed a particular affinity with the tenth-century founder of his orthodox "Southern school" of painting, Dong Yuan, on the basis of their shared surname.[33] In mimicking a familial relationship—the same pattern Chan Buddhist patriarchs followed in the construction of their nonbiological, dharma lineages—Dong asserted that his model's essence had been conveyed to him unadulterated—not genetically, but by a Chan-like, wordless mind seal—and that his experiences in painting therefore replicated Dong Yuan's. Likewise Dong's contemporary, the scholar-painter Mi Wanzhong, modeled himself on a great Northern Song literatus and painter, Mi Fu, to the point of copying his famous calligraphy and even emulating Mi Fu's adoration of strange rocks.

When Qianlong adopts this idea in his colophons on Ding Guanpeng's copies of Ding Yunpeng's paintings, however, he takes the late-Ming usage a step further by claiming for himself the right to apply it to his painter-in-attendance. The emperor's point is that Guanpeng's paintings are something other than workmanlike, accurate copies and that this fact is evident in the punning coincidence of his name with that of his illustrious predecessor, Ding Yunpeng. At stake is the nature of identity, the extent to which history can be shown to repeat itself in harmonious, poetic patterns, so that each moment rhymes and resonates with an earlier moment and prophetically anticipates the shape of the future. In 1749, writing on a Ding Guanpeng copy of Yunpeng's *Five Hundred Lohans*, Qianlong quips: "How is the spirit transmitted? Yunpeng—Guanpeng, former body—latter body" (or "preincarnation—reincarnation").[34] On another copy of the same painting completed a few years later in 1753, the emperor amplifies his equation of the two painter-incarnations, seeing in the one a prefiguration of the other:

Soaring among clouds and seas, gazing at holy monks,

Guanpeng's brush is so subtle it appears to be Yunpeng's.

It's just as before—whoever recognizes what the preincarnation is,

Awe-struck, knows the talent of the reincarnation.

In a company of *saṅghāṭī* [robes] the lohans descend.[35]

On the same painting, Guanpeng claims in his own short inscription that he is "following Yunpeng's brush idea *(biyi)*," thereby assuming a somewhat compromised mantle of scholarly communion mediated by his role as a servant *(chen)* working to fulfill the emperor's command.

The emperor also uses the same rhetorical flourish when describing a 1762 painting by Ding Guanpeng of a *Lohan Subduing a Dragon* (Figure 43). Here, referring not to the artist but to the lohan, he says "former body, latter body, not two, not one," implying the basic contingency and dependency of each lohan on all the others.[36] And as we have already seen, Qianlong applies an inversion of this same phrase to himself by asking "Are they one or two" (the same wording Dong Hao used in 1796 to describe Wu Bin and his model) when inscribing the short series of portraits most likely done around the same time, in which he is dressed as a Han Chinese Buddhist layman seated before a landscape screen where a mirror image portrait of himself hangs (Chapter 2, Figure 13). Invoking this Buddhistic formula of nonduality—a doctrine that admits difference but insists that all things are joined in a fabric of mutual dependence—allows him to accelerate his rhetoric to claim that two painters coincidentally named Ding (or the many lohans; or himself, a painted image of himself, and a painting of a painted image) are not just joined together by lineage or stylistic resemblance but are, in fact, equally dependent on one another. If Ding Guanpeng needed Ding Yunpeng for inspiration, in Qianlong's view Yunpeng needed Guanpeng to assure his presence in history.

Writing a eulogy in 1758 on Ding Guanpeng's copy of the sixteenth lohan in Guanxiu's Shengyin Monastery set, Qianlong picked up the same note when he said: "Guanxiu made

Figure 43. Ding Guanpeng, *Lohan Subduing a Dragon*, 1762. Hanging scroll, ink and colors on paper. 94.3 x 67 cm. (National Palace Museum, Taipei.)

the images; Ding Guanpeng copied them true. Yellow flowers, kingfisher blue bamboo—a billion transformation bodies." And in a separate inscription on the same scroll, the emperor continues: "Transformation bodies are all egoless. Before and after are all gathered up in present appearances."[37] Aside from his reference to the skillful shape-shifting abilities of Buddhist deities (lohans included), Qianlong enigmatically addresses here the congruence and mutual dependence of past and present forms; the copy, in other words, is no different in status from the original because it has been "copied . . . true." Despite the emperor's claim for the entwined, mimetic relationship of original and copy, it is precisely the differences between the two that make the copy, in a sense, better, at least for now, because the copy has been actualized and put in proper order, translated into a more complex present, as past and future have been egolessly "gathered up in present appearances."

How could Qianlong conflate the work (and indeed the separate identities) of artists so different as Ding Yunpeng and Ding Guanpeng? Ding Yunpeng was one of the more daring, radical Buddhist

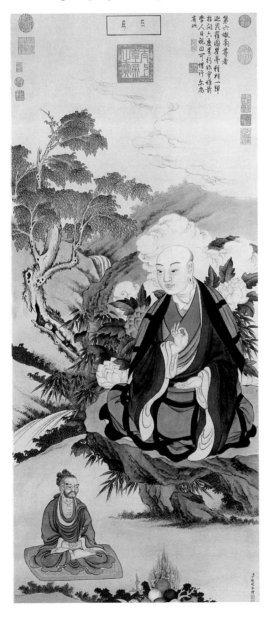
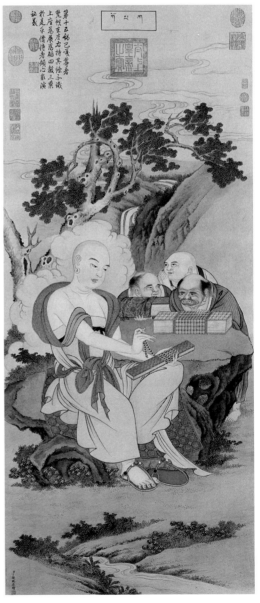

painters in later Chinese history; his early style was deliberately and gracefully transparent, his later style "bland and rough," and his blurring of distinctions between iconographic types (most famously the feminized bodhisattva Guanyin and the lohans) set new limits for the representation of visionary experiences.[38] As he was an educated man, if not a government official, the details of his life, his relationships with scholars, monks, and publishers, were well known in the eighteenth century. Ding Guanpeng, by contrast, was a talented and highly professional figure painter whose release from almost complete anonymity in the context of the Qing court came because he was, biographically speaking, an empty vessel, a talented painter and copyist whose name accidentally, charmingly, harmonized with one of Qianlong's favorites, Ding Yunpeng. However wishful Qianlong may have been in thinking he could command Ding Yunpeng through the medium of Ding Guanpeng, his comments spark yet another series of questions that the Tibetan system of directed rebirth also provokes, questions that were often on the imperial mind: What distinction can be made between creative imagination and remembering when the spirit is transmitted across generations and the process of learning and revelation is equated with the slow reawakening of memory, understood as Buddhist *smṛti* (recall)? How, under the circumstances of rebirth, is the individual self—never mind creative genius—to be understood? The bricolage of the self with fragments of historical biography, the delight in historical guises as a means of self-expression that were so much a part of elite Han Chinese practices of personal cultivation in the late-Ming dynasty, are here given an additional twist, one that takes us back into the realm of Tibetan Buddhism.

To Yerpa and Beyond

In 1796 (a decade after Rolpay Dorje's death), Qianlong's amanuensis Dong Gao (1740–1818) recorded imperial comments on a set of sixteen lohans Ding Guanpeng had completed thirty years earlier in 1768 (Figure 44).[39] The inscription begins by immediately recalling the copies Ding Guanpeng did ten years before of Guanxiu's *Sixteen Lohans.* Dong compares the Guanxiu copies with Ding's later set and also notes their substantial differences. Superficially Ding Guanpeng's 1768 *Sixteen Lohans* seem to play off a separate but equally formidable stylistic strain in

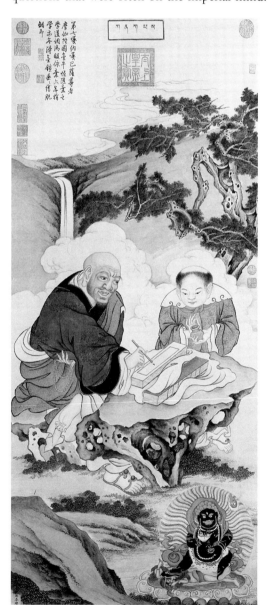

Figure 44. Ding Guanpeng, *Sixteen Lohans: (left) Bhadra* (number 6); *(center) Gopaka* (number 15); *(right) Kanakavatsa* (number 7). Sixteen hanging scrolls, ink and colors on paper. Each scroll 135 x 56 cm. (National Palace Museum, Taipei.)

lohan depictions allegedly begun by the Northern Song painter Li Gonglin but perhaps dating back to the Tang dynasty. This refined vision found some of its finest renditions in the highly professional *Five Hundred Lohans* by the Southern Song Ningbo painters Zhou Jichang and Lin Tinggui, now split between Daitoku-ji, the Boston Museum, and the Freer Gallery,[40] and later in the court productions of the Ming Yongle emperor and his immediate successors. Like those earlier or contemporaneous works, Ding's *Lohans* sometimes appear to be ethnically Chinese, sometimes Indian or Central Asian, but unlike Guanxiu's they are never grotesque. Their intelligent faces are by no means identical—some are lined and wizened, with long, streaming eyebrows, others are young, either tonsured like monks or with full heads of curly hair. All sixteen are well groomed, and, though not all dressed in Chinese style, they sit at eroded stone tables like elegant Jiangnan scholars whiling away their time in opulently painted, carefully descriptive, Chinese landscapes, some with young acolytes standing in attendance. Their gestures are refined and precise and their inner composure is reflected in their collected expressions and careful, formal costumes, the chthonic power of Guanxiu's wildmen effectively tamed and exchanged for urbane, courtly blandness.

A second glance, though, is enough to shatter the sense that these lohans occupy the same world, however elegant, as the rest of us. For one thing, they keep very strange company—in spirit if not in substance like the imaginative assemblies of the late-Ming painter Wu Bin. They accept tribute from white monkeys, gnomes, boys in leaf skirts, scarved babies, and civil monsters bearing flaming jewels, scrolls, and trays of lotuses and jewels. Bhadra, the sixth, offers instruction to a miniature, hirsute *mahāsiddha* (great adept), sketching out a lineage of the descent of his dharma from his own suave self to this wild-haired *tantrika*. Style confronts style as Gopaka, the fifteenth, unwraps a manuscript while three rotund monks, among them a swarthy twin of Guanxiu's lohan Panthaka (number thirteen in the revised Shengyin Monastery set), look on. There are even more intrusive quotations: Ding violates his own carefully constructed, descriptive space when the seventh lohan, Kanakavatsa, sits in a garden energetically writing a sutra, while the great protector, Mahākāla, accurate to the iconometrics of Central Tibetan painting, grips a skull cup of roiling blood and blazes fiercely in the lower corner. Mahākāla's image is intrusive and surreal, an indiscreet nightmare that Kanakavatsa politely ignores even as he is apparently the source of it. The great protector is quoted like Adorno's "explosive material of enlightenment" into the protected Chinese world behind him, shielded from it by an aureole of opaque, rainbow-colored light as he hovers above the ground on a cushion of fungus-shaped clouds.

Qianlong and his court painters seriously addressed the question of whether it was possible to translate, not just from one language to another, but from one culturally determined visionary world to another. If even the inner life was plagued by culturally bound forms, then a thorough blending of style would result not in a distillation and synthesis of several different traditions but in a meaningless, incoherent mistransmission—a built-in problem akin to the unavoidably inaccurate or clumsy transliteration of mantras or lohans' names into Chinese characters. The solution, as we see here, is a system of representation that is not blended, nor truly hybridized, but which juxtaposes and layers two approaches with very distinct goals, quoting one in the context of the other. In this suite of lohan paintings, Ding Guanpeng seems perfectly (if uncomfortably) aware of the different ways Chinese and Tibetan representational modes convey meaning, and he maintains both in a curious relationship of mutual commentary. His terse signatures ("reverently painted") say nothing here about "brush ideas," a typical literati trope in his inscriptions on more "Chinese" images, but his paintings reveal nonetheless a combination of intent similar to the complex rationales of scholarly painting as it was practiced in late Ming and Qing literati circles. Ding's lohans may be heirs to a professional Buddhist painting tradition, marked by denotive, descriptive line, color, and space, but they also use this elegant and imperially subsidized tradition indexically to point to and actualize

past experience, referring obliquely to the work of elite painters (and imperial patrons) of the past. In this series of lohans, the "Chinese" portions of the pictures are layered with all kinds of meaning, pictorial and calligraphic, that are posed against—not blended with—a very different, Tibetan way of making pictures through the massing of precisely rendered icons, attributes, and symbols and the explicit presentation of several different phenomenal registers. But how much of this was Ding Guanpeng's doing? Was he simply playing the role of the emperor's substitute brush, or did he represent the Chinese embodiment of a complex tradition already well established in Tibet?

Another set of lohans, painted by Han Chinese court artist, Yao Wenhan, offers additional insight into this problem of agency. Yao's paintings delve, not into the Chinese past, but into the visionary world of Tibetan Buddhism, even going so far as to take on the sexually charged imagery of the supreme *yogatantras* (Plate 14 and Figure 45). Yao's undated paintings of the *Eighteen Lohans* (following the Tibetan sequence that adds Upāsaka-Dharmatāla and Hvashang) are part of a suite of twenty-three paintings that includes a lead image of Śākyamuni and four concluding scrolls of the guardian kings of the four directions.[41] His dark, Indianized Śākyamuni (Figure 45, left) makes the *bhūmisparśa mudrā* (earth-touching gesture marking his triumph over the obstructions to enlightenment) from an opulent, flowery throne of glory that explodes, Nepalese style, with a plump garuda, crocodilian *makaras,* and *kalavinka* birds, while below the seven treasures of the *cakravartin* (read: Qianlong, the Mañjughoṣa emperor) acknowledge the Buddha's triumph over temptation and desire, and auspicious, pastel clouds in the form of *ruyi* ("as-you-will" fungi) roll by in the sky above. The lohans—who sit in gardens filled with camellias, bamboo, willow, banana, plum, and peach, meditate in wild mountain crevasses, or hover cloud-borne over rolling waves—are all revealed in a master/disciple relationship that ties them to explicitly Vajrayāna figures: Indian pundits, lamas, *mahāsiddhas*, even bare-chested *ḍākinī* (the provocative, vision-granting female space vixens who are every *tantrika's* best friends). Here Yao seems to figure out clever ways to conceal his fierce and unlovely *ḍākinī's* chests and genitals (which might not have embarrassed a Tibetan artist, because their femaleness is the source of their wisdom), but he seems equally uncomfortable with the disruption of his deep pictorial space by their aureoled, wildly dancing shapes (see Kanakavatsa in Figure 45, center).

There are all kinds of conceits to keep them and their visionary counterparts aloft—unlikely, eroded cantilevers of stone, a cloud of incense, a supportive peach branch, magic carpets, even a potted plant. Rāhula, the tenth lohan, calmly accepts a gently proferred dove, a magnificent elephant tusk, and a flaming jewel topped with a fleur-de-lis-shaped *vajra*, while above and behind him a duck nests in a stone niche, courted by an acrobatic suitor (Figure 45, right). This traditional Chinese symbol of marital felicity—aimed at celebrating the prospect of children—reads on the surface as Chinese prudishness pointing to, but refusing to depict, the sexual great bliss yoga of the supreme *yogatantra*, whose fruit is not children but enlightenment. Meanwhile Śāntarakṣita, an eighth-century pundit and incarnation of Rāhula, sweetly contemplates the scene from behind, having maneuvered his cloud onto the top of a floral arrangement. This unlikely composition, painted in an unassertive style indistinguishable from Ding Guanpeng's, seems like a potpourri overflowing with contradictory claims on the senses; it reverberates dreamlike with multiple layers of meaning and multiple actions, moving the eye back and forth between the portraitlike representation of Rāhula's thoughtful face, his rocky, bamboo-filled, and thoroughly scholarly setting (which points to the fact that here sits a lohan of profound learning), the marital, covertly sexual symbolism of the nesting and cavorting ducks, and the suggestion of lineage contained in the appearance and promise of the young Śāntarakṣita who watches the whole auspicious scene reverently as the recipient and practitioner of Rāhula's wisdom. Such a bold, if not entirely successful, rethinking of an old theme seems somehow out of place in Qianlong's approach to the subject of the lohans, which he otherwise treated with such grave reverence for antiquity. Or are the emperor and Yao up to something else entirely?

Figure 45. Yao Wenhan, *Eighteen Lohans: (left) Śākyamuni Buddha; (center) Kanakavatsa* (number 7); *(right) Rāhula* (number 10). From a set of twenty-three hanging scrolls also depicting the guardians of the four directions, all ink and colors on paper. 114.4 x 66.8 cm. (National Palace Museum, Taipei.)

It seems almost a shame that Qianlong had nothing to say about Yao Wenhan's paintings, because they are, in fact, not at all a Chinese court painter's daring or failed attempt to work independently within the Tibetan Buddhist tradition but something more intriguing altogether. In 1796, Dong Gao added an inscription to the mounting of the last lohan in the set as it is presently arranged: the Tibetan-garbed Upāsaka-Dharmatāla (Plate 14). Dong commented predictably that the whole suite was arranged properly according to the teachings of Rolpay Dorje and that despite what he perceived to be their "Tibetan painting style" *(Xifan huifa)*—a style that comes closest to what Tibetan observers called "Chinese"—and their notable differences from all the other paintings in the *Bidian zhulin* collection, their ornament was "awesomely virtuous, the fruit of wisdom, penetrating the spirit."[42] Lest we think that Dong Gao himself was a Tibetophile, it is important to note that in revisiting the suite he apparently misnumbered the seventeenth and eighteenth lohans—thereby destroying Rolpay Dorje's order. (Hvashang, the plump monk who, like the Chinese Budai or laughing Maitreya, loves children, should be the last lohan and Upāsaka-Dharmatāla should be the seventeenth.) He also mistook the Tibetan inscriptions at the top of each mount for Sanskrit. Dong, in other words, did not quite understand what he was seeing.

Despite Dong's confusion, he did notice that Yao's paintings were not precisely Chinese in style;

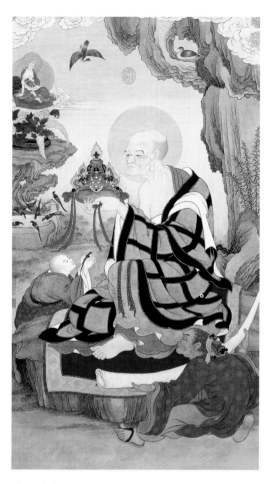

they were just different enough with their Tibetan inscriptions to reduce him to platitudes. Nonetheless, Yao's antecedents were well established, if only distantly Chinese. His Rāhula is, in fact, a very close version of a lone image that survives as a thangka of the seventeenth or eighteenth century, which Gilles Béguin has described as "Eastern Tibetan, Chinese or Sino-Tibetan" (Figure 46).[43] Béguin's refusal to commit to any one of these possibilities is more than reasonable; the thangka is mounted with Chinese brocades (but has no other signs of Chinese ownership) and features all the subtle equivocations of Yao's work, including the somersaulting bird and floating pundit. All Yao has changed are the textile patterns of the main characters' robes and the female bird's nest, which appears in his version in a perforation that bores all the way through the rocky overhang instead of sitting snugly in a lofty cave. Yao's version also seems to open more convincingly into deep space while at the same time flattening and sharpening the edges of everything that occupies its frame. In other words: Yao has verged far from the models of Guanxiu and Li Gonglin into a tradition that is marked by earlier Sino-Tibetan stylistic and iconographic preferences. His model and his product are both done in a Chinese style filtered through Tibet and put to the service of a list of lohans expanded, in eighteenth-century Tibetan style, by two.

These pictures can be compared to the colorful, roomy, Chinese-style thangkas developed in Eastern Tibet (and thus appropriately called Sino-Tibetan, as defined by Ulrich von Schroeder and Marylin Rhie)—best exemplified in the still active painting tradition sponsored by the traveling encampment of the Karmapa Kagyu as early as the sixteenth century. This Karmapa style likewise depends on the elegant rupturing or effacement of rationally plotted deep pictorial space to reveal the vivid visions for which the Kagyu, in particular, are famous.[44] Eastern Tibetan style, generated on the Tibet-China border, and Qing court style are therefore equally "hyphenated." But exactly who got to determine meaning, "host" or "guest," is difficult to unravel, since artists consciously mixed parts of both traditions of representation to convey new kinds of messages by the juxtaposition, layering, and blending of Chinese and Tibetan materials, techniques, and compositional types.

By the late seventeenth and eighteenth centuries, the Karmapa lineage of painters had created a tradition of Sino-Tibetan painting remarkably similar to the Tibeto-Chinese works of Ding Guanpeng, Yao Wenhan, and others at the Qianlong court, and their tradition radiated outward to the south and east into Derge, where the aesthetically sensitive royal family remained faithfully tied to the Karmapas even after their defeat at the hands of the Fifth Dalai Lama and his Mongol patron Gushri Khan. There such prominent painters as Situ Panchen Chökyi Jungney (1700–1774), whose lifetime almost exactly parallels Ding Guanpeng's, worked in a manner that is strikingly Chinese, producing icons and portraits set in Chinese landscapes, where diaphanous visions of deities seem

both to veil and intensify the sensory data of the everyday world in which they manifest themselves (see Figure 47). Situ Panchen described his own paintings thus: "I have followed the Chinese masters in color and in mood expressed and form, and I have depicted lands, dress, palaces and so forth as actually seen in India."[45] He was, in other words, perfectly aware and in command of his own complex sources.

In their own adoption of the elements of Tibetan style and vision, the Manchus were also aware they were dealing with a consciously multistylistic tradition, one in some instances already deeply imbricated on the Tibetan side with the history of Chinese art. Tibetan connoisseurs and patrons such as the Fifth Dalai Lama had long since developed an elaborate art criticism that included a taxonomy of schools (including Nepalese, Indian, Kashmiri, and Chinese, as well as various Tibetan traditions). The Great Fifth had a great deal to say about lohans and their representation too. His treatise of 1676, *The Gem of the Immeasurably Steadfast Offering to the Sixteen Lohans*

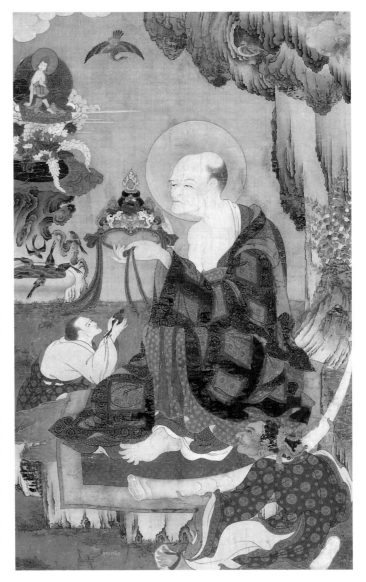

Figure 46. *Rāhula*, seventeenth–early eighteenth century. Hanging scroll, ink and colors on silk. 110 x 64 cm. (Musée Guimet, Paris.)

(reproduced in 1711 as the Longshan Monastery *Sixteen Lohan Sutra*), recites the original sixteen lohans of Atīśa's list. His text, but not its illustrations, adds as a seventeenth Upāsaka-Dharmatāla, whom the Dalai Lama identifies as a man of the Tang dynasty.[46] He conspicuously ignores the eighteenth lohan, the fat monk Hvashang, who nonetheless appears pictorially on the last page of the book opposite the wheel-turning emperor.[47]

The Manchus were completely conscious of all this. The Tibetan-language *Lohan Sutra*, produced in 1711 at the Longshan Monastery for the Protection of the Nation in Beijing, makes these painting lineages the focal point of its illustrative program (Chapter 4, Figure 26). I have already noted the covert interplay of its text and illustrations, which trace two very different, even contradictory, stories—one that implies sixteen characters (plus Śākyamuni), the other eighteen (plus Śākyamuni and the Kangxi emperor-as-*cakravartin*). Curiously, two of this second group are Chinese in origin

(Upāsaka-Dharmatāla, who appears in the text, and Hvashang, who appears in illustration) but are only recognized as lohans in Tibet. Thus the sutra and its illustrations simultaneously and economically present two different scenarios as if there is really no contradiction, just as they draw equally on two different sources, liturgical and pictorial.

This version of the sutra also points to a reason why the Qing emperors, especially Qianlong, found the lohans such food for thought—and that is their role as protectors of the dharma, a Mahāyāna redefinition of them that left a great deal of room for political exploitation, which Qianlong likewise cites in his long "Record of the Five-Hundred-Lohan Hall at Wanshoushan" of 1756.[48] The lohans, in this view, are not merely self-serving disciples of the Buddha intent on their own enlightenment; they become dharma heroes who guard the major mountainous sites and outposts of the Buddhist world and beyond in anticipation of the death of the dharma and the coming of Maitreya, the new buddha. Originally four in number, to echo the four quarters of Buddhist cosmology, they rapidly squared to sixteen and joined forces with the guardians of the four quarters (who accompany Yao's version in four separate scrolls). This explosion in numbers and the inherently geographic significance of the group begged for articulation in mandala form, which was accomplished in the Śākyamuni-centered, lotiform lohan mandala of the Sakyapa lama Kunga Rinchen.[49] But it also presented a powerful metaphor for the expanding Manchu empire itself, with the lohans sitting at its outposts

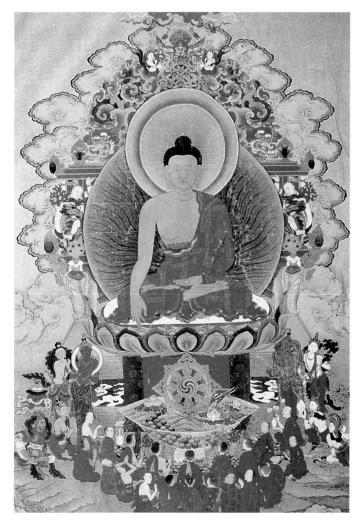

protecting the dharma. As Giuseppe Tucci observes, the spatial qualities of the lohans were only part of the picture; as guardians of the law, they also took on a temporal quality, selflessly refusing nirvana until the coming of the next buddha. Central to this new, expanded, millennial mythology is the *dharmarāja* or *cakravartin*, the righteous king whose rule is paradoxically a prophecy of the death of the dharma and Maitreya's descent into the world of men. All Buddhist monarchs craved this role; the Qing, as we have seen, claimed it by prophecy of the Fifth Dalai and Third Panchen Lamas. In the Longshan Monastery *Sixteen*

Figure 47. *Śākyamuni Buddha*, after a design by Situ Panchen. Eighteenth–nineteenth century (Eastern Tibet, Kham). Thangka, colors on cloth. 80 x 58.5 cm. (E. Jucker Collection; after Jackson, *History of Tibetan Painting*, pl. 49.)

Lohan Sutra, it is the Kangxi emperor who boldly grasps it, presenting the wheel as the true symbol of his right to preside over the end of the kalpa, all the while acting as a sensitive force for reconciliation.

Qianlong, of course, emulated his grandfather throughout his life. And in at least two of his portraits as Mañjughoṣa-*cakravartin* (at the Yonghegong and from the Pule Temple in Chengde), he sits in a landscape full of auspicious signs, surrounded by an abbreviated pantheon that includes fifteen monks who sit below the emperor on either side of a pond blooming with multi-colored lotuses (Plate 15). These monks are broken into two unbalanced groups of seven and eight, an extremely strange array given the strong symmetry of the rest of the composition. Could they, together with the greatest protector of the empire, Qianlong himself, make up a body of sixteen lohans? The presence of Maitreya, the Future Buddha, who watches over the scene below from the porch of his palace in Tuṣita Heaven, monitoring the signs that foretell his descent, suggest that, in more ways than one, projecting the emperor in the role of guardian of the empire's most distant outposts may be one of the esoteric messages of the thankgas. One bit of Beijing folklore gives some credence to this reading. At the Wofosi (Reclining Buddha Temple) in the Western Hills outside the capital, there is a poly-

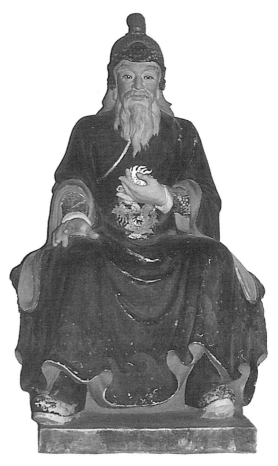

Figure 48. *Portrait of Qianlong Seated Among the Lohans.* Clay with polychrome, Wofo Monastery, Beijing. (After *Beijing gucha mingsi,* p. 60.)

chrome clay statue said to represent Qianlong (Figure 48). As the story goes, he had it made to be placed, as it is now, among the temple's statues of the eighteen lohans, also polychrome clay. In this unusual representation the emperor appears as an old layman, with white eyebrows, beard, and mustache, seated with his booted feet firmly on the ground and his right hand raised to his chest as if ready to hold a *dharmacakra.* He wears a blue-green robe decorated with dragons and waves and a plumed, helmetlike, tight-fitting cap decorated with a grim-faced, leaf-eared monster who glares directly out while wrapping his thin, scaly legs around the emperor's skull.[50] Though the emperor is the only figure in the group who is dressed in Manchu-style robes, in every other way he conforms to his lohan companions, especially in vividness.

Another Intervention Across Time and Space

Our understanding of why Qianlong ordered copies of paintings, whether Chinese or Tibetan, is complicated by one of his most carefully considered commissions: an edited, two-part replica by Ding Guanpeng of the beautiful *Long Roll of Buddhist Images,* attributed in a colophon dated 1180 to an otherwise unknown, perhaps Sichuanese, master named Zhang Shengwen. The original was painted sometime between 1173 and 1176 at the Yunnanese court of the Hou Li ruler, the Lizhen

emperor and *piaoxin* (a local title probably derived from the Burmese "ruler of Pyu") (Figure 49). Zhang Shengwen's scroll has been the subject of intense study—particularly in the pioneering work of Helen Chapin (later edited by Alexander Soper) and also in several important essays by Li Lin-ts'an and Sekiguchi Masayuki, as well as many others.[51] According to them the scroll records the pantheon of Buddhism as it was practiced in the Dali kingdom, located in what is now Yunnan province. This remote, mountainous southwestern region was independent through the Tang dynasty and continued to assert its independence during the Song, when, as Chapin and Li agree, the rulers of Dali also maintained some of the diverse Buddhist practices of Tang-dynasty Chang'an, welcoming both Chan and tantric masters to court. The *Long Roll* thus records local belief and practice in Dali in the twelfth century and preserves much of what is now lost of the Tang pantheon, Chan and tantric, with certain significant local additions. As the scroll unrolls, we see the king of Dali, his family and court, the guardians of Dali's Lake Erhai (Ear-Sea), the Buddha Śākyamuni, more guardian kings and *nāga* kings, the lohans, the Chan patriarchs, the debate between Vimalakīrti and Mañjuśrī, assemblies of the Medicine Buddha and Maitreya, the Future Buddha, intercessions of the Medicine Buddha, more buddha assemblies, the transformations of Guanyin, fierce and tantric guardians (including such Vajrayāna standards as Mahākāla and Vajrabhairava), two standards bearing banners with the *Heart Sutra* and the *Sutra for the Protection of the Nation (Huguo jing),* both in Sanskrit, and, finally, the sixteen kings of India bearing tribute.

When the *Long Roll* came into the Qing imperial collection is not known, although most likely it was early in the Qianlong period, probably between 1744 and 1763, when an imperial colophon shows it was clearly in Qianlong's hands. The painting is not recorded in the original edition of *Bidian zhulin*, finished in 1744, but does appear, together with an entry describing Ding Guanpeng's two-scroll copy, in the supplement to the catalog, completed in 1793.[52] The *Long Roll* had been long out of Yunnan, however, and its movements from one monastery to another in Yunnan and beyond are recorded in a series of colophons attached at the end. The first of these, written by the Yunnanese monk Miaoguang in 1180, says that Zhang Shengwen asked the writer to look at the scroll, apparently at Lizhen's court. The second, by the early-Ming Hanlin scholar Song Lian, is undated but describes the painting as "a roll of Buddhist images . . . in color and gold and all extremely well painted" shown to him by a Chan monk named Detai, from Dongshan, who had "acquired the roll by purchase—not cheaply" (but from whom he does not say).[53] Four more colophons by Ming-dynasty monks follow; they record several changes of ownership, and all but the first describe the painting as a "portfolio" or "covered book" *(zhi),* probably like an accordion-fold book, which Li Lin-ts'an argues must have been its original format given the regular alternations of *vajra* and bells along the top and bottom borders. The final colophon in this group (the writer's name is illegible), dated 1459, tells how the painting was swept away in a sudden flood in 1449 and remounted again as a portfolio.

In other words: Between 1459 and Qianlong's colophon of 1763, almost three hundred years, the *Long Roll* sinks into silence, quite different from Guanxiu's *Lohans*, which continued to live in the work of painters of the late Ming and early Qing. Qianlong's extensive, cursive-script colophon to the *Long Roll,* however, provides interesting clues as to how, or at least why, he might have come to take an interest in the picture:

> *A Painting of Indian Images, the Work of Zhang Shengwen of the Dali Kingdom, in Song Times:*
> Paintings of the Dali kingdom are not to be seen every day; there are only a few attrib-
> uted ones in the catalogs of collections of paintings of different dynasties. In the palace
> there is a long roll of Buddhist images by Zhang Shengwen, a man of that country. It has an
> inscription by the monk Miaoguang, written in the fifth year of Shengde, the cyclical year

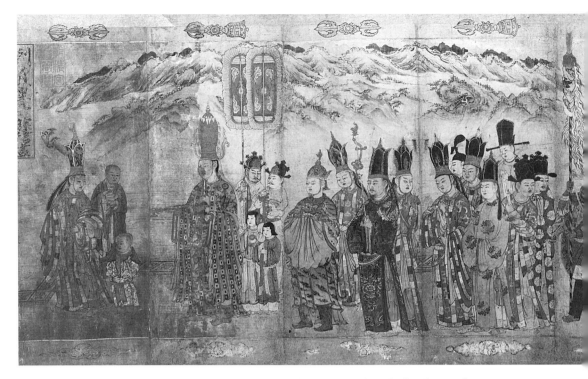

gengzi, and one by Song Lian which states that this date corresponds to the fourth year of
Jiaxi during the reign of Lizong of the Song dynasty [1240].

I once saw in Zhang Zhao's collected writings a colophon for a picture scroll by an
unnamed artist of the Five Dynasties, but I doubt that he was referring to this same painting.
He had made a thorough study of the Dali style. At the beginning of this colophon he gives
a date, the first year of the period Wenjing of the spurious Duan Siying, which is calculated
to correspond with the third year of Kaiyun of the Posterior Jin [946]. Now, this roll is a
Southern Song piece, a difference of some three hundred years. [Qianlong is basing this
estimate on Song Lian's incorrect reading of the date of Miaoguang's inscription, which was
really written in 1180.] [Zhang] records the trace of the Acuoye Guanyin; but this painting
of buddhas, bodhisattvas, Brahma, the lohans, the eight classes, and other divinities does not
include the name Acuoye Guanyin. Thus it is very clear that this is not the same painting
Zhang Zhao saw.[54]

In the first part of his inscription, the emperor wonders about the relationship of the *Long Roll*
to another painting, one he never saw, but which he had read about in the collected writings of Zhang
Zhao, the compiler of the first editions of Qianlong's painting catalogs, *Shiqu baoji* and *Bidian zhulin*.[55]
Zhang Zhao spent the early years of his official career in the southwest—first, in 1723, as a junior
deputy supervisor of instruction in Yunnan and later, in 1726, as chief examiner in the Yunnan provin-
cial examination. By 1731 he was back in Beijing, and in 1733 he volunteered to lead troops into
Guizhou, also in southwestern China, to quell the insurrection of the Miao, a project that ultimately
failed, bringing Zhang in 1736 to the brink of execution. It is said that he was only pardoned because
of his and Qianlong's shared passion for calligraphy and because his own hand resembled the
emperor's. (The implication is that he served as the emperor's ghost scribe, a job later taken over by
Dong Gao.)

The text Qianlong refers to in his colophon is the inscription Zhang Zhao composed for

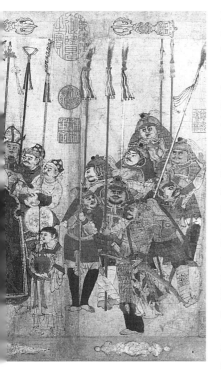

Figure 49. Zhang Shengwen, *The Long Roll of Buddhist Images.* Dali kingdom, before 1180. Detail, the Royal Family of Dali. Handscroll, ink, colors, and gold on silk. 30.4 x 1,900 cm. (National Palace Museum, Taipei.)

another Yunnanese painting, the *Nanzhao tuzhuan*, a long handscroll that depicts the founding in 946 of the Nanzhao state, Dali's predecessor in the Yunnanese highlands. That Qianlong never saw this painting (now in the Fuji Yurinkan, Kyoto) is apparent in his confusion over Zhang Zhao's record of the Acuoye Guanyin, whose arrival as a spiritual presence and whose subsequent depiction in sculptural form in Nanzhao is celebrated in the scroll Zhang inscribed. For even though Acuoye Guanyin is uniquely depicted in the *Long Roll* as a gilded bronze statue (Figure 50), the only such image of an image among many other depictions of the bodhisattva in fleshy form, and with his appearance underscored by a scene showing the actual production of the image and the casting of a bronze drum in the Yunnanese, Dongson-style mushroom shape, he is not labeled with his Sanskrit-derived name, Acuoye (which Soper reads as the Sanskrit *ajaya*, meaning "victorious"). Instead he is identified, on the one hand, as "Bodhisattva Guanshiyin, Founder of the Nation" (Jianguo Guanshiyin Pusa),[56] and, on the other, as the "True Body of Guanshiyin Bodhisattva" (Zhenshen Guanshiyin Pusa)—a name that takes him far beyond mere celebration and into the realm of

Figure 50. Zhang Shengwen, *The Long Roll.* Detail, "True Body of Guanyin" (known as Acuoye or Ajaya Guanyin), right.

absolutes and attests to the significance of this image, Śrīvijayan rather than Tang Chinese in style, in the creation and protection of the Nanzhao state. Zhang Zhao signed his colophon "Zhang Zhao Amidst the Clouds" (Yunjian, his nickname, is a play on Yunnan, "south of the clouds") and dated it to 1727, the year after he assumed the position of chief examiner for Yunnan's provincial examination. We can conclude, therefore, that Zhang saw and inscribed the painting in Yunnan and that it was only taken from China to Japan in the early twentieth century.

Qianlong, in other words, undertook his comments on the *Long Roll* with a severe gap in evidence—because, unlike Zhang Zhao, he had not seen the *Nanzhao tuzhuan*. And we can suppose that Zhang Zhao never saw the *Long Roll* either—at least he never mentioned it in writing and did not connect it to the *Nanzhao tuzhuan*. He certainly did not bring it to the emperor's attention, though the reasons for this were probably simple. First of all, Zhang Zhao died in 1745, one year after the completion of the imperial catalog, *Bidian zhulin* (which notably did not include the *Long Roll*), and, more important, Qianlong had no pressing reason to interest himself in a beautiful but obscure painting from Dali until nearly twenty years later.

Qianlong's colophon goes on to point out other difficulties with the *Long Roll*, which he notes was fragmentary and only partially restored by the time it came into his hands:

> Inspection of the various icons in the roll shows them to be fair in appearance, ornamented, and splendid. The coloring and gilding are both extremely delicate and varied.
>
> The paper, made from the mulberry, is of excellent quality and old, fine in texture and durable, comparable to old Jinsujian paper. An old painting carefully handed down should be esteemed and treasured. The fact that the work was done by a professional painter among the far-off southern natives should not cause anyone to regard it lightly.
>
> The first and last parts of the painting are out of order. By examining the eulogies and criticisms, we learn that in the time of Hongwu of the Ming dynasty this painting was in the form of a long roll and was kept in the Tianjie Temple [part of the famous Lingyun Monastery near Hangzhou] by the monk Detai. At the time of Zhengtong [1436–1449] the roll was damaged by water and turned into an album. It is not known when it was remounted as a roll and restored to its earlier form. The mounting and remounting made it easy to make mistakes. At the beginning of the roll there are standard-bearers and retainers in procession, as well as the likeness of the ruler of that country, holding an incense burner in an attitude of reverence, with his crown and incense spendidly conceived.
>
> The relationships between figures are not consistent—the kings of sixteen countries in India are painted at the scroll's end. The monk Zongle [in his colophon to the scroll] says that these kings are outside guardians of the law. Members of the same class should be put together. Therefore I have ordered that Ding Guanpeng shall do a picture in imitation of the style of this image, showing a southern native king worshiping the Buddha. Besides this he will make another scroll copying everything else from the four guardian kings, the various buddhas, patriarchs, and bodhisattvas, down to the two precious standards, as the *Source and Flow of the Dharma World (Fajie yuanliu tu)*. These two will prevent further disorder and the original scroll will stay as it was before.
>
> In ancient times there were [Wu] Daozi and [Lu] Lengjia and others who knew how to paint events and to teach by disseminating images. Their illustrations to the *Flower Ornament Sutra* have been imitated time and again. I have not heard that on the Lion Throne or in the Deer Park there were traces of vulgarity.

Although the Buddha is without ego—and, whether unified or dispersed, has no discriminating thoughts—nevertheless if we in this world of desire wish to paint the contemplative state *(chan)*, we must seek to do so by means of symbols like Mount Sumeru and the fragrant sea that surrounds it. Thus even one drop in the tide of dharma we naturally separate into the pure and the ordinary.

Written by the imperial brush in the year *guiwei* of the Qianlong reign [1763], the tenth month, the fifteenth day.[57]

This last section of the imperial colophon shows Qianlong unhappy over the inappropriate misalignment of images—somewhat different from his complaint about the Shengyin Monastery lohans, whose names did not harmonize with Sanskrit sounds. The *Long Roll* figures are, he suggests, by the accident of many remountings, forced into relationships that are not "consistent." Most disturbing of all in his view is the placement of the kings of Dali at the beginning of the scroll against the arrival of the sixteen kings of India at the end. In his clear directions to Ding Guanpeng, once again brought in to put things in order, he commands not just one scroll but two. The first has the kings of Dali and their Indian counterparts brought together as the now-lost *Manwang li fo tu*, the *Barbarian Kings Bringing Tribute to the Buddha* (even though they travel in opposite directions and must still meet, we suppose, at either side of a centrally placed Buddha). The second reorganizes all the figures of the *Fajie yuanliu tu* (Source and Flow of the Dharma World), now in the Jilin Museum.[58] He also insists that the new pair of scrolls be stored together with the original *Long Roll* "to prevent further disorder," suggesting that, like the small-type commentary written between lines of canonical text, the new scrolls will shed light on the old one. It would be inappropriate to think, however, that Ding Guanpeng's scrolls were, in Qianlong's mind, subordinate in any sense to Zhang Shengwen's. In fact the pictorial commentary provided in Ding's scrolls was crafted to accord with a distinct, deliberately embedded ideological point of view. Though the "inexactness" of the two new copies seems highmindedly designed to separate the temporal world of political advantage from the timeless truths of the Buddhist pantheon, it was actually politically driven.

Much more than this simple division into two unequal parts separates the original *Long Roll* from its transfiguration into the *Barbarian Kings* and the *Dharma World*, as even a cursory examination of the *Dharma World* and its model reveals. Ding Guanpeng eliminated the splendidly painted ink monochrome landscapes that Zhang Shengwen counterposed against the supernatural, colored, sensorily heightened revelation of the pantheon (which made it easy for the connoisseur Qianlong emperor to place the painting in the Southern Song), for the most part presenting the buddhas and bodhisattvas against a colorful, bejeweled landscape that does not create the same hierarchy of real and more real that the juxtaposition of black-and-white against brilliant color does (see Figures 51–52). We do not, in other words, get a sense of deities revealed on this monochromatic earth as if in a vision; they are much more concrete, at home in their own paradisal world. Ding Guanpeng also retains some narrative details while eliding others. He leaves the Dali kings in place in several scenes—their tall, bulbous filigreed crowns easily identify them—despite their expulsion from the beginning of the scroll. But he glosses innocently over other points of local historical interest, notably the telling scene of the manufacture of the Acuoye Guanyin (again labeled the "True Body of Guanyin," Figure 53), which appears at the feet of the transcendent gilt figure in the *Long Roll*.

Qianlong laid out his plan for the translation of the *Long Roll* into contemporary terms in the colophon attached to the front of the *Dharma World* scroll. The colophon is carefully written in the imperial hand, depicted as a bannerlike standard. Its format mirrors that of the *Heart Sutra* at the end of the scroll, which the emperor also transcribed and which is similarly framed. (The original *Long Roll* has both the *Heart Sutra* and the *Sutra for the Protection of the Nation* inscribed on banners

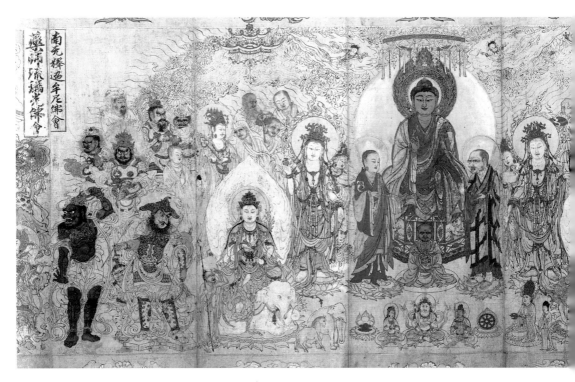

Figure 51. Zhang Shengwen, *The Long Roll*. Detail, Śākyamuni Assembly.

at its end; both are written in Sanskrit. Here the *Sutra for the Protection of the Nation* has been eliminated, perhaps consigned to the now-missing *Barbarian Kings* scroll, and the *Heart Sutra* is translated into Chinese.) Qianlong's text, composed in 1767, four years after his initial commission, contains much of the same rhetoric and argument as his original colophon for the *Long Roll*. He claims that "the order of the buddhas and bodhisattvas on this scroll require rectification according to their nominal order" and that "the manifestations of Guanyin are especially mixed up."[59] There is an important difference, however. Writing on the *Long Roll*, Qianlong projects himself as editor-in-chief; writing on the *Dharma World* scroll, he appoints his Tibetan guru, the Imperial Preceptor Rolpay Dorje, whom he says "was called upon to demonstrate the proper ordering of the images." (This he certainly did, applying, for instance, his usual list of names to the lohans, complete with by now standardized phoneticized "spellings" in Chinese characters.) Ding Guanpeng, in turn, the emperor "ordered to execute a painting in accordance with the *khutukhtu*'s instructions, so as to perfect good works and devotions."[60]

Ding Guanpeng, meanwhile, simply states that he is following Zhang Shengwen's "brush idea," emphasizing the aesthetic and historical implications of his work while denying any iconographic responsibility. But the emperor has something else on his mind—something, I believe, that had very little to do with the art of painting as it was understood among eighteenth-century scholarly Chinese artists, even by the court master Ding Guanpeng, and everything to do with the magical manipulation of the phenomenal world as it was practiced in Tibetan Buddhist ritual circles and even by the emperor himself.

First compare Qianlong's silence concerning Rolpay Dorje's instruction in his inscription on the *Long Roll* itself with his straightforward assignment of credit to his guru in the upfront, emblazoned colophon on the *Dharma World* scroll. This masked reticence in the face of the original parallels Qianlong's elision of his reliance on Rolpay Dorje's system in the colophons he wrote on Ding Guanpeng's copies of Guanxiu's *Lohans*, a silence broached in the separate but otherwise similar inscrip-

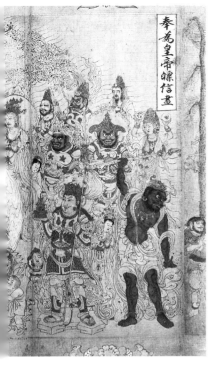

tions he wrote for the very private sixteenfold lacquer screen commissioned the same year. Is it possible that these subtly altered colophons were designed to serve as audience-sensitive translations, as inner records versus outer records, just as the masterful translations into the four languages of the empire—Chinese, Manchu, Mongolian, and Tibetan—produced in the Imperial Chancery were edited, abridged, and augmented to serve different audiences?[61] Should the *Dharma World* scroll be construed as an internal document—a commentary on, and correction of, a painting that was well known in certain Han Chinese circles?

Why should a beautifully painted old scroll that records the pantheon and royal patrons of Buddhism at the marginalized twelfth-century Dali court stand in need of correction by the Qianlong emperor? The answer may lie, at least in part, not in its Buddhist content but in its political ramifications. Qianlong's chief objection to the original scroll was to the way it mixed categories. By this he explicitly meant the placement of a group of local rulers at the head of the scroll where they are seen as an entire family and court in their most splendid regalia coming to pay homage to the Buddhist assemblies that follow. This local dynasty Qianlong refers to as "spurious" *(wei²)* in his inscription on the *Dharma World* scroll (a comment again notably absent from the inscription on the *Long Roll* itself).

His comment was more than simply the statement of a historical fact as he read it; the Manchus had been engaged in a decades-long struggle with Yunnan's many minorities, a situation that persisted through Qianlong's reign, and the ethnic blocks that formed a fluid and mobile frontier around

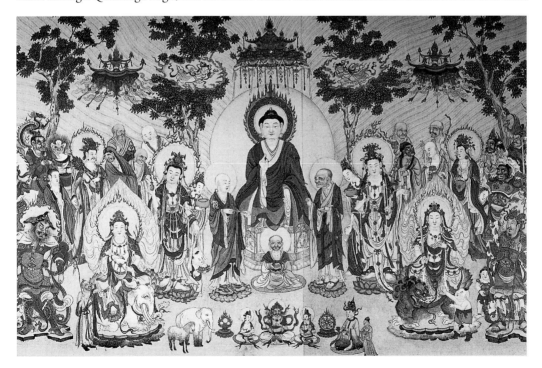

Figure 52. Ding Guanpeng, *Fajie yuanliu tu* (Dharmadhatu scroll), 1767. Detail, Śākyamuni Assembly. Handscroll, ink, colors, and gilt on paper. 33 x 1,635 cm. (Jilin Museum.)

Yunnan—southeastern Tibet to the north and Burma to the west and southwest—were by no means engaged in happy diplomacy with the Qing. On the contrary, southeastern Tibet and the Lijiang region immediately to the south in Yunnan were strongholds of the Karmapa Kagyus, who had aligned themselves with the Tibetan kings and were defeated just before the founding of the Qing by a Mongol-Gelukpa alliance later coopted by the Manchus. The Lijiang region, in particular, was under the thumb of the local Mu family (who had provided asylum to the exiled Southern Ming court), but in the 1740s the Qing ousted the Mu and replaced them with a Qing magistrate.

Burma was a stickier problem still, and here the entwined chronologies of embattled frontier and the connoisseurship and duplication of ancient paintings seem too tight to ignore. Trouble began in 1762 when the Burmese Shan lords broke out in an open conflict that engulfed the entire border region and prevented Yunnanese merchants from making their way to the annual fair at Bhamo, about 320 kilometers west along the Burma Road from Dali. Many of the Shan paid tribute to both the Burmese and Qing states; we might see this region, therefore, as completely

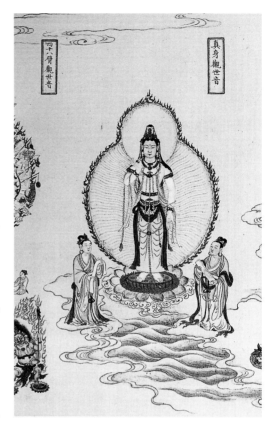

Figure 53. Ding Guanpeng, *Dharmadhatu Scroll.* Detail, "True Body of Guanyin."

marginalized and of fluid allegiance, certainly beyond easy Manchu control. (And they remain so today; these eighteenth-century lords are the ancestors of the present drug lords of the Golden Triangle.) In 1765 the conflict escalated when a Chinese merchant was killed within Burma at Kengtung. Qianlong ordered Qing troops into Burma in 1766, where they were quickly defeated. But early in 1767, the Qing nearly captured the Burmese capital, Ava (Mandalay). The repercussions of this siege were severe; the Burmese king Hsin-hpyu-shin ordered his general back from Ayuthia, in Thailand, a sudden withdrawal that ultimately allowed Thai forces to rally against the Burmese and reconsolidate their rule in 1770.[62]

As the Qing were laying siege to Ava and a few months before the emperor put the finishing touches on the *Dharma World* scroll, the National Preceptor Rolpay Dorje, following imperial command, conducted a seven-day *ḍākinī* offering in aid of the Yunnanese forces at Yong'ansi (located in Beihai on Jingdao, just outside the northeastern corner of the Forbidden City). The *ḍākinī* offering was staged as an "auspicious exorcism" and a food offering. When offerings of food and drink (in the form of *torma,* or ritual cakes) were scattered and just as Rolpay Dorje had taken a ritual taste, a tremendously loud noise burst forth and all the attendant lamas said they saw a panoramic scene in which the city was filled with troops. Rolpay Dorje's disciple and biographer, Thukwan, reports: "On the day food offerings were scattered, a battleground in front and on both sides opened up, surging with conflict. The enemy were using a great many war chariots, which billowed as they came on; suddenly they turned around and retreated, and the enemy troops trampled one another." When they questioned an oracle about the meaning of the vision, he told them: "The Chinese capital

has a Wheel-Turning Yogin Tathāgata, whose body is concealed. It seems he personally saw the situation in the field and used his magical powers to protect Han troops."[63] This Wheel-Turning Yogin Tathāgata was Qianlong, of course, and the visionary experience provoked by his guru in the *ḍākinī* offering coincided nicely with the siege of Ava, when Qing troops surprisingly reversed Burmese momentum and were able to claim a limited, if temporary, victory on the Yunnanese border.

Tantric rituals were often staged by the Manchu to provide supernatural aid in battle. In describing the second Jinchuan (Gold Stream) campaign in 1772, a year after Qianlong's triumphant sixtieth-birthday celebration, Dan Martin notes that Qianlong sought Rolpay Dorje's help again, a fact notably absent from Chinese historians' accounts of the same incident.[64] The people living in the Gold Stream region of what is now the Apa Tibetan district in northern Sichuan (directly north of Yunnan) were devoted to the native Tibetan Bon religion and to the Nyingma (Old Tantra) order, both of which were suppressed under Qianlong's father, Yongzheng. Qianlong sent troops into the region in 1772 and at the same time asked Rolpay Dorje to perform a tantric ritual similar to the one he had performed in aid of the Yunnanese situation. This time the National Preceptor invoked the great and violent "*torma* rite of She Who Wields Power Over the Desire Realm," the fierce goddess Dokham Wangmo, another name for Mazorma or Lhamo, the principal female protector of the Gelukpa. Just as soon as the ritual *torma*-weapon was launched, "the great *torma* came down, [and] a huge mass of flames broke into pieces and went in the direction of the enemy. Everyone saw it. It was told that a great flaming mass came down on the field of battle. General A asked the emperor about this and it happened to be at the exact time when the great *torma* was launched."[65] Rolpay Dorje continued to launch *tormas* at the Bon enemy and (with the aid of Jesuit cannons) the Bon were brought to their knees. Qianlong later claimed: "This gradual victory over the enemy is not due only to our strength and might; it is rather because of earnest application to worship and devotion to Buddha's teachings, because of the magical power *(mthu)* which achieves actions *('phrin las)* by the Religious Defenders."[66] Rolpay Dorje's biographer compared this military success to Qing victories in Dzungaria and among the tribes of southwestern China, possible only because Qianlong was a true *cakravartin* and an emanation of Mañjuśrī/Mañjughoṣa, the bodhisattva of wisdom.[67]

The heavenly battlefield invoked by the *ḍākinī* offering recalls a section of the *Nanzhao tuzhuan*, the painting of the founding of the Nanzhao kingdom that Zhang Zhao saw in Yunnan. There an army appears cloud-borne in the sky, obliterating Nanzhao's enemies and bringing peace and unity to the region, all through the unseen beneficent intervention of the Acuoye (Victorious) Guanyin (Figure 54). But what is depicted in the *Nanzhao tuzhuan* is simply a local version of a more widely practiced Tang-dynasty tantric rite to protect the nation and secure the frontier by invoking the guardian protector of the north, Vaiśravaṇa, and his powerful warrior sons, vividly described in the *Pishamen yigui* (Rules for the rite of Vaiśravaṇa).[68] This text details the ritual of invocation and recounts how, during the western campaign against Anxi launched by Tang Xuanzong (r. 713–756), Vaiśravaṇa's celestial troops were invoked at the emperor's request by the Central Asian monk Amoghavajra (Bukong Jingang, 705–774). Amoghavajra chanted a *dhāraṇī* from the *Sutra on Benevolent Kings (Renwang jing)* twenty-seven times, whereupon the emperor saw hundreds of soldiers led by Vaiśravaṇa's son Dujian. This same vision appeared at Anxi on the same day, when Tang troops saw soldiers dressed in golden armor arise out of an obscuring haze. Golden rats gnawed through the enemy's bowstrings and destroyed their traps, and Vaiśravaṇa himself appeared above the northern gate of the city. Based on this vision an image of the great guardian was painted and attached to a report sent back to the capital.

In the Qianlong period these rituals were translated into Tibetan and, more specifically, Gelukpa terms. The tantric rites of the *ḍākinī* offering and the offering to Lhamo do not just depict a hoped-for event in symbolic terms but literally and simultaneously provoke and mirror the event in actual

Figure 54. *Nanzhao tuzhuan,* late ninth–early tenth century. Handscroll, ink and colors on paper. Detail, heavenly battle scene. (Fuji Yurinkan, Kyoto.)

time. The ritual, therefore, is an active agent, just as it was in the Tang dynasty, a perfect substitute for action on the battlefield, a televisionary exercise in seeing and acting at a great distance. I believe that the *Long Roll,* or more precisely its redaction by Ding Guanpeng, can also be read this way: in tantric terms. It was not Qianlong's wish to produce an imitation or even a parody of the *Long Roll.* Rather his copying must be located in a different sphere altogether—not in the comfortable, if obsessive, world of painting and collecting but as part of his ongoing, repetitive experiments into the nature of cause and effect, a centerpiece of Buddhist epistemology. By innocently misrepresenting proper relations in Yunnan through damage, loss, and improper mounting, the *Long Roll* of Zhang Shengwen was a skewed record of the past—and thus it distorted the present and endangered the future. The painting had, in other words, been improperly transmitted and, therefore, improperly read to imply the independent status of the Dali kings, worthy, like the mythic kings of India, of the protection of the entire Buddhist pantheon. Ding Guanpeng's job, as Qianlong saw it, was not to produce an identical copy of the *Long Roll* but to create two separate works—whose power lay in the ways they differed from the earlier scroll—injected with an edited, ideologically correct point of view. In rectifying relationships, in removing the Dali kings from their too prominent role, in placing his own colophon explaining the situation at the head of the scroll—all manipulations not of the real but of signs of the real—Qianlong and Rolpay Dorje worked to bring Yunnan back into a state of universal harmony.

Although the concealed, tantric motivation behind Qianlong's interest in the *Long Roll* and its revision is only suggested circumstantially, it seems reasonable in light of the course of events—political and artistic—that followed. The Burmese situation cooled down after 1769, when Qianlong imposed a trade embargo and the *Long Roll* and its companion commentary scroll went into storage in the Qianqing Palace. But between 1788 and 1796, there was a sudden flurry of diplomatic

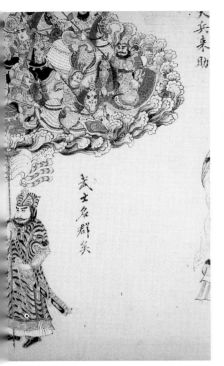

relations between China and Burma, attempts on the part of Yunnanese traders to dupe the emperor into believing that Burma had finally submitted. Their clever ruse was to persuade the Burmese to send missions to the Chinese court, which Qianlong interpreted as tribute. This farce was revealed in 1796—when Qianlong had already abdicated (but continued to rule from his retirement villa)—and official contact between Burma and China ceased. It should be no surprise, however, that a few years earlier, in 1792, the emperor once again turned to his court artists to help seal the present and future along the southwestern border (Rolpay Dorje being long dead). Perhaps as a way of rekindling an earlier victory on the same front, he ordered the painter Li Ming to produce yet another copy of the *Long Roll*, this one based not on Zhang Shengwen's original but on Ding Guanpeng's carefully edited version.[69]

The True Image

In their collaborative reworking of the *Long Roll*, Rolpay Dorje and Ding Guanpeng were at a loss to identify and reconfigure one image that skews the seemingly immediate, revelatory representation of its pantheon as a vision of deities who appear, lifelike and resplendent, to the "usurper" kings of Dali. This was the "True Body of Guanyin" (Zhenshen Guanshiyin), the local manifestation of the bodhisattva originally known in Dali as Acuoye—Victorious (Figure 50). He appears not in a flesh-and-blood transformation body but in his "art body" as a vision of a golden sculpture with specific sculptural antecedents.[70] Zhang Shengwen makes a particular point of Acuoye's difference from the other deities in his scroll by depicting him as he hovers in a sphere of clear light as if modeling for the sculptor who is caught crafting a smaller, identical image of him below. The "styling" of Acuoye Guanyin is starkly different from all the other images of the bodhisattva that surround him. He is dressed as an Indian prince in dhoti and jewels, his hair is piled up in the tall crowned coiffure of Indian deities, his skin is golden, and he emulates the rigid posture of contemporary Southeast Asian images, in particular those from the Indonesian kingdom of Śrīvijaya. Immediately we are drawn into the peculiar cultural context of this vision—peculiar, at least, from the perspective of the kingdom of Dali—and, with it, into the distinctive mind-set of those who received the vision as something exotic and beyond their ken.

Helen Chapin and Alexander Soper both consider that Zhang Shengwen and his patrons had already lost track of the significance of Acuoye Guanyin when he painted the *Long Roll* in the late twelfth century. They note the significance of the artist's cartouche, which simply identifies this Guanyin as the bodhisattva's True Body, omitting any reference to his ancient Sanskritized name. Yet remnants of Acuoye's story are embedded in Zhang's depiction, particularly the simultaneity of his self-revelation and his manufacture as an image in bronze. Zhang stresses (and Ding does not) just how local this story must have been when he balances the sculptor against the figure of a man pounding a drum that has a classic Dongson shape. Its mushroom-shaped form was widespread in Yunnan province and much of the rest of Southeast Asia from at least the fourth century B.C.E. on, and the drum's presence here emphasizes the fact that Yunnan was part of a vast region that was culturally distinct from Han China.

However misunderstood, Zhang's rendition of this scene of apparition, drum pounding, and sculpture production derives whole cloth from the tale of Acuoye Guanyin related in the *Nanzhao*

tuzhuan and its accompanying text scroll, which Soper translated completely and annotated in his revisiting of Helen Chapin's landmark study of the *Long Roll*. The story of Acuoye Guanyin related twofold in image and text in these scrolls is just part of a larger tale of disguise and gradual revelation that served as the founding myth of the Nanzhao ruling family, the Meng. Both the illustrated scroll and written text provide abundant but ultimately confusing material about the origins of the image and its place in the larger story of how Nanzhao was legitimated. According to the tale they tell, Acuoye's arrival in Yunnan was heralded by a "king bird" who landed atop an iron pillar (another significant source of royal strength in Nanzhao) just as the king was worshiping it. Other miraculous signs appeared, including a white "dragon dog" with a black head, two orange trees that bloomed continuously, and a hawk who came to the house of the future king. Three days later, a Brahman arrived with his white dog. Several tens of hostile villagers promptly ate the dog, who revealed his presence in their stomachs by howling for his master. Claiming the Brahman was an evil spirit, the villagers attacked him too, cut him into small pieces, and burned what remained of his body until it was reduced to ashes. They even poured the ashes into a bamboo tube and threw it into the water. The Brahman broke the tube and emerged unscathed, however, making a quick escape into the mountains with a vase holding a spray of willow (the first clue to his true identity as Guanyin). There he began his work of conversion, apparently meeting stiff resistance along the way. So, according to the text scroll, he "mounted into the air, riding on clouds, and transformed himself into the likeness of the Acuoye," whereupon the commander-in-chief of the region, Li Mangling, pounded a drum to call the villagers to witness the luminous vision—just as we see in Zhang Shengwen's illustration. Out of nowhere an old man appeared who claimed to understand metal casting and said: "[I] will make you an image that in no jot nor tittle will differ from the holy likeness you see," an amazing offer indeed.[71]

The story of this Acuoye image and the self-revelation of the Brahman monk as Guanyin picks up again more than two centuries later when a monk arrived at the court of the Nanzhao "maharaja" Meng Longshun (posthumously Nanzhao's Xuanwudi, r. 877–897) asking the whereabouts of Acuoye Guanyin. The image was found and brought to court, where the maharaja had it copied in pure gold. It was this image that spawned the very distinctive, seemingly Śrīvijayan, group of Yunnanese images Chapin identified as a particular type she called the "Luck of Yunnan," the palladium of the Nanzhao state. Soper suggests, however, that Acuoye's source image may really have been Śrīvijayan in the first place, only later sanctified as "true" by the tale of the Brahman and his dog. He notes that the maharaja of Nanzhao sought a Tang princess as a bride but the envoys he sent to Chang'an were murdered by the Tang emperor. Right after this incident, the maharaja received a beloved new bride from the "realm of Kunlun," a term that in ninth-century China roughly designated Malaysia and Indonesia, that is, Śrīvijaya. Could this Kunlun bride have been the source of the Acuoye Guanyin? Soper points to the intriguing congruence of the image's name—Acuoye (Victorious)—to the name of its apparent stylistic source, Śrīvijayā (Fortunate and Victorious), and to the transliteration of the maharaja's title into Chinese characters—Maheluocuo—where the same character used in Acuoye, *"-cuo,"* renders *"-ja."*

These coincidences come together to produce a named image that presents itself as "authentic" in no small measure because of its coincidental, verbal associations. Although it claims to be a true portrait of Avalokiteśvara-Guanyin, based in Nanzhao's founding myth on direct revelation rather than imaginative representation, in fact its authenticity was highly manipulated. If we accept that the Acuoye image came to Yunnan in the hands of the Kunlun bride, then the genuineness of its claim to authenticity had to be established by linking it, however fraudulently, to indigenous rather than foreign vision—hence the exotic Brahman monk's revelation of himself as Guanyin in Yunnan proper and in the presence of the local commander-in-chief, who beats the drum to herald its arrival.

In the grand conversion myth Nanzhao's maharaja built around the Acuoye image, the location of true vision was just as significant as the vision itself.

Visions at Wutaishan

These same issues of authenticity of form and site also attached themselves to an image that Qian-long, Rolpay Dorje, and Ding Guanpeng knew very well: the famous, miraculous sculpture of Mañjuśrī riding on the back of a lion that was kept in the Shuxiang Monastery at Wutaishan, site of the bodhi-sattva's regular appearances. This sculpture, as the ninth-century Japanese monk Ennin reported in his diary, dated to the Tang dynasty and, like Acuoye Guanyin, was based on the artist's clairvoyance. Ennin learned that the sculptor had tried in vain six times to cast the image in bronze, but each time it cracked to pieces despite his "unique ability" and "religious abstinence." According to Ennin:

> The Master said . . . "I humbly pray that His Holiness the Bodhisattva Monju (Mañjuśrī) show his true appearance to me in person. If I gaze directly on his golden countenance, then I shall copy it to make [the image]." When he had finished making this prayer, he opened his eyes and saw the Bodhisattva Monju riding on a gold-colored lion right before him. After a little while [Monju] mounted on a cloud of five colors and flew away up into space. The master, having been able to gaze on [Monju's] true appearance, rejoiced [but also] wept bitterly, knowing then that what he had made had been incorrect. Then, changing the original appearance [of the image], he elongated or shortened, enlarged or diminished it [as necessary], so that in appearance it exactly resembled what he had seen, and the seventh time he cast the image it did not crack and everything was easy to do, and all that he desired was fulfilled.[72]

In 1761, while on one of the many western tours he took during his reign, Qianlong, his mother, and Rolpay Dorje visited Wutaishan. During the course of the visit, the empress dowager was so taken with the famed Mañjuśrī image that she asked her son to establish a monastery to house a copy of it near Beijing. And so, as a special present for her seventieth birthday, Qianlong built the Baoxiangsi (Precious Form Monastery) in Xiangshan, the hills to the west of Beijing.[73] The new monastery stood just to the side of the all-Manchu Baodi Monastery, established in 1751 as a copy of the Pusading at Wutaishan.[74] Qianlong dedicated the new Baoxiang Monastery to Mañjuśrī, staffed it with Manchu monks, and fitted it with a statue that copied the Shuxiang Monastery image. In one of several poems he wrote to catalog his awe at seeing the Mañjuśrī, he sought to capture its uncanny immediacy, saying "It is an image and then again it is not," attributing its uniqueness to the perfection of its special setting, where it rested "like a bead blazing in a mirror."[75] Later, in the dedicatory stele he wrote in 1762 for the new Baoxiang Monastery, the emperor relied once again on Mādhyamika-inspired terms of nonduality when he observed that, despite the great distance between Wutaishan and Xiangshan, Mañjuśrī "is one and he is two—in Mañjuśrī we really cannot see any distinctions arising. So if Qingliang [Wutaishan] is his field of activity, then we do not know that Xiangshan is not also."[76] (Here again the Tibetan text gives us *"dkyil 'khor,"* which usually translates the Sanskrit *"mandala."*) Similarly, when Qianlong established yet another monastery in 1774 that was modeled on Wutaishan's Shuxiang Monastery at Chengde (this time named after its model), he again staffed it with Manchu monks and in his stele also wondered again if Chengde might not also be another of Mañjuśrī's fields of action.

Both monasteries were specifically constructed to conform to a mandalic shape, square on the outside and round on the inside, with the major sculptural image of Mañjuśrī right at the center.[77]

As Mañjuśrī's fields of enlightened action proliferated in places closer to home, they increasingly seemed to define specifically Manchu territory, with the pun on Mañjuśrī (Smooth Lord) as "Lord of the Manchu" clearly intended. Not coincidentally, in the same year, perhaps piqued by a clearer recognition of Mañjuśrī's special relationship to the Manchus, Qianlong asked Rolpay Dorje to undertake a translation of the whole Tibetan Buddhist canon into Manchu.

The statue that gave its name to the Baoxiang Monastery does not survive, nor do we know the precise date it was installed. As soon as Qianlong and his mother returned from Wutaishan, however, Qianlong's court painter Ding Guanpeng produced two large, nearly identical, hanging scrolls of Mañjuśrī on lionback, which reproduce the Shuxiang Monastery's famed image and suggest what Qianlong's sculptural copy might have looked like. Ding also uncharacteristically wrote a lengthy inscription on one of the versions recording the circumstances of the visit, the particular qualities of the "true image," and his commission to copy it in painting. The intangibility of Mañjuśrī and his many transformations from vision to two-dimensional realization occupy Ding's reminiscence and suggest he was part of the emperor's entourage during this important pilgrimage, an eyewitness to the original visionary sculpture's remarkable powers. He writes that the Mañjuśrī was "fully bright with secret knowledge, like the moon's seal on a river," and that once the imperial entourage had returned to Beijing he set about making a properly ornamented, colored copy of it based on a rough sketch. His two final products are similar in conception (see Figure 55). Both are strange and shocking pictures. Grand in scale, they offer the bodhisattva turned frontally toward the viewer while mounted sideways in *lalitāsana* on a sweet-faced lion. There is no setting whatsoever. The bodhisattva and his mount seem to emerge from incalculable space—and this, coupled with the suave, illusionist style Ding employs, produces a sense of Mañjuśrī's inescapable, benign virtual presence.

Of all the Qing emperors, Qianlong was the one who projected his identity with Mañjuśrī most boldly in visual terms. But his link with Mañjuśrī was also promoted in ways that depended on the subtle distinctions of various Tibetan and Mongolian terms for "incarnation" (Tibetan: *sprul sku*; Mongolian: *qubilgan*) and "emanation" (Tibetan: *rnam tul*), a semantic distinction that does not carry over into Chinese, where incarnations and emanations are all grouped together as "living buddhas" (*huofo*). The differences between the languages of the empire provided, in this case, a mechanism that allowed for almost perfect deniability. The aftermath of Qianlong's visit to Wutaishan in 1761 suggests the degree to which the distinction between incarnation and emanation or even mere symbol was never really clarified in the minds of many, even after the Qing adopted the Mongols' idea. It was, it seems, effectively hedged.

Though Ding Guanpeng's Mañjuśrī scrolls and the copied image they preserve do not resemble Qianlong, at least not the "real" Qianlong we know from Castiglione's portraits, the strong association of the "true image" of Mañjuśrī with specific monasteries was apparently enough to cause the general population to view another copy of the same true image as a portrait of Qianlong himself or, at least, as a mark of his indelible presence. Eugen Pander notes that even in the last years of the nineteenth century there was a colossal sculpture of Mañjuśrī on lionback at the "Chang chueh ssu" (perhaps the Zhengjuesi at the Yuanmingyuan, which Qianlong extensively repaired in 1761, again as a birthday present for his mother). Pander describes the piece as "Emperor Ch'ien-lung as Mañjuśrī," in which "the emperor sits on a fabulous Ch'i-lin [*sic*], guarded by two attendants, one of them . . . portrayed as a Hui hui (Mohamedan)."[78]

In almost the same breath, Pander turns in a footnote to another "true image"—the *ur*-image of all East Asian Buddhism, the so-called Sandalwood Buddha or Jowo (Chinese: *Zhantan fo*). Like

Figure 55. Ding Guanpeng, *The Shuxiang Temple's True Image of Mañjuśrī*. Hanging scroll, ink and colors on paper. 297.3 x 159.1 cm. (National Palace Museum, Taipei.)

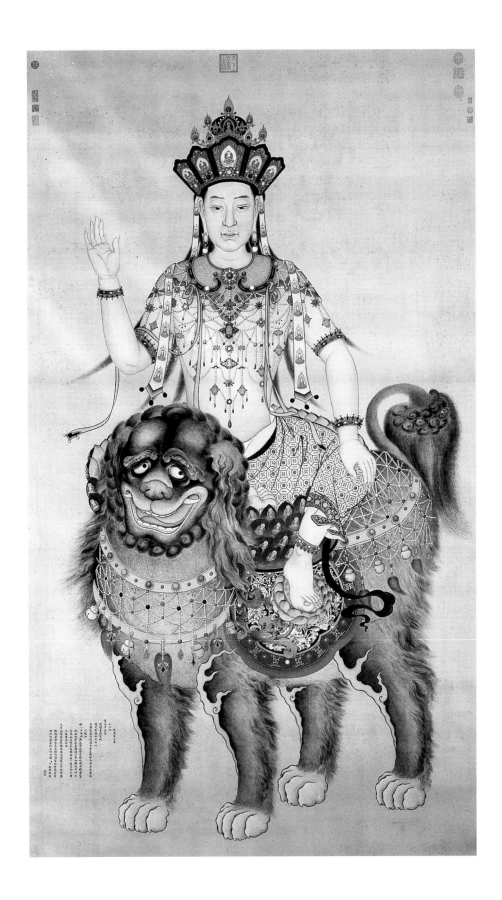

Acuoye Guanyin and the Shuxiang Monastery's Mañjuśrī, the Sandalwood Buddha held claim to both immediacy and authenticity. It was an image believed to have been taken from the original—not a contact relic but a literal portrait done by an artist face-to-face with the historical Buddha Śākyamuni, albeit while he was in Tuṣita Heaven on a yearlong visit with his deceased mother. The Sandalwood Buddha was a royal image from the outset, commissioned by King Udrayana when he feared he would be unable to recall the Buddha's form during his absence and, later, after his nirvana. So he begged the Buddha's disciple Maudgalyāyana to take thirty-two artisans (one for each of the Buddha's thirty-two marks) and a huge trunk of sandalwood to Tuṣita to make a portrait of him. The image was thus what the Chinese call a *ruixiang*: an auspicious, semiotically charged image that bore clear signs of its authenticity for all to see, in this case, the thirty-two major marks the Buddha Śākyamuni bore upon his body, envisioned during what must have been Maudgalyāyana's transporting *samādhi*.

The Sandalwood Buddha's movements charted the course of Buddhist conversion across Central and East Asia. In the third century, it moved miraculously to Khotan and then was carried in the fourth century—appropriately or, given its acultural absoluteness, ironically—by the famous translator Kumārajīva to Liangzhou, an independent border state and major Buddhist translation center. After that it followed the course of Chinese history: moving to the Tang capital at Chang'an, then on to the southern Chinese Jiangnan region, then to Huainan, back north to the Song capital at Bian (Kaifeng), and finally to Beijing, always an object of imperial desire and a constant model for a certain type of "true image," that is, an image which claimed privileged access to the physical form the historical Buddha manifested during his last life. In 1676 the Kangxi emperor reconstructed an earlier Ming temple just west of Beihai and dedicated it to the Sandalwood Buddha.[79] Rolpay Dorje later wrote a short treatise on its history.[80] Pander describes his own efforts to see the image and its culturally heterogeneous surroundings:

> Chan tan ssu [Zhantansi] is totally inaccessible to Europeans. I was allowed to enter the temple after long negotiations. I had to undertake the costly celebration of a mass and during that had to climb the stairs of Chan t'an chao [Zhantan Jowo] and offer a khatag (kha.btags), i.e., a silken scarf, as well as a big piece of silver at his feet. There I also saw a gigantic and richly adorned mandala made of silver . . . , a splendid, coloured porcelain statue of Kuan yin, and a complete version of the Kanjur in Manchu language.[81]

Another, nearly contemporary notice of the Sandalwood Buddha provides an Inner Asian counterpoint to Pander's tale of negotiated access. It appears in the history of Mongolian Buddhism written by the late-nineteenth-century Inner Mongolian lama Damcho Gyatsho Dharmatāla, who shrouds the image in prophecy, providing a uniquely Mongolian, late-Qing perspective on its significance. He says that after the Sandalwood Buddha was brought to King Udrayana, "it walked six steps to meet him. The Buddha then said that, in future, this image would go to China to gather benefits for sentient beings. Fulfilling the prophecy to a letter, the Sandalwood Jowo was invited, and the Emperor made prostrations and offering, and paid service to it. As it contained the Buddha's relics, it became the focus of offerings to all religious kings, from the Thang [Tang] rulers until now." Dharmatāla's prophecy hints that the viability of the Qing dynasty was somehow tied to the fate of the Sandalwood Buddha. In fact, the Sandalwood Monastery was burnt to the ground during the Boxer Rebellion in 1900, an event that signaled the end of the dynasty. The whereabouts of its wondrous image are unknown, though numerous copies were made of it, large and small, including a miniature model enshrined in an elaborate case that was kept at the summer retreat at Chengde (Figure 56).[82]

The interest in authentic images and in the proliferation of copies of authentic images during the Qing dynasty suggests that the Manchus understood they were heirs to a received tradition; the process of interpretation and translation of the Tibetan Buddhist culture was a gradual one that spanned four reigns and, in the meanwhile, access to its correct, if uninterpreted, material trappings was essential. The real source of potency for images that claimed to be authentic, as the Manchus rapidly found, was their seeming resistance to translation and analysis. But could they only be "copied true"? Could a figure purportedly made in the Buddha's presence be viewed in the eighteenth century with the naked eye without a filtering lens? This issue was troubled by the fact that an authentic image also proclaimed its authority by virtue of its historical baggage—the legends that surrounded its creation and its movements through time and space—as well as by the authoritative, antique *way* it was fash-

ioned. Like mantras, authentic images traveled through Asia as exotic, undigested, untranslated, untranslatable forms, depending both on their air of antiquity and on legendary reputations for effect.

The issue of style thus emerges paradoxically as essential to images that claim to be true, putting themselves forward as unstyled or unmediated by artful tricks. Yet in all these tales of true images, from Guanxiu's *Lohans* to the Sandalwood Buddha, the artist who translates vision into image is the key. Is he simply an empty vessel who gives his vision permanent form without analysis or comment? Or do the traces of his brush, the quirks of his hand, provide additional clues to the nature of his extraordinary experience? While archaic style seems to offer special, unmediated insight into the past, in the present it works also to emphasize the ultimate unknowability of the object and our distance from it. Thus the very strangeness of the archaic forces attention back onto its particular habits of form in any context but its own. Yet true images might also be said to grant double access to the past—to the form the vision

Figure 56. Miniature replica of the Sandalwood Buddha (Jowo). Eighteenth century. Gold-lacquered wood. H: 95 cm. (Chengde Summer Retreat.)

took and to the visceral response of the artist. What we see is the record of an encounter precisely situated in time and place.

How could this effect be meaningfully copied and effectively represented in the present? Could the visionary moment embodied in the true image be revitalized and presented fresh? It may be to this end that Qianlong played a major role in promoting a style of painting that was, to their eyes, almost perfectly anonymous. His artists came up with two very different approaches to the problem he posed—both of them forcing the painter or sculptor to work at a new psychological distance from his subject. One was to adhere to the untranslatable, culturally mannered, archaic style of the original; the other was to work in the smoothly illusionistic, handless style of the emperor's acculturated Jesuit painters, slightly skewing the forms of the original image to make them seem more virtually "real." These two approaches came together in the work Ding Guanpeng produced for his imperial patron, particularly in his copies of true images. While Ding faithfully copied the overall outlines of archaic vision, in an illusionist's trick he also fleshed them out, plumped them up, and made them uncannily real. Simultaneously his own presence, even his name, was effaced and subsumed by tradition. With his own artists almost absent from their products, hidden behind a veil of clever illusion, could it ever be doubted that Qianlong's copies were true?

Resemblance and Recognition

Say rather, man's as perfect as he ought:

His knowledge measur'd to his state and place;

His time a moment, and a point his space.

If to be perfect in a certain sphere,

What matter, soon or late, or here or there?

—Alexander Pope, *Essay on Man* (1733)

The Tenth Panchen Lama of Tibet delivered what would be his last discourse from his monastic seat at Tashilunpo on January 17, 1989. Caught between China's Communist government and his traditional, always politically sensitive, role in Tibet, he focused on his lineage's close ties to China and conspicuously chose to speak in the idiom of the Beijing regime:

> The Panchen Erdenis have historically loved the ancestral land. They have made a series of outstanding contributions to the great enterprise of safeguarding its unification, including both the unity of all the peoples and the internal unity of the Tibetan people. To secure and develop the relationship between the political authority of the Tibetan region and central political authority, and the fraternity of the Tibetan people and all the peoples of the ancestral land, the Sixth Panchen Erdeni, Paldan Yeshe, for one, did not shrink from traveling ten thousand hard miles, crossing mountains and rivers and leading hundreds of followers to court to offer congratulations to the Qianlong emperor on his seventieth birthday, as well as to discuss national affairs. He was granted special honors and given liberal encouragement by the emperor. But as a result of this patriotic, heroic feat, he unfortunately became ill and died in Beijing. His great and meritorious acts have entered the annals of history and will always be admired by posterity.[1]

In Beijing this speech was taken as more evidence of the long-standing and natural relationship between Tibet and China, which the Panchen Lama carefully referred to as the "ancestral land" (*zuguo*), a nation composed of many different peoples all harmoniously united under the Chinese umbrella. It is no surprise that he also chose to characterize this relationship by raising the example of his sixth incarnation by Chinese count, Losang Paldan Yeshe (1738–1780), who traveled to Chengde and Beijing in 1780 to participate in the Qianlong emperor's seventieth birthday celebration and "discuss national affairs." As the Tenth Panchen reminded his audience, his previous incarnation's heroism resulted in his death in Beijing of smallpox just a few months after he had arrived, a catastrophe for everyone concerned. Clearly the Tenth Panchen felt a certain resonance with the Sixth, recognizing himself in his representation of his early incarnation. He too had gone to Beijing, where he learned how to survive politically and even married, and his comments suggest that he felt he could best explain his own life by reflecting on his most notable previous one. This was not unlike the way his sixth incarnation (as well as his hosts in the Qing court) saw the long journey to China—as a mirror of the trip the Fifth Dalai Lama took to the court of the Shunzhi emperor in 1650. From the perspective of Tibetan Buddhism, the Panchen Lama, a manifestation of the

Western Buddha Amitābha and spiritual father of Avalokiteśvara (and hence of the Dalai Lamas and Tibet itself), still operated within the samsaric web of constant rebirth, where, out of compassion, he repeated the same pattern of incarnation over and over again. The Tenth Panchen Lama's final effort at self-justification and self-description is therefore remarkably poised between the fatuous rhetoric of late-twentieth-century Chinese nationalism and the sense that, for an incarnate lama, the past and the present may sit in a different, more conspicuously revealed relationship than they do for the rest of us.

Capturing the Model

If the Tenth Panchen Lama diplomatically chose to deflect a summation of his own career into a recapitulation of the legendary accomplishments of his former self, the striking expediency of the terms he chose also demonstrates how well he understood that any description must be made in the idiom of the day. The Tenth Panchen Lama had a great deal of material to work with when it came to recalling his earlier life. His sixth incarnation, Losang Paldan Yeshe, was a figure whose fame eventually stretched from Shigatse to Beijing and even to Europe and the United States. His physique, his character, his psychology, and the overt signs of his unique status as Tibet's most powerful incarnate lama were vividly described in a Rashomon of words and pictures by observers from vastly different backgrounds—Tibetan, Mongolian, Manchu, Chinese, Indian, even British. It might be said that the Sixth Panchen Lama was the first Tibetan to be subjected to the curious gaze of so many different kinds of people, all of them possessing only part of the picture, each one observing the lama from his own, never disinterested, perspective. Their various efforts at representing him help bring him into focus more clearly than any such figure before; they also shed light on the motives, expectations, interests, and cultural habits of each witness, anonymous and otherwise.

Consider, for example, the passage in the journal of George Bogle, the special trade envoy of India's governor-general Warren Hastings, in which he describes his first sight of the Sixth Panchen Lama in 1774: "The Lama was upon his throne, formed of wood, carved and gilt, with some cushions above it, upon which he sat cross-legged. He was dressed in a mitre-shaped cap of yellow broadcloth, with long bars lined with red satin; a yellow cloth jacket without sleeves, and a satin mantle of the same colour thrown over his shoulders."[2] Bogle was a Scot, the first representative of the British Empire, commercial or diplomatic, to meet one of the grand lamas of Tibet. He had been well coached in proper protocol beforehand. After a mutual exchange of gifts (among them "white Pelong handkerchiefs," that is, prayer scarves, and a pearl "necklace," or prayer beads), he reported that the formality of the first moment evaporated and "the lama received [him] in the most engaging manner," offering him plates of boiled mutton, rice, dried fruits, sweetmeats, sugar, bundles of tea, and dried sheep's carcasses, all "without saying any grace." Bogle was able to fill out his first impression of the Panchen Lama over the course of many subsequent visits and the two men quickly became friends. Their immediate liking for one another helped Bogle's true goal (at least so he thought), which was nothing less than enlisting the Panchen Lama to plead England's proposal to institute trade over the Indian-Tibetan border before the Qianlong emperor in Beijing.

Bogle's journal conveys a lively sense of his keen powers of observation—and subtly of his particular biases. He notes that the Panchen Lama "is about forty years of age, of low stature, and though not corpulent, rather inclining to be fat. His complexion is fairer than that of most of the Tibetans, and his arms are as white as those of a European; his hair, which is jet black, is cut very short; his beard and whiskers never above a month long; his eyes are small and black." Though Bogle describes the Panchen Lama as ungraced by exceptional good looks, he also found him to be affable and kindhearted. "His disposition is open, candid, and generous," he wrote. "He is extremely merry and enter-

taining in conversation, and tells a pleasant story with a great deal of humour and action. I endeavoured to find out, in his character, those defects which are inseparable from humanity, but he is so universally beloved that I had no success, and not a man could find it in his heart to speak ill of him."[3] At the time of their meeting the Sixth Panchen Lama was the single most powerful incarnate prelate in Tibet, which may account for the Scot's surprise at his easy informality. He presided over Tashilunpo, one of the foundational Gelukpa monasteries. Set in Tsang, which the Manchus called "Ulterior" or "Back" Tibet, Tashilunpo was some distance removed from the Dalai Lama's Lhasa. The Sixth Panchen Erdeni was thirty-seven years old in 1774 and in his prime, however, while the Eighth Dalai Lama, his disciple and protégé, was a youth of seventeen and still subject to his regent, the court-appointed Seventh Demo Khutukhtu (d. 1777).

The man Bogle describes so precisely is, almost to the hair, the very figure we see in a full *en face* court portrait done in Beijing, perhaps in the fall of 1780, when the Sixth Panchen Lama made his fateful trip first to the summer retreat at Chengde and then to the Qing capital to participate in the continuing celebration of the Qianlong emperor's seventieth birthday (Figure 57). The carved gilt throne; multicolored brocade cushions; garments of high rank; gently smiling, pale face; plump body; even the "white Pelong handkerchief" covering a sutra he holds in his lap—all are in place. His throne is set in the familiar magical, blue-green landscape that re-

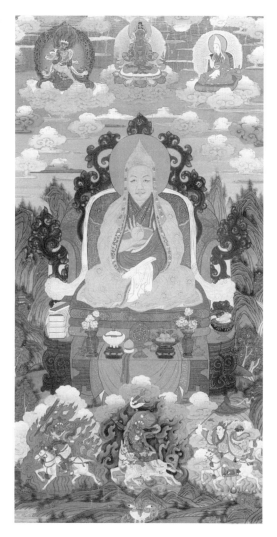

Figure 57. *The Sixth Panchen Lama in Monastic Dress,* 1780. Thangka, colors on cloth. 125 x 68 cm. (Palace Museum, Beijing.)

appears in the productions of Qianlong's court over and over again, located more specifically here by the golden, knob-shaped finial of Tashilunpo that pushes its way discreetly into view to the right. Benign offerings of flowers, fruits, and yoghurt are set out on a table in front of the lama and religious texts and a white conch shell rest within close reach on the front corners of his seat. Three figures float easily on fungus-shaped, pastel clouds: to the left, blue Yama, bull-headed Lord of Death, shown embracing his consort; in the center, Amitāyus, Buddha of Boundless Life; and, to the right, a figure the Palace Museum in Beijing identifies as Losang Palden Yeshe's immediate predecessor, the Fifth Panchen Lama (Losang Yeshe, 1663–1737). Even Yama's brute ferocity does not disturb the symmetrical harmony of the upper parts of the picture. Below, however, three terrifying mounted figures gallop in flames and smoke through the gentle countryside brandishing long, skull-capped *khatvanga* staffs, a banner, and a bowl of flaming jewels. At the center of this hideous trio is the protectress of the Gelukpa: blue-skinned Lhamo riding on her white mule. Red Hayagrīva rides to the left and a white figure, Jambhala, god of wealth, to the right. Just below Lhamo is another array of

offerings, this time designed to appeal to bloodthirsty protectors—a *kapala* skull cup filled with brains, guts, tongues, and disembodied eyeballs, resting on three minuscule skulls and seething in flames.

Bogle's carefully staged verbal portrait of the Panchen Lama and the seemingly routine court painting done in Beijing in 1780 provoke many of the same questions about the nature of the descriptive process. Foremost among these is an especially difficult issue. How can we recognize and represent a saint—particularly an incarnate saint with high institutional status whose body and accoutrements are nothing more than assumed phenomenal forms? Is spiritual achievement a quality that shows infallibly in the face? Is the habit of the monk and his extended ritual setting enough to convey a sense of his charisma? Bogle's analytic description founds itself on the premise that knowing the man begins with carefully observing his outer form. His answer to what he must have considered an inevitable question from Hastings—but what did he look like?—starts with a detailed, dramatic description of the moment of encounter. At first he notes the distinctive cultural markers of the Panchen Lama's status: his cross-legged posture, his distinctive, arm-baring costume, and his immediate, luxurious environment. Only then does he turn to the lama's physique ("low" and tending to fat), his pale "European" complexion, his grown-out monastic tonsure. Materially the Panchen Lama, in Bogle's eye, begins to display his true self in the ambivalent idiosyncrasies of his unexceptional but also somehow familiar body set against the thoroughly exotic but still legible details of his costume and setting. As their friendship blossoms, however, Bogle narrows in on the Panchen's remarkable ability to be ordinary. The casual baring of his head, chest, and arms causes Bogle to experience a growing sense of intimacy with the object of his interest and elicits in him a sense of exceptional privilege. As he puts it: "For although venerated as God's viceregent through all the eastern countries of Asia, endowed with a portion of omniscience, and with many other divine attributes, he throws aside, in conversation, all the awful part of his character, accommodates himself to the weakness of mortals, endeavours to make himself loved rather than feared, and behaves with the greatest affability to everybody, particularly to strangers." In other words: It is the Panchen Lama's ability to be himself, despite his immense ritual burden, that, in the end, catches Bogle's attention and reveals him as truly remarkable.

However amazed and gratified Bogle may have been by the easy intimacy and openheartedness of the Panchen Lama, he himself was also the object of stunned curiosity. His own Scottish exoticism in the midst of an environment that was totally alien to him produced a kind of bemused tolerance. He notes the unending floods of visitors who come to his room to stare at him, "the first European they had ever seen," bearing offerings of snuff, tea, and more sheep's carcasses and making friendly attempts at conversation. When the Panchen Lama tries to intervene, fearing Bogle might be overwhelmed by an excess of kindness, the Scot observes: "When I could gratify the curiosity of others at so easy a rate, why should I have refused it?" In Bogle's reactions to his status as honored ambassador and outlandish wonder we begin to sense a character as affable and complex as the lama's. And Bogle takes full advantage of this, hinting that it is his otherness which privileges him uniquely to consort with Tibet's greatest incarnation. (Bogle eventually married a Tibetan noblewoman from the Panchen Lama's court; their descendants live on in Scotland.)

But Bogle's description also conveys a more complex and, I suspect, initially ambivalent reaction. His sense of his own oddness and the undercurrent of his unease as he prepares to confront a figure of such awesome and mysterious powers are palpable. He describes his arrival at the border town of Desheripgay, where the Panchen was staying: the small, neat bedchamber, reached by a ladder, and the action of the great lama's unseen hand as tea, rice, flour, sheep carcasses, and whiskey arrive unbidden along with a stream of visitors who come to stare. Clearly he is expected—and, more remarkably, with a keen, worldly appreciation of his need for a stiff drink. Bogle's abilities as a raconteur are well up to creating the sense of excited tension that preceded his first meeting with the Panchen

Lama, put off until the next day. He describes a group of yellow-robed Khampas, a "hard-featured race," who wait with him for their group audience, and decides that they look like Malays. Clearly he is nervous with anticipation and his journal conveys a sense of the tension-diffusing small talk and crowd watching among the lama's guests as they collect themselves in preparation for their joint audience. As he steps into the audience chamber, Bogle's first glimpse of his host produces, in retrospect, a succinct, objective, controlled description of the lama and the ritual of greeting. The Panchen Lama appears first as a starkly reified object, the sum of his accoutrements, immobile on his elaborate throne. Bogle heightens the drama of his recollection by halting this moment of contact in time until his description is thick enough to create a vivid picture in the mind's eye. Then, suddenly, the scene comes to life as his host leans forward, "most engagingly," to receive him and all anticipatory tensions dissolve. No longer simply the object of Bogle's unidirectional gaze, the lama's gesture initiates the process of self-revelation on both sides.

The portrait Qianlong commanded of the Panchen Lama also presents him as the object of intense, descriptive scrutiny. But this painted portrait is a static picture that, like so many of the hybrid productions of the court, simultaneously views several different aspects of the lama's extended identity in very different ways. His softly modeled face, fulfilling the expectations generated by Bogle's description completely, is painted without outlines to reveal all the slight asymmetries of the flesh: its not quite even roundness; the hint of a double chin; the blunt, slightly bent nose; the eyelids dipping down at the outer corners just as the eyebrows arch up. The details of his clothing and the rest of his setting appear with a different sort of brilliant, diagrammatic clarity. At the same time the deities who hover above and below and the radiant landscape that seems to emanate from the lama's body suggest the regular habits of his mind, simultaneously encompassing extremes of passion and dispassion. In both portraits, verbal and visual, the Panchen Lama is caught in the crosshairs, captured in the phenomenal nature of his incarnate, fleshy emanation body—the startling ordinariness of how he happens to look this time around—and in the deeper patterns of his practice through several rebirths.

This portrait is not the only image of the Sixth Panchen Lama still kept in the Forbidden City. A similar picture shows him as an official of the Qing state in a Manchu prince's embroidered yellow robes and fur-colored yellow surcoat, partly covered with a dark red monastic shawl and pearl rosary (Plate 16). He wears a fur-brimmed court hat with a pointed gold brocade crown and holds a gilt container crowned with three multicolored jewels representing the three refuges: Buddha, Dharma, and Sangha. Both the monastic and official portraits have identical gold silk inventory labels attached to their back faces that state simply: "On the twenty-first day of the seventh month of Qianlong 45 [August 20, 1780], the Panchen Lama came from Tibet." The labels go on to say that a painter (or painters) of the Huayuan (Painting Academy) received an order from on high to produce a "true likeness" *(zhenru)* of the lama.[4]

This double record of face-to-face portrayal, portraits done from life, is corroborated indirectly in two of the more than five hundred extant records of the arrangements the Qing court made to expedite the Panchen Lama's trip to China. The two documents are separated by more than three months. The first, dated to the twenty-sixth day of the seventh month (August 25), four days after the Panchen Lama arrived in Chengde, came from a eunuch in the Imperial Manufactory (Zaobanchu) who transmitted an order to direct the *huahuaren* or *huaqiang* (a painter specifically of the Southern school) Lu Can to prepare to paint the Panchen's portrait sometime after he arrived in Beijing late in the ninth month or early in the tenth (October–November). The second document notes that on the thirtieth day of the tenth month (November 25), the same eunuch directed Lu Can to proceed to the Yellow Temple in Beijing to undertake the portrait.[5] The choice of Lu Can, like every other detail of his elaborately planned itinerary, shows the high regard Qianlong had for the Panchen

Lama. The painter was a native of Loudong (modern Shanghai) whom the emperor had personally summoned to court specifically to paint portraits of himself and various other statesmen.[6] But it is unlikely that a Zaobanchu painter, Lu Can or anyone else, did anything more than complete the sitter's face in the modified, unemphatic westernized style that dominated the portraits of Qianlong's court. For one thing, he would hardly have had time, for the Sixth Panchen Lama died the next day of smallpox, an event laconically recorded in a report filed by court doctors on the second day of the eleventh month (November 27), the day after his death. Most likely Lu Can sketched the Panchen's portrait quickly (presumably at the ailing lama's bedside) and then returned to the palace workshops to integrate it into a much more collaborative work. The two portraits' unintegrated juxtaposition of the subdued westernized style that was the standard at the Beijing court, emphasizing the physical, fleshy characteristics of the man, with a Tibetan-inspired mise-en-scène designed to suggest his inner qualities indirectly, puts them in the same category of production as Yao Wenhan and Ignatz Sichelbart's *Return of the Torghuts* or the multiple images of Qianlong in the role of Mañjuśrī.

We have seen that through a combination of circumstances Qianlong's court painters produced any number of portraits of Buddhist figures, including the emperor himself, that juxtaposed Western and Tibetan portrait styles. These images of the Panchen Lama seem, nonetheless, to make a particular point of the different nature of portraiture in the context of reincarnation—hinting that each sitter, however unique, is simply part of a series that extends backward into the past and forward into the future. Though the choice of the term *"zhenru"* (true likeness) in the imperial order to Lu Can may seem on its face to demand only an accurate representation of the Panchen's physical and social person, it also translates the Sanskrit term *"bhūtatathatā,"* the unchanging or immutable in contrast with form and phenomena, the "self-existent pure mind." Read this way, Qianlong's order was to produce not just an image of the Panchen's phenomenal body but something that went beyond to represent what was fundamental and unchanging about him, even after death and reincarnation. There are only certain limited variables at play in the Panchen's portraits to fill such a tall order, and the compactness of the artist's vocabulary tends to underline connections between the two different versions rather than emphasizing distinctions. Costume, which can vary, as we see, from one portrait of the same man to the next, defines not just the role of the sitter but also the specific role he takes up in the intended context of the picture. The signs of the Panchen's inner life also change: Blue Lhamo, the Gelukpa protectress who dominates the middle of the bottom portion of the first, monastic portrait, moves to the right in the second, courtly picture, yielding the center to black Mahākāla, protector of the Mongols, while a third protector, a two-armed, blue Yamāntaka, guardian of Beijing and manifestation of Mañjuśrī (hence China), occupies the left. Except for these remarkable signs of spiritual cultivation and lineage, however, these pictures are really composed as court portraits which differ only in offering a setting that seems external to the artist's main subject but really is an internal landscape inhabited by definitive and, in the latter case, discreetly politicized visions.

However routinized the externals of these portraits seem, they represent a significant and, in a sense, radical departure from some of the other images of the great lamas of Tibet with which the Qing court was already familiar—particularly in the way they insist upon recalling the lama's precise physical form. By the late eighteenth century, however, the Panchen Lamas had long been the object of intense painterly observation and a very differently inspired, but equally hybrid, pictorial description in Tibet. A core series of portraits of the Panchen Lamas and their preincarnations in India and Tibet was produced at Tashilunpo in the mid-seventeenth century, quite possibly by the founder of the New Menri school, the painter Chöjing Gyatso.[7] This series originally concluded with the Fourth Panchen Lama, who, along with the Fifth Dalai Lama, was an active patron of the

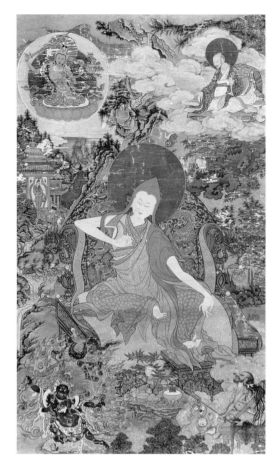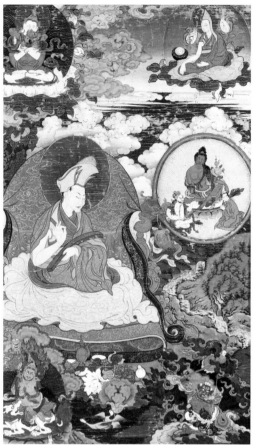

Figure 58. *Portraits from the Panchen Lama Lineage*, Narthang series, late seventeenth–eighteenth century. Thangkas, colors on cloth. *(left)* Sakya Pandita (1182–1251) 62.2 x 35.6 cm. (Newark Art Museum); *(right)* the Fourth Panchen (Losang Chökyi Gyaltsen, 1570–1662) 82.5 x 51.5 cm. (Palace Museum, Beijing).

artist (Figure 58, right). The portraits soon became authoritative sources for the Panchen's complicated, multiple life history and iconography and the series was repeatedly extended to include each subsequent Panchen. Chöjing Gyatso's New Menri style, like the original Menri style of Menla Dondub (also known as Manthangpa, the "man from Menthang") that spread widely through Central Tibet beginning in the 1450s, used Chinese blue-green landscapes to form the backgrounds of thangkas instead of the decorative designs typical of Nepalese Newar or Balri style. Menla Dondub, however, claimed his style was not new at all but came to him as he was looking at a Chinese painting of the Buddha's life when suddenly he recalled that he himself was the artist who had painted it, though in a previous life. More pragmatically, David Jackson observes that the artist also apparently studied and copied a significant Chinese painting, representing the great deeds of the Buddha, kept at Nenying.[8]

In Chöjing Gyatso's hands, this hybrid, broad-ranging style was transformed into a powerful tool for portraying both outward form and inward psychic states, allowing him to counterpose vividly the emotionalized attachments of the unenlightened and the radiant dispassion of the Buddha. An anonymous nineteenth-century Bhutanese scholar-painter described Chöjing Gyatso's work in his painting manual, *Rimokan:*

The divine bodies have many ornaments and are perfect in their beauty or ugliness. By the bodily forms, dances and strutting gestures, and the forms of such things as fluttering robes, clouds, fire and wind, the decorative forms (?), designs, flowers, waves, trees, birds, game animals, and gestures of human bodies, the charm of the landscape, rocky crags, slate [mountains] and glaciers, and by the form of waterfalls, jewels, etc., the [viewer's] mind is enchanted by the many emotional expressions *(nyams)* and feelings *('gyur ba)*.[9]

Chöjing Gyatso's painting is indeed dizzying. The murals that have been attributed to him at Tashilunpo combine pristine line, subtle modeling, vivid color, and agitated, complex, overlapping form to produce flamboyant displays of emotion—"a festival delighting gods and men!" as his Bhutanese admirer put it (Figure 59). His crowds of lay and monastic devotees, glaring ascetics, pensive noblemen, and smoking protectors boil with energy, each face presenting a totally different state of mind ranging from perfect calm to painful yearning or fierce attention. But it is his placement of spotlighted assemblies of worshipers, alternately agitated and introspective, against unstable landscapes partly obscured by clouds, smoke, and ominous banks of fog that allows the viewer an insight into the fleeting, unstable nature of samsara against the rock-solid, flat calm of the enlightened, gilded Buddha. His draftsmanship is ever-changing, as well, sometimes depending solely on Chinese-style outline and wash, sometimes on soft modeling, even in the same figure. And his painting is filled with free quotes from other traditions: a twisted, solitary Chinese pine here, a group of multicultural bodhisattvas there, a bazaar of all the human types of Tibet and beyond. He is also master of any number of illusionistic tricks that allow him to express, for example, the transparency of glass, the

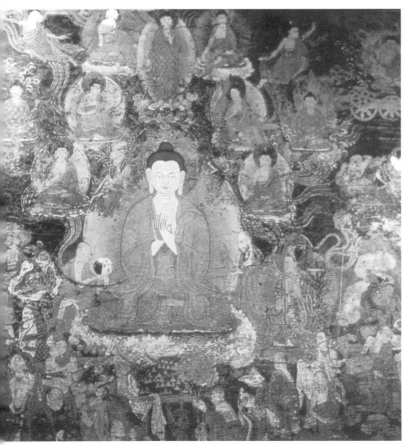

intricacies of a three-dimensional lattice, or the ripple of waves down a rocky stream.

The series of eleven Panchen Lama lineage portraits that reappeared and were augmented in numerous early and late copies share many of these same qualities. Their compositions present each central figure luxuriously enthroned in a Chinese blue-green landscape under a deep blue sky filled with pastel-tinted clouds. But in all eleven original compositions except two, the subject sits at an angle to the picture plane, clearly preoccupied with the swirling visions, worldly and otherworldy, that surround him. Even the two figures who face us directly, a youthful Sakya Pan-

Figure 59. Chöjing Gyatso, mural from Tashilunpo. (After Jackson, *History of Tibetan Painting*, pl. 42.)

dita (the sixth in the series; Figure 58, left) and a mustached Yungtön Dorje (the seventh), are hardly stable and stationary. Both literally dance in their seats, one leg up, the other down, hands raised in dramatic, theatricalized gestures. Meanwhile nothing is still and every inch of the compositions yields up wonderful details, all presented in a puff of illusionist's smoke: plants, bodies of glistening water, glimpses of palatial architecture, gamboling animals, and overflowing offerings. What we see is not just the outer form of the subject but also biographical bits that reveal both his outer and inner life. Thus each figure sits below encapsulated, haloed images of his tutelary deity and his guru while other protectors and disciples sit at his feet. Each of these peripheral figures stakes his own claim to personal style; even the weathered ascetic with his matted hair and grown-out nails has the body and grace of a dancer. They are all, in other words, "perfect in their beauty and ugliness."

New Menri was a masterful style that made immense demands on its practitioners. While it flourished at Tashilunpo, not all Tibetan artists adopted it nor did critics consider it to be the bedrock upon which the Central Tibetan Lhasa style was built during the seventeenth and eighteenth centuries, despite Chöjing Gyatso's work at the Potala. Tibetan critics preferred to see the more constrained, lighter manner patronized by the Dalai Lamas as a direct descendant of the original Menri of the fifteenth century. Nonetheless, the emotional hyperbole and visionary quality of the New Menri style gave it great allure beyond Tashilunpo. Its wide proliferation did not have so much to do with a corps of masterful artists as with technology, however. Sometime around 1740, if Giuseppe Tucci's calculations are correct,

Figure 60. *The Sixth Panchen Lama*, woodblock print from the Narthang series. (After Tucci, *Tibetan Painted Scrolls*, vol. 2, fig. 104.)

the original series of the Panchen Lama portraits (see Figure 60) was carved into woodblock form at Narthang (where a comprehensive woodblock Kanjur had been produced just a few years earlier). David Jackson and others have argued that these large-scale woodblock prints, which were sometimes straightforwardly mounted as thangkas, were used in lieu of underdrawing to produce colored "paint by the numbers" images, since the urge toward wider and wider proliferation also carried with it the risk of dilution.[10] The woodblock system of near-perfect replication solved this problem by giving each copy the same weight as an original.

These woodblocks, which were augmented as new rebirths of the Panchen Lama appeared (Tucci publishes the Musée Guimet set of fourteen that runs through the Seventh Panchen Lama), were

undoubtedly the repository that permitted a very particular memory and recollection to be perpetrated of the Panchen Lamas as supreme visionaries who, nonetheless, conformed broadly to a limited number of facial types.[11] Chöjing Gyatso characterizes the group more strikingly by attribute, posture, and setting, joining them together by certain threads of vague physical resemblance that weave in and out of the first eleven images. The proliferation of this woodblock print collection may also have made it possible for painters in the Qing court to produce their own accurate New Menri-style portraits of the Panchen Lamas. Records of the Zaobanchu document the progress that court painters and mounters made on a series of thirteen lineage portraits of the Panchen Lamas—beginning with the command to undertake them issued on the twenty-ninth day of the first month of Qianlong 44 (March 16, 1779), shortly after the invitation to visit China was sent out to the Sixth Panchen Lama.[12] Though surviving documents do not discuss the actual preparations for painting, one record notes that the suite was newly produced by the Hall of Central Uprightness.[13] The paintings were then mounted, taken to the Yangxindian for inspection, and on the third day of the fourth month (May 18) deployed to the Jixiang Faxilou, part of the Xumifushou (Tashilunpo) complex at Chengde built especially for the Sixth Panchen Lama. A few months later, in the ninth month (late October–early November), this suite or another just like it was moved to the middle room of the first floor of the Fazanglou and five more sets of lineage portraits, this time woodblock prints, were mounted in various silks and hung in some of the other rooms in the building. Together with eight scrolls depicting different buddhas, possibly a present from the Panchen Lama to Qianlong, a set of mounted prints was also sent for hanging to the east side building of the Hall of Central Uprightness.[14]

The Fourth Panchen's painted portrait reproduced here (Figure 58, right) suggests that whether or not the woodblock-printed suites that were hung in various parts of the Forbidden City were the Narthang versions, Qianlong's painters in the Hall of Central Uprightness were familiar with the New Menri style. This portrait, painted in Tibet, is almost exactly like the Narthang woodblock image, even down to the startled ducks in the pond below, which seem, however, like quotes from a Song-dynasty bird-and-flower painting. The verse below, which may originally have been composed by Chöjing Gyatso, reads: "Losang Chökyi Gyaltsen accomplished his realization according to the agency of Namthorey [that is, Vaiśarvaṇa, shown seated lower left], received Heruka's graces, and leaned on the great scholar and ascetic Samjey Yeshe Zhab [Buddhajñāna, seen upper right]." Thus Chöjing Gyatso and his followers in Narthang ensured a double authenticity for the Panchen Lama's portraits by establishing their visual contours and reiterating their spiritual content in verse. The lasting effect of their collaboration as artist and publisher carried into the twentieth century, when copies of the series were still being woven as thangkas of brocaded silk. One such copy of Sakya Pandita (the first in the series) is still preserved in the Potala Palace, Lhasa;[15] another set of seventeen, commissioned by the Ninth Panchen Lama, are at Tashilunpo, in the chamber where the Panchen Lama officially received the Chinese government's colonial administrator (amban).[16] Their woven inscriptions note that they were made in the Republican period (that is, after February 1912) at the Capital Brocade Silk Factory in Hangzhou (Figure 61).

The Narthang series took a fairly radical turn after the death of its original patron. Beginning with the Fifth Panchen Lama, Losang Paldan Yeshe (1663–1737), each new incarnation appeared in two portraits: one harmonizing with the earlier portraits in the lama's dynamic three-quarters pose, a second showing him seated upright and *en face* (as in Figure 58).[17] With the Fifth Panchen Lama, in other words, the Narthang series comes to correspond perfectly with the composition of the Sixth Panchen Lama's portrait in monastic dress, done in Beijing, except for the uncannily "real" representation of the face in the latter, presumably the work of the Huayuan painter Lu Can. In sum, then, Qianlong's painters introduced a single, but notable, contribution to the authoritative Narthang

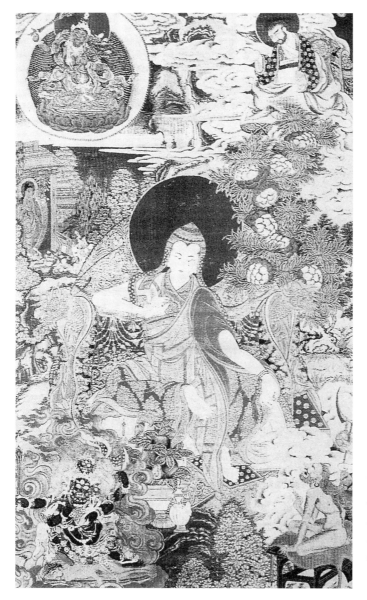

Figure 61. *Sakya Pandita.* Early twentieth century, Hangzhou. Brocaded silk scroll. 70 x 41.5 cm. (Potala Palace, Lhasa.)

series that had specifically to do with the collaborative, multicultural nature of their painting process—the emphasis placed on the phenomenal appearance of the face, which could be framed by or inserted into any symbolically laden context whatsoever. The question of how influential this new portrait concept was in Tibet can be tentatively answered by comparing the Beijing portrait with one of the two portraits of the Sixth Panchen Lama that were eventually added to the Narthang series (see Figure 60). The Narthang *en face* portrait depicts the lama in a setting that amalgamates the slightly different settings of the two Qing court portraits of 1780. The lama's face is similarly round, with wide-set eyes gazing benignly out from under heavy lids that dip down dramatically at the outer corners, as they do in Lu Can's rendition. But even though the Narthang version gives us a face that has been tugged away from the imperfections of the flesh toward a refined idealism, the woodcut suggests that Tibetan artists were as aware of the emperor's painters as the court was of them.[18]

Material Recognition

Qianlong, of course, did not miss the opportunity to react to the Panchen's visible presence in Chengde in poetry and prose. None of his comments, however, gives more than the most oblique hint of what the lama looked like—despite the emperor's clear interest in having the actual shape of his face recorded in painting. (This indifference to verbal portraiture was not true of Kangxi's court and its reaction to his lama Zanabazar, whom the emperor's mother succinctly described as beautiful, "like the full moon.")[19] But in one poem, written on the day the Panchen Lama arrived in Chengde, Qianlong voices his surprise at the very thing that caught George Bogle off guard—that is, the lama's

palpable, credible presence. He writes: "First sight was like recognizing a familiar form / As a matter of fact, as if [he] were not supernatural *(shentong)*."[20] The emperor uses a term that refers to the ten ubiquitous supernatural powers of a buddha, including his ability to shake the earth, issue light from his pores, extend his tongue to the Brahma heavens, cause divine flowers to rain from the sky, be omnipresent, take on a multitude of shapes, and so on. Part of Qianlong's wonder at the Panchen's humanity may have had to do with his extraordinary expectations of a lama who was the manifestation of Amitābha and therefore a true "living buddha." He was a figure the emperor had, until that moment, only known secondhand from his talks with Rolpay Dorje and from the fantastic, magical New Menri portraits of his preincarnations. Part of his reaction, however, as ever, seems calculated to create the right dramatic effect—as a visit so long awaited was finally consummated face-to-face in front of an audience of potentially dissident Mongol lords. Only the emperor, ignorant of Bogle's earlier report, could see through the lama's supernatural reputation to view the man himself.

The disjunction in the tellings and retellings of the Panchen Lama's trip, from first intentions to tragic completion, begins to hint at the complexity of his role from Qianlong's perspective. As Rolpay Dorje's biographer Thukwan tells it, the National Preceptor was largely responsible for urging the Panchen Lama to come and for advising on all the arrangements after he reluctantly agreed, finally overcoming his fear of smallpox and his forebodings that he would not return. The emperor's guru is, in fact, ubiquitous in both Thukwan's version of the tale and in the drier account that can be gleaned from official Qing sources, both documentary and embellished. Thukwan reports that when Rolpay Dorje was in Tibet between 1757 and 1758 overseeing the discovery and selection of the Eighth Dalai Lama, he became great friends with the young Sixth Panchen Lama, even visiting with him at Tashilunpo.[21] As the difficult choice between three potential reincarnations of the Dalai Lama was put to diviners from several great monasteries, dissension immediately arose. Rolpay Dorje gave the final determination to the Panchen Lama, who settled on the candidate from Ulterior Tibet (Tsang), where, of course, Shigatse and his own Tashilunpo were located. Thus the Panchen had helped determine the true incarnation in a way that solidified Manchu control over Tibet, for which he earned Rolpay Dorje's and Qianlong's gratitude, and he diplomatically continued to maintain excellent relations with the Dalai Lama's court-appointed regent in Lhasa, the Seventh Demo Khutukhtu, Ngawang Jampal Deleg Gyatso (d. 1777). He also confided to Rolpay Dorje that he hoped one day to visit Beijing to pursue his religious studies with him and pay his respects to the emperor.[22]

Thukwan therefore begins his account with events that took place nearly thirty years before, during the decisive period when Rolpay Dorje helped secure Qing control over Tibet while at the same time managing the contested choice of the Eighth Dalai Lama. The Sixth Panchen Lama emerges in this account as a fast friend and disciple of Rolpay Dorje and a lifelong ally of the Manchu Beijing government. Moreover, Rolpay Dorje appears throughout his own biography as the savior of Tibet— the figure who singlehandedly kept Qianlong from building a "Chinese-style city" from which to administer the whole country, a proposal that the *khutukhtu* argued would destroy Tibetan Buddhism and Qing hopes in Tibet with it.[23] (This advice has not affected recent Chinese rebuilding near the Lhasa Potala.) The Panchen's decision to risk the trip to China is, in Thukwan's telling, the consummation of a long-held desire to honor an emperor who, with his talented guru, finally pacified and stabilized Tibet. This uncritical view also faithfully represents the official Qing position as it emerges in hundreds of memorials and the emperor's vermilion comments on them. Qianlong sought the blessings of the Dalai and Panchen Lamas every time he passed a new decade, usually dispatching official retinues to make the trek to Lhasa and Shigatse in order to obtain them. The impression he wished to create was that the Panchen eagerly planned his trip, without prodding, to correspond with the imperial seventieth birthday.

But however gratified Qianlong may have been when the Panchen Lama finally agreed to come, his reasons were more complicated than simply wanting him at his party. The seventieth imperial birthday was carefully planned to mirror the great double-decade celebrations of 1771, when the empress dowager passed her eightieth year and Qianlong his sixtieth in the midst of the glorious return of the Torghut Mongols to their ancestral land. The auspiciousness that crowned this earlier event, recorded in the collaborative painting of Sichelpart and Yao, demonstrated itself as much in the apparently harmonious reconciliation of all the Mongol tribes and lamas, under the Manchu emperor's benevolent gaze, as in the radiant displays in the heavens above. Qianlong clearly saw his seventieth birthday as another opportunity to impress (and suppress) the Mongols, whose khans were all invited to attend and marvel at the Panchen's triumphant entry into Chengde.[24]

The retelling of the Panchen's trip takes on a different, slightly delusional, dimension in Western versions of it, however. A major source for early Western commentators was the highly embroidered account written by Purangir Gosain, an Indian mendicant and agent of the East India Company who joined the retinue of the Panchen Lama at Kumbum in Amdo after the first leg of the journey. Gosain seems to have joined the lama after Bogle's preparations for a second trip to Tibet were thwarted by the Panchen's leave-taking in 1779. Gosain, whom Bogle knew, sees the Panchen's motivations in light of English desires to open trade with Tibet, and he skews his account to highlight the moments (if they happened at all) when the Panchen Lama directly asked Qianlong to begin correspondence with India's governor-general, Warren Hastings. According to Gosain, who reports these few conversations as if he had been present himself, the Panchen Lama asked Rolpay Dorje to hint to the emperor that he wished to talk to him about an important matter—namely, an imperial letter addressed to Hastings. Qianlong agreed, Gosain says, and offered to have a letter carried by courier (but to where?) or to draft a letter that the Panchen Lama could carry back to Tibet. In the end, the letter was never written. At least it never arrived in Calcutta, despite the report of the Tashilunpo regent that Hastings' message to Qianlong had been delivered, nor has a draft of it been discovered in the Qing archives. As Schuyler Cammann observes, the inability of the English to pursue their interests after the Panchen Lama's early death in Beijing led to dark rumors that he had been murdered at Qianlong's order. Cammann demonstrates how unlikely this dramatic scenario was—however much it might have helped the English explain themselves back home. The Panchen Lama, as Cammann put it, "was much more valuable to [the emperor] alive than dead."[25]

In fact every aspect of the court's preparations for the Panchen Lama's trip validates Cammann's assessment. The staging of the Panchen Lama's visit began almost two years before his arrival in Chengde with the invitation sent by Rolpay Dorje on the sixth day of the twelfth month (January 23), 1779. Nonetheless, the Panchen's delayed acceptance allowed little enough time given the vast distance he had to cross and the logistics of supplying him for his yearlong journey. Hundreds of records of memorials, suggestions, and orders for everything from post-horses and fodder to hats, robes, rosaries, and buddha images show how intimately Qianlong was involved in the planning and orchestration of what he imagined would be his finest diplomatic hour. To perfect the plan, the emperor drew on every possible historical precedent to create impressive sets for his guest in both Chengde and Beijing. Anticipation of his arrival forced the renovation of the Yellow Temple in Beijing, which had been rebuilt for the Fifth Dalai Lama's trip in 1652 but had fallen into disarray. Every effort was made to make the Panchen feel at home. Qianlong studied Tibetan and Tangut so he could speak with him directly (though in the end he was forced to admit that his Tibetan was not up to the requirements of the Panchen's sophisticated teachings, putting Rolpay Dorje back into his role as interpreter). He even ordered a copy of the Panchen Lama's Tashilunpo to be built at Chengde to reinforce the notion of the Panchen's "homecoming," an idea that mirrored the events of ten years before when the Torghuts returned to the Qing empire (Figure 62). Suites of thangkas, sculptures,

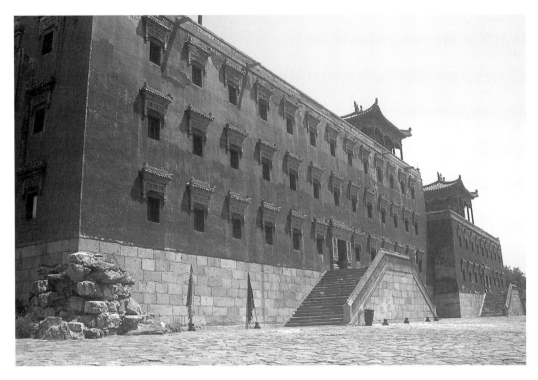

Figure 62. Xumifushou, built in 1780. Chengde Summer Retreat, Hebei. (Photo: Charles Drucker.)

and ritual objects, all designed according to the standards of Tashilunpo and overseen by Rolpay Dorje, were prepared to fill the new temple, and rituals, banquets, and festivities were choreographed for him.

Meanwhile Qianlong's Manchu aides saw to the comfort of the Panchen's entourage on the road. They arranged audiences with him at every stop, ensured the comfort of his winter layover at Kumbum in Amdo, regularly sent him long lists of gifts, and rushed back the gifts he gave in return. Even before he arrived in Chengde, Qianlong's sixth son greeted him along the road and then conspicuously inserted himself into menu planning—running suggestions for hundreds of dishes back and forth between the Panchen's camp and Qianlong's palace. In Chengde, he and his brothers doted on the lama's every move and ushered him solicitously to the Eight Outer Temples and into the emperor's presence (who sent word ahead of time that he need not perform the kowtow). Capping the choreographed symbolism of his approach to court was his ultimate arrival. This first greeting most probably took place in front of Sichelpart and Yao's screen depicting the return of the Torghuts in 1771, which stood in the main audience chamber of the imperial palace-*ger* at Chengde.[26] And a worthy backdrop it was, since everything about the Panchen Lama's visit was designed to recapitulate the greatest historical moments in the relationship between China and Tibet.[27]

Xumifushou: Stage for an Imperial Moment

None of the preparations for the Panchen Lama's visit captures the heady mixture of desire and statecraft that dominated the event so vividly as the construction of the Xumifushou. In terms of timing, the order to construct a temple to house the Panchen Lama at Chengde, dated to the ninth day of the twelfth month of Qianlong 43 (January 26, 1779), was one of the first the emperor sent down,[28] coming only three days after issuing the official invitation composed by Rolpay Dorje,[29] and two

days after ordering a golden mandala, the first of a long, tightly coordinated series of gifts.[30] Though this document does not mention that the new temple would be modeled on the Panchen Lama's own Tashilunpo Monastery, it must have been a given: A little more than a week later, another document explicitly describes the temple-to-be as the Chengde Tashilunpo, switching quickly to the Chinese translation of the name, Xumifushou, meaning "Blessings and Longevity of Sumeru." Just a month later, in a letter written on the third day of the first month, Qianlong 44 (February 18, 1779), the emperor wrote to thank the Panchen Lama for the gifts he forwarded by messenger, mentioning that "reflecting on the precedent of the Fifth Dalai Lama's coming to court, the Xumifushou is being built." He also noted that he had deputized princes and officials to welcome the lama and had even undertaken the study of Tangut so that the two could speak "face to face."[31] Subsequently, over the next year and a half, documents record the huge numbers of objects that were shifted to the new monastery from the temples of the Forbidden City as well as fabricated specifically for it by the palace workshops of the Zaobanchu. And the emperor kept pressing his point through all the edicts he wrote to dedicate the new temple: The Xumifushou was not simply like its model, Tashilunpo; its construction reiterated a ritual precedent, when the Fifth Dalai Lama's arrival in China was heralded by the construction and restoration of such monasteries as the Yellow Temple in Beijing.

Qianlong's reasoning went even further. Beyond this double resemblance—formal and ritual—in his view the apparent likeness of the Xumifushou to its immediate neighbor at Chengde, the Putuo-zongchengmiao (Potala), created yet another connection through contiguity. In his four-language stele of 1780 celebrating the dedication of the Xumifushou, Qianlong carefully laid out his argument.[32] He began by observing that Tsongkhapa, the founder of the Gelukpa, had two main disciples whose incarnations were, in turn, the Dalai and Panchen Lamas, the one the student and spiritual son of the other. Each occupied a separate monastic stronghold, widely separated in space, the one in Ü (east-central Interior Tibet), the other in Tsang (west-central Ulterior Tibet). Yet now both of these extraordinary edifices were copied side-by-side in Chengde in celebration of imperial birthdays. Moreover he restated the point he had made in his letter: Because the Xumifushou would serve as the Panchen Lama's residence while he was in Chengde, it also followed the precedent of the Yellow Temple in Beijing, which Qianlong's great-grandfather, the Shunzhi emperor, had built to accommodate the Fifth Dalai Lama. Beyond these purposes, all the Chengde temples, Qianlong wrote, had served a significant political function by uniting China and what lay beyond into "a single family." Thus by emulating the form and intent of previous temples, Qianlong (now switching to verse) could celebrate his own "nonaction" as the key to his successful reign and could compare his works to a "great suspended mirror that reflects in ten directions" and is "basically mindless, just as transference [of merit, 'what goes back'] is." "What goes back" (*huixiang ¹*) is a pun on "echo" (*huixiang ²*) and refers specifically to karmic supererogation, the purposeful transfer of merit from oneself to someone else. Using formal likeness, analogy, and proximity, therefore, Qianlong could allow what Confucians might have called his "leading virtue" (*de*)—in Buddhist terms, the insights of his nondual self—to radiate outward for the benefit of others without seeming to lift a finger.[33]

Despite Qianlong's rhetorical use of these many different modes of resemblance to link his own enterprise to the historical past, in fact the Xumifushou visibly resembles its original model Tashilunpo in only the loosest, most superficial ways. In essence, as Anne Chayet has shown, the two complexes are based on fundamentally different plans.[34] The original monastery comprises a group of red-toned, golden-roofed buildings situated side-by-side in a line, immediately revealing much of its facade on approach. The Chengde replica, however, is arrayed Chinese-style, axially from north to south, and, like the nearby Putuozongchengmiao, builds up to a gradually revealed climax in the red mass of an identically named terrace, the Dahongtai (Great Red Platform). In contrast to the Putuozong-chengmiao's Dahongtai, however, the Xumifushou version is more than just an elaborate exercise in

stagecraft; it actually houses apartments and its four corners are crowned with gold-roofed pavilions. It is the details of decoration in this central part of the monastery that point directly to Tashilunpo—specifically the gold-tiled, upturning roof of the Miaogao Zhuangyandian, sited within the embracing walls of the Dahongtai, and the fluid, writhing golden dragons adorning its roof lines.

This is a very interesting kind of copy indeed, one that pays little heed to the basic structure or visual impact of its model and makes only passing gestures at formal or material similitude, brief quotes scattered throughout a very different kind of architectural exercise, but apparently enough to spark the imaginations of Qianlong and his adviser, Rolpay Dorje. The attenuation of the original model continued in yet another replica created for the Panchen Lama in the Western Hills outside of Beijing, the Zhaomiao.[35] This temple was designed as another *xinggong* (traveling palace) for the Panchen, part of the staging of his eventual, highly ceremonialized entry into Beijing. According to plan, the Panchen first made his way to the Deshousi (Monastery of Virtue and Longevity). There he rested, "escaping the heat," and was greeted by the emperor right after his return from Dongling, the Eastern Tombs where his great-grandfather and grandfather (Shunzhi and Kangxi) were buried. Subsequently Qianlong went to Xiling, the Western Tombs where his father was entombed. On return, he greeted the Panchen Lama again, this time at the Zhaomiao. The temple's unusually brief name is a transliteration of the Tibetan "Jowo," meaning "revered image,"[36] though the pun on another *zhao*, meaning "reflecting," is irresistible. The Zhaomiao, like the Xumifushou, was another Tashilunpo, hinted at in its similar "Tibetan-style" red terrace. But by this stage in his journey, the mere fact of the Panchen's presence was enough to turn any set of buildings into a "Tashilunpo," regardless of how attenuated any physical resemblance had become. In this we begin to see resonances of the pair of Mañjuśrī temples Qianlong built at Xiangshan and Chengde in the early 1760s after his return from Wutaishan, when he commented: "If Qingliang [Wutaishan] is his [Mañjuśrī's] field of enlightened activity, then we do not know that Xiangshan is not also."[37]

Naturally, Qianlong treated the approach of the Panchen Lama to the Qing capital as a cause for poetic celebration. His stele at the Zhaomiao is composed as six couplets that cleverly complicate the reader's understanding of the Panchen's own origins in Ulterior Tibet by saying that this temple, constructed to honor him, actually emulated the style of Western Ü (meaning the region centered on Lhasa). It was just this difference between west-central and east-central Tibet that Qianlong articulated in his stele for the Xumifushou, when he used the geographic and political split in the Tibetan heartland as an analogy for the Dalai and Panchen Lamas and then argued, in effect, that the pair, if carefully balanced against one another, were like two sides of the same coin.

In the end, it could be said that the construction of the Xumifushou and, to a lesser extent, the Zhaomiao did more for the giver than it did for the recipient. Qianlong revisited the Chengde temple, even after his abdication in 1795, and he also returned to it in his writing several times over as he attempted to sort out the repercussions of the Panchen Lama's trip and his death in Beijing. These two magnificent presents were created as illusionistic settings designed to stage an imperially orchestrated event of great moment by replicating one of Tibet's greatest monasteries in a manner that was far from direct. Both of them wound up as apt symbols of something altogether different: sites of memory for an adventure gone horribly awry.

What Goes Back

Qianlong never gave a meaningless gift. Each object transferred from his coffers was carefully weighed in the balance against objects he received and against objects he had given to persons of similar status in the past. In the documents surrounding the Panchen Lama's visit, for example, we see the emperor ordering his officials to check old gift lists to determine the proper number and

quality of things to give to lamas in the Panchen's entourage. The size, quantity, and uniqueness of gifts clearly determined the imperial, correct view of the status of each lama—as did the ongoing wrangling about who should sit where, and at what height, during the many celebratory banquets the emperor held for his guest. Evoking delight in the recipient was certainly one aim of Qianlong's gift giving, but even more important was correct regard. This had little to do with perfect reciprocity in economic terms. For what sort of even balance could be established between the emperor and his lamas, who, in the end, had to know they were dependent on his largesse? The imbalance between gifts that went out and gifts that came in is most apparent in the fact that the objects the Panchen Lama chose to give to the emperor often did not resemble, either in number or in kind, the gifts the emperor gave him.

Even the vocabulary of court visits, tribute missions, and gift giving reflected this discrepancy. Ning Chia, for instance, has said that the vocabulary of missions to court varied greatly, depending on where the mission originated. All the Mongol tribes participated in the so-called *chaojin*, an annual ritual with distinct religious overtones that she argues means "pilgrimage to court." This regular pilgrimage, which was staged during the New Year festivities, included ample opportunities for trade and participants were provided with housing and expenses while in the capital. Even more interesting is the fact that, while in town, the emperor visited his guests in their quarters and not the other way around—thus, according to Ning Chia, expressing his "personal intimacy" with these privileged subjects.[38] Tibetan visitors, by contrast, undertook tribute duty *(chaogong)* even though the exchange of gifts from lamas differed notably from other tribute in being more symbolic than pragmatic. The Panchen Lama seems to have occupied a special niche in this arrangement, since the many documents detailing his trip to Chengde and Beijing use another term that suggests the uniqueness of his venture—"*rujin*," meaning he both entered *(ru)* and had an audience with the emperor *(jin)*. It would be difficult, however, to construe the Panchen's trip as a pilgrimage of the incarnation of the buddha Amitāyus to pay homage at the feet of the bodhisattva Mañjuśrī.

Similarly, the vocabulary of gift giving used in the Qing court provides a clear sense of the status of giver and recipient. When Qianlong gave things to his subjects, he actually bestowed, conferred, granted, or rewarded them *(shang, ci, or zeng)*. The first of these words, "*shang*," also carries a sense of appreciation (hence "reward"); it is, for example, also commonly used to express high regard for works of art. In other words, it carries a sense of subjective, admiring judgment on the part of the giver toward the recipient. But underlings could only "respectfully advance or put forward" *(gongjin)* or "offer with both hands" *(gongfeng)* the things they gave to the emperor. This dichotomy of giving changed, however, when Tibetan lamas began coming to court and a new, Tibetan-derived vocabulary was developed to finesse the gap between the imperial patron and his lamas—who, after all, had very different things to offer one another. Throughout the documents compiled to record the details of the Panchen Lama's trip, the verb combination "*di danshuke*" appears over and over again to describe the specific act of transfer from the Panchen Lama to the emperor. The first part of this combination, "*di*" (to forward, transmit, give), is Chinese and suggests upward movement, as in the term "*dizou*" (memorialize). But the second part, "*danshuke*," is a transliteration of the Tibetan term "*brtan bzhugs*" (pronounced something like "*tenzhug*"), which can be defined as a wish for abiding, steadfast, and firmly seated long life, particularly suitable for birthday gifts "offered with the wish 'live long'." Together the two terms project a complex bilingual meaning that simultaneously suggests correct obsequiousness toward the emperor while appropriating for the giver a special ability to confer the blessings of long life.

"*Danshuke*" is not the only Tibetan term that appears transliterated in the court documents surrounding the Panchen's doings and in the labels attached to gifts that came into the court from Tibet. Articles are often inventoried as "*li ma*" (transliterated into Chinese as "*lima*"), a Tibetan term meaning

"made of metal," which may have allowed the emperor's catalogers to avoid guessing about the precise composition of Tibetan alloys. Objects are also often *"zhashi,"* a transliteration of the Tibetan *"tashi"* meaning "blessed" (as in the Panchen Lama's Tashilunpo, carried over in its translation into Chinese as Xumifushou, "Blessed Long Life Sumeru"). Describing a partial gilt copper image of Amitāyus the Dalai Lama gave Qianlong, for instance, we find the phrase *"jin zhashi lima Wuliangshou fo yizun"* (put forward a blessed metal Amitāyus, one image).

However finely and biculturally these reciprocal acts were defined, they still played subtly on the same themes of historical resonance. The work of Arjun Appadurai and Igor Kopytoff, who have both argued that the lives of objects should be understood biographically and the symbolic value of their exchange politically and socially, provides any number of important insights into this aspect of the exchange between Qianlong and his guests.[39] But especially appropriate to the Manchu–Inner Asian relationship in general, and to relations between Qianlong and the Panchen Lama in particular, is Appadurai's point that intercultural exchanges, even those where a vast universe of shared understandings exist (in this case, the premises of Tibetan Buddhism as practiced by the Gelukpa), can be based on deeply divergent perceptions of value or meaning. Qianlong's gifts, however sumptuous (or even useless in practical terms), were carefully conceived and executed to produce the most calculated effects of favoritism; all his gifts were new productions, but, as we have seen, they were almost always based on clear historical models. The gifts the emperor received from the Panchen Lama and others, however, indeed the gifts he preferred, were historically venerable objects, old figures from Nepal, Kashmir, or India, or "returned goods," gifts that the emperors of the Ming dynasty had sent to Tibet that were now brought back by great lamas who regularly visited Qianlong's courts in Chengde and Beijing. A particularly important example is a bronze bell cast during the Ming Xuande period (1426–1435), the gift of which emulated what may have been an earlier gift of the Dalai Lama (either the Seventh or, more likely, the Eighth), who sent the emperor a handbell cast about 350 years before in the Ming Yongle court (1403–1424).[40] This earlier bell had originally been presented to a high lama of Tibet sometime around 1407. That date marked the arrival in Nanjing of the Fifth Karmapa of the Black Hat Kagyu order, Helima (Dezhin Shegpa), who visited the Ming capital to perform a lengthy funerary mass for the Yongle emperor's deceased father, the dynastic founder Hongwu, and his empress (née Ma). Helima's visit spurred Yongle's interest in Tibetan Buddhism, and the emperor's active courting and titling of important lamas were attempts to resurrect the relationship between China and Tibet established earlier by the Yuan dynastic founder Khubilai Khan and his guru Phagpa. In the view of the Qing emperors and their Mongol associates, Yongle's relationship with Tibet was simply part of a chain of incarnation that saw this Han Chinese emperor as yet another emanation of Mañjuśrī.[41]

Still other gifts specifically recalled symbolically meaningful exchanges of an earlier time by means of resemblance. Their appeal, in other words, lay not in their own histories as possessions but in the histories of pieces like them, in their movements from one collection to another, and in the fact that they materially embodied the lama/patron relationship with a kind of calculated ambiguity. The Panchen Lama's gift of a right-turning conch shell exemplifies this style of gift giving, which was quite typical of the Qing court's tributaries as a whole (Figure 63). From the Panchen Lama's perspective, the extraordinary but natural right-turning shell, which is used in Tibetan Buddhist ritual to produce a mellifluous, penetrating tone, was valuable because of its rarity: Most conches turn to the left—counterclockwise, that is, against the normal path of the vast majority of Buddhist rituals—while only the right-turning conch conforms to orthopraxis. This is rich and secret symbolism, readable only by cognoscenti, but from Qianlong's perspective the piece assumed an even more astonishing "semantic virtuosity."[42] Certainly it carried symbolic significance within the practices of Tibetan Buddhism, but it also resonated with the great military successes of the founders of the Qing, who

typically used conch shells to rally their troops. Even Qianlong followed this practice, though in a more ritualized setting, during the Jinchuan campaign, an adventure that was, as we have seen, successfully concluded with elaborate Tibetan Buddhist rituals.[43] Moreover, as a sport of nature, a conch that turned to the right also came as an explicitly auspicious sign *(ruixiang)* that heaven, in the Confucian, politically active sense, approved of his reign. Qianlong immediately had the Zaobanchu fabricate a gold-painted leather box to house the Panchen's conch (or perhaps to hide it away as charismatic treasure).[44] The fitted, reliquary-like casket where the conch still rests in Beijing is lined with imperial yellow silk and supplied with a white silk inventory label that records the details of its presentation, further empowering it with the imperial seal of approval. Qianlong's response to the Panchen Lama's gift indicates that he was well aware of the deeper ramifications of the conch. From his point of view and probably from the historically astute Panchen's, the gift must also have reverberated with the memory of an earlier, famous present of pan-Asian significance—when the Mongol emperor Khubilai Khan gave his guru, the Sakyapa lama Phagpa, a similar precious shell, one that had allegedly come down from Śākyamuni himself. With this gift Khubilai sealed their lama/patron relationship and Tibet's future as a Mongol protectorate.[45]

The Panchen Lama's conch was not, therefore, a mute or inert object. It was an object that could simultaneously assume several different registers of meaning, signifying different things to different viewers, all of them redolent with historic significance, requiring historical awareness on the part of giver and receiver to be perceived in the same key. Yet the Panchen Lama's conch was not singular or unique in Qianlong's experience.[46] It was, in fact, only one of several right-turning conches that

Figure 63. Right-turning conch shell (Wind-Stabilizing Treasure) presented to Qing Qianlong by the Sixth Panchen Lama in 1780. L: 10.8 cm. (Palace Museum, Beijing.)

Qianlong received from Tibetan lamas, and dozens of others, turning left as well as right, were kept in the monasteries Qianlong supported, such as the Yonghegong and the Eight Outer Monasteries of Chengde. The particular power of the Panchen's conch owed something to its rarity but much more to its particular, eventually contended, ability to calm the ocean's waves, a power explicitly mentioned in the label attached to its box.[47] Qianlong wrote a poem about it; it is inscribed in four languages on another, mounted conch that was kept at Chengde.[48] Which conch was truly the Panchen's gift has become a minor but highly symbolic bone of political contention in recent years—primarily because of its pacifying role in Qianlong's campaign against Taiwan, which brought the island into the Manchu empire and made it temporarily part of greater China. It accompanied Fukang'an's troops when they safely crossed the rough straits in 1787, returned to Beijing to be honored with an imperial inscription in 1793, and returned to Taiwan in 1802. The National Palace Museum, Taiwan, displays its own carved and inscribed conch as the famed "Wind-Stabilizing Treasure" *(Dingfeng zhi bao)*, but Beijing claims that the leather-encased, inventoried pristine version is the true shell. The emperor's writings directly on and about the treasure (or treasures) embedded it in a new, politically charged web by poeticizing it, aestheticizing it, and calling attention to its multiple meanings and its charismatic power as a natural object, albeit an unusual one, to affect the course of events. Given its extraordinary powers, it was bound to multiply.

The conch was thus the subtlest of gifts, an object that demonstrated how much the lama respected Qianlong's abilities as a connoisseur—a "knower"—privy to the secrets of Buddhist practice but also sensitive to the implications of behavior that mirrored in a very specific way the actions of earlier figures. Despite the special resonance of this gift, the range of acceptable presents—prayer scarves of various qualities, lengths of silk, clothing, ritual implements, paintings, and sculpture—was much more routinized than creative, determined in large measure by ritualized tradition. By far the vast number of the Panchen's presents to the emperor followed well-established patterns. Some of them, however, were so inspired they spurred innovations in gift giving. One elaborate gift the Panchen Lama sent the Qing court in 1777—two years before the official invitation to come to the imperial birthday celebrations was issued but still part of the delicate dance that resulted in his acceptance—caused a great flurry in the Buddhist world of the palace. This was a set of thangkas of the seven buddhas of the past, an iconographic group hitherto unknown at the court, which Rolpay Dorje was called in to explain. The crux of the matter was that these thangkas showed each of the seven, as we might expect, with two attendants and two disciples, and also with his mother and father kneeling reverently in the lower corners. These thangkas played in a very original way to a core dilemma of the Buddhist monastic life: its requirement that the attachments between an aspiring monk and his family be broken. Was this new iconography a subtle gesture of sympathy from the Panchen Lama to the emperor, whose beloved mother had just died?

Whatever the motivation for the gift, it hit the mark. Submitted to Rolpay Dorje for exegesis, copies of the images then were carved into an octagonal stone pillar, the Qifota (Seven Buddha Pagoda), originally located north of the Five Dragon Pavilion at Beihai.[49] Each of the seven buddhas appears enthroned on a jeweled seat with his attendants, disciples, and parents while inscriptions in four languages record his name above. Small inscriptions written below in Tibetan identify the other figures. In the dragon-laced frame, four cartouches, placed in the vertical borders near each of the four corners, record the work in Manchu, Chinese, Mongolian, and Tibetan as an imperial production dating to Qianlong *dingchou* (1777). The eighth face of the pillar is inscribed with a text in Tibetan and Chinese explaining that the seven buddhas were all "doubles" *(ou)*; the seventh was Śākyamuni, the historical Buddha. The inscription also broaches the question of the meaning of the decline of the dharma in the face of a lineage of seven identical buddhas: "Intrinsic dharma is dharmaless; dharmaless dharma is also dharma; now comes a dharmaless age; how then could past dharma be dharmaful dharma?"

But for the four-language inscriptions at the top of each face, these stone engravings resemble a traditional Tibetan thangka, down to the double border that mimics the fabric mount, here filled with dragons chasing pearls. Qianlong was so struck with the aptness of this gift that he not only had it immortalized in stone but also had his court painters make copies, not of the originals sent by the Panchen Lama, but of rubbings of the stone engravings (Figure 64). These were done in gold ink on a black ground, turning them into perfect handmade replicas of a rubbing of the stone surface of the pagoda.[50] He then apparently sent a set to the Dalai Lama; it still survives in the Potala. Another set was prepared for storage in the palace, where it also survives. Yet another set went to the palace at the ancestral capital of Shengjing.[51]

Death and Depiction

Once the Panchen Lama arrived in Chengde, Qianlong's gifts and attentions began to take on a more personal character reflected in the poem he composed right after they met, in which he records his first shock of recognition. However ordinary and unlike a magically produced transformation body the Panchen appeared in person, Qianlong consistently saw him in the larger sense of the word as a being marked by his passage through many human lives. Yet he also believed the Panchen Lama was a man of taste, susceptible to the sorts of elegant, cultivated, and gentlemanly blandishments Qianlong showered on other very important persons. One gift that he prepared for the Panchen Lama (and his by-now fast friend and constant attendant Rolpay Dorje) was a pair of fans, both of which he himself painted with white lotuses and inscribed with a poem while at the summer retreat. The poem alludes to the origins of the lotus in the dust, where it nonetheless manages to stay pure and true and where, despite its first, common blush, it cultivates a blank white karma. He concludes by asking: "Having transcribed the image, on whom shall I bestow it? On Asaṅga (Chinese: Wuzhu) and Vasubhandu (Tianqin)!"[52] These two Indian, most likely Gandharan, brothers, of whom Asaṅga was the elder, lived in the fourth century. Asaṅga brought his brother to the practice of Mahāyāna Buddhism and is credited with founding the tantric Yogācārya school by "transcribing" its fundamental treatise, the *Yogācāryabhūmi-śāstra*, which Maitreya was said to have dictated to him in Tuṣita Heaven. In this poem, therefore, Qianlong develops his earlier rhetoric in which he described his construction of the Xumifushou and the rest of the replica temples of Chengde as another aspect of his policy of uniting China and its frontiers into one family. Here, "among family," he casts his two great lamas—the one preeminent in Tibet, the other in Inner Mongolia, China, and Manchuria—as brothers: The Panchen Lama, though chronologically younger and technically Rolpay Dorje's disciple, finds himself in the role of the elder, while Rolpay Dorje takes the role of the younger. This particular metaphor of family harmony was soon to be played out completely, as it happened, because the death of the Panchen Lama shortly after his arrival in Beijing forced Rolpay Dorje, along with the emperor and all the workshops of the court, into the role of bereaved family responsible for the Panchen Lama's earthly remains and for the equitable redistribution of his newly acquired vast wealth.

Like a grief-stricken family member, Rolpay Dorje's biographer Thukwan tells us that Qianlong "fainted" when he heard the news of the Panchen's death, even though court documents seem to pass over his illness and quick demise with bureaucratic indifference. (Or perhaps the hushed tone had to do with shame for having let such an important guest sicken and die.) Qianlong quickly moved (December 28, 1780) to have two of the Panchen's Buddhist robes boxed in a fine, gold-painted leather case and stored in the Pavilion of Western Salubriousness (Xinuange), part of his own private quarters at the Yangxindian. Moreover, he ordered that a "shadow hall" (*yingtang*) to honor the Panchen Lama be set up in the Xipeilou, a small building just to the west of his own Pavilion of Raining Flowers. Just six years later, when Rolpay Dorje died at Wutaishan, leaving the emperor

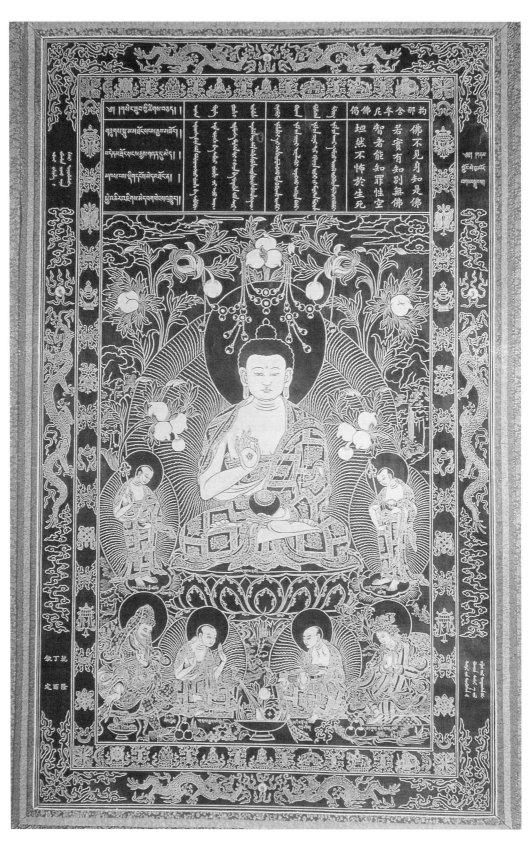

even more deeply bereft, he once again returned to the theme of the profound similarities between his two greatest lamas, both of whom had been politically adept and pliable and had filled symbolic roles as guardians of the western and eastern extremes of his empire. And so to match the shrine to the Panchen Lama to the west of the Pavilion of Raining Flowers, within a year Qianlong ordered that another shrine be outfitted to honor Rolpay Dorje just to the east.

On the day he died, Rolpay Dorje sent a package from Wutaishan to the Pavilion of Raining Flowers that contained the bell, *vajra,* drum, and buddha image he used in his private practice, along with his will, written in verse. These contact relics were ultimately placed in his memorial hall to substitute for his body, which was enshrined in a golden stupa modeled on the Panchen Lama's and buried at his beloved Wutaishan. Otherwise the contents of the pavilion's two flanking halls were once nearly identical by design. Each held a sculptural portrait of the lama as well as a painted portrait and a full collection of other sculpted and painted images. They were, in other words, conceived from the outset to be mirror images of one another with buildings and contents arrayed to reinforce the concept of their brotherhood, united in death as members of a single Gelukpa family. The Panchen Lama's formal *en face* portrait in court dress was likely to have been the image chosen and perhaps even designed posthumously to fulfill this function in his chapel to the west. Evidence for this comes in the form of another portrait depicting not the Panchen Lama but Rolpay Dorje (Plate 17).

The National Preceptor's portrait is nearly identical to the Panchen Lama's except, of course, for the face. Rolpay Dorje is likewise shown in court robes, swathed with his monastic shawl and pearl rosary. (And we know from court documents that the Panchen Lama and Rolpay Dorje both received several gifts of nine-dragon court robes when the Panchen first arrived in Chengde.)[53] The preceptor sits on a fabulously carved throne, with paisley scroll finials, set against an equally gem-like landscape. Like the Panchen he holds a gilt vase containing the elixir of life, likewise carefully cradled in a white cloth. The same figures, benign and fierce, accompany him top and bottom: Amitāyus—flanked by Yama and a lama the Palace Museum here identifies as the Second Zhangjia Khutukhtu—and the three protectors Mahākāla, Yamāntaka, and Lhamo. Yet the figure we see is certainly Rolpay Dorje, for so his yellow silk label says (as does the subtle lump on his right jowl). The label documents the fact that the portrait was done by imperial order in the Hall of Central Uprightness by "lamas who paint buddhas." The date of the order that led to its creation, January 13, 1787, places it about a year after Rolpay Dorje's death on April 29, 1786. The preceptor's portrait is, in other words, clearly posthumous, done to honor the emperor's beloved lama on the first anniversary of his death.

The positioning of the two court dress portraits in opposed spaces helps explain why the array of deities in the Panchen Lama's portrait is so exactly copied in Rolpay Dorje's. These include the red Amitāyus, Buddha of Boundless Life, and the identical lama repeated in the upper right of both pictures, most likely Tsongkhapa (though identified by the Palace Museum as the Fifth Panchen Lama in one portrait and the Second Zhangjia Khutukhtu in the other). The third figure, to the left, is Yama, lord of death, whose fearsome presence is countered below by Yamāntaka, Yama's destroyer and manifestation of Mañjuśrī. Thus the images that surround the two play directly into notions of long life (Amitāyus), death (Yama and Yamāntaka), and the continuity ensured by lineage (Tsongkhapa). Yamāntaka, Mahākāla, and Lhamo also add a political and geographical note. As protectors of Beijing, the Mongols and Manchus, and the Tibetans, respectively, they map the outer and inner reaches of the Qing empire in symbolic, Buddhist terms.

Figure 64. *Kanakamuni* (*Tib:* gSer thub), one of seven buddhas. Thangka, gold on black paper. 110 x 64.5 cm. (Palace Museum, Beijing.)

At least one court document also supports the speculation that there is a chance the Panchen Lama's portrait might have been posthumous as well; certainly it shows that the portraits done of him in Beijing were only deployed after his death (there being little time to do otherwise). This detailed order from the Zaobanchu, dated January 18, 1787, and kept in the daily records of the court, is directed at the Hall of Central Uprightness' lama-painters, ordering them to prepare two new portraits of the Panchen Lama to be added to two they already had (most likely Lu Can's work). These four scrolls, lavishly mounted according to the directions laid out in the order and equipped with four-language inscriptions, were deposed as follows: one to the Fayuanlou (Dharma-Source Tower), a second to the Zifou (Imperial Float) at Chengde where the Panchen Lama had chanted sutras, a third to the Xumifushou at Chengde, and the fourth to the west side tower (Xipeilou) of the Hall of Central Uprightness, the Panchen's two-story memorial shrine just to the right of the Pavilion of Raining Flowers.[54]

What Remained

What remained after the Panchen Lama's unexpected death at the Yellow Temple was a nightmare for the emperor and his court, all of whom had been preparing, not for a funeral, but for the celebration of the Panchen's own upcoming birthday. All of the bounty the emperor expected to lavish on the Panchen was abruptly diverted to his brother, the Jungba Khutukhtu, who now became the vastly wealthy, de facto over-lord of Tashilunpo. Meanwhile Qianlong ordered that sutra chanting to ensure the Panchen's safe transmigration be undertaken immediately in all the imperial temples of the capital, and he wrote to the Dalai Lama asking him to begin the same actions in Lhasa. He also ordered that a large reliquary be cast of gold to hold the Panchen Lama's remains, which were arranged within, seated upright, in a posture of meditation. At the same time, another large, stone stupa-reliquary in Himalayan style, the Clear and Pure Transformation Wall Pagoda, was constructed at the Yellow Temple to hold a few of the Panchen's per-

Figure 65. The Diamond Seat Pagoda at the Huangsi, Beijing. (Reproduced courtesy of the Huangsi.)

sonal belongings—his hat and a monastic robe (Figure 65). This "Diamond Seat" (Vajrāsana) stupa copied the famous monument marking the spot of the Buddha's enlightenment in Bodhgayā; it was only one of four such models in Beijing.[55] Despite Qianlong's disclaimers in his 1771 edict establishing the Putuozongchengmiao at Chengde that his new replica of the Potala could not take the Indian original as a model because it was too far away to investigate in detail, the shape and plan of Bodhgayā's temples were well known in China in the form of scale models from at least the early Ming period.[56]

In his stele of 1782 commemorating the foundation of the Panchen's Diamond Seat at the Yellow Temple, Qianlong provides the reader with an equivocation of his first, shocked reaction to the news of the lama's death:

> *Record of the Clear and Pure Transformation Wall Pagoda*:
> I have heard that those who act are dharmaless; the root of dharma is nonaction. [At the same time] those who often desist have not attained the Way; the Way returns without desisting. The great compassionate one's wish was to be of great assistance. His strength came from beginningless kalpas; his marvelous, bright, rounded consciousness benefited men and heaven universally and caused many thousands of beings to be delighted, peaceful and secure, each with his wishes satisfied. Thus this wisdom lamp will long continue to illuminate; thus the *dharmacakra* can be depended on to turn for the good.
>
> On the *dingzhou* day of the seventh month, in autumn of the *gengzi* year [1780], the holy monk Panchen Erdeni came from Ulterior Tibet, crossing twenty thousand *li* to come to court. The Tashilunpo was constructed at the Mountain Retreat in imitation of his dwelling so that he could meditate in peace. After a month had passsed I sent him to the capital, where he was cared for here at the Yellow Temple. Then, on the *bingzi* day in the eleventh month, he died in this monastery. On the *bingzhen* day of the second month of *xinchou* [1781], we took his relics and sent them back to Ulterior Tibet. The periods from his coming to court to his death, and from his death to his return to Tibet, each adds up to one hundred days. The cause of his coming and going cannot be fathomed. Therefore I order that to the west side of the monastery the Clear and Pure Transformation Wall Pagoda court be established to keep his Tibetan sutras, Buddhist garments, and shoes in memory of his great worth. At first, the Panchen's coming as a guest purified and calmed the universe, and people and things were prosperous and harmonious. He was happy to see how the Yellow Doctrine flourished in China, and the Mongols and Tibetans, as soon as they heard of this event, could only be delighted, show him reverence, and pour out their hearts to serve him. In the inner lands, too, men craned their necks and stood on tiptoe [to see him] and hastened to take refuge. They considered it an auspicious and good event for the nation and felt that his proclaiming the lineage vehicle [that is, Vajrayāna] to China and Tibet would result in boundless merit.
>
> How do you know that those who point to the raft in their search for the source cannot give proof of the sea of enlightenment or that those who seize a ladder as a shortcut cannot ascend the divine mountain? Birth and annihilation have the same source, going and coming are one dharma, which then enters into stillness. Even then, nonetheless, the doctrine may still be proclaimed. Thus even when he was a mendicant monk in India, the Panchen Lama was already completely unobstructed. So on the day we received his prophecy at the Mountain Retreat and he left his eminent disciple Losang Donzhub [b. 1740] and others

at Tashilunpo to transmit practices, sutras, and *vinaya* and proclaim them to be the correct doctrine, it was just as the Tathāgata said at his nirvana: "I have the unsurpassed mind method, which I transfer completely to Mahākāśyapa so that you all will have a great support to rest on tomorrow." Then how is it you do not yet believe those who act are dharmaless and those who desist lack the Way? What the Clear and Pure Transformation Wall and the Tashilunpo explain about the practices of this lineage, what they promulgate about the marvelous truth, is one and two. Do not expect this weighty topic to be discussed interminably.[57]

Qianlong grapples here and in the long poem that follows with the problem of publicly rationalizing the Panchen's death as part of a process of reincarnation that was already under way "beginningless kalpas" ago and is therefore something he must come to grips with in a posture of nonaction *(wuwei)*. Even from nirvana, which Qianlong conceives as "stillness," this holy monk will continue to proclaim the dharma; his death is merely a brief pause in a career that will go on even after he escapes the wheel of transmigration. Not acting, he will nonetheless never desist from not acting. Posing as a eulogy, this text is really a political defense that attempts to balance the necessity for "nonaction," a core concept of Chinese political philosophy, against the sustained effort of never desisting that is required to find the Way. Qianlong has learned that outward show and ritual action are, in the end, empty forms at best. But he also understands (and he does not regret) that his whole life has been devoted to precisely this kind of formal, materialized action: a "rain of flowers" that does not stick. Thus he demands to know why taking the raft as evidence of the sea of enlightenment or seeking shortcuts to realization are wrongheaded. (For if they are, what does this say about his own actions?) The "raft" that carries the practitioner to enlightenment (on which he has been floating unknowingly all along) and the "ladder" that enables him to scale the "divine mountain" both refer to a broad category of material and mental supports—sculpture, paintings, temples, ritual panoply, and even the "unsurpassed mind method" that Śākyamuni passed on to Mahākāśyapa— all of which are left behind in the "stillness" of nirvana.[58] These props and methods are the reverberating echo of Śākyamuni's unceasing efforts over many lives, which now play themselves out in pointing the way to perfect nonactivity. In the end, Qianlong argues, there is really no difference between these props and the enlightenment mind—they are, in his favorite phrase, "one and two." It is only in making a distinction between them that the whole unceasing effort falls apart.

Two years before composing this final memorial and only about a month after the Panchen Lama's death, Qianlong wrote one of several poems in which he expressed a somewhat different, more personal, understanding of the event—one that nonetheless stands as another testament to his own Buddhist-inflected thinking and his sense of the inherent conflict between undesisting effort and nonaction. In it he embedded several numerical references to the lama, to himself, and to the first patriarch of Chan Buddhism, Bodhidharma, couching all of them in the framework of the seven buddhas, the very group introduced to him by the Panchen Lama's early gift of seven thangkas copied at the Seven Buddha Pagoda:

> *Writing an accompanying eulogy on the long life of his holiness, the Panchen:*
> To the Indian city's Śāla tree China yielded another intertwined.
> An ancient tree that was born alike, its long-life boundless.
> Bishefou Buddha, the third of the Seven Buddhas,
> Achieved the Way beneath a tree; looking at a mirror, he saw how to penetrate it.
> Likewise it is said that the First Patriarch cultivated the Way beneath a tree,
> Directly pointing to the mind transmission, the Sixth Perfection (i.e., wisdom).

A holy monk came from the west and proclaimed the Yellow Doctrine;

Coincidentally it was my birthday and the sun of his wisdom radiated universally.

Writing this epitaph, I am advanced in years;

Seven leaves have randomly fallen, a thousand years have slowly unfolded.

At the nirvana dharma-gathering a *nirmāṇakāya* was cremated;

Not one, nor two, his transformations have no limit.

> Qianlong *gengzi* [1780], mid-winter month,
> *shanghuan* (first ten days), an accompanying eulogy
> on the long life of his holiness the Panchen, written
> by the imperial brush.[59]

The poem is composed as a series of interwoven, only apparently random, connections that simultaneously record the tenor of Qianlong's mind and cast the Panchen Lama as the third of the seven buddhas, an analogy based on the Tibetan accounting of his lineage, where he is numbered the third incarnation, not the sixth. This third buddha, Bishefou Fo (*Tib*: Themchen kyob), like Bodhidharma, the first patriarch of Chan Buddhism, reached enlightenment while sitting beneath a tree, one that grew in China but was intertwined *(jiao)* with the Śāla tree beneath which Śākyamuni, the buddha of this kalpa, first sat. Citing this ancient Chinese tree *(chun)*, Qianlong chooses a word that also means "patriarch," suggesting a plant that is a progenitor and will sprout countless branches. The fruit of the third buddha's meditation is the sixth and last perfection *(pāramitā)*, which is wisdom *(prajñā)*—a clever play that allows Qianlong to number the Panchen both ways, as third and sixth. Only then does he introduce the holy monk from the west (in ordinary usage both Śākyamuni and the first Chan patriarch Bodhidharma, but here also clearly the Panchen Lama) who arrives, "coincidentally," on the emperor's seventieth birthday. Turning his brush briefly back upon himself, Qianlong numbers his seven decades as "leaves," perhaps fallen from this same great tree. Or do these leaves also refer to the five-leaf flower whose opening signaled the Chan patriarch Bodhidharma's transfer of the dharma? This famous dharma event was the subject of another of Qianlong's poems written in 1780, titled *Qiye tang* (Seven Leaf Hall). Setting his "withered meditator" in Beijing's Xiangshan, he asks how to "follow the sound" of the Chan master's parting *gāthā*: "A single flower opens to five leaves."[60] The phrase embodies the prophecy that there would be six founding Chan patriarchs in all, raising the question of whether the Panchen Lama might also be the final exponent of his line. But in his final verse Qianlong dispels all doubt when he concludes with the thought that the one just cremated (or "transformed," since the Panchen was not cremated) was simply a *nirmāṇakāya* (transformation body); he is beyond duality—"not one, nor two"—and his transformations are unbounded.

This eulogy plays on hybrid intertextual connections in more ways than one. Accompanying the emperor's numerological eulogy, which was inscribed in stone in four languages and placed at the Yellow Temple, is an image of a flourishing tree whose two main branches twine upward in vigorous growth while a third, smaller bough grows off to the side (Figure 66). Its stout, twisting trunk and upper reaches show evidence of vigorous pruning; many potential limbs have been cut away from its base, allowing the crown to rise in an enmeshed tangle of positive and negative foliage. Its strange, giant leaves identify it as a pipal, the exact type of tree Śākyamuni sat under in his last pre-enlightenment meditation.[61] Two weathered rocks, one large, one small, flank its trunk, bending inward as if engaged in conversation like immortalized versions of Śākyamuni and his greatest exponent, the Panchen Lama. Peppered around the image are engraved versions of three of Qianlong's seals. A fourth—reading *"Gu xi tianzi"* (Son of Heaven Rare Since Ancient Times), the seal he designed

Figure 66. *Tree of Long Life*, with an inscription by the Qianlong emperor, 1780. Ink rubbing of a stone engraving at the Huangsi, Beijing. (After Franke and Laufer, *Epigraphische Denkmäler*, pl. 12.)

in his seventieth year specifically to celebrate his birthday—sits in the center of the negative space created by the divergence of the tree's two main branches, where it is underscored by the wayward third branch. Its meaning, referring indirectly to his own advanced age, reflects the personal turn of his poetic eulogy. The term *"gu xi¹"* is an alternative writing of *"gu xi²,"* which derives from the phrase *"ren sheng qi shi gu lai xi"* (from ancient times men of seventy years have come rarely). (There were, in fact, only eight emperors of China who lived this long.) This classical trope was the topic of Qianlong's poetic seventieth-birthday discourse, offered to his guests at the Xinuange (the same building where he was shortly to enshrine the Panchen's robes),[62] and it was the subject of a poem, also titled *Gu xi*, that he wrote a few months after the Panchen's death in 1781. In this poem he summed up the Dragon Vehicle, the imperial way he had constantly practiced without desisting, as "using the translation of forms to penetrate the six sounds." But what are these six sounds? Are they a six-syllable mantra (perhaps Avalokiteśvara's *"Oṃ maṇi padme hūṃ"* or Mañjuśrī's *"Oṃ arapacana"*)? Or are they the six languages mentioned in his self-commentary, where he once again returned to his lifelong passion?

> I have studied the national language [Manchu] since my youth and Chinese writing from the age of six. In the eighth year of my reign [1743] I began studying Mongolian; in the twenty-fifth year [1760], after pacifying Uighur territory, I studied Uighur; in the forty-first year [1776], after pacifying the two Jinchuan territories, I studied Tibetan. Last year, in the forty-fifth year [1780], I studied Tangut because the Panchen Lama came. My Mongolian and Uighur are already fluent and I understand the names of things, objects, and numbers in Tibetan and Tangut, though I am still not well acquainted enough with them to discuss issues from beginning to end. But using Manchu and Chinese I have come to grips with the sounds of the languages of the Six Regions. I have not practiced [speaking] the languages of four of these regions for eight years and so today I still lean on others to interpret whenever I cannot understand all the facts. Thus even in those regions I have not visited, in these past several decades I have been able to see that no one can depict *(hua)* himself without diligent study.[63]

Qianlong's final thoughts in this commentary offer language (which we might amplify to include visual language) as a primary means of self-depiction or "picturing." No one, he argues, can "depict himself without diligent study." His meaning is clear enough: Only fluency allows the crafting of a self-image that appears seamless, unmediated, and "true." The emperor links his study of Tangut, which he undertook just to speak with the Panchen Lama, with his earlier study of Uighur and Tibetan, both of which he learned in celebration of his "pacification" of border territories. All three efforts suggest that he felt the need to represent or depict himself accurately and without translation to these new subjects. Such immediacy would be felt on both sides, with proper homage due to Qianlong for his singular diligence. The Panchen Lama's willingness to come to the Qing court was, in his view, a kind of bloodless coup in which Tibet's eldest and most powerful lama agreed publicly to ally himself with the Manchus.

His death, however, was another matter. The reallotment of his gifts to his younger brother, the Jungba Khutukhtu, made Tashilunpo even wealthier than before. According to Wei Yuan, the early-nineteenth-century historian who wrote at length about China's historic relations with Tibet, it was news of the immense bounty of gifts from Qianlong's court that enticed the Nepalese Gurkhas to cross the border into Tibet and raid Tashilunpo and other wealthy monasteries in Tsang in 1790. Fukang'an, who had overseen the Panchen Lama's trip from Shigatse to Chengde and supervised the construction of the Xumifushou, was commanded to deal with the problem. He and his troops

reached the border in 1792 and, against all odds, managed to drive the Gurkhas all the way back to the gates of their capital. The emperor finally and bitterly summarized these events, an unexpected outcome of the Panchen Lama's fateful trip, in his *Lama Shuo*, carved into the massive, quadrilingual stone monolith at the Yonghegong in 1792.[64] With this document, written after both the Panchen Lama and Rolpay Dorje had died, his long affection for the Tibetan and Mongolian Buddhist establishment appears to have transformed into cynicism.

Epilogue

The death of the Sixth Panchen Lama in Beijing recalled several Buddhist themes that had occupied Qianlong's thinking intermittently over four decades, among them the nature of the reincarnated self, the codependence of all phenomena (whether Manchu, Chinese, Tibetan, or Mongolian), and the desire for immediacy against the imperial Dragon Vehicle's unremitting requirement of translation. The great lama's visit, designed in all its details to echo triumphant historical moments in the Manchu past, suggests the degree to which Qianlong and the Tibetan Gelukpa establishment were complicit in a precise construction of history that they knew would continue to write itself—projecting what they hoped would be a predictable trajectory and pattern onto the future. But the Sixth Panchen Lama's very ordinariness, his common humanity, struck another chord, which we can only see as friendship. Even as Qianlong ensconced a veristic memory of the Panchen's form and inner life in the courtyard of the Pavilion of Raining Flowers, he also kept his robes as contact relics even closer to home and mourned him in texts both bureaucratic and emotional.

After Qianlong's formal (if not actual) abdication in 1796 to his son, the Jiaqing emperor, he kept up his Buddhist practices as he continued to rule as "Super Emperor" from his new retirement villa in the northeastern corner of the Forbidden City (just adjacent to the Fanhualou and its pantheon of 780 gilt bronze figures). He made nostalgic tours to the models of the Potala and Tashilunpo he had built at Chengde. Heshen, the Rasputin-like figure who corrupted the emperor's final years, by now his constant companion and main conduit to the world, reports on one far from unique incident during which Qianlong turned tantric practice against his enemies. Heshen claims that in 1796, after Qianlong had already abdicated the throne, the emperor asked him to remain after the morning court assembly. He witnessed Qianlong, eyes closed, muttering strange, incomprehensible incantations. When Qianlong opened his eyes, he asked Heshen: "What are the names of those people?" Heshen replied: "Gao Tiande and Xun Wenming." When Jiaqing asked Heshen to explain, he said that Qianlong had been chanting *mizhou*, "secret *dhāraṇī*," in order to curse the two men Heshen had named, both of them leaders of the White Lotus Rebellion.

After Qianlong died on February 7, 1799, he was buried at Yuling, near his grandfather, the Kangxi emperor. The doorways of his tomb were bounded by Buddhist images of the guardians of the four quarters, and the outer and inner chambers displayed the eight great bodhisattvas and the Gelukpa trinity that occupied his meditations at the Pavilion of Raining Flowers: Vajrabhairava, Guhyasamāja, and Cakrasaṃvara. Many have pointed to this choice of images as final, lasting evidence of Qianlong's sincere devotion to Buddhism, since his tomb was, in essence, a Buddhist temple and his own material remains were situated there as charismatic relics. Its construction was begun in 1743, even before the emperor underwent his first Buddhist initiation, and its structure and design closely resembled those of his immediate ancestors, the first three emperors of the Qing. Buddhist protective images were incorporated into the tombs of all the Qing monarchs, pious or not, and even in the late nineteenth century the emperors' mortal remains were covered with silk shrouds woven with *dhāraṇī*, a practice that tells us little about their states of mind while alive. The truth

is, these practices were significant innovations in Vajrayāna Buddhism that were put into place by the early Qing emperors, when their potency was certainly understood, but they faded into politically advantageous, rote usage by the end of the dynasty.

What, in the end, can we say about the sincerity of the Qing emperors' attachment to Vajrayāna Buddhism? For every writer who urges that their many projects of Buddhist patronage show them to be true believers, several others step forward to cast them as profoundly cynical, manipulative, and even duplicitous strategists—loud in their support of the Buddhist establishment and its patrons when it was advantageous and clever in their deployment of Buddhist rhetoric. Qianlong, especially, emerges in these depictions as a great masquerader, an actor whose command of several very different cultural idioms provided a convenient way for him to disguise and conceal himself as *cakravartin*, bodhisattva, lohan, and enlightened layman and thus simultaneously to appropriate and command several fields of discourse, Buddhist and otherwise. Both of these views of the man, the one negative, the other comparatively neutral, agree, however, that Qianlong was really a hollow vessel, empty at the core.

Empty or not, this emperor understood the allure and power of emptiness, that desirable condition where forms no longer stick. The paradox Qianlong presents goes beyond the Double Truth he embraced, where samsara and nirvana conflate. However much he promoted the view that he had no attachment to the things that surrounded him and proliferated boundlessly under his gaze, his copious writings also make it clear that he longed to be recognized as a connoisseur, collector, taxonomist, patron, and artist. He clearly digested and frequently reiterated the lesson that images (whether "rafts" or "ladders") were neither valuable in and of themselves nor, for those of us still caught in the samsaric web, really separable from the goals they supported. They were, in the end, "neither one nor two." When viewed with an unjaundiced eye, the real goal of Qianlong's practice, visual and verbal, reveals itself as ultimately aimed at direct action, unfettered by limitations of language, style, or cultural difference.

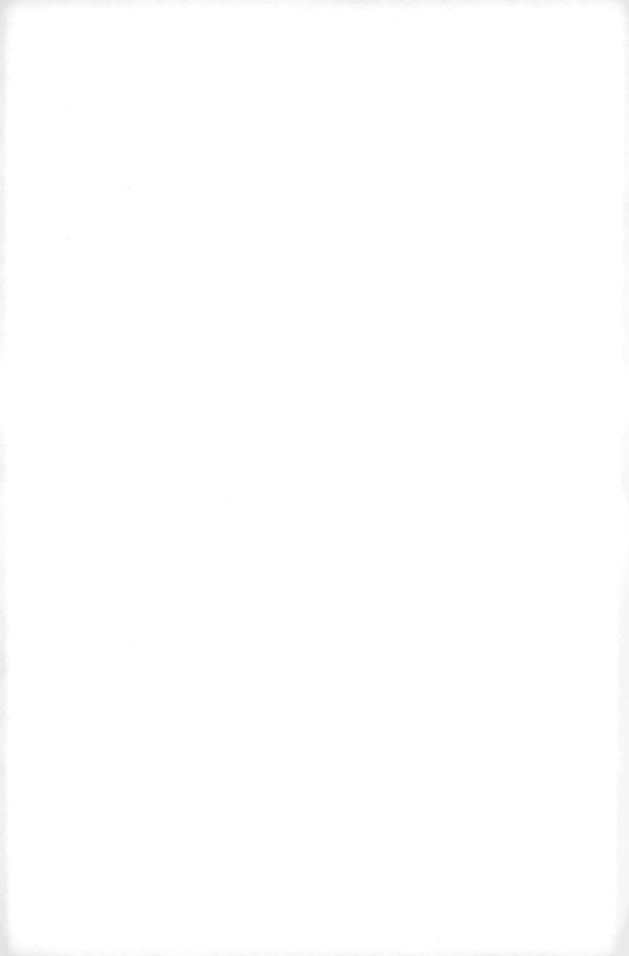

Notes

Introduction

1. Robert A. F. Thurman, trans., *The Holy Teaching of Vimalakīrti: A Mahāyāna Scripture* (University Park: Pennsylvania State University Press, 1976), 58–59; all subsequent quotations from the sutra come from chap. 7, titled "The Goddess," 56–63. Thurman's translation is primarily based on Tibetan versions of the text while Burton Watson's *The Vimalakīrti Sūtra* (New York: Columbia University Press, 1997) is based on the early translation into Chinese by Kumārajīva. There is also a classic translation into French with copious annotations by Etienne Lamotte, *L'ensensignment de Vimalakīrti* (Louvain: Publications universitaires, 1962).

2. This painting may be a handscroll now in the National Palace Museum, Taiwan, which was itself modeled on an earlier work by the Northern Song literatus Li Gonglin. See Wen Fong and Maxwell K. Hearn, "Silent Poetry: Chinese Paintings in the Douglas Dillon Galleries," *Metropolitan Museum of Art Bulletin* 39, no. 3 (Winter 1981–1982): 28. For a thorough discussion of this compositional type see Marsha Weidner, ed., *Latter Days of the Law: Images of Chinese Buddhism, 850–1850* (Lawrence, Kans.: Spencer Museum of Art in association with University of Hawai'i Press, 1994), 349–354.

3. Specifically to artists like Weichi Yiseng, a Central Asian at the court of the Tang famous for his agitated line.

4. Recorded in *Qing Gaozong yuzhi shiwen chuanji* [Qing Gaozong collected works], vol. 4, *juan* 43, 22b.

5. The humorous aspects of this sutra cannot be ignored. Ferdinand Lessing records seeing a ritual called the *Nian da ha ha jing* (Recalling the Great Ha-ha Sutra) in the 1930s at the Yonghegong in Beijing. More like a theatrical performance, it featured a cast of characters borrowed from the famous novel *Journey to the West*, among them the Monkey King, the Tang monk Xuanzang, and Pigsy. See Ferdinand Lessing, *Yung-ho-kung: An Iconography of the Lamaist Cathedral in Peking* (Stockholm: Elanders Boktryckeri Aktiebolag, 1942), 54–55.

6. Other poems of the early 1750s on Vimalakīrti, often mixed with the emperor's musings on the "Lohan Cave," appcar in thc *Collected Works*, vol. 3, *juan* 32, 13b–14a (1752); and vol. 4, *juan* 43, 4a (1753).

7. Ibid., vol. 4, *juan* 46, 24b.

8. See, among others, Harold Kahn, "A Matter of Taste: The Monumental and Exotic in the Qianlong Reign," in Ju-hsi Chou and Claudia Brown, eds., *The Elegant Brush: Chinese Painting Under the Qianlong Emperor, 1735–95* (Phoenix: Phoenix Art Museum, 1985), 288–302; Wu Hung, *The Double Screen: Medium and Representation in Chinese Painting* (Chicago: University of Chicago Press, 1996); and Wu Hung, "Emperor's Masquerade—Costume Portraits of Yongzheng and Qianlong," *Orientations* 26, no. 7 (July–August 1995): 25–41.

9. For the most comprehensive study of temples in the Qing capital at Beijing see Susan Naquin, *Peking: Temples and City Life, 1400–1900* (Berkeley: University of California Press, 2000), a magisterial survey that presents a wealth of information on the social and economic implications of religious patronage. Qianlong's other architectural projects appear as the subject of his edicts, poetry, and belles-lettres in general and as the focus of a number of modern studies, of which the most complete in a Western language is Anne Chayet's book on the temples of Chengde: *Les temples de Jehol et leurs modèles tibétains* (Paris: Éditions Recherche sur les Civilisations, 1984).

10. Thurman, *The Holy Teaching of Vimalakīrti*, especially chap. 2, "Inconceivable Skill in Liberative Technique," 20–23.

11. Charles D. Orzech, *Politics and Transcendent Wisdom: The* Scripture for Humane Kings *in the Creation of Chinese Buddhism* (University Park: Pennsylvania State University Press, 1998).

12. James A. Millward, "New Perspectives on the Qing Frontier," in Gail Hershatter et al., eds., *Remapping China: Fissures in Historical Terrain* (Stanford: Stanford University Press, 1996), 113–129.

13. Ning Chia, "The Lifanyuan and the Inner Asian Rituals in the Early Qing," *Late Imperial China* 14, no. 1 (June 1993): 60–92. As Chia observes, the translation of Lifanyuan as "Barbarian Control Office" or "Court of Colonial Affairs" is reasonable given its Chinese name. Its name in Manchu, however, "Tulergi golo be dasara jurgan" (Ministry Ruling the Outer Provinces), lacks the perjorative connotations of the Chinese; see p. 61.

14. See, for example, Mark Elliott, *The Manchu Way: The Eight Banners and Ethnic Identity in Late Imperial China* (Stanford: Stanford University Press, 2001); Pamela Crossley, *The Manchus* (Cambridge, Mass.: Blackwell, 1997); Pamela Crossley, *A Translucent Mirror: History and Identity in Qing Imperial Ideology* (Berkeley: University of California Press, 1999); and Evelyn Rawski, *The Last Emperors: A Social History of Qing Imperial Institutions* (Berkeley: University of California Press, 1998).

15. Beatrice S. Bartlett, *Monarchs and Ministers: The Grand Council in Mid-Ch'ing China, 1723–1820* (Berkeley: University of California Press, 1991).

16. Most notably in Angela Zito, "Silk and Skin: Significant Boundaries," in Tani E. Barlow and Angela Zito, eds., *Body, Subject, and Power in China* (Chicago: University of Chicago Press, 1994), 103–130; and *Of Body and Brush: Grand Sacrifice as Text-Performance in Eighteenth-Century China* (Chicago: University of Chicago Press, 1997).

17. James Hevia, *Cherishing Men from Afar: Qing Guest Ritual and the Macartney Embassy of 1793* (Durham: Duke University Press, 1995), 30.

18. The importance of architectural form in Qianlong's projects of knowledge formation is treated in depth in Cary Liu, "The Ch'ing Dynasty Wen-yüan-ko Imperial Library: Architectural Symbology and the Ordering of Knowledge" (Ph.D. dissertation, Princeton University, 1997).

19. The proper packaging of works of art concerned Qianlong deeply. See *Qingdai gongting baozhuang yishu* (Beijing: Palace Museum, 2000).

20. Thukwan's biography of Rolpay Dorje has been translated into Chinese by Chen Jingying and Ma Dalong, *Zhangjia Guoshi Ruobi Duoji zhuan* (Beijing: Minzu chubanshe, 1988). Another Mongolian biography has been summarized and annotated in Hans-Rainer Kämpfe, *Ni ma'i 'od-zer/Naran-u gerel: Die Biographie des 2 Pekinger lCan skya-Qutuqtu Rol pa'i rdo rje (1717–1786)*, Monumenta Tibetica Historica, sec. 2, vol. 1 (St. Augustin: VGH Wissenschaftsverlag, 1976).

21. The political uses of Mādhyamika are still apparent in contemporary Mongolia, where, after years of Soviet domination, a new constitution was based on the Middle Way. Prime Minister Enkhbayar, who was then head of the reformed Communist Party, told me that the Middle Way unfortunately resulted in a series of debilitating stalemates as each side refused to utilize "skillful means" to forge mutually satisfactory compromises (interview with Enkhbayar, August 1996).

22. John King Fairbank, ed., *The Chinese World Order: Traditional China's Foreign Relations* (Cambridge, Mass.: Harvard University Press, 1968); Millward, "New Perspectives," 129.

23. Ibid., 120.

24. This Confucianist position has been the subject of strong critique, too, particularly in the famous interchange between Evelyn Rawski and Ho Ping-ti. See Evelyn Rawski, "Presidential Address: Reenvisioning the Qing: The Significance of the Qing Period in Chinese History," *Journal of Asian Studies* 55, no. 4 (November 1996): 829–850; and Ho Ping-ti, "In Defense of Sinicization: A Rebuttal of Evelyn Rawski's 'Reenvisioning the Qing,' " *Journal of Asian Studies* 57, no. 1 (February 1998): 123–155.

25. See especially Rawski, *The Last Emperors*; Crossley, *A Translucent Mirror*; and Zito, *Of Body and Brush*; and "Silk and Skin: Significant Boundaries."

26. This lack of interest is much more true of Western art historians, who have only begun to explore the complexities of court culture during the Qing—most importantly in Chou and Brown, *The Elegant Brush*. There is an abundance of studies by Chinese scholars such as Yang Boda, Yang Xin, Wang Jiapeng, Luo Wenhua, and others.

27. See, for example, David Farquhar, "Emperor as Bodhisattva in the Governance of the Ch'ing Empire," *Harvard Journal of Asiatic Studies* 38, no. 1 (1978): 5–35; and Samuel Grupper, "The Manchu Imperial Cult of the Early Ch'ing Dynasty: Texts and Studies on the Tantric Sanctuary of Mahakala at Mukden" (Ph.D. dissertation, Indiana University, 1979), and "Manchu Patronage and Tibetan Buddhism During the First Half of the Ch'ing Dynasty: A Review Article," *Journal of the Tibet Society*, no. 4 (1984): 46–75.

28. Nelson Goodman, *The Languages of Art* (Indianapolis: Hackett, 1976).

29. I borrow the term "translingual" from Lydia Liu, *Translingual Practice: Literature, National Culture, and Translated Modernity. China, 1900–1937* (Stanford: Stanford University Press, 1995).

30. Hans Belting, *Likeness and Presence: A History of the Image Before the Era of Art,* trans. Edmund Jephcott (Chicago: University of Chicago Press, 1994), 16.

31. It is no small irony that some of the most powerful theorists in this debate were Jesuits, whose attempts to proselytize in China beginning in the later sixteenth century were launched on the back of images. Their particular representational style—a subdued, precise, emotionless baroque—remained their last effective weapon in the Qing court.

32. Alexander Coburn Soper, *Literary Evidence for Early Buddhist Art in China,* Artibus Asiae suppl., no. 19 (Ascona, Switz.: Artibus Asiae, 1959); and Wu Hung, "Rethinking Liu Sahe: The Creation of a Buddhist Saint and the Invention of a 'Miraculous Image,'" *Orientations* 27, no. 10 (November 1996): 32–43. I owe this insight to Catherine Karnitis, who raised the distinction between meta-images and pantheons in a paper she wrote for my graduate seminar, "Art and the Production of History," at the University of California, Berkeley, Fall 2001.

33. Thomas Cleary, ed., *The Buddha Scroll* (New York: Shambhala, 1996).

34. Robert Thurman, *The Holy Teaching of Vimalakīrti,* 7.

Chapter 1: Like a Cloudless Sky

1. *Mémoires concernant l'histoire, les sciences, les arts, les moeurs, etc., des Chinois* (Paris: 1776–1790), vol. 1, 413.

2. The text of the Ili monument is quoted by Amiot in *Mémoires* 1776. Rubbings of the quadrilingual inscriptions at Putuozongchengmiao are in Otto Franke and Berthold Laufer, *Epigraphische Denkmäler aus China, erster Teil. Lamatische Klosterninschriften aus Peking, Jehol, und Si-ngan* (Berlin: n.p., 1914), pls. 63–66; and Zhang Yuxin, *Qing zhengfu yu lamajiao* (Xuchang, Henan: Xizang renmin chubanshe, 1988), 433–436. Qianlong's poems are anthologized along with many verses honoring his mother's birthday and the foundation of Putuozongchengmiao in Qing Gaozong, *Collected Works*, vol. 6, *juan* 99, 31b–33b; *juan* 100, 27b, 30a–32b. Qianlong also commissioned the renowned frontier poet Ji Yun, who was out of favor at the time, to write a poem on the Torghuts' return. According to Hummel, it was good enough to get him pardoned. See Arthur W. Hummel, *Eminent Chinese of the Ch'ing Period* (Washington, D.C.: Government Printing Office, 1943), 120–123.

3. Philippe Forêt, *Mapping Chengde: The Qing Landscape Enterprise* (Honolulu: University of Hawai'i Press, 2000), 47–49. Qianlong often feted his Mongolian guests in this grand *ger*. He also had parties for the Sixth Panchen Lama there in 1780 and for the British envoy George McCartney in 1796. One famous party, held to welcome the returning Durbut Mongols in 1754, is detailed in a large-scale handscroll, the joint creation of Philippe

Attiret, Giuseppe Castiglione, and Yao Wenhan. See Nie Chongzheng, *Qing gongting huihua* (Hong Kong: Commercial Press, 1996), pls. 57–58.

4. Yang Boda, *Qingdai yuanhua* (Beijing: Zijincheng chubanshe, 1993), 75. Yang notes that the court's *Daily Records* (*Huoji dang*, nos. 3567–3570) show that Sichelpart did two bust portraits of the young Jebtsundamba of Urga the same year, basing his depiction of the young lama's clothes on sketches provided by Yao Wenhan. When he was done, he turned the pictures over to lama-painters and the two completed portraits were mounted as hanging scrolls. See Wang Jiapeng, "Zhongzhengdian yu Qinggong Zangchuan fojiao," *Gugong bowuyuan yuankan* 53, no. 2 (1991): 59.

5. Thukwan, *Biography of Rolpay Dorje,* Tibetan ed., 577–579; Chinese translation, 325–327.

6. This kind of organized spontaneity informed other activities at Qianlong's court, too, especially his daily poetry production. (He produced ten thick volumes of verse and prose over the course of his long life, now brought together as *Qing Gaozong Yuzhi shiwen quanji* [hereafter Qing Gaozong, *Collected Works*].) Qianlong would come out with a line of verse in the middle of a court session, then another some time later. It was left to his closest associates (Yu Minzhong was one of the best at this difficult game) to memorize the emperor's lines and record them accurately—or perhaps with some light editing—at the end of each day.

7. Anne Chayet, *Les temples de Jehol et leurs modèles tibétains* (Paris: Éditions Recherche sur les Civilisations, 1984), 41–46.

8. Zhang Yuxin, *Qing zhengfu yu lamajiao*, 383–386.

9. Ibid. The Dzungars provided a second opportunity for Qianlong to build at Chengde, when he ordered the construction of the Anyuan Temple (Temple of Far-off Peace), also known as the Ili Temple because it was modeled on one of the famous Dzungar temples of Kulja, in Ili, destroyed in 1756 by Qing troops. The construction of the Anyuan Temple was therefore an act of restitution, though one not admitted in the stele Qianlong wrote to establish it for the Dzungars of Dasi Dava, who were repatriated in the region around Chengde in 1764. Again, Qianlong saw great virtue in celebrating the end of hostilities with temple building—particularly temple building that diverted attention away from past hostilities and toward the new harmonious future prophesied by the Tibetan Gelukpa (Yellow Hats) and their Dalai Lama.

10. Zhang Yuxin, *Qing zhengfu yu lamajiao*, 430–431. The Chinese version of the text uses the term "*daochang*," which translates the Sanskrit "*bodhimanda*" (enlightened field or circle). (My thanks to Raoul Birnbaum for clarifying this point.) The Tibetan text reads "*dkyil 'khor*," usually used to translate the Sanskrit "*mandala*," a much more explicitly constructed and even diagrammatic space. "*Dkyil 'khor*" can also translate Chinese terms meaning, for example, something rounded and level, environment, arena or altar, or "field of action." See, for example, *Zangwen cidian* [Tibetan dictionary] (Beijing: Minzu chubanshe, 1995), 23.

11. In the Chinese version of his edict, Qianlong uses the term "E-na-te-ke-ke," that is, Entekka or Indica, for India. One wonders if he came up with this very unusual transliteration, instead of the more usual Yindu (which he does, in fact, use later in the edict), because he relied so much for his geography on Jesuit maps.

12. Chayet, *Les temples de Jehol,* fig. 24; Jiang Huaiying et al., *Xizang Budalagong xiushan gongcheng baogao* (Beijing: Wenwu chubanshe, 1994), especially fig. 11.

13. The visiting Torghuts find themselves in the second group. Though small in comparison to their voluminous new emperor, they are carefully portrayed. Sichelpart and his Jesuit brethren quite often painted portraits of visiting Mongol lords when they attended the emperor at Chengde and the Mongols kept up a delighted running commentary as they watched the brothers paint. Quite a few Jesuit portraits of Mongol khans survive; one that apparently does not is the portrait of the young Third Jebtsundamba, presumably done during this very visit, which Qianlong sent as a memorial to Urga after the boy's premature death two years later. Several are reproduced in Walther Heissig and Claudius C. Muller, *Die Mongolen* (Innsbruck: Pinguin-Verlag; Frankfurt: Umschau-Verlag, 1989), 83–84. I have not located the Third Jebtsundamba's portrait, but it is proudly recalled in several Mongolian histories. See, for example, Charles Bawden, trans., *The Jebtsundamba Khutukhtus*

of Urga (Wiesbaden: Otto Harrassowitz, 1961), 89; and Alexei M. Pozdneyev, *Mongolia and the Mongols*, trans. John Roger Shaw and Dale Plank (Bloomington: Indiana University Press; The Hague: Mouton, 1971), 354. It may be the very portrait described in a court document of 1771 (9th month, 20th day), which says that the eunuch Hu Shijie directed Sichelpart to paint a portrait of the Jebtsundamba, using Yao Wenhan's designs for the young lama's robes. See Wang Jiapeng, "Zhongzhengdian yu Qinggong Zangchuan fojiao," 59.

14. The phrase comes from Qianlong's inscription, dated 1758, on Ding Guanpeng's copies of the Tang-dynasty monk Guanxiu's famous lohan paintings at the Shengyin Monastery, Hangzhou. See *Bidian zhulin, xubian*, 139b.

15. Samuel M. Grupper, "Manchu Patronage and Tibetan Buddhism During the First Half of the Ch'ing Dynasty: A Review Article," *Journal of the Tibet Society,* no. 4 (1984): 72, fn. 29.

16. Pierre Nora, "Between Memory and History: *Les Lieux de Mémoire,*" *Representations* 26 (1989): 9.

17. For a detailed history of the Manchu conversion see Samuel Grupper, "The Manchu Imperial Cult of the Early Ch'ing Dynasty: Texts and Studies on the Tantric Sanctuary of Mahākāla at Mukden" (Ph.D. dissertation, Indiana University, 1979); and "Manchu Patronage."

18. There were ample precedents for this relationship in the Tangut state of Xixia, which controlled northwestern China and parts of what is now Xinjiang province, Tibet, and Inner Mongolia. See Ruth Dunnell, *The Great State of White and High: Buddhism and State Formation in Eleventh-Century Xia* (Honolulu: University of Hawai'i Press, 1996). For a detailed recounting of the progress of relations between the Mongols and Tibetan lamas see Giuseppe Tucci, *Tibetan Painted Scrolls* (Rome: Libreria dello Stato, 1949), vol. 1, 3–80.

19. Heather Stoddard, "A Stone Sculpture of mGur mGon-po, Mahākāla of the Tent, Dated 1292," *Oriental Art,* n.s. 31, no. 3 (Autumn 1985): 278–282; Anning Jing, "The Portraits of Khubilai Khan and Chabi by Anige (1245–1306), a Nepali Artist at the Yuan Court," *Artibus Asiae* 54, nos. 1–2 (1994): 49–86. Two other images of Mahākāla dated to the Ming dynasty (one with a Yongle reign mark, 1403–1424), in the collection of the Palace Museum, Beijing, resemble the Guimet piece in iconography and style. See *Qinggong Zangchuan fojiao wenwu* (Beijing: Cijincheng chubanshe, 1992), pls. 74–75.

20. A similar genius, traceable to Anige, pervades the extant monuments of Tibetan Buddhism constructed by the Mongols during their Chinese overlordship—a period when Nepalese style was also the fashion in Tibet, particularly among Phagpa's order, the Sakyapa. The most brilliant examples of this style are the Ngor Mandalas, done between 1429 and 1456 for the main Sakya monastery by Nepalese artists who were mysteriously summoned there in a dream. See David Jackson, *A History of Tibetan Painting* (Vienna: Verlag der Österreichischen Akademie der Wissenschaften, 1996), 78; and Steven M. Kossak and Jane Casey Singer, *Sacred Visions: Early Paintings from Central Tibet* (New York: Metropolitan Museum, 1998). Yuan-dynasty commissions—such as the Jisha Tripitaka (1301), the silk tapestry Vajrabhairava mandala of Tugh Temur (r. 1329–1332), and the Juyong Gate reliefs (1345)—all work in a similar way by setting a plethora of precisely rendered detail off against easily readable compositions, providing both opulent ornamentation and clear schemata to spur the memory and invention of the viewer. For the Vajrabhairava mandala see Heather Stoddard, in Patricia Berger and Terese Bartholomew, *Mongolia: The Legacy of Chinggis Khan* (San Francisco: Asian Art Museum; London: Thames & Hudson, 1995), 209–210. Heather (Stoddard) Karmay also traces the slow development of this style from the Tang dynasty through the Ming in her *Early Sino-Tibetan Art* (Warminster, England: Aris & Phillips, 1975).

21. The inscription is quoted in Grupper, "Manchu Patronage," 67, n. 19. Grupper provides a corrected version of the transcription of the Manchu text given in Oshibuchi Hajime, *Manshū hiki kō* (Tokyo: n.p., 1943), 135–140.

22. Grupper, "Manchu Patronage," 68, n. 20.

23. Grupper, "Manchu Imperial Cult," 165.

24. Ibid., 184–185. See also L. C. Arlington and William Lewisohn, *In Search of Old Peking* (Peking: Henry Vetch,

The French Bookstore, 1935), 127–128. Recent attempts to trace the fate of the Mahākāla produced information from Luo Wenhua of the Palace Museum, Beijing, who reported that one of two things happened to it. Either it did not leave Mukden for Beijing and was taken by the Japanese in World War II, or it did come to Beijing's Mahākāla Temple (Pudusi), whence it disappeared. According to Luo, an image of Mahākāla now (or until recently) in the temple (and mentioned by Arlington and Lewisohn) is not Phagpa's.

25. Thukwan, *Biography of Rolpay Dorje,* 183–184. See also Wang Xiangyun, "Tibetan Buddhism at the Court of Qing: The Life and Work of lCang-skya Rol-pa'i-rdo-rje (1717–1786)" (Ph.D. dissertation, Harvard University, 1995), 293–294.

26. The prayer is titled *rJe bla ma'i khungs rabs gsol 'debs* (The Venerable Lama's lineage prayer). See Thukwan, *Biography of Rolpay Dorje,* 297–298 (Tibetan version) and 13 (Chinese version).

27. For a detailed history of this interchange of missions and gifts see Karmay, *Early Sino-Tibetan Art,* especially 72–93.

28. See, for example, Igor Kopytoff, "The Cultural Biography of Things: Commoditization as Process," in Arjun Appadurai, ed., *The Social Life of Things: Commodities in Cultural Perspective* (Cambridge: Cambridge University Press, 1986), 64–91; and Richard H. Davis, *The Lives of Indian Images* (Princeton: Princeton University Press, 1997).

29. Two biographies available in English are Bawden, *The Jebtsundamba Khutukhtus;* and Pozdneyev, *Mongolia and the Mongols,* 321–338.

30. For a longer discussion of Zanabazar's work see Berger and Bartholomew, *Mongolia;* and Françoise Aubin et al., *Trésors de Mongolie, XVIIᵉ – XIXᵉ siècles* (Paris: Éditions de la Réunion des musées nationaux, 1993). Many of Zanabazar's surviving sculptures that do not appear in these catalogs can be found in N. Tsultem, *The Eminent Mongolian Sculptor—G. Zanabazar* (Ulaanbaatar: State Publishing House, 1982).

31. For details of this renovation project see Tucci, *Tibetan Painted Scrolls,* 196–201.

32. Pozdneyev, *Mongolia and the Mongols,* 328. Bawden, *The Jebtsundamba Khutukhtus,* pp. 44–45, records that Zanabazar gathered up numerous images before leaving Tibet for Mongolia.

33. Yang Boda, "Zhanabazha'er di liujintong zaoxiang yishu," *Gugong bowuyuan yuankan* 4 (1996): 59–65.

34. Anne Chayet and Corneille Gest, "Le monastère de la Félicité tranquille, fondation impériale en Mongolie," *Arts Asiatiques* 46 (1991): 72–81.

35. Bawden, *The Jebtsundamba Khutukhtus,* 50.

36. Ibid., 58.

37. Ibid., 50.

38. Kangxi also had himself portrayed as a devout Buddhist in the midst of chanting before a set of the Eight Buddhist Treasures. He appears quite old in the picture, adding evidence to the claim of his heightened piety after 1701. See *Qingdai gongting huihua,* pl. 14.

39. Conversations with the Khampa Lama of Erdeni Zuu in 1996 made it clear that this particular group of Sakyapa felt no alliance with the Dalai Lama and the Gelukpa and that they believed Erdeni Zuu had always been a purely Sakyapa establishment. Although Zanabazar never took up residence at Erdeni Zuu, he was consecrated there as a boy and often meditated nearby. Throughout his career he supplied goods and concepts to its monastic establishment, suggesting that sectarian lines were not so firmly drawn in seventeenth- and eighteenth-century Khalkha Mongolia.

40. Stephan Beyer, *The Cult of Tara: Magic and Ritual in Tibet* (Berkeley: University of California Press, 1973), 11.

41. Tāranātha, *The Origin of the Tārā Tantra*, trans. David Templeman (Dharamsala: Library of Tibetan Works and Archives, 1981); Martin Willson, *In Praise of Tara* (London: Wisdom, 1986), 33–36, 169–206.

42. See, for example, Bawden, *The Jebtsundamba Khutkhtus*, 45.

43. Wang Jiapeng et al., *Qinggong mizang: Chengde Bishushanzhuang Zang chuan fojiao wenwu tezhan tulu* (Taipei: Jeff Hsu's Oriental Art, 1999), pls. 22, 25. The Uṣṇīṣavijayā, now in the State Hermitage, St. Petersburg, is illustrated in Marylin Rhie and Robert Thurman, *Wisdom and Compassion: The Sacred Art of Tibet* (San Francisco: Asian Art Museum; New York: Tibet House, 1991), 318, cat. no. 124.

44. Pozdneyev, *Mongolia and the Mongols,* 21.

45. Paola Mortari Vergara Caffarelli, "International dGe-lugs-pa Style of Architecture from the 16th–19th Century," *Journal of the Tibet Society* 21, no. 2 (Summer 1996): 53–89.

46. Pamela Crossley, *A Translucent Mirror: History and Identity in Qing Imperial Ideology* (Berkeley: University of California Press, 1999).

Chapter 2: When Words Collide

1. The texts of the steles are reproduced and transcribed in many places: as rubbings in Otto Franke and Berthold Laufer, *Epigraphische Denkmäler aus China, erster Teil. Lamaistische Klosterninschriften aus Peking, Jehol, und Si-ngan,* Mappe I, pls. 2–3; as Chinese text in Zhang Yuxin, ed., *Qing zhengfu yu lamajiao,* 336–338; and as translations drawn from all four versions in Ferdinand Lessing, *Yung-ho-kung: An Iconography of the Lamaist Cathedral in Peking with Notes on Lamaist Mythology and Cult* (Stockholm: Elanders Boktryckeri Aktiebolag, 1942), 9–13. Yonghegong was originally converted to monastic use by its former occupant, the Yongzheng emperor, in 1725. The 1744 stele therefore marks a second rededication.

2. Lydia Liu, *Translingual Practice: Literature, National Culture, and Translated Modernity. China, 1900–1937* (Stanford: Stanford University Press, 1995), 16 and passim.

3. Rubbings in Franke and Laufer, *Epigraphische Denkmäler*, pls. 4–7; Chinese transcription in Zhang Yuxin, *Qing zhengfu yu lamajiao,* 339–343; English translation, mostly from the Chinese text, in Lessing, *Yung-ho-kung,* 57–61.

4. Qianlong goes on to say in his self-commentary: "Now suppose I had merely nourished the vain ambition of clinging to old patterns (as furnished by Chinese books) I could not have hoped to inspire awe and preserve peace among the Old and New Mongol tribes (maintaining order) for several dozens of years (among them), nor would I have been able to chastise the lamas fomenting trouble in ulterior Tibet. . . . Admitting that Our government protects the Yellow Church (We feel) in perfect agreement with the 'Kingly Institutions' which say: 'The tribes were instructed without changing their customs. Their institutions were regulated, without changing their conveniences [*Liji, Wangzhi*]' "; see Lessing, *Yung-ho-kung,* 61.

5. Ibid., 62.

6. Even a quick look at Qianlong's collected works (in ten volumes) shows that his style in both prose and poetry evolved toward self-commentary in the last decades of his life. Not only are his later works riddled with smaller blocks of explanation, reading much like footnotes (all approved by himself), but his style is, in general, increasingly self-referential, relying often on pastiches of quotes from earlier pieces. Qianlong's writing—in fact, his entire artistic production—has been heavily criticized by nearly everyone who writes about him. (One Chinese historian delicately said that while Qianlong was one of the greatest of Chinese poets by sheer virtue of his prolific output—he wrote more poems than are preserved by all the poets of the Tang dynasty put together—his major fault was that he "came to the point.") But, in fact, *Lama Shuo* is elegantly composed and quite typical of the simple, straightforward diction of his later prose.

7. The quote is from the nineteenth-century Inner Mongolian historian Damcho Gyatsho Dharmatāla's summa-

tion of his chapter on translation: *Rosary of White Lotuses, Being the Clear Account of How the Precious Teaching of Buddha Appeared and Spread in the Great Hor Country,* trans. Piotr Klafkowski (Wiesbaden: Otto Harrassowitz, 1987), 409 (492 in the original manuscript).

8. Ibid., 391–408; all the succeeding quotes are from Dharmātala, *Rosary of White Lotuses,* 391–408.

9. In this he resembles another universalist monarch, Pope John Paul II, famous for his annual Christmas greetings in fifty or more languages and his ability to address any crowd in their native tongue, using multilingualism as a way to transform himself—the outsider, Polish pope—into everyone's Papa.

10. Evelyn S. Rawski, *The Last Emperors: A Social History of Qing Imperial Institutions* (Berkeley: University of California Press, 1998), 6; note to Yuan Hongqi, "Qianlong shiqi de gongting jieqing huodong," *Gugong bowuyuan yuankan* 53, no. 3 (1991): 85.

11. Wei Yuan, *Shengwuji* (Beijing: Zhonghua shuju, 1984), *juan* 5, 215; translated by Ernest Ludwig, *The Visit of the Teshoo Lama to Peking: Ch'ien Lung's Inscription* (Peking: Tientsin Press, 1904), 11–12. Wei Yuan's comment is based on the emperor's own reminiscence in his commentary to his seventieth birthday poem, *Gu xi* (Rare since ancient times); see Qing Gaozong, *Collected Works,* vol. 8, *juan* 77, 2b–3a.

12. This equivalence is much more assertively stated than in the Western formula, *ut pictura poesis.* A particularly concise statement of this understanding is in the learned late-Yuan–early-Ming scholar Song Lian's (1310–1381) *Huayuan* (Origin of painting): "Writing and painting are not different Ways, but are as one in their origin." See Yu Jianhua, *Zhongguo gudai hualun leibian* [Collection of Chinese art theories] (Beijing: Renmin meishu, 2000), vol. 1, 95; and Craig Clunas, *Pictures and Visuality in Early Modern China* (Princeton: Princeton University Press, 1997), 109.

13. See Wang Xiangyun, "Tibetan Buddhism at the Court of Qing," 149–151, who cites *Qing shilu*, vol. 926, 457; and Zhaolian (1780–1833), *Xiaoding zalu* (Beijing: Zhonghua shuju, 1997), vol. 1, 12–13. (Zhaolian specifically comments that Qianlong did not feel that Chinese could give a sense of the Buddha's voice, but the Manchu language could be precisely sounded out, allowing practitioners of *dhāraṇī* to experience *samādhi*.) The new quadrilingual *dhāraṇī* collection is titled *Han-i araha manju nikan monggo tanggut hergen-i kamchiha amba g'anjur nomun-i uheri tarni* (Manchu); *Yuzhi man han menggu xifan hebi dazang quanzhou* (Chinese); *Kha-ghan-u bichigsen manju kitad mongghol töbet kelen kabsuraghsan buguli ganjur-un tarni* (Mongolian); and *rGyal pos mdzad pa'i man dzu rgya hor bod yig bzhi yi skad shan sbyar ba'i bka' 'gyur gyi snags tshang bar bkod pa* (Tibetan).

14. See, for example, Rawski, *The Last Emperors.* See also Pamela Crossley, "Thinking About Ethnicity in Early Modern China," *Late Imperial China* 11, no. 1 (June 1990): 1–35; *The Manchus* (Cambridge, Mass.: Blackwell, 1997); and *A Translucent Mirror: History and Identity in Qing Imperial Ideology* (Berkeley: University of California Press, 1999).

15. Mark Elliott, "The Limits of Tartary," paper given at the Center for Chinese Studies, Institute for East Asian Studies, University of California, Berkeley, March 1, 2000.

16. Steven West advanced this idea during the discussion of Mark Elliott's paper documented in note 15.

17. Thukwan, *Biography of Rolpay Dorje,* contains numerous references to gift exchanges between the court and Tibetan and Mongolian lamas, often carried by Rolpay Dorje. See also Wang Xiangyun, "Tibetan Buddhism at the Court of Qing." For numerous plates illustrating gifts brought to court see *Qinggong Zangchuan fojiao wenwu* (Beijing: Cijincheng chubanshe, 1992).

18. Alexei Pozdneyev, *Mongolia and the Mongols* (Bloomington: Indiana University Press; The Hague: Mouton, 1971), 336.

19. See Elliot Sperling, "Ming Ch'eng-tsu and the Monk Officials of Gling-tshang and Gon-gyo," in Lawrence Epstein and Richard F. Sherburne, eds., *Reflections on Tibetan Culture: Essays in Memory of Turrell V. Wylie,* Studies in Asian Thought and Religion, vol. 12 (Lewiston, N.Y.: Edward Mellen Press, 1990), 75–90.

20. The Potala copy is published in Ou Chaogui, "Jieshao liangfu Ming Qing tangka," *Wenwu* 11 (1985): 79–81 and fig. 2; and *Xizang tangka* (Beijing: Wenwu chubanshe, 1985), pl. 25. The Asian Art Museum of San Francisco's version is published in Marsha Weidner, ed., *Latter Days of the Law: Images of Chinese Buddhism, 850–1850* (Honolulu: University of Hawai'i Press, 1994), pl. 2 and cat. 6; and Feng Zhao, *Treasures in Silk* (Hong Kong: ISAT/Costume Squad, 1999), pl. 10.08. Zhao also illustrates another example in lampas weave, which replaces the guardians of the four quarters with a crowd of lohans. (Examples are in the Palace Museum, Beijing, and the Chester Beatty Collection, Dublin.) Two much larger tapestries, which include the eighteen lohans, are, incredibly, glued side-by-side to the ceiling of Empress Eugénie's "Chinese museum" at the Chateau de Fontainebleau outside of Paris (for which information I thank Susan Naquin). See Colombe Samoyault-Verlet et al., *Le Musée chinois de l'impératrice Eugénie* (Paris: Éditions de la réunion des musées nationaux, 1994), 70–72.

21. Feng Zhao, *Treasures in Silk*, owing to the inscription above, identifies the central buddha as Amitābha.

22. *Bidian zhulin,* 823–613.

23. *Bidian zhulin, xubian*, 159b–160. Lu Lengjia's original is listed on 142b.

24. Qing Gaozong, *Collected Works*, vol. 1, *juan* 42, 5a–b.

25. Ibid., vol. 1, *juan* 44, 14–15.

26. For a schedule of sutra chantings in the Qing palace see Wang Jiapeng, "Qinggong Zangchuan fojiao wenhua kaocha," in Wang Shuxiang, ed., *Qingdai gongshi congtan* (Beijing: Wenwu chubanshe, 1996), 146–149. Wang gives an abbreviated list in *Qinggong Zangchuan fojiao wenwu*, 11.

27. *Buddhas of the Three Generations*, in Weidner, *Latter Days of the Law*, cat. 6, 237–238.

28. Thukwan, *Biography of Rolpay Dorje,* 236.

29. *Xizang Tangka*, pl. 97. An example in silk embroidery is in the National Palace Museum, Taiwan; see *Guoli Gugong bowuyuan cixiu* (Tokyo: Gakken; Taipei: National Palace Museum, 1970), pl. 46. An identical piece is in the Asian Art Museum of San Francisco; see *Looking at Patronage* (San Francisco: Asian Art Museum, 1989), 66–67, and Weidner, *Latter Days of the Law*, 255–256 and colorpl. 6.

30. *Bidian zhulin, xubian*, 160b.

31. For the San Francisco version see Weidner, *Latter Days of the Law*, 255–256, pl. 13; *Looking at Patronage,* 66–67 and frontispiece; Terese Tse Bartholomew, "Sino-Tibetan Art of the Qianlong Period from the Asian Art Museum of San Francisco," *Orientations* (June 1991): 34–45, fig. 20; Robert E. Fisher, *Buddhist Art and Architecture* (London: Thames & Hudson, 1993), 24, pl. 13.

32. Thukwan, *Biography of Rolpay Dorje*, 187.

33. Richard K. Payne, "Language Conducive to Awakening: Categories of Language Use in East Asian Buddhism," *Buddhismus-Studien* 2 (1998): 2.

34. For a mimetic understanding of tantric language see Janet Gyatso, "Letter Magic: A Peircean Perspective on the Semiotics of Rdo Grub-chen's Dhāraṇī Memory," in Janet Gyatso, ed., *In the Mirror of Memory: Reflections on Mindfulness and Remembrance in Indian and Tibetan Buddhism* (Albany: State University of New York Press, 1992), 173–214. Gyatso's understanding of the mimetic emptiness of *dhāraṇī* seems distinctly different from Frits Staal's view of mantra (and by extension all ritual) as having value but no meaning. See Frits Staal, *Rules Without Meaning: Ritual, Mantras, and the Human Sciences*, Toronto Studies in Religion, vol. 4 (New York: Peter Lang, 1990).

35. Ryūichi Abé, *The Weaving of Mantra: Kūkai and the Construction of Esoteric Buddhist Discourse* (New York: Columbia University Press, 1999). All the following quotes are from pp. 141–149.

36. Here I am intentionally using Nelson Goodman's terms but reversing their polarities to point up the

peculiarities of mantra versus more conventional speech acts. Goodman argues that it is pictures that possess this "density (and consequent total lack of articulation)" as against the differentiation and discontinuities (and hence clarity) of language. In contrast to the perilous fullness of the mantra, Ṣaḍakṣarī Lokeśvara embodied just below seems the essence of disambiguated clarity. The mantra, as Abé asserts, operates more like a material symbol (and like a picture) than like language. Mantras are "replete" in Goodman's sense because their "meaning" plays out as an endless chain of signification (the descent into the abyss that, in the West, seems like a nauseating void but in Buddhism spells emptiness, that is, pure relationality). See Nelson Goodman, *The Languages of Art* (Indianapolis: Hackett, 1976), 226.

37. For the mnemonic uses of *dhāraṇī* and the *arapacana* syllabary see Gyatso, "Letter Magic," 173–214.

38. Thukwan, *Biography of Rolpay Dorje*, 44.

39. Wang Jiapeng et al., *Buddhist Art from Rehol*, 173, 259.

40. Walter Eugene Clark, *Two Lamaistic Pantheons*, Harvard-Yenching Monograph Series, vols. 3–4 (Cambridge, Mass.: Harvard University Press, 1937), xii–xiii. Clark cites *Guochao gongshi, juan* 18, 2a, 2b, 10a, 12b–15a.

41. Ibid.

42. See Wu Hung, "Art in Ritual Context: Rethinking Mawangdui," *Early China* 7 (1992): 111–144.

43. Larry Moses, "Legends by the Numbers: The Symbolism of Numbers in the *Secret History of the Mongols*," *Asian Folklore Studies* 55 (1996): 73–97; and "Triplicated Triplets: The Number Nine in the *Secret History of the Mongols*," *Asian Folklore Studies* 45 (1986): 287–294.

44. Orzech has discussed the relationship of the earliest Tang-dynasty mandalas, which break down into nine squares (three by three), and Daoist charts; see Charles Orzech, *Politics and Transcendent Wisdom* (University Park: Pennsylvania State University Press, 1998), especially 171–174. He explains this in light of Bukong's interest in the technique of "matching meanings," an ancient practice in the translation of Buddhist texts into Chinese. In a system developed during the Han dynasty, the emperor was associated with the Pole Star and understood to be at the center of nine courts. (This played out architecturally in the imaginative architecture of the Mingtang.) This structure is similar to that of the *mahāmandala* described by Vajrabodhi, which ultimately influenced the shape of the classic *Vajradhātu* mandala.

45. Wang Jiapeng et al., *Buddhist Art from Rehol*, pl. 92, 202–203.

46. On the miniature and its particular powers see Susan Stewart, *On Longing: Narratives of the Miniature, the Gigantic, the Souvenir, the Collection* (Durham: Duke University Press, 1993), especially 37–69.

47. Wang Jiapeng et al., *Buddhist Art from Rehol*, 180–181, pl. 80.

48. Sung-peng Hsu, *A Buddhist Leader in Ming China: The Life and Thought of Han-Shan Te-Ch'ing* (University Park: Pennsylvania State University Press, 1979), 181, n. 58. Hsu translates from the commentary to Deqing's autobiography, *Hanshan Dashi mengyu ji, Zixu nianpu* (Taipei: Chen-shan-mei, 1967), 64, 136. My thanks to Raoul Birnbaum for pointing out the prevalence of lineage-generation poems among Han Chinese Buddhist lineages. These are designed to simplify the placement of a monk within a lineage. The custom, Birnbaum suggests, may go back to the Tang dynasty.

49. See Patricia Berger and Terese Tse Bartholomew, *Mongolia: The Legacy of Chinggis Khan* (San Francisco: Asian Art Museum; London: Thames & Hudson, 1995), 126–137, 307–309 (James Bosson's transcription and translation of the Tibetan inscription).

50. For the Chinese text see Zhang Yuxin, *Qing zhengfu yu lamajiao*, 469–470.

51. See Angela Zito, "Silk and Skin: Significant Boundaries," in Tani E. Barlow and Angela Zito, eds., *Body, Subject, and Power in China* (Chicago: University of Chicago Press, 1994), 103–131; repeated in Angela Zito, *Of Body and Brush: Grand Sacrifice as Text/Performance in Eighteenth-Century China* (Chicago: University of Chicago

Press, 1997), especially 38–43; Wu Hung, "Emperor's Masquerade—Costume Portraits of Yongzheng and Qianlong," *Orientations* 26, no. 7 (July–August 1995): 25–41; and *The Double Screen: Medium and Representation in Chinese Painting* (Chicago: University of Chicago Press, 1996), 231–236. Zito's reading was later criticized for ignoring art historical method by Charles Lachman in "Blindness and Oversight: Some Comments on a Double Portrait of Qianlong and the New Sinology," *Journal of the American Oriental Society* 116 (October–December 1996): 736–744.

52. Sung-peng Hsu, *A Buddhist Leader in Ming China,* 75–76.

53. Qianlong's interest in the *Śūraṃgama Sutra*, which Deqing actively promoted and wrote a commentary on, is apparent in his concern that, alone of all sutras, it did not exist in the Tibetan canon. He therefore asked Rolpay Dorje to see to its translation and wrote a preface (in Chinese) for the finished product. See Nicholas von Staël-Holstein, "The Emperor Ch'ien-lung and the larger *Śūraṃgamasūtra*," *Harvard Journal of Asiatic Studies* 1, vol. 1 (1936): 136–146, where there is a partial translation of the preface. The Chinese text is published in, among other places, Thukwan, *Biography of Rolpay Dorje,* 384–385.

54. This strongly suggests the painting was kept there. The three known versions are identical in size (119.8 x 90.3 cm), and the dreadful condition of one of them may be evidence that two subsequent copies were made to replace the worn original as needed.

55. On Giuseppe Castiglione (Lang Shining, 1688–1766) and other Jesuit painters at the Qing court see Michel Beurdeley, *Peintres Jésuites en Chine au XVIIIᵉ siècle* (Arcueil Cedex, France: Anthèse, 1997); and Michel Beurdeley and Cécile Beurdeley, *Giuseppe Castiglione: A Jesuit Painter at the Court of the Chinese Emperors* (London: Lund Humphries, 1972).

56. The preparatory drawing is in the Musée de l'Homme, Paris, and the final product, a handscroll in monumental scale, is in the Palace Museum, Taipei. The drawing is published in *From Beijing to Versailles: Artistic Relations Between China and France* (Hong Kong: Urban Council, 1997), 306–307, cat. 121.

57. In this the emperor echoes the opinions of late-Ming and Qing literati, who compared Western painting admiringly to sculpture and to images reflected in a mirror—all the while, like the painter Gong Xian, denigrating Chinese artists who insisted "on a specific subject or the representation of some event [as] very low class." See Clunas, *Pictures and Visuality in Early Modern China,* 172–188; Gong Xian's quote, translated by James Cahill, is on p. 184.

58. As translated by Wu Hung, "Emperor's Masquerade," 25. The painting is fig. 1.

59. Wu Hung, *The Double Screen,* 225. Wu bases his identification on the long, thin mustache worn by the older figure, which he claims was a style only Yongzheng espoused. But in fact, numerous portraits of Qianlong from the 1750s forward show that he adopted the same style. See, for example, the "One and/or Two" portraits Wu himself discusses a few pages later; see p. 118, fig. 98; pp. 234–235, figs. 167–168.

60. Norman Bryson, *Vision and Painting: The Logic of the Gaze* (New Haven: Yale University Press, 1983), 89–92.

61. Ibid. That is, language containing within itself references to the source of the utterance.

62. This rare record of audience reaction is preserved in Manchu court documents, *Junjichu Manwen lufu zouzhe* [Manchu versions of memorials of the Grand Council of State], *quanzong* 3, *mulu* 177, *juan* 16. See Wang Xiangyun, "Tibetan Buddhism at the Court of Qing," 227–228.

63. See Crossley, *Translucent Mirror,* especially 217ff.

64. A thorough study of the imperial identification with Mañjuśrī can be found in David Farquhar, "Emperor as Bodhisattva in the Governance of the Ch'ing Empire," *Harvard Journal of Asiatic Studies* 38, no. 1 (June 1978): 5–35.

65. Renderings of the gate and rubbings of its inscriptions can be found in Murata Jirō, ed., *Kyoyōkan* (Kyoto: Kyōto Daigaku Kogakubu, 1957).

66. Farquhar, "Emperor as Bodhisattva," 12.

67. Ibid., 14.

68. Heather Stoddard has questioned the commonly held assumption that the Qing emperors ever understood themselves to be "incarnations" of Mañjuśrī. She cites the biography of the Zhangjia Khutuktu Rolpay Dorje, written in Tibetan, which makes a clear distinction between *sprul sku* (incarnation or rebirth) and *rnam sprul* (emanation), referring to the emperor by the former term. See Heather Stoddard, "Dynamic Structures in Buddhist *Maṇḍalas: Apradakṣina* and Mystic Heat in the Mother *Tantra* Section of the *Anuttarayoga Tantras*," *Artibus Asiae* 58, nos. 3–4 (1999): 211.

69. The Dalai Lama's text is reproduced in his collected works: *gSung 'bum*, vol. *na* (Gangtok: Sikkim Research Institute, 1993).

70. Or "emperor of the central plain" *(gong thang hu rgyal)*. I am reading *"hu rgyal"* as a conflation of *"hu 'ang di"* and *"rgyal"* (that is, the Chinese "emperor" and "king") rather than as "Mongolian king."

71. Titled *dPal brtan chen po bcu drug gi mchod brgya la bstan 'dzad med nor bu.*

72. Farquhar, "Emperor as Bodhisattva," 9.

73. Hans-Rainer Kämpfe, *Ñi ma'i od-zer/Naran-u gerel: Biographie des 2 Pekinger Lcan skya-Qutuqutu Rol pa'i rdo rje (1717–1786)*, Monumenta Tibetica Historica, sec. II, vol. 1 (St. Augustin: VGH Wissenschaftsverlag, 1976), 52.

74. See Wu Hung, "Emperor's Masquerade," fig. 6a–k. Another Yongzheng guise portrait album appears in Nie Chongzheng, *Qing gongting huihua* (Hong Kong: Commercial Press, 1996), pl. 16.1–16. This album, however, shows the emperor only in roles drawn from famous Chinese paintings.

75. Qing Shizong, *Yongzheng yuxuan yulu* (Taipei: Ziyou chubanshe, 1967).

76. James Cahill, *The Compelling Image: Nature and Style in Seventeenth-Century Chinese Painting* (Cambridge, Mass.: Harvard University Press, 1982), 106–145; and Richard Vinograd, *Boundaries of the Self* (Cambridge: Cambridge University Press, 1992), especially 68–83. Many other early examples can be gleaned from historical texts. A particularly fascinating example is that of the Southern Song emperor Lizong (r. 1225–1264), who had his own face inserted into a series of paintings of the *Thirteen Sages and Rulers of the Orthodox Lineage*, five of which still exist in the collection of the National Palace Museum, Taiwan. They are the subject of a pair of articles—Hui-shu Lee, "Art and Imperial Images at the Late Southern Song Court," 249–268; and Wang Yao-t'ing, "From *Spring Fragrance, Clearing After Rain* to *Listening to the Wind in the Pines.* Some Proposals for the Courtly Context of Paintings by Ma Lin in the Collection of the National Palace Museum, Taipei"—both in Maxwell K. Hearn and Judith G. Smith, eds., *Arts of the Sung and Yuan* (New York: Department of Asian Art, Metropolitan Museum of Art, 1996), 269–291.

77. For a description of the emperor's first initiation see Thukwan, *Biography of Rolpay Dorje*, 183. Heather Stoddard has shed new light on the emperor's interest in Cakrasaṃvara in her article "Dynamic Structures in Buddhist *Maṇḍalas*," 169–213. She points out that the Indic Cakrasaṃvara and his *sakti* fought numerous titanic battles with Śiva, marking the landscape of India and Tibet with phallic stones. This battle was extended as far as Chengde, the Manchu summer retreat, where a tantric monk and his consort claimed the valley, which is marked by the unusual phallic rock known as Jiubang Shan (Washclub Mountain), from Śiva and for Cakrasaṃvara. Qianlong had the Pule Temple built opposite the rock in 1765, equipping it with a figure of Cakrasaṃvara *yab yum*, which directly faced the rock, neutralizing its power. At the same time, he asked Rolpay Dorje to give him tantric training in a commentary on Cakrasaṃvara by Tsongkhapa and "practical training in *gtum mo*, the Yoga of Inner Heat," which is particularly connected to the counterclockwise rituals of Cakrasaṃvara.

78. See Wang Xiangyun, "Tibetan Buddhism at the Court of Qing," 291–298, who quotes Thukwan, *Biography of Rolpay Dorje*, 290–293, in the Tibetan version.

79. This version of the thangka, which came on the London market in the late 1990s, is published in Christopher Bruckner et al., *Chinese Imperial Patronage: Treasures from Temples and Palaces* (London: Christopher Bruckner, Asian Art Gallery, n.d.), 16. It is now in the collection of the Freer-Sackler Gallery, Washington, D.C.

80. Clark translates *"rol-pa'i"* (Skt: *lalita*) as "to take the role of." It also can mean "playful" with all its overtones of joyful lightheartedness. (Rolpay Dorje then means "Playful-Type Vajra." Rolpay Dorje is also an epithet of Hevajra, whose Chinese name, Jixiang Xi Jingang, might be rendered as "Auspicious Joy Vajra.")

81. See, for example, a gilt brass portrait of Rolpay Dorje with sword and *Prajñāpāramitā Sutra* in Rhie and Thurman, *Wisdom and Compassion*, 276, cat. 100.

82. This mandalic arrangement is countered on the left by a group of female bodhisattvas (mostly forms of Tārā) and more dancing *ḍākinī*.

83. My thanks to Tibetologist Steven Goodman for revealing these other readings to me—as well as the fact that Tibetan texts regularly embed subtext, which is often underscored graphically with small circles (like following the dancing dots) so the acrostically impaired can find the secret meaning.

84. W. J. T. Mitchell, "Word and Image," in Robert S. Nelson and Richard Shiff, eds., *Critical Terms for Art History* (Chicago: University of Chicago Press, 1996), 55.

Chapter 3: Artful Collecting

1. Ban Gu, preface to the "Two Capitals Rhapsody," in *Wen xuan or Selections of Refined Literature,* trans. David Knechtges (Princeton: Princeton University Press, 1982), vol. 1, 92–94, fn. 6. Knechtges renders "*qu*" as "canal," though Su Shi's use of a fragment of the same construction as an inkstone suggests something a bit less grand.

2. *Hanshu* 36.1928, no. 8. The Stone Drain Pavilion is also included in Bi Yuan's (1730–1797) description of the sites of the three capital districts, *Sanfu huangtu*, written in 1784 (Taipei: Chengwen chubanshe, 1970), *juan* 3, 97.

3. *Shuijing zhu.*

4. "Ti Su Shi peishou shiqu yan," in Qing Gaozong, *Collected Works*, vol. 8, *juan* 76, 13a.

5. The name Qianlong chose for his collections of ancient bronze vessels and antique inkstones likewise harks back to the Han dynasty. A second-century poem calls a particularly pleasant and peaceful part of the imperial palace "Xiqing" (Western Clarity), and the Qing used the same phrase to describe the Nan Shufang—the Southern Library in the Forbidden City and the site where many important cataloging projects were carried out by members of the Hanlin Academy.

6. On the Han Bishujian and the continued use of the term see R. Kent Guy, *The Emperor's Four Treasuries: Scholars and the State in the Late Ch'ien-lung Era*, Harvard East Asian Monographs, no. 129 (Cambridge, Mass.: Council on East Asian Studies, Harvard University, 1987), 12; and Cary Y. Liu, "The Ch'ing Dynasty Wen-yüan-ko Imperial Library: Architectural Symbology and the Ordering of Knowledge" (Ph.D. dissertation, Princeton University, 1997), 90ff.

7. *Bidian zhulin, Siku yishu congshu* ed. (Shanghai: Guji chubanshe, 1991), vol. 5, 823–443.

8. There are really over 1,400 entries in the catalog by my quick count. Many of these are for multiples, however, such as the Kangxi emperor's 420 renditions of the *Heart Sutra*, which are listed in the catalog table of contents as a single entry but are detailed laboriously in the text.

9. *Shiqu baoji*, facsimile reprint of an original manuscript copy (Taipei: National Palace Museum, 1971). Other bibliographic information is in Hin-cheung Lovell, *An Annotated Bibliography of Chinese Painting Catalogues and Related Texts* (Ann Arbor: University of Michigan Center for Chinese Studies, 1973), 51–54.

10. Hin-cheung Lovell suggests the few post-1745 colophons included in *Shiqu baoji* were added when the catalog was incorporated into *Siku quanshu* in the 1770s and 1780s.

11. *Bidian zhulin, Shiqu baoji, xubian*, facsimile copy of an original manuscript edition (1948), 1–5. For additional bibliographic information see Lovell, *Annotated Bibliography*, 50–51.

12. Kohara Hironobu, "The Qianlong Emperor's Skill in the Connoisseurship of Chinese Painting," in Ju-hsi Chou and Claudia Brown, eds., *Chinese Painting Under the Qianlong Emperor, Phoebus* 6, no. 1 (1988): 56–73, 61. See also his full article, "Kenryū Kōtei no gagaku ni tsuite," *Kokka* 1079 (January 1985): 9–25; 1081 (March 1985): 35–43; 1082 (April 1985): 33–41. For a critique of Qianlong's approach to authentication see Zhang Hengyi, "Dzenyang jianding shuhua," *Wenwu* 161, no. 3 (1964): 9.

13. Arthur Hummel, ed., *Eminent Chinese of the Ch'ing Period* (Washington, D.C.: Government Printing Office, 1943), vol. 1, 24–25.

14. Ibid., 503.

15. Ibid., 490–491.

16. Ibid., 55.

17. Peng was grouped with the great poet Jiang Shiquan as one of the "Two Celebrities of Jiangxi" *(Jiangyou liang mingshi)*. He rose to become president of the Board of Civil Office (1789–1791).

18. Kohara, "The Qianlong Emperor's Skill," 65; 179, fn. 36. Some of the sutras these men copied to honor the empress dowager's eightieth birthday are listed in *Bidian zhulin, xubian*, 148b–155a.

19. Nayancheng was a brilliantly educated scholar who quelled uprisings in Guangdong and Kokonor—and, after Qianlong's death, by the Tianlijiao (Heavenly Principle Doctrine), the claimed ancestors of the late-nineteenth-century Boxers. The Tianlijiao was very successful, even storming the Forbidden City, but eventually fell to forces led by Nayancheng. Nayancheng was later posted to Turkestan to rehabilitate the war zone there. His appointment to the cataloging team was probably based on his talent as a calligrapher and poet.

20. Translation mostly from Kohara, "The Qianlong Emperor's Skill," 65; for the whole text see Ruan Yuan, "Preface," in Shen Chu, *Xiqing biji* (Shanghai: Shangwu yinshuguan, 1936), 1.

21. Kohara, "The Qianlong Emperor's Skill," 61.

22. Many objects did not make it into the supplement and its Jiaqing-period successor, the *sanbian*, at all. Kohara argues that the total number of paintings and calligraphies in the collection was suppressed in the second two editions to avoid outshining the first. See Kohara, "The Qianlong Emperor's Skill," 66–67.

23. All of these imperial works are listed chronologically by emperor in the first *juan* of the catalog.

24. *Bidian zhulin*, 823/456–484. Still other versions follow.

25. Yongzheng even had his courtiers—including Fupeng (a probable son-in-law of the great man of letters Cao Yin), Yinlu (the sixteenth son of Shengzu and the phonologist who helped Qianlong with rectifying the pronunciation of mantras), and Zhang Tingyu (the famous father of *Bidian zhulin* cataloger Zhang Ruo'ai)—participate in koan conversations with him. See the court document quoted in Wang Yuegong, "Qing Shizong chanhua—luelun Yongzhengdi shi chanxue sixiang ji zaoyi," in Wang Shuxiang, ed., *Qingdai gongshi congtan* (Beijing: Zijincheng chubanshe, 1996), 293–294.

26. Yongzheng's cause of death is somewhat controversial. In *Eminent Chinese of the Ch'ing Period*, 918, Fang Chaoying flatly claims that the emperor died of overindulgence in Daoist elixirs—pointing out that immediately after his death, all Buddhists and Daoists were expelled from the palace. This claim has been closely scrutinized by Li Guoying, who finds that the documentary evidence of the palace around the time of Yongzheng's death regarding orders for lead, the primary component of immortality elixirs, gives serious credence to the claim. See his "Lun Yongzheng yu dandao," in Wang Shuxiang, *Qingdai gongshi congtan*, 175–189.

27. See, for example, Li Guoqiang, "Qiannian gushuye poso junchen xunxun xie Xinjing," *Zijin cheng* 68, no. 1 (1992): 22–25.

28. John Hay has detailed the extent to which the critique of the art of calligraphy was bound to the body through the use of descriptive terms drawn from anatomy ("bone," "sinew," "muscle," "blood"). See John Hay, "The Body Invisible in Chinese Art," in Tani E. Barlow and Angela Zito, eds., *Body, Subject, and Power in China* (Chicago: University of Chicago Press, 1994), 42–77; and, with specific reference to Dong Qichang, "Subject, Nature, and Representation in Early Seventeenth-Century China," in Wai-ching Ho and Hin-cheung Lovell, eds., *Proceedings of the Tung Ch'i-ch'ang International Symposium* (Kansas City: Nelson-Atkins Museum of Art, 1992), 4.1–21.

29. Qianlong, following his Tibetan guru, was a noted gradualist and on this occasion even argues for the superiority of the gradualist approach to enlightenment in political contexts. See, for example, his pronouncement at the end of the lengthy Jinchuan conflict on the Sichuan-Tibetan border, where (with the aid of Jesuit cannons) the Bon were brought to their knees. Qianlong later claimed: "This gradual victory over the enemy is not due only to our strength and might; it is rather because of earnest application to worship and devotion to Buddha's teachings, because of the magical power *(mthu)* which achieves actions *('phrin-las)* by the Religious Defenders." See Dan Martin, "Banpo Canons and Jesuit Cannons: On Sectarian Factors Involved in the Ch'ien-lung Emperor's Second Goldstream Expedition of 1771–1776. Based Primarily on Some Tibetan Sources," *Tibet Journal* 15 (1990): 10.

30. *Bidian zhulin, juan* 18, 823/677–681.

31. *Bidian zhulin, xubian*, 146a–147b.

32. Wang Jiapeng, "Qinggong Zangchuan fojiao wenhua kaocha," in *Qingdai gongshi congtan* (Beijing: Zijincheng chubanshe, 1996), 138.

33. On the Cining Palace and its uses see, for example, *Zijin cheng* 14 (1981): 24.

34. Kohara, "The Qianlong Emperor's Skill," 66–67.

35. Jinliang, *Shengjing Gugong shuhua lu*, preface dated 1913. For a succinct summary of this catalog see Lovell, *Annotated Bibliography*, 89–90.

36. He Yu et al., eds., *Neiwubu chenliesuo shuhua mulu* (Beijing: Jinghua yinshu chu, 1925), 10 vols. Hin-cheung Lovell points out that the Mukden and Jehol collections were evacuated from Beijing in the 1930s by the Bureau of Exhibitions staff. After World War II, the bureau was abolished and the objects it controlled were sent to the Central Museum. In 1948, the most significant pieces in the collection were sent, along with a large part of the holdings of the Palace Museum in Beijing, to Taiwan. They were cataloged together in *Gugong shuhua mulu*, where the Central Museum's holdings, 231 paintings and 59 pieces of calligraphy, are identified as *zhongbo*. Most of the collection apparently remained in Nanjing. See Lovell, *Annotated Bibliography*, 94–96.

37. On Jesuit mnemonics in China see Jonathan D. Spence, *The Memory Palace of Matteo Ricci* (New York: Viking Penguin, 1984). The tradition of memory systems and meditation in medieval Europe has been richly explored by Frances A. Yates, *The Art of Memory* (New York: Penguin Books, 1969), and by Mary Carruthers in *The Book of Memory: A Study of Memory in Medieval Culture* (Cambridge: Cambridge University Press, 1990) and *The Craft of Thought: Meditation, Rhetoric, and the Making of Images, 400–1200* (Cambridge: Cambridge University Press, 1998). Buddhist mnemonics are discussed from many perspectives in Janet Gyatso, ed., *In the Mirror of Memory: Reflections on Mindfulness and Remembrance in Indian and Tibetan Buddhism* (Albany: State University of New York Press, 1992).

Chapter 4: Remembering the Future

1. Craig Clunas, *Pictures and Visuality in Early Modern China* (Princeton: Princeton University Press, 1997), 102–111.

2. Thukwan, *Biography of Rolpay Dorje*, 144.

3. Wang Xiangyun, "Tibetan Buddhism at the Court of Qing" (Ph.D. dissertation, Harvard University, 1995), for example, suggests this project was the famous *Three Hundred Icons*. I believe that, for a number of reasons, the *Three Hundred Icons* was a slightly later work intended for a different purpose.

4. Recorded by Thukwan, *Biography of Rolpay Dorje*, 138, 225, 187, 221.

5. *Zaoxiang liangdu jing* can be found in *Taishō*, no. 1419, and separately in Chinese and Japanese editions together with the supplements its translator added. My references are to the Taiwan edition (1956).

6. Ibid., 17.

7. Damcho Gyatsho Dharmatāla, *Rosary of White Lotuses* (Wiesbaden: Otto Harrassowitz, 1987), 393.

8. *Zaoxiang liangdu jing*, 1–2.

9. Ibid., 9–11.

10. Ibid., 12–13.

11. Ibid., 1.

12. Ibid., 3.

13. Qianlong's own fascination with Mādhyamika probably developed from his directed study of Tsongkhapa's biography, which he undertook with Rolpay Dorje probably sometime after his first initiation in 1745. Rolpay Dorje subsequently assigned him a work of his own on the subject: *Zab mo dbu ma'i lta ba nyams su len tshul de kho na nyid snang bar byed pa'i sgron me*. See Wang Xiangyun, "Tibetan Buddhism at the Court of Qing," 292; and Thukwan, *Biography of Rolpay Dorje*, Tibetan text, 293.

14. *Zaoxiang liangdu jing*, 5.

15. Ibid., 14–17.

16. Ibid., 1–10, preceding the text of the sutra itself. These illustrations are also reproduced in *Taishō*, no. 1419.

17. Ibid., 23–64.

18. For the many recensions of the Kanjur see Helmut Eimer, ed., *Transmission of the Tibetan Canon* (papers presented at a panel of the seventh seminar of the International Association for Tibetan Studies, Graz, 1995). Yoshiro Imaeda analyzes the different ways in which the texts of various Kanjur were arranged in his *Catalogue du Kanjur tibétain de l'édition de 'Jang Sa-tham* (Tokyo: International Institute for Buddhist Studies, 1982–1984), 182–189.

19. See, for example, Nicholas von Staël-Holstein, "The Emperor Ch'ien-lung and the Larger *Śūraṃgamasūtra*," *Harvard Journal of Asiatic Studies* 1, no. 1 (1936): 136–146. For the Chinese text of the sutra itself see *Taishō*, no. 945. The emperor's preface is reproduced in Thukwan, *Biography of Rolpay Dorje*, 384–385. For the details of Qianlong's interest in the *Śūraṃgama Sutra* see, for example, Wang Xiangyun, "Tibetan Buddhism at the Court of Qing," 145–147.

20. Rolpay Dorje's Sanskrit and Tibetan sources were numerous. He was certainly intimately familiar with one of the earliest tantric texts, written around 300 c.e., the *Guhyasamāja Tantra*, which contains brilliant descriptions of deities. Another early source well known in Tibet and China was the *Mañjuśrīmulakalpa*. There were also collections of deity descriptions, including the *Niṣpannayogāvalī*, written by the Mahāpandita Abhayakara Gupta of Vikrāmaśila Monastery (he flourished ca. 1084–1130), which describes twenty-six mandalas in twenty-six chapters (Gaekwad's Oriental Series, no. 109); and the *Sādhanamālā*, a "rosary" of 312 *sādhana*, or realization texts, that closely describe deities seen in authoritative visions, which must have been put together before 1165 (Gaekwad's Oriental Series, nos. 26 and 41). Moreover, many other tantras, such as the Heruka, Hevajra, Caṇḍamahāroṣaṇa, Vajravārāhi, and Vajrāvalī, also are filled with vivid descriptive passages.

21. Gonpokyab makes the pitfalls of incorrect representation clear in the sixth addendum to his translation of

the *Sutra on Iconometry*, titled *Wangzaojie* (Warning against reckless production), *Zaoxiang liangdu jing*, 39–41. The worst "maladies" of incorrect image making are all faults of proportion: making the eyes, nose, and fingers too short, for example. Even the most disorderly artisans can find redemption, the text says, so long as they change their proportions.

22. See, for example, Wang Xiangyun, "Tibetan Buddhism at the Court of Qing," 291–292. Citing Thukwan, Wang says that sometime between 1736 (when he succeeded) and 1745 (when he received his first initiation) Qianlong asked Rolpay Dorje to teach him Tibetan and then requested more detailed instruction on Buddhism. Rolpay Dorje suggested he begin with two *lam rim* texts: *mDo sngags kyi lam gyi rim pa nyis* (Graduated path to sutras and tantras) and *Byang chub lam gi rim pas* (Graduated path to enlightenment). Qianlong was delighted and said he would begin with the graduated path and then move on to tantras. See Thukwan, *Biography of Rolpay Dorje*, Tibetan text, 290–293.

23. Heather Karmay, *Early Sino-Tibetan Art* (Warminster, England: Aris & Phillips, 1975), 35–71.

24. Ibid., 55.

25. Kenneth Chen, "The Tibetan Tripitaka," *Harvard Journal of Asiatic Studies* 9 (1945): 58–59.

26. Karmay, *Early Sino-Tibetan Art*, 66.

27. The illustrations to the Mongolian Kanjur have been twice published by Lokesh Chandra, whose father, Ragu Vira, found them in Ulaanbaatar. For the complete multivolume set see Ragu Vira and Lokesh Chandra, eds., *A New Tibeto-Mongol Pantheon* (New Delhi: International Academy of Indian Culture, 1961–1972). Lokesh Chandra's condensed *Buddhist Iconography: Compact Edition* (New Delhi: International Academy of Indian Culture and Aditya Prakashan, 1991), 8–21, presents a historical analysis and a streamlined version of the images that culls out figures when they appear more than once.

28. For Zanabazar's oeuvre see N. Tsultem, *The Eminent Mongolian Sculptor—G. Zanabazar* (Ulaanbaatar: State Publishing House, 1982); and Patricia Berger and Terese Tse Bartholomew, *Mongolia: The Legacy of Chinggis Khan* (San Francisco: Asian Art Museum; London: Thames & Hudson, 1995).

29. Yang Boda, "Zhanabazha'er di liujintong zaoxiang yishu," *Gugong bowuyuan yuankan* 4 (1996): 59–65.

30. The Great Longshan Monastery for the Protection of the Nation is still located in the western part of Beijing, on Huguo (Protecting the Nation) Street. It was first established in the Yuan dynasty, according to an imperial stele placed there in 1284, when it was known as the Dadu Chongguo Monastery (Monastery in the Great Capital for Venerating the Nation). In 1429 (fourth year of Ming Xuande), the name was changed to Great Longshan Monastery; in 1472 (eighth year of Ming Chenghua), the phrase "Huguo" (Protecting the Nation) was added. For a description of the monastery's highlights (including a stele, ca. 1407, memorializing one of the Dabao Fawang—Great and Precious Dharma Kings—of the Ming, dPal ldan bkra shis), see Huang Hao, *Zai Beijing di Tsangzu wenwu* (Beijing: Minzu chubanshe, 1993), 10–14; and Susan Naquin, *Peking: Temples and City Life, 1400–1900* (Berkeley: University of California Press, 2000), 115, 162–163, and passim.

31. A copy of this edition is in the collection of the East Asian Library, University of California, Berkeley. My sincere thanks to librarian Jean Han for showing me this text.

32. Giuseppe Tucci, *Tibetan Painted Scrolls* (Rome: Libreria dello Stato, 1949), vol. 2, 555–564.

33. Ibid., 561.

34. Wang Jiapeng, "Qinggong Zangchuan fojiao wenhua kaocha," in *Qingdai gongshi congtan* (Beijing: Wenwu chubanshe, 1961–1972, 1996), 137–139.

35. Wang Jiapeng, "Zhongzhengdian yu Qinggong Zangchuan fojiao," *Gugong bowuyuan yuankan* 53, no. 2 (1991): 58–71.

36. *Da Qing huidian* (Jiaqing reign, 1816) on the functioning of Zhongzheng Hall, *juan* 886.

37. *Qinggong Zangchuan fojiao wenwu*, 231 and pl. 96; Wang Jiapeng, "Zhongzhengdian yu Qinggong Zangchuan fojiao," 58–71.

38. The first thorough study of the Pavilion of Raining Flowers was Wang Jiapeng, "Gugong Yuhuage tanyuan," *Gugong bowuyuan yuankan* 47 (1990): 50–62. Wang combs through and reproduces significant court documents recording the restructuring and furnishing of the pavilion.

39. References to this inspiration appear in a number of modern sources, all drawing on Thukwan, *Biography of Rolpay Dorje*, 220–221.

40. Wang Jiapeng, "Yuhuage," 54.

41. Ibid., 53.

42. Wang Jiapeng, "Qinggong Zangchuan fojiao wenhua kaocha," 144–145.

43. Luo Wenhua, "Gugong Yuhuage shenxi yu mizong sibu yanjiu," *Foxue yanjiu* 6 (1997): 8–12.

44. Ferdinand Lessing, "The Topographical Identification of Peking," in Lou Ts'u-k'uang and Wolfram Eberhard, eds., *Ritual and Symbol: Collected Essays on Lamaism and Chinese Symbolism*, Asian Folklore and Social Life Monographs, vol. 91 (Taipei: Orient Cultural Service, 1976), 89–90. Lessing says the "three-fold mandala of Yamāntaka (i.e., Vajrabhairava) was read into the rectangular plan of the city, the so-called Forbidden City being the first, the Imperial City the second, and the Outer "Chinese" City the third mandala." He identifies the well-known Yamāntaka-ekavira (Yamāntaka without his *śakti*) in Beihai Park's Yong'ansi as the lord of the first mandala. Interestingly, Lessing also says that the Taihedian, one of the greatest audience halls in the Forbidden City, was the center of the mandala and that its architecture faithfully played out the structure of the deity's mandalic palace. This would place the emperor on his great chair right in the middle—identified directly with Yamāntaka as protector of the capital.

45. Luo Wenhua, "Yuhuage tangka bianxi—jian 'Zhufo pusa shengxiang zan' zhi guanxi," unpublished manuscript, 2000. My warm thanks to Luo Wenhua for letting me see a copy of this essay.

46. See Musashi Tachikawa, Shunzo Onoda, Keiya Noguchi, and Kimiaki Tanaka, *The Ngor Mandalas of Tibet: Listings of the Mandala Deities* (Tokyo: Centre for East Asian Cultural Studies, 1991), for several slightly different transmissions of the mandala, including one held by the Gelukpa (pp. 217–218).

47. From west to east: Sūryaprabha; Samantabhadra; Akāśagarbha; and Kṣitigarbharāja, Avalokiteṇvara, Candraprabha. Only a few of them follow the Guhyasamāja-Akṣobhyavajra mandala.

48. Luo Wenhua, "Yuhuage tangka bianxi," ms. 21.

49. Wang Jiapeng, "Gugong Yuhuage tanyuan," 53.

50. The Golden Temple, along with several other western Tibetan temples—at Tabo in Spiti, for example, and at Alchi in Ladakh—was labeled a *chos 'khor*, literally *dharmacakra* or "wheel of the law." Giuseppe Tucci says that the term has been taken in several different ways. Some scholars, like A. H. Francke, thought it indicated a temple designed for circumambulation. But Tucci argues that it probably was meant to evoke the *dharma-cakrapravartana*, Śākyamuni's first sermon, that is, the first spinning of the wheel of the law. It may also have referred to the use of temples in Guge for convocations of Indian masters. Such a gathering, called a *chos 'khor*, took place in 1076 when King Rtse lde invited masters with prodigious memories from all over Tibet to come together in Guge to reconstruct and preach the law. From the Qing point of view, the term established a different kind of legitimacy, doctrinal rather than architectural, for the Pavilion of Raining Flowers, but it also strongly defines the building by the activities it houses. See Giuseppe Tucci, *Rin-chen-bzan-po and the Renaissance of Buddhism in Tibet Around the Millennium*, trans. Nancy Kipp Smith, vol. 2 (New Delhi: Aditya Prakashan, 1988), 72–73.

51. See Roger Goepper, Robert Linrothe, et al., *Alchi: Ladakh's Hidden Buddhist Sanctuary, the Sumstek* (Boston:

Shambhala, 1996), especially Robert Linrothe's concluding analysis, which ties the plan of the structure and its decorations to the three levels of teaching.

52. On the Kangxi Red Kanjur see Chen, "The Tibetan Tripitaka," 58–60.

53. See the complete recitation table in Wang Jiapeng, "Qinggong Zangchuan fojiao wenhua kaocha," 146–149. For an abbreviated version of the table see *Qinggong Zangchuan fojiao wenwu,* 11.

54. For a history of von Staël-Holstein's aborted photographic project, which he originally intended would document the entire Cininggong complex, see Walter Eugene Clark, *Two Lamaistic Pantheons* (Cambridge, Mass.: Harvard University Press, 1937). Clark publishes the entire set of photographs von Staël-Holstein took at the Baoxianglou and later gave to Harvard Library.

55. The Da Fotang originally had statues of the buddhas of the three ages and the eighteen lohans, all Yuan dynasty in date. Such figures could serve either Chinese or Tibetan-style rituals. See *Qinggong Zangchuan fojiao wenwu,* 239 and pl. 122, for a view of the exterior of the Cining Palace.

56. Wang Jiapeng, "Qinggong Zangchuan fojiao wenhua kaocha," 137.

57. Clark, *Two Lamaistic Pantheons,* xii–xiii. Clark's citations from *Guochao gongshi* can be found in *juan* 18, 2a–b, 10a, 12b.

58. R. Kent Guy, *The Emperor's Four Treasuries* (Cambridge, Mass.: Council on East Asian Studies, Harvard University, 1987), describes the *Siku* project in detail. Endymion Wilkinson recounts these nearly incomprehensible figures, noting that the scribes were unpaid with all except a promise of official employment once they had finished a certain number of words in a set time. Four copies of the compilation (the Four Treasuries) were produced: for the Forbidden City, the Yuanmingyuan (Old Summer Palace), the old capital at Mukden, and the summer retreat at Chengde. In 1782, Qianlong ordered three more copies to be made publicly available in three southern cities: Yangzhou, Hangzhou, and Zhenjiang. All the copies were shelved together with the imperial encyclopedia *Gujin tushu jicheng.* The entire *Siku quanshu* was reproduced photolithographically in the 1980s. See Endymion Wilkinson, *Chinese History: A Manual* (Cambridge, Mass.: Harvard University Asia Center, 1998), 262–266.

59. *Qinding nanxun shengdian* (Beijing: Beijing guji chubanshe, 1996).

60. The emperor wrote a long preface, at turns scholarly and exuberantly affectionate, for the eighty-one-volume copy of the *Huayanjing* (Flower ornament sutra) he had his Hanlin scribes copy for his mother. (They also appended their own congratulatory colophon at the end.) For a record of these texts see *Bidian zhulin, xubian,* 149a–154b.

61. See, for example, an image of a seated Akṣobhya, dated to the Xuande period (1426–1435), which is still in the palace collection, in *Qinggong Zangchuan fojiao wenwu,* 73, pl. 45. This facial type, just slightly later than the Ming Yongle period (1403–1424), owes much to its courtly predecessor but is much more portraitlike, suggesting a real face with humanized charm. There are many examples of this type from the Qianlong period, both in painting and sculpture. (Many of Ding Guanpeng's buddhas and bodhisattvas have this look.) See, for example, the Qianlong-period, 50-cm-tall Maitreya, cast in gold and inlaid with pearls, now in the Palace Museum, Beijing, in Yang Xin and Zhu Chengru, *Secret World of the Forbidden City: Splendors from China's Imperial Palace* (Santa Ana, Calif.: Bowers Museum of Cultural Art in association with the Palace Museum, Beijing, 2000), 81.

62. There is ample use of this idea in Gelukpa thinking. *The Six Yogas of Naropa,* a tremendously influential text that was the centerpiece of Kagyupa practice and which Tsongkhapa brilliantly commented on, clearly conceives of what we think of as our lives in this world as another "in-between," just like the after-death *bardo* and the dream state. All of these states, the Six Yogas show, are contingent and thus susceptible to yogic intervention and manipulation. See, for example, Tsongkhapa, *Tsongkhapa's Six Yogas of Naropa,* ed. and trans. Glenn H. Mullin (Ithaca: Snow Lion, 1996).

63. This does not begin to take into account the almost immediate expansion of the pantheon as Buddhism spread into Mongolia and northern China. Ferdinand Lessing reports that in Beijing any number of indigenous, non-Buddhist Chinese figures (such as Confucius and Laozi) found their way into liturgy and practice at the Yonghegong. See, for example, Ferdinand Lessing, "Bodhisattva Confucius," in Lou and Eberhard, *Ritual and Symbol*, 91–94 . According to Heissig, moreover, Mongolian Buddhists quickly offered Yamāntaka and Guhyasamāja as substitutes for the shamanic spirits who, in their view, prevented conversion and fomented dissent—a process that emulated the conversion of local deities in all the other cultures Buddhism infiltrated. See Walther Heissig, "A Mongolian Source to the Lamaist Suppression of Shamanism," *Anthropos* 48 (1953): 1–29 and 493–536, especially 19 and 526–531.

64. Nicholas von Staël-Holstein, "Remarks on the Chu Fo P'u Sa Shēng Hsiang Tsan," *Bulletin of the Metropolitan Library* 1, no. 1 (1928): 78–80, lists the twenty-three groups as:

1.	(1–10)	Prajñāpāramitā Masters
2.	(11–18)	Esoteric Masters
3.	(19–28)	Bodhi Masters
4.	(29–62)	Great Esoteric Buddhas
5.	(63–76)	Other Esoteric Buddhas
6.	(77–81)	Buddhas of the Five Directions
7.	(82–116)	Thirty-Five Buddhas of Confession
8.	(117–126)	Buddhas of the Ten Directions
9.	(127–132)	Six Buddhas of the Present Kalpa
10.	(133–139)	Medicine Buddha
11.	(140–144)	Miscellaneous Buddhas
12.	(145–157)	Transformations of Mañjuśrī
13.	(158–177)	Transformations of Avalokiteśvara
14.	(178–193)	Bodhisattvas of Vairocana's Mandala
15.	(194–200)	Miscellaneous Bodhisattvas
16.	(201–205)	Protective Buddha Mothers
17.	(206–227)	Tārās
18.	(228–271)	Miscellaneous Buddha Mothers
19.	(272–289)	Eighteen Lohans
20.	(290–296)	Miscellaneous Lohans
21.	(297–317)	Great Protectors
22.	(318–322)	Kings of Wealth
23.	(323–360)	Miscellaneous Protectors

65. Clark, *Two Lamaistic Pantheons*, x; von Staël-Holstein, "Remarks on the Chu Fo P'u Sa Sheng Hsiang Tsan," 79–80. *Tsa tsas* filled the temples of the Forbidden City too; the second floor of the Jiyunlou (Tower of Auspicious Clouds), part of the Cining Palace compound, still displays more than ten thousand plaques, all with the image of the six-armed buddha mother Sitātapatrā, invincible goddess of the white parasol, whose powerful *dhāraṇī* protects from all harm. This form of the goddess does not appear in *All the Buddhas and Bodhisattvas* or in the *Three Hundred Icons*. She can be found, however, in another pantheon of five hundred associated with Rolpay Dorje: *Mizong wubai foxiang kao,* in *Fo zang jiyao* (Chengdu: Bashu shudian, 1993), 485–575; see nos. 436 and 561. Von Staël-Holstein also notes (p. 78, fn. 5) that the Xianruoguan, a major temple in the Cining Palace complex, held at the time of his writing more than four thousand plaques, all of them with exact counterparts in *All the Buddhas and Bodhisattvas*, none of them, however, identified by the two-part numbering system of the text and the plaque molds.

66. Luo Wenhua, "Yuhuage tangka bianxi," ms. 20–22. Von Staël-Holstein notes that the Chinese preface to the album is signed by a Zhangjia Khutukhtu, using the characters Rolpay Dorje favored, rather than the "less elegant" characters used by his predecessor. This, he points out, pushes the composition of the album to at

least 1714, the year of Rolpay Dorje's birth. Despite Rolpay Dorje's prodigious talents, it is much more probable that he was a mature man by the time he compiled his new vocabulary for the pantheon.

67. Tārā may never have caught on because she served much the same purpose as Guanyin did for Chinese Buddhists: coming to the aid of those in peril. (Both have forms particularly aimed at sets of terrifying perils.) But Tārā was known in China quite early; the Tang monk Xuanzang reports on seeing a statue of what may well be Tārā in India in the early seventh century.

68. Luo Wenhua, "Yuhuage tangka bianxi," ms. 21, fn. 31. The document reads: "Document of specifics, Qing Palace Zaobanchu [Manufactory]: Twentieth year of Qianlong [1756], twelfth month, twenty-seventh day: Second-class Secretary Bai Shixiu will make 360 gilded metal negative buddha molds for 360 positive buddha models in sections and arrange them exactly in the Yangxindian for submission and inspection. Supervisor Hu Shijie transmitted the instruction for Prince Zhuang [Yinlu] that, using the 360 negative molds, 360 positive impressions are to be distributed over three floors, 120 pieces per floor, each one behind a glass door. The designs should be submitted for inspection first."

69. It has to be said that *All the Buddhas and Bodhisattvas* did not exactly satisfy the lohan issue either, even though the order of eighteen of the lohans is "orthodox" and Tibetan (adding Upāsaka-Dharmatāla and the fat monk Hvashang). But the album also adds, immediately after, seven other would-be lohans, including the Buddha's close disciples, Ānanda and Mahākāśyapa (who indeed figure in some early Chinese groupings). See Clark, *Two Lamaistic Pantheons*, 292–298, nos. 272–289, for the orthodox eighteen and nos. 290–296 for the interlopers.

70. The last Panchen Lama in the book is the Fifth (Clark, no. 27), who died in 1737. The exclusion of the Sixth, who would become a special object of Qianlong's interest, is curious, though the *Three Hundred Icons* is equally spotty in its selection of Dalai and Panchen Lamas.

71. Wang Jiapeng collects several of these truly shocking anecdotes in "Gugong Yuhuage tanyuan," 57–58.

72. This pantheon has been well published in the West—first by Eugen Pander, *Das Lamaische Pantheon* (Berlin: Berliner Zeitschrift für Ethnologie, Heft 2, 1889), and Arthur Grünwedel, ed., "Das Pantheon des Tschangtscha Hutuktu, ein Beitrag zur Iconographie des Lamaismus," *Veröffentlichungen aus dem königl. Museum für Völkerkunde* 1, nos. 2–3 (1890). Grünwedel subsequently redrew all the figures and republished them as *Sbornik izobrazenii 300 burkanov* (St. Petersburg: Bibliotheca Buddhica, 1903). The original xylograph, together with its text of mantras and *dhāranī* (but not its preface), was once again published in Chandra, *Buddhist Iconography,* 683–784. Chandra's sister, Sushama Lohia, has also published a translation of Eugen Pander's two works: *Lalitavajra's Manual of Buddhist Iconography* (New Delhi: International Academy of Indian Culture and Aditya Prakashan, 1994). The second half of her book reproduces Rolpay Dorje's *Three Hundred Icons* with the valuable addition of handwritten Chinese names.

73. An early, original edition, printed entirely in red, is in the East Asian Library, University of California, Berkeley. (My thanks to Bruce Williams for helping me comb through the library's collection of rare Tibetan books.) The Berkeley volume seems to be an early imprint with its line quality completely undegraded. It also has a mistake in its Chinese-character pagination that is corrected in later published versions. (Page 46 appears twice but the two pages are otherwise different; in later versions, the two top strokes on the number six have been cut away to produce an eight in the version Lokesh Chandra reproduces.)

74. The exclusion of the Third Dalai Lama, Sonam Gyatso, could be interpreted as a slap in the face to the Mongols, since the entire lineage of Dalai Lamas received their title from the Mongol Altan Khan. But by the end of Qianlong's reign, Manchu relations were much tighter with the Panchen Lamas. The emperor ostentatiously adored the Sixth Panchen Lama (who died in Beijing in 1780, a victim of smallpox) and was curiously withdrawn from the Eighth Dalai Lama, whom he so lavishly gifted upon his selection in 1757.

75. Eugen Pander's sources misidentified the Khri chen Blo bzang bstan pa'i nyi ma as the Sixth (*sic*) Panchen Lama, probably a scribal error for the Seventh (1780–1853), who had the same religious name. But the Panchen Lama did not hold the title "Thrichen" (Great Throne), while the Gandan Shiregetü, Rolpay Dorje's tutor,

did. Pander also identifies the rJe drung Khutukhtu as "Hutuktu Tsirong," an incarnate lama he says was part of the Dzungar army during the battle of Ulan Putong. In a separate note Pander mentions that there was a post at the Yonghegong for the rJe drung Khutukhtu even in the late nineteenth century. See Pander, *Das Pantheon des Tschangtscha Hutukhtu*, 99 and n. 15. The Chinese name for this figure that Pander provides on p. 98, Jilong Shanyi Weiquan Master, suggests he is indeed the Jilong Khutukhtu (even though the characters Pander uses are not the ones most often seen), one of four great incarnate Mongolian lamas who, according to the *Da Qing huidian,* resided periodically in Beijing at the Yonghegong. (The others were Rolpay Dorje himself, the Gandan Shiregetü Khutukhtu, and the Minjur or sMin grol Khutukhtu.) For these four see Sechin Jagchid [Zhaqi Sijin], "Manzhou tongzhixia Menggu shenquan fengjian zhidu di jianli," *Gugong wenxian* 2, no. 1 (1970): 4.

76. In his edict Qianlong cites numerous precedents, both Qing and earlier, for his decision to convert his father's palace into a monastery. Yongzheng, he pointed out, converted his own father's palaces into Buddhist temples. (Kangxi's youthful palace became the Fuyou Monastery; the place where he died became the Enyou Monastery.) In this, Qianlong argues, Yongzheng followed earlier Tang- and Song-dynasty precedents, when imperial residences were also converted to religious use out of filial regard for the deceased emperor: "In truth they are coves where the spirit is bright. Past and present have made the same estimate; today and yesterday agree. Based on this I inscribe this place as a 'Jetavana Grove.' " For the text see, for example, Zhang Yuxin, *Qing zhengfu yu lamajiao,* 336–338. Ferdinand Lessing also publishes a translation in *Yonghegong,* 9–12, but may go a bit too far in identifying Yongzheng as "King Śākyamuni." The thrust of the text suggests that the two are not exactly conflated but are alike in their capability and benevolence, having similarly manifested themselves in *nirmāṇakāya* to rain benefits upon all sentient beings.

77. Qianlong's own grasp of Buddhism was still rudimentary in 1744, a year before his first initiation and well before the 1750s, when he immersed himself in study and practice. So it is not entirely surprising to see him describing his father as simultaneously *in* nirvana, as if it were a place, and in heaven.

78. Lessing, *Yung-ho-kung,* 15–16. A long, thorough discussion of Hvashang's history, iconography, and cult follows; 19–37.

79. Walther Heissig, *The Religions of Mongolia,* trans. Geoffrey Samuel (London: Routledge & Kegan Paul, 1980), 99–101.

80. Berger and Bartholomew, *Mongolia,* 158–159.

81. Thukwan, *Biography of Rolpay Dorje,* 130–131.

82. Ibid., 145–146.

83. See Berger and Bartholomew, *Mongolia,* 79, fig. 4; 281, cat. 100 and fig. 2. For depictions of the Maitreya festival see 172–175, cat. 42; and 63, fig. 9a–b.

84. Thus almost perfectly contemporary with another popularly subscribed colossus, the gigantic repoussé copper Avalokiteśvara built at Urga's Gandan Monastery to allay the encroaching, syphilis-induced blindness of the Eighth Jebtsundamba, who died in 1924. This figure was destroyed in the years of revolution that followed but has been recently replaced with another colossus, also paid for by subscription.

85. Pander, *Lalitavajra's Manual,* 40. I have not been able to find a reference to the Mañjuśrī figure in this temple and wonder if this could not be the same gigantic Mañjuśrī on lionback at Wanshoushan. Pander describes the emperor as sitting "on a fabulous Ch'ilin, guarded by two attendants, one of them portrayed as a Hui hui (Mohamedan)."

86. See, for example, *Yonghegong tangka guibao* (Beijing: Zhongguo minzu yingshe yishu chubanshe, 1998), 99.

87. See Wang Xiangyun, "Tibetan Buddhism at the Court of Qing," 293.

88. Tibetan dance rituals were first introduced to the Qing court, where they were also actively performed, in

1752. A Qing court document asserts that the dances were done in front of the Zhongzheng Hall sometime between the 27th and 29th day of the 12th month. The performance required 184 lamas, who chanted the *Sutra for the Protection of the Dharma* (*Baofa jing*). Twenty-eight other lamas impersonated the constellations and twelve more took on other roles, including that of a deer (an accomplice of Yamāntaka). The evil to be exorcised was embodied, in the palace performances, in a figure of grass (much like the "duplicates" sent to the grave in the place of human victims in the Zhou dynasty; the document uses the same term, "*ou*," or double, to refer to them). According to the biography of the Seventh Panchen Lama, *'cham*-style dance was introduced to the palace from Tashilunpo. See Wang Jiapeng, "Qinggong Zangchuan fojiao wenhua kaocha," 143–144. Wang also details other esoteric activities having exorcistic ends, such as the creation of sand mandalas and the making of magical pills, on p. 143.

89. However Inner Asian these rites might have been, they also excited the people of Beijing. According to Dun Lichen's *Yanjing suishi ji:* "The beating of devils was originally a Buddhist practice of the western borderlands, and has nothing particularly strange about it. It is the same as the custom coming down from olden times of the exorcism of evil spirits at the nine gates (of the Capital). Each year at the time of the Devil Beating, the Lama priests all dress themselves up as deities of Heaven, so as to drive out the evil devils. So many are the people of the Capital who go to look on, that it appears as if ten thousand families had deserted the streets." See Derk Bodde, trans., *Annual Customs and Festivals in Peking* (Hong Kong: Hong Kong University Press, 1965), 10. See also Wang Jiapeng, "Qinggong Zangchuan fojiao wenhua kaocha," 96. Other kinds of exorcism went on in the Yonghegong on a regular basis, especially the Vedic-derived *homa* fire sacrifice (a favorite throughout the Qianlong period), which only occasionally served the purpose of subduing demons and overcoming enemies. (It could also be used to appease or propitiate deities, especially horrific tutelary deities and *dharmapalas*, but also the better-natured god of wealth, Vaiśravaṇa, entreated to increase prosperity.) Lessing provides a detailed eyewitness account of a two-hour-long *homa* fire sacrifice that took place on the stage-like porch of the original Yonhe Palace, the building that gave its name to the whole monastery. He describes the rite as doubled—involving sacrifice to Agni, the god of fire, as well as to the deity whose attention is sought. Variations in intent were signaled by changing the color of the stepped triangular, brick fire wall protecting the officiant and altering the shape of the mandalic fire altar, which could be respectively white and round (for propitiation), yellow and square (for prosperity), red and crescent-shaped (for subduing demons), or black and triangular (for defeating enemies). See Lessing, *Yung-ho-kung*, 150–161.

90. Wang Jiapeng, "Qinggong Zangchuan fojiao wenwu kaocha," 148.

91. Jean Baudrillard, "The System of Collecting," trans. Roger Cardinal, in John Elsner and Roger Cardinal, eds., *The Cultures of Collecting* (Cambridge, Mass.: Harvard University Press, 1994), 24; excerpted from *The System of Objects*, trans. James Benedict (London: Verso, 1996), 105.

92. Harold Kahn, "A Matter of Taste: The Monumental and Exotic in the Qianlong Reign," in Ju-hsi Chou and Claudia Brown, eds., *The Elegant Brush* (Phoenix: Phoenix Art Museum, 1985), 296.

93. Baudrillard, "System of Collecting," 13.

Chapter 5: Pious Copies

1. The term was coined by Hillel Schwartz in his study of the Western fascination with simulacra of all sorts: *The Culture of the Copy: Striking Likenesses, Unreasonable Facsimiles* (New York: Zone Books, 1996). Schwartz, however, finds this fascination tinged with desperation. He quotes, for example, William Gaddis—"all the desperate variety of which counterfeit is capable"—as his first epigraph (p. 11), an emotional response that seems absent from the proliferation of copies in Qing China.

2. Lydia Liu points out that "despite its antiquity as a Chinese word, the classical Chinese term *wenhua* carries none of the modern ethnographic connotations of 'culture' now associated with the word. In its earlier usage, *wenhua* denoted the state of *wen* or artistic cultivation in contrast to *wu* or military prowess. The new ethnographic notion of *wenhua* did not enter the Chinese language until after *bunka*, the Japanese *kanji* transla-

tional equivalent of 'culture,' was borrowed back by the Chinese at the turn of the twentieth century." See Lydia Liu, *Translingual Practice: Literature, National Culture, and Translated Modernity. China, 1900–1937* (Stanford: Stanford University Press, 1995), 239.

3. The five court painters were Chen Mei, Sun Gu, Jin Kun, Dai Hong, and Cheng Zhidao. For the history of the original painting and its many copies see Roderick Whitfield, "Chang Tse-tuan's Ch'ing-ming shang-ho t'u" (Ph.D. dissertation, Princeton University, 1966). For the Qing court copy see especially pp. 151–176 and Na Chih-liang, *Qingming shanghe tu* (Taipei: Gugong congkan, 1977).

4. Stephen H. West, "Memory, Ritual, and Orality in Court: Huizong's Birthday Ceremony in the 1120's" (Colloquium, Center for Chinese Studies, University of California, Berkeley, November 19, 1999).

5. Michael Camille, "Simulacrum," in Robert S. Nelson and Richard Shiff, eds., *Critical Terms for Art History* (Chicago: University of Chicago Press, 1996), 39. Camille is referring to Fredric Jameson's argument about contemporary film as simulacra, which treat "the past as a nostalgic referent rather than a focus of action," but his comment is remarkably apt in the context of late imperial Chinese painting practice. See Fredric Jameson, *Postmodernism, or the Cultural Logic of Late Capitalism* (Durham: Duke University Press, 1991), 18.

6. See *Bidian zhulin, juan* 1; *Bidian zhulin, xubian*, 1a–13b.

7. On the issue of replication, the substitutability of replicas, and effects of copying on meaning see Whitney Davis, *Replications: Archaeology, Art History, Psychoanalysis* (University Park: Pennsylvania State University Press, 1996), 4. Davis' idea that the meaning of an object "is constructed cumulatively and recursively—a pro- and retrospective 'activation'—in and through the structure and history of its replication" is particularly applicable to the Buddhist case.

8. Maxwell K. Hearn, "Document and Portrait: The Southern Tour Paintings of Kangxi and Qianlong," in Ju-hsi Chou and Claudia Brown, eds., *Chinese Painting Under the Qianlong Emperor, Phoebus* 6, no. 1 (1988): 98.

9. Ibid., 99.

10. The entire set is reproduced in *Gugong shuhua tulu* (Taipei: National Palace Museum, 1994), vol. 13, 147–148 (Śākyamuni seated on three grimacing demons) and 183–214 (the sixteen lohans).

11. *Bidian zhulin, xubian*, 139a–140a.

12. *Taishō,* no. 2030. The text has been annotated and translated by Sylvain Lévi and Edouard Chavannes, "Les Seize Arhat Protecteurs de la Loi," *Journal Asiatique* 8 (July–August 1916): 5–50; (September–October 1916): 189–304. Rolpay Dorje's list is not a simple rearrangment of Nandimitra's, however, but introduces new characters and eliminates others:

 1. Piṇḍola-Bharadvāja becomes Aṅgaja
 2. Kanakavatsa becomes Ajita
 3. Kanaka-Bharadvāja becomes Vanavāsin
 4. Subinda becomes Kālika
 5. Nakula becomes Vajrīputra
 6. Bhadra stays Bhadra
 7. Kālika becomes Kanakavatsa
 8. Vajrīputra becomes Kanaka-Bharadvāja
 9. Supaka becomes Bakula
 10. Panthaka becomes Rāhula
 11. Rāhula becomes Cūḍapanthaka
 12. Nāgasena becomes Piṇḍola-Bharadvāja
 13. Iṅgada becomes Panthaka
 14. Vanavāsin becomes Nāgasena

15. Ajita becomes Gopaka
16. Cūḍapanthaka becomes Abheda

Even Nandimitra's list does not explain some of the peculiarities of Guanxiu's order—at least, not as it was understood in the last years of the Ming dynasty, when the artist Wu Bin made a set of copies of the Shengyin Monastery set. Either he or someone else added the names of the lohans in Chinese characters; none of these transliterations agrees with the Qianlong list, and a few have names that do not seem to appear on either Nandimitra's or Qianlong's list, including Nandimitra himself, who is Wu Bin's sixteenth and final lohan. These Wu Bin copies were in Qianlong's collection and have careful inscriptions on the mounts noting the name changes made by his "imperial order." See Figure 41a–c; see also *Bidian zhulin, xubian,* 56b–57a.

13. In a classic lohan hall, two sets of eight or nine lohans sit on either side and the visitor walks between them. This arrangement either mimics or was the source for the typical layout of patriarchs' portraits in a Chan-style lineage hall, where chronological order is staggered—beginning on the right of the main image of Bodhidharma, then passing to the left, then right, and so on. There, however, the inherent structure has to do with descent of the dharma from generation to generation. In a lohan hall, a group of contemporaneous, long-lived adepts simultaneously act out their role as protectors of the dharma from outposts that are widely separated in space.

14. Li Zhonglu, "Qianlong yu zan shiliu luohan shanfeng," *Zijin cheng* 57 (1990): 21–26.

15. Ibid.

16. Ibid., 21. The author quotes the *Fazhuji ji suoji aluohan kao,* 145.

17. See, for example, the *Third Worthy One, Piṇḍola-bharadvāja,* 1764, ink rubbing of a stone engraving (Art Institute of Chicago), in Marsha Weidner, ed., *Latter Days of the Law* (Lawrence, Kans.: Spencer Museum of Art; Honolulu: University of Hawai'i Press, 1994), 262–264. Amy McNair, author of the catalog entry, notes that Qianlong also believed the Shengyin Monastery lohans to have been the set originally in the collection of the Northern Song emperor Huizong (r. 1101–1127). See the catalog of his collection, *Xuanhe huapu,* preface dated 1120 (Taipei: Yishu congbian ed., 1962), *juan* 3, 73–74. This bit of information is recorded on the image of another of the lohan copies, depicting Nandimitra.

18. For Guanxiu's biography see Richard M. Barnhart, in Herbert Franke, ed., *Sung Biographies: Painters,* Münchener Ostasiatische Studien, no. 17 (Wiesbaden: Franz Steiner, 1976), 55–61. A major biographical source is *Yizhou minghua lu,* a record of late Tang–Five Dynasties painters in the state of Shu.

19. For a history of lohan painting in China see Richard K. Kent, "Depictions of the Guardians of the Law: Lohan Painting in China," in Weidner, *Latter Days of the Law,* 182–213.

20. See Beata Grant, *Mount Lu Revisited: Buddhism in the Life and Writings of Su Shih* (Honolulu: University of Hawai'i Press, 1994), 39, 169–171. She quotes "Shiba da luohan song," *Su Shi wenji* (Beijing: Zhonghua shuju, 1986), vol. 2, 586–591; and "Zhuangbei luohan qian Ouyang fushu," *Su Shi wenji,* vol. 5, 1909. Su Shi was the inspiration for another huge lohan-related project Qianlong began in 1756, recorded in his "Record of the Five-Hundred-Lohan Hall at Wanshoushan." At Wanshoushan in the summer palace, Yuanmingyuan, he constructed a lohan hall with five hundred figures and cited the originals he had seen on his southern tour in Qiantang. Su Shi's *Chanyuan wubai lohan ji* provided most of the information the emperor had on the original project, leading him to speculate that every place could have its own five hundred lohans. The lohans, he argued, had begun as Hinayāna figures and then moved out to become the guardians of the law in all four quarters. Subsequently they traveled to Qiantang and from there, with imperial help, on to Wanshoushan. Qianlong's long "Record," complete with descriptions of the lohans, appears in *Bidian zhulin, xubian,* 4a–7b.

21. Richard Vinograd, *Boundaries of the Self: Chinese Portraits, 1600–1900* (Cambridge: Cambridge University Press, 1992), 101–126. Vinograd discusses portraits based on Guanxiu's lohans, including one of Ding Jingshen, a famous antiquarian and seal carver.

22. Ibid., 125.

23. Wu Hung, *The Double Screen* (Chicago: University of Chicago Press, 1996), 221–236; Harold Kahn, *Monarchy in the Emperor's Eyes: Image and Reality in the Ch'ien-lung Reign* (Cambridge, Mass.: Harvard University Press, 1971), 260–262, and "A Matter of Taste: The Monumental and Exotic in the Qianlong Reign," in Ju-hsi Chou and Claudia Brown, *The Elegant Brush: Chinese Painting Under the Qianlong Emperor, 1735–95* (Phoenix: Phoenix Art Museum, 1985), 288–302.

24. See E. H. Gombrich, *Art and Illusion: A Study in the Psychology of Pictorial Representation* (Princeton: Princeton University Press, 1960).

25. This is a significant concept in Vinograd's *Boundaries of the Self.* A similar slippage between what was truly ancient and what could be represented as ancient is also apparent in the proliferation in late Ming of handbooks designed to teach the tasteless the art of connoisseurship, which Craig Clunas has addressed so astutely in *Superfluous Things: Material Culture and Social Status in Early Modern China* (Urbana: University of Illinois Press, 1991).

26. For Dong Qichang's abilities as a connoisseur in light of contemporary practices see Richard Barnhart, "Tung Ch'i-ch'ang's Connoisseurship of Sung Painting and the Validity of His Historical Theories: A Preliminary Study," in Wai-kam Ho and Hin-cheung Lovell, eds., *Proceedings of the Tung Ch'i-ch'ang International Symposium* (Kansas City: Nelson-Atkins Museum of Art, 1991), 11.1–11.20.

27. The issue of transcribing sounds properly was intensely important to the Manchus. Qianlong complains repeatedly about the inadequacy of the Chinese language as a vehicle for conveying non-Chinese sounds, and he worries about the impact of this imprecision on the ritual performance of mantras and *dhāraṇī*. See, for example, Thukwan, *Biography of Rolpay Dorje*, 187.

28. Jan Nattier has suggested that the *Heart Sutra* itself was a Chinese apocryphal text. See "The *Heart Sutra*: A Chinese Apocryphal Text?" *Journal of the International Association of Buddhist Studies* 15, no. 2 (1992): 153–223.

29. By the time the supplement to *Bidian zhulin* was completed in 1793, the emperor had collected nine works by Wu Bin, six of which depicted lohans.

30. James Cahill, *The Distant Mountains: Chinese Painting of the Late Ming Dynasty, 1570–1644* (New York: Weatherhill, 1982), 222–223.

31. Ibid.

32. The set is reproduced in *Gugong shuhua tulu*, vol. 8, 289–320, and listed in *Bidian zhulin, xubian*, 56b.

33. Barnhart, "Tung Ch'i-ch'ang's Connoisseurship," 11.4–11.5.

34. *Bidian zhulin, xubian*, 138a. The Manchu love of puns carried over into visual arts as well, particularly in their appreciation and rhetorical use of *jixiang tu*, auspicious rebuses or embedded visual puns, for which see Chapter 2. See also Terese Tse Bartholomew, *Myths and Rebuses in Chinese Art* (San Francisco: Asian Art Museum, 1988).

35. *Bidian zhulin, xubian*, p. 138b.

36. Ibid., 142a. The painting is now in the National Palace Museum, Taiwan; see *Gugong shuhua tulu*, vol. 13, 149–150.

37. *Bidian zhulin, xubian*, 139b.

38. See especially Ding's *Five Transformations of Guanyin*, a handscroll in which Guanyin is revealed in five different forms, the last an ancient haglike lohan wearing white robes and seated in a cave. The painting is in the collection of the Nelson-Atkins Museum, Kansas City. See, for example, Weidner, *Latter Days of the Law*, 360–362, cat. 49, and pl. 26.

39. *Gugong shuhua tulu*, vol. 13, 151–182.

40. See Wen Fong, *The Lohans and a Bridge to Heaven* (Washington, D.C.: Freer Gallery of Art, 1958).

41. *Gugong shuhua tulu*, vol. 13, 379–424.

42. Ibid., vol. 13, 414.

43. Catalog entry by Gilles Béguin, in Marylin Rhie and Robert Thurman, *Wisdom and Compassion* (San Francisco: Asian Art Museum; New York: Tibet House, 1991), 118–119, cat. 19.

44. Jackson, *History of Tibetan Painting*, especially 289–299, figs. 148–157, pls. 61–62.

45. Ibid., 264, 259–282.

46. Tucci's magisterial treatment of lohan painting in Tibet is still the most comprehensive; see Giuseppe Tucci, *Tibetan Painted Scrolls* (Rome: Libreria dello Stato, 1949), vol. 2, 555–581.

47. Ibid., 561.

48. *Bidian zhulin, xubian*, 4a–7b.

49. See, for example, Tucci, *Tibetan Painted Scrolls*, vol. 2, 560.

50. For the two thangkas see Christopher Bruckner, *Chinese Imperial Patronage* (London: Christopher Bruckner, Asian Art Gallery, n.d.). For the Pule Temple thangka, now in the Palace Museum, Beijing, see p. 20 (upper left) and *Qinggong Zangchuan fojiao wenwu*, pl. 32. The Yonghegong version is on p. 21 (lower left). The Qianlong portrait statue appears in *Beijing gucha mingsi* [Ancient monasteries in Beijing] (Beijing: China Esperanto Press, 1995), 60.

51. Scholarship on the *Long Roll* is vast. Some of the classic literature on the painting includes, for example, Li Lin-ts'an, *Nanchao Daliguo xin ziliaode zonghe yanjiu,* Institute of Ethnology, Academia Sinica, Monograph 9 (Taipei: Academia Sinica, 1967); reprinted with color plates as well as additional material on the Ding Guanpeng version of the scroll (Taipei: National Palace Museum, 1982). See also Sekiguchi Masayuki, "On the Buddhist Images Painted by Chang Sheng-wen of the Ta-li Kingdom," *Kokka* 895 (1966): 9–21 and 898 (1967): 11–27. See also the detailed, four-part study by Helen B. Chapin, later revised by Alexander Soper, which appeared in *Artibus Asiae* and was subsequently published as a separate work, *A Long Roll of Buddhist Images* (Ascona, Switz.: Artibus Asiae, 1972).

52. For Qianlong's inscription on the *Long Roll* see *Bidian zhulin, xubian*, 25a–26a; *Gugong shuhua lu* (Taipei: National Palace Museum, 1965), *juan* 4, 80–81. For his inscription on Ding Guanpeng's copy see *Bidian zhulin, xubian*, 136b–137b.

53. Chapin, *Long Roll*, 70–71.

54. My rendition is indebted to Helen Chapin's, which was partially edited by Alexander Soper. The original text appears in *Gugong shuhua lu*, 80–81.

55. See Chapin, *Long Roll*, 20. For Zhang Zhao's biography see, for example, Arthur W. Hummel, *Eminent Chinese of the Ch'ing Period* (Washington, D.C.: Government Printing Office, 1943), 24–25.

56. See Chapin, *Long Roll*, pl. 34, where Acuoye Guanyin appears hovering in the flame-shaped aureole of the main figure.

57. English rendition again indebted to Chapin and Soper. For the whole see *Gugong shuhua lu*, 80–81.

58. Published completely in Xu Yujun and Zheng Guo, eds., *Fajie yuanliu tu: Jieshao yu xinshang* [Source and Flow of the Dharma-World Scroll: Introduction and appreciation] (Hong Kong: Commercial Press, 1992).

59. Recorded in *Bidian zhulin, xubian*, 136b–137b.

60. Ibid.

61. One of the most famous of these is the quadrilingual 1792 stele at the Yonghegong, Beijing, where Qianlong acknowledges that his adherence to Tibetan Buddhism was the subject of criticism specifically by (Han) Chinese, but only in the Manchu-language version. See Lessing, *Yung-ho-kung*, vol. 1, 56–62.

62. See William J. Koenig, *The Burmese Polity, 1752–1819: Politics, Administration, and Social Organization in the Early Kon-baung Period*, Michigan Papers on South and Southeast Asia, no. 34 (Ann Arbor: University of Michigan, Center for South and Southeast Asian Studies, 1990), 17–22.

63. Thukwan, *Biography of Rolpay Dorje*, 322–323.

64. Dan Martin, "Banpo Canons and Jesuit Cannons: On Sectarian Factors Involved in the Ch'ien-lung Emperor's Second Goldstream Expedition of 1771–1776. Based Primarily on Some Tibetan Sources," *Tibet Journal* 15 (1990): 3–28. The incident is also recorded in Thukwan, *Biography of Rolpay Dorje*, 331–332.

65. Martin, "Banpo Canons and Jesuit Cannons," 8.

66. Ibid., 10.

67. Qianlong's incarnate status as Mañjughoṣa is mentioned often in Rolpay Dorje's biography. (See especially pp. 181 and 187 [*gāthā*] in the Chinese translation, where Rolpay Dorje confirms Qianlong's identity as a transformation body of Mañjuśrī.) See also Farquhar, "Emperor as Bodhisattva," which traces this identification back to the posthumous recognition of Khubilai Khan as Mañjuśrī in the Mongolian versions of the Juyong Gate inscriptions, dated 1345. The Ming Yongle emperor (r. 1403–1424) also sought this status for his deceased father, the Ming founder and Hongwu emperor (r. 1368–1399).

68. *Pishamen yigui*, Taishō, no. 1249.

69. See *Fajie yuanliu tu*, 1. This second copy is not recorded in *Bidian zhulin*, despite the fact that the supplement to the catalog was not completed until 1793, a year after Li Ming finished his version.

70. Wu Hung has called these representations of active images "meta-images." They were a regular category in Chinese Buddhist art from at least the fifth century. See Wu Hung, "Rethinking Liu Sahe: The Creation of a Buddhist Saint and the Invention of a 'Miraculous Image,' " *Orientations* 27, no. 10 (November 1996): 32–43.

71. Alexander Soper's translation in his comments to Chapin, *Long Roll*, 14.

72. Edwin O. Reischauer, *Ennin's Travels in T'ang China* (New York: Ronald Press, 1955), 200.

73. Just ten years later he built her the Baoxianglou in the Forbidden City, with a different play on the name.

74. Wang Jiapeng, "Qianlong yu Manzu lama siyuan," *Gugong bowuyuan yuankan* 67, no. 1 (1995): 58–65. Wang describes the entire site surrounding the Baodi Monastery as populated by Manchu monks.

75. "Shuxiangsi," in Qing Gaozong, *Collected Works*, vol. 5, *juan* 11, 18b.

76. "Baoxiangsi beiwen," in Qing Gaozong, *Collected Works*, vol. 5, 409–410.

77. This same design was also used in the Pule Monastery at Chengde, dedicated to Cakrasaṃvara.

78. Eugen Pander, *Das lamaische Pantheon*, 53 (Sushama Lohia, trans., *Lalitavajra's Manual of Buddhist Iconography*, 40). I wonder if Pander has mistaken his temples here, taking the Baoxiangsi to be the Zhengjuesi (Monastery of Right Enlightenment; also known as the Zhenjuesi, Monastery of True Enlightenment). The Zhengjuesi, which he may be mistranslating here as Zhangjuesi, is west of the capital's Xizhimen, located to the east of the Wanshousi (Monastery of Ten Thousand Long Lives), another extravagant, Tibetan-style present Qianlong had built for his mother. The emperor's stele for the repair of the Zhengjuesi, written in

1761, makes no mention of any statue of Mañjuśrī. Instead he concentrates on the major focus of the restoration work, the construction of a five-buddha pagoda in Indian style, which he says represents the Buddha's ideas (or mind) while images represent his body and the sutras his speech. This pagoda provides an alternative name for the monastery: Wutasi (Five Pagoda Monastery). See *Zhongxiu Zhengjuesi beiwen,* in Zhang Yuxin, ed., *Qing zhengfu yu Lamajiao,* 407–408. Alternatively Pander may be referring to the Xiangjuesi (Monastery of Fragrant Enlightenment), one of the Badachu (Eight Great Sites) group of monasteries in the Western Hills. This monastery had a traveling palace that Qianlong used, as well as a complete edition of the Manchu Kanjur, and it was staffed by Manchu monks. See *Beijing gucha mingsi* (Beijing: China Esperanto Press, 1995), 46–47.

Heather Stoddard ties the copying of the Shuxiang Monastery Mañjuśrī to the emperor's renewed interest in Cakrasaṁvara and the Yoga of Inner Heat. She notes the near simultaneity of Qianlong's receiving teachings from Rolpay Dorje on Cakrasaṁvara at Chengde in 1765, after taking retreats there and at Wutaishan together. At that time the emperor decided to build the Pulesi—a large, mandalic temple to Cakrasaṁvara at Chengde designed to counteract the Śiva energy of the lingam-like Wash Club Peak that dominates the valley below. A few years later the Mañjuśrī was installed in the Western Hills—celebrated in Qianlong's 1767 poetic stele titled *Baoxiangsi shi bei* (Stele of the poem on the Baoxiang Monastery) and with days of tantric teachings, the last of which was Tsongkhapa's commentary on Cakrasaṁvara. See Heather Stoddard, "Dynamic Structures in Buddhist *Maṇḍalas*," *Artibus Asiae* 58, nos. 3–4 (1999): 212.

79. See L. C. Arlington and William Lewisohn, *In Search of Old Peking* (Peking: Henri Vetch, The French Bookstore, 1935), 135; and Damcho Gyatsho Dharmatāla, *Rosary of White Lotuses,* 418. Dharmatāla provides an earlier date, 1665, for the establishment of the Sandalwood Monastery. His history of Mongolian Buddhism also highlights the degree to which the Sandalwood Buddha was both a point of pilgrimage and obeisance to the throne in the Qing dynasty. He notes, among other episodes, that the Sixth Panchen Lama dutifully paid homage to the image right after he arrived in Beijing (p. 308). He also observes that the "precious Jowo Rinpoche [is] inseparable from the real Buddha." Likewise, Alexei Pozdneyev reports that it was at the Sandalwood Monastery that Zanabazar and his patron the Kangxi emperor sat together on the same mat—a historic moment that enabled the two to envision themselves as reflections of Phagpa and Khubilai. See Pozdneyev, *Mongolia and the Mongols*, 333. Moreover, Pozdneyev says that Zanabazar's incarnation, the Second Jebtsundamba, specifically requested permission to worship the Sandalwood Buddha, which Qianlong granted (p. 342). Finally, Pozdneyev's diary attests to the lasting attraction of the Sandalwood Buddha. On November 14, 1892, he met two Mongol foot travelers near the Khangai Range who told him they were on their way to Beijing to worship at the Sandalwood Monastery (p. 399). Eight years later, it had been turned into barracks for the Boxers and was subsequently destroyed. The fate of the image is not known.

80. See *Tsan dan jo bo'i lo rgyus skor tshad phan yon mdor bsdus rin po che'i phreng ba* [Precious garland of the authentic, beneficial, and concise account of the Sandalwood Buddha], in Rolpay Dorje, *gSung-'bum* [Complete works] (Beijing: n.p., n.d.), vol. 7. Rolpay Dorje bases his retelling on the classic tale of Maudgalyāyana and on another story of Central Asian origin concerning a king named Udrayana.

81. Pander, *Das lamaische Pantheon* (Sushama Lohia, trans.), 40, fn. 12.

82. Dharmatāla, *Rosary of White Lotuses,* 418. Another classic telling of the tale is in the *Zuo Fo xing xiang jing, Taishō,* no. 692; see Robert H. Sharf, "The Scripture on the Production of Buddha Images," in Donald S. Lopez Jr., ed., *Religions of China in Practice* (Princeton: Princeton University Press, 1996), 261–267. For a thorough study of the "true image" in Japan see Donald McCallum, *Zenkōji and Its Icon: A Study in Medieval Japanese Religious Art* (Princeton: Princeton University Press, 1994); Gregory Henderson and Leon Hurvitz, "The Buddha of Seiryoji: New Finds and New Theory," *Artibus Asiae* 19, no. 1 (1956): 5–55. For the greater history of the image in Asia and China see Alexander Soper, *Literary Evidence for Early Buddhist Art in China* (Ascona, Switz.: Artibus Asiae, 1959); and Martha L. Carter, *The Mystery of the Udayana Buddha*, suppl. 64 agli Annali, vol. 50, fasc. 3 (Naples: Instituto Universitario Orientale, 1990). Carter recounts two separate stories that are conflated in Rolpay Dorje's version.

Chapter 6: Resemblance and Recognition

1. As quoted in Chinese in Wang Jiapeng, "Minzu tuanjie di lishi chuan—Liu Panchan huaxiang," *Zijin cheng* 1 (1990): 11.

2. Clements Robert Markham, *Narratives of the Mission of George Bogle to Tibet* (London: Trubner, 1879), 83.

3. Ibid., 82–84.

4. Terese Bartholomew, citing *Gugong bowuyuan yuankan* 12 (1992), says these two pictures were done the day the Panchen Lama arrived in Chengde.

5. Zhongguo diyi lishi dang'an and Zhongguo Zangxue yanjiu zhongxin, *Liushi Panchan chaojin dang'an xuanbian* (Beijing: Zhongguo Zangxue chubanshe, 1996), Neiwufu Zaobanchu documents 334 and 433.

6. Yang Xin, "Court Painting in the Yongzheng and Qianlong Periods of the Qing Dynasty," in Ju-hsi Chou and Claudia Brown, eds., *The Elegant Brush* (Phoenix: Phoenix Art Museum, 1985), 345, 349.

7. David Jackson, *A History of Tibetan Painting* (Vienna: Verlag der Österreichischen Akademie der Wissenschaften, 1996), 219–246.

8. Ibid., 52.

9. Ibid., 53, citing 13a–14d; transliterated text is in his app. J.

10. Narthang produced many more woodblock series besides the Panchen Lama lineage portraits, including a life of Tsongkhapa and a complete version of the "Hundred Tales," or *Avadāna Kalpālata* (Tib: *dPag bsam 'khri shing*), a set of moral stories and *jatakas* told in verse by the Kashmiri poet Kṣemendra. With the patronage of the imperial treasurer Losang Konchog Chinwang Phuntshog Dorje (Blo bzang dkon mchog, Cin wang Phun tshogs rdo rje) and his sons and ministers, the monastery also published a huge iconography, the *Five Hundred Gods of Narthang*, in 1810, still an authoritative source for Buddhist artists. See Lokesh Chandra, *Buddhist Iconography* (New Delhi: International Academy of Indian Culture and Aditya Prakashan, 1991), 39–40.

11. Giuseppe Tucci, *Tibetan Painted Scrolls* (Rome: Libreria dello Stato, 1949), vol. 2, 412–417 and figs. 90–105.

12. *Liushi Panchan chaojin dang'an xuanbian*, document 34.

13. Ibid., document 56.

14. Ibid., documents 119–120.

15. Jackson, *History of Tibetan Painting*, 237, fig. 118.

16. See, for example, Stephen Batchelor, *The Tibet Guide: Central and Western Tibet* (Boston: Wisdom, 1998), 238–239.

17. Wen Fong et al., *Possessing the Past: Treasures from the National Palace Museum, Taipei* (New York: Metropolitan Museum; Taipei: National Palace Museum, 1996), 331–332.

18. David Jackson notes that a set of thirteen rebirth-lineage thangkas of the Panchen Lama were offered by the Qing emperor, most likely Qianlong, in 1796 and enshrined in the 'Dra thang lha khang (portrait-thangka chapel) at Tashilunpo. See Jackson, *History of Tibetan Painting*, 366, fn. 809. Jackson cites bKras dgon lo rgyus rtsom 'bri tshogs chung [Tashilunpo Historical Committee], *dPal gyi chos sde chen po bkra shis hun po* (Lhasa: Bod ljongs mi dmangs dpe skrun khang, 1992). Qianlong also owned a set of thirteen Dalai Lama lineage portraits in the somewhat more restrained Lhasa Menri style. In an important article, Wang Zheng has shown how these portraits came to serve as political barometers. He points out that the portrait of the Sixth Dalai Lama, which Rolpay Dorje identified in 1761 on imperial order, is included and that the Sixth is specifically identified as such in the inscriptions in four languages attached to the back, despite earlier Manchu refusal

to recognize his legitimacy. The last one in the series is the Seventh, shown in monk's clothes. Hence it must postdate 1727, when he was initiated. Rolpay Dorje's reexamination of the set in 1761 came after establishment of Qing control in Tibet (with the help of the Sixth Panchen Lama) and after the evaporation of Mongol influence in Tibet. Qianlong paid particular attention to the choice of the new Eighth Dalai Lama in 1757, when he deputized Rolpay Dorje to oversee the discovery and selection of the spirit boy. The earlier crisis of succession—which came about because of the long-concealed death of the Great Fifth by his regent (and putative son) and the scandalous life and mysterious death of the Sixth Dalai Lama—had also passed, as the Gelukpa and the Manchus reached a moment of what Wang terms "tacit agreement." See Wang Zheng, "Luetan 'Dalai Lama yuanliu' di lishi jiezhi," *Gugong bowuyuan yuankan* 62, no. 4 (1993): 79–87. This was not to last, however. In his *Lama Shuo* of 1792, Qianlong once again excised the Sixth Dalai Lama from the lineage, lowering everyone's generation after him by one.

19. Charles Bawden, trans., *The Jebtsundamba Khutukhtus of Urga* (Wiesbaden: Otto Harrassowitz, 1961), 52.

20. *Chiyue ershiyi ri Panchan E Erdeni zhi Bishushanzhuang,* summer Qing Gaozong, *Collected Works*, vol. 8, *juan* 76, 2a.

21. The new Dalai Lama was not enthroned until 1762. From 1757 to 1762 he remained under the control of his court-appointed regent, the Seventh Demo Khutukhtu.

22. Thukwan, *Biography of Rolpay Dorje*, 258–262, tells the story of Rolpay Dorje's visit to Tashilunpo after the selection of the Eighth Dalai Lama.

23. Ibid., 210.

24. The Inner Mongolian lama Damtsho Gyatsho Dharmatāla's late-nineteenth-century account of the events surrounding the Panchen's trip surprisingly follows Thukwan's almost word for word, even in the way the text skims over his sudden death in two sentences. Dharmatāla's text may well be lifted directly from Thukwan. (He included a translation of Rolpay Dorje's translation manual in his work.) See Dharmatāla, *Rosary of White Lotuses*, trans. Piotr Klafkowski, 300–311 (354–369 in the original manuscript). The Khalkha Mongols had a particularly close relationship with the Panchen Lamas that began with Zanabazar's famous dream in which he envisioned the Panchen as dead and, using magical means, rushed to Tibet in a matter of days where he was able to revive him with a mandala offering. See Bawden, *The Jebtsundamba Khutukhtus*, 46–48.

25. Schuyler Cammann, "The Panchen Lama's Visit to China: An Episode in Anglo-Tibetan Relations," *Far Eastern Quarterly* 9, no. 1 (1949): 15.

26. Anne Chayet, *Les temples de Jehol et leurs modèles tibétains* (Paris: Éditions Recherche sur les Civilisations, 1984), 48–50.

27. The division of labor in preparing for the Panchen's visit literally spanned all the workshops of the Forbidden City, including those that specialized in Chinese-style and Tibetan-style objects. Artists from Qianlong's personal quarters in the Yangxindian participated, as well, assuring his close supervision of every step in the preparation process.

28. *Liushi Panchan chaojin dang'an xuanbian*, document 3.

29. Ibid., document 1.

30. Ibid., document 2.

31. Ibid., document 10.

32. Zhang Yuxin, *Qing zhengfu yu lamajiao* (Xuchang, Henan: Xizang renmin chubanshe, 1988), 463–464.

33. These various modes of similitude recall Michel Foucault's description of the "sixteenth-century mind"; see *The Order of Things* (New York: Vintage Books, 1970), especially 17–44. By the seventeenth and eighteenth centuries, Foucault argues, this sort of creation of meaning through resemblance had largely been discarded

in favor of a view that valued language only as discourse (p. 43). Qianlong appears to have held both views simultaneously.

34. Chayet, *Les temples de Jehol*, 105.

35. See, for example, Huang Hao, *Zai Beijing di Zangzu wenwu* (Beijing: Minzu chubanshe, 1993), 68–69.

36. Chayet, *Les temples de Jehol*, 72.

37. *Baoxiangsi beiwen*, in Zhang Yuxin, *Qing zhengfu yu lamajiao*, 409–410.

38. In later dictionaries (*Cihai* and *Minzu cidian*, for example), "*chaojin*" is defined as "pilgrimage" and offered as a direct translation of the Arabic "*al-hadj*," the pilgrimage to Mecca. Ning Chia suggests that it was the role of the emperor as bodhisattva which lent the term its religious overtones, since early uses of the term seem to carry strictly political weight. See Ning Chia, "The Lifanyuan and the Inner Asian Rituals in the Early Qing (1644–1795)," *Late Imperial China* 14, no. 1 (June 1993): 64 and fn. 17. There is a rich literature in English on tribute to the Qing court. See, for example, James Hevia, "Sovereignty and Subject: Constructing Relations of Power in Qing Imperial Ritual," in Tani E. Barlow and Angela Zito, eds., *Body, Subject, and Power in China* (Chicago: University of Chicago Press, 1994), 181–200; and James Hevia, *Cherishing Men from Afar: Qing Guest Ritual and the Macartney Embassy of 1793* (Durham: Duke University Press, 1995).

39. Arjun Appadurai, ed., *The Social Life of Things* (Cambridge: Cambridge University Press, 1986); Igor Kopytoff, "The Cultural Biography of Things: Commoditization as Process," in Appadurai, *The Social Life of Things*, 64–91.

40. *Qinggong Zangchuan fojiao wenwu*, pls. 131–132.

41. A concept recorded in the nineteenth-century history written (or collated) by Dharmatāla, *Rosary of White Lotuses*, 221.

42. Appadurai's term; see *The Social Life of Things*, 38.

43. Li Li, "Hou Jin zhi Qing chu shiqi hailei di shiyong," *Gugong bowuyuan yuankan* 50, no. 4 (1990): 89–93. Li notes that there are numbers of military conches in the collection of the Shengyang Palace Museum, Liaoning.

44. *Liushi Panchan chaojin dang'an xuanbian*, document 431, dated Qianlong 45, 10th month, 28th day.

45. This famous incident is illustrated in a series of originally thirty (now twenty-five) Tibetan-made thangkas once owned by the Ming Chenghua emperor, whose inscription, dated 1480, appears on the third scroll. See *Thangka, Buddhist Painting of Tibet: Biographical Paintings of 'Phags-pa* (Beijing: New World Press and People's Publishing House of Tibet, 1987), 66–67, pl. 10-1.

46. One of the earliest gifts the Zaobanchu prepared for the Panchen Lama incorporated a white conch into a set of the eight auspicious things. See *Liushi Panchan chaojin dang'an xuanbian*, document 6, dated Qianlong 43, 12th month, 20th day (February 7, 1779).

47. "In the 45th year of Qianlong [1780], Panchen Erdeni forwarded a greatly beneficial right-turning white conch that guards the safety of crossing rivers and seas, in the hope that all affairs be concluded without hindrance. [It has] inconceivable merit and virtue." For a reproduction of the label see *Qinggong Zangchuan fojiao wenwu*, 174, 242, and pl. 130-1, 2.

48. *Falei zan* [In praise of the dharma conch]: "Conch of the expansive sea, tool of India's heaven. / Used to sound the chant—whole words, half words. / Śākyamuni plucks a flower—flute, drum and zither. / To the ten directions, throughout the three ages—different sounds, the same sounds. / Put it to rest, display its brightness, / Use the broad, greater vehicle and take universal refuge in the Buddha's excellence." See Qing Gaozong, *Collected Works*, vol. 1, *juan* 44, 7b–8a. For the mounted Chengde conch see Wang Jiapeng et al., *Buddhist Art from Rehol*, 152–153.

49. Huang Hao, *Zai Beijing di Zangzu wenwu*, 70–71.

50. This sort of cunning material masquerade was typical of court productions, where ceramics, for example, were glazed to resemble wood, metal, lacquer, jade, and even woven silk.

51. Another black-ground thangka is reproduced in Henmi Baiei, *Man-Mō ramakyō bijutsu zuhan* [Illustrations of lamaist art of Manchuria and Mongolia] (Tokyo: Shiryo-hen, 1943); translated into Chinese as *Man Meng lamajiao meishu tuban* (Taipei: Hsin Wen-geng, 1979), pl. 3.1.

52. Qing Gaozong, *Collected Works*, vol. 8, *juan* 76, 4b–5a.

53. *Liushi Panchan chaojin dang'an xuanbian*, document 319, original in Manchu; and document 372, in Chinese.

54. Ibid., document 479.

55. Of them the Zhenjue Temple stupa, which dated to 1473, was the earliest. Others included the Biyun Temple (1748) and the Miaogao Pagoda.

56. Heather Karmay, *Early Sino-Tibetan Art* (Warminster, England: Aris & Phillips, 1975), 92–93. Karmay documents that it was Ming Yongle who sent a miniature stone and wood replica of the Bodhgayā temple complex to Tibet. She also notes that one such model—comprising twenty-one separate buildings and inscribed "Donated in the Yongle reign of the Great Ming"—wound up at Narthang, while several other models "belonging to the same group and bearing the same inscription" were found in the former residence of a prince who reigned before the Phag mo gru period, located between rTse thang and sMing gro gling.

57. The entire text of the *Qingjing huacheng ta ji* [Record of the Clear and Pure Transformation Wall Pagoda] is cited in Zhang Yuxin, *Qing zhengfu yu lamajiao*, 470–473.

58. Ludwig translates this sentence as: "How is it that you don't know, that by pointing out the images and speculating on their origin, you will not be able to obtain the proofs of enlightenment?" See Ernest Ludwig, *The Visit of the Teshoo Lama to Peking* (Peking: Tientsin Press, 1904), 31.

59. Franke and Laufer, *Epigraphische Denkmäler*, Mappe I, pl. 12.

60. Qianlong identifies the first patriarch as Bodhidharma in his own commentary to the poem, where he also cites his parting *gāthā*. See Qing Gaozong, *Collected Works*, vol. 8, *juan* 71, 15b.

61. Cuttings from this original tree were lovingly cultivated in China, so the species was known if not widely propagated. Their leaves were used for paintings—often of lohans—and for writing sutras. Examples written by Qianlong himself survive.

62. *Gu xi shuo* [On "Rare Since Ancient Times"], in Qing Gaozong, *Collected Works*, vol. 8, *juan* 77, 2b–3a.

63. *Gu xi* [Rare Since Ancient Times], in Qing Gaozong, *Collected Works*, vol. 8, *juan* 80, 1a–b.

64. Presiding over all these momentous final events was Heshen, the young Manchu parvenu who caught the emperor's eye in 1775 and solidified his standing in the aftermath of the Panchen Lama's death. Among the memorials and other documents that surround the Panchen's coming and going, Heshen's name is notably absent until the lama's demise. Other border specialists—such as Fukang'an (Heshen's good friend) and the great, incorruptible general Agui—appear to have managed most of the lama's triumphant passage from Tashilunpo to Chengde and on to Beijing while Heshen was on special assignment in Yunnan. But it was Heshen who managed the rest.

Glossary

Acuoye Guanyin　阿嵯耶觀音

Anxi　安西

Ba-ha-da-la　拔哈達喇

baimiao　白描

Ban Gu　班固

Baodi　寶諦

Baoxianglou　寶相樓

Baoxiangsi　寶相寺

Beihai　北海

bi　璧

Bian　汴

Bidian zhulin　秘殿珠林

Bidian zhulin sanbian　秘殿珠林三編

Bidian zhulin xubian　秘殿珠林續遍

Bishefou Fo　毗舍浮佛

Bishujian　秘書監

Bishushanzhuang　避暑山庄

biyi　筆意

Budong Fo　不動佛

Bu'er tu　不二圖

Bukong Jingang　不空金剛

ce　冊

chan　禪

Chanyue Dashi　禪月大師

Chanyue ji　禪月記

chaogong　朝貢

chaohua　朝話

chaojin　朝覲

chen　臣

Chen Mei　陳枚

Chen Xiaomu　陳孝沐

Chengde　承德

Cheng Zhidao　程志道

Chuhuang　楚黃

chun　椿

Chunhuamen　春華門

ci　賜

ci long bao ye　慈隆寶葉

Cining Gong　慈寧宮

Cishan　慈善

Ciyinlou　慈蔭樓

Da Aluohan jing Nandimiduoluo suo shuofazhuji
　大阿蘿漢難提密多蘿所説法住記

Da Buwei tancheng jing　大怖畏壇城經

Daci fawang　大慈法王

Da Fotang　大佛堂

dagui　打鬼

Dahongtai　大紅臺

Dai Hong　戴洪

Dali　大理

Da Longshan Huguosi　大隆善護國寺

Da Qing huidian　大清會典

Dashengge　大乘閣

Dashi　大士

Da Xitian　大西天

de　德

Dengchun huaji　鄧椿畫繼

Deshousi　德壽寺

Detai　德泰

di　遞

di danshuke　遞丹書克

Dingfeng zhi bao　定風之寶

Dingguang Jiezhu　定光界珠

Ding Guanpeng　丁觀鵬

Ding Yunpeng　丁雲鵬

dishi　帝師

Dishi　帝師

dizou　遞奏

Dong Gao　董誥

Dongjing meng Hua lu　東京夢華錄

Dongling　東陵

Dong Qichang　董其昌

Dongshan　東山

Dong Yuan　董源

Douzan 抖贊

Dujian 獨健

duobaoge 多寶閣

du shi wu liang 度世無量

Erhai 耳海

Fajie yuanliu tu 法界源流圖

fan 梵

Fanfulou 梵福樓

Fanhualou 梵華樓

fanseng 梵僧

fansheng 梵聲

fanyu 梵苑

fang 仿

Fayuan zhulin 法苑珠林

fei yi fei er 非一非二

fomu 佛母

Foshuo zaoxiang liangdu jing jie 佛說造像量度
 經解

Foxiangge 佛香閣

fu[1] 蝠

fu[2] 福

fu[3] 賦

Fukang'an 福康安

gong'an 公案

Gongbu Chabu 工布查布

gongfeng 供奉

gongjin 恭進

Guandi 關帝

Guan Laoye 關老爺

Guan Wuliangshou fo jing 觀無量壽佛經

Guanxiu 貫休

Guanyin 觀音

Guan Yu 關羽

Guan Yunchang 關雲長

guohua 國話

guoshi 國師

Gu Qiyuan 顧起元

gu xi[1] 古希

gu xi[2] 古稀

Hanshan Deqing 憨山德清

Hanshu 漢書

Heshen 和珅

Hongli 弘曆

Hou Li 後理

hua 畫

huahuaren 畫畫人

huangdi 皇帝

Huang Tingjian 黃庭堅

huaqiang 畫匠

Huguo jing 護國經

huixiang[1] 回向

huixiang[2] 回響

Huizongsi 匯宗寺

Hu Jing 胡敬

huofo 活佛

Hu Shijie 胡世杰

Jianguo Guanshiyin pusa 建國觀世音菩薩

jiao 交

Jiaqing 嘉慶

Jilong 濟隆 or 吉龍

Jinchuan 金川

jing 經

jingang 金剛

Jingdao 璟島

Jin Kun 金昆

Jinling fancha zhi 金陵梵剎志

Jin Nong 金農

jinshi 進士

Jin Shisong 金士松

jin zhashi lima Wuliangshou fo yizun 進扎什利
 瑪無量壽佛一尊

jiu 九

jiu[1] 久

jiu[2] 柩

Jiudu Fomu 救度佛母

jixiang tu 吉祥圖

Jiyunlou 吉雲樓

juan 卷

Juyongguan 居庸關

Kangxi 康熙

kaozheng 考正

kesi 緙絲

Lama Shuo　喇嘛說

Lang Shining　郎世寧

Laoshan　牢山

Lengyanjing　楞嚴經

Liang Qingbiao　梁清標

Liang Shizheng　梁詩正

Lifanyuan　理藩院

Li Gonglin　李公麟

Lijiang　麗江

Li Lin-ts'an　李霖燦

lima　利瑪

Li Ming　黎明

lin　臨

lingjiu　靈柩

Lin Tinggui　林庭珪

Linxiting　臨溪亭

Li Zhen *huangdi piaoxin*　利真皇帝驃信

Li Zongwan　勵宗萬

Longde　隆德

Longzang　龍藏

Lu Can　陸粲

Lu Lengjia　盧楞伽

Lülü zhengyi houbian　律呂正義後編

luohan　羅漢

Luo Ping　羅聘

Manwang li fo tu　蠻王禮佛圖

Ma Yunqing　馬雲卿

Miao　苗

Miaoguang　妙光

Mi Fu　米芾

mingwang　明王

Mi Wanzhong　米萬鐘

mizhou　密咒

mo　模

Mouqindian　懋勤殿

Mu　牧

Naluoyan Ku　那羅延窟

Nanshufang　南書房

Nanxun shengdian　南巡盛典

Nanzhao tuzhuan　南詔圖傳

Nayancheng　那彥成

Neifu　內府

Neiwubu chenliesuo shuhua mulu　內務部陳列所書畫目錄

Neiwufu　內務府

nian fo　念佛

Ni Zan　倪瓚

ou　偶

Peiwenzhai shuhua pu　佩文齋書畫譜

Peng Yuanrui　彭元瑞

Pilu fo tancheng jing　昆盧佛壇城經

Pishamen yigui　毗沙門儀軌

Pudusi　普渡寺

Pule　普樂寺

Pumenpin　普門品

Puming yuanjue　普明圓覺

Puning　普寧寺

Pusading　菩薩頂

Putuozongchengmiao　普陀宗乘廟

Qianlong　乾隆

Qian lu　錢錄

Qianqing Gong　乾清宮

Qifota　七佛塔

Qin'an Dian　欽安殿

Qing　清

Qingdao　青島

Qinghe shuhua fang　清河書畫舫

Qinghua　清話

Qingliang Dashi　清涼大士

Qingming shanghe tu　清明上河圖

Qingningsi　慶寧寺

Qiye tang　七葉堂

qiyun　氣韻

ren sheng qi shi gu lai xi　人生七十古來稀

renwang　仁王

Renwang jing　仁王經

Ruan Yuan　阮元

ruixiang　瑞像

rujin　入覲

Rulin waishi　儒林外史

ruyi　如以

Ruyiguan　如以館

Sanjiao heyi　三教合一

Sanqingshen　三清神

Sanshi Fo　三世佛

Sanshi Juemu　三世覺母

san yi yi san　三一一三

Sekiguchi Masayuki　關口正之

seshen　色身

seyun　色蘊

shang　賞

shangdeng　上等

Shangle　上樂

Shen Chu　沈初

Shengjing Gugong shuhua lu　聖京故宮書畫錄

Shengwuji　聖武記

Shengyin Monastery　聖因寺

Shengzu Ren　聖祖仁

shenhui　神會

shentong　神通

shi　十

Shiliu luohan jing　十六羅漢經

Shiqu baoji　石渠寶

Shiqu Ge　石渠閣

shi yi shi er　是一是二

　bu ji bu li　不即不離

　ru ke mo ke　需可墨可

　he cong he si　何匆何思

Shiyin ji　失音記

Shizong Xian　世宗憲

Shizu Zhang　世祖章

shou　壽

Shu　蜀

shu　書

Shuijing zhu　水經注

Shunzhi　順治

Shuxiangsi　殊像寺

si　死

Siku quanshu　四庫全書

Sishier jiang jing　四十二章經

siti　四體

Song Lian　宋濂

Songzhusi　嵩祝寺

Sun Gu　孫祜

Su Shi　蘇軾

Tang Taizong　唐太宗

Tang Xuanzong　唐玄宗

Tianqin　天親

tieluo　貼落

tu　圖

Waibamiao　外八廟

wan　萬

Wanfaguiyi　萬法歸一

wan fo　萬佛

Wanfuge　萬福閣

Wang Jie　王杰

Wang Youdun　王由敦

Wang Yuanqi　王原祁

Wanshandian　萬善殿

wanshou　萬壽

Wanshou shengdian　萬壽盛典

Wanshuyuan　萬樹園

wei[1]　緯

wei[2]　偽

Weituo　韋馱

Wei Yuan　魏源 (1794–1856)

wen　文

wenhua　文化

Wofosi　臥佛寺

wu　武

Wu Bin　吳彬

Wu Daozi　吳道子

Wu huang ershiba xiu zhenxing tu　五皇二十八
　宿真形圖

Wuliangshou zun fo　無量壽尊佛

Wutaishan　五臺山

Wuti Qingwen jian　五體清文鑑

wuwei　無為

Wuzhu　無著

xiang　像

Xiangshan　香山

Xianlou　仙樓

Xianruoguan　咸若館

Xiaosheng　孝聖

xie　寫

Xifan huifa　西番繪法

Xiling　西陵

xinggong　行宮

Xinuange　西暖閣

Xipeilou　西配樓

Xiqing biji　西清筆記

Xiqing gujian　西清古鑑

Xiqing yanpu　西清硯譜

Xiujishanzhu　修積善住

Xixiang tu　洗象圖

Xuanhe huapu　宣和畫譜

Xumifushou　須彌福壽

Xu Yang　徐揚

Yangxindian　養心殿

Yao Wenhan　姚文瀚

Yiheyuan　頤和園

Yinchen　胤禎

yingtang　影堂

Yinlu　胤祿

yipin　逸品

Yong'ansi　永安寺

Yonghegong　雍和宮

Yongzheng　雍正

Youningsi　佑寧寺

Yuhuage　雨花閣

Yuhuashi　雨花室

Yuling　裕陵

Yulu　語錄

Yu Minzhong　于敏中

Yunguanglou　雲光樓

Yunjian　雲間

yuti　御題

zan　讚

Zaobanchu　造辦處

Zaoxiang liangdu jing　造像量度經

zeng　贈

Zhang Chou　張丑

Zhangjia　章嘉 or 張家

Zhang Ruo'ai　張若靄

Zhang Sengyou　張僧繇

Zhang Shengwen　張勝溫

Zhang Tingyu　張廷玉

Zhang Zeduan　張擇端

Zhang Zhao　張照

Zhantan fo　旃檀佛

zhao　照

Zhao Mengfu　趙孟頫

Zhaomiao　昭廟

zhashi　扎什

Zhengjuesi　正覺寺

zhenru　真如

Zhenshen Guanshiyin pusa　真身觀世音菩薩

zhi　帙

Zhizhu xinyin　智珠心印

zhongbo　中博

Zhongzhengdian　中正殿

Zhou Jichang　周季常

Zhuang Qinwang Yinlu　莊親王胤祿

Zhufo pusa miaoxiang minghao jingzhou　諸佛菩薩妙相名號經咒

Zhufo pusa shengxiang zan　諸佛菩薩聖像贊

Zhulin qixian　竹林七賢

Zifou　紫浮

zuguo　祖國

Zunsheng fomu　尊勝佛母

Bibliography

Sources in Asian Languages

Ban Gu. *Qian Hanshu* [History of the Former Han]. Sibu beiyao series. Edited by Yan Shigu. Shanghai: Zhonghua shuju, 1936.

Baozang [Precious deposits]. 5 vols. Beijing: Chaohua chubanshe, 2000.

Beijing gucha mingsi [Ancient monasteries in Beijing]. Beijing: China Esperanto Press, 1995.

bKras dgon lo rgyus rtsom 'bri tshogs chung [Tashilunpo Historical Committee]. *dPal gyi chos sde chen po bkra shis lhun po* [Tashilunpo, a great monastic center]. Lhasa: Bod ljongs mi dmangs dpe skrun khang, 1992.

Dalai Lama V. Ngag dbang blo bzang rgya mtsho (1617–1682). *gSung 'bum* [Collected works]. Gangtok: Sikkim Research Institute, 1993.

———. *Gnas brtan bcu drug gi mchod pa rgyal bstan 'dzad med nor bu* [Inexhaustible jewel of the victorious teaching of veneration of the sixteen elders]. In *gSung 'bum* [Collected works], vol. 12 *(na)*.

Fo shuo zuo fo xing xiang jing [Sutra on the production of buddha images]. Taishō Tripitaka, vol. 16, no. 692.

Fo zang jiyao [Compilation of Buddhist treasuries]. Chengdu: Bashu shudian, 1993.

Gugong bowuyuan tulu [Pictorial record of calligraphies and paintings in the Palace Museum]. Taipei: Guoli Gugong bowuyuan, 1989–1999.

Gugong shuhua lu [Record of paintings and calligraphy in the Palace Museum]. Taipei: National Palace Museum, 1944.

Guoli Gugong bowuyuan cixiu [Embroideries in the National Palace Museum]. Tokyo: Gakken; Taipei: National Palace Museum, 1970.

Hanshan Dashi mengyu ji [Record of Master Hanshan's dream journey]. Taipei: Chen-shan-mei, 1967.

Henmi Bai'ei. *Chūgoku ramakyō bijutsu taikan* [Overview of Chinese lamaist art]. Tokyo: Tokyo Bijutsu, 1975.

———. *Man-Mō ramakyō bijutsu zuhan* [Illustrations of lamaist art of Manchuria and Mongolia]. Shina bunkashi seki zokushu, Dai 2. Tokyo: Shiryo-hen, 1943. Translated into Chinese as *Man Meng lamajiao meishu tuban*. Taipei: Hsin Wen-geng, 1979.

He Yu et al. *Neiwubu chenliesuo shuhua mulu* [Catalog of paintings and calligraphy in the exhibition department of the Imperial Household]. 10 vols. Beijing: Jinghua yinshu chu, 1925.

Huang Hao. *Zai Beijing di Zangzu wenwu* [Cultural relics of the Tibetans in Beijing]. Beijing: Minzu chubanshe, 1993.

Huang Xiufu. *Yizhou minghua lu* [Record of famous paintings of Yizhou]. Yingyin Wenyuange Siku quanshu, fasc. 821. Taipei: Taiwan shangwu yinshuguan, 1983.

Jagchid, Sechin [Zhaqi Sijin]. "Manzhou tongzhixia Menggu shenquan fengjian zhidu di jianli" [The establishment of the Manchu-controlled Mongolian feudal system of incarnation]. *Gugong wenxian* 2, no. 1 (1970): 1–18.

Jiang Huaiying et al. *Xizang Budalagong xiushan gongcheng baogao* [Report on the restoration of the Potala Palace in Tibet]. Beijing: Wenwu chubanshe, 1994.

Jinliang, ed. *Shenjing Gugong shuhua lu* [Record of calligraphy and painting in the Old Palace at Shenjing]. Preface dated 1913. Yishu congbian, vol. 21. Taipei: Shijie shuju, 1962.

Kohara Hironobu. "Kenryū Kōtei no gagaku ni tsuite" [On the Qianlong emperor's connoisseurship]. *Kokka* 1079 (January 1985): 9–25; 1081 (March 1985): 35–43; 1082 (April 1985): 33–41.

lCang skya II, Ngag dbang blo bzang chos ldan (1642–1714), ed. *dPal brtan chen po bcu drug gi mchod brgya la bstan 'dzad med nor bu;* also titled in Chinese *Shiliu luohan jing* [Sixteen lohan sutra]. Beijing: Longshan huguo si, 1711. Collection of the East Asian Library, University of California, Berkeley.

lCang skya III, Rolpa'i rdo rje (1717–1786). *Tsan dan jo bo'i lo rgyus skor tshad phan yon mdor bsdus rin po che'i phreng ba* [Precious garland of the authentic, beneficial, and concise account of the Sandalwood Buddha]. In *gSung 'bum* [Collected works], vol. 7. Beijing: n.p., n.d.

———. *Zhabs brtan* [Feet firm rites]. In *gSung 'bum* [Collected works], vol. 4. Beijing: n.p., n.d.

Li Guoqiang. "Qiannian gushuye poso junchen xunxun xie Xinjing" [The *Heart Sutra* sincerely written on the leaves of a thousand-year-old bodhi tree]. *Zijin cheng* [Forbidden City] 68, no. 1 (1992): 22–25.

Li Guoying. "Lun Yongzheng yu dandao" [On Yongzheng and the elixir path]. In *Qingdai gongshi congtan* [Conference on the history of the Qing palace], edited by Wang Shuxiang, 175–189. Beijing: Zijincheng chubanshe, 1996.

Li Li. "Hou Jin zhi Qing chu shiqi hailei di shiyong" [The function of conches in the Latter Jin and early Qing periods]. *Gugong bowuyuan yuankan* [Palace Museum Journal] 50, no. 4 (1990): 89–93.

Li Lin-ts'an. *Nanchao Daliguo xin ziliaodi zonghe yanjiu* [Study of the Nan-chao and Ta-li kingdoms in light of art materials found in various museums]. Institute of Ethnology, Academia Sinica, Monograph 9. Taipei: Academia Sinica, 1967. Reissued with color plates, Taipei: National Palace Museum, 1982.

Li Taoyuan, ed. *Shuijing zhu* [Commentary on the Waters Classic]. Guoxue jiben congshu. Shanghai: Shangwu yinshuguan, 1933.

Li Zhonglu. "Qianlong yu zan shiliu luohan shanfeng" [The sixteen lohan screen with Qianlong's imperial encomium]. *Zijin cheng* [Forbidden City] 57 (1990): 21–26.

Luo Wenhua. "Gugong Yuhuage shenxi yu mizong sibu yanjiu" [Research into the lineages of deities and the four divisions of the tantras in the Old Palace's Pavilion of Raining Flowers]. *Foxue yanjiu* [Buddhist studies research] 6 (1997): 8–12.

———. "Gugong zang Menggu tong fo zaoxiang yanjiu—shilun Yishi Jebutsundanba shiqi fo zaoxiang yishu fengge di laiyuan" [Research on the Mongolian bronze buddha images collected in the Palace Museum—a discussion of the origins of the artistic style of buddha images during the period of the First Jebtsundamba]. *Gugong bowuyuan yuankan* [Palace Museum Journal] no. 2 (1999): 81–87.

———. "Yuhuage thangka bianxi—jian 'Zhufo Pusa shengxiang zan' zhi guanxi" [Analysis of the thangkas in the Pavilion of Raining Flowers—their relationship to the *Zhufo Pusa shengxiang zan*]. Unpublished manuscript, 2000.

Mizong wubai foxiang kao [Five hundred buddha images of the esoteric lineages]. In *Fo zang jiyao* [Compilation of Buddhist treasuries]. Chengdu: Bashu shudian, 1993.

Murata Jirō, ed. *Kyoyōkan* [Juyong Gate]. Kyōto: Kyōto Daigaku Kogakubu, 1957.

Na Chih-liang. *Qingming shanghe tu* [Spring festival on the river picture]. Taipei: Gugong congkan, 1977.

Nandimitra. *Da Aluohan jing Nandimiduoluo suo shuofazhuji* [Record of the decline of the dharma according to the great lohan Nandimitra]. Taishō Tripitaka, vol. 49, no. 2030.

Nie Chongzheng. *Qing gongting huihua* [Qing-dynasty palace painting]. Hong Kong: Commercial Press, 1996.

Oshibuchi Hajime. *Manshū hiki kō* [Investigation into Manchu stele inscriptions]. Tokyo: n.p., 1943.

Ou Chaogui. "Jieshao liangfu Ming Qing tangka" [Introducing two Ming-Qing thangkas]. *Wenwu* 11 (1985): 79–81.

Pishamen yigui [Rules for the rite of Vaiśravaṇa]. Taishō Tripitaka, vol. 21, no. 1249.

Qinding Bidian zhulin, Shiqu baoji, sanbian [Imperially ordered Beaded Grove of the Secret Hall and Precious Bookbox of the Stone Drain, part 3]. Taipei: Guoli Gugong bowuyuan, 1969.

Qinding Bidian zhulin, Shiqu baoji, xubian [Imperially ordered Beaded Grove of the Secret Hall and Precious Bookbox of the Stone Drain, supplement]. N.p.: Kaiping Danshi Ouzhai yingyin, 1948.

Qinding Da Qing huidian [Imperially ordered statutes of the great Qing] (Jiaqing reign). Beijing: Wuyingdian, 1818.

Qinding nanxun shengdian [Imperially ordered Magnificent record of the southern tours] (Qianlong reign, 1764). Beijing: Beijing guji chubanshe, 1996.

Qingdai gongting huihua [Qing-dynasty palace painting]. Beijing: Wenwu chubanshe, 1992.

Qing Gaozong (r. 1736–1795). *Qing Gaozong yuzhi shiwen quanji* [Qing Gaozong, collected works]. 10 vols. Taipei: National Palace Museum, 1976.

Qing gongting baozhuang yishu [The imperial packing art of the Qing dynasty]. Beijing: Zijincheng chubanshe, 2000.

Qinggong Zangchuan fojiao wenwu [Cultural relics of Tibetan Buddhism collected in the Qing palace]. Beijing: Zijincheng chubanshe, 1992.

Qing Shilu [Veritable records of the Qing]. Beijing: Zhonghua shuju, 1985.

Qing Shizong (r. 1723–1735). *Yongzheng yuxuan yulu* [Yongzheng's imperially selected discourse records]. Taipei: Ziyou chubanshe, 1967.

Sekiguchi Masayuki. "Dairikoku Chō Shōon ga Bonzō ni tsuite" [On the Buddhist images painted by Chang Sheng-wen of the Ta-li kingdom]. *Kokka* 895 (1966): 9–21; 898 (1967): 11–27.

Shen Chu. *Xiqing biji* [Record of Xiqing Hall]. Preface by Ruan Yuan. Shanghai: Shangwu yinshuguan, 1936.

Shi'er chao Donghua lu [Twelve dynasties' record of Donghua]. Taipei: Wenhai chubanshe, 1963.

Shiqu baoji [Precious bookbox of the stone drain]. Facsimile reproduction of an original manuscript copy. Taipei: National Palace Museum, 1971.

Su Shi. *Su Shi wenji* [Collected works of Su Shi]. Beijing: Zhonghua shuju, 1986.

Taishō shinshū daizōkyō [Newly restored Tripitaka of the Taishō era]. Edited by Junjiro Takakusu and Taikyoku Watanabe. Tokyo: Taishō Issaikyō Kankōkai, 1924–1932.

Thu'u bkwan blo bzang chos kyi nyi ma. *lCang skya Rol pa'i rdo rje'i rnam thar* [Biography of Rolpay Dorje]. In *Collected Works of Thu'u bkwan blo bzang chos kyi nyi ma*, vol. 1 *(ka)*. Edited by Ngawang Gelek Demo; introduction and English summary by E. Gene Smith. Gedan Sungrab Minyam Gyunphel Series, vol. 1. New Delhi: n.p., 1969.

———. *Zhangjia Guoshi Ruobi Duoji zhuan* [Biography of the National Preceptor Rolpay

Dorje]. Translated into Chinese by Chen Jingying and Ma Dalong. Beijing: Minzu chubanshe, 1988.

Wang Jiapeng. "Gugong Yuhuage tanyuan" [Inquiry into the origins of the Pavilion of Raining Flowers]. *Gugong bowuyuan yuankan* [Palace Museum Journal] 47 (1990): 50–62.

———. "Minzu tuanjie di lishi chuan—Liu Panchan huaxiang" [Historical scroll that united the people—a painted portrait of the Sixth Panchen). *Zijin cheng* [Forbidden City] 1 (1990): 11.

———. "Qianlong yu Manzu lama siyuan" [Qianlong and Manchu lama monasteries]. *Gugong bowuyuan yuankan* [Palace Museum Journal] 67, no. 1 (1995): 58–65.

———. "Qinggong Zangchuan fojiao wenhua kaocha" [Investigation into Tibetan Buddhist culture in the Qing palace]. In *Qingdai gongshi congtan* [Conference on Qing-dynasty palace history], ed. Wang Shuxiang, 135–152. Beijing: Zijincheng chubanshe, 1996.

———. "Zhongzhengdian yu Qinggong Zangchuan fojiao" [The Hall of Central Uprightness and Tibetan-style Buddhism in the Qing palace]. *Gugong bowuyuan yuankan* [Palace Museum Journal] 53, no. 2 (1991): 58–71.

Wang Jiapeng et al. *Qinggong mizang: Chengde Bishushanzhuang Zang chuan fojiao wenwu tezhan tulu* [Buddhist art from Rehol: Tibetan Buddhist images and ritual objects from the Qing-dynasty summer palace at Chengde]. Taipei: Jeff Hsu's Oriental Art, 1999.

Wang Shuxiang, ed. *Qingdai gongshi congtan* [Conference on Qing-dynasty palace history]. Beijing: Zijincheng chubanshe, 1996.

Wang Yuegong. "Qing Shizong chanhua—luelun Yongzhengdi shi chanxue sixiang ji zaoyi" [The Chan sayings of Qing Shizong—a consideration of the Yongzheng emperor's Chan thought and attainments]. In *Qingdai gongshi congtan* [Conference on Qing-dynasty palace history], ed. Wang Shuxiang, 290–307. Beijing: Zijincheng chubanshe, 1996.

Wang Zheng. "Luetan 'Dalai Lama yuanliu' di lishi jieshi" [Brief discussion of the historical value of the *Dalai Lama's Source and Flow*]. *Gugong bowuyuan yuankan* [Palace Museum Journal] 62, no. 4 (1993): 79–87.

Wei Yuan. *Shengwuji* [Exalted military record]. Preface dated 1842. Beijing: Zhonghua shuji, 1984.

Xizang tangka [Tibetan thangkas]. Beijing: Wenwu chubanshe, 1985.

Xu Yujun and Zheng Guo, eds. *Fajie yuanliu tu: Jieshao yu xinshang* [*Source and Flow of the Dharma-World Scroll*: Introduction and appreciation]. Hong Kong: Commercial Press, 1992.

Xuanhe huapu [Painting register of the Xuanhe era]. Taipei: Yishu congbian, 1962.

Yang Boda. *Qingdai yuanhua* [Court painting of the Qing dynasty]. Beijing: Zijincheng chubanshe, 1993.

———. "Zhanabazha'er di liujintong zaoxiang yishu" [The art of Zanabazar's gilt bronze sculpture]. *Gugong bowuyuan yuankan* [Palace Museum Journal] 4 (1996): 59–65.

Yonghegong tangka guibao [Precious thangkas in the Yonghe Palace]. Beijing: Zhongguo minzu yingshe yishu chubanshe, 1998.

Yu Jianhua. *Zhongguo gudai hualun leibian* [Collection of Chinese art theories]. Beijing: Renmin meishu, 2000.

Yuan Hongqi. "Qianlong shiqi de gongting jieqing huodong" [Activities of invitation and welcome in the court of the Qianlong period]. *Gugong bowuyuan yuankan* [Palace Museum Journal] 53, no. 3 (1991): 81–87.

Zangwen cidian [Tibetan dictionary]. Beijing: Minzu chubanshe, 1995.

Zaoxiang liangdu jing [Sutra on iconometry]. Translated by mGon po skyabs. Taiwan: n.p., 1956. Also Taishō Tripitaka, vol. 21, no. 1419.

Zhang Hengyi. "Dzenyang jianding shuhua" [How to authenticate painting and calligraphy]. *Wenwu* 161, no. 3 (1964): 3–23.

Zhang Yuxin. *Qing zhengfu yu lamajiao* [The Qing government and lamaism]. Xuchang, Henan: Xizang renmin chubanshe, 1988.

Zhang Zhao and Liang Shizheng, eds. *Bidian zhulin.* In *Siku yishu congshu,* vol. 5. Shanghai: Shanghai guji chubanshe, 1991.

———. *Yuding Peiwenzhai shuhuapu.* In *Siku yishu congshu,* vols. 1–5. Shanghai: Shanghai guji chubanshe, 1991.

Zhaolian (1814–1826). *Xiaoting zalu* [Miscellaneous records of the Whistling Arbor]. Beijing: Zhonghua shuju, 1997.

Zhongguo diyi lishi dang'an guan and Zhongguo Zangxue yanjiu zhongxin. *Liushi Panchan chaojin dang'an xuanbian* [Selected archival documents of the Sixth Panchen's visit to court]. Beijing: Zhongguo Zangxue chubanshe, 1996.

Sources in Western Languages

Abé, Ryūichi. *The Weaving of Mantra: Kūkai and the Construction of Esoteric Buddhist Discourse.* New York: Columbia University Press, 1999.

Adorno, Theodore. *Notes to Literature.* Translated by Shierry Weber Nicholsen. New York: Columbia University Press, 1991–1992.

Appadurai, Arjun, ed. *The Social Life of Things: Commodities in Cultural Perspective.* Cambridge: Cambridge University Press, 1986.

Arlington, L. C., and William Lewisohn. *In Search of Old Peking.* Peking: Henry Vetch, The French Bookstore, 1935.

Aubin, Françoise, Gilles Béguin, et al. *Trésors de Mongolie, XVIIᵉ–XIXᵉ siècles.* Paris: Éditions de la Réunion des musées nationaux, 1993.

Barnhart, Richard. "Tung Ch'i-ch'ang's Connoisseurship of Sung Painting and the Validity of His Historical Theories: A Preliminary Study." In *Proceedings of the Tung Ch'i-ch'ang International Symposium,* ed. Wai-kam Ho and Hin-cheung Lovell. Kansas City: Nelson-Atkins Museum of Art, 1991.

Bartholomew, Terese Tse. *Myths and Rebuses in Chinese Art.* San Francisco: Asian Art Museum, 1988.

———. "Sino-Tibetan Art of the Qianlong Period from the Asian Art Museum of San Francisco." *Orientations* (June 1991): 34–45.

———. "Thangkas for the Qianlong Emperor's Seventieth Birthday." In *Cultural Intersections in Later Chinese Buddhism,* ed. Marsha Weidner. Honolulu: University of Hawai'i Press, 2001.

Bartlett, Beatrice S. *Monarchs and Ministers: The Grand Council in Mid-Ch'ing China, 1723–1820.* Berkeley: University of California Press, 1991.

Batchelor, Stephen. *The Tibet Guide: Central and Western Tibet.* Boston: Wisdom, 1998.

Baudrillard, Jean. *The System of Objects.* Translated by James Benedict. London: Verso, 1996.

Bawden, Charles, trans. *The Jebtsundamba Khutukhtus of Urga: Text, Translation, and Notes.* Asiatische Forschungen, vol. 9. Wiesbaden: Otto Harrassowitz, 1961.

Belting, Hans. *Likeness and Presence: A History of the Image Before the Era of Art.* Translated by Edmund Jephcott. Chicago: University of Chicago Press, 1994.

Berger, Patricia. "Preserving the Nation: The Political Uses of Tantric Art in China." In *Latter Days of the Law: Images of Chinese Buddhism, 850–1850,* ed. Marsha Weidner. Lawrence, Kans.: Spencer Museum of Art; Honolulu: University of Hawai'i Press, 1994.

Berger, Patricia, and Terese Tse Bartholomew. *Mongolia: The Legacy of Chinggis Khan.* San Francisco: Asian Art Museum; London: Thames & Hudson, 1995.

Beurdeley, Michel. *Peintres Jésuites en Chine au XVIIIe siècle.* Arcueil Cedex, France: Anthèse, 1997.

Beurdeley, Michel, and Cécile Beurdeley. *Giuseppe Castiglione: A Jesuit Painter at the Court of the Chinese Emperors.* London: Lund Humphries, 1972.

Beyer, Stephan. *The Cult of Tara: Magic and Ritual in Tibet.* Berkeley: University of California Press, 1973.

Bruckner, Christopher, et al. *Chinese Imperial Patronage: Treasures from Temples and Palaces.* London: Christopher Bruckner, Asian Art Gallery, n.d.

Bryson, Norman. *Vision and Painting: The Logic of the Gaze.* New Haven: Yale University Press, 1983.

Caffarelli, Paola Mortari Vergara. "International dGe-lugs-pa Style of Architecture from the 16th–19th Century." *Journal of the Tibet Society* 21, no. 2 (Summer 1996): 53–89.

Cahill, James. *The Compelling Image: Nature and Style in Seventeenth-Century Chinese Painting.* Cambridge, Mass.: Harvard University Press, 1982.

———. *The Distant Mountains: Chinese Painting of the Late Ming Dynasty, 1570–1644.* New York: Weatherhill, 1982.

Camille, Michael. "Simulacrum." In *Critical Terms for Art History,* ed. Robert S. Nelson and Richard Shiff. Chicago: University of Chicago Press, 1996.

Cammann, Schuyler. "The Panchen Lama's Visit to China: An Episode in Anglo-Tibetan Relations." *Far Eastern Quarterly* 9, no. 1 (1949): 3–19.

Carruthers, Mary. *The Book of Memory: A Study of Memory in Medieval Culture.* Cambridge: Cambridge University Press, 1990.

———. *The Craft of Thought: Meditation, Rhetoric, and the Making of Images, 400–1200.* Cambridge: Cambridge University Press, 1998.

Carter, Martha L. *The Mystery of the Udayana Buddha.* Suppl. 64 agli Annali, vol. 50, fasc. 3. Naples: Instituto Universitario Orientale, 1990.

Chandra, Lokesh. *Buddhist Iconography: Compact Edition.* New Delhi: International Academy of Indian Culture and Aditya Prakashan, 1991.

Chapin, Helen B. *A Long Roll of Buddhist Images.* Revised by Alexander Soper. Ascona, Switz.: Artibus Asiae, 1972. Originally appeared in *Artibus Asiae* 32, no. 1 (1970): 5–41; nos. 2–3 (1970): 157–199; no. 4 (1970): 259–306; 33, nos. 1–2 (1971): 75–142.

Chayet, Anne. *Les temples de Jehol et leurs modèles tibétains.* Paris: Éditions Recherche sur les Civilisations, synthèse 19, 1984.

Chayet, Anne, and Corneille Gest. "Le monastère de la Félicité tranquille, fondation impériale en Mongolie." *Arts Asiatiques* 46 (1991): 72–81.

Chen, Kenneth. "The Tibetan Tripitaka." *Harvard Journal of Asiatic Studies* 9 (1945): 53–62.

Chia, Ning. "The Lifanyuan and the Inner Asian Rituals in the Early Qing (1644–1795)." *Late Imperial China* 14, no. 1 (June 1993): 60–92.

Chou Ju-hsi and Claudia Brown, eds. *The Elegant Brush: Chinese Painting Under the Qianlong Emperor, 1735–95.* Phoenix: Phoenix Art Museum, 1985.

Clark, Walter Eugene. *Two Lamaistic Pantheons.* Harvard-Yenching Monograph Series, vols. 3–4. Cambridge, Mass.: Harvard University Press, 1937.

Cleary, Thomas, ed. *The Buddha Scroll.* New York: Shambhala, 1996.

Clunas, Craig. *Pictures and Visuality in Early Modern China.* Princeton: Princeton University Press, 1997.

———. *Superfluous Things: Material Culture and Social Status in Early Modern China.* Urbana: University of Illinois Press, 1991.

Crossley, Pamela. *The Manchus.* Cambridge, Mass.: Blackwell, 1997.

———. "Thinking About Ethnicity in Early Modern China." *Late Imperial China* 11, no. 1 (June 1990): 1–35.

———. *A Translucent Mirror: History and Identity in Qing Imperial Ideology.* Berkeley: University of California Press, 1999.

Davis, Richard H. *The Lives of Indian Images.* Princeton: Princeton University Press, 1997.

Davis, Whitney. *Replications: Archaeology, Art History, Psychoanalysis.* University Park: Pennsylvania State University Press, 1996.

Dharmatāla, Damcho Gyatsho. *Rosary of White Lotuses, Being the Clear Account of How the Precious Teaching of Buddha Appeared and Spread in the Great Hor Country.* Translated by Piotr Klafkowski. Asiatische Forschungen, vol. 95. Wiesbaden: Otto Harrassowitz, 1987.

Donato, Eugenio. "The Museum's Furnace: Notes Toward a Contextual Reading of *Bouvard et Pécuchet.*" In *Textual Strategies: Perspectives in Post-Structuralist Criticism,* ed. Josué Harari. Ithaca: Cornell University Press, 1979.

Dun Lichen. *Annual Customs and Festivals in Peking as Recorded in the Yen-ching Sui-shih-chi by Tun Li-ch'en.* Translated and annotated by Derk Bodde. Hong Kong: Hong Kong University Press, 1965.

Dunnell, Ruth. *The Great State of White and High: Buddhism and State Formation in Eleventh-Century Xia.* Honolulu: University of Hawai'i Press, 1996.

Eimer, Helmut, ed. *Transmissions of the Tibetan Canon.* Papers presented at a panel of the seventh seminar of the International Association for Tibetan Studies. Graz, 1995.

Elliott, Mark. "The Limits of Tartary." Paper given at the Center for Chinese Studies, Institute for East Asian Studies, University of California, Berkeley, March 1, 2000.

———. *The Manchu Way: The Eight Banners and Ethnic Identity in Late Imperial China.* Stanford: Stanford University Press, 2001.

Elsner, John, and Roger Cardinal, eds. *The Cultures of Collecting.* Cambridge, Mass.: Harvard University Press, 1994.

Everding, Karl-Heinz. *Die Präexistenzen der lCan skya Qutuqtus: Untersuchungen zur Konstruktion und historischen Entwicklung einer lamaistischen Existenzenlinie.* Asiatische Forschungen, vol. 104. Wiesbaden: Otto Harrassowitz, 1988.

Fairbank, John King, ed. *The Chinese World Order: Traditional China's Foreign Relations.* Cambridge, Mass.: Harvard University Press, 1968.

Farquhar, David. "Emperor as Bodhisattva in the Governance of the Ch'ing Empire." *Harvard Journal of Asiatic Studies* 38, no. 1 (1978): 5–35.

Feng Zhao. *Treasures in Silk.* Hong Kong: ISAT/Costume Squad, 1999.

Fisher, Robert E. *Buddhist Art and Architecture.* London: Thames & Hudson, 1993.

Fong, Wen. *The Lohans and a Bridge to Heaven.* Occasional Papers 3, no. 1. Washington, D.C.: Freer Gallery of Art, 1958.

Fong, Wen, and Maxwell K. Hearn, "Silent Poetry: Chinese Paintings in the Douglas Dillon Galleries." *Metropolitan Museum of Art Bulletin* 39, no. 3 (Winter 1981–1982).

Fong, Wen, et al. *Possessing the Past: Treasures from the National Palace Museum, Taipei.* New York: Metropolitan Museum; Taipei: National Palace Museum, 1996.

Forêt, Philippe. *Mapping Chengde: The Qing Landscape Enterprise.* Honolulu: University of Hawai'i Press, 2000.

Foucault, Michel. *The Order of Things: An Archaeology of the Human Sciences.* New York: Vintage Books, 1970.

Franke, Herbert, ed. *Sung Biographies: Painters.* Münchener Ostasiatische Studien, no. 17. Wiesbaden: Franz Steiner, 1976.

Franke, Otto, and Berthold Laufer. *Epigraphische Denkmäler aus China, erster Teil. Lamatische Klosterninschriften aus Peking, Jehol, und Si-ngan.* Berlin: n.p., 1914.

From Beijing to Versailles: Artistic Relations Between China and France. Hong Kong: Urban Council, 1997.

Gaekwad's Oriental Series. Baroda: Oriental Institute.

Goepper, Roger, Robert Linrothe, et al. *Alchi: Ladakh's Hidden Buddhist Sanctuary, the Sumstek.* Boston: Shambhala, 1996.

Gombrich, E. H. *Art and Illusion: A Study in the Psychology of Pictorial Representation.* Princeton: Princeton University Press, 1960.

Goodman, Nelson. *The Languages of Art.* Indianapolis: Hackett, 1976.

Grant, Beata. *Mount Lu Revisited: Buddhism in the Life and Writings of Su Shih.* Honolulu: University of Hawai'i Press, 1994.

Grünwedel, Arthur, ed. "Das Pantheon des Tschangtscha Hutuktu, ein Beitrag zur Iconographie des Lamaismus." *Veröffentlichungen aus dem königl. Museum für Völkerkunde* 1, nos. 2–3 (1890).

———. *Sbornik izobrazenii 300 burkanov.* St. Petersburg: Bibliotheca Buddhica, 1903.

Grupper, Samuel. "The Manchu Imperial Cult of the Early Ch'ing Dynasty: Texts and Studies on the Tantric Sanctuary of Mahākāla at Mukden." Ph.D. dissertation, Indiana University, 1979.

———. "Manchu Patronage and Tibetan Buddhism During the First Half of the Ch'ing Dynasty: A Review Article." *Journal of the Tibet Society,* no. 4 (1984): 46–75.

Guy, R. Kent. *The Emperor's Four Treasuries: Scholars and the State in the Late Ch'ien-lung Era.* Harvard East Asian Monographs, no. 129. Cambridge, Mass.: Council on East Asian Studies, Harvard University, 1987.

Gyatso, Janet, ed. *In the Mirror of Memory: Reflections on Mindfulness and Remembrance in Indian and Tibetan Buddhism.* Albany: State University of New York Press, 1992.

———. "Letter Magic: A Peircean Perspective on the Semiotics of Rdo Grub-chen's Dharani Memory." In *In the Mirror of Memory: Reflections on Mindfulness and Remembrance in Indian and Tibetan Buddhism,* ed. Janet Gyatso. Albany: State University of New York Press, 1992.

Hay, John. "The Body Invisible in Chinese Art." In *Body, Subject, and Power in China,* ed. Tani E. Barlow and Angela Zito. Chicago: University of Chicago Press, 1994.

———. "Subject, Nature, and Representation in Early Seventeenth-Century China." In *Proceedings of the Tung Ch'i-ch'ang International Symposium,* ed. Wai-ching Ho. Kansas City: Nelson-Atkins Museum of Art, 1992.

Hearn, Maxwell K. "Document and Portrait: The Southern Tour Paintings of Kangxi and Qianlong." In *Chinese Painting Under the Qianlong Emperor,* ed. Ju-hsi Chou and Claudia Brown. *Phoebus* 6, no. 1 (1988): 91–131.

Hearn, Maxwell K., and Judith G. Smith, eds. *Arts of the Sung and Yuan.* New York: Department of Asian Art, Metropolitan Museum of Art, 1996.

Heissig, Walther. "A Mongolian Source to the Lamaist Suppression of Shamanism." *Anthropos* 48 (1953): 1–29, 493–536.

———. *The Religions of Mongolia.* Translated by Geoffrey Samuel. London: Routledge & Kegan Paul, 1980.

Heissig, Walther, and Claudius C. Muller, *Die Mongolen.* Innsbruck: Pinguin-Verlag; Frankfurt: Umschau-Verlag, 1989.

Henderson, Gregory, and Leon Hurvitz. "The Buddha of Seiryoji: New Finds and New Theory." *Artibus Asiae* 19, no. 1 (1956): 5–55.

Hevia, James. *Cherishing Men from Afar: Qing Guest Ritual and the Macartney Embassy of 1793.* Durham: Duke University Press, 1995.

———. "Sovereignty and Subject: Constructing Relations of Power in Qing Imperial Ritual." In *Body, Subject, and Power in China,* ed. Tani E. Barlow and Angela Zito. Chicago: University of Chicago Press, 1994.

Ho Ping-ti. "In Defense of Sinicization: A Rebuttal of Evelyn Rawski's 'Reenvisioning the Qing'." *Journal of Asian Studies* 57, no. 1 (February 1998): 123–155.

Ho, Wai-ching, and Hin-cheung Lovell, eds. *Proceedings of the Tung Ch'i-ch'ang International Symposium.* Kansas City: Nelson-Atkins Museum of Art, 1992.

Hsu, Sung-peng. *A Buddhist Leader in Ming China: The Life and Thought of Han-Shan Te-Ch'ing.* University Park: Pennsylvania State University Press, 1979.

Hummel, Arthur W., ed. *Eminent Chinese of the Ch'ing Period.* Washington, D.C.: Government Printing Office, 1943.

Imaeda, Yoshiro. *Catalogue du Kanjur tibétain de l'édition de 'Jang Sa-tham.* Bibliographia philologica Buddhica Series maior, 2. Tokyo: International Institute for Buddhist Studies, 1982–1984.

Jackson, David. *A History of Tibetan Painting.* Vienna: Verlag der Österreichischen Akademie der Wissenschaften, 1996.

Jameson, Fredric. *Postmodernism, or the Cultural Logic of Late Capitalism.* Durham: Duke University Press, 1991.

Jing, Anning. "The Portraits of Khubilai Khan and Chabi by Anige (1245–1306), a Nepali Artist at the Yuan Court." *Artibus Asiae* 54, nos. 1–2 (1994): 49–86.

Kahn, Harold. "A Matter of Taste: The Monumental and Exotic in the Qianlong Reign." In *The Elegant Brush: Chinese Painting Under the Qianlong Emperor, 1735–95,* ed. Ju-hsi Chou and Claudia Brown. Phoenix: Phoenix Art Museum, 1985.

———. *Monarchy in the Emperor's Eyes: Image and Reality in the Ch'ien-lung Reign.* Cambridge, Mass.: Harvard University Press, 1971.

Kämpfe, Hans-Rainer. *Ñi ma'i od-zer/Naran-u-gerel: Biographie des 2 Pekinger Lcan skya-Qutuqtu Rol pa'i rdo rje (1717–1786).* Monumenta Tibetica Historica, sec. II, vol. 1. St. Augustin: VGH Wissenschaftsverlag, 1976.

Karmay, Heather. *Early Sino-Tibetan Art.* Warminster, England: Aris & Phillips, 1975.

Kent, Richard K. "Depictions of the Guardians of the Law: Lohan Painting in China." In *Latter Days of the Law: Images of Chinese Buddhism, 850–1850,* ed. Marsha Weidner. Lawrence, Kans.: Spencer Museum of Art; Honolulu: University of Hawai'i Press, 1994.

Koenig, William J. *The Burmese Polity, 1752–1819: Politics, Administration, and Social Organization in the Early Kon-baung Period.* Michigan Papers on South and Southeast Asia, no. 34. Ann Arbor: University of Michigan, Center for South and Southeast Asian Studies, 1990.

Kohara Hironobu. "The Qianlong Emperor's Skill in the Connoisseurship of Chinese Painting." In *Chinese Painting Under the Qianlong Emperor,* ed. Ju-hsi Chou and Claudia Brown. *Phoebus* 6, no. 1 (1988): 56–73.

Kopytoff, Igor. "The Cultural Biography of Things: Commoditization as Process." In *The Social Life of Things: Commodities in Cultural Perspective,* ed. Arjun Appadurai. Cambridge: Cambridge University Press, 1986.

Kossak, Steven M., and Jane Casey Singer. *Sacred Visions: Early Paintings from Central Tibet.* New York: Metropolitan Museum, 1998.

Lachman, Charles. "Blindness and Oversight: Some Comments on a Double Portrait of Qianlong and the New Sinology." *Journal of the American Oriental Society* 116 (October–December 1996): 736–744.

Lamotte, Etienne, trans. *L'enseignement de Vimalakīrti*. Louvain: Publications universitaires, 1962.

Lee, Hui-shu. "Art and Imperial Images at the Late Southern Song Court." In *Arts of the Sung and Yuan*, ed. Maxwell K. Hearn and Judith G. Smith. New York: Department of Asian Art, Metropolitan Museum of Art, 1996.

Lessing, Ferdinand. "Bodhisattva Confucius." In *Ritual and Symbol: Collected Essays on Lamaism and Chinese Symbolism*, ed. Lou Ts'u-k'uang and Wolfram Eberhard. Asian Folklore and Social Life Monographs, vol. 91. Taipei: Orient Cultural Service, 1976.

———. "The Topographical Identification of Peking." In *Ritual and Symbol: Collected Essays on Lamaism and Chinese Symbolism*, ed. Lou Ts'u-k'uang and Wolfram Eberhard. Asian Folklore and Social Life Monographs, vol. 91. Taipei: Orient Cultural Service, 1976.

———. *Yung-ho-kung: An Iconography of the Lamaist Cathedral in Peking with Notes on Lamaist Mythology and Cult*. Stockholm: Elanders Boktryckeri Aktiebolag, 1942.

Lévi, Sylvain, and Edouard Chavannes. "Les Seize Arhat Protecteurs de la Loi." *Journal Asiatique* 8 (July–August 1916): 5–50; (September–October 1916): 189–304.

Liu, Cary Y. "The Ch'ing Dynasty Wen-yüan-ko Imperial Library: Architectural Symbology and the Ordering of Knowledge." Ph.D. dissertation, Princeton University, 1997.

Liu, Lydia. *Translingual Practice: Literature, National Culture, and Translated Modernity. China, 1900–1937*. Stanford: Stanford University Press, 1995.

Looking at Patronage. San Francisco: Asian Art Museum, 1989.

Lou Ts'u-k'uang and Wolfram Eberhard, eds. *Ritual and Symbol: Collected Essays on Lamaism and Chinese Symbolism*. Asian Folklore and Social Life Monographs, vol. 91. Taipei: Orient Cultural Service, 1976.

Lovell, Hin-cheung. *An Annotated Bibliography of Chinese Painting Catalogues and Related Texts*. Ann Arbor: University of Michigan Center for Chinese Studies, 1973.

Ludwig, Ernest. *The Visit of the Teshoo Lama to Peking: Ch'ien Lung's Inscription*. Peking: Tientsin Press, 1904.

Markham, Clements Robert. *Narratives of the Mission of George Bogle to Tibet*. London: Trubner, 1879.

Martin, Dan. "Banpo Canons and Jesuit Cannons: On Sectarian Factors Involved in the Ch'ienlung Emperor's Second Goldstream Expedition of 1771–1776. Based Primarily on Some Tibetan Sources." *Tibet Journal* 15 (1990): 3–28.

McCallum, Donald. *Zenkoji and Its Icon: A Study in Medieval Japanese Religious Art*. Princeton: Princeton University Press, 1994.

Mémoires concernant l'histoire, les sciences, les arts, les moeurs, etc., des Chinois par des missionaires de Pékin. Paris: Chez Lyon, Libraire, 1776–1814.

Millward, James. "New Perspectives on the Qing Frontier." In *Remapping China: Fissures in Historical Terrain*, ed. Gail Hershatter et al. Stanford: Stanford University Press, 1996.

Mitchell, W. J. T. "Word and Image." In *Critical Terms for Art History*, ed. Robert S. Nelson and Richard Shiff. Chicago: University of Chicago Press, 1996.

Moses, Larry. "Legends by the Numbers: The Symbolism of Numbers in the *Secret History of the Mongols*." *Asian Folklore Studies* 55 (1996): 73–97.

———. "Triplicated Triplets: The Number Nine in the *Secret History of the Mongols*." *Asian Folklore Studies* 45 (1986): 287–294.

Naquin, Susan. *Peking: Temples and City Life, 1400–1900*. Berkeley: University of California Press, 2000.

Nattier, Jan. "The *Heart Sutra*: A Chinese Apocryphal Text?" *Journal of the International Association of Buddhist Studies* 15, no. 2 (1992): 153–223.

Nelson, Robert S., and Richard Shiff, eds. *Critical Terms for Art History.* Chicago: University of Chicago Press, 1996.

Nora, Pierre. "Between Memory and History: *Les Lieux de Mémoires.*" *Representations* 26 (1989): 7–25.

Orzech, Charles D. *Politics and Transcendent Wisdom: The* Scripture for Humane Kings *in the Creation of Chinese Buddhism.* University Park: Pennsylvania State University Press, 1998.

Pander, Eugen. *Das lamaische Pantheon.* Berlin: Berliner Zeitschrift für Ethnologie, Heft 2, 1889.

———. *Das Pantheon des Tschangtscha Hutukhtu.* Edited by Albert Grunwedel. In *Veröffentlichungen aus dem kgl. Museum für Völkerkunde in Berlin,* I, 2/3, 1890.

———. *Lalitavajra's Manual of Buddhist Iconography.* Translated by Sushama Lohia. New Delhi: International Academy of Indian Culture and Aditya Prakashan, 1994.

Payne, Richard K. "Language Conducive to Awakening: Categories of Language Use in East Asian Buddhism. With Particular Attention to the Vajrayāna Tradition." *Buddhismus-Studien* 2 (1998): 1–47.

Pozdneyev, Alexei M. *Mongolia and the Mongols.* Translated by John Roger Shaw and Dale Plank. Bloomington: Indiana University Press; The Hague: Mouton, 1971.

Rawski, Evelyn S. *The Last Emperors: A Social History of Qing Imperial Institutions.* Berkeley: University of California Press, 1998.

———. "Presidential Address: Reenvisioning the Qing: The Significance of the Qing Period in Chinese History." *Journal of Asian Studies* 55, no. 4 (November 1996): 829–850.

Reischauer, Edwin O. *Ennin's Travels in T'ang China.* New York: Ronald Press, 1955.

Rhie, Marylin, and Robert Thurman. *Wisdom and Compassion: The Sacred Art of Tibet.* San Francisco: Asian Art Museum; New York: Tibet House, 1991.

Rogers, Howard. "For the Love of God: Castiglione at the Qing Imperial Court." In *Chinese Painting Under the Qianlong Emperor,* ed. Ju-hsi Chou and Claudia Brown. *Phoebus* 6, no. 1 (1988): 141–160.

Samoyault-Verlet, Colombe, et al. *Le Musée chinois de l'impératrice Eugénie.* Paris: Éditions de la réunion des musées nationaux, 1994.

Schwartz, Hillel. *The Culture of the Copy: Striking Likenesses, Unreasonable Facsimiles.* New York: Zone Books, 1996.

Sharf, Robert H. "The Scripture on the Production of Buddha Images." In *Religions of China in Practice,* ed. Donald S. Lopez Jr. Princeton: Princeton University Press, 1996.

Soper, Alexander Coburn. *Literary Evidence for Early Buddhist Art in China.* Artibus Asiae suppl., no. 19. Ascona, Switz.: Artibus Asiae, 1959.

Spence, Jonathan D. *The Memory Palace of Matteo Ricci.* New York: Viking Penguin, 1984.

Sperling, Elliot. "Ming Ch'eng-tsu and the Monk Officials of Gling-tshang and Gon-gyo." In *Reflections on Tibetan Culture: Essays in Memory of Turrell V. Wylie,* ed. Lawrence Epstein and Richard F. Sherburne. Studies in Asian Thought and Religion, vol. 12. Lewiston, N.Y.: Edward Mellen Press, 1990.

Staal, Frits. *Rules Without Meaning: Ritual, Mantras, and the Human Sciences.* Toronto Studies in Religion, vol. 4. New York: Peter Lang, 1990.

Staël-Holstein, Nicholas von. "The Emperor Ch'ien-lung and the Larger *Śūraṃgamasūtra.*" *Harvard Journal of Asiatic Studies* 1, no. 1 (1936): 136–146.

———. "Remarks on the Chu Fo P'u Sa Shēng Hsiang Tsan." *Bulletin of the Metropolitan Library* 1, no. 1 (1928): 78–80.

Stewart, Susan. *On Longing: Narratives of the Miniature, the Gigantic, the Souvenir, the Collection.* Durham: Duke University Press, 1993.

Stoddard, Heather. "Dynamic Structures in Buddhist *Maṇḍalas: Apradakṣina* and Mystic Heat in the Mother *Tantra* Section of the *Anuttarayoga Tantras.*" *Artibus Asiae* 58, nos. 3–4 (1999): 169–213.

———. "A Stone Sculpture of mGur mGon-po, Mahākāla of the Tent, Dated 1292." *Oriental Art,* n.s. 31, no. 3 (Autumn 1985): 278–282.

Tachikawa, Musashi, Shunzo Onoda, Keiya Noguchi, and Kimiaki Tanaka. *The Ngor Mandalas of Tibet: Listings of the Mandala Deities.* Tokyo: Centre for East Asian Cultural Studies, 1991.

Tāranātha. *The Origin of the Tārā Tantra.* Translated by David Templeman. Dharamsala: Library of Tibetan Works and Archives, 1981.

Thangka, Buddhist Painting of Tibet: Biographical Paintings of 'Phags-pa. Beijing: New World Press and People's Publishing House of Tibet, 1987.

Thurman, Robert A. F., trans. *The Holy Teaching of Vimalakīrti: A Mahāyāna Scripture.* University Park: Pennsylvania State University Press, 1976.

Tsongkhapa. *Tsongkhapa's Six Yogas of Naropa.* Edited and translated by Glenn H. Mullin. Ithaca: Snow Lion, 1996.

Tsultem, N. *The Eminent Mongolian Sculptor—G. Zanabazar.* Ulaanbaatar: State Publishing House, 1982.

Tucci, Giuseppe. *Rin-chen-bzan-po and the Renaissance of Buddhism in Tibet Around the Millennium.* Indo-Tibetica, vol. 2. Translated by Nancy Kipp Smith. New Delhi: Aditya Prakashan, 1988.

———. *Tibetan Painted Scrolls.* Rome: Libreria dello Stato, 1949.

Vinograd, Richard. *Boundaries of the Self: Chinese Portraits, 1600–1900.* Cambridge: Cambridge University Press, 1992.

Vira, Ragu, and Lokesh Chandra, eds. *A New Tibeto-Mongolian Pantheon.* New Delhi: International Academy of Indian Culture, 1961–1972.

Wang Xiangyun. "Tibetan Buddhism at the Court of Qing: The Life and Work of lCang-skya Rol-pa'i-rdo-rje (1717–1786)." Ph.D. dissertation, Harvard University, 1995.

Wang Yao-t'ing. "From *Spring Fragrance, Clearing After Rain* to *Listening to the Wind in the Pines*: Some Proposals for the Courtly Context of Paintings by Ma Lin in the Collection of the National Palace Museum, Taipei." In *Arts of the Sung and Yuan,* ed. Maxwell K. Hearn and Judith G. Smith. New York: Department of Asian Art, Metropolitan Museum of Art, 1996.

Watson, Burton, trans. *The Vimalakīrti Sūtra.* New York: Columbia University Press, 1997.

Weidner, Marsha, ed. *Latter Days of the Law: Images of Chinese Buddhism: 850–1850.* Lawrence, Kans.: Spencer Museum of Art; Honolulu: University of Hawai'i Press, 1994.

Wen xuan or Selections of Refined Literature. Translated and annotated by David Knechtges. Princeton: Princeton University Press, 1982.

West, Stephen H. "Memory, Ritual, and Orality in Court: Huizong's Birthday Ceremony in the 1120's." Colloquium, Center for Chinese Studies, University of California, Berkeley, November 19, 1999.

Whitfield, Roderick. "Chang Tse-tuan's Ch'ing-ming shang-ho-t'u." Ph.D. dissertation, Princeton University, 1966.

Wilkinson, Endymion. *Chinese History: A Manual.* Cambridge, Mass.: Harvard University Asia Center, 1998.

Willson, Martin. *In Praise of Tara.* London: Wisdom, 1986.

Wu Hung. "Art in Ritual Context: Rethinking Mawangdui." *Early China* 7 (1992): 111–144.

———. *The Double Screen: Medium and Representation in Chinese Painting.* Chicago: University of Chicago Press, 1996.

———. "Emperor's Masquerade—Costume Portraits of Yongzheng and Qianlong." *Orientations* 26, no. 7 (July–August 1995): 25–41.

———. "Rethinking Liu Sahe: The Creation of a Buddhist Saint and the Invention of a 'Miraculous Image.' " *Orientations* 27, no. 10 (November 1996): 32–43.

Yang Boda. "The Development of the Ch'ien-lung Painting Academy." In *Words and Images: Chinese Poetry, Calligraphy, and Painting,* ed. Alfreda Murck and Wen Fong. New York: Metropolitan Museum of Art; Princeton: Princeton University Press, 1991.

Yang Xin. "Court Painting in the Yongzheng and Qianlong Periods of the Qing Dynasty." In *The Elegant Brush: Chinese Painting Under the Qianlong Emperor,* ed. Ju-hsi Chou and Claudia Brown. Phoenix: Phoenix Art Museum, 1985.

Yang Xin and Zhu Chengru. *Secret World of the Forbidden City: Splendors from China's Imperial Palace.* Santa Ana, Calif.: Bowers Museum of Cultural Art in association with the Palace Museum, Beijing, 2000.

Yates, Frances A. *The Art of Memory.* New York: Penguin Books, 1969.

Zito, Angela. *Of Body and Brush: Grand Sacrifice as Text/Performance in Eighteenth-Century China.* Chicago: University of Chicago Press, 1997.

———. "Silk and Skin: Significant Boundaries." In *Body, Subject, and Power in China*, ed. Tani E. Barlow and Angela Zito. Chicago: University of Chicago Press, 1994.

Index

Numbers in italics refer to illustrations.

For Tibetan names and terms, the Wylie transcription has been supplied in parentheses.

253

Qianlong's studio name, 53; and shared surnames, 138, 160; of Tibetan deities in China, 111–112, 128, 131, 135, 142, 222n.12

Nanzhao ruling family, founding myth of the Meng, 160–161

Nanzhao tuzhuan, 151–152, 157, *158*

Narthang, Five Hundred Gods of, 228n.10

Narthang series of Panchen Lama portraits, *173*, 174–175, 176; woodblock prints after, 175–176, *175*, 177, 228n.10

National Preceptor. *See* Rolpay Dorje (Rol pa'i rdo rje), Third Zhangjia Khutukhtu

Nayancheng, 71, 212n.19

Nenying (gNas rnying), 173

Nepalese style, 33; painting, 173; of sculpture, 24, *24*, 26, 28–29, *28*, 203n.20

New Menri school style, 172–173, 175, 176

Ngök Jangchub Jungney (rNgog Byang chub 'byung gnas), 95

Nian da ha jing (Recalling the Great Ha-ha Sutra) ritual, 199n.4

nine, meaning of in gifts, 48, 105

nine Buddhas of Boundless Life (Amitāyus), 49–50, *49, 50*

Nine Whites gift, 48

nirvana, 117, 192; and samsara, 3, 4, 197

nonduality: and emptiness, 8, 127, 196; of Mādhyamika, 22, 23; Qianlong's engagement with issues of, 8, 23, 52, 139

numerology, 193; and the number of gifts, 48

"one and/or two," 51–54, *51*; the paradox of, 86, 138, 192, 197; portrait series, 51–54, *51*, 139; Qianlong's portraits depicting, 1, 2, 4, 13, *51*, 52, 103, *Pl. 1*

painters. *See* artists

painting, 141–148; "brush, traces of the," 122; "brush idea" *(biyi)*, 137, 139, 142, 154; "hand," 138; hybrid and hyphenated styles of, 22, 142, 144–145, 166, 172, 177, 201n.3; Karmapa style, 145-146; mandala structure, 21–22; multistylistic tradition of, 146; New Menri school, 172–173, 175, 176; *Rimokan*, painting manual, 173–174; and *shenhui* (spiritual communion) through emulation, 134; verbal and visual media mixed in, 61–62, 83, 176, 206n.12; *yipin* (untrammeled class), 138

paintings, writing comments on. *See* inscriptions; Qianlong's inscriptions

Palsang Chöje (dPal bzang chos rje), 119

Panchen Erdeni. *See* Sixth Panchen Lama, Losang Paldan Yeshe

Panchen Lama: Fourth, Losang Chökyi Gyaltsen (bLo bzang chos kyi rgyal mtshan), 27, 55, *173*, 175, 176; Fifth, Losang Yeshe (bLo bzang ye shes), 167, 169, 176; Ninth, 176; Tenth, 167–168; Sakya Pandita (preincarnation), *173*, 174–175, 176; Yungtön Dorje (g.Yung ston rdo rje, pre-incarnation), 175. *See also* Sixth Panchen Lama, Losang Paldan Yeshe

Panchen Lamas, 119–120; and the Dalai Lamas, 167–168, 178, 181, 182; death and depiction of, 187, 189–190; and Khalka Mongols, 229n.24; lineage of, 25–26, 115, 193; portraits, series of, 168–177; and selection of Ishi-damba-nima, 16, 17, 21, 26, 202nn.4, 13

pantheon, Tang. *See Long Roll of Buddhist Images* (Zhang Shengwen)

pantheon, the Tibetan Buddhist: for Chinese-reading audiences, 91; Chinese version of, 111–112, 135; ever-changing nature of, 89, 110–116, 218n.63; field of assembly or refuge tree, 60; *Five Hundred Gods of Narthang*, 228n.10; and meta-image, 12; politically significant deities, 23–24, 25–26, 92, 101, 203n.24; pre-Qing precedents of, 89–96; Rolpay Dorje's, 88, 96–97, 109–116, 214n.20, 222n.12; twenty-three categories of (list), 218n.64

pantheons, instructional, by Rolpay Dorje, 109–116; for artists or practitioners, 115–116; the first, 112–113; *Three Hundred Icons*, 110–111, 113–116, *114*, *Pl. 12*

pantheons, sites of enlightenment, 96–110; Baoxianglou, 104–108; Fanhualou, 108–110, *109*, *Pl. 11*; Qianlong's patronage of systematic, 123; Yuhuage, 97–104, *97, 101*

paradox: of dharma as dharmaless, 186; of the Double Truth, 3, 4; of form and emptiness, 7–9, 13, 110, 123; of "one and/or two," 86, 138, 192, 197. *See also* ambiguities

pattern: arithmetical, 107, 115; ritualized, 8, 221n.1; transformation by, 124

Pavilion, Stone Drain (Shiqu Ge), 64

Pavilion of Raining Flowers (Yuhuage), 97–104; architecture as a mandala, 102; Daoguang inventory of, 102; exterior view, *97*; the hidden floor in, 103–104; layout of sculptural groups in (chart), 100; main sculptural group, *101*; the naming of, 103; paradox of the Double Truth and form of, 3; precedents for, 97–98; recitations in, 104; Rolpay Dorje's design and purposes for, 103–104, 109, 110, 189; second purpose of, 101–102; thangkas in the, 101–103, 111; Yuhuage three-dimensional mandalas (first floor), 98, *Pl. 10*

peace, temples celebrating, 202n.9

Patricia Berger is an associate professor in the Department of the History of Art, University of California, Berkeley, after spending many years as curator of Chinese Art at the Asian Art Museum of San Francisco. She is co-author, with Terese Bartholomew, of *Mongolia: The Legacy of Chinggis Khan* (1995), a contributor to *Latter Days of the Law: The Chinese Transformation of Buddhist Art* (1994), and author of numerous articles on Chinese and Inner Asian art.